THE ENGRAVED GEMS OF THE GREEKS
ETRUSCANS AND ROMANS
BY G. M. A. RICHTER

PART ONE:
ENGRAVED GEMS
OF THE GREEKS AND THE ETRUSCANS

THE ENGRAVED GEMS OF THE GREEKS
ETRUSCANS AND ROMANS ～ PART ONE

ENGRAVED GEMS
OF THE GREEKS
AND THE ETRUSCANS

A HISTORY OF GREEK ART
IN MINIATURE

BY GISELA M. A. RICHTER

PHAIDON

© 1968 PHAIDON PRESS LTD · 5 CROMWELL PLACE · LONDON SW7

PHAIDON PUBLISHERS INC · NEW YORK
DISTRIBUTORS IN THE UNITED STATES: FREDERICK A. PRAEGER INC
111 FOURTH AVENUE · NEW YORK · N.Y. 10003
LIBRARY OF CONGRESS CATALOG CARD NUMBER: 68–27417

SBN 7148 1347 8

MADE IN ENGLAND
TEXT PRINTED BY R. & R. CLARK LTD · EDINBURGH
PLATES PRINTED BY COTSWOLD COLLOTYPE CO LTD · WOTTON-UNDER-EDGE · GLOUCESTERSHIRE

CONTENTS

II. ETRUSCAN GEMS

PREFACE

THE immediate incentive to write a general, comprehensive account of Greek, Etruscan, and Roman engraved gems was a recent review of my *Catalogue of Engraved Gems of the Metropolitan Museum of Art* (1956), by Victor Tournier (in the Belgian periodical *Phoibos*, 1964, p. 125). In it – after criticizing me for only illustrating the gems in enlarged views taken from the impressions – he said that this catalogue was the 'meilleur instrument de travail pour les archéologues qui veulent s'initier à la connaissance des pierres gravées antiques'. Knowing full well that my book, being merely a descriptive catalogue of a single collection, was an inadequate introduction to this vast and complicated subject, Mr. Tournier's kind remark made me realize that an up-to-date general treatment of the subject did not exist and was needed. And the Phaidon Press encouraged me in this project, even suggesting a larger book than I had at first envisaged, and allowing me a generous number of illustrations, thereby making my text intelligible.

To explain the absence of general books on engraved gems in contrast to the many volumes that have appeared during the last years on other aspects of Greek art – on pottery, bronze and terracotta statuettes, metalware, coins, and of course sculpture and painting – I may quote a remark made by Furtwängler while he was spending many years preparing the catalogue of engraved gems in the Museum of Berlin: 'Only to very few people do outward circumstances permit to take part in this branch of our studies – to those few, I mean, who can day by day, without hindrance, examine an important collection of engraved gems and impressions. For, as everyone knows who has had experience in this matter, it is only through constant practice that the eye gradually acquires the ability to arrive at sound judgments' (cf. *J.d.I*, III, 1888, p. 105; reprinted in his *Kleine Schriften*, II, p. 147).

These 'outward circumstances' will explain that since Furtwängler's monumental *Antike Gemmen*, published in 1900, no comprehensive book on engraved gems has appeared, only a few catalogues of specific collections and articles dealing with special questions (see Bibliography). And yet a study of these gems is singularly rewarding. We can there watch the whole evolution of Greek art, beginning with the Geometric period of the late ninth and eighth centuries, proceeding to the epoch of heterogeneous Oriental influences, and then passing stage by stage to the pure Greek forms of the archaic, the developed, and the Hellenistic periods. Moreover, we can watch this epoch-making development in Greek originals, often in almost pristine condition, small, it is true, but thereby enabling us to hold and turn them in our hands and to study them at close range.

I have had two primary aims in writing this book. First I have tried to give a representative selection of examples to bring home the beauty and interest of these stones. For this purpose – profiting by Mr. Tournier's criticism – I have given, when possible, two illustrations of each gem – one of the original stone in its actual size, and another of the impression made by the intaglio, enlarged generally three diameters. The photographs taken directly from the originals illustrate not only the minute size in which the designs were cut – which constitutes one of their special attractions – but they can convey some feeling of the luminosity and preciousness of the material, and, above all, they bring us in direct contact with the artist's work. The photographs taken from the impressions, on the other hand, will show the engravings not in reverse as they appear in the intaglios, but as they were intended to be seen when used as seals; and the

enlargements will avoid the laboriousness and fatigue of a constant use of the magnifying glass, sometimes even revealing details not otherwise easily visible. The two views of each gem have been placed side by side, so that the eye can pass from one to the other, for only so can one, I think, fully appreciate and enjoy these often masterly products.

The second aim of this book is to present a history of Greek art in miniature. Since the engraved gems supply original examples of this art, period by period, generally unbroken and unrestored, they can usefully supplement our histories of Greek sculpture and painting. I have, therefore, arranged my material in chronological sequence, and given an introductory chapter for each period.

In the early examples one can watch the steady progress of knowledge in human anatomy, in the rendering of drapery, in foreshortening, and one can detect the beginnings of linear perspective. Especially in the developed period of the fifth and fourth centuries B.C. one sometimes encounters masterpieces which can hold their own with the best products in other fields of Greek art; and all, even the most cursory, show the proficiency attained in this exacting craft. Revealing are also the Hellenistic gems, both the intaglios and the then newly introduced cameos. They constitute an important enlargement of extant later Greek art, exemplifying the creativeness of Hellenistic artists in many new directions.

Of great interest are also the Etruscan engraved gems. They too have been a comparatively neglected field of study, rarely treated in detail in the many recent histories of Etruscan art. And yet some rank among the best products of this art. They, moreover, throw an interesting light on the relationship of Greeks and Etruscans; for one can sometimes compare an actual Greek creation with its Etruscan adaptation, and one can learn when the relationship between the two peoples was close and when it was not; and this in its turn clarifies the history of the time. Furthermore, many of the representations on Etruscan intaglios preserve Greek legends which have not otherwise survived, and so contribute to our knowledge of Greek mythology.

To some degree also the Roman engraved gems can teach us much that supplements other fields of Roman art. They too show the deep admiration in Roman times of Greek culture, and the widespread knowledge of Greek mythology. In addition, they supply many representations of purely Roman scenes, supplementing those on the coins; and, above all, they give us a series of splendid Roman portraits, many of them of finer quality than any that exist in the larger sculptures.

I have confined my account to these three categories – the strictly Greek, the Etruscan, and the Roman – as I did in my 1956 catalogue of the New York collection – for it is only they that present a continuous and unified story. Though recent discoveries have shown that the Mycenaeans were of Greek stock, it is nevertheless apparent that in art there is no real continuity. Mycenaean art is closely allied to the Minoan, in subjects, in spirit, and in style. The Greek geometric, on the other hand, constitutes the beginning of a new era, starting from primitive, linear designs, presently vitalized by Oriental influences, and then proceeding on its own independent path. The Minoan and Mycenaean examples form a study by themselves, which, moreover, has been and is being extensively explored by other writers.[1]

I have divided my story into two parts, published in two separate volumes: (1) the Greek and the con-

[1] I understand that a handbook of engraved gems, from Near Eastern to Roman, by the Rev. V. E. G. Kenna, J. Boardman, and M.-L. Vollenweider, with special emphasis on the Minoan-Mycenaean, is to be published by the Phaidon Press, and that in Germany a corpus of Minoan and Mycenaean gems is in preparation. J. Boardman's *Engraved Gems, The Ionides Collection* (1968) appeared when the page proof of this book was in its last stages, and when his *Archaic Greek Gems* had been announced but not yet published. The interest in Greek gems is evidently suddenly on the increase.

temporary Etruscan; and (2) the Italic, that is the Roman Republican, and the Imperial Roman. Historically and numerically this seemed a convenient division. The present part, on the Greek and the Etruscan, is soon to be followed by the Roman.

To bring out the evolution of styles and of subjects I have grouped my material in various categories, each with a short introduction, and in the descriptions of the individual gems I have called attention to details in the representations, which, being of minute size, might otherwise escape the reader. In addition, I have given the information relating to engraved gems as a whole in a general introduction.[1]

In the selection of the gems to serve as illustrations I have drawn on the treasure houses of the British Museum, the Cabinet des Médailles, and the Staatliche Museen of Berlin; on the outstanding collections of the Museum of Fine Arts in Boston, the Metropolitan Museum in New York, and the Ashmolean Museum in Oxford; and I have supplemented these with examples in the Hermitage, Vienna, Munich, Hamburg, Leipzig, Copenhagen, Baltimore, Chicago, Bowdoin College, The Hague, Cambridge, Brussels, Athens, Taranto, Naples, Syracuse, Florence, Rome, Venice, Sofia, and in a few private collections. Together, in the 870 specimens which I have been able to assemble for this volume, they should give a fairly comprehensive picture of the styles and subjects current in each period. Many of the examples are well known, others are here published for the first time.

Any writer on Greek and Etruscan engraved gems will, even after the lapse of almost seventy years, use Furtwängler's epoch-making *Antike Gemmen* as a fundamental source. Furtwängler was the first to put this whole intricate subject on a sound, scientific basis. By his incomparable gift of comprehending both the general and the particular, he was able to give a consecutive historical account, illustrated by several thousands of examples. It was a feat rarely equalled in our archaeological literature. Though since Furtwängler's time our knowledge of engraved gems has naturally been enlarged and some rectifications of his text have become necessary,[2] in essentials the story has changed little, at least in comparison with that of other branches of Greek art.

I have naturally also profited from some of the more recent writings, especially from J. D. Beazley's *Lewes House Gems* (1920), and, for the early period, from J. Boardman's *Island Gems and Greek Seals in the Geometric and Early Archaic Periods* (1963); cf. also his articles cited in my Bibliography and footnote on p. viii.

I cannot sufficiently thank the authorities of the various Museums where I have worked – e.g., the British Museum, the Ashmolean Museum, the Fitzwilliam Museum, the Corpus Christi College in Cambridge, the Cabinet des Médailles, the Museum of the Louvre, the Numismatic section of the National Museum of Athens, the Vatican Library, and the Museo Nazionale Romano delle Terme for their help in my studies. Without the privilege of handling many hundreds of their gems outside their cases and examining them with my magnifying glass I could not have written this book. And without the necessary photographs and impressions sent me by the various Museums all over Europe and America the book could not have been as useful as I hope it will be. Furthermore, I want to acknowledge the invaluable assistance given me by Mrs. Nina Longobardi and her associates during the many delightful hours I have

[1] In these introductions, and in the descriptions of the gems in the collection of the Metropolitan Museum, I have sometimes freely borrowed from the text of my 1956 catalogue – with the kind permission of the Museum authorities.

[2] For some of these cf. also O. Rossbach in *R.E.*, VI, 1 (1910), s.v. Gemmen.

spent in the Library of the American Academy; by Professor Margherita Guarducci for help in deciphering and evaluating the Greek inscriptions on the gems; by Mr. Kenneth Jenkins for revising my chapter on Hellenistic portraits and making many valuable suggestions; and by S. von Bockelberg and G. Scichilone for verifying various references. In addition my thanks go out to many a friend and colleague for precious information.

 The quality of the photographs taken from the original gems varies according to the ability of the photographer to cope with the peculiar difficulties presented by the often luminous surfaces and transparencies of the stones. In some Museums there was no one with the skill required by this meticulous work. It was furthermore impossible in some cases to obtain good impressions of the gems, for they too required professional skill and experience.[1] Fortunately several of the principal Museums in which the gems reside had expert workmen and have been able to send me adequate and sometimes superb specimens, so that in most cases I have been able to carry out my plan of illustrating each gem in two good views – the chief exception being those in the Staatliche Museen in Berlin. Of these, in order not to conflict with the prospective new catalogue of that collection by Erika Diehl, I could only obtain twenty out of the *circa* ninety I had selected in views taken from the original stones; but I am particularly grateful to Dr. Greifenhagen for sending me excellent impressions of all the gems I needed and allowing me to illustrate them in my book. My largest contingent comes from the British Museum, of which about sixty have been photographed for me by Mrs. Czako Stresow – to whom and to the keeper of the department, Mr. Denys Haynes, and to R. Higgins, the Deputy Keeper, I am much beholden. I have also been fortunate in having the noted photographer J. Felbermeyer, here in Rome, make the enlarged photographs from practically all the impressions. Their excellence will add to the usefulness of this book. On pls. A, B, C, D appear some of the masterpieces included in this book enlarged from the originals.

 G. M. A. R.

[1] As is well known, plaster, when dry, becomes crumbly; and so, when the impression is removed from the intaglio, certain injuries sometimes result. When these were confined to the edges or to a few unimportant details, I have left well enough alone. When, however, the design itself was affected, I have tried to get better impressions. In a few Museums experiments are being made with other materials which are yielding good results.

DIRECTIONS FOR THE USE OF THE BOOK

In my selection of engraved gems for this book are included the designs both on stones and on metal rings. In the latter I have confined my descriptions to the design on the bezel, and do not give a detailed description of the ring; but I mention its type (often with a reference to Marshall's *Catalogue of Finger Rings in the British Museum*) and I give illustrations of the chief forms current in each period. The same applies to the beetle scarab, which I have also not tried to describe in detail, although I have, when possible, stated whether there is a marginal vertical ornament, since that is sometimes a useful distinguishing mark between archaic Greek and archaic Etruscan work.

In the text relating to the individual gems I give the material, the shape, the dimensions, the provenance when known, the present location, and a description of the design. The dimensions are taken both from existing publications, and from the impressions and the photographs of the original stones, which are supposed to be actual size. When the design is on a ring the dimensions given are generally those of the bezel. The materials are also taken mostly from the published catalogues, except when obvious rectifications were called for. As is well known, the names for the different stones used by archaeologists and by mineralogists are often diverse. As this book is intended for archaeologists and the general public, it seemed better to adhere to the accepted names than to introduce new ones. Nor is the distinction between archaeological and mineralogical terms generally important; for many of the semi-precious stones come from the same rocks, and are distinguished merely by their colouring (cf. pp. 9 ff.). The colour plates with examples of the various stones used by ancient gem engravers (all in the British Museum) will help to give an idea of their great variety and attraction. In systematizing these plates I have had the help of Miss Bimson of the Research Laboratory of the British Museum, and of R. Higgins of the Greek and Roman Department; and on it I have added the mineralogical term to the archaeological one (cf. pp. 8 f.).

After the description of the scene represented and a short discussion of it. I give a few bibliographical references. These are mostly confined to the early publications (which shed light on the history of the gem), to Furtwängler's *Antike Gemmen*, and to the catalogues of the collections in which the gems are. Other references will be found in my general bibliography, which includes both the recent writings and those of the Renaissance and the eighteenth and nineteenth centuries.

The gems are arranged in their respective periods, beginning with the Greek geometric and the period of Oriental influences (including the Graeco-Phoenician and the Island), followed by the archaic, the developed (including the Graeco-Persian), and the Hellenistic (with a special subdivision for Hellenistic portraits). In a separate chapter come the Etruscan gems, early, middle, and late. Within these large divisions I have arranged the gems both chronologically and by subjects. Thus by turning the pages of this book the reader can view the development of Greek and Etruscan art in their various phases and aspects.

I should add that I have not tried to localize 'schools' in the production of the engraved gems, for this seems to me still a hazardous pastime. Only in the case of Graeco-Phoenician and Graeco-Persian, and in the Island Gems, have I made separate groups, helped not only by their style, but by the subjects represented. Nor have I attempted to distinguish the works of individual artists – except of course where gems are signed by their makers. I leave this fascinating work to the other scholars who are at work on this study. To me the chief interest has been to trace the evolution of styles and subjects within the framework of our present knowledge of Greek and Etruscan art.

In my descriptions of the engravings the terms 'right' and 'left' refer to the impression, not to the original, except of course when the design is in relief, e.g., in the cameos.

To signify the ornament on the outer (vertical) side of the scarab I use the expression 'marginal ornament' (as did Walters), and I call the border that appears on the majority of the scarabs 'hatched' border (as did Beazley), not 'cable' border (as did Walters). 'Ground line' signifies the horizontal line placed at the bottom of the scene (regularly in the earlier gems, only occasionally later); generally it is continuous, as the ground should be on which people stand; but sometimes it becomes irregular – to indicate uneven terrain – or a series of dots or little hatchings, when, for instance, it indicates the air in which Eros is flying (cf. no. 534), or wavy lines when it indicates the sea.

The abbreviations of periodicals are the customary ones; those of books will be understood by consulting the Bibliography.

GENERAL INTRODUCTION

THE engraving of stones to serve as seals and amulets and decorations is an ancient art. It was practised in Western Asia as early as the fourth millennium B.C., and was continued by the Egyptians, Minoans, and Mycenaeans. It is from these predecessors that the Greeks learned the essentials of the craft. But, as in other fields, Greece was an independent borrower. What she adopted was external, the spirit was her own. She transformed both subjects and style. Instead of representing stock themes, instead of endlessly repeating daemons and potentates, the Greek artists explored the world of nature, and so gradually liberated themselves from ancient conventions. Gods and heroes are made to resemble human beings, the incidents of daily life and the animal world are observed with eager curiosity.

This transformation is visible in the engraved gems, as it is in other branches of Greek art, and indeed forms a story of absorbing interest. Before viewing the evolution of this story in specific examples of various periods, we must first study the aspects common to all Greek gems; for only so can one obtain a proper understanding of this branch of Greek art.

1. THE USES OF ENGRAVED GEMS

Engraved gems had three chief uses – as seals, as amulets, and as ornaments. And since these uses are essentially personal, the stones shed light also on their possessors.

(a) *Gems as seals*

The primary object of a Greek engraved gem was, as it had been in the Orient,[1] to serve as a seal. That is, the engraved design was impressed on some soft material like clay, to serve for identification. The gems, in other words, took the place of our Yale keys and combination locks, and so played an important role in everyday life. The Greek householder guarded against theft by placing his seal on the doors of the chambers and closets and boxes in which he kept his supplies, his secret papers, and his jewellery. Ancient writers refer to this practice. On Agamemnon's return from Troy, Klytemnestra sends him a message that he will find his treasures intact, with no seal broken: σημαντήριον οὐδὲν διαφθείρασαν (Aischylos, *Agamemnon*, 609 f.). In the *Thesmophoriazousai* of Aristophanes (414 ff.) the women complain that the stores of meal, oil, and wine are guarded too well by their husbands' seals, σφραγῖδας ἐπιβάλλουσιν. Isokrates (*Orations*, XVII, 33, 34) is shocked by the action of Pythodoros, who opened the voting urns 'sealed by the Prytanes and countersealed by each of the choregoi'.

The seal, moreover, corresponded to the written signature of today. At a time when many people could not write the impression of a personal seal was the only reliable identification mark. And before the time of a postal service, letters had to be entrusted to private messengers who might or might not be

[1] In speaking of the Babylonians Herodotos (I, 195) says: 'every man has a seal' σφρηγῖδα ἕκαστος ἔχει.

trustworthy. When Agamemnon sends a slave with a letter to his wife Klytemnestra and the slave asks him, 'Yet how shall thy wife and thy daughter know my faith therein that the thing is so', Agamemnon answers, 'Keep thou this seal, whose impress lies on the letter thou bearest', σφραγῖδα φύλασσ' ἣν ἐπὶ δέλτῳ τήνδε κομίζεις (Euripides, *Iphigeneia in Aulis*, 156f.; tr. A. S. Way). Again, Theseus, on discovering the tablet fastened to his dead wife's hand, knows it is truly hers by the 'impress of the carven gold', τύποι γε σφενδόνης χρυσηλάτου, and then proceeds to 'unveil the seal's envelopings', ἐξελίξας περιβολὰς σφραγισμάτων, to see what the tablet contains (Euripides, *Hippolytos*, 862 ff.).

Only in a case of dire necessity were such seals broken surreptitiously; as when Menelaos suspects Agamemnon's plot (cf. Euripides, *Iphigeneia in Aulis*, 325); or when king Pausanias' messenger thinks the letter entrusted to him might contain the order of his own death (Thucydides, I, 132, 5).

The seal was also used to attest a spoken message. When Deianeira sends Lichas to Herakles with the fatal robe, she gives him 'the impress of her signet ring as a token that he will surely recognize', σφραγῖδος ἕρκει τῷδ' ἐπὸν μαθήσεται (Sophokles, *Trachiniai*, 615). And Orestes, to convince the doubting Elektra of his identity, asks her to look at their father's signet ring, τήνδε προσβλέψασά μου σφραγῖδα πατρὸς ἔκμαθ' εἰ σαφῆ λέγω (Sophokles, *Elektra*, 1222 f.).

Against the danger of fraud naturally strict precautions had to be taken. And as early as the sixth century we hear of Solon making a law forbidding gem-engravers to keep copies of the seals they engraved (Diog. Laert., I, 57, and my p. 45).

There is also archaeological evidence for the custom of sealing precious possessions. For instance, several hundred terracotta sealings came to light near temple C at Selinus, where they had apparently been attached to important papyri. The fire that destroyed the documents in 249 B.C. preserved the sealings, turning the perishable clay into indestructible terracotta (cf. Salinas, *Not. d. Sc.*, 1883, pp. 288 ff., pls. VII–XV; Pace, *Arte e civiltà della Sicilia Antica*, II, pp. 497 ff., fig. 361; and my p. 143).

Similar examples dating from the Hellenistic period have been discovered elsewhere. In Seleucid Babylonia were found hundreds of perforated clay 'bullae' and tablets with single or multiple seal impressions, used for the sealing of documents. The documents and the strings used for attachment are gone, but the sealings were found scattered over the site of the temple of Warka, and are now housed in various Museums; cf. the important publication of the material by Rostovtzeff, 'Seleucid Babylonia: Bullae and Seals of Clay with Greek inscriptions', *Yale Classical Studies*, III, 1932, pp. 1 ff., pls. I–XI. Of special interest among these sealings are some bearing portrait heads of Seleucid kings (see my nos. 658–661).

Other clay sealings have come from Seleucia on the Tigris (cf. McDowell, 'Stamped and Inscribed Objects from Seleucia on the Tigris', *The University of Michigan Studies*, XXXVI, 1935); from Carthage (cf. Delattre, 'Le Cosmos', *Revue des sciences et de leur application*, XXVII, 1894, pp. 213 ff.); from Elephantos (cf. O. Rubensohn, *Elephantine Papyri*, Berlin, 1907, pp. 7 ff., pl. II); from Priene (cf. Wiegand and Schrader, *Priene*, p. 465, no. 235); and from various sites – e.g., Egypt, Baalbek, Tarentum, Halikarnassos – all now in the British Museum (cf. Walters, *Catalogue of Terracottas*, pp. 443 ff.).

Furthermore, several thousands of such sealings, dating from the late Hellenistic period of the first century B.C., were found in the Nomophylakion of Cyrene (cf. E. Ghislanzoni, *Rendiconti Acc. Lincei*, serie VI, vol. I, fasc. 6 (1925), pp. 408 ff.), and have now been published by G. Maddoli in the *Annuario della Scuola Arch. di Atene*, XLI–XLII, 1963–64 (1965), pp. 39–145 (a reference I owe to Maria Santangelo). They comprise all manner of subjects, mythological, from daily life, and portraits. Here again the papyri

to which the clay sealings were attached were converted into ashes by a fire but the sealings were turned into terracotta and have survived. Some of the better preserved and most interesting are shown in my nos. 658–661; others will appear in volume II of this book.

In fact, since the custom of sealing valuable possessions was wide-spread in the ancient world, the only reason that not more of the original impressions now exist is that they were mostly of unfired clay which crumbled in the course of time. It is only through an accidental fire that some have been preserved; and all date from the turbulent Hellenistic times. So do also two interesting seal impressions on a loom-weight, recently found in Corinth and Satrianum, cf. p. 149. For sealings from Israel cf. *The Biblical Archaeologist*, XXV, 1963, p. 26, fig. 10, and XXVIII, 1965, p. 114, fig. 6.

For some Minoan sealings cf., e.g., D. Levi, 'L'archivio di credule a Festos', *Annuario*, XXXV–XXXVI, 1957, and the seal impressions on disk-shaped weights, also from Phaistos, published by D. Levi, *Annuario*, 1965–66, p. 588, figs. 17–23.

(b) *Gems as amulets*

Another important use of gems in antiquity was that of acting as amulets, since they were supposed to have curative and protective power. There is abundant evidence for this, both for Greek and Roman times. Aristophanes, in *Ploutos*, 883 f., for instance, speaks of a ring (δακτύλιον) serving as an antidote, which druggists sold to their clients. And in the scholia to this passage we are told that some rings could avert the evil eye and guard against snakes.

This belief in engraved gems as amulets became, as is well known, particularly wide-spread in Roman times. Thus Pliny in the 36th and 37th books of his *Natural History* – in large part culled from earlier writings – gives a long account of the magical properties of stones. In the Orphic poem περὶ λίθων, of the fourth century A.D., but recording earlier practices and beliefs, it is said that Hermes, at the behest of Zeus, gave these stones to mortal men for the prevention of suffering, and ordered Orpheus to announce their properties to them.

On this subject cf. especially Campbell Bonner, *Studies in magical amulets, chiefly Graeco-Egyptian*, 1950.

(c) *Gems as ornaments*

Gems were also used merely as ornaments, but at first mostly without engravings. Naturally, the glitter of the stones and their variegated colours furnished an attractive adjunct to costly articles. Thus Pausanias (v, 11) describes the throne of the statue of Zeus at Olympia as 'adorned with gold and precious stones', χρυσῷ καὶ λίθοις, as well as with ebony and ivory. The eyes of statues were also sometimes inlaid with ivory and precious stones; cf., e.g., Plato, *Hippias major*, 290, b, c.

The custom increased in Hellenistic times, when many more precious stones were made available to the Greeks through the Eastern conquests of Alexander the Great (cf. p. 134). Such stones were now used for the decoration of all sorts of objects. One hears of gold and silver vases studded with gems having been brought to Italy from Greece and Asia Minor as booty by the Roman conquerors; cf. Strabo, xv, 69, and Theophrastos, 23. The enormous wealth in such precious materials is brought home when one hears that in Pompey's triumphal procession 'gold vases adorned with gems, enough for nine buffets' were carried among the spoils; cf. Pliny, xxxvii, 6.

Though coloured stones sometimes occur in earlier Greek jewellery, such use was always limited and discreetly applied. In Hellenistic times, the practice increased, and rich and generally harmonious compositions were created, in which the gold was set off by the red, yellow, and blue of the stones. In general, however, these ornamental coloured stones were unengraved, the use of engraved stones being reserved for sealing. Only the cameos, where the design was worked in relief, were often used merely as decorations (cf. p. 135).

2. THE CHOICE OF DESIGNS

In the choice of the designs for their seals the Greeks borrowed from the prevalent artistic stock. In contrast to the people of Mesopotamia, who favoured ritual scenes, and to the Egyptians, who mostly used inscriptional devices, the Greeks drew their inspiration from the life around them and from their many colourful legends. Furthermore, it would have been an alien thought to a Greek to have as a device merely his monogram, as we might nowadays. His name, generally in shortened form, might appear in a secondary place, but the principal design was as a rule pictorial.[1] The choice would be a favourite deity, or mythological hero, or animal, or symbol. Occasionally the device might have no special relevancy, but be merely a beautiful composition that appealed to individual taste, or perhaps one that was supposed to have magical properties. Frequently, of course, the significance of a scene or of the emblems added in the field of the gem now escapes us; for we do not have, as we often have in coins, a knowledge of the historical background to help in the interpretation (cf. pp. 23 f.). On the whole, however, the devices on extant gems furnish an attractive supplement to those that appear on Greek vases and in other branches of Greek art. We meet here – in abbreviated form – the same deities, the same legends, and similar scenes from daily life, including animals and various objects in current use. And this assortment is especially interesting to us today on account of its very character. Each represents the choice of a specific individual, selected by him as an appropriate emblem.

[1] For a few exceptions, i.e., inscriptions giving the name of the owner as the sole decoration, or some greeting, cf. nos. 484 ff.

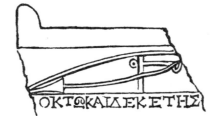

Fig. a. Gravestone of a gem cutter. Drawing. Cf. p. 5.

3. THE TECHNIQUE

Only soft stones and metals can be worked free-hand with cutting tools. The harder stones require the wheel technique, which was known to the Mycenaeans, who had probably learned it from artists of Western Asia. It was discontinued during the Geometric period, when only the softer stones were used; but was reintroduced during the archaic epoch, and then was used continuously until late Roman times. It is indeed only with the wheel technique that the best results can be attained.

Our knowledge of the methods employed by Greek and Roman gem engravers is based: (1) on the somewhat general references to the craft occasionally made by ancient writers;[1] (2) on a few ancient representations of gem engravers; (3) on an examination of the stones themselves.

From this evidence it may be deduced that the ancient method of engraving hard stones was much the same as that used today. The stones were worked with variously shaped drills which are made to rotate by the help of the wheel or some other device such as a bow. The actual cutting was not done by the drills, which were of comparatively soft metal (in Mycenaean times of bronze or copper, later of iron), but by the powder that was rubbed into the stone with the drill. This is nowadays the diamond powder, mixed with oil. What it was in ancient times is not certain, as it is not known how early the diamond came into use. It must have been accessible in Roman times, as it is mentioned both by Pliny (xxxvii, 15) and by M. Manilius (*Astronomicon*, iv, 926). It has been thought that the Greeks used the so-called Naxian stone, a species of corundum found in the island of Naxos.

The wheel used by gem engravers today is either worked by the foot or by an electric motor lathe. On the gravestone of a gem cutter of the Roman empire, found at Philadelphia in Asia Minor, a tool is represented which looks like the bow used by modern jewellers[2] (cf. fig. a on p. 4). A similar bow drill used by a carpenter is engraved on a scarab in the British Museum (cf. my no. 771). By being drawn quickly back and forth, the bow could impart a rotating movement similar to that of the wheel. As, however, the wheel was well known to the ancients in the making of pottery, it is probable that they made use of it in gem engraving also.

Nowadays the gem to be engraved is fastened to a handle and held to the drill, and moved as required.

[1] The most important are:

Theophrastos, Περὶ λίθων, I, 5: γλυπτοὶ γὰρ ἔνιοι, καὶ τορνευτοὶ καὶ πριστοί, τῶν δὲ οὐδὲ ὅλως ἅπτεται σιδήριον, ἐνίων δὲ κακῶς καὶ μόλις. 'There are some stones which can be engraved, others which are worked by the aid of the drill, still others which can be sawn; upon some an iron tool makes no impression; upon others again only slightly and with great effort'. vii, 41: ἔνιαι δὲ λίθοι καὶ τὰς τοιαύτας ἔχουσι δυνάμεις εἰς τὸ μὴ πάσχειν, ὥσπερ εἴπομεν, οἷον τὸ μὴ γλύφεσθαι σιδηρίοις, ἀλλὰ λίθοις ἑτέροις. ὅλως μὲν ἡ κατὰ τὰς ἐργασίας καὶ τῶν μειζόνων λίθων πολλὴ διαφορά. πριστοὶ γάρ, οἱ δὲ γλυπτοί, καθάπερ ἐλέχθη, καὶ τορνευτοὶ τυγχάνουσι (Teubner text). 'There are some stones which have the property, as I have said, of resisting an iron graver, but may be engraved by means of other stones. And in general there is a great difference between even the ... stones in the manner of working them, for some may be cut by the saw, some engraved as has been described, and some worked with the drill.'

Pliny, xxxvii, 76: 'Tantaque differentia est, ut aliae ferro scalp non possint, aliae non nisi retuso, verum omnes adamante. Plurimum vero in his terebrarum proficit fervor'. 'There is such a difference in the hardness of gems that some cannot be engraved with an iron tool, others only with a blunt graver, but all may be cut with the diamond. The heat of the drill is of great assistance in engraving.' By heat Pliny must of course mean the heat engendered by the rapid rotation of the drill.

xxxvii, 15: 'Et adamas cum feliciter rumpere contigit, in tam parvas frangitur crustas ut cerni vix possint. Expetuntur a scalptoribus ferroque includuntur, nullam non duritiam ex facili cavantes.' 'And when a diamond by good luck happens to break, it separates into particles so small that they can hardly be seen. These are in great request among engravers, who set them in iron and by this means are able to hollow out any hard surface with ease.'

[2] Cf. A. E. Kontoleon, *Ath. Mitt.*, xv, 1890, p. 333; Furtwängler, *A.G.*, iii, p. 399, fig. 206.

It has been thought that in ancient times the process was reversed, and the stone was held stationary while the rotating tools were guided by the hand. There is no means of settling this question. Fig. d on p. 25 shows an eighteenth-century engraver at work, sitting by his wheel and controlling the speed with his foot.

The tools must have been essentially the same as those in use today, that is, drills with a ball, disk, cylinder, or little wheel at one end, in sizes ranging from about a quarter of an inch to a pin point (cf. fig. b which shows the various tools used by the eighteenth-century gem engraver seen on p. 25). In the earlier Greek period the diamond point was apparently not used; but on Hellenistic and Roman gems there are occasionally fine lines with sharp ends that could only have been produced by such means; for lines made with drills always have rounded ends. The passage in Pliny (XXXVII, 15) which speaks of particles of diamond being set in iron has been thought to refer to the diamond point; but it may refer simply to work with diamond powder. Natter, in his *Traité*, p. XI, mentions the use of the diamond point for making a preliminary sketch. The unfinished engraving on a four-sided chalcedony reproduced on p. 7 (fig. c) shows two different stages in the work – a preliminary sketch drawn in fine lines, similar to that on Athenian vases, and rounded depressions made by the drill.[3]

After the cutting of the engraving was finished, the surface was often polished. Practice varied at different times. In early Greek times the engraving was either left dull, or the polish was confined to the larger surfaces. Etruscan scarabs, on the other hand, often have a high polish, even when the carving is cursory. Beginning with the Hellenistic period and throughout Roman times the more carefully worked gems are generally highly polished. Modern gem engravers use very fine diamond powder and

Fig. b. Tools used by eighteenth-century gem engravers. oil for a surface polish, and tripoli powder mixed with water for a polish of the engraving. According to Pliny (XXXVI, 10), the ancients used Naxian stone (*naxium*) for polishing.

Glass gems were cast from terracotta moulds made from existing stone gems, both intaglios and cameos. A number of these moulds have been found in Tarentum and are now in a private collection. The design was occasionally retouched afterwards. For a description of the modern method of making glass reproductions cf. Mariette, *Traité de pierres gravées* (1750), pp. 92 f., 210 ff.

The technique of cameos is in all respects similar to that of intaglios, so that the same remarks apply to both.

It is not definitely known whether the ancient gem cutters made use of the magnifying glass. The general principle of magnification by concentrating rays was known to Aristophanes, who refers to 'the transparent stone used to start fire', τὴν [λίθον] διαφανῆ, ἀφ' ῆς τὸ πῦρ ἅπτουσι (*Clouds*, 766 ff.). Pliny (XXXVI, 67, and XXXVII, 10) mentions balls of glass or crystal brought in contact with the rays of the sun to generate heat, and Seneca (*Quaestiones naturales*, 1, 6, 5) speaks of this principle applied for magnifying objects: 'quid mirum maiorem reddi imaginem solis, quae in nube umida visitur, cum ex duabus causis hoc accidat? Quia in nube est aliquid vitro simile, quod potest perlucere, est aliquid et aquae, quam, etiamsi nondum

[3] This gem was formerly in the possession of Professor Furt-wängler (cf. *A.G.*, III, p. 400, note 2), later in that of Sir Robert Mond. Its present whereabouts are not known either to Sir Robert's descendants, or in the British Museum.

Fig. c. Unfinished engraving on a four-sided chalcedony.

habet, iam parat, id est iam eius natura est, in quam ex sua vertatur.' It may be difficult to believe that the ancients could execute the fine work they did without lenses, and merely looked, as Pliny (xxxvii, 16) prescribes, at emeralds when their eyes were tired; but it is a fact that even nowadays, when strong lenses are easily available, gem engravers do not always use them. The well-known gem cutter, Mr. O. Negri, for instance, told me that he used lenses only in his later years.

The manifold difficulties of gem engraving are well set forth by Natter, the famous eighteenth-century engraver, in his *Traité*, pp. x f.:

'Certainly (the art of gem engraving) is more painful and discouraging than all others. For besides the knowledge of drawing, which is as necessary to an engraver in stone as to a sculptor or painter, he is obliged when he does whole figures or groups to regulate his design or composition according to the method of engraving; he must avoid, for example, perspective, which is so great an advantage to a painter, and the foreshortening of the parts of the body[1]; he must always strive to give his figures a light and easy position. . . . Another difficulty attending this art is that the engravings are commonly done on such small stones . . . that it is scarcely possible to draw the just proportions with the diamond point, which greatly fatigues the eyes; nor can they be cut afterwards without excellent eyesight and very good light. Furthermore, you cannot have the assistance of another to forward your work; and the least mistake in executing the design is very difficult if not impossible to correct. You must also form your idea of the design for the reverse of the engraving and engrave deep what is to appear in relief. Add to this that the stone is liable to be spoiled by many accidents. All these reasons discourage people from cultivating an art that requires so much precaution and labour, and which is at the same time not patronized by the rich and great.'

[1] We shall see, however, that the Greek gem-engraver by no means avoided the foreshortening of his figures. One can follow the progress achieved by Greek artists in this respect on engraved gems as one can in other branches of Greek art.

4. THE MATERIALS USED

For our knowledge of the materials used by the ancients for their engravings the extant stones of course supply the most reliable information. There is furthermore an extensive ancient literature on the subject. (On this cf. also Rossbach, in *R.E.*, VII, 1, s. v. Gemmen, cols. 1102–1115.)

Herodotos (III, 41) mentions the famous stone belonging to the tyrant Polykrates (cf. p. 20). Plato in his *Phaidon* (110c), in *Politikos* (303e), and in *Timaios* (59b, 60c, and 80c) occasionally refers to specific stones. Aristotle (*Meteor.*, IV, 9, p. 387 b, 17) speaks of the sealstone made of ἄνθραξ as the one hardest to destroy by fire. In Pseudo-Aristotle, περὶ θαυμαστ. ἀκουσμ. 76, are mentioned the elektron and the lynkurion as being used for sealing (81, p. 836 b, 3; 76, p. 835 b, 29).

Extensive information is derived from Theophrastos' essay περὶ λίθων, in which he discusses the qualities and places of origin of a number of stones (8, 29, 39, 27, 23, 35, 32, 33).

Some information can also be gleaned from Agatharchides' περὶ ἐρυθρ. θαλάσσ., 54; from Diodoros III, 38, II, 52, V, 23; as well as from various passages in Strabo's *Geography* in which he speaks of certain stones found especially in India (cf. XV, 718 C, XII, 540), or at the entrance of the Persian Gulf, or in Aethiopia (XVI, 767, XVII, 821).

Dionysios of Halikarnassos furnishes further information in his οἰκουμένης περιήγησις, in which he describes certain stones with their finding places (315 ff., 318 ff., 723 ff., 780 ff., 1011 ff., 1030 ff., 1075 ff., 1098 ff.).

The physician Dioskourides refers to a number of stones and discusses their possible medical properties (περὶ ὕλης ἰατρικῆς, I, 10, V, 104, 106, etc.).

Finally Pliny, in the last book of his *Natural History*, devotes many pages to gems – to their names, properties, and places of origin, classifying them principally by their rarity and their colours.

All this information would be more valuable to us today if the names which the ancients used could with certainty be identified with the stones that have survived. This is, however, in most cases not possible, because the science of mineralogy was in ancient times still somewhat primitive, the various classes being distinguished by their colours and shapes, instead of by their hardness, crystalline structure, specific gravity, and chemical composition, as is done nowadays. Moreover, the stones to which the ancient writers refer are often unengraved and so are not contained in our collections of engraved gems. Furthermore, several names seem to have been applied to the same stone. It is only occasionally, therefore, that it has proved possible to cite with confidence the ancient name of a specific variety of engraved stone.

The terms given to the various stones by modern mineralogists likewise do not always coincide with those in use in our archaeological books; cf., e.g., Lintock, *A Guide to the Collection of Gems in the Geological Museum* (1951); G. F. Herbert Smith, *Gemstones*, 13th ed., revised by F. C. Phillips, 1958 (reprinted in 1962), with an extensive bibliography on pp. 532 ff.

I have, therefore, in the following pages and in my text, mostly used the names hallowed by usage in archaeological writings during the last few centuries, even though they may not always coincide either with the ancient appellations or with those of modern mineralogists. My list is largely based on that given in Furtwängler's *Antike Gemmen*, III, pp. 383 ff., revised here and there by Mr. H. P. Whitlock, curator of Mineralogy in the American Museum of Natural History in New York (in 1920), and by Miss Mavis Bimson of the Research Laboratory of the British Museum (in 1966). In addition, however, on the coloured

plates – arranged with the help of R. Higgins – I give first the name suggested by Miss Bimson, and, in brackets, the 'archaeological' term when the latter is different.

TRANSLUCENT AND OPAQUE QUARTZES

CARNELIAN, of reddish colour, shading from dark red to golden yellow; sometimes clear and translucent, at other times dull. The whitish appearance of some ancient specimens is due to contact with great heat.

SARD, of light yellowish brown or dark brown colour. It is often difficult to distinguish from carnelian, and some authorities use the terms interchangeably. Ancient writers refer to both varieties by the names σάρδιον, sardius, sarda. The carnelian and sard are the commonest stones in Greek and Roman glyptic art. They were used in all periods and were particularly favoured for Etruscan, Italic, and Roman gems.

CHALCEDONY, of pale, smoky, milky white, yellowish, or bluish gray colour; generally only semi-translucent, and sometimes besprinkled with other substances. It was used in Minoan times and became the chief material for Ionic Greek and Graeco-Persian gems of the fifth and fourth centuries B.C. The ancient name appears to have been ἴασπις, iaspis.

PLASMA, of greenish colour and translucent; it often contains flaws. It occurs in the archaic Greek period and is popular in the Hellenistic and Roman. Probably identical with the green iaspis or ἴασπις ὁ ὑπόχλωρος, of which a special variety seems to have been the prasius (= the English prase[1]).

JASPER, of vivid colours and opaque. There are a number of varieties – black, red, green, and yellow jasper. They are often besprinkled with coloured spots and stains. A variety of green jasper, transparent around the edges and besprinkled with red spots, is called heliotrope.

Green jasper was commonly used for Graeco-Phoenician gems and in the late Roman period; in the Greek, Etruscan, and earlier Roman times it is seldom employed. Perhaps comprised in the ancient term iaspis. The use of heliotrope is confined to late Roman times. Apparently identical with the ancient heliotropium.

Red jasper occurs in the Minoan period, but is then generally besprinkled with white substances. Pure red jasper is common in the Augustan epoch, and even more so in the later Roman period. It is perhaps a variety of the ancient haematitis.

Yellow jasper occurs only in the late Roman period. Its ancient name is not known.

AGATE, a variegated quartz which is formed by being deposited in various layers, often with inclusions. These layers are either similar to or different from one another both in colour and transparency. The colours consist of all those in which quartzes occur: that is, milky white, grayish, bluish, yellowish, brownish, or a deeper yellow, brown, or red. According to the appearance of the layers different terms are applied. When the stone has greenish moss-like or tree-like inclusions, it is called moss agate. When the stone is cut transversely and the layers are more or less level so that they appear in bands, it is called banded agate. When the layers present irregular outlines the name agate is applied. When the stone is cut horizontally so that the layers are superimposed, it is called either onyx or sardonyx; when one of the layers is of sard, the stone is called sardonyx, otherwise the term onyx is generally used; some authorities, however, apply the term sardonyx to stones of more than two layers, irrespective of their quality, and

[1] 'Prase is not a scientific term, but is used in general to denote a green quartz slightly less bright in colour than plasma, and usually less opaque' (M. Bimson).

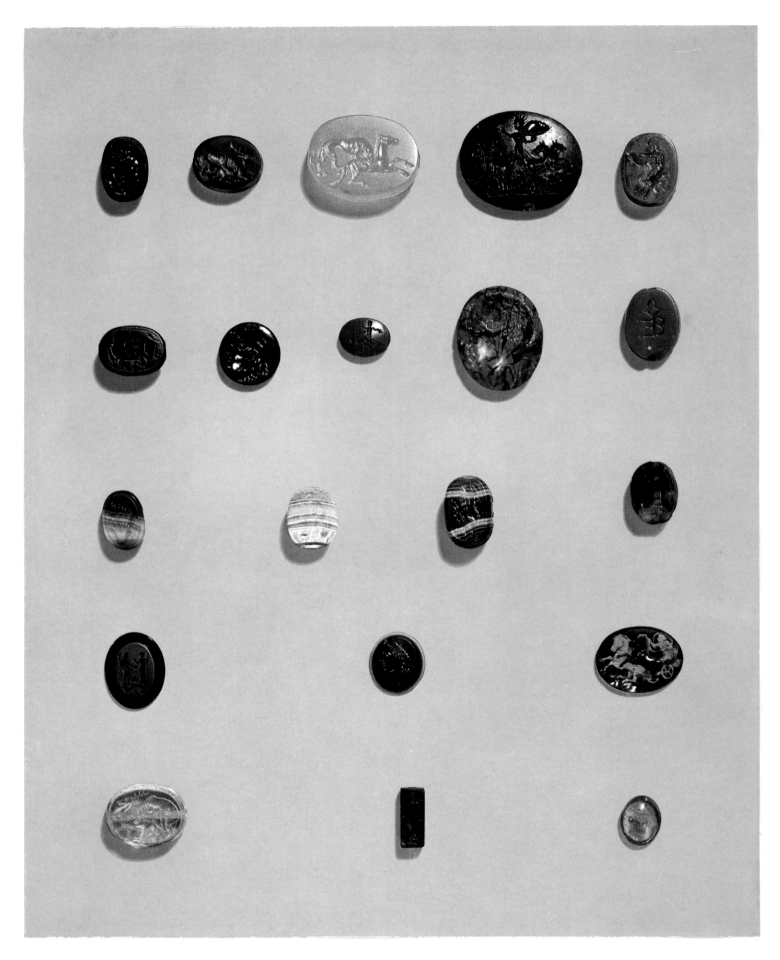

All the gems shown on these two plates are in the British Museum and the numbers in brackets given below are those in
H. B. Walters, *Catalogue of Engraved Gems* (1926).

TRANSLUCENT AND OPAQUE QUARTZES
1st row – dark red carnelian (630); brown carnelian (sard) (540); chalcedony (536); heliotrope (bloodstone) (1663); plasma (527)
2nd row – green jasper (483); black jasper (1188); red jasper (1308); yellow jasper and chalcedony (1184); brown jasper (596)
3rd row – banded agate (624); banded agate (671); banded agate (656); moss agate (913)
4th row – nicolo (1260); sardonyx (1180); sardonyx (3528)
5th row – clear quartzes: rock crystal (538); amethyst (608); citrine ('topaz') (1835)

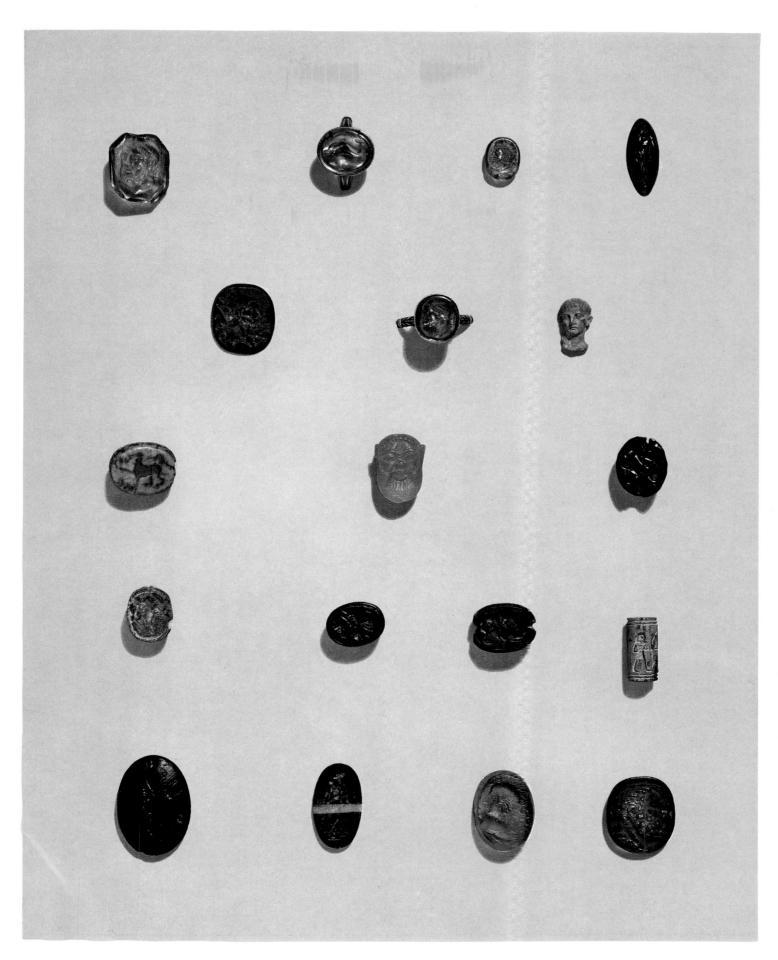

MORE PRECIOUS STONES

1st row – peridot (chrysolite) (1881); blue beryl (aquamarine) (2500); green beryl (emerald) (1878); garnet (1162)
2nd row – lapis lazuli (1183); blue corundum (sapphire) (1990); turquoise (3945)

MISCELLANEOUS MATERIALS

3rd row – marble (306); mudstone (hallyosite) (492); amber (852)
4th row – faience (403); haematite (340); obsidian (450); ivory (264)
5th row – glass (1212); glass (1214); glass (1221); glass (1225)

give the name onyx to two-layered stones. The name *nicolo* is given to a special variety of two-layered onyx in which the lower layer is usually of black jasper, sometimes of a dark sard, and the upper layer thin and of bluish-white colour.

The different varieties of agate occur as follows: The banded agate was popular in the Minoan period, and in the sixth, fifth, and fourth centuries B.C., both in Greece and Etruria. After that it disappears. The sardonyx and onyx were used by the Greeks from the earliest times; they were also popular with the Etruscans, especially in the later periods. In the Italic Etruscanizing gems they are very common. Sardonyx is the chief material used for cameos in the Hellenistic and Roman epochs. The nicolo began to be used in the first century B.C. and lasted throughout the Roman period.

The ancient names for these agates appear to have been ἀχάτης, *achates*, for the general class. Ὄνυξ, onyx, first signified apparently what we call alabaster, but the term was later used also for onyx and sardonyx. The ancient name for nicolo was probably *aegyptella*.

CLEAR QUARTZES

ROCK CRYSTAL, transparent and colourless. It is used not infrequently in Minoan and classical Greek times. In Italy it does not appear until the first century B.C. The ancient name was κρύσταλλος, *crystallus*.

AMETHYST, of violet colour and transparent. The colour is generally not distributed evenly on the same stone, some parts being lighter, others darker. The amethyst was used from Minoan times on. In Italic gems it is almost unknown; but it is common in Hellenistic and imperial Roman times. The paler variety is perhaps identical with the ancient ὑάκινθος, *hyacinthus*.

CITRINE ('TOPAZ'), yellow and transparent, occurs occasionally in the Hellenistic and Roman periods. Difficult to distinguish from yellowish beryl. Some authorities identify the topaz with the ancient τοπάζιον, τόπαζον, τόπαζος, *topazon*, others with χρυσόλιθος, *chrysolithus*.

MORE PRECIOUS STONES

GARNET. There are a number of varieties distinguished by their colours. All are transparent.

The pure red stones which show no admixture of violet or orange are called pyrope or Syriam garnet. The name Syriam is supposedly derived from the town of Syriam, the capital of Pegu, in Burma. Some excellent examples are preserved from Hellenistic and Roman times.

The garnets with orange and brown tints are commonly called hyacinthine garnets. They were popular in the Hellenistic period.

The garnets with a violet hue are called almandine garnets. They were common in Hellenistic and Roman times, especially in the East.

Garnets are often cut with a strongly convex surface (*en cabochon*), which increases the beauty of their colouring. When so cut they are often referred to as carbuncles.

The ancient name for the garnet is ἄνθραξ, *carbunculus*.

BERYL. There are two chief types:

Emerald, of a deep green, transparent colour, occurs from the archaic Greek period on, but is never common. It is mentioned by ancient writers under the name of σμάραγδος, *smaragdus*, as a favourite stone,

but seems to have been used chiefly unengraved. The sealstone that Polykrates valued so highly was an emerald (see p. 20).

Aquamarine, of greenish or bluish colour and highly transparent, occurs from the Hellenistic period on and was especially popular in the Augustan epoch. The ancient name was βήρυλλος, beryllus.

PERIDOT or CHRYSOLITE, yellowish-green, sometimes translucent, sometimes semi-transparent, occurs only rarely. Variously identified as the ancient τοπάζιον, topazon, and χρυσόλιθος, chrysolithus.

MOONSTONE, of milky colour and translucent, is rare; when it occurs it is generally engraved on the convex side. The ancient name is not known.

SAPPHIRE, blue and transparent, the hardest stone used in ancient glyptic art. It is rare and only occurs in the Roman period. The ancient name is not known; it is not σάπφειρος, sapphirus.

LAPIS LAZULI, of deep blue colour, opaque, often with brilliant particles of pyrite. It occurs rarely; occasionally as early as the fifth and fourth centuries B.C., but mostly for poorer gems of the Roman period. It is common in the Renaissance. Probably identical with the Greek κύανος and σάπφειρος, and with the Latin cyanus and sapphirus.

TURQUOISE, of opaque greenish or sky blue colour, does not occur in ancient intaglios, but was occasionally used for cameos and for works in the round in the Augustan period. It may be identical with the ancient callais, callaina.

The RUBY and the DIAMOND are not known to have been used by ancient engravers.

MISCELLANEOUS MATERIALS

HEMATITE, opaque and dark steel gray to brownish red, one of the chief materials used for Oriental cylinders. It occurs occasionally in Minoan and archaic Greek times, but was afterwards practically discontinued until the late Roman period, when it again became popular. Probably identical with the ancient αἱματίτης, haematites (of which the red jasper was thought to be a special variety).

STEATITE, or SOAPSTONE, occurs in several different colours, such as white, gray, yellowish, brownish, blackish, greenish, and reddish. It is opaque, though sometimes slightly translucent at the edges. As it is a soft stone it was commonly used in the geometric period, before the introduction of the wheel, but rarely later. The ancient name is steatitis.

SERPENTINE, opaque, generally green, but occurs also in other colours. Popular only in Minoan times. By some identified with Pliny's ophites.

PORPHYRY, an opaque, variegated white and red rock. Used only by the Minoans and afterwards by the Gnostics.

SLATE, GYPSUM, OBSIDIAN, AMBER, FAIENCE, and IVORY (or BONE) also occasionally occur.

In addition, GLASS, in various colours, was used throughout antiquity as a substitute for precious stones. In Greek times glass was evidently precious, for in the inventories of the Parthenon glass seals (σφραγῖδες ὑάλιναι) are specially mentioned. In Roman times, according to Pliny, glass gems were often sold as stones by fraudulent dealers (XXXVII, 26); but this may apply chiefly to unengraved gems. Glass gems were mostly cast in moulds taken from engraved stones. In a few instances both the original stone and the glass copy are preserved (cf., e.g., Babelon, Cat. des camées, nos. 53, 52, and my no. 189), as well as identical glass gems that must have been cast from the same stone (cf., e.g., Furtwängler, Berlin Kat., nos. 2320, 2321). There are also examples of glass gems cast from ancient coins; cf. my no. 612.

5. GEM ENGRAVERS AND THEIR SIGNATURES

Greek and Latin writers mention the names of several gem engravers and many more are known from their signed works. Rarely, however, have several gems signed by the same artist survived, and rarer still is a name both recorded in literature and preserved on a gem. So only in a few cases can one form an idea of the stylistic development of an artist.

In judging the signatures of artists on gems, it must be remembered that a name inscribed on a gem, besides referring to the maker of the design, can denote the owner of the seal, or the figure represented. A signature, however, can generally be differentiated from other inscriptions by its inconspicuous character. It did not form part of the composition, but was added to the finished design. The owner's name, on the other hand, was an important part of a personal seal and so had to occupy a prominent place. If, therefore, an inscription is obviously added after the design was completed, in small letters, in an inconspicuous place, it generally may be taken to refer to the artist.

The artist's name appears either in the nominative, with or without ἐποίει or ἐπόει, 'made it' (once in the signature of Syries with ἐποίησε), or in the genitive, with ἔργον, 'the work of', understood, as in signatures on coins. Generally the inscription reads from left to right in the impression, but especially in the earlier periods, the contrary also occurs. In the earlier cameos the inscription is often in relief, in the later it is incised. It is also noteworthy that the same artist does not always sign in the same way: sometimes he uses the genitive form, at other times the nominative. Dexamenos' flying heron is signed Δεξαμενὸς ἐποίε Χῖος, his portrait of a man, Δεξαμενὸς ἐποίε, his seated woman and his standing heron Δεξαμενός. This incidentally shows that, even when the verb is omitted and only the name given, it can refer to the maker, rather than the owner; but, of course, only when the verb 'made it' is added is there absolute certainty.

Though the form of the signature by the same artist differs, his handwriting does not. He is apt to use the same-sized and same-shaped letters and to place them in similar locations, vertically or horizontally; though this is, of course, not a hard and fast rule.

The signatures give also valuable evidence for chronology. The forms of the letters naturally change from epoch to epoch, just as in other inscriptions. Thus the three-stroked sigma precedes the four-stroked, which in turn precedes the rounded, and so on. What is particularly valuable is that the inscriptions sometimes help to distinguish between Hellenistic and Roman work, which is often difficult to do stylistically (cf. my vol. II). For instance, the little balls at the ends of the strokes of the letters that regularly (though not always) appear conspicuously on genuine Graeco-Roman stones are rarely used in the third century B.C., and only gradually make their appearance in the second century B.C.; the form ἐπόει is frequent in the fourth to third century, less so in the second century, and in the first century is superseded by ἐποίει; the four-stroked sigma becomes rounded (lunar) by the third century; and so on. In the Hellenistic period the omikron and the theta are often of minute size.

These distinguishing marks are useful also in detecting forged inscriptions; for eighteenth- and nineteenth-century engravers rarely had sufficient knowledge of ancient epigraphy to prevent mistakes (see p. 22).

As comparatively few gems bear the artist's signature, the question arises, why were some gems signed,

others not. Though many signed gems are of high quality, some are not, and some of the best intaglios and cameos are not signed. As in vase paintings, therefore, a signature was evidently due to the whim of the artist.

Both in the Renaissance and in the eighteenth and nineteenth centuries an ancient gem with an artist's signature was highly prized. The natural consequence was that forgers added such signatures both on genuine ancient gems and on their own works. As these signatures are often well cut, they have created great confusion for collectors and experts. Moreover, the engravers of the eighteenth and nineteenth centuries were in the habit of signing their names on their own works in Greek letters (see p. 19). To distinguish between ancient and modern signatures is, therefore, peculiarly difficult.

Of the ARCHAIC names which appear on gems so far known and which were apparently artists' signatures the most important is *Epimenes*, who signed the stone with a representation of a youth in three-quarter back view holding the bridle of a restive horse (no. 116). It is a masterpiece of the late archaic period, which produced also several prominent vase-painters. Two other works of the same high order, also showing a youth in a three-quarter back view, have been attributed to Epimenes – a youth testing his arrow, in New York (no. 115), and the crouching archer in Boston (no. 114). The rendering of the three-quarter view is least advanced in no. 114; then comes no. 115; and lastly no. 116, where it is best understood. If these three gem engravings are indeed by Epimenes, they mark a steady development in the rendering of foreshortening, a subject which aroused the eager interest of Greek artists at the end of the sixth and the first half of the fifth century B.C. One must remember, however, that with the scarcity of preserved gems of the archaic period, the attribution of extant ones to the few engravers known by name is not secure. If as many gems as vases of that period had survived, one might be on firmer ground.

Of the other archaic gem engravers known by name, two, closely related in style, are *Syries* and *Onesimos*. Both worked in the old manner, that is, they engraved their designs by hand on soft steatite, and so perhaps were close associates. Of Syries a single work is extant – a lyre-player in the British Museum (no. 164); by Onesimos there is a stone in Boston with a satyr tuning his lyre (no. 103), and perhaps another stone in the Cabinet des Médailles with a warrior testing his arrow (cf. p. 17). By *Semon* there seems to have survived a design of a woman at a fountain, in Berlin (no. 104), where the name appears in the genitive. Then there is a stone of which the present location is not known, allegedly found in Pergamon, with an expert carving of a lioness, inscribed *Aristoteiches* (no. 187), and a stone in New York with a reclining satyr, inscribed *Anakles* (no. 113). Both inscriptions are not inconspicuous and so may refer to the owner of the stone rather than the artist.

From the DEVELOPED PERIOD of the fifth and fourth centuries there are also only a few artists' signatures extant. But here we are fortunate in having four works by the same artist, two of which are signed with the verb 'made it', the two others merely with the name *Dexamenos*. On one he gives his origin: 'Of Chios'. In these four stones one can trace a development in freedom of expression: The woman with her maid, in the Fitzwilliam Museum (no. 277), is probably his earliest work; then perhaps comes the portrait in Boston (no. 326); and lastly the two herons in Leningrad (nos. 467, 468) of which no. 467 may be said to be the greatest masterpiece in gem engraving that has come down to us. Based on this exceptional knowledge of the individuality of a gem engraver, several attributions to him have been made: the herons (nos. 464, 466), the flying goose (no. 456), the horses (nos. 418, 421), a griffin attacking a horse (no. 422), and a woman playing the trigonon (no. 278); cf. Beazley, *Lewes House Gems*, pp. 48 f. The attributions are based

on general stylistic grounds, and specifically on the delicacy of the engraved lines. Most of them have been assembled on pl. A in enlarged views of the original stones; we must remember, however, that Dexamenos doubtless had prominent contemporaries, who may have approximated his ability, but did not sign their works. And we learn from the four signed gems that Dexamenos' work was many-sided.

In addition to Dexamenos there have survived from this period the names of *Athenades* (no. 262), and of *Perga(mos)* (Furtwängler, *A.G.*, pl. XII, 2), both on stones in the Hermitage; of *Olympios* on a stone in Berlin (no. 233), possibly identical with the Olympios who put his name on a coin of this same period; of *Onatas*, who signed the well-known stone in the British Museum with a Nike erecting a trophy (no. 247); of *Phrygillos*, on a stone now 'lost' (Furtwängler, *A.G.*, pl. XIV, 6), again perhaps identical with an artist whose name appears on a coin of this period; and of *Sosias*, on a stone in Naples (no. 319).

From the HELLENISTIC PERIOD more names of gem engravers have survived than from the previous epochs, and a number of them occur with the verb 'made it', so that one can be sure that they refer to the artists rather than to the owners of the stones (cf. pp. 18 f.). They are *Agathopous* (no. 685), *Athenion* (nos. 594, 694), *Boethos* (Furtwängler, *A.G.*, pl. LVII, 3), *Daidalos* (no. 675), *Gelon* (no. 552), *Herakleidas* (no. 686), *Nikandros* (no. 636), *Onesas* (nos. 544, 553, 602), *Pheidias* (no. 531), *Philon* (no. 680), *Protarchos* (nos. 592, 593), *Skopas* (no. 676), *Sosis* (no. 529), and others (see *infra*). Of several of these artists more than one work exists – at least the same name appears on several stones and was presumably that of the same man. It must be admitted, however, that in some of these cases the stylistic resemblance between the extant stones is not marked, possibly owing to the diversity of the subjects represented – some being portraits, others scenes from mythology. Practically all are works of high competence and enrich our knowledge of Hellenistic art and of the high level of production then attained.

After this come the much more numerous names of gem engravers of the ROMAN PERIOD – one of them the great *Dioskourides*. They are treated in the second volume of this book.

Though the known names of Greek archaic, classical, and Hellenistic gem engravers are relatively few, fortunately our knowledge regarding them is not confined to their signatures. Welcome though it is to have some of their names preserved, the more important testimony remains their actual work. As Sir John Beazley once said, 'The name of an artist is the least important thing about him'.

H. Brunn in the chapter on 'Gemmenschneider' in his *Gesch. der griech. Künstler* (1859) was the first to give a scientific account of ancient gem engravers. Furtwängler, in his 'Studien über die Gemmen mit Künstlerinschriften' in the *Jahrbuch des Archäologischen Instituts* of 1888 and 1889, and later in his *Antike Gemmen* (1900), put this study on sound foundations.

GEM ENGRAVERS MENTIONED BY ANCIENT WRITERS:

Apollonides, Pliny, *N.H.*, XXXVII, 8. Roman period.

Kroinios (Cronius), Pliny, XXXVII, 8. Roman period.

Dioskourides, Pliny, XXXVII, 38; Suetonius, *Octavius*, L. Period of Augustus.

Mnesarchos of Samos, father of the philosopher Pythagoras, VI century B.C., Diogenes Laertios, VIII, 1.

Pyrgoteles, time of Alexander the Great, Pliny, XXXIV, 4.

Theodoros of Samos, time of Polykrates, VI century B.C., Herodotos, III, 40, 41.

Tryphon, made a representation of Galene on an Indian beryl, *Greek Anthology*, IX, 544. Roman period.

The only ancient examples that have survived signed with these names are those by Dioskourides and

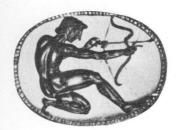

114

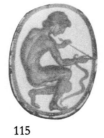

115

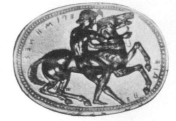

116

113

226

234

237

243

262

301

544

GREEK GEMS, FIFTH AND FOURTH CENTURIES B.C.
Crouching, sitting and standing figures
Enlargements from the originals

216

423

365

338

415

334

375

398

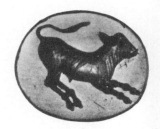

403

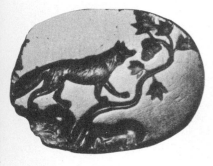

409

333

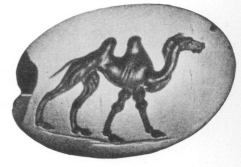

428

GREEK GEMS, FIFTH AND FOURTH CENTURIES B.C.
Animals
Enlargements from the originals

Plate C

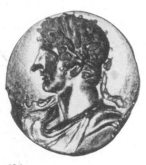

624

627

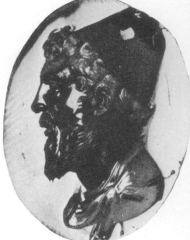

625

648

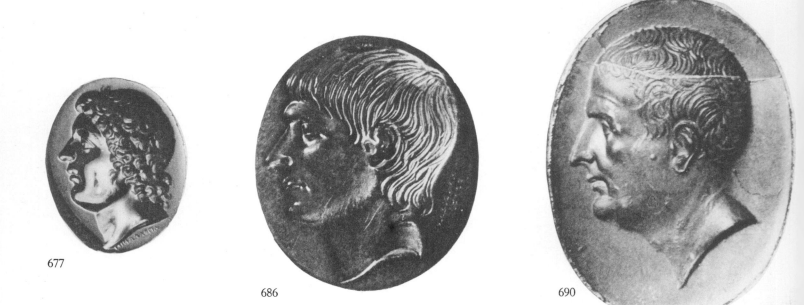

664

665

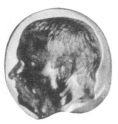

683

684

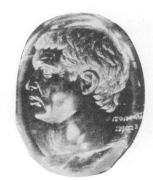

685

677

686

690

HELLENISTIC PORTRAITS OF GREEK AND ROMANS, THIRD TO FIRST CENTURY B.C.
Enlargements from the originals

Tryphon (described in my vol. II). Signatures by Apollonides and Kronios not infrequently occur on modern stones; cf. Brunn, *Gesch. d. griechisch. Künstler*, II, pp. 409 ff.; Furtwängler, *J.d.I.*, IV, 1889, pp. 74 f.; Rossbach, in *R.E.*, II, 1, col. 121, no. 34 (Apollonides); Sieveking, in *R.E.*, XL, 2, col. 1982 (Kronios). An unpublished modern example signed by Apollonides will be included in my vol. II.

For the convenience of the reader I give here a list of the extant names of gem engravers of the Greek period, arranged by periods and alphabetically, with the subjects represented, the locations, the form of the signature, and references to Furtwängler's and a few other publications. The number after the artist's name refers to that in this book. The entries marked with an asterisk are cameos, the others intaglios.

The following abbreviations are used: Athens: National Museum. Baltimore: Walters Art Gallery. Berlin: Staatliche Museen. Boston: Museum of Fine Arts. Cambridge: Fitzwilliam Museum. Chicago: Oriental Institute. Florence: Archaeological Museum. Leningrad: The Hermitage. London: British Museum. Naples: National Museum. New York: Metropolitan Museum of Art. Paris: Cabinet des Médailles. Rome: National Museum of the Terme. Vienna: Kunsthistorisches Museum.

ARCHAIC PERIOD, ABOUT 580–480 B.C.

ENGRAVER	SUBJECT, LOCATION, AND SIGNATURE	PUBLISHED
ANAKLES (Perhaps owner's not artist's name). No. 113.	Satyr. New York. Inscribed Ἀνακλης.	Richter, *M.M.A. Catalogue*, 1956, no. 46.
ARISTOTEICHES (Perhaps owner's not artist's name). No. 187.	Lioness. Present location not known. Inscribed Ἀριστοτειχης.	Furtwängler, *A.G.*, pl. VIII, 43, and *J.d.I.*, III, 1888, p. 194, pl. 8, no. 2.
EPIMENES. No. 116.	Youth with horse. Boston. Inscribed Ἐπιμηνες ἐποιε.	Furtwängler, *A.G.*, pl. IX, 14; II, p. 44, text to no. 14; Beazley, *Lewes House Gems*, no. 28.
ONESIMOS. No. 103.	Satyr tuning his lyre. Boston. Inscribed Ὀνεσιμος.	Beazley, *Lewes House Gems*, no. 24.
	Warrior testing his arrow. Louvre, Paris. Inscribed (perhaps) Ὀνεσιμος.	Furtwängler, *A.G.*, pl. VI, 35; Beazley, *op. cit.*, p. 18. The name was read by Furtwängler as Onesilos.
SEMON. No. 104.	Woman at fountain. Berlin. Inscribed Σημονος.	Furtwängler, *A.G.*, pl. VIII, 28, and *J.d.I.*, III, 1888, p. 116, pl. 3, no. 6.
SYRIES. No. 164.	Lyre-player. London. Inscribed Συριες ἐποιεσε.	Furtwängler, *A.G.*, pl. VIII, 11, and *J.d.I.*, III, 1888, pp. 195 f., pl. 8, no. 1; Beazley, *Lewes House Gems*, pp. 18 f.

DEVELOPED PERIOD, V AND IV CENTURIES B.C.

ENGRAVER	SUBJECT, LOCATION, AND SIGNATURE	PUBLISHED
ATHENADES. No. 262.	Scythian testing an arrow. Leningrad. Inscribed Ἀ]θηναδης.	Furtwängler, *A.G.*, pl. X, 27, and *J.d.I.*, III, 1888, p. 198, pl. 8, no. 3.
DEXAMENOS OF CHIOS. No. 277.	Woman with maid. Cambridge. Inscribed Δεξαμενος.	Furtwängler, *A.G.*, pl. XIV, 1, and *J.d.I.*, III, 1888, pp. 202 ff., pl. 8, no. 6; Beazley, *Lewes House Gems*, p. 48.
No. 468.	Standing Heron. Leningrad. Inscribed Δεξαμενος.	Furtwängler, *A.G.*, III, p. 137, fig. 94; *J.d.I.*, III, 1888, pp. 199 f., pl. 8, no. 7.
No. 467.	Flying Heron. Leningrad. Inscribed Δεξαμενος ἐποιε Χιος.	Furtwängler, *A.G.*, pl. XIV, 4, and *J.d.I.*, III, 1888, pp. 200 f., pl. 8, no. 9; Beazley, *Lewes House Gems*, p. 48, pl. B, 3.
No. 326.	Portrait of man. Boston. Inscribed Δεξαμενος ἐποιε.	Furtwängler, *A.G.*, pl. XIV, 3, and *J.d.I.*, III, 1888, pp. 201 f., pl. 8, no. 8; Beazley, *Lewes House Gems*, no. 50.

OLYMPIOS. No. 233. Eros shooting an arrow. Berlin, Furtwängler, *A.G.*, pl. XIV, 8, and *J.d.I.*,
 Inscribed 'Ολυμπιος. III, 1888, pp. 119 ff., pl. 3, no. 7.

ONATAS. No. 247. Nike erecting a trophy. London. Furtwängler, *A.G.*, pl. XIII, 37, and *J.d.I.*,
 Inscribed 'Ονατα. III, 1888, pp. 204 ff., pl. 8, no. 10;
 Walters, *B.M.Cat.*, no. 601.

PERGAMOS. Youth with Phrygian cap. Leningrad. Furtwängler, *A.G.*, pl. XIII, 2, and *J.d.I.*,
 Inscribed Περγα [. . .]. III, 1888, pp. 198 f., pl. 8, no. 5.

PHRYGILLOS. Eros. Present location not known. Furtwängler, *A.G.*, pl. XIV, 6, and *J.d.I.*,
 Inscribed Φρυγιλλος. III, 1888, p. 197, pl. 8, no. 4.

SOSIAS. No. 319. Female head. Naples. Richter, *A.J.A.*, LXI, 1957, p. 263, pl. 80,
 Inscribed Σωσιας. fig. 1.

HELLENISTIC PERIOD, III–II CENTURY B.C.

ENGRAVER	SUBJECT, LOCATION, AND SIGNATURE	PUBLISHED
AGATHOPOUS. No. 685.	Portrait of man. Florence. Inscribed 'Αγαθοπους εποιει.	Furtwängler, *A.G.*, pl. XXXIII, 9, and *J.d.I.*, III, 1888, pp. 211 f., pl. 8, no. 15.
APOLLONIOS I. No. 677.	Portrait of man. Baltimore. Inscribed 'Απολλωνι[ος or ου].	Furtwängler, *A.G.*, pl. LXIII, 36; D. K. Hill, *Journal of the Walters Art Gallery*, VI, 1943, p. 62, fig. 3.
No. 678.	Portrait of man. Fragment. Athens. Inscribed 'Απολλωνιος.	Svoronos, *Journal international d'archéologie numismatique*, XV, 1913, no. 355.
ATHENION. No. 594.	*Contest of Zeus and Giants. Naples. Inscribed 'Αθηνιων.	Furtwängler, *A.G.*, pl. LVII, 2, and *J.d.I.*, III, 1888, pp. 215 f., pl. 8, no. 19.
No. 654.	*Eumenes II (?) in a chariot driven by Athena. (Exists only in two fragmentary glass reproductions in Berlin and London.) Inscribed 'Αθηνιων.	Furtwängler, *A.G.*, III, p. 158, fig. 110; *J.d.I.*, III, 1888, pp. 113 f., pl. 3, no. 3, IV, 1889, pp. 84 ff.; and *Berl. Kat.*, no. 11142.
BOETHOS.	*Philoktetes. Once Beverley Collection. Present location not known. Inscribed Βοηθου.	Furtwängler, *A.G.*, pl. LVII, 3, and *J.d.I.*, III, 1888, pp. 216 ff., pl. 8, no. 21.
DAIDALOS. No. 675.	Portrait of man. Private collection, Paris. Inscribed Δαιδαλος.	De Ridder, *Collection de Clercq*, VII, 2, no. 2854.
GELON. No. 552.	*Aphrodite arming. Boston. Inscribed Γελων εποει.	Furtwängler, *A.G.*, pl. LXVI, 4; Beazley, *Lewes House Gems*, no. 102.
HERAKLEIDAS. No. 686.	Portrait of man. Naples. Inscribed ['Ηρ]ακλειδας εποει.	Furtwängler, *A.G.*, pl. XXXIII, 15, and *J.d.I.*, III, 1888, pp. 207 ff., pl. 8, no. 12.
LYKOMEDES (perhaps artist's name). No. 635.	Portrait perhaps of Berenike I as Isis. Boston. Inscribed Λυκομηδης.	Furtwängler, *A.G.*, pl. XXXII, 31, and *J.d.I.*, III, 1888, p. 206, IV, 1889, p. 80, pl. 11, no. 2; Beazley, *Lewes House Gems*, no. 95.
MENOPHILOS. No. 689.	Portrait of man. Chicago. Inscribed Μενοφιλος εποει.	*Archaeology*, VIII, 1955, pp. 256 ff.
NIKANDROS. No. 636.	Portrait of woman (Berenike II?). Baltimore. Inscribed Νικανδρος εποει.	Furtwängler, *A.G.*, pl. XXXII, 30, and *J.d.I.*, III, 1888, pp. 210 f., pl. 8, no. 14; D. K. Hill, *op. cit.*, VI, 1943, pp. 64 f.
ONESAS. No. 553.	Athena. London. Inscribed 'Ονεσας επο.	Furtwängler, *A.G.*, pl. XXXIV, 43; Walters, *B.M.Cat.*, no. 1143.
No. 544.	Muse tuning lyre. Florence. Inscribed 'Ονησας εποιει.	Furtwängler, *A.G.*, pl. XXXV, 23, and *J.d.I.*, III, 1888, pp. 212 f., pl. 8, no. 16.
No. 602.	Head of Herakles. Florence. Inscribed 'Ονησας.	Furtwängler, *A.G.*, pl. XXXV, 26, and *J.d.I.*, III, 1888, pp. 213 f., pl. 8, no. 17.
PAZALIAS (probably owner's name). No. 542.	Leda and the swan. Naples. Inscribed Παζαλιας.	Breglia, *Cat.*, no. 40; Becatti, *Oreficeria antica*, no. 339.

PHEIDIAS. No. 531. Youth (Alexander?) putting on a greave. Furtwängler, *A.G.*, pl. xxxiv, 18, and *J.d.I.*,
 London. III, 1888, pp. 209 f., pl. 8, no. 13; Walters,
 Inscribed Φειδιας ἐποει. *B.M.Cat.*, no. 1179.

PHILON. No. 680. Portrait of man. Once Tyszkiewicz Col- Furtwängler, *A.G.*, pl. xxxiii, 13, and *J.d.I.*,
 lection. Present location not known. III, 1888, pp. 206 f., pl. 8, no. 11, and IV,
 Inscribed [Φ]ιλων ἐποει. 1889, p. 80.

PROTARCHOS. No. 592. *Eros riding a lion. Florence. Furtwängler, *A.G.*, pl. lvii, 1, and *J.d.I.*,
 Inscribed Πρωταρχος ἐποιει. III, 1888, p. 218, pl. 8, no. 20.

 No. 593. *Aphrodite and Eros. Boston. Furtwängler, *A.G.*, III, p. 447, fig. 230;
 Inscribed Πρωταρχος ἐποιει. Beazley, *Lewes House Gems*, no. 128.

SKOPAS. No. 676. Portrait of man. Leipzig. Furtwängler, *A.G.*, pl. xxxiii, 8, and *J.d.I.*,
 Inscribed Σκοπας.[1] VIII, 1893, pp. 185 f., pl. 2, no. 2.

SOSIS. No. 529. *Herakles and Centaur. Once in a private Furtwängler, *A.G.*, pl. lxv, 11.
 collection, Leipzig. Present location not
 known.
 Inscribed Σωσις ἐποιει.

[1] The inscription Σκοπα on a fourth-century stone in Florence, once thought ancient by Furtwängler (cf. *A.G.*, pl. l, 13), was subsequently considered to be modern by himself (cf. *A.G.*, vol. II, p. 314, addendum to pl. l, 13).

THE CHIEF GEM ENGRAVERS OF THE EIGHTEENTH AND EARLY NINETEENTH CENTURIES WHO WORKED IN THE CLASSICAL STYLE AND SOMETIMES SIGNED THEIR WORKS, WITH THEIR NAMES OCCASIONALLY TRANSLITERATED INTO GREEK:

A. Amastini, M. Aschari, F. Bernabè (BHPNABH), P. C. Becker, G. Beltrami, A. Berini, C. Brown, W. Brown, E. Burch (BVPX), T. Cades, N. Cerbara, C. Costanz i(K. KOCTANCI), C. Dorsch, F. Ghingi (ΓΙΝΓΙΟC), Gibbon, G. Girometti (ΓΙΡΟΜΕΤΤΟΥ), J. Guay, A. Jacobson, G. Krafft, Manson, N. Marchant (MAPXANT), N. Morelli, J. L. Natter (NATTEP or ΥΔΡΟΥ), A. Passaglia (ΠΑΖΑΛΙΑΣ), Antonio, Giovanni and Luigi Pichler (ΠΙΧΛΕΡ), B. Pistrucci, F. Rega (PEΓA), G. Rosi (IEP. POΣIOC), G. A. Santarelli, L. Siries, Flavio Sirleti (ΦΛΑΒΙΟΥ), Francesco Sirleti (ΦΡΑΓΚ. ΣΙΡΛΗΤΟΣ), G. A. Torricelli (ΤΟΡΡΙΚΕΛΙΟC), Marc Tuscher (MAPXOC), Vernon, J. T. Walther (OΥΑΛΘΕΡ), L. M. Weber, R. B. Wray (OΥΡΑΙΟΣ). Cf. also Dalton, *Catalogue of Engraved Gems of the Post-Classical Period in the British Museum* (1915), pp. xlviii ff.

NAMES OF ANCIENT GEM ENGRAVERS FREQUENTLY USED IN FORGED SIGNATURES:

The ancient names used most frequently by the eighteenth- and nineteenth-century gem engravers are those familiar from extant signatures, namely: Dioskourides, Aulos, Hyllos, Anteros, Gnaios, Pamphilos, Aspasios, Euodos, Mykon, Sostratos, Skylax, and Epitynchanos – all of the Roman period. The name Pyrgoteles, by whom no ancient signature has survived, but whose name is mentioned in ancient literature as a favourite artist of Alexander the Great, appears on an eighteenth-century gem engraved with the head of Alexander (once in the Blacas Collection, now in the British Museum; cf. Dalton, *Post-Classical Gems*, no. 1032, pl. xxxiv).

The Renaissance artists of the fifteenth to seventeenth centuries apparently did not forge ancient signatures; and, as we have said, their style is so different from that of the ancients that the addition of an ancient name would not have deceived anyone. They were inspired by Graeco-Roman art, but did not try to imitate it exactly. It should be noted, however, that Alessandro Cesati (1540–61) sometimes signed his name in Greek letters, Ἀλέξανδρος ἐποίει, which has occasionally led to confusion; cf. Dalton, *op. cit.*, p. xli.

6. APPRECIATION AND COLLECTING OF GEMS

The appreciation of gems in antiquity varied at different times. It was naturally greatest when the artistic side was emphasized, less so when the practical or magical qualities were the chief concern. For the archaic epoch our information is scanty, but sufficient to show that a fine gem ranked with the highest works of art. Herodotos (III, 40, 41) in one of his most dramatic anecdotes relates how the tyrant Polykrates was advised by Amasis, king of Egypt, to forestall the gods' envy at his good fortune by casting away his most valued possession: 'Take thought and consider, and that which thou findest to be most valued by thee, and for the loss of which thou wilt most be vexed in thy soul, that take and cast away in such a manner that it shall never again come to the sight of men.' And Polykrates chose among his many treasures his signet 'encased in gold and made of an emerald stone, the work of Theodoros, the son of Telekles, of Samos', σφρηγὶς χρυσόδετος, σμαράγδου μὲν λίθου ἐοῦσα, ἔργον δὲ ἦν Θεοδώρου τοῦ Τηλεκλέος Σαμίου; and threw it into the sea; and 'when he came to his house he mourned for his loss'. How the stone afterwards turned up in the belly of a fish is a familiar story. The incident, imaginary or not, shows the value placed on a good gem. An unengraved sardonyx was centuries later displayed in Rome as Polykrates' stone (Pliny, XXXVII, 4). Another archaic gem engraver mentioned in ancient literature is Mnesarchos, father of the philosopher Pythagoras (cf. p. 16).

In the fifth and fourth centuries B.C., when engraved gems reached their highest artistic level, they also had a discriminating public. In the treasure lists of temples, of the Parthenon and Hekatompedon for instance, seals are frequently mentioned as gifts of votaries (C.I.G., II, 645, 646, 649, 652, 654, 751, 758, 835). The form in which such offerings are listed is generally ὄνυξ τὸν δακτύλιον χρυσοῦν (or ἀργυροῦν) ἔχων, 'an onyx having a gold (or silver) ring' – an interesting commentary on the importance of the seal compared with the setting, and appropriate when we remember the size of fifth-century rings and their plain swivel hoops (cf. p. 75, fig. a). In a Delian inventory of c. 279 B.C. the order is reversed, the phrase being δακτύλιος χρυσοῦς ἀνθράκιον ἔχων, 'a gold ring having a carbuncle' (I.G., XI, 2, 199 B, 5, 18), indicating a change both in the point of view and in ring setting. How common dedications of finger-rings were is also shown by an inscription of the second century B.C. in which it is recorded that it was forbidden to enter the sanctuary of Despoina at Lykosoura wearing a finger-ring, unless it was intended as a dedication to the goddess; cf. Leonardos, *Eph. arch.*, 1898, cols. 249 ff., Furtwängler, *A.G.*, III, p. 446.

According to Pliny (XXXVII, 4), Alexander the Great allowed his portrait to be carved on gems only by Pyrgoteles, presumably the best engraver of his time – a sign that good workmanship was appreciated.

In the strenuous days of the upbuilding of Rome's power, art played a secondary role, and gems served a useful rather than an aesthetic purpose. In late Republican and early Imperial times, however, when Greek influence was strong, the collecting of gems – ancient and contemporary – became a passionate pursuit. Wealthy men vied with each other in procuring fine specimens and paid enormous prices for them. The keenness of this rivalry can be gauged by the story that the senator Nonius was exiled from Rome because he refused to give a certain gem, valued at 20,000 sesterces, to Marc Antony (Pliny, XXXVII, 21). Public-spirited men, after having formed their collections, presented them to the people and deposited them in temples. Scaurus, the son-in-law of Sulla, is said to have been the first Roman to have had a cabinet of gems (Pliny, XXXVII, 5). Pompey placed in the Capitol the famous collection of Mithridates,

part of his Eastern spoils (Pliny, *loc. cit.*). Julius Caesar was an eager and discriminating collector, and especially keen to obtain gems by old engravers (Suetonius, *Julius Caesar*, XLVII); he is said to have deposited as many as six cabinets (*dactyliothecae*) in the temple of Venus Genetrix (Pliny, *loc. cit.*). Marcellus, the son of Octavia, dedicated his gem collection in the temple of Apollo Palatinus, perhaps mindful of his illustrious ancestor, who stripped Syracuse 'of the most beautiful of the dedicatory offerings' in order to introduce among his countrymen a taste for 'the graceful and subtle art of Greece'.

In the Augustan and Julio-Claudian periods intaglios and cameos enjoyed a special vogue. The keen collecting of gems at this time shows a discriminating appreciation of art, reflected in the high level of the contemporary engravings, especially of portraits.

The engraving of gems for seals, ornaments, and amulets continued throughout Roman imperial days, and that fine work was achieved also in the second and third centuries A.D. is indicated by the excellent portraits attributable to that time (see my volume II).

Though the production of classical gems ended with the break-up of the Roman empire in the fourth and fifth centuries A.D., their history continues. In the Middle Ages the estimation in which they were held is seen by their insertion in precious Christian reliquaries and by being worn in rings by Episcopal dignitaries; but this esteem was not always accompanied by good judgment; for the gems are often of poor quality, and this applies also to the majority of the gems produced at that time. In the Renaissance the case was different. Enthusiasm for Greek and Roman art was combined with a critical faculty, and not only were ancient gems ardently collected for their artistic value, but a spirited output of contemporary work was thereby engendered. A good illustration of the value placed on ancient gems at this time is the much quoted story of Pope Paul II, who offered to build a new bridge for the city of Toulouse in exchange for a large ancient cameo in its possession (the *Gemma Augustea*, now in Vienna, cf. Furtwängler, *A.G.*, pl. LVI, and my volume II), and whose offer was refused.[1]

The work of the Renaissance gem engravers, though strongly influenced by classical prototypes, always had a marked character of its own. In the eighteenth and early nineteenth centuries – the second great period of post-classical gem engraving – admiration for the antique was also keen. Many famous collections, as well as of impressions, of ancient gems were formed by eager patrons; and these collections were published in sumptuous volumes with finely etched illustrations by famous artists. Enthusiasm for the beauty of the antique could not have been more ardent; but it suffered from a fatal defect – it was uncritical. Even Natter, in his *Traité de la méthode antique de graver en pierres fines* (1754), calls a number of stones ancient which could only have been made by his own contemporaries. Every collection became flooded with forgeries, and the forgers became bolder and bolder, until the whole fabric collapsed with the scandal of the Poniatowski collection in 1840. When people's eyes were at last opened to the deceit that had been practised, their faith was undermined and their desire for gem collecting ceased.

During the second half of the nineteenth century, when archaeology gradually became scientific, the study of engraved gems, from a recreation practised by dilettanti, became a profession of scholars. Scientific approach, together with the greatly increased material derived from excavations, has enabled us to emerge from a mass of fanciful theories and to build up a history of classical art on sound foundations. The change is seen in the publications of gem engravings. In the handsome eighteenth-century catalogues in which the ancient gems are published each gem is beautifully engraved on a separate plate, and the

[1] Not long afterwards, however, Francis I took the cameo and paid nothing for it; cf. S. Reinach, *Pierres gravées*, p. 2.

descriptive text finely printed. But the discussions of subjects and periods are based on so little knowledge that the text is now almost worthless, and the plates are too inaccurate to serve for study. There could not be a greater contrast between these books and Furtwängler's *Antike Gemmen* published in 1900, in which a scientific account of the evolution of gem engraving was presented and each gem was assigned its place historically and artistically; in the identification of subjects the attempt was made to penetrate the intention of the artist, that is, to view the gem with Greek instead of modern eyes. The illustrations are photographic reproductions that provide a trustworthy basis for study and appreciation.

Furtwängler's *Antike Gemmen* does not, of course, stand alone. It was the result of several decades of patient research. As a consequence, during the last thirty years of the nineteenth century and the first few decades of the twentieth a number of excellent private as well as public collections were formed. The private collections – e.g., the Marlborough, the Francis Wyndham Cook, the Morrison, the Evans, the Newton Robinson, the Edward Warren, the Tyszkiewicz, the Pourtalès, the Fould, the Thorvaldsen, the Cesnola, the Froehner, the De Clercq, the Southesk, and others assembled in our own times – have gradually found or are finding their way into public Museums by sale or gift. Catalogues of these collections are appearing from time to time, and interest in the ancient craft of gem engraving is thereby becoming stimulated.

7. FORGERIES

The problem of differentiating between a genuine work and a forgery that confronts the archaeologist in every branch of ancient art is nowhere more difficult than in engraved gems (cf. vol. II). There are no helpful physical criteria. The stones used in antiquity are practically the same as those in modern use, and the methods of engraving employed in ancient and modern times are likewise the same (see p. 5). Moreover, a gem remains unaltered by age, it acquires no patina or incrustation, and only glass gems become iridescent. The only appreciable change is that the surface sometimes becomes slightly worn and covered with little scratches. But as ancient gems were often repolished in later times, and modern gems can be artificially scratched, such evidence is often misleading. Even when a stone is in its original mount, this is no decisive proof of antiquity, as ancient designs were sometimes partly drilled out and re-engraved.

Stylistic criticism is also confronted with unusual difficulties in this field. In the eighteenth and nineteenth centuries we have the rare phenomenon of eminent artists willing and able to copy directly the products of an earlier age. Such imitations were, moreover, made on a large scale to supply a widespread demand, and are, therefore, not isolated products but exist in large quantities. When such copying from ancient designs is free, detection is easy, for almost invariably there are differences in expression, pose, composition, or treatment. When the copying is close, however, a real problem confronts us. There are certain gems about which even trained archaeologists will always disagree. Nevertheless, the really doubtful cases are comparatively rare. The eighteenth-century engraver had too little real knowledge of ancient art, and was too strongly influenced by his own outlook, not almost unconsciously to modify what he was copying – and his variation is our clue. An impossible costume, a strange headdress, unstructural modelling, a stilted pose, a wrong attribute, a faulty inscription, some mistake somewhere, almost always gives the forger away.

Ability to detect forgeries rests, therefore, on long familiarity with genuine works, and on a thorough knowledge of ancient art, which teaches what is possible and what is impossible in ancient representations. It is also well to remember that the dangers of too great credulity and too great scepticism are about equal. In passing judgment on a gem, it is helpful to recall the golden rule in art criticism – that the defendant should be held innocent until proved guilty.

Though I have not included in this volume – as I have in the second – a separate section on post-classical gems, I have in a few cases placed a genuine, ancient example next to one of doubtful antiquity (cf. nos. 527, 528a, 528b). The differences between them are instructive.

For extensive illustrations of post-classical gems and discussions regarding them cf. Dalton, *Post-classical Gems in the British Museum* (1915), and Eichler and Kris, *Die Kameen im Kunsthistorischen Museum, Wien* (1927); also my *Catalogue of Engraved Gems in the Metropolitan Museum* (1920 ed.), pp. 189–211. In *A.G.*, III, pp. 373–383, Furtwängler gives a concise but comprehensive sketch of this post-classical art, with a few illustrations of the various epochs on pl. LXVII.

8. THE RELATIONSHIP BETWEEN COINS AND GEMS

Coins and engraved gems have several obvious properties in common. Both are of relatively small size and generally roundish in form; so their designs presented similar problems to their makers. Moreover, in both the design had to be made incuse, that is, in negative – though in the case of the coins, the dies, that is the negatives, have almost all disappeared, whereas actual coins, that is the positives, have survived in quantity; in the case of the gems, on the other hand, it is the actual intaglios that have survived, whereas the sealings which they produced have in large part disappeared (for survivals cf. pp. 2 f.). Furthermore, both coins and gems were occasionally made by artists of stature, who took pride in their work and sometimes even attached their signatures.

Between coins and gems there is, however, the fundamental difference that the coins were so to speak the official seals of the state, while the gems were private property. Though it is possible that occasionally a gem served an official purpose (cf. *infra*), certainly as a rule they belonged to private individuals. Consequently the design on a coin had an intimate connection with the city state for which it was minted – and minted in quantity – whereas the design on a gem represented the choice of an individual for use as his seal, and was therefore made once only. Solon's law forbidding the makers of gems to retain copies of them (cf. p. 45) was presumably kept in force also later, for it was an obvious precaution against fraud.

It is of course true that one often finds similar designs on coins and on engraved stones – various animals in similar attitudes, and even sometimes similar mythological scenes, such as Diomedes stealthily carrying the Palladion (cf. no. 234), or a Nike erecting a trophy (cf. no. 246). The question arises: Was there a special significance in these similarities? Did the plunging bull on the gems (cf. nos. 387–389) have a connection with the almost identical device on the coins of Thourion? Did the boar on the gem no. 405 have some connection with the similar boars on the coins of Lycia? Did the kithara on the gem no. 480 bear some relation to the kitharas on the approximately contemporary coins of the Chalcidian League?

It must be admitted that if such a connection existed it now escapes us – for the obvious reason that we know nothing about the possessors of the gems and the reasons for their choice of the designs on their

seals. On the whole, however, it seems likely that the similarity between the representations on coins and gems is simply due to the fact that in both there was a restricted field at the disposal of the artist, who, therefore, chose from the prevalent artistic stock the design most adapted to his purpose. In other words, similar technical problems and a similar artistic background and repertoire engendered similar results. Furthermore, it is a well-known fact that in Greek art a type once established was used by all artists and repeated again and again.

In a few cases, however, the similarity between the design on a gem and on a coin is so close that a definite connection would seem to have existed. For instance, the Herakles throttling the lion on no. 308 recurs in exactly the same composition on the Syracusan gold coins signed by Euainetos and Kimon (cf. Regling, *Münze*, no. 580; *British Museum Guide*, pl. 17, no. 62); so that long ago Evans suggested that the gem served as an official seal (cf. his *Syracusan Medallions and their Engravers*, pl. v, 5, pp. 117 ff.; also Furtwängler, *A.G.*, vol. III, p. 126). Other instances of such a close resemblance between a coin and a gem are the head on a gem in Naples (no. 319) and those on Syracusan coins signed by Kimon; the quadrigas on the gems nos. 335–337 and some of those on Syracusan decadrachms; the monster in the form of the forepart of a winged boar terminating at the back in the tail of a bird, which appears in remarkably similar fashion on gems and coins; and so forth.

As has often been pointed out, the same artist may sometimes have worked in both fields – in the production of coins for the city state and of gems for private patrons – since the work in both is technically related. And so he may occasionally have reproduced the same, or at least a similar, design in two commissions – perhaps even at the request of his private client; and in such cases the similar representations need not have had a common significance, and were simply due to private taste.

The following list gives some instances of representations on coins and gems (generally about contemporary) with nos. of gems in this book added.

SUBJECT	GEM	COIN
Lion, with forelegs extended	Nos. 187, 271	Regling, *Münze*, no. 271 (Cyprus); Head, *H.N.²*, p. 89, fig. 47 (Velia); Regling, *Münze*, no. 232 (Etruria)
Lion attacking a stag	Nos. 383 ff.	*H.N.²*, p. 89, fig. 48 (Velia)
Lion attacking a bull	Nos. 379 ff.	Regling, *Münze*, nos. 99, 213 (Akanthos); *Br. Mus. Guide*, pl. 10, no. 10
Bull with head lowered and one leg lifted	No. 388	*H.N.²*, p. 86, fig. 46 (Thourion)
Bull with head turned	Nos. 389 ff.	Regling, *Münze*, no. 110 (Sybaris)
Bull with human face turned frontal	No. 370	*H.N.²*, pp. 38 f., figs. 16, 17 (Neapolis); Franke-Hirmer, pls. 56, 57
Forepart of bull	Nos. 395, 396	*H.N.²*, p. 140, fig. 73 (Gela); *B.M.C.*, Ionia, pls. xxxiv–xxxvi; *Br. Mus. Guide*, pl. 8, no. 29 (Samos)
Boar with head lowered	No. 212	*H.N.²*, p. 83, fig. 43; Regling, *Münze*, no. 275 (Lycia)
Sow	No. 405	Regling, *Münze*, no. 150 (Ionian Revolt)
Winged boar combined (1) with bird's tail (2) with human legs	Nos. 177, 179	Franke-Hirmer, pls. 180, 188 (Klazomenai; Ialyos); Regling, *Münze*, no. 143 (Kyzikos)
Stag standing	No. 433	*H.N.²*, p. 94, fig. 51 (Kaulonia)
Winged forepart of horse ending in bird's tail	No. 179	Regling, *Münze*, nos. 155, 632 (Lampsakos)
Horse walking	No. 420	*Br. Mus. Guide*, pl. 22, no. 24 (Larisa, Thessaly)
Two dolphins swimming	No. 473	*H.N.²*, p. 438, fig. 240 (Argos); Regling, *Münze*, no. 38 (Thera)
Griffin	No. 368	Regling, *Münze*, no. 754 (Chersonnese)
Dove standing	No. 454	Regling, *Münze*, no. 602 (Paphos)
Dove flying	No. 455	*B.M.C.*, Peloponnese, pl. vii, 18 (Sikyon)

Kithara	No. 480	Regling, *Münze*, no. 304 (Kolophon); Regling, *Münze*, no. 646 (Smyrna)
(a) Bee, (b) stag	Nos. 478, 440	Coins of Ephesos, *Br. Mus. Guide*, pl. 19, no. 35
Goat	Nos. 441, 442	Coins of Ainos, *Br. Mus. Guide*, pl. 21, no. 5
Frog	No. 471	*Br. Mus. Guide*, pl. 5, no. 46
Quadrigas	Nos. 335–337	*Br. Mus. Guide*, pl. 17, nos. 65–67 (Syracuse); Hill, *Select Greek Coins*, pl. LII, 1, pl. LI, 2
Female head	No. 319	Regling, *Münze*, no. 579 (Syracuse)
Head with pilos	No. 310	Regling, *Münze*, no. 451 (Melos)
Nike erecting trophy	Nos. 246–248	*H.N.*², p. 181, fig. 105; Regling, *Münze*, no. 847 (Syracuse); *B.M.C.*, Sicily, p. 195
Diomedes with Palladion	No. 234	*H.N.*², p. 438; *B.M.C.*, Peloponnese, pl. XXVII, 12, 13 (Argos)
Herakles throttling the Nemean lion	No. 308	Regling, *Münze*, no. 580
Woman sitting on the stern of a ship	No. 288	*B.M.C.*, Central Greece, pl. 24, nos. 6 f.
Eagle with serpent	No. 451	*Br. Mus. Guide*, pl. 12, no. 41
Crab	No. 476	*Br. Mus. Guide*, pl. 19, no. 44

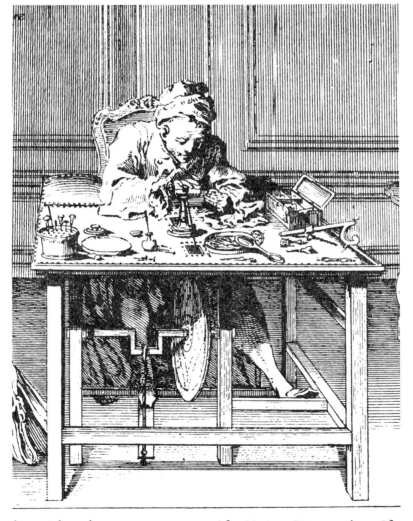

Fig. d. An eighteenth-century gem engraver. After Mariette, *Pierres gravées*, I. Cf. p. 6.

I. GREEK GEMS

1. THE GEOMETRIC PERIOD,
EIGHTH TO EARLY SEVENTH CENTURY B.C.

The downfall of the Minoan–Mycenaean civilization toward the end of the second millennium B.C. was followed by several centuries which have been called by various names – the Dark Ages, on account of the contrast they show to the preceding and succeeding epochs; or the Early Iron Age, because of the increasing use of iron instead of bronze; or the Geometric Period, after the character of the decorations. During this primitive period sealstones were at first not needed. It is, therefore, not until about the middle of the eighth century that stone seals reappear. Naturally, during the intervening epoch the achievements of the Minoan–Mycenaean gemcutters had been forgotten. Instead of the expert cutting of hard stones by means of a rotating wheel, one finds the engraving by hand of soft stones, and, instead of the former exuberant representations inspired by nature, there are merely linear designs, in which zigzags, chequers, lozenges, and shaded triangles predominate. Only occasionally – probably toward the end of the eighth century – one finds attempts at representing human and animal forms, but even then they are formalized into linear patterns.

The historical background of this Geometric style is still being explored. The former theory that an abrupt change was occasioned by the 'Dorian invasion' is now being somewhat modified, first because the geometric style flourished especially in Attica, which, according to the ancient historians, was by-passed by the Dorians; secondly, because the vases that have survived show that there was not a sudden change but a gradual development from sub-Mycenaean to Proto-Geometric to Geometric. The prevalent opinion, therefore, now tends to be that the Geometric style was locally evolved, with some influence, it would seem, from the East.

Nevertheless, it is clear that the downfall of the Mycenaean civilization was caused by some widespread catastrophe. The burnt palaces all over the Mycenaean world indicate this. It is, therefore, natural to suppose that the general havoc was due to the invasions from the North – and East – which are referred to by ancient writers.[1] But, even if these invaders brought about the ultimate downfall of the Mycenaean world, they evidently did not bring with them a ready-made geometric style. This was slowly evolved from within, in successive stages, each locality producing its own distinctive style.

The most noteworthy products of this Geometric period that have survived are bronze statuettes and reliefs and painted pottery. It is they which have supplied our detailed knowledge of the art of the time; for, though the same linear patterns occur on these bronzes and pots as on the engraved stones, they occasionally do so in amplified form evincing a developed sense for large compositions. Human and animal forms are there introduced sometimes even in such ambitious representations as a battle at sea and the lying-in-state of the dead surrounded by mourners.

[1] For a detailed account of the complex evidence which has now become available – both archaeological and literary – cf. especially V. R. d'A. Desborough, *The last Mycenaeans and their Successors*, 1964, with the summary in chapter X, pp. 216–267.

Since Geometric vases have been found in quantity on many different sites, it has been possible to distinguish various styles and techniques and to assign them to their respective localities; e.g., to Attica, Laconia, Argos, Boeotia, Euboea, the Cyclades, Crete, the Near East, and Italy. This is not possible with the few engraved gems of the Geometric period that have so far come to light. They must be viewed as a group, characteristic of their time, and contributing their share to our visualization of Greek art 'in embryo'.

The chief sites on which Geometric sealstones have been found are the Argive Heraion, Sparta (in the sanctuary of Artemis Orthia), Perachora, Megara – all in continental Greece. Other sites not yet excavated may yield further examples.

The material used was what is known to archaeologists as steatite[1] – a soft stone which occurs in different colours (blackish, greyish, greenish) and is soft enough to be engraved by hand. The resultant designs, made with variously shaped tools, demonstrate this technique by the sometimes scratchy lines and a certain lack of corporeality. Occasionally, however, the use of the gouge resulted in more rounded forms.

There were no standard forms for the stones. Conical, domed, rectangular, and rounded, as well as cylindrical shapes appear (cf. figs a–c). They were all evidently borrowed from the East, principally it seems from Syria. Occasionally a form approximating the later scaraboid is used (cf. fig. d), perhaps, it has been thought, developed from the Oriental dome-shaped bead. The stones were regularly perforated to be worn on a string.

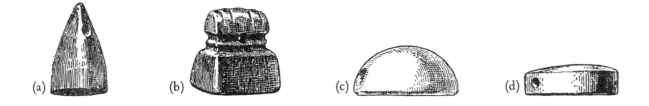

(a) (b) (c) (d)

Since the material and the shapes and even the designs of these Geometric stones were sometimes inspired or even copied from Eastern models, it is not surprising that occasionally one cannot be certain whether a specific example is Greek or Eastern. Geometric designs are apt to resemble one another, and only a certified provenance can be decisive; and even then one must reckon with imports. In my account I have included stones on which the designs strikingly resemble those on other geometric Greek products. Nos. 1–11 show a selection of such Geometric stones from various collections. It will be seen that the conventions observable in the representations on the vases and bronzes of this epoch recur in the engravings. The human figure is shown with a triangular trunk, a narrow waist, spindly arms, slightly more robust legs, and all with little detail. Front and profile views for different parts of the body are combined without the proper transitions. The same applies to the figures of animals – which consist of those native in Europe, i.e., horses, deer, dogs, and birds. In the fields are inserted 'filling ornaments', only occasionally recognizable as birds or quadrupeds or plants. Specially enterprising designs are those of a chariot in front view (no. 5), and of Herakles and Nessos (no. 3). It is noteworthy that in these representations both arms and

[1] I shall retain the word steatite in my discussions and descriptions, though mineralogically it may not always be correct (cf. p. 13). Common usage has made the term so familiar that to change it might lead to a lack of understanding.

all four legs are generally indicated, not, as regularly in the archaic period, only the leg and arm in the front plane. In this respect also the engravings on the stones resemble the renderings on the contemporary vases.

At the end of the period, in the early seventh century B.C., the figures acquire more volume, they are less linear, and the attitudes tend to be more naturalistic (cf. nos. 10, 11).

1. *Octagonal grey steatite*, perforated vertically. Chipped at perforations. Height 43 mm.

In the Metropolitan Museum of Art, 41.160.479. Bequest of W. G. Beatty, 1941.

MAN STANDING, with arms bent; the head and trunk are shown frontal, the legs in profile to the right and left. Eyes, nose, and hair are indicated. On the body and in the field are linear patterns.

Probably eighth century B.C.

Richter, *Evans and Beatty Gems*, no. 3; *M.M.A. Handbook*, 1953, p. 146, pl. 125, a; *Cat.*, no. 1, pl. I.
Boardman, *Island Gems*, p. 111, note 2 ('not proven Greek').

2. *Black steatite pendant*. The upper-side is in the form of a lion. The engraving is on the flat under-side. 18 × 10 mm.

From Attica. In the Staatliche Museen, Berlin.

SIX HUMAN FIGURES, standing side by side. The trunks are in front view, the head and limbs in profile.

Eighth century B.C.

Furtwängler, *Beschreibung*, no. 65.
Boardman, *Island Gems*, p. 122, D 5.

3. *Quadrangular brown stone*, engraved on both sides. 21 × 21 mm.

In the Cabinet des Médailles, M5837.

On front and back:

(1) Geometric pattern.
(2) HERAKLES, SHOOTING AN ARROW AT THE CENTAUR NESSOS, who holds two branches in his raised hands. All four legs of the Centaur are shown. Various geometric ornaments in the field.
(3) MAN, with head and trunk frontal, legs in profile to the left, perhaps conceived as walking. Zigzag ornament in the field.
(4) Geometric pattern of zigzags.

Eighth to early seventh century B.C.

Casson, *Antiquaries Journal*, VII, 1927, pp. 38 ff., pl. V.
Pierres gravées, Guide du visiteur (1930), p. 12, M 5837, pl. VI.

4. *Basalt* 'scarab form, but beetle not executed'. 20 × 16 mm.

From Mycenae. In the British Museum, 1905.6–10.6. Bought 1905.

ARTEMIS (?), wearing a long chiton, in frontal view. In one hand she holds a bow, in the other a torch. By one side is a stag, by the other a bird (?). Hatched border.

Probably eighth century B.C.

Walters, *Cat.*, no. 315 (not ill.).
Boardman, *Island Gems*, p. 118, B 24, pl. XII ('not wholly sure of its authenticity').

5. *Dark red steatite, of scaraboid form*. Engraved with the wheel. Diam. 24 mm.

From Corinth. In the Staatliche Museen, Berlin.

FOUR-HORSE CHARIOT, in front view. Only the fore-parts of the horses are indicated, each with its forelegs. The outer horses are in profile to the right and left, with a slight indication of the bodies by a horizontal line; the inner horses have frontal bodies and profile heads; between them the railing of the chariot is indicated. Curving ground line.

Eighth to seventh century B.C.

Furtwängler, *Beschreibung*, no. 69; *A.G.*, pl. IV, 46.
Boardman, *Island Gems*, p. 125, no. F 18 ('mid-sixth century').

6. *White marble square seal*. 44 × 44 mm.

From Melos, or 'the Greek Islands'. In the Ashmolean Museum, 1894.5A (XXVI). Once in the Evans Collection.

TWO MEN, standing on either side of a tree. They are shown with trunks frontal, the heads and legs in profile. Ornaments in the field.

Late eighth century B.C.

Casson, *Antiquaries Journal*, VIII, 1927, pl. V, 2; *Technique*, fig. 17, 2.
Boardman, *Island Gems*, p. 115, no. A, 4, pl. XIV.

7. *Oval black steatite*, with convex back. 25 × 21.

In the British Museum, 84.2–9.15. Said to be from Comana in Cappadocia. Bought 1884.

FEMALE (?) FIGURE, seated on a stool, with one arm extended, the other raised; the hair is tied in a curving pigtail. Both arms and legs are indicated. In the field are various ornaments, perhaps intended for two dogs running after a deer. On the back of the stone is a decoration of triangles and straight lines.

Perhaps early seventh century B.C.

For two figures in a similar style cf. Richter, *Catalogue*, M.M.A., 1956, no. 3; Boardman, *Island Gems*, p. 129, G6, pl. XV (said to be from Crete).

Furtwängler, *A.G.*, pl. IV, 33.
Walters, *Cat.*, no. 225, pl. V.

8. *White marble seal*, engraved on three sides. 9 × 17 mm.

From Melos. In the Ashmolean Museum, 1894.5A (XXVII).

(1) TWO CENTAURS (with human forelegs) confronted, each holding a branch; between them is another branch. Round ornaments in the field.
(2) TWO SPHINXES CONFRONTED. Between them is an upturned branch, and in the field are round ornaments.
(3) COUCHANT STAG.

Eighth to early seventh century B.C.

For the couchant stag with legs bent under compare the hind on a late geometric vase in Copenhagen, 727, Arias and Hirmer, *Tausend Jahre Griechische Vasenkunst*, pl. 8.

Boardman, *Island Gems*, p. 136, L, 1, pl. XVII.

9. *Dark greenish steatite scarab*. 14 × 18 mm.

From Cyprus. In the Staatliche Museen, Berlin. Once in the de Montigny Collection.

TWO NUDE, HELMETED MEN, standing opposite each other, each holding the other by the hand. Bodies and arms are shown frontal, heads and legs in profile, to right and left. The helmets have high crests. Cross-hatched exergue.

Sub-geometric, early seventh century B.C.
Cf. the similar representation on a stone in the Ashmolean Museum, Furtwängler, *A.G.* III, p. 65, fig. 54.

Furtwängler, *Beschreibung*, no. 76; *A.G.*, pl. IV, 47.
Boardman, *Island Gems*, p. 142, note 2.

10. *Green steatite disk*. 11 × 12 mm.

Perhaps from Amorgos. In the British Museum, 89.8–2.1. Presented by Rev. Greville Chester, 1889.

HORSEMAN, in profile to the left. He holds the reins in the right hand, a spear in his raised left, and wears a helmet. In front of the horse is a bird. The man's trunk is frontal, the rest in profile.

Sub-geometric, early seventh century B.C.

Casson, *Antiquaries Journal*, VII, 1927, pl. 5, no. 10, p. 41.
Walters, *J.H.S.*, XVII, 1897, pl. III, 10, p. 70.
Furtwängler, *A.G.*, vol. III, p. 61.
Walters, *Cat.*, no. 224, pl. V.
Boardman, *Island Gems*, p. 132, G. 31.

11. *Lentoid steatite*. 25 × 17 mm.

Said to be from East Greece (Samos ?). In the Staatliche Münzensammlung, Munich. From the Arndt Collection.

HORSE, neighing, in profile to right. The mouth is wide open, with teeth and tongue indicated; the mane is marked by straight lines, the tail is bushy, the eye large; all four legs are shown. Above the horse is a bird, below a fish, with mouth wide open and its fins indicated on either side; at the back is a tree, and in front a saw pattern.

About 700 B.C. (Boardman). Everything is simplified, but expressive.

Erlenmeyer, *Orientalia*, XXIX, 1960, p. 123, pl. 26, fig. 10.
Ohly and Czako, *Griechische Gemmen*, no. 5.
Boardman, *Island Gems*, p. 135, J4.

2. THE PERIOD OF ORIENTAL INFLUENCES, LATE EIGHTH TO EARLY SIXTH CENTURY B.C.

Into the meagre, attenuated representations of the geometric age there presently entered a vitalizing force. Beginning with the late eighth century, and especially during the seventh, a new outlook is apparent. It was evidently engendered by a closer contact with the ancient civilizations of the East; and so this epoch is mostly referred to in archaeological parlance as the Period of Oriental influence. This influence did not of course come from only one source; that is, not only from Assyria, or Syria, or Phoenicia, or Egypt, but from all in turn. It was a time when the Greeks were coming out of their isolation, when they travelled extensively, founding colonies all over the Mediterranean, East, North, South, and West. Furthermore, their activities ran parallel with those of the Phoenicians, the great traders of antiquity, who brought their Eastern wares to many a Greek settlement.

As a consequence of these new contacts – and also because the time was ripe – there is noticeable a marked upswing in Greek civilization. In these changes all Greek states participated, not least Corinth and Athens. Also prominent – through their proximity to the East – were of course the Ionians, that is, the Eastern Greeks of Asia Minor – of Rhodes, Miletos, Melos, and the Cyclades. Doubtless the Greek trading settlement at El Mina in Syria, at the mouth of the river Orontes, acted as a stimulus. It was the Eastern Greeks, moreover, who were the pioneers in the adoption of coinage, and all that this implied.

Bronze implements and statuettes, ivories, and especially painted pottery again constitute the primary sources of our knowledge. They supply a many-sided picture of the art of the time, in which the separate contributions of several regions can be distinguished. And presently, about the middle of the seventh century, came the rise of monumental sculpture, evidently inspired by association with Egypt and, to a less degree, with Assyria. Concurrently began the building of temples. The characteristic elements of Greek civilization were in the making.

In comparison with these larger products the engraved gems of this period are less numerous and less important; but they too effectively reflect the new influences. They are not uniform; even less so than the vases, for they not only eminate from different regions and different peoples, but the borrowing is some-times made without the usual transformations. In all, however, are apparent the Oriental elements respon-sible for the revolutionary changes in Greek art: curving instead of straight lines; the introduction of Eastern animals such as the lion and the leopard, and of fantastic creatures like the sphinx and the griffin; and the adoption of Eastern floral motifs, for instance the lotus flower and bud, the rosette, the palmette, and the spiral, all of which were to have a great future in Greek art. But most significant of all was the transformation of the human figure. The thin, abstract forms begin to acquire substance and volume, with the separate parts clearly defined. Moreover, these human figures are often shown in action, some even in scenes of mythology – harbingers of things to come.

Naturally, the transition from one style to the other was gradual in the engraved stones, as it was in the other branches of Greek art. Moreover, the technique of cutting soft stones by hand persisted for some time – though occasional inept attempts at working hard stones with the help of a rotating instrument occur – as they apparently also did in Geometric times.

Among the heterogeneous engraved stones of this period one can segregate several principal classes.

31

They illustrate the different influences which brought about, in greater or less degree, the birth of Greek art as such in the sixth century B.C. Furthermore, in addition to the Oriental influences, there is a strange revival of Mycenaean forms and subjects in the so-called Island gems, which also exercised some influence on the succeeding products (cf. pp. 38 ff.).

I shall try briefly to examine each of these various classes of Orientalizing gems current during the seventh century B.C. and later, though in the present state of our knowledge the distinctions between them are not always easy to draw. The dates assigned are more or less tentative, for naturally in this period, even more than at other times, old conventions persisted in some regions and with some artists longer than else-where. Furthermore, as the transition from these 'Orientalizing' gems to the early archaic is of course gradual, it is sometimes difficult to distinguish between the two.

First may be mentioned the direct imitations of Egyptian scarabs which have come to light on various sites (cf. figure below). It was natural that at a time when the Phoenician traders brought their wares to the Greek world, they should include both genuine Egyptian scarabs and cheap imitations. And it was also natural that presently the Greeks should make such imitations themselves. These copies are mostly in faience, engraved with Egyptian hieroglyphs, which, however, to the Greeks were evidently meaningless symbols, though perhaps imbued by them with some mysterious apotropaic significance.

The influence that these Egyptian sealstones and amulets – genuine and imitations – exercised on the future of Greek glyptic art was limited but nevertheless important. The material of faïence and the in-scriptional content were discarded; but the scarab form was adopted and remained the prevalent shape of Greek engraved sealstones for a considerable time.

Presently Oriental contacts made themselves felt more constructively than through mere imitations. That is, Oriental motifs and styles were adopted by the Greeks and transformed into Greek designs. They show deities and human beings no longer in the geometric style, but with a new sense of volume, and they illustrate a love of fantastic creatures and grotesque combinations dear to Oriental art, and adopted by the Greeks during this early period. In form and content, in fact, the representations on these gems parallel those on Protocorinthian, Corinthian, and Ionian vases, generally, however, nearer to their Oriental prototypes. Often purely Oriental deities are introduced.

Also belonging to this Orientalizing group – as a sub-division so to speak – are the so-called Graeco-Phoenician, some of which are purely Oriental in style, whereas others show a mixture of Oriental and Greek elements. They have been found in Cyprus and Syria, as well as in the Carthaginian cemeteries of Sardinia, evincing Carthaginian contacts. Some of the 'Graeco-Phoenician' gems are chronologically a strange phenomenon. Though of early archaic style, they can be dated as not earlier than the middle of the sixth century B.C., that is, the period of the Carthaginian supremacy; and the archaic style even persists into the fourth century, long after freer representations have been current in Greece. The shape is regu-larly the scarab, generally of small dimensions. The favourite material is the green or blackish jasper, though carnelian and chalcedony also occur, as well as serpentine, and even glass. The subjects show a mixture of Oriental and of Greek motifs – Greek heroes such as Herakles, and Greek mythological creatures like silenoi and Medusa, side by side with Oriental deities, such as the Egyptian Bes (Besa), in a multitude of attitudes.

In the following selection I have put first what seem to be the purely 'Orientalizing' examples of the seventh century B.C.; then the 'Graeco-Phoenician' ones, dividing the latter into two categories, those with predominantly Oriental influence, and those with strong Greek influence – some of which are of later date, and might almost have been included in the archaic Greek group, except for some alien features.

12. *Carnelian scarab*, in ancient silver ring. 12 × 8 mm.

From Cyprus. In the Museum of Fine Arts, Boston, 98.738. Formerly in a private collection in England.

LION, lying down, with forelegs extended, amid lotus flowers and lotus buds on long stems. Ground line and cross-hatched exergue.

Seventh century B.C.

Furtwängler, *A.G.*, pl. LXI, 8.
Osborne, *Engraved Gems*, pl. VI, 14, p. 313.

13. *Banded agate scarab* (?). 17 × 19 mm.

Perhaps from Cyprus. In the British Museum, 98.2–22.3. Bought 1898.

LION AND GRIFFIN, locked in combat. Both are standing on their hindlegs. Between them are two letters which have been interpreted as perhaps the Cypriote *ja-si*. Ground line, line border.

Perhaps early sixth century B.C.

Furtwängler, *A.G.*, pl. LXIV, 2.
Walters, *Cat.*, no. 331, pl. VI.

14. *Banded agate scarab*, set in a swivel mount. 17 × 11 mm.

From Mari, Cyprus. In the British Museum, 89.10–15.2. Bought 1889.

LION ATTACKING A STAG. The lion has jumped on the stag from behind; one hindleg is still on the ground, the other is placed on the stag's outstretched hindleg. The stag lies prostrate, with head turned back. In the background are long-stemmed flowers, signifying the out-of-doors. Ground line. Line border.

Seventh to sixth century B.C.

For the motif of the lion's hindleg placed on the victim's outstretched leg cf., e.g., the representation on the archaic Greek gem no. 199.

Walters, *Cat.*, no. 333, pl. VI.

15. *Banded agate scarab*. 15 × 13 mm.

From Etruria. In the Cabinet des Médailles. Acquired through the gift of Pauvert de La Chapelle in 1899.

LION ATTACKING A DEER. The lion is biting the deer in the back; one of its hindlegs is still on the ground, the other is placed on the deer's left hindleg. The deer is collapsing and lifts its head in pain.
Above is a globe within a crescent, and two other globes, each within a circle. Guilloche border.

The upper surface of the beetle is carved in the form of a hoplite in relief.

Sixth century B.C.

Bull. dell'Inst., 1834, p. 116, no. 2.
Lajard, *Mithra*, pl. LXVIII, 6.
King, *Antique Gems and Rings*, I, p. 124, and p. 126 with drawing; *Handbook*, pl. XVII, 6.
E. Babelon, *Coll. Pauvert de La Chapelle*, no. 58, pl. V.
Furtwängler, *A.G.*, pl. VIII, 44, pl. XVI, 4 (hoplite).

16. *Chalcedony*, cut; slightly convex on engraved side. 17 mm.

In the Metropolitan Museum of Art, 81.6.1. Gift of John Taylor Johnstone. From the King Collection.

LION ATTACKING A BULL. The lion has sprung on the bull from the front and is biting it in the back. The bull is standing, with head lowered. The lion's mane is indicated by a chequer pattern. Curving ground line.

Seventh to sixth century B.C.

King, *Antique Gems*, p. 156; *Antique Gems and Rings*, II, p. 70, woodcuts pl. LVIII, 1.
Richter, *M.M.A. Handbook*, 1953, p. 147; *Cat.*, no. 20, pl. IV.

17. *Carnelian scarab*. Edge chipped. Mounted in a modern swivel ring. 13 × 21 mm.

In the Thorvaldsen Museum, Copenhagen.

LION ATTACKING A BULL. The lion has jumped on the bull from the front, with both forelegs placed on its back, and one hindleg on its head, the other on the ground. The bull is standing still, with head lowered.

The mane of the lion is indicated by crossed lines, with a series of straight bristles above. Ground line.

Seventh to sixth century B.C.

Fossing, *Cat.*, no. 3, pl. I.

18. *Green jasper scarab.* 17 × 12 mm.

In the British Museum, 1923.4–1.13.

TWO LIONS ATTACKING A BULL. One lion is biting the bull in the back, the other has placed a foreleg round its head, but with its own head turned away. In the field a flower.

The bull's tail ends in two loops, as in no. 19.
Hatched border and cross-hatched exergue.

Seventh to sixth century B.C.

For an Oriental prototype cf. the group on the Regulini Galassi bowl in the Villa Giulia Museum, Randall-Mac Iver, *Villanovans and Early Etruscans*, pl. 38, 1.

Imhoof-Blumer and Keller, pl. XIV, 41.
Furtwängler, *A.G.*, pl. VII, 18.
Walters, *Cat.*, no. 334, pl. VI.

19. *Dark green jasper scarab.* 16 × 12 mm.

Found at Agrigentum. In the Cabinet des Médailles, 55. Gift of Pauvert de La Chapelle, 1899. Formerly in the Collection of Al. Castellani.

TWO LIONS ATTACKING A BULL, one from the front, the other from the back. The one in front is shown in profile, with all four legs indicated, and with one hindleg perched on a rectangular protuberance; of the one at the back only the frontal head and two paws are visible. The bull is quietly standing, one foreleg bent under the attack. Below are two flowers, to indicate the out-of-doors. Line border and cross-hatched exergue.

Early sixth century B.C.

Cf. the replica from Tharros in the British Museum, Walters, *Cat.*, no. 416, pl. VII.

Froehner, *Catalogue des objets de la succession Alessandro Castellani*, Rome, 1884, no. 976.
E. Babelon, *Catalogue de la Collection Pauvert de La Chapelle*, no. 55, pl. V.

20. *Green translucent steatite scaraboid.* Two grooves round edge; perforated horizontally. Chipped above lion's head. L. 25 mm.

'Supposed to come from Aegean Island' (Evans). 'From Rethymnon, Crete' (Bourdman). In the Metropolitan Museum of Art, New York, 42.11.5. Pulitzer Fund, 1942. From the Evans collection.

LION ATTACKING A MAN. The man has collapsed on the ground; his head is inside the lion's wide-open mouth, and the lion's forepaw is mauling his shoulder. Both hindlegs of the lion, but only one foreleg are indicated.

Early seventh century B.C.

Evans, *Selection*, no. 27.
Richter, *Evans and Beatty Gems*, no. 6; *M.M.A. Handbook*, 1953, p. 146; *Cat.*, no. 6, pl. I.
Cat., no. 6, pl. I.
Boardman, *Island Gems*, p. 82, no. 354.

21. *Green jasper cone*, broken at the bottom. Transverse hole. Diam. 14 mm.

In the Cabinet des Médailles. Acquired through the gift of Pauvert de La Chapelle in 1899.

MAN ABOUT TO SACRIFICE A WILD GOAT. He holds it by one horn, and has the knife ready in his other hand. He wears a sleeveless, belted tunic, which leaves the left leg bare, and a headdress with lappets. The upper part of his body is shown in front view, the rest in profile. The goat stands erect on its hindlegs, with head turned back. Line border and cross-hatched exergue.

Seventh century B.C.

Cf. Lajard, *Le Culte de Mithra*, pl. XV, 2, pl. XIX, 2, pl. XXIX, 8, pl. XLVI, 7, pl. XLVII, 4, pl. LI, 3.
E. Babelon, *Coll. Pauvert de La Chapelle*, no. 20, pl. IV.

22. *Mottled chalcedony scarab.* 12 × 15 mm.

From Hamah, Syria. In the British Museum, 1923.4–16.3. Bought 1923.

GRIFFIN, looking at a hare. The griffin is seated, with beak slightly open. The hare is standing on its hindlegs, with paw lifted. Both are in profile to the right; but of the hare both ears are shown, also part of the further hindleg, though only one foreleg. Line border.

Perhaps sixth century B.C.

Walters, *Cat.*, no. 320*.

23. *Green jasper scarab*, mounted in a gold setting attached to a silver swivel ring. 12 × 17 mm.

In the Cabinet des Médailles. Gift of the duc de Luynes in 1862 (no. 213).

SEA-MONSTER, of human form to the waist, and then ending in the body and tail of a fish. In one hand it holds a two-handled cup, in the other a wreath. In the field is a dolphin. Hatched border.

Probably sixth century B.C.

Bull. dell'Inst., 1839, p. 100, no. 4.
Micali, *Storia*, III, pl. XLVI, 19.
Babelon, *Cabinet des antiques*, pl. XLVII, 19.
Furtwängler, *A.G.*, pl. VII, 6.
Pierres gravées, Guide du visiteur (1930), p. 137, no. 213 (not ill.).

24. *Dark green jasper scarab.* Fractured at bottom and chipped round edge. 13 × 9 mm.

Found in Sardinia. In the Cabinet des Médailles. Acquired through the gift of Pauvert de La Chapelle in 1899.

FOREPARTS OF A LION AND OF A BOAR conjoined, the latter upside down. The lion is shown vigorously walking, with mouth wide open. The boar's forelegs are hanging down. Hatched border.

Seventh to sixth century B.C.

Cf. the coins of Asia Minor of about the sixth century B.C., Head, *The Coinage of Lydia and Persia*, pl. I, 6; E. Babelon, *Les Perses Achéménides*, Intr., p. XLIV, XLVIII.

E. Babelon, *Cat., Coll. Pauvert de La Chapelle*, no. 43, pl. V.

25. *Green jasper scarab*, mounted in a modern gold ring. 18 × 11 mm.

In the Cabinet des Médailles. Gift of the duc de Lyunes in 1862 (no. 292).

WINGED MONSTER. To the forepart of a boar are attached two large wings, one placed below the other. Hatched border. No marginal ornament.

Later sixth century B.C.(?)

The same convention of placing one wing below the other occurs on the coins of Ialysos, dated *c.* 500–480 B.C.; Franke-Hirmer, *Die griechische Münze*, pl. 188, middle.

26. *Haematite scaraboid.* 18 × 17 mm.

From Egypt. In the British Museum, 1923.4–1.9.

COW AND CALF. In the field a tree and a rosette.

Sixth century B.C.

King, *Antique Gems and Rings*, II, pl. 2, fig. 4; *J.H.S.*, VII, 1897, p. 345.
Walters, *Cat.*, no. 308, pl. VI.

27. *Burnt chalcedony scaraboid.* 21 × 15 mm.

From Egypt. In the British Museum, 1923.4–1.7.

On the convex side is a rosette or star.

SPHINX, lying down in profile to the left. Only two legs are indicated. In the field, in front, is a comb-like ornament and, above, a flower. Curving ground line.

Sixth century B.C.

Furtwängler, *A.G.*, III, p. 77, note.
Walters, *Cat.*, no. 296, pl. VI.

28. *Green jasper scarab.* H. 17 mm.

In the Metropolitan Museum of Art, New York, 37.11.7. Fletcher Fund, 1937.

THE GOD BES, with an Egyptian crown of feathers on his head. He is carrying a lion on his left shoulder, holding it by one of its hindlegs, and is holding a boar by its tail with the other hand. He wears a lion's skin, of which the tail appears behind his buttocks. The lion has its mouth wide open, with tongue protruding, but no teeth indicated; only one hindleg and no forelegs are shown.

In the field are a papyrus flower and a papyrus bud. Hatched border and cross-hatched exergue.

Sixth century B.C.

For the Egyptian god Bes on Graeco-Phoenician stones cf. Furtwängler, *A.G.*, III, pp. 110 f. He was considered an averter of evil.

Alexander, *M.M.A. Bull.*, XXXII, 1937, p. 176, fig. 2.
Richter, *M.M.A., Handbook*, 1953, pl. 147, pl. 125, f; *Cat.*, no. 16, pl. IV.

29. *Green jasper scarab.* 18 × 14 mm.

From Syria (?). In the British Museum, 68.5–20.24. Acquired from the Pulsky Collection in 1868.

THE GOD BES, striding to the left. A long-horned goat issues from each shoulder, and two uraei from the waist. Line border and cross-hatched exergue.

Beazley, *Lewes House Gems*, p. 7.
Walters, *Cat.*, no. 276, pl. V.

30. *Chalcedony scarab.* 18 × 13 mm.

From Cyprus (?). In the British Museum, 98.2–22.2. Bought in 1898.

THE GOD BES AND A GRIFFIN, confronted. Bes extends both arms toward the griffin, which has its head turned back. Hatched border and cross-hatched exergue.

Furtwängler, *A.G.*, pl. LXIV, 3.
Beazley, *Lewes House Gems*, p. 7.
Walters, *Cat.*, no. 277, pl. V.

31. *Carnelian scarab.* 15 × 12 mm.

In the British Museum, RPK 103. Formerly in the Payne Knight Collection.

DAEMON SEIZING A GOAT. The daemon is in the form of the god Bes, with large wings, and with the hind part of a lion attached to his back. He has seized the goat by one foreleg. The goat is in profile to the left, confronting the daemon, but with its head turned back. Hatched border and exergue of zigzags.

Imhoof-Blumer and Keller, pl. XXVI, 52.
Keller, *Tiere des classischen Altertums*, p. 338.
Furtwängler, *A.G.*, pl. VII, 41, and vol. III, pp. 101, 112.
Walters, *Cat.*, no. 317, pl. VI.

32. *Dark green jasper scarab*, in a modern setting. Chipped here and there. 17 × 11 mm.

In the Fitzwilliam Museum, Cambridge. Bequeathed by C. H. Shannon in 1937, no. 3, 81. From the Uzielli Collection.

BES STRUGGLING WITH A LION. They are shown confronted, in heraldic fashion.

Exhibition of Greek Art, Burlington Fine Arts Club, 1904, p. 254, O, 89, pl. CX.
Sale Catalogue of the Newton Robinson Collection, no. 4, pl. I.

33. *Carnelian scaraboid.* 35 × 26 mm.

From Damanhur, Egypt. In the Ashmolean Museum, 1892.1355. Acquired through the Chester bequest.

WINGED, FEMALE SPHINX, with the head of the god Bes, in profile to the left. The head is turned to the front. Hatched border.

Early fifth century B.C.

34. *Green jasper scarab.* Chipped at the top. 15 × 11 mm.

From Iviza. In the Metropolitan Museum of Art, New York, 31.11.14. Fletcher Fund, 1931. Formerly in the collection of Miss Winifred Lamb.

FOREPART OF ISIS, combined with the rear of a four-legged, winged scorpion. The hands are raised in adoration. Hatched border.

Early fifth century B.C.

For scorpion bodies on Oriental stones cf. A. Moortgart, *Vorderasiatische Rollsiegel*, pl. 88, nos. 752, 753.
The same gesture of adoration appears on another Graeco-Phoenician scarab, now in Boston, Beazley, *Lewes House Gems*, no. 11, pl. II: 'The posture of the worshipper is transferred to the deity'.

Vives, *La necropoli de Ibiza*, pl. XXIV, 21.
Beazley, *Lewes House Gems*, p. 7.
Kunze, *Ath. Mitt.*, LVII, 1932, p. 129, note 1.
Richter, *M.M.A. Handbook*, 1953, p. 147, pl. 125, h; *Cat.*, no. 15, pl. IV.

35. *Green jasper scarab.* Part is missing. 18 × 13 mm.

Found to the north of Defenneh (Daphnae), Egypt. In the British Museum, 88.2–8.161. Presented by the Committee of the Egypt Exploration Fund in 1888.

HEAD OF HERAKLES. He wears the lion's skin and has a pointed beard, below which is an aegis (?) with serpents' heads (?). Hatched border.

About 500 B.C.

Walters, *Cat.*, no. 321, pl. VI.

36. *Green jasper scarab.* 10 × 13 mm.

From Iviza. In the Museum of Fine Arts, Boston, 27.764. Formerly in the Kennedy Collection.

HEAD OF A YOUTH, wearing a crested helmet, which in front is in the form of a silenos head, and at the back in that of a lion's head. The youth has long hair, divided by horizontal grooves, in the archaic manner. Hatched border.

Beginning of the fifth century B.C. The style closely approaches the Greek.

Vives, *Estudio de arquelogia cartaginesa, La necropoli di Ibiza*, pl. 25, no. 21.
Perez-Cabrero, *Ibiza arqueológica*, p. 28, no. 5.
Sale Catalogue of the Kennedy Collection, no. 212, 1.
Beazley, *Lewes House Gems*, no. 12, pl. 2.

37. *Sard scaraboid*, in gold setting. 15 × 12 mm.

Found at Amathus, Cyprus (tomb 256, sarcophagus III). In the British Museum. Acquired through the Turner bequest, 1894.

MAN STABBING A LION. He holds the lion by the head with his left arm, while he stabs him with his sword. He is nude and wears a helmet. In the field are two Egyptian eye-amulets. Line border.

For the possibility of this being an Orientalized version of Herakles and the Nemean lion cf. Furtwängler in Roscher's *Lexikon*, I, 2, s.v. Herakles, cols. 2196 and 2145.

Excavations in Cyprus, pl. 4, Amathus, fig. 4, pl. 14, fig. 33, pp. 98, 125.
Furtwängler, *A.G.*, pl. VI, 42, and vol. III, p. 93.
Walters, *Cat.*, no. 299, pl. VI.

38. *Green jasper scarab.* 14 × 11 mm.

In the British Museum, 89.8–5.4. Bought 1889.

HERMES, walking to the right and holding his kerykeion in his right hand. He wears a petasos and a chlamys hanging down from his arms. The chest is frontal, the rest more or less in profile. In the field are a dolphin, and what may be intended for a bird. Hatched border.

Walters, *Cat.*, no. 316, pl. VI.

39. *Agate scarab*, in a gold swivel ring. 16 × 14 mm.

In the British Museum, 91.6–23.2. Bought 1891.

GRIFFIN ATTACKING A WARRIOR, who has fallen on his right knee, holding his sword in his right hand, a shield in his left. He wears a helmet and a belted chiton; the sheath of his sword is hanging by his side. The griffin has placed one forepaw on the man's chest, the other on his shield, and one hindleg on his left leg; both wings are indicated. Ground line. Hatched border and hatched marginal ornament.

Walters, *Cat.*, no. 320, pl. VI.

40. *Green jasper scarab.* Fractured at back. 15 × 11 mm.

From Tharros (grave 10). In the British Museum, 56.12–23.865. Acquired in 1856.

WARRIOR, moving to the left and looking back. He wears a helmet, a cuirass, with a necklace of bullae, greaves, and what look like short knickers but are probably meant for his chiton (indicated by stripes). In his right hand he holds a spear (which is shown passing behind him instead of in front), and on his left arm is his shield, which has a large silenos mask as a device. Hatched border.

Furtwängler, *A.G.*, pl. VII, 48.
Walters, *Cat.*, no. 405, pl. VII.
Lippold, *Gemmen und Kameen*, pl. 52, fig. 8.

41. *Green jasper scarab.* Fractured at bottom. 6 × 15 mm.

From Iviza. In the Museum of Fine Arts, Boston, 27.660. Formerly in the Kennedy Collection.

YOUTH, running to the right. He holds a bow and arrow in his right hand, and a cock is perched on his left. He is nude and his hair is looped up behind. The upper part of his body is shown frontal, the rest in profile. Hatched border.

Beginning of the fifth century B.C. The style is almost pure Greek.

Cf. the similar figures on the green jasper scarabs from Tharros in the Museum of Cagliari, Furtwängler, *A.G.*, pl. XV, 47, and from Iviza, Vives, *op. cit.*, pl. XXIII, 7; Beazley, *op. cit.*, pl. A, 13.

Vives, *La necropoli di Ibiza*, pl. XXIII, 6.
Perez-Cabrero, *Ibiza arqueológica*, p. 28, no. 1.
Sale Catalogue of the Kennedy Collection, no. 212, 2.
Beazley, *Lewes House Gems*, no. 13, pls. 2 and 9.

42. *Jasper scarab.* 16 × 12 mm.

In the Fitzwilliam Museum, Cambridge. Bequeathed by C. H. Shannon in 1937, no. 4 (9).

HERMES (?), in the semi-kneeling posture used to signify flying or running, is moving to the left, with a cock on his right hand, a lyre in the left. He is nude and wears a diadem in his hair. The body is shown frontal, the head, arms and legs in profile. Hatched border.

Fifth century B.C. The style approximates the Greek, but to see the difference cf. the Greek version, no. 122.

3. ISLAND GEMS, SEVENTH TO SIXTH CENTURY B.C.

Artistically perhaps the most important of the seventh-century gems are the so-called Island or Melian. They have been found principally in the Aegean islands, including Crete, and especially in Melos, where they were presumably produced; but they have come to light also elsewhere, occasionally even in far-off Babylonia and India. They show a revival of Mycenaean gem-engraving, both in the shapes used and in the subjects represented. The shapes are the lentoid and the glandular (amygdoloid) – only occasionally others, such as disks, cylinders, and three-sided stones – here included since their style approximated that of the Island gems. The subjects consist mostly of animals – stags, goats, bulls, boars, horses, lions, fish, dolphins – and monsters – e.g., the chimaera, the sphinx, the griffin, the gorgon – often in contorted poses rhythmically designed. Occasionally human figures appear, several times even in a mythological context, such as Ajax committing suicide, or Prometheus being attacked by the eagle, or Herakles wrestling with a merman. In the field various motifs are often added of which the significance, if any, generally escapes us, only occasionally identifiable as plants, shrubs, etc.

These representations often so closely resemble the Mycenaean that when the stones were first discovered and also later they were not always distinguished from the Mycenaean. Technically, however, there is a fundamental difference, in that the designs are worked by hand on softish stones (serpentine, steatites, limestone), generally of a light greenish tint, instead of being carved on hard stones with the help of a rotating instrument as were the Mycenaean.

To explain this strange revival of Mycenaean shapes and designs centuries after the decline and downfall of the Mycenaean civilization it has been suggested that during the seventh century actual Mycenaean gems were accidentally discovered and utilized by the artists of the time. This theory seems in fact – to judge by the present evidence – to be convincing, for only in such a way could Mycenaean gems have exercised this potent influence. There was, as is well known, no continuous tradition.

The period assigned to the 'Island' stones is from the second quarter of the seventh century into the sixth century B.C.[1] In the middle of the sixth century they were succeeded – all over Greece, not only in the Islands – by the 'archaic Greek' gems; and from then on the steady evolution of the Greek style from archaic to developed to Hellenistic can be observed on the engraved gems as in the other products of Greek art. And it is noteworthy that in this development the Island gems played a part. For in the Greek gems of the later sixth and the fifth century there occur representations of animals in a variety of poses sometimes strikingly similar to the Mycenaean (cf., e.g., no. 51). And this could be explained by the theory that the Island stones acted as intermediaries; for in other branches of art there was a distinct break between the Mycenaean and the Greek (cf. p. VIII). Furthermore, in these Island gems one can observe a masterly feeling for design, that is, for the filling of the available space with the representation chosen; and this sense of composition remains a characteristic of Greek gems throughout their history.

[1] Cf. J. Boardman, *Island Gems, A Study of Greek Sealstones in the Geometric and Early Archaic Periods* (published by the Society for the Promotion of Hellenic Studies, Supplementary Paper, no. 10, 1963). He divides the stones into several chronological classes: Class A; Class B, from the second quarter of the seventh century B.C.; Class C, *floruit* second half of the seventh century B.C.; Class D, around 600 B.C. and during the early sixth century. As there is virtually no external evidence for a detailed chronology of Island gems, these classes are necessarily based on 'style and subject' (cf. his p. 89), and 'technique' (cf. his pp. 18 ff., i.e., Class A = incised; Class B = cut; Class C = gouged; Class D = carved). In my references, therefore, I shall add the class assigned to each stone by Boardman, but shall not try myself to give a specific date to individual examples.

The following examples include the prevalent monsters and animals, as well as human beings in mythological context. Of special interest is also a warship with a sea serpent swimming alongside (cf. no. 59).

43. *Lentoid steatite*, engraved on both sides. Slightly fractured. 21 × 20 mm.

In the British Museum, 74.3–5.16. Bought 1874.

(1) JOINED FOREPARTS OF WINGED HORSES, one inverted.
(2) CHIMAERA, with left forepaw raised. Only one hindleg is indicated. Plants (?) in the field.

Milchhöfer, *Anfänge der Kunst*, p. 81, fig. 52a, b.
Imhoof-Blumer and Keller, pl. xxv, 37.
Keller, *Tiere des classischen Altertums*, p. 337.
Furtwängler, *A.G.*, pl. v, 16.
Walters, *Cat.*, no. 208, pl. v.
Boardman, *Island Gems*, p. 66, no. 203B (Class C).

44. *Glandular white steatite*, with brown flecks. 25 × 17 mm.

In the British Museum, 83.5–8.5. Bought 1883.

FOREPARTS OF TWO WINGED HORSES, joined. One is in profile to the right, the other to the left.

Imhoof-Blumer and Keller, pl. xxvi, 14.
Walters, *Cat.*, no. 169, pl. iv.
Boardman, *Island Gems*, p. 67, no. 283, not ill. (Class C).

45. *Lentoid steatite.* 16 × 16 mm.

In the British Museum, 74.3–5.17. Bought 1874.

PEGASOS, flying to the left. All four legs and both wings are indicated. In the field a branch.

Furtwängler, *A.G.*, pl. v, 13.
Walters, *Cat.*, no. 207, pl. iv.
L. Malten, *J.d.I.*, xxxx, 1925, p. 147, fig. 51.
Boardman, *Island Gems*, p. 65, no. 261, p. 87 (early Class D).

46. *Lentoid translucent light green steatite.* W. 18 mm.

In the Metropolitan Museum of Art, New York, 42.11.12. Pulitzer Fund, 1942. Formerly in the Fortnum and Evans Collections.

Engraved on both sides:
(1) WINGED HORSE, with reversed rear. The wings are directed downward. In the field a dolphin.
(2) WINGED MONSTER, composed of the forepart of a goat and the scaly body of a fish.

Both designs fill the space in a masterly way. The stone is 'the finest extant example of the type' (Boardman).

Evans, *Selection*, no. 37.
Richter, *Evans and Beatty Gems*, no. 11; *M.M.A. Handbook*, 1953, p. 146, pl. 125, c; *Cat.*, no. 10, pl. iii.
Boardman, *Island Gems*, pp. 63, 66, no. 253 A and B, pl. ix, and p. 87 (Class D).

47. *Lentoid white limestone.* 21 × 20 mm.

From the Greek Islands. In the British Museum, 89.5–13.1. Bought 1889.

WINGED SEA-HORSE, with curling fish-tail. In the field, on either side, is a notched line, perhaps signifying a branch.

Furtwängler, *A.G.*, pl. v, 21, and vol. iii, p. 72.
Walters, *J.H.S.*, xvii, 1897, pp. 63 ff., pl. iii, 13; *Cat.*, no. 210, pl. v.
Shepard, *The Fish-tailed Monster*, p. 26, pl. v, 33.
Boardman, *Island Gems*, p. 68, no. 291, p. 88 (Class D, early).

48. *Glandular steatite.* 18 × 25 mm.

From Melos. In the British Museum, 1921.12–12.2. Bought 1921.

WINGED HIPPOCAMP, moving rapidly to the left. Both forelegs are indicated, but only one wing. In the field, above and below, a branch.

Walters, *Cat.*, no. 171, pl. iv.
Boardman, *Island Gems*, p. 63, no. 258 (early Class D). Not ill.

49. *Lentoid rock crystal.* 16 × 17 mm.

In the Ashmolean Museum, 1892.1468. From Athens.

PANTHER, in profile to the left, with head turned to the front. All four legs are indicated.

Boardman, *Island Gems*, p. 81, note 1 ('mid-sixth century B.C.').

50. *Glandular steatite*, dark greenish brown. 19 × 15 mm.

In the British Museum, 74.3–5.3. Bought 1874.

GRIFFIN, in profile to the right, with head turned back. Only two legs and one wing are indicated; there are no ears and no headdress. The mane is marked by dots.

Imhoof-Blumer and Keller, pl. xxv, 56.
Furtwängler, *A.G.*, pl. v, 38.
Walters, *Cat.*, no. 170, pl. iv.
Boardman, *Island Gems*, p. 59, no. 219, pl. viii (Class D).

51. *Mottled white lentoid steatite.* L. 26 mm.

In the Ashmolean Museum, 1921.1225. Once in the Story-Maskelyne Collection. Gift of Sir John Beazley.

STAG, OR GOAT, FALLING, in profile to the right, with head turned back. Two dolphins in the field. Hatched groundline.

Furtwängler, *A.G.*, pl. vi, 26.
Sotheby Sale Catalogue, July 4th–5th, 1921, no. 26.
Boardman, *Island Gems*, pp. 38, 87, no. 108 (early Class D).

52. *Light green lentoid steatite.* Diam. 14 mm.

From the Greek Islands. In the Staatliche Museen, Berlin.

WILD GOAT, jumping to the left, with head turned back. Behind it is a branch.

Imhoof-Blumer and Keller, pl. xviii, 27.
Furtwängler, *Beschreibung*, no. 90; *A.G.*, pl. v, 2.
Boardman, *Island Gems*, p. 28, no. 35, p. 87 (Class D).
Matz, *Geschichte*, i, pl. 295b, 1.

53. *Pale green circular steatite*, mounted in a gold hoop. Diam. 18 mm.

In the National Museum, Athens, Numismatic section, inv. 92. Gift of K. Karapanos, 1910–11.

SWAN-LIKE BIRD. In the field a snake.

Furtwängler, *A.G.*, ii, under pl. v, 8.
Svoronos, *Journal international d'archéologie numismatique*, xv, 1913, no. 466.
Boardman, *Island Gems*, p. 41, no. 127, pl. v, and p. 87 (Class D).

54. *Lentoid white steatite.* 22 × 21 mm.

From Naxos. In the Fitzwilliam Museum, Cambridge, GR 51.1952. Bought 1952. From the A. B. Cook Collection.

COCK, standing in profile to the right. Both legs are indicated, and the tail is spread out. In the field are two saw patterns.

Sotheby Sale Catalogue, Jan. 15, 1952, lot 26.
Boardman, *Island Gems*, p. 41, no. 132, pl. v.

55. *Glandular pale greenish steatite.* 24 × 17 mm.

In the British Museum, 82.10–14.6. Bought 1882.

CENTAUR, galloping to the left, with head turned back, and arms extended. He is bearded and has long hair. All four legs and both arms are indicated. In the field is a branch.

Rossbach, *Arch. Ztg.*, XLI, 1883, p. 16, fig. 16.
Imhoof-Blumer and Keller, pl. xxv, 33.
Furtwängler, *A.G.*, pl. v, 33.
Baur, *Centaurs*, p. 13, no. 12.
Walters, *Cat.*, no. 173, pl. iv.
Boardman, *Island Gems*, p. 55, no. 197, pl. vii (late in Class C).

56. *Light green lentoid steatite*, burnt. 23 × 18 mm.

From Melos. In the Staatliche Museen, Berlin.

CENTAUR, in profile to the right, with head turned back. In one hand he holds a branch, in the other a stone. All four legs are indicated.

Furtwängler, *Beschreibung*, no. 93; *A.G.*, pl. v, 29.
Boardman, *Island Gems*, p. 55, no. 198, p. 87, pl. vii (Class D, early).
Baur, *Centaurs*, pp. 7 f., no. 11.

57. *Lentoid translucent green steatite.* W. 19 mm.

Said to be from Perachora. In the Metropolitan Museum of Art, New York, 42.11.13. Pulitzer Fund, 1942. Formerly in the Evans Collection.

THE SUICIDE OF AJAX. He has fallen on his sword, of which the hilt is stuck in a mound of earth (indicated by a cross-hatched triangle); it has passed right through him, the tip of it appearing above his back. He is nude, bearded, and has short, bristly hair. His legs are straight and taut, his arms fall limply down. In the field the inscription *Hahifas* = Ajax – the only one so far known on an Island gem.
On the subject of Ajax's suicide, common on archaic gems, cf. Kunze, *Archaische Schildbänder*, p. 154; Beazley, *Lewes House Gems*, pp. 37 f.; Dunbabin, *The Greeks and their Eastern Neighbours*, p. 82.
On the inscription being perhaps Etruscan, cf. Jeffery, loc. cit. 'It does not fit into East Greek archaic script' (Guarducci). And yet it seems to be genuine.

Evans, *Selection*, no. 38.
Beazley, *Lewes House Gems*, p. 38; *Etruscan Vase-Painting*, p. 137.
Richter, *Evans and Beatty Gems*, no. 14; *M.M.A. Handbook*, 1953, p. 146, pl. 125, e; *Cat.*, no. 13, pl. iii.
Boardman, *Island Gems*, pp. 49 f., no. 178, pl. vii (placed in his Class D, early).
Jeffery, *Local Scripts of Archaic Greece*, p. 322.

58. *Lentoid yellow steatite.* 19 × 19 mm.

In the British Museum, 74.3–5.1. Bought 1874.

HERAKLES WRESTLING WITH A MERMAN. Herakles is shown in a striding attitude, encircling the merman with both arms. He wears a tight-fitting, belted tunic, and has a quiver on his back. The merman has no arms; his fish body is dotted, as also Herakles' quiver. In the field are two dolphins.

E. Babelon, *La Gravure,* p. 89, fig. 60.
Milchhöfer, *Anfänge der Kunst,* p. 84, fig. 55.
Imhoof-Blumer and Keller, pl. xxv, 45.
Furtwängler, *A.G.,* pl. v, 30, and vol. III, p. 72.
Walters, *Cat.,* no. 212, pl. v.
Buschor, *Meermänner,* p. 9, fig. 6.
Boardman, *Island Gems,* p. 51, no. 181, pl. VII (Class D).

59. *Glandular pale green steatite.* Chip at one of the perforations. Perforated horizontally. L. 27 mm.

From Epidauros Limera. In the Metropolitan Museum of Art, New York, 42.11.11. Pulitzer Fund, 1942. From the Evans Collection.

FOREPART OF A WARSHIP, with a sea-serpent swimming alongside. The ship has a railing and a ram, which is decorated with a large round eye, and with wavy lines, front and back. The serpent has fins, a fish's tail, ears, and teeth. In the field is a large lotus flower.

Second half of seventh century B.C.

This is one of the earliest known representations of the sea serpent (κῆτος), the monster killed by Perseus. For lists of representations cf. Bloesch, *Antike Kunst in der Schweiz,* pp. 44, 162, pl. 15, and the references there cited; Boardman, *op. cit.,* p. 68. Another, more primitive, representation on an Island gem appears on a prism from Siphnos in Athens; cf. Boardman, *op. cit.,* p. 75, no. 316B, pl. XI.

Evans, *Selection,* no. 35.
Furtwängler, *A.G.,* pl. VI, 34.
Richter, *Evans and Beatty Gems,* no. 12; *M.M.A. Handbook,* 1953, p. 146, pl. 125, d; *Cat.,* no. 14, pl. III.
Shepard, *The Fish-tailed Monster,* 1940, p. 29, pl. v, fig. 40.
Boardman, *Island Gems,* p. 69, no. 293, pl. x, and p. 88 (placed in his Class D).

60. *Three-sided green steatite* prism. Engraved on the three sides. C. 13 × 14·5 mm.

In the Ashmolean Museum, 1873.136. Gift of the Rev. G. J. Chester. Bought in Smyrna.

(1) YOUTH, RUNNING TO THE RIGHT, with arms extended. He seems to be wearing a helmet. Behind him are two strokes.

(2) FEMALE BUST, in profile to the right, holding a branch. She has long hair, and seems to be wearing a cap or a fillet, and an earring.
(3) HORSE, walking to the right. Above, a branch.

Evans, *Cretan Pictographs,* p. 65, fig. 53, and p. 137 f.
Matz, *Die frühkretischen Siegel,* pl. 17, no. 1.
Biesantz, *Marburger Winckelmannsprogramm,* 1958, p. 10, no. 12, pl. II.
Boardman, *Island Gems,* p. 75, no. 315, pl. x (placed in his Section 5, 'as Class B').

61. *Green steatite disk,* engraved on both sides. 21 × 21 mm.

In the British Museum, 90.5–12.3. Bought in Athens in 1890.

(1) MAN RUNNING, with head turned back. In his raised right hand he holds a sword. In the field is a plant.
(2) WINGED HORSE, galloping. Only two of his legs are indicated, and only one wing. In the field a branch.

Furtwängler, *A.G.,* pl. VI, 20, 21.
Walters, *Cat.,* no. 223, pl. v.
Shepard, *The Fish-tailed Monster,* pl. III, 11.
Boardman, *Island Gems,* p. 76, no. 328, pl. XI ('as Class C/D').

62. *Black serpentine disk.* Engraved on both sides. 13 × 14 mm.

In the Ashmolean Museum, 1895.4. Gift of Sir John Myres. Bought in Athens.

(1) WILD GOAT, in profile to the left. Ornaments in the field.
(2) MAN, walking to the left, holding a branch in his right hand, the left raised. Another branch is by his side.

Casson, *Ant. Journ.,* VII, 1927, pl. v, 8.
Boardman, *Island Gems,* p. 132, G32, pl. XVI ('as Class B').

63. *Lentoid grey micacious stone.* Perforated vertically. Chip missing at back. 27 × 27 mm.

Said to have been found in Melos. In the Metropolitan Museum of Art, New York, 42.11.7. Pulitzer Fund, 1942. From the Evans Collection.

SPHINX, seated in profile to the right, with head turned back. She has a recurving, tufted tail and hair arranged in horizontal layers, Daedalid fashion. In the field are a star-like and an elongated ornament.

Evans, *Selection,* no. 34.
Richter, *Evans and Beatty Gems,* no. 9; *M.M.A. Handbook,* 1953, p. 146; *Cat.,* no. 8, pl. II.
Boardman, *Island Gems,* p. 60, no. 226 (Class C).

64. *White lentoid steatite.* W. 18 mm.

From Melos (bought at Phylakopi). In the Ashmolean Museum, 1948.92. Gift of Miss H. Lorimer.

WINGED LION, with wide-open mouth, in profile to the right. In the field various ornaments.

Boardman, *Island Gems*, p. 59, no. 215, pl. VIII (Class C).

65. *Light green lentoid steatite.* Grooved at the back. L. 21 mm.

In the Staatliche Museen, Berlin. Acquired in 1842 from the Russian painter Hintz.

BOAR, in profile to the left, with head lowered. The bristles are indicated by short vertical lines, with the usual gap in the middle.

Imhoof-Blumer and Keller, pl. XIX, 48.
Furtwängler, *Beschreibung*, no. 92; *A.G.*, pl. V, 14.
Boardman, *Island Gems*, p. 23, no. 2, pp. 87 f., pl. I (Class D).

66. *Pale green limestone glanduloid.* L. 20·5 mm.

In the Ashmolean Museum, 1938.1135. From Crete. Once in the Evans Collection.

SCORPION. Two long lines in the field.

Boardman, *Island Gems*, p. 47, no. 171, pl. VI (Class D).

67. *Round steatite.* Diam. 18 mm.

From the temenos of Poseidon, Sounion. In the National Museum, Athens.

BULL, with head turned back, in profile to the left. Only three legs are indicated, but both horns and both ears.

In the field cross-hatching.

Stais, *Eph. arch.*, 1917, p. 96, fig. 8, last row, middle. Cf. also Boardman, *Island Gems*, pp. 123 f.

68. *Elongated steatite.* L. 22 mm.

From the sanctuary of Poseidon, Sounion. In the National Museum, Athens.

MONSTER, of human form, but with the head of a cow, in a contorted position.

Stais, *Eph. arch.*, 1917, p. 96, fig. 8. Cf. also Boardman, *Island Gems*, pp. 123 f.

69. *Gold ring*, with engraved design on the bezel. Bezel 24 × 12·5 mm.

From one of the Greek Islands. In the Ashmolean Museum, 41 (Fortnum 91). Acquired through the Fortnum bequest.

TWO COUCHANT GOATS. One is placed in the middle of the field and occupies the full height; the other is placed vertically at the right side, and is much smaller. In the field various ornaments.
The style, as Boardman (*loc. cit.*) says, is 'sub-geometric', and yet different. Since it has been found 'in one of the Greek islands', he has made the ingenious suggestion that it might be 'an Island essay in a different Bronze Age seal type, analagous to the Minoanising Island gems in stone'. I have accordingly included it here, since its date should be contemporary with the Island gems, and it does not belong to the Orientalizing groups, and does not ring true as a 'geometric' product.

Boardman, *Island Gems*, p. 157.

4. IVORY AND BONE DISKS, SEVENTH CENTURY B.C.

Another class of engravings which can be assigned to the seventh century B.C. – from shortly before 700 to *c.* 600 B.C. – consists of ivory or bone seals, generally disks and plaques, with either flat or stepped sides, and often decorated with designs on both sides. They are perforated either lengthwise or transversely, in the latter case, it has been thought, for the attachment of a handle, otherwise supposedly to be strung on a string.

So far they have been found chiefly in the excavations of the Argive Heraion, of the Sanctuary of Artemis Orthia at Sparta, and at Perachora; that is, in the Peloponnese; but other sites, e.g., Delphi, Eleusis, Rhodes, Delos, Chios, etc., have yielded similar round and four-sided disks and plaques.

The subjects represented are mostly monsters, animals, and rosettes. The style is similar to that of the Island stones, and shows the same skilful filling of the space.

That these ivory and bone disks were actually used for sealing is indicated by the fact that at least in one case an impression made from such a disk has survived, cf. Stubbings, in Dunbabin, *Perachora*, II, p. 411, A 112, pl. 182.

70. *Ivory disk*, stepped, perforated vertically. Engraved on both sides. Cracked and chipped in places. 32 mm.

Said to be from Mykonos, or the Peloponnese. In the Metropolitan Museum, New York, 42.11.8. Pulitzer Fund, 1942. From the Evans Collection.

(1) LION, in profile to the right, with head turned back. The mouth is wide open, with protruding tongue and teeth showing. Only the near legs are indicated. In the field, below, a star-like ornament.
Zigzag border.
(2) EAGLE DISPLAYED. In the field two club-like ornaments. Zigzag border.
Cf. especially Stubbings, in Dunbabin, *Perachora*, II, 44, b, on pl. 178 (for the lion) and 33 on pl. 176 (for the bird); Dawkins, *Artemis Orthia*, pl. CXXXIX, e, m, pl. CXLV, 2, pl. CXLVI, 3 (for the flying bird), and pl. CXLII, 4 (for the lion).

Evans, *Gems*, no. 31.
Richter, *Evans and Beatty Gems*, no. 8; *M.M.A. Handbook*, 1953, p. 146, pl. 125, b; *Cat.*, no. 5, pl. II.
Alexander, *M.M.A. Bulletin*, 1942–43, pp. 144 f., fig. 3, p. 147.
Boardman, *Island Gems*, p. 146.

71. *Ivory disk*. Engraved on both sides (side 2 = stepped). Diameters 24–26 mm.

In the Ashmolean Museum, 1923.116. From the Sanctuary of Artemis Orthia, Sparta. Presented by the Greek Government.

(1) LION. Ornaments in the field. Hatched border.
(2) EAGLE, displayed. Hatched border.

Dawkins, *Artemis Orthia*, pl. 146, 3, and pl. 144.
Boardman, *Island Gems*, p. 145, pl. XIX, b.

72. *Ivory disk*. Engraved on both sides. Diam. 25 mm.

In the Ashmolean Museum, 1923.120. From the sanctuary of Artemis Orthia, Sparta. Presented by the Greek government.

(1) EAGLE, displayed. Ornaments in the field. Hatched borders.
(2) ROSETTE PATTERN.

Boardman, *Island Gems*, p. 145, pl. XIX, c.

73. *Bone disk*. Diam. 27 mm.

From the Sanctuary of Artemis Orthia, Sparta. In the Fitzwilliam Museum, Cambridge, 147.1923. Presented by the Greek government in 1923.

EAGLE, displayed.

74. *Ivory disk*, engraved on both sides. Diam. *c.* 35 mm.

Found at Perachora. In the National Museum, Athens.

(1) HELMETED HEAD, in profile to the right. In the field a single spiral.
(2) SWAN, in profile to the right. In the field various ornaments.

Stubbings, in Dunbabin, *Perachora*, II, pl. 175, A28, a and b.

75. *Ivory disk*, with engraved design on both sides. Diam. *c.* 26 mm.

Found in the sanctuary of Artemis Orthia, Sparta. In the National Museum, Athens, inv. 15635.

(1) FACE OF A BEARDED GORGON, with protruding tongue and a lock descending on each side. Shown frontal. Hatched border.
(2) ROSETTE, with central hole.

Dawkins, *Artemis Orthia*, p. 229, pl. CXLI, 3.
Cf. also Boardman, *Island Gems*, pp. 146 f.

76. *Ivory stepped disk*. Diam. 29 mm.

From Perachora. In the National Museum, Athens.

WINGED DAEMON, in the form of a bearded man, in a half-kneeling position, with two large wings and spindly arms outstretched. His hair is done in horizontal layers, Daedalid-fashion. Zigzag border.

Stubbings, in Dunbabin, *Perachora*, II, p. 416, no. A32, pl. 176.

77. *Stepped bone disk*, with engraved design on each side. Diam. 38 mm.

From Perachora. In the National Museum, Athens.

(1) TWO WARRIORS IN COMBAT. Each is fully armed, with crested helmet, cuirass, and greaves, and carries a shield, one a Boeotian, the other a round one. The former is aiming his spear at his opponent, the other has his drawn sword in his hand. In the field various ornaments and two spears. Dotted border and exergue ornamented with spirals.
(2) LION ATTACKING A BOAR (?). The lion has jumped on the back of his prey and is biting it in the back. Surface much weathered. Dotted border.

Stubbings, in Dunbabin, *Perachora*, II, p. 417, no. A35, pl. 177.

78. *Four-sided ivory bead* with oval faces, perforated lengthwise. Engraved on all four sides. Thickness 15·5 mm.; overall length 19 mm. Designs 12 × 16 mm.

Probably from Sparta. In the Ashmolean Museum, Oxford, 1957.49. Bought in London. Once in the possession of R. M. Dawkins.

(1) DEER, in profile to the left. Both antlers and all four legs are indicated. Line border.
(2) WINGED HORSE, in profile to the left. Both forelegs are indicated but not the hindlegs and only one wing. In the field a spiral. Line border.
(3) LION, walking to the left, open-mouthed, with protruding tongue. The two forelegs and the tail are indicated but not the hindlegs. Line border.
(4) DOUBLE PALMETTE ORNAMENT. Line border.
For similar four-sided beads cf. Dawkins, *Artemis Orthia*, p. 228, pls. CXXXIX, CXL.

Boardman, in *Visitors' Report*, 1957, pl. I, c, and *Island Gems*, p. 149, fig. 17, pl. XX, a.

79. *Ivory disk*, engraved on both sides. Diam. *c.* 38 mm.

Found at Perachora. In the National Museum, Athens,

(1) MAN RUNNING. Hatched border.
(2) WINGED LION, with wide-open mouth and one paw lifted.

Stubbings, in Dunbabin, *Perachora*, II, pl. 181, A81, a and b.

80. *Bone or Ivory disk*, with an engraved design on both sides. Much corroded. Diam. *c.* 38 mm.

From the Sanctuary of Artemis Orthia, Sparta. In the National Museum, Athens,

(1) MONSTER, in the form of a human figure with long hair, two (or four (?)) wings, and legs bent, as if running. In the field various ornaments. Hatched border.
(2) ROSETTE, with the usual central hole for the attachment of the metal handle of the seal, which, to judge by the one surviving specimen, consisted of a loop and ring (cf. Dawkins, *Artemis Orthia*, pl. CXLI, 1, p. 229, Boardman, *Island Gems*, p. 146, fig. 15, right).

Dawkins, *Artemis Orthia*, p. 229, pl. CXLI, 2.
Cf. also Boardman, *Island Gems*, pp. 146 f.

5. THE ARCHAIC GREEK PERIOD, ABOUT 550-480 B.C.

By the sixth century B.C. the various contacts with the outside world and a steady interior development had borne abundant fruit. All branches of Greek art bear witness to this growing importance of the Greek civilization, not least the engraved gems.

In this field a primary consideration is of course the fact that with the rising prosperity sealstones had become a necessity for guarding possessions. Eloquent in this respect is Solon's law forbidding the retention of the impression of a seal by its maker: δακτυλιογλύφῳ μὴ ἐξεῖναι σφραγῖδα φυλάττειν τοῦ πραθέντος δακτυλίου (Diog. Laert., I, 57). One must remember that banks and safe deposits were not yet known.

This new widespread custom of sealing was intimately connected with the now general use of writing and of coinage, fostered by the growing importance of commerce. The coins indeed, which are so to speak the seal of the state, are the counterparts of the engraved gems bearing the seal of the individual. Hence we find that especially at this period the representations on coins and gems are often similar. One may compare in this connection the inscriptions which occur respectively on a coin of Ephesos (Head, H.N.², p. 571, fig. 294): 'I am the seal of Phanes', Φάενος (Φάννος) ἐμὶ σῆμα, and on an archaic gem in Breslau (Furtwängler, A.G., pl. VII, 66): 'I am the seal of Thersis, do not open me', Θέρσιός εἰμι σᾶμα, μή με ἄνοιγε. Cf. also the scarab in the Fitzwilliam Museum (my no. 211) inscribed 'I am (the seal) of Kreontidas', Κρεοντίδα εἰμί, and the scaraboid in the Metropolitan Museum inscribed with the name of Charidemos in the genitive (Cat., no. 32).

Of fundamental importance in the development of the Greek sealstones is also the renewed importation of hard stones from the East, with the reintroduction of the working of these stones, no longer by hand but with the help of a rotating instrument. This renewal of an old technique opened up an era in which the art of engraving gems could reach new heights.

The favourite stones employed were the coloured quartzes – the carnelian, chalcedony, agate, rock crystal, and jasper. Occasionally the green plasma, the haematite, the lapis lazuli appear; and glass sometimes occurs as a substitute for stone. Not only technically but aesthetically these stones, with their brilliant colours and shining surfaces, were a welcome change from the former dull, opaque, softish stones; and through their durability they have made possible the occasional survival of the designs engraved on them in pristine condition.

Naturally the change from the use of soft stones to hard and from the engraving by hand to the wheel technique was not abrupt. A few artists would continue the old methods and even proudly sign their hand-cut work. So Syries in the well-known stone in London (cf. no. 164), and so Onesimos in the stones in Boston and Paris (cf. my no. 103), both datable in the last quarter of the sixth century. Similarly in the statues of the kouroi one comes across conservatives who cling to the old practices, side by side with progressives who welcome new ideas.

The scarab form, long known in Greek lands from Egyptian importations and imitations (cf. p. 32), now became prevalent (cf. overleaf drawing, a). Being relatively small and compact, it lent itself better than the other shapes to the new requirement of being worn in swivel rings (cf. fig. b). But the beetle had not the religious significance that it had in Egypt. It seems to have been purely ornamental – as shown also by the fact that other forms, such as masks, lions, sirens, and negroes' heads, were sometimes used

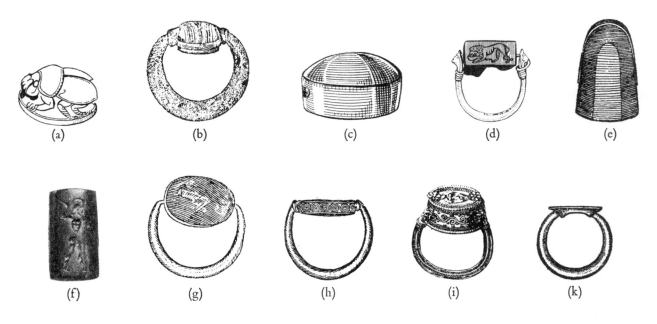

<div align="center">(a) (b) (c) (d) (e)</div>

<div align="center">(f) (g) (h) (i) (k)</div>

instead of the beetle to decorate the back of the gem. The scaraboid, with plain, rounded back and flattened front, (cf. fig. c) known from earlier times, and later to become the principal shape, occurs occasionally; also sometimes a four-sided bead and the Oriental forms of cone and cylinder (cf. figs. d–f). All are regularly perforated, to be set in metal swivel rings. The latter often have thick hoops, which were clearly not intended to be worn on the finger, but which acted as convenient handles for the seals. They are either provided with sockets on which the gem turned (cf. fig. d) or the settings were soldered to the hoops, which then became correspondingly lighter (cf. figs. g, h). Rings entirely of metal with stationary bezels also now appear (cf. figs. i, k); and sometimes the representations are stamped in relief instead of cut in intaglio. (On early archaic rings of this type cf. under Etruscan, pp. 173 ff.)

In the subjects chosen for the engravings a great change from earlier times is likewise observable. The monsters and wild animals lose their popularity and are replaced by human beings, shown in all manner of poses, at rest and in action (flying, running, exercising, fighting, singly or in groups). The chief themes are those prevalent also in other branches of Greek art – warriors, archers, athletes, hunters, horsemen, charioteers; only occasionally women. They are supplemented by animals – the bull, lion, boar, deer, ram, horse, dog, eagle, cock, etc., shown singly, or in combat, or in the company of a human being. In other words, it was the life and the sights around them that the artists of archaic Greece mostly chose for their representations. The endless cult scenes and the glorious deeds of potentates which formed the chief subjects on Eastern stones are conspicuous by their absence. Mythology, however, also had an important place. The Medusa, the siren, the sphinx, satyrs, and silenoi are occasionally represented. Deities are not frequent, but Greek heroes often occur, Herakles being especially popular. Theseus, Ajax, Achilles, Kastor, Tityos, also now and then appear. Moreover, the list of such heroes on extant Greek stones is supplemented by the representations on archaic Etruscan scarabs, evidently copied from Greek originals (cf. pp. 178 f.).

The design is generally encircled by a border, either in the form of hatching, or of a row of dots, or of a single line. Rarely a more ambitious design is used, for instance, a guilloche. A ground line is sometimes added, with or without a decorative exergue. Toward the end of the period one finds a polish occasionally imparted to the engraving – a practice that was to become more popular later (cf. p. 6).

The scarab is carved competently without excessive care. It was reserved for the Etruscans to make little masterpieces of their scarabs, even sometimes when the intaglio design was cursorily worked (cf. p. 178). The Greeks, on the other hand, devoted their chief attention to the device which was to serve as a seal, and since this had to be carved incuse and in reverse, in the restricted space of the back of the scarab – averaging *c.* 15 by 10 mm. – the greatest proficiency was needed. These very difficulties, it seems, acted as a stimulus; for even among the relatively few surviving stones that chance has preserved for us there are many masterpieces – in composition, in spacing, and in execution. That is why they have to be viewed in their original minute size and in magnification (cf. pp. VII f.). That these stones were appreciated also in ancient times is abundantly indicated by the famous story of Polykrates (cf. p. 20).

The over 150 examples that I have selected from various museums should give a fair idea of the styles and prevalent subjects in archaic Greek gems. They will form an instructive adjunct to our studies of early Greek art. As in the larger representations, so in the little engravings, one can observe the gradual increase in the understanding of naturalistic form – in the rendering of the complicated structure of the human body, placed in various positions, in the representation of drapery, and in composition, that is, in the relation of several figures to one another.

To bring out these progressive changes I have grouped my material in a number of different categories. First come the representations of the nude human figure (generally male), quietly standing, or stooping, or crouching, or reclining; then those of the draped human figure (generally female); next compositions in which more than one figure is included; lastly a series of monsters and animals. It will be observed that at first certain conventions are invented and constantly followed, until step by step a natural pose is attained – the same method, in fact, that was used by all artists throughout Greece. I have arranged the gems within these groups in tentative chronological order, that is relatively so. It must be stressed, however, that the absolute dates do not always necessarily correspond with the relative ones. For again we must remember that there were progressives as well as conservatives among the artists.

(a) *Nude male figures showing the development in the rendering of the structure of the human body*

Nos. 81, 84 show two figures with the head, trunk, legs, and arms all placed in profile in the same direction. It will be observed that in the early examples three instead of two divisions are marked above the navel in the rectus abdominis muscle, whereas in the later ones the muscle is correctly rendered with only two divisions visible.

One of the great interests of the time, however, evidently was to represent the torsion of the human body in various attitudes. The early struggles of the Greek artists to achieve this are reflected also on the gems. At first the upper part of the trunk is placed in front view, the lower in profile – again with an indication of the rectus abdominis first with three divisions above the navel, then with two (cf. nos. 82, 83, 87).

Presently there are attempts to show a more natural transition between the upper and lower parts of the body. This is done by placing both parts in front view, but keeping the head and limbs in profile (cf. nos. 85, 91, 97). Or the chest is retained in front view, but the lower part of the trunk (with an indication of

the rectus abdominis muscle) is moved to one side; first with hardly any attempt to show it in fore-shortened view, but gradually with the foreshortening rendered more and more successfully. One can watch this epoch-making transformation in several stances – standing erect, stooping, and crouching (cf. nos. 87–89, 93–96, 99, 104–106, 109).

In the reclining figures the same changes may be observed (cf. nos. 110–113). First a frontal chest is com-bined with a profile view of the lower part of the trunk (cf. no. 110). Then the muscles of the rectus abdominis, though shown frontal, are moved to one side (cf. nos. 111, 112). Presently, the torsion is shown in a more natural way. Lastly the two parts of the trunk are expertly interconnected, and the muscles naturalistically rendered (cf. no. 113).

The back view likewise was attempted in a three-quarter view. Nos. 114–116 show three stages of development: First comes no. 114 where the further side of the back is indicated almost entire. Then no. 115 in which the farther shoulder-blade is shown partly foreshortened but the abdomen in full profile. Lastly comes no. 116 with a more advanced rendering.

Nos. 100–102 show several figures not in torsion but in front view, with only the head and limbs in profile. The stance is at first stiff and the modelling hard; later the stance becomes more natural, and the muscles are better understood. In no. 102, in fact, we have come to the end of the archaic period, that is, to the time of the Olympia sculptures.

Finally nos. 107, 108 show two late archaic representations of a youth playing with his dog, which recall the relief on the stele of Alxenor in Athens. Their similarity exemplifies once again the constant repetition of certain compositions, always, however, with slight variations.

81. *Sard scarab*. Fractured at bottom. 14 × 10 mm.

From Catania. In the Ashmolean Museum, 1892.1490. Acquired through the Chester bequest.

NUDE YOUTH, in profile to the right, playing the lyre. He is standing on the right foot, and with the left knee bent. Beneath him is a deer. Apollo (?). Five ridges indi-cate the lower boundary of the thorax and the divisions of the rectus abdominis. Hatched border.

About 560 B.C.

Furtwängler, *A.G.*, pl. VI, 36.

82. *Rock crystal scaraboid.* 20 × 13 mm.

In the Ashmolean Museum, 1892.1479. Acquired through the Chester bequest.

NUDE, HELMETED YOUTH, holding a cock on his left hand, a lyre in the right. He is in a half-kneeling position, in profile to the right, except the upper part of the trunk which is frontal. In the rectus abdominis three divisions are indicated above the navel. Hatched border.

Third quarter of the sixth century.

Furtwängler, *A.G.*, pl. VI, 38.
Lippold, *Gemmen und Kameen*, pl. 58, no. 13.

83. *Sardonyx discoloured scarab*; now dark brown with creamy yellow patches. 12 × 17 mm.

In the Museum of Fine Arts, Boston, 23.577. Formerly in the Postolakka Collection. Bought in Athens in 1901.

SILENOS seizing a sphinx by the hair. He has horse's ears, tail, and hoofs. His head and chest are frontal, the rest in profile. Three divisions are indicated in the rectus ab-dominis. The sphinx is wingless and is shown in profile to the right, with head turned in profile to the left; her left paw is lifted. Cable border.

About 550 B.C.

Cf. the somewhat similar scene of a youth seizing a girl by the hair on a carnelian in New York, *Cat.*, no. 29.

Imhoof-Blumer and Kenner, pl. XXVI, 44.
Furtwängler, *A.G.*, pl. LXIII, 1, and vol. III, p. 102.
Perrot and Chipiez, *Histoire de l'art*, IX, p. 26, fig. 28.
Beazley, *Lewes House Gems*, no. 17, pl. 2.
Lippold, *Gemmen und Kameen*, pl. 14, no 1.

84. *Carnelian scaraboid.* 17 × 11 mm.

In the British Museum, 49.6–23.1. Acquired from the Stewart Collection in 1849.

LYRIST. A nude youth, in a half-kneeling position, is playing the lyre. His hair is indicated by stippling. There are three transverse divisions in the rectus abdominis above the navel. Hatched border.

Third quarter of the sixth century B.C.

Babelon, *La gravure*, p. 102, fig. 72.
Furtwängler, *A.G.*, pl. VIII, 35.
Lippold, *Gemmen und Kameen*, pl. LIX, 3.
Walters, *Cat.*, no. 493, pl. VIII.

85. *Gold ring*, with engraving on pointed oval bezel. Ht. of bezel 15 mm.

In the Cabinet des Médailles. Gift of the duc de Luynes in 1862 (no. 519).

YOUTH, seated on a rock, holding his bow in his left hand, an arrow in his right. His body and legs are more or less frontal, the head and arms in profile. Two transverse divisions in the rectus abdominis above the navel. He has short, curly hair. Hatched border.

Late sixth to early fifth century B.C.

For the type of ring cf. Marshall, *Cat. Finger Rings*, p. XL, no. CIX.

Babelon, *Cabinet des antiques*, 1888, pl. XLVII, 3.
Furtwängler, *A.G.*, pl. X, 12.
Boardman, *Antike Kunst*, X, 1967, p. 27, no. N42, pl. 7 ('c. 500 B.C. or just after').

86. *Carnelian scaraboid*. 10 × 14 mm.

From Greece. In the Staatliche Museen, Berlin.

NEGRO BOY, crouching, with the trunk and right leg frontal, the rest more or less in profile. Both hands are placed on the right knee, and the head is inclined, in an impassive attitude (sleeping (?)). From the right elbow hangs an aryballos by a string. He is nude and has short, curly hair. The body is shown without any anatomical detail, evidently left unfinished, whereas the head and limbs are completed. Hatched border and hatched exergue.

Early fifth century B.C.

For similar representations cf. Schneider, *Jahrb. österreich. Kunsts.*, III, pp. 3 ff., IV, pp. 320 f., and Boardman, *Ionides Collection*, no. 5.

Furtwängler, *Beschreibung*, no. 176; *A.G.*, pl. X, 28.
Lippold, *Gemmen und Kameen*, pl. 66, no. 8.

87. *Carnelian scarab*. Ht. 18 mm.

Found at Perachora. In the National Museum, Athens, inv. 1203.

ARCHER, about to shoot an arrow from his bow. He is half kneeling, nude, bearded, with short hair indicated by pellets. In the left hand he holds the bow, in the right the arrow. The chest is frontal, the rest more or less in profile. Two divisions are indicated above the navel. Hatched border.

Last quarter of the sixth century B.C. The transition between the frontal chest and the profile lower part of the trunk is still tentative. The toes of the feet are curved upward along the border. The carving is careful, the rendering of the head being specially fine. The general type is that of Herakles, and, though his attributes are missing, it may be that he was intended.

Payne, *J.H.S.*, LII, 1932, p. 243, fig. 7.
Stubbings, in Dunbabin, *Perachora*, II, p. 454, no. B24, pl. 191.

88. *Mottled agate scaraboid*. 11 × 15 mm.

In the National Museum, Athens, Numismatic section, inv. 105. Gift of D. Tsivanopoulos.

SATYR, dancing (?), holding an amphora on his shoulder by the handle with his left hand. The trunk is in three-quarter view, the rest more or less in profile. In the field is a Cypriote inscription. Ground line.

Late sixth century B.C.

Svoronos, *Journal international d'archéologie numismatique*, XVII, 1915, p. 71, pl. VI, 6.

89. *Banded agate scarab*. 12 × 9 mm.

In the British Museum, T76. From the Towneley Collection.

WARRIOR, holding a sword in one hand and with a shield strapped to the other arm, is moving slowly to the left, with head turned back. He wears a crested, Attic helmet and has a chlamys loosely draped over his shoulders. Ground line and dotted border.

C. 500–480 B.C.

Walters, *Cat.*, no. 477, pl. VIII.

90. *Rock crystal scaraboid*. 14 × 17 mm.

In the Fitzwilliam Museum, Cambridge. Formerly in the possession of Col. Leake, who obtained it in the Peloponnese. Purchased 1864.

YOUTH, bending forward, with left leg raised, putting on his greave. He is nude, and wears a crested Corinthian helmet. His rectus abdominis muscle and the serratus muscle are carefully indicated; in the former there is an attempt at foreshortening, though the figure is shown in profile. Hatched border.

Early fifth century B.C., time of the Aegina pediments.

Middleton, *Cat.*, p. v, no. 5, pl. I.
King, *Antique Gems and Rings*, II, pl. XLIII, 4.

91. *Carnelian scarab*. Ht. 15 mm.

In the Royal Cabinet of Coins and Gems, The Hague.
Formerly in the Corazzi Collection in Cortona.

HERAKLES, carrying off the Delphic tripod on his left
shoulder, and brandishing his club in the right hand. He
is beardless, nude, and has his lion's skin hanging down
his back. In his hair is a fillet. His trunk is shown frontal,
head and limbs in profile. The three handles on the rim
of the tripod are marked, as also the three legs, between
two of which is a star; one of the legs is firmly grasped
by Herakles.

Latter part of the sixth century B.C.

For other representations of Herakles, alone, carrying off
Apollo's tripod, cf. Furtwängler, in Roscher's *Lexicon*,
s.v. Herakles, col. 2212, where also the similar composi-
tion on an archaic scarab (my no. 794) is illustrated – like-
wise with a star in the field, signifying Herakles 'as the
deity of light, another Apollo' (Furtwängler).

Museum Cortonense, 1750, p. 48, pl. 38.
Stephani, *Compte rendu*, 1868, p. 41, note I.
Furtwängler, in Roscher's *Lexikon*, s.v. Herakles, col. 2212;
A.G., pl. VIII, 8.

92. *Green plasma scaraboid*, unperforated. 17 × 12 mm.

From Cyprus. In the British Museum, 99.6–3.2. Bought
1899.

WARRIOR COLLAPSING. He wears an Attic helmet and
holds a curved, one-edged sword, of the μάχαιρα type, in
his right hand, while his shield is still strapped to his left
arm. The body is frontal, the right arm and right leg are
in profile, the left leg and arm are slightly foreshortened.
Line border.

Early fifth century B.C.

For a replica cf. Furtwängler, *A.G.*, pl. LXIII, 4 (also from
Cyprus, with Cypriote letters in the field) – in his time in
a private collection in Smyrna. On such replicas cf. Furt-
wängler, *A.G.*, III, pp. 92 f.

Furtwängler, *A.G.*, pl. LXV, 3.
Walters, *Cat.*, no. 500, pl. IX.
Lippold, *Gemmen und Kameen*, pl. 52, no. 5.

93. *Carnelian scarab*. 17 × 12 mm.

From Amathus, Cyprus. In the British Museum, 94.11–
1.460. Acquired through the Turner bequest, 1894.

ATHLETE, bending down to lift his diskos with his right
hand, while the left arm is raised in a nice balancing
movement. Behind him is a large strigil. He is nude and
his hair is rolled up at the nape of the neck. His trunk is
frontal with an attempt to show the torsion of the body;
his left leg is also frontal, and so is the left hand, seen from
the back; the rest is in profile. Hatched border.

Late sixth century B.C.

A. H. Smith, *Excavations in Cyprus*, section on Amathus, pl.
4, fig. 8, pp. 98, 125.
Furtwängler, *A.G.*, pl. IX, 6, vol. III, p. 311.
Lippold, *Gemmen und Kameen*, pl. 55, fig. 8.
Beazley, *Lewes House Gems*, p. 25.
Walters, *Cat.*, no. 481, pl. VIII.

94. *Sard scarab*, slightly burnt. 15 × 11 mm.

In the British Museum, T. From the Towneley Col-
lection.

ATHLETE, standing on his right leg, with the left lifted,
and holding a stick in his left hand; his right arm is
extended to keep his balance, and from his left forearm
hangs an aryballos by a string. The different parts of his
body are shown from various points of sight, not properly
co-ordinated. As in no. 92 the artist was evidently ex-
perimenting with a difficult pose. Hatched border.

Early fifth century B.C.

Furtwängler, *A.G.*, pl. VIII, 50.
Walters, *Cat.*, no. 482, pl. VIII.

95. *Carnelian scarab*, mounted in an ancient silver swivel
ring. Scratched on surface. Ht. 17 mm.

In the Cabinet des Médailles. Gift of the duc de Luynes in
1862 (no. 222).

WARRIOR, a sword in one hand, stooping to lift his
shield. He is nude and has his hair rolled up at the nape
of the neck. The chest is shown in front view, the lower
part of the trunk in three-quarter, the rest more or less in
profile. In the field are the letters sigma and omikron.
Ground line and hatched border.

Early fifth century B.C.

96. *Chalcedony scarab*, burnt. 22 × 16 mm.

From Asia Minor. In the Cabinet des Médailles. Acquired
through the gift of Pauvert de La Chapelle in 1899.

YOUTH, nude, standing with his left foot raised, and
leaning on a stick to keep his balance, while a small boy
is putting on his sandal. His chest is shown in front view,
the lower part of his body in three-quarters, the rest in

profile. The boy is in profile to the left. A leafy garland in the field indicates the out-of-doors. Hatched border and ground line. No marginal ornament.

Early fifth century B.C.

E. Babelon, *Coll. Pauvert de La Chapelle*, no. 84, pl. VI (there interpreted as the wounded Philoktetes).
Furtwängler, *A.G.*, II, p. 311 (addendum to pl. IX, 4 and 6); vol. III, p. 445, fig. 223.
Lippold, *Gemmen und Kameen*, pl. 56, no. 15.

97. *Carnelian scarab*, slightly chipped along the edge. 11 × 15 mm.

In the Metropolitan Museum of Art, New York, 25.78.94. Fletcher Fund, 1925. Formerly in the collections of Dr. Nott and Wyndham Cook.

HERAKLES, wielding the club in one hand and holding a lion by the tail with the other. He is shown in profile, except the trunk which is frontal. In the field is a quadruped (a fox or a dog (?)). Hatched border.

About 530 B.C.

The motif of holding a lion by the tail is probably borrowed from the East; cf. the coins of Baena in Phoenicia, Regling, *Münze*, no. 268; also Furtwängler, in Roscher's *Lexikon* I, 2, s.v. Herakles, col. 2146. For representations on gems cf. my nos. 32, 146.

Bull. dell'Inst., 1831, p. 106, no. 16.
Ann. dell'Inst., 1835, p. 250, pl. H, 5.
Lajard, *Recherches sur le culte public et les mystères de Mithra* (1867), p. 205, pl. LXVIII, no. 28.
King, *Handbook*, pl. LXIII, 2.
Furtwängler, *A.G.*, pl. VII, 54, and vol. III, p. 99.
Burlington Fine Arts Club Exh., 1904, p. 207, pl. CX, no. M123.
Smith and Hutton, *Cook Collection*, pl. II, 35.
Lippold, *Gemmen und Kameen*, pl. 37, no. 7.
Christie's Sale Catalogue of the Cook Collection, July 14–15, 1925, p. 10, no. 37.
Richter, *M.M.A. Handbook*, 1953, p. 147, pl. 125, j; *Cat.*, no. 31, pl. V.

98. *Plasma scaraboid*, discoloured and cracked through the middle, in gold setting. 11 × 15 mm.

From Cyprus. In the Metropolitan Museum of Art, New York, 74,51.4173. From the Cesnola Collection, purchased 1876–77.

YOUTH HOLDING TWO PRANCING HORSES. He is nude and has long hair, tied on the crown of his head in horse-tail fashion. The trunk is frontal, the rest in profile.

Late sixth century B.C.

For similar compositions of youths with prancing horses cf. e.g., Furtwängler, *A.G.*, III, p. 178, fig. 123.

The horse-tail coiffure occurs on charioteers and musicians on Clazomenian sarcophagi; cf. Murray, *Terracotta Sarcophagi in the British Museum*, pp. 9 f., pls. I–III, VI.

Cesnola, *Cyprus*, pl. XXXIX, 5, and *Atlas*, III, pl. XXIX, 141.
Myres, *Handbook of the Cesnola Collection*, no. 4173.
Richter, *M.M.A. Handbook*, 1953, p. 148; *Cat.*, no. 38, pl. VI.

99. *Chalcedony scarab*, bespeckled with brown. Ht. 20 mm.

From Greece. In the Staatliche Museen, Berlin.

WARRIOR. A nude youth, holding a spear in one hand, and with a shield strapped to his other arm, is leisurely walking to the right. He wears a crested Corinthian helmet, pushed back from his face. His chest is frontal, the rectus abdominis is foreshortened, head, arms and legs are in profile. Ground line. Hatched border.

Early fifth century B.C.

The beautifully executed figure brings to mind the warriors from the Aegina pediments.

Furtwängler, *Beschreibung*, no. 156; *A.G.*, pl. VIII, 51.

100. *Chalcedony scarab*. 16 × 12 mm.

In the British Museum, 98.7–15.7. Acquired from the Morrison Collection, 1898.

ATHLETE, standing in a frontal pose, with head turned in profile to the right, and the right leg in profile to the left. In his right hand he holds his strigil, the left is placed on his hip. In the field hangs a diskos in its case, from a hook. On the ground is an oil flask, with a string attached, placed on a stand or footstool (?), only half of which is shown. Hatched border.

Probably Greek rather than Etruscan, first quarter of the fifth century B.C.

Morrison Sale Catalogue, 1898, lot 65.
Walters, *Cat.*, no. 490, pl. VIII.

101. *Chalcedony*, mounted in a modern ring. Ht. 19 mm.

From Aegion. In the Staatliche Museen, Berlin.

HERAKLES, nude, bearded, is standing in front view, with his club in one hand, the bow in the other; a lion's skin is hanging from his left forearm, and an owl is perched on his right shoulder – evidently to show that he is under the protection of Athena. His body and right leg are frontal, the head and left leg in profile to the right. The two transverse divisions of the rectus abdominis above the navel are carefully and expertly indicated, with the linea alba beneath.

Careful work of the first half of the fifth century B.C.

Furtwängler, in Roscher's *Lexikon*, s.v. Herakles, col. 2159; *Beschreibung*, no. 177; *A.G*, pl. X, 4.

102. *Sard ringstone*, slightly convex on engraved side. Cut down at the back. 13 × 18 mm.

In the Museum of Fine Arts, Boston, 27.691. Formerly in the Tyszkiewicz and E. P. Warren Collections. About 1890 it was acquired by a Dr. Töpfer at Sparta, but it must have been known long before that, because Furtwängler (in *c*. 1900) said that he knew an impression of the stone, which was 40–50 years old.

APOLLO, standing in front view, with head in profile, a sceptre in his right hand, a spray of olive in his left. On his left forearm is a hawk; behind him, and looking up at him, is a roebuck. Apollo wears a cloak over both shoulders, and a taenia in his hair. The weight of the body is on the left leg, the right is flexed and set back. Line border, stopping at ground line.

C. 470–460 B.C., the time of the Olympia pediments. The front view is consistently carried out, with both feet foreshortened.

On the association of the hawk with Apollo cf. A. B. Cook, *Zeus*, I, p. 241.

Froehner, *Collection Tyszkiewicz*, pl. XXIV, 6; *Sale Cat. of the Tyszkiewicz Collection*, June 8–10, 1898, pl. XXVII, 286.
Furtwängler, *A.G.*, pl. X, 3.
Perrot and Chipiez, *Histoire de l'art*, IX, p. 28, fig. 30.
Burlington Fine Arts Club Exh., 1904, p. 238, no. O, 32 (not ill.).
Beazley, *Lewes House Gems*, no. 47, pl. 3.
Lippold, *Gemmen und Kameen*, pl. 8, no. 4.

103. *Light greenish steatite scarab*. 16 × 12 mm.

In the Museum of Fine Arts, Boston, 27.673. Formerly in the collection of E. P. Warren. Acquired in Naples.

SATYR TUNING HIS LYRE. He supports the lyre on his left thigh, holds it with the left hand, and turns the peg with his right. He is ithyphallic, with horse's ears and tail, a bushy beard, and human feet. His head is thrown back. In the field the inscription Ὀνέσιμος, Onesimos, hastily written. 'The epsilon is indistinct owing to an abrasion.' Hatched border.

Late sixth century B.C.

Similar in style to the kitharist signed by Syries (cf. no. 164), and like it worked by hand on a soft stone.
Another inscription 'Onesimos', appears on a stone in Paris; cf. Beazley, *op. cit.*, p. 18, pl. A, 5, also without *epoie*, and of rather different style from the Boston stone. On Onesimos cf. pp. 15, 17.

Burlington Fine Arts Club Exh., 1904, p. 249, no. O, 70 (not ill.).
Beazley, *Lewes House Gems*, no. 24, pl. 2.
Boardman, *Island Gems*, no. 337, pl. XII, p. 80.

104. *Bluish-black agate scarab*, bespeckled with white. 11 × 14 mm.

Found near Troy. In the Staatliche Museen, Berlin. Formerly in the possession of Gerhard.

WOMAN AT A FOUNTAIN. A nude woman is shown crouching to the right, holding up a hydria to fill it with the water that is flowing from a lion's head spout. She has long hair and wears a round earring. In the field is the inscription Σήμονος, 'of Semon' – in Ionic script – the name either of the artist or of the owner of the stone, probably the former. Cf. p. 17. Hatched border.

Late sixth century B.C.

King, *Antique Gems and Rings*, I, p. 115.
Brunn, *Gesch. d. Künstler*, II, p. 430, no. 633.
Furtwängler, *J.d.I.*, III, 1888, p. 116, pl. III, 6; *Beschreibung*, no. 159; *A.G.*, pl. VIII, 28, and vol. III, p. 80.
Lippold, *Gemmen und Kameen*, pl. 63, no. 4.

105. *Banded agate scarab*. Fractured at the bottom. 15 × 12 mm.

In the Nicosia Museum, Cyprus.

HELMET-MAKER, seated on a diphros, with a cover or shallow cushion on it, working on a helmet. He holds the helmet with his left hand, a mallet in his right. The helmet is placed on an anvil (of which only the curving support now remains); it is of the Corinthian type, and is almost completed: only a few hammer strokes are still needed. The youth is nude; his hair is arranged in horizontal tiers round the skull and rolled up at the back. He is shown in profile view, but part of the chest is frontal. Line border.

About 500 B.C., or a decade or so later.

For representations of helmet-makers cf. the list given by Beazley, *C.V.A.*, Oxford, fasc. 1, pl. II, 8, and for an account of metalworking see Blümner, *Technologie u. Terminologie*, IV, pp. 360 ff. For an Etruscan replica of the Cyprus helmet-maker cf. Furtwängler, *A.G.*, pl. XVI, 58; Beazley, *loc. cit.* Very similar is the stone in Munich, my no. 106.

Dikaios, *Guide to the Cyprus Museum*[2], 1953, p. 96, no. 11.
Richter, *A.J.A.*, LXI, 1957, p. 264, pl. 81, no. 8.

106. *Rock crystal scaraboid*. 13 × 17 mm.

In the Staatliche Münzsammlung, Munich.

HELMET-MAKER. A nude youth is seated on a diphros, a hammer in his right hand, a helmet in the left, evidently engaged in giving the last touches to his work. Only two

legs of the stool are indicated. Hatched border.

Early fifth century B.C.

Similar to the preceding, q.v.
The helmet is not placed on an anvil, as is usual in similar representations, but is held in the hand. The shape was evidently completed, and only details were to be rectified.

Arch. Anz., 1917, p. 35.
Beazley, *C.V.A.*, Oxford, fasc. i, p. 6, under no. 8.
Czako and Ohly, *Griechische Gemmen*, fig. 9.

107. *Dark grey chalcedony scaraboid.* Chipped along the edge. A piece was broken off and reattached. 17 mm.

From Cyprus. In the Metropolitan Museum of Art, New York. From the Cesnola Collection, 74.51.4200 (CE 11). Purchased by subscription, 1874–76.

YOUTH WITH DOG. The youth is leaning on a staff and bending forward, presumably holding something in his hand to which the dog is jumping up.

About 480–470 B.C.

Cesnola, *Cyprus*, pl. XXXIX, 6, and *Atlas*, III, pl. XXXI, 8.
Imhoof-Blumer and Keller, *Tier- und Pflanzenbilder*, pl. XV, 55 (there said to be in the British Museum).
Furtwängler, *A.G.*, pl. IX, 9.
Myres, *Handbook of the Cesnola Collection*, no. 4200.
Richter, *Enc. Britannica*, 1929, vol. X, 'Gems in Art', pl. III, 4; *Cat.*, no. 66.

108. *Banded agate scarab.* Ht. 18 mm.

In the National Museum, Athens, Numismatic section, inv. 107. Gift of D. Tsivanopoulos.

YOUTH WITH DOG. He is leaning on a staff and bending forward, with something in his right hand to which the dog is expectantly looking up. The dog is seated to the left, with one paw raised. Line border.

First quarter of the fifth century.

Similar to the preceding.

Svoronos, *Journal International d'archéologie numismatique*, XVII, 1915, p. 71, pl. VI, 5.

109. *Rock crystal scaraboid.* 22 × 17 mm.

From Curium, Cyprus (tomb 73). Acquired by the British Museum through the Turner bequest, 1895. Inv. no. 96.2–1.157.

YOUTH, bending forward. He holds a staff in one hand and on the other is a hare, to which a dog is leaping up. He is nude and wears a wreath; along his right upper leg is a series of knobs. In the field is a Cypriote inscription, which has been read *la-me-ti-le-so, Λαμπτίλης*.

First quarter of the fifth century B.C.

Cursory but spirited work. Parts, such as the upper right leg, were evidently left unfinished.

Excavations in Cyprus, pp. 63, 83, pl. 4, Curium, fig. 6.
Furtwängler, *A.G.*, pl. IX, 9.
Walters, *Cat.*, no. 502, pl. IX.

110. *Carnelian scarab.* 18 × 13 mm.

In the Staatliche Museen, Berlin. Acquired from the Alessandro Castellani Collection.

SILENOS, seated on the ground, holding a wreath in one hand, the other extended to catch a cock which is walking away to the left. He is nude, bearded, long-haired, and large-eyed. The chest is frontal, the rectus abdominis muscle is shown in slight three-quarter view, the rest in profile. Hatched border.

Sixth century B.C., probably third quarter.

Furtwängler, *Beschreibung*, no. 139; *A.G.*, pl. VIII, 2.
Lippold, *Gemmen und Kameen*, pl. 13, no. 10.

111. *Agate scarab.* 22 × 16 mm.

In the British Museum, 65.7–12.106. Acquired from the Castellani Collection in 1865. Formerly in the collections of S. Mertens and of Schaafhausen.

SATYR, reclining, holding a kantharos in his left hand. He has a long, bushy tail, pointed horse's ears, horse's hoofs, and developed breasts. The head is frontal, the body in three-quarter view, the legs are partly in profile, partly in three-quarter view, the arms likewise. There are three transverse divisions above the navel in the rectus abdominis, marked by pellets. In the field is a volute-krater with narrow neck. Hatched border.

Second half of the sixth century B.C.

Furtwängler thought that the satyr was dancing, but a comparison with no. 112, where the satyr is reclining on a wineskin, and with no. 113, shows, I think, that he must be reclining.

King, *Antique Gems*, pl. I, fig. 8, and *Antique Gems and Rings*, II, pl. 27B, fig. 8.
Middleton, *Engraved Gems*, p. 25, fig. 16.
Furtwängler, *A.G.*, pl. VIII, 4, vol. III, pp. 90, 95.
Lippold, *Gemmen und Kameen*, pl. XIV, 8.
Walters, *Cat.*, no. 465, pl. VIII.

112. *Carnelian scarab.* Fractured at bottom. 21 × 14 mm.

In the Cabinet des Médailles, 65A1389 (M4485 = 1642A).

SATYR, seated on a wineskin, with legs outstretched, and holding the kantharos which he has just emptied by the

handle. Head and chest are frontal, the lower part of the trunk is in three-quarter view, arms and legs are in profile. In the field is a krater with voluted handles and narrow neck, containing more wine. Hatched border.

Toward the end of the sixth century B.C.

Pierres gravées, Guide du visiteur (1930), p. 20, no. 1642a, pl. VII.

113. *Black jasper scaraboid.* Small chips along the edge. 12 × 16 mm.

Said to be from Candia, Crete. In the Metropolitan Museum of Art, New York, 42.11.16. Purchase, 1942. Pulitzer bequest. From the Evans Collection.

SATYR, nude and bearded, in a half-reclining position, leaning against a wineskin and holding out his kantharos. The trunk is in three-quarter view; the left upper leg is frontal, with the lower part eclipsed; the rest is in profile. Hatched border. Cf. pl. B.
In the field, above, is the inscription 'Ανακλ ῆς, Anakles, the name either of the owner or of the artist, perhaps the latter, for the letters are comparatively inconspicuous. A potter named Anakles lived two or three generations before the time of this gem.

About 480–470 B.C.

Cf. the reclining satyrs on the kantharos by the Brygos Painter in New York, Richter and Hall, *Red-Figured Athenian Vases*, no. 43; Beazley, *A.R.V.²*, p. 382, no. 183; and the seated satyrs on the coins of Naxos.

Evans, *Selection*, no. 42.
Richter, *Evans and Beatty Gems,* no 21; *M.M.A. Handbook*, 1953, p. 148, pl. 126, b; *Cat.*, no. 46, pl. VII.

114. *Chalcedony scaraboid*, cut. 17 × 12 mm.

Said to be from Aegina. In the Museum of Fine Arts, Boston, 21.1194. Formerly in the Prokesch-Osten, the Tyszkiewicz, and the E. P. Warren Collections.

ARCHER, crouching, about to shoot an arrow from his bow. His trunk is in three-quarter back view, the rest more or less in profile. Hatched border. Cf. pl. B.

About 500 B.C. Expertly cut.

Coll. Tyszkiewicz, pl. XXIV, 11.
Furtwängler, *A.G.*, pl. VIII, 38, pl. LI, 11.
Bulle, *Neue Jahrbücher*, V, 1900, p. 671, pl. I, 14.
Beazley, *Lewes House Gems*, no. 27, pl. 2, and pl. 9.
Lippold, *Gemmen und Kameen*, pl. 53, no. 5.

115. *Chalcedony scaraboid*, discoloured; chipped along edge. Ht. 17 mm.

Said to be from Naukratis. In the Metropolitan Museum of Art, New York, 31.11.5. Fletcher Fund, 1931. Formerly in the Southesk Collection.

ARCHER, testing his arrow. He is shown crouching, holding the arrow in both hands, the bow hanging from his left arm. The trunk is shown in three-quarter back view, the rest in profile. He is nude, and the hair is done up in a roll at the back, and arranged in rows of ringlets in front. Hatched border. Cf. pl. B.

About 500 B.C.

A masterpiece both in execution and in design. The spinal column, the ribs, the shoulderblades, the rectus abdominis, the arch below the thorax, and the muscles of legs and arms are all carefully indicated. Beautiful also is the rendering of the hands holding the arrow and of the hair. Archers testing arrows often appear on gems and vases; for a list of such representations cf. Beazley, in Caskey and Beazley, *Attic Vase-Paintings, Boston*, II, p. 28.

Middleton, *Engraved Gems*, pp. 25 f., fig. 17; *Lewis Collection*, pp. 27 f., fig. 3.
Furtwängler, *A.G.*, pl. IX, 23.
Catalogue of the Southesk Collection, pp. 27 f., B8.
Beazley, *Lewes House Gems*, p. 20, pl. A, 10.
Lippold, *Gemmen und Kameen*, pl. 53, fig. 3.
Richter, *Bull.*, *M.M.A.* XXVI, 1931, p. 267; *M.M.A. Handbook*, 1953, p. 148, pl. 125, n; *Cat.*, no. 42, pl. VII.

116. *Sapphirine chalcedony scaraboid.* 17 × 12 mm.

Said to have been found in the Egyptian Delta, perhaps at Naukratis. In the Museum of Fine Arts, Boston, 27.677. Formerly in the Tyszkiewicz and E. P. Warren Collections.

YOUTH HOLDING A RESTIVE HORSE. He has seized it by the bridle with both hands and placed his right leg firmly on the ground. His trunk is ably foreshortened in back view, the right leg is in full back view, the rest in profile. The horse has a top-knot and a richly decorated breast-band. Its head is thrown back, the forelegs are raised, the mouth is open, with teeth showing, and the nostrils are extended. Hatched border. Cf. pl. B.
In the field is inscribed the signature: Επιμηνες επωιε, i.e. 'Επιμένης εποίει, 'Epimenes made it'. 'The use of the ω instead of o points to Paros, that of ε instead of η occurs in the Cyclades' (M. Guarducci).

First half of the fifth century B.C.

The movement of the horse, the details of the bridle, mane, hoofs, etc., all are expertly rendered. So is the bold stance of the youth, with its foreshortened body. The heads of the youth and of the horse are especially fine. The eye of the youth is still frontal.

On Epimenes cf. pp. 15, 17.

Furtwängler, *A.G.*, pl. IX, 14, pl. LI, 7.
Bulle, *Neue Jahrbücher*, V, 1900, pl. I, 13, p. 684.

Burlington Fine Arts Club Exh., 1904, p. 234, no. 0, 14 (not ill.).
Perrot and Chipiez, *Histoire de l'art*, IX, p. 18, fig. 19.
Beazley, *Lewes House Gems*, no. 28, pls. 2 and 9.

(b) *Figures showing the development in the rendering of rapid motion*

The adoption and constant repetition of a certain convention is demonstrated particularly clearly in the early attempts by the Greek artists to represent rapid motion, that is, running or flying. For this, as in contemporary sculpture, the scheme was adopted of showing the figure in a half-kneeling position, with both legs strongly bent, one raised, the other knee touching the ground, and with the trunk regularly shown frontal, the head and limbs in profile (cf. nos. 117, 118).

Presently the legs, though retaining the same bent positions, are placed further apart (cf. nos. 119–123). To indicate flying, the whole body is sometimes placed obliquely, with a frontal chest and a three-quarter view of the lower part of the trunk (cf. nos. 124–126). Gradually a more natural pose is evolved, with the body in an approximately erect position and the front leg only slightly bent (cf. nos. 127–129). Lastly no. 130 shows a Centaur in which the motion is convincingly rendered with the legs in natural positions and the trunk foreshortened.

117. *Carnelian scarab.* 14 × 10 mm.

From Orvieto. In the Staatliche Museen, Berlin.

TITYOS, struck by Apollo's arrow, in a half-kneeling position, to the right. He is nude, bearded, long-haired, and wears a long necklace. With one hand he tries to extract the arrow from his side, the other is laid on his abdomen. The body and arms are shown in front view, the head and legs in profile. Guilloche border.

Middle of the sixth century B.C.

Whether Tityos is conceived as collapsing or in flight is not certain.

Rossbach, *Ann. dell'Inst.*, 1885, p. 218, pl. GH, 34 (interpreted as a silenos).
Overbeck, *Kunstmythologie*, III, Apollon, p. 385, no. 3, fig. 21.
Furtwängler, *Beschreibung*, no. 137; *A.G.*, pl. VIII, 18.
Waser, In Roscher's *Lexikon*, s.v. Tityos, col. 1051 (where a list of representations of this subject is given).

118. *Sard scarab.* 20 × 10 mm.

In the British Museum. Once in the Hamilton Collection.

SATYR, in a half-kneeling stance, holding a kantharos in one hand and an oinochoe by the handle in the other. He has horse's ears, human feet, and developed breasts; the end of the tail is indicated below the left thigh. The upper part of the body is shown frontal, the lower in profile.

The head is unduly large, with hair and beard rendered by fine, straight lines. Hatched border. No marginal ornament.

Middle of the sixth century B.C.

A replica of the design is on a carnelian scarab, which in Furtwängler's time was in a private collection in Smyrna; cf. Furtwängler, *A.G.*, pl. XIII, 5. On similar representations, see Beazley, *op. cit.*, under no. 16.

Raspe, no. 4658.
Furtwängler, *A.G.*, pl. VIII, 20, vol. III, p. 93.
Perrot and Chipiez, *Histoire de l'art*, IX, p. 41, fig. 49.
Beazley, *Lewes House Gems*, p. 11.
Walters, *Cat.*, no. 466, pl. VIII.

119. *Carnelian scarab*, cut. At the back traces of the perforation. 10 × 14 mm.

In the Staatliche Museen, Berlin.

HERAKLES, in a half-kneeling position to the left. He holds his bow and arrow in his right hand, and with his left grasps the tail of the lion's skin which covers his head and back. His trunk is shown in front view, head, arms and legs are in profile. Hatched border.

Last quarter of the sixth century B.C.

Furtwängler, *Beschreibung*, no. 148.

120. *Banded agate scarab*, set in a silver ring. 12 × 9 mm.

From Curium, Cyprus (tomb 83). Acquired by the British Museum through the Turner bequest in 1895.

HERAKLES, in a half-kneeling position, is holding his club in one hand and his bow in the other. He is bearded, and nude, except for the lion's skin that covers his head. His chest is frontal, his abdomen is in three-quarters view, the rest in profile. Hatched border.

About 530–520 B.C.

H. B. Walters, *Excavations in Cyprus*, Curium, pl. 4, fig. 5, p. 83.
Marshall, *Cat. of Finger Rings*, no. 1055.
Walters, *Cat.*, no. 475, pl. VIII.

121. *Sard scarab*. 11 × 8 mm.

In the British Museum, Blacas, 55. From the Blacas Collection. On the back of the beetle is carved a Siren, in low relief.

APOLLO HYAKINTHIOS (?). A nude, long-haired youth, in a half-kneeling position, is holding a lyre under one arm and a flower in the other. Hatched border.

About 530 B.C.

A similar figure, also with lyre and flower, appears on archaic coins of Tarentum, and has been interpreted as representing Apollo Hyakynthios; cf. de Luynes, *Ann. dell'Inst.*, II, 1830, pp. 340 ff.; *British Museum, Guide to the Principal Coins* (1959), p. 10, pl. 6, no. 2. The figure on the gem may, therefore, also represent Apollo Hyakinthios. Furtwängler, *loc. cit.*, suggested that such gems were perhaps worn by votaries of this Apollo.

E. Curtius, *Knieende Figuren*, fig. 15.
Furtwängler, *A.G.*, pl. VIII, 23, vol. III, p. 96.
Weicker, *Seelenvogel*, p. 99 (on the Siren).
Walters, *Cat.*, no. 459. The Siren is there illustrated in figs. 28a, 28b.

122. *Grey chalcedony scaraboid*. Ht. 16 mm.

In the Staatliche Museen, Berlin. From the Tyszkiewicz Collection.

HERMES, in a half-kneeling position, holding a kerykeion in his right hand, the left raised. He is beardless and wears a petasos and a small mantle, which is hanging down from his shoulders. Head, arms, and legs are more or less in profile, the chest is frontal, the lower part of the trunk in slight three-quarter view. The folds of the mantle are stacked in two directions. Hatched border.

Fine late archaic work of about 500 B.C.

For an Etruscan copy cf. no. 745 (Furtwängler, *A.G.*, pl. XVI, 49).

Scherer, in Roscher's *Lexikon*, I, col. 2406.
Furtwängler, *Beschreibung*, no. 160; *A.G.*, pl. VIII, 37.
Lippold, *Gemmen und Kameen*, pl. 9, no. 4.

123. *Rock crystal scaraboid*. Chipped along the edge. 22 × 17 mm.

From Corinth. In the British Museum, 92.11–30.1. Bought 1892.

WINGED DAEMON, in the half-kneeling position used to signify motion. To judge by the protruding breasts, the figure seems to be female. She wears a short chiton with overfold and holds a snake in one hand. Body and wings are shown in front view, the rest in profile. Hatched border.

Last quarter of the sixth century B.C.

For a replica in Boston, from the E. P. Warren Collection, cf. Beazley, *op. cit.*, no. 19, pl. 2, there called 'Gorgon or possibly an Erinys'. Furtwängler, followed by Walters, thought the daemon was male, clothed in a cuirass, and was perhaps intended for Phobos. But since we have so many flying Gorgons with snakes, a Gorgon is perhaps the best guess.

Furtwängler, *A.G.*, pl. VI, 61, vol. III, pp. 93, 100.
Beazley, *Lewes House Gems*, p. 13, pl. A, 8.
Walters, *Cat.*, no. 497, pl. IX.

124. *Stone seal*.

Found at Brauron, Attica, in 1961. To be placed in the Museum of Brauron.

BOREAS, rushing to the left, with wings and arms outspread. He is nude, bearded, and has hair descending to the nape of the neck. His chest is shown in front view, the rest in profile. Above, to the right and left of his head, are a number of whirls to designate the tumult in the air that he is causing by his rapid flight. Below is a snake, evidently reminiscent of the snaky legs with which he was represented, e.g., on the Chest of Kypselos (cf. Pausanias, V, 19, 1).
In the field the inscription Βορέα; also two separate letters A and E.

Spirited work of about 530–520 B.C. The strength of the North wind is admirably conveyed.

This is one of the earliest extant representations of Boreas, in fact, as far as I know, the earliest. Later, through the fifth and fourth centuries, he frequently appears on red-

figured vases pursuing or carrying off Orytheia, the daughter of Erechtheus (cf. the list given by Wernicke, in *R.E.*, s.v. Boreas, vol. III, 1, cols. 727 f.; Beazley, *A.R.F.*[2] p. 1722) and on handle attachments of bronze hydriai.

Rarely he appears alone, as, e.g., on the Tower of the Winds.

Orlandos, *Ergon*, kata to 1961, p. 33, fig. 32 (on p. 31).
Daux, *B.C.H.*, LXXXVI, 1962, p. 679, fig. 15 (on p. 677).
E. Simon, *Antike und Abendland*, XIII, 1967, p. 111.

125. *Sard scarab*, set in a gold swivel ring. 12 × 8 mm.

In the Museum of Fine Arts, Boston, 27.680. Said to be from Cyprus.

EROS, flying to the left, with wings spread. He holds a bow in one hand and a sprig in the other; a chlamys is draped over both shoulders. The head and legs are in profile, the arms and chest frontal, and the rectus abdominis is slightly foreshortened. Hatched border.

Early fifth century B.C.

Furtwängler, *A.G.*, pl. LXI, 30.
Burlington Fine Arts Club Exh., 1904, p. 237, no. O, 28 (not ill.).
Beazley, *Lewes House Gems*, no. 32, pl. 2.

126. *Discoloured sard* (?) *scaraboid*, mounted in a gold ring. 14 × 10 mm.

Said to have been found in Caria. In the Museum of Fine Arts, Boston, 27.767. Formerly in the E. P. Warren Collection.

EROS, flying to the right, holding a lyre in his left hand, a wreath in his right. He has recurved wings at his shoulders and ankles, and long hair, of which two locks fall on his chest. His chest is shown frontal, the lower part of his trunk in slight three-quarter view, the rest more or less in profile. Hatched border.

Early fifth century B.C.

Beazley, *Lewes House Gems*, p. 28, no. 33, pl. 2 (with references to various replicas); cf. now also Boardman, *Ionides Collection*, no. 4.

127. *Sard scarab*. 14 × 10 mm.

From Cyprus (Mari (?)). In the British Museum, 89.10–15.1. Bought 1889.

NIKE, flying to the right, holding a wreath in one hand and a flower (?) in the other. She wears a long, belted chiton, and has wings on her feet, as well as large, recurving ones on her back, shown frontal, one beneath the other, with dotted ornaments. The head and legs are in profile, the upper part of the body is in front view. Line border.

About 500 B.C.

Furtwängler, *A.G.*, pl. VI, 55, vol. III, p. 103.
Walters, *Cat.*, no. 467, pl. VIII.
Lippold, *Gemmen und Kameen*, pl. 32, no. 1.

128. *Rock crystal scarab*. 15 × 11 mm.

In the British Museum. From the Hamilton Collection.

NIKE, flying to the right, holding a flower in one hand and a fold of her chiton in the other. She wears a fillet and a long chiton ornamented with dotted borders at top and bottom. A dotted ornament is used also on the wings. The upper part of the body is frontal, the head, legs, and arms in profile. Dotted border round the design.

First quarter of the fifth century B.C.

Furtwängler, *A.G.*, pl. VIII, 27, and vol. III, p. 103.
Walters, *Cat.*, no. 468, pl. VIII.

129. *Banded agate scaraboid*. 17 × 10 mm.

Found in 1894 at Amathus, Cyprus (tomb 256, sarcophagus III, together with Walters, *Cat.*, nos. 299, 481). Acquired by the British Museum through the Turner bequest, 94.11–1.459.

WINGED FIGURE moving rapidly to the right. She wears a peaked cap, a long, sleeveless chiton, and winged shoes, and has long hair. From the back emerge six wings, shown frontal, while the figure itself is in profile. Ground line, and border of dots (now mostly obliterated).

About 500 B.C.

Furtwängler thought the figure was male, since no breasts seem to be indicated (but the surface is worn), and compared the Hermes in New York (cf. my no. 160) with a similar cap. Walters thought it was female, and compared no. 496 in his catalogue, where, however, the breasts are clearly indicated. I am inclined to the same view, on account of the general appearance of the figure. In any case, the figure is a daemoniac creature, such as appealed to the Orientalized Cypriotes.

A. H. Smith, in *Excavations in Cyprus*, section on Amathus, pp. 98, 125, pl. IV, 7.
Furtwängler, *A.G.*, no. 447, pl. VIII.
Walters, *Cat.*, no. 447, pl. VIII.

130. *Rock crystal scaraboid*, in an ancient swivel mount. 10 × 16 mm.

From Sicily. In the Fitzwilliam Museum, Cambridge. Given by Alfred A. de Pass in 1933.

CENTAUR, in full gallop to the left. His hair is flying, and he holds a branch in one hand, ready to throw it at some opponent. Beneath him is a shrub to indicate the out-of-doors. Two round ornaments in the field. Hatched border.

Cursory but spirited work of about 500–480 B.C.

(c) *Designs showing the development in placing several figures in a composition*

The problem of showing several figures together in a composition was likewise courageously tackled by the archaic gem-engraver – in spite of the small space at his disposal. We see riders, walking alongside the horse, or sitting on it, sometimes accompanied by a dog (nos. 131–135). Even such complicated compositions as a chariot with a charioteer and several horses is attempted and fairly successfully solved (cf. nos. 138–141); or a chariot and a horseman appear in somewhat unnatural positions, back to back (no. 142). Sometimes a swan is substituted for the horse, and the rider becomes Apollo or Hyakinthos (nos. 136, 137), or Europa appears riding Zeus' bull, holding on to its tail and horn (cf. no. 137a). Nos. 143, 144 show two ambitious scenes of a galley with a complement of warriors, a steersman and rowers. Combat scenes, so frequent in archaic vase-paintings, appear also on the early gems (cf. nos. 145–150). Generally the two combatants are seen facing each other, and to accommodate the two the back part of the body of one has to be raised in an unnatural position; or both are made to stand erect. No. 150 shows the problem beautifully solved, with Achilles striding forward, and Penthesileia in a half-reclining attitude.

Nos. 152–154 show similar representations of the Sphinx holding a Theban youth, the latter with legs raised. Finally the complicated composition is beautifully and convincingly designed on a late archaic gem in Boston, with a griffin, however, substituted for the sphinx (no. 155).

Lastly nos. 156–159 show several representations of one figure carrying another, in progressively natural poses.

131. *Carnelian scarab*, mounted on a gold ring. 16 × 11 mm.

In the Cabinet des Médailles. Gift of the duc de Luynes in 1862 (no. 269).

RIDER. A nude youth, wearing a crested helmet, and with a shield strapped to his left arm, is sitting on a horse, holding the reins tightly in the right hand. In front of him is a boar, shown walking upward along the hatched border of the stone. The man's trunk is apparently in back view, head and limbs are in profile. All four legs of the horse and boar are indicated, but only the near leg of the man. Hatched border.

Second half of the sixth century B.C.

In the *Guide du visiteur* the rider is interpreted as Meleager, but the only allusion to the hunt is the presence of the boar.

Furtwängler, *A.G.*, pl. IX, 13 (Luynes 205).
Pierres gravées, Guide du visiteur (1930), p. 140, no. 269 (not ill.).

132. *Banded onyx scarab*. Fractured round edge. 14 × 10 mm.

In the British Museum, 88.10–15.4. Bought 1888.

WARRIOR LEADING A HORSE. He is pulling at the reins with one hand, and has a forked whip in the other. On his head is a crested helmet. His chest is frontal, the lower part of his trunk is slightly foreshortened, arms, legs, and head are in profile. Hatched border.

Second half of the sixth century B.C.

Walters, *Cat.*, no. 478, pl. VIII.

133. *Chalcedony scaraboid*. 17 × 13 mm.

From Macedonia. In the British Museum, 88.10–15.2. Bought 1888.

YOUTH LEADING A HORSE. He is nude and holds the horse by the bridle; no reins are indicated. His trunk is in back (?) view, with the shoulders too prominently

marked, the rest is in profile. The horse has a large head and a long tail. Hatched border.

Late sixth century B.C.

Furtwängler, *A.G.*, pl. IX, 15.
Walters, *Cat.*, no. 501, pl. IX.

134. *Carnelian scarab.* 16 × 11 mm.

From Samos. In the British Museum, 1907.10–1.21. Bought 1907.

RIDER. A nude warrior, wearing a crested helmet, is sitting on a horse, not astride, but with both legs on one side, perhaps in the act of jumping off. A dog is running alongside. At the rider's back hangs his shield, drawn frontal, to show off the device in the form of a panther's mask. In the exergue below is another mask of a panther. Ground line below the dog, and hatched border.

Late sixth century B.C.

Cf. the similar intaglio on a scarab in the Hermitage, Furtwängler, *A.G.*, pl. VIII, 63. The horsemen on coins of Tarentum (Head, H.N.², p. 59, fig. 27; Evans, *Horsemen of Tarentum*, pl. II, 6, 7, etc.) give a similar composition in a later style.

Walters, *Cat.*, no. 442, pl. VIII.

135. *Sard scarab.* 12 × 9 mm.

In the Museum of Fine Arts, Boston, 27.670. Formerly in the Bruschi Collection at Corneto (Tarquinia), then in that of E. P. Warren.

HERAKLES, leading one of Diomedes' horses by the bridle. He is nude, except for the lion's skin, which covers his head and chest. In his left hand he holds his club; in the field hangs his bow-case. His trunk is in slight three-quarter view, the rest in profile. The horse's mouth is wide open, with teeth showing; its bridle is rendered by little pellets. Dotted border.

About 520 B.C.

Furtwängler, *A.G.*, pl. VI, 47.
Burlington Fine Arts Club Exh., 1904, p. 234, no. 0, 15 (not ill.).
Beazley, *Lewes House Gems*, no. 21, pl. 2.

136. *Rock crystal scarab.* 13 × 10 mm.

In the British Museum, H 367. From the Hamilton Collection.

HYAKINTHOS OR APOLLO, nude, with long hair, riding over the sea on a swan. He holds the reins (round the swan's beak) in one hand and a large branch in the other.

The sea is indicated by a wavy line below and a dolphin in the field. Hatched border. No marginal ornament.

Late sixth century B.C.

The swan, indicative of spring, was a regular attribute of Apollo; cf. Furtwängler in Roscher's *Lexikon*, s.v. Apollon, col. 444.
Apollo riding a swan appears on a fourth-century bell-krater in the British Museum, E232, with two women (Muses (?)); cf. Tillyard, *Hope Vases*, pl. 26, no. 162; Beazley, *A.R.V.²*, p. 1410, no. 16.
On Hyakinthos, a favourite of Apollo, riding on a swan cf. Hauser, *Philologus*, LII, 1894, pp. 209 ff.; Furtwängler, *A.G.*, vol. LII, p. 443.
Furtwängler at first suggested that Apollo is here conceived as returning from the far-off Hyperborians, where he was wont to spend the winter. Later, influenced by Hauser's article, he veered toward the interpretation of Hyakinthos.

Raspe, no. 1187.
Furtwängler, *A.G.*, vol. III, p. 96, fig. 66, and p. 443.
Walters, *Cat.*, no. 460, pl. VIII.

137. *Greyish-reddish four-sided agate.* 23 × 12 mm.

Found in the Peloponnese. In the Cabinet des Médailles. Acquired through the gift of Pauvert de La Chapelle in 1899.

APOLLO OR HYAKINTHOS, long-haired, riding astride on a swan. The swan's wings are shown spread out, one in front, the other at the back. Both legs of the swan are indicated, but only one of the rider (emerging below the swan's neck). In the field the inscription EROS. Hatched border.

Later sixth century B.C.

For the subject cf. no. 136.

E. Babelon, *Coll. Pauvert de La Chapelle*, no. 71, pl. VI.
Furtwängler, *A.G.*, vol. III, p. 443, fig. 218.

137a. *Plasma scaraboid*, cut. Traces of the perforation remain at the back. The edge has been bevelled. There is a fracture near the head of the bull. 20 × 14 mm.

From Cyprus. In the Ashmolean Museum, Oxford, 1966.596. Gift of Sir John Beazley, 1966, who bought it 'from a refugee during the war'.

EUROPA ON THE BULL. She sits sidewise, holding on to the bull's horn with one hand and to its tail with the other. She wears a sleeveless, belted chiton and over it a short mantle, which descends from her upper right arm and is then wound round her left; also a sakkos on her

head, a bracelet on each arm, a necklace, and a disk ear-ring. The upper part of her body is shown frontal. the lower part in profile, as also the head.

The bull is represented as actually swimming, with legs appropriately bent – not walking as in some similar scenes. The water is not rendered by wavy lines, but the fish, which appears in front of the bull, symbolizes the sea.

Late archaic work of about 480 B.C. One of the finest representations of this popular subject.

For the myth and its representations in Greek and Roman art cf. now R. Pincelli, in *Enciclopedia dell'Arte Antica classica e orientale*, vol. III (1960), s.v. Europa, and the many references there cited.

Catalogue of the Select Exhibition of Sir John and Lady Beazley's Gifts to the Ashmolean Museum, 1912–1966 (1967), p. 167, no. 640, pl. LXXXII.

138. *Sard scarab*, somewhat burnt. 13 × 10 mm.

In the British Museum, 68.5–20.17. Acquired in 1868, from the Pulsky Collection.

CHARIOTEER. A bearded man is driving a four-horse chariot, holding the reins in both hands, and a two-forked whip in the right. All four heads of the horses are represented and most of their legs, but only one wheel of the chariot. Curving ground line. Border of super-imposed zigzags.

About 530 B.C.

The attitude of the driver, bending forward and pulling at the reins, is masterly. The minuteness of the work, skil-fully composed in the small space, and the subject bring to mind Pliny's 'currum et aurigam . . . parvitatis mira-culo fictam', which Theodoros of Samos is said to have placed in the hand of a bronze statue of himself (*N.H.*, XXXIV, 83).

Imhoof-Blumer and Keller, pl. XVI, 64.
Furtwängler, *A.G.*, pl. VIII, 55, and vol. III, p. 82.
Beazley, *Lewes House Gems*, p. 16.
Walters, *Cat.*, no. 479, pl. VIII.

139. *Veined marble cone*, truncated. Diam. 13 mm.

In the Ashmolean Museum, 1892.1408. Acquired through the Chester bequest. From Sardes.

ONE-HORSE CHARIOT, proceeding slowly to the right, The charioteer holds the reins and a kentron. Triple ground line, hatched.

Late sixth century B.C. Very delicate work.

140. *Greenish steatite scarab*. Engraved by hand. L. 12 mm.

In the Staatliche Museen, Berlin.

CHARIOT. A man is driving a two-horse chariot, holding the reins in one hand, the whip in the other.

Cursory, spirited work of the last quarter of the sixth century B.C.

Furtwängler, *Beschreibung*, no. 155.
Boardman, *Island Gems*, p. 80, no. 345.

141. *Green steatite scarab*. Worked by hand. 17 × 12 mm.

In the Ashmolean Museum, 1921, 1220. Once in the Story-Maskelyne Collection.

FOUR-HORSE CHARIOT, moving slowly to the right. The charioteer is bearded and wears a long, girt chiton; he is bending forward, holding the reins in both hands. The horses wear decorated peytrels.

Last quarter of the sixth century B.C.

Sotheby Sale Catalogue, July 4th–5th, 1921, no. 27.
Boardman, *Island Gems*, p. 80, no. 341, pl. XII.

142. *Carnelian scarab*. Fractured along the edge. 14 × 10 mm.

In the British Museum, 65.7–12.98. Acquired from the Castellani Collection in 1865.

CHARIOTEER AND RIDER. One man is driving a two-horse chariot to the right, another is leading a horse to the left, with head turned back. The charioteer is standing erect and holds the reins of the near horse in one hand, and the reins of the far horse, as well as a whip, in the other. The rider is apparently standing on the ground, on the farther side of the horse (but his legs are not indicated) and holds the reins in both hands. Cross-hatching in the exergue, and hatched border.

A bold but rather confused composition of the later sixth century B.C.

Furtwängler, *A.G.*, pl. VIII, 49.
Walters, *Cat.*, no. 443, pl. VIII.

143. *Carnelian scaraboid*, in gold box-setting. 14 × 9 mm.

In the British Museum, 94.11–1.379. Acquired through the Turner bequest in 1894. Found at Amathus, Cyprus, together with a fifth-century coin of Idalion.

WAR-GALLEY. The prow terminates in a battering ram, the stern in an akrostolion. On the hull, near the prow, is a large eye. On the deck are seen the upper parts of three

warriors, evidently standing, ready for action. Each wears a crested helmet and holds a shield and a spear. In the stern the steersman is sitting with a large steering-paddle. Below, along the gunwale, are the rowers; about 20 heads can be made out. No border.

The crowded composition, compressed into a small space, is skilfully designed, but somewhat cursorily worked.

About 500 B.C.

On Greek warships cf. Torr, *Ancient Ships*, *passim*, and for one especially like the example on the gem cf. pl. IV, 15, 16 = the ship on the vase by Aristonophos in the New Conservatori Museum, *c.* 550 B.C.

Walters, *Cat.*, no. 449, pl. VIII.

144. *Chalcedony scaraboid*. A large chip at the top and smaller ones along the edge. 24 × 30 mm.

Said to be from Phaleron. In the Metropolitan Museum of Art, New York, 42.11.21. Purchase, 1942, Joseph Pulitzer bequest. From the Evans Collection.

WARSHIP, similar to the preceding, but more carefully executed. On the curved prow is a human eye, and the ram is in the form of a boar's head. At the stern is an aphlaston. Instead of three warriors on the deck there are five, each with a round shield, and below appear the upper parts of five rowers, evidently an abbreviation, for there are thirteen oars. In the stern is the steersman, wearing a long chiton and holding a large rudder.

About 500 B.C.

Evans, *Selection*, no. 51.
Richter, *Evans and Beatty Gems*, no. 18; *M.M.A. Handbook*, 1953, pp. 147 f.; *Cat.*, no. 43.

145. *Rock crystal scaraboid*. 26 × 19 mm.

In the Museum of Fine Arts, Boston, 01.7558.

MEDUSA AND A LION. She is winged, with a draped human body to which is attached an equine hind-part, and holds the lion by both its forelegs. Her long locks are in the form of serpents. Her head and shoulders are frontal, the rest in profile. The diminutive lion is standing on its hindlegs, offering no resistance. Hatched border and exergue with zigzags.

Last quarter of the sixth century B.C.

Osborne, *Engraved Gems*, pl. V, 22, p. 310.

146. *Plasma scarab*, burnt (?). 19 × 14 mm.

From the necropolis of Falerii. In the Staatliche Museen, Berlin. Acquired in 1893.

HERAKLES AND ACHELOOS. Herakles, bearded, and wearing the lion's skin, has grasped Acheloos' horn with his right hand and the end of his long tail with his left. Acheloos is shown as a horned man-headed bull, with head lowered for attack. Above him is an open-mouthed snake, and behind Herakles a monstrous fish, evidently indicating the forms of Acheloos' transformations. Hatched border and cross-hatched exergue.

Third quarter of the sixth century B.C., perhaps around 530.

Furtwängler, *Beschreibung*, no. 136; *A.G.*, pl. VIII, 3.

147. *Plasma scarab*, cut. 18 × 13 mm.

In the British Museum, 88.6–1.82. Bought 1888.

HERAKLES, ACHELOOS, AND DEIANEIRA. Herakles holds his club in his raised right hand, ready to hit Acheloos, who is shown in the form of a bull with human face, head lowered for attack. By his side is Deianeira, with hands raised in supplication. Herakles wears his lion's skin; Deianeira has a long chiton and long hair falling down her back. Guilloche border.

Third quarter of the sixth century B.C.

Cf., for the Acheloos, the archaic electron coins of Phokaia, *B.M.C.*, Ionia, pl. IV, 4.

King, *Antique Gems*, II, pl. 34, fig. 3.
Furtwängler, in Roscher's *Lexikon*, I, 2, s.v. Herakles, col. 2209; *A.G.*, pl. VI, 39, vol. III, pp. 93, 104.
Beazley, *Lewes House Gems*, p. 11.
Walters, *Cat.*, no. 489, pl. VIII.

148. *Carnelian scarab*. 11 × 8 mm.

In the British Museum, 91.6–25.5. Bought 1891.

HERAKLES AND TRITON. Herakles is striking with his club at Triton, who lies prostrate before him, with his fish-tail raised and one arm stretched toward Herakles's leg, the other to his arm. Hatched border. No marginal ornament.

An effective and lively composition of around 530 B.C.

Furtwängler, *A.G.*, pl. IX, 2.
Walters, *Cat.*, no. 474.

149. *Carnelian scarab*, cut. 16 × 12 mm.

In the British Museum. From the Blacas Collection.

HERAKLES AND KYKNOS. Kyknos has fallen to the ground; his right hand is raised in supplication; his shield is strapped to his left arm, his sheathed sword is by his side Herakles has his right foot placed on Kyknos' left

leg, and is brandishing his club to strike. Both are nude. Herakles' trunk is frontal; head, arms, and legs are in profile. Hatched border. No marginal ornament.

The illustration of the original should be turned to the left, to show Herakles standing.

Probably late sixth century B.C.

Bull. dell'Inst., 1839, p. 101, no. 21.
Walters, *Cat.*, no. 770, pl. XIII.

150. *Brownish sard scaraboid*, cut. Fractured round edge. 14 × 15 mm.

From Cyprus. In the Museum of Fine Arts, Boston, 27.682. Formerly in the collections of Mrs. W. T. Ready and E. P. Warren.

ACHILLES AND PENTHESILEIA. Achilles has placed his right foot on the leg of the fallen Amazon and is piercing her side with his spear. He wears a Corinthian helmet, pushed back from his face, and a chlamys, fastened at the neck with a brooch; on his left arm is a large round shield, and a sword is hanging by a baldric from his right shoulder. Penthesileia wears a short, belted chiton (pulled up into a kolpos, exposing the pubes) and also apparently an undervest, of which the ends of the sleeves are indicated at the wrists; a chlamys is fastened at her neck, and on her head is a cap-like helmet; in her limp right hand is her spear, in the left her bow; a large quiver is at her side. In the field, behind Achilles, is a star. Dotted ground line and hatched border.

Early fifth century B.C.

Beazley, *Lewes House Gems*, no. 31, pl. 2.

151. *Carnelian scarab*. 17 × 13 mm.

Found at Orvieto. In the Cabinet des Médailles. Acquired through the gift of Pauvert de La Chapelle in 1899.

SPHINX AND ANTELOPE. The sphinx is seated and lifts one paw to the hindquarters of an antelope, which is shown in front of it, diagonally downward, with the head on the ground and the mouth open, as if in pain. Hatched border. No marginal ornament.

About 550 B.C.

E. Babelon, *Cat., Coll. Pauvert de La Chapelle*, no. 48, pl. V ('excellent style étrusque').
Furtwängler, *A.G.*, vol. III, p. 444, fig. 221 ('altgriechisch').
Lippold, *Gemmen und Kameen*, pl. 78, no. 9.

152. *Carnelian scarab*. Chipped along the edge. 15 × 12 mm.

Found at Orvieto. In the Cabinet des Médailles. Acquired through the gift of Pauvert de La Chapelle in 1899.

SPHINX, with a Theban hero in her claws. She has long hair, tied at the nape of the neck. Its claws are on the shoulders of the diminutive man, who is lying in front of it, with legs raised. Hatched border.

Second half of the sixth century B.C., about 530 B.C.

The composition occurs in several replicas; cf. nos. 153–154, and Furtwängler, *A.G.*, vol. III, p. 443.

E. Babelon, *Coll. Pauvert de La Chapelle*, no. 47, pl. V.
Furtwängler, *A.G.*, vol. III, p. 443, fig. 217.

153. *Rock crystal scaraboid*. 21 × 15 mm.

From Crete. In the Staatliche Museen, Berlin.

SPHINX, recumbent, with a young Theban in her claws. The sphinx is winged and long-haired. The youth is lying on the ground and raises both his legs. Hatched border.

Second half of the sixth century B.C.

Furtwängler, *Beschreibung*, no. 141; *A.G.*, pl. VIII, 7.

154. *Chalcedony scarab*, burnt. 12 × 17 mm.

In the National Museum, Athens, Numismatic section, inv. 889. Gift of K. Karapanos, 1910–11.

SPHINX, seated in profile to the left, with a young Theban in her claws. The youth is lying beneath the sphinx, one arm lifted to his face, both legs raised. Hatched border.

Second half of the sixth century B.C., about 530 B.C.

Svoronos, *Journal international d'archéologie numismatique*, XV, 1913, pl. VI, no. 459.

155. *Chalcedony scaraboid*, cut. Fractured at top; ends of griffin's ears are missing. 18 × 13 mm.

In the Museum of Fine Arts, Boston, 23.578. Formerly in the Naue Collection in Munich, then in that of E. P. Warren.

GRIFFIN, holding a nude, prostrate youth within its claws. The youth's right arm is raised to his head, the left hangs down by his side, with fingers spread. The griffin is especially fierce-looking, with wide-open beak (tongue and teeth showing), goggle eyes, spiny comb, and what must once have been long straight ears. It has a ruff at its throat, and large wings, with the feathers arranged in three tiers (the tip of the second wing is indicated). Hatched border.

Early fifth century B.C.

Furtwängler, *A.G.*, pl. VI, 30, and vol. III, p. 104.
Burlington Fine Arts Club Exh., 1904, p. 233, no. O, 12 (not ill.).
Beazley, *Lewes House Gems*, no. 29, pl. 2.
Lippold, *Gemmen und Kameen*, pl. 81, no. 1.

156. *Sard scarab*, burnt. 13 × 10 mm.

In the British Museum, H340. From the Hamilton Collection.

AJAX WITH THE BODY OF ACHILLES. Ajax, wearing a crested, Attic helmet and a cuirass, is carrying the nude, dead body of Achilles on his right shoulder. Ajax is in the half-kneeling posture indicating motion. His trunk, and also that of Achilles, are in front view, whereas the heads, arms, and legs are in profile. Achilles' head is shown upside down with streaming, straight hair. Hatched border. No marginal ornament.

Late sixth century B.C.

Raspe, no. 9344.
Koehler, *Gesammelte Schriften*, V, p. 149.
Furtwängler, *A.G.*, pl. VIII, 31, vol. III, p. 100.
Beazley, *Lewes House Gems*, p. 17.
Walters, *Cat.*, no. 476, pl. VIII.

157. *Onyx scarab.* 20 × 15 mm.

From Sicily. In the British Museum, 72.6-4.1136. Acquired from the Castellani Collection in 1872.

CENTAUR CARRYING OFF A NYMPH. He has a human body to which the hind part of a horse is attached, and has a wreath in his hair. The nymph wears a long chiton, bordered at the bottom, and has long, straight hair. Hatched border. No marginal ornament.

Late sixth century B.C.

The subject appears on coins of Thrace and Macedonia; *B.M.C.*, Macedonia, p. 147; *Guide to the Principal Coins, British Museum*, pl. III, 2, 3.
As Furtwängler, *loc. cit.*, pointed out, the Centaur here has assumed the role and appearance of a silenos.

Heydemann, *Bull. dell'Inst.*, 1869, p. 55, no. 2.
King, *Antique Gems and Rings*, II, pl. 33, fig. 8; *Handbook*, pl. 65, fig. 6.
Imhoof-Blumer and Keller, pl. 25, fig. 34.
Keller, *Antike Tierwelt*, I, pl. III, 16, p. 250.
Perrot and Chipiez, *Hist. de l'art*, IX, p. 26, fig. 26.
Furtwängler, *A.G.*, pl. VIII, 5, vol. III, p. 101.

Lippold, *Gemmen und Kameen*, pl. 75, fig. 13.
Baur, *Centaurs*, p. 134, no. 325.
Walters, *Cat.*, no. 470, pl. VIII.

158. *Carnelian scaraboid*, in a gold-band setting, mounted in a gold swivel ring. The swivel sockets are missing. 14 × 19 mm.

From Cyprus. In the Metropolitan Museum, New York, 74.51.4223 (C.E.16). From the Cesnola Collection. Purchased 1876–77.

EROS CARRYING A GIRL to her lover (?). A long-haired, nude youth, with large recurving wings is shown flying, carrying a nude, struggling girl in his arms. She wears a sakkos and holds a lyre in her left hand. The trunks of both figures are in slight three-quarter view, the rest is in profile. Line border.

Early fifth century B.C.

On Eros' early role as a god inspiring passion, A. D. Nock referred me to the references given in the *Oxford Classical Dictionary*, s.v. Eros, p. 338. For Eros carrying off a boy holding a lyre cf. the kylix in Berlin, also of the early fifth century B.C., Furtwängler, *Beschreibung*, no. 2305; Beazley, *A.R.V.²*, p. 450, no. 31 (attributed to Douris). Cf. also the single figures of Eros on the coins of Peparethos, Regling, *Münze*, pl. VII, no. 190 (520–480 B.C.).

Cesnola, *Cyprus*, pl. XXXIX, 1; *Atlas*, III, pl. XXVIII, 8.
Furtwängler, *A.G.*, pl. IX, 22, and vol. III, p. 103.
Myres, *Handbook*, no. 4223.
Beazley, *Lewes House Gems*, p. 28, pl. A, 3; *Etruscan Vase Painting*, p. 4.
Richter, *M.M.A. Handbook*, 1953, p. 148, pl. 125, o; *Cat.*, no. 41, pl. VII.
Lippold, *Gemmen und Kameen*, pl. 28, no. 2.

159. *Agate scaraboid.* 22 × 17 mm.

In the British Museum. From the Towneley Collection.

SATYR CARRYING A MAENAD, holding her with both arms round her waist. She wears a long-sleeved chiton and has a thyrsos in her right hand; the left arm is extended, with fingers spread. Ground line and hatched border.

First half of the fifth century B.C.

Furtwängler, *A.G.*, pl. X, 9.
Walters, *Cat.*, no. 495.

(d) *The rendering of drapery*

Nos. 160–165 illustrate the rendering of drapery on archaic Greek gems. It will be seen that it closely corresponds to that in contemporary sculpture, with the same conventions of stylized and stacked folds.

160. *Eight-sided bluish chalcedony cone.* Chipped here and there. 14 × 17 mm.

In the Metropolitan Museum of Art, New York, 81.6.3. Gift of John Taylor Johnston, 1881. From the King Collection.

HERMES, beardless, is standing holding a lotus flower in one hand, the kerykeion in the other. By his side is a large bird, an eagle or a hawk. He wears a long chiton, a himation with ends draped over both arms, a cap surmounted by a recurving wing, and winged shoes. His long hair falls down his back. Ground line.

About 530–525 B.C., the time of the Siphnian frieze.

For Hermes' winged cap cf. the coins of Kyzikos, Regling, *Münze*, no. 126, and a Caeretan hydria in the Villa Giulia Museum, Ricci, *op. cit.*, pls. III, V.
As has been pointed out, the absence of a beard in Hermes points to Ionia, for in the mainland representations of the archaic period Hermes is regularly bearded and wears a chlamys and a petasos; cf. Scherer, *op. cit.*, col. 2399.

King, *Antique Gems and Rings*, II, copper pls., pl. IV, no. 39, p. 75; *Handbook*, p. 3, pl. VII.
Furtwängler, *A.G.*, pl. VI, 49, and vol. III, p. 97.
Scherer, in Roscher's *Lexikon*, I, 2, s.v. Hermes, col. 2399.
Richter, *M.M.A. Handbook*, 1953, p. 147, pl. 125, I; *Cat.*, no. 33, pl. VI.
Ricci, *Annuario*, VIII–X, 1946–48, p. 51, note I.

161. *Banded onyx scarab*, set in the gold-band setting of a bronze ring. 17 × 12 mm.

From Amathus, Cyprus. In the British Museum, 89.5–15.1. Bought 1889.

ATHENA standing, holding her spear in one hand and with the other lifting the skirt of her chiton. She has two recurved wings, placed low on her back, and a crested helmet, of which the neckpiece ends below in the head of a silenos. The folds of her chiton are indicated by a series of thin, straight lines, arranged in fish-bone formation on her chest, and with a border of dots along the edge. Along her back, above the wings, is seen a fringe of serpents (not attached, however, to an aegis). Both breasts are prominently indicated, side by side in profile to the right. Hatched border.

Late sixth century B.C.

For a winged Athena on coins cf. Imhoof-Blumer, *Num. Ztschr.*, III, 1871, pp. I ff. The Greek winged Athena with attributes of Medusa was evidently the prototype of similar representations on Etruscan gems; cf. Furtwängler, *A.G.*, pl. XVI, 9, 10, 11, 13.
Beazley, *loc. cit.*, thought that the silenos head belongs to

the aegis, not to the helmet; but on Graeco-Roman gems Athena wearing a helmet of which the neckpiece ends in the head of a silenos frequently occurs (cf. Furtwängler, *Beschreibung*, Berlin, nos. 5332 ff., 7809 f., 8518 f.). And they, it would seem, should go back to an old tradition.

Furtwängler, *A.G.*, pl. VI, 56, vol. III, pp. 93, 98, 115.
E. M. Douglas, *J.H.S.*, XXXII, 1912, p. 178.
Beazley, *Lewes House Gems*, pp. 8, 20, pl. A, 6.
Lippold, *Gemmen und Kameen*, pl. XX, 5.
Walters, *Cat.*, no. 437, pl. VIII.

162. *Carnelian scaraboid*, in a gold-box setting, mounted in a swivel ring. 10 × 17 mm.

From Cyprus. In the Metropolitan Museum of Art, New York, 74.51.4220 (C.E.14). From the Cesnola Collection. Purchased 1874–76.

NIKE, holding a flower in one hand, a wreath in the other. Behind her rises a snake, open-mouthed. Nike wears a long chiton, and has a himation hanging from her left arm; in her hair is a fillet. A large recurving wing grows from her body and hides most of her chest. Short ground line in front of her feet.

Late sixth century B.C.

For the type of ring cf. Marshall, *Cat. of Finger Rings*, p. XLI, no. XIX.

Cesnola, *Cyprus*, pl. XXXIX, 3; *Atlas*, III, pl. XXVIII, 15.
Myres, *Handbook*, no. 4220.
Richter, *M.M.A. Handbook*, 1953, p. 147, pl. 125, m; *Cat.*, no. 34, pl. VI.

163. *Rosy brown chalcedony scarab*, cut. 14 × 17 mm.

In the Museum of Fine Arts, Boston, 27.676. Formerly in the Evans and E. P. Warren Collections.

ATHENA, in full armour, striding to the right, holding a spear in her right hand and a shield on her left arm. She wears a chiton, a crested Attic helmet with cheek-pieces, a himation over both shoulders, and a long aegis, of which the serpent fringe is visible along both outer edges of the himation. The gorgoneion of the aegis appears in profile above her right shoulder. Ground line and hatched border.

End of the sixth century B.C., a short time before the sculptures of the western pediment of the temple of Aegina.

Similar striding Athenas appear on Etruscan scarabs (cf. Furtwängler, *A.G.*, XVI, 9, 10, 11, and my nos. 739, 740) – similar, but changed into Etruscan style, and therefore offering instructive comparisons.

For the profile gorgoneion Beazley compares that on a hydria of Etrusco-Ionian style, Kleiner, *Oest. Jahr.*, XIII, 1910, pls. V, VI, p. 164.

Beazley, *Lewes House Gems*, no. 26, pl. 2.

164. *Light green steatite pseudo-scarab.* 18 × 11 mm.

In the British Museum. Bought 1873.

On the back, instead of the usual beetle is carved the head of a silenos, in front view.

KITHARIST. A bearded man, wearing a long chiton and a wreath, is about to mount on a two-stepped platform for a musical performance. He holds his kithara in one hand, the plektron in the other. In the field, around the edge, is the inscription (now much worn): Συρίες ἐποίεσε, Syries made it. Hatched border.

Last quarter of the sixth century B.C.

The engraving is done by hand on the soft steatite, as in the earlier Island gems. Evidently even after the introduction of wheel-work, the engraving by hand continued for some time; cf. p. 45, and for other examples of this period my no. 103.
The style is akin to that of the stone inscribed Onesimos, cf. no. 103).
Syries is one of the first Greek gem engravers to sign his work. To judge by his name, he must have been an Ionian, but the spelling of the name, with ε instead of η, and with a three-stroked instead of a four-stroked sigma, has been thought to suggest that he was a resident of

Euboea (cf. Roehl and Furtwängler, *loc. cit.*[1]). 'Could be Attic' (M. Guarducci). The execution of the design, though competent, is not of the first order, showing that on gems, as on vases, not always the best work was signed. On Syries see also my p. 17.

Babelon, *La gravure*, p. 99, fig. 71.
Froehner, *Mélanges d'épigraphie et d'archéologie* (1873), p. 14.
Roehl, *Inscr. gr. ant.* (1882), p. 103, no. 376.
Furtwängler, *J.d.I.*, III, 1888, p. 195, pl. VIII, 1 (= *Kleine Schriften*, II, p. 186, pl. 26, no. 1); *A.G.*, pl. VIII, 11, vol. III, pp. 80, 92.
Beazley, *Lewes House Gems*, pp. 11, 18.
Walters, *Cat.*, no. 492, pl. VIII, and fig. 31, on p. 60 (drawing of the head of silenos).
Boardman, *Island Gems*, p. 80, no. 340, pl. XII.

165. *Rock crystal scaraboid.* 20 × 15 mm.

Found in Samos. In the Cabinet des Médailles. Gift of Pauvert de La Chapelle, 1899.

ARCHER, in a half-kneeling position, with his bow hanging from his left forearm; his quiver is fastened to his side, and in both hands he holds an arrow, as if examining it. He wears a pointed leather cap with lappets, a tight-fitting belted, sleeved jacket, and trousers. Hatched border.

First quarter of the fifth century B.C.

E. Babelon, *Coll. Pauvert de La Chapelle*, no. 78, pl. VI.
Furtwängler, *A.G.*, pl. IX, 20.

[1] M. Guarducci points out that a three-stroked sigma occurs also in Ionia.

(e) *Heads*

There are relatively few single heads on archaic gems. Nos. 166–167 show two good examples, one in profile view, the other frontal.

166. *Black jasper scarab.* 11 × 8·5 mm.

In the Museum für Kunst und Gewerbe, Hamburg. From the collection of Dr. J. Jantzen, Bremen.

FEMALE HEAD, probably of Aphrodite, in profile to the right. She wears a beaded necklace; her hair is tied with a fillet at the base of the skull. Beaded ground line, and line border with half circles attached.

Early fifth century B.C.

Cf. the similar small heads on coins of Lycia, *B.M.C.*, Lycia, pl. 4. 16, 6, 6.
Zazoff, *Arch. Anz.*, 1963, cols. 56 ff., no. 10, fig. 3.
Lullies, *Griechische Plastik, Vasen und Kleinkunst*, Leihgaben aus Privatbesitz, Kassel, Staatliche Kunstsammlungen, 1964, no. 47.

167. *Sard scarab.* 15 × 11 mm.

In the British Museum, 72.6–4.1157. Acquired from the Castellani Collection in 1872. Formerly in the Santangelo Collection.

HEAD OF MEDUSA, frontal, with protruding tongue, large nose, and snakes standing erect on her head. Hatched border.

Last quarter of the sixth century B.C.

Cf. the similar Gorgon heads on coins of Neapolis, opposite Thasos, *Guide to the Principal Coins of the British Museum*, pl. 3, no. 6.

Walters, *Cat.*, no. 473, pl. VIII.

(f) *Monsters, daemons, and fantastic combinations of human and animal parts*

The monsters so popular in the Orientalizing period of Greek art became somewhat less frequent in the Greek archaic. Nos. 168-184a show a selection of them on engraved gems: the sphinx, the chimaera, and the siren (a particularly fine work); a winged bull; foreparts of animals with wings and human legs or birds' tails; a fantastic rider; etc.

For the similarities between some of these monsters and those that appear on contemporary coins cf. p. 24.

168. *Black steatite scaraboid.* 16 × 13 mm.

From Cyprus. Presented by A. H. Smith to the British Museum in 1894 (94.3-16.1).

SPHINX, seated, with one foreleg raised. Line border.

Late sixth century B.C.

The design was evidently engraved by hand – a survival of earlier times; cf. p. 45 and no. 164.

Walters, *Cat.*, no. 448, pl. VIII.

169. *Chalcedony scarab.* L. 12 mm.

In the National Museum, Athens, Numismatic section, inv. 537. Gift of K. Karapanos, 1910–11.

SPHINX, seated in profile to the left. In the field three round ornaments.

About 500 B.C.

Svoronos, *Journal international d'archéologie numismatique*, XV, 1913, p. 167, no. 460, pl. VI.

170. *Sard scarab*, mounted in an eighteenth-century ring. Small chip at the bottom; cut round the edge. 10 × 8 mm.

In the Royal Cabinet of Coins and Gems, The Hague, no. 832.

SIREN. She has human arms, and holds a mirror in one hand, a necklace in the other. On her head appears to be a sakkos. The feathers on body, wings, and tail are carefully marked. The hatched border is still preserved here and there.

Last quarter of the sixth century B.C. She has the grace of the later Attic korai.

Furtwängler, *A.G.*, pl. VIII, 26.
Guépin, *Hermeneus*, 1964, p. 283, fig. 1; *Bull. van de Vereeniging . . . te 's-Gravenhage*, XLI, 1966, pp. 51 ff.

171. *Sard quasi-scarab.* 11 × 9 mm.

In the British Museum, H352. From the Hamilton Collection.

The back of the beetle is in the form of a negro's head, in relief.

SIREN, shown flying, holding a bead necklace in one hand. She wears a cap with a crested ornament. Her head, body and legs are in profile, the tail and the wings frontal. Hatched border.

Late archaic, about 500 B.C.

Raspe, no. 9555.
Furtwängler, *A.G.*, pl. VIII, 30.
Lippold, *Gemmen und Kameen*, pl. LXXIX, 8.
Weicker, *Seelenvogel*, p. 124, fig. 50.
Walters, *Cat.*, no. 487, fig. 30, pl. VIII.

172. *Rock crystal scaraboid*, chipped at bottom. 18 × 13 mm.

In the British Museum, 1923.4–1.21.

CHIMAERA, in profile to the left. Inscribed χαῖρε, 'hail'. Line border.

Late sixth century B.C.

For the inscription cf. no. 552. 'Evidently meant for a greeting to the person receiving the sealed object' (Furtwängler).
'The χ in an archaic inscription points to an Eastern alphabet – Ionia, Cyclades, Attica – the Corinthian and Sikyonian being excluded on account of the ε' (M. Guarducci).

Imhoof-Blumer, pl. 25, fig. 40.
Furtwängler, *A.G.*, vol. III, pp. 136, 145.
Beazley, *Lewes House Gems*, p. 85, pl. A, 9.
Walters, *Cat.*, no. 522, pl. IX.

173. *Glass scaraboid.* 16 × 11 mm.

In the Ashmolean Museum, 1941.1198. Bequeathed by Sir Arthur Evans.

FOREPARTS OF A LION AND A GOAT conjoined. The lion's head is turned. Line border.

Late sixth century B.C.

174. *Rock crystal scaraboid.* 21 × 20 mm.

In the National Museum, Athens, Numismatic section, inv. 108. Gift of D. Tsivanopoulos.

MONSTER. The forepart of a goat terminates in a coiled, open-mouthed snake.

Late sixth century B.C.

Svoronos, *Journal international d'archéologie numismatique*, XVII, 1915, pl. VI, 3.

175. *Silver ring*, with engraved design on elongated bezel. 19 × 12 mm.

In the National Museum, Athens, Numismatic section, inv. 108. Gift of K. Karapanos, 1910–11.

RHYTON, ending in the forepart of a hind.

Greek, late archaic.

Svoronos, *Journal internationale d'archéologie numismatique*, XV, 1913, no. 594.

176. *Sard scarab*, burnt. 10 × 8 mm.

In the British Museum. From the Hamilton Collection.

DAEMON, in a half-kneeling posture. It has a human body, a bull's head, and four wings on its back. The trunk is shown in front view, the head and limbs in profile. Hatched border.

Second half of the sixth century B.C.

Daemons with bull's heads remained popular in Greece for a long time, presumably on account of their magical powers; cf. Furtwängler, *A.G.*, vol. III, p. 100.

Raspe, no. 8246.
Fabretti, *I.A.*, no. 533.
Montfaucon, *Ant. expliquée et représentée en figures* (1922), II, 2, pl. 155.
Furtwängler, *A.G.*, pl. VII, 52, vol. III, p. 100.
Koehler, *Gesammelte Schriften*, V, p. 164.
Walters, *Cat.*, no. 469, pl. VIII.

177. *Steatite scarab.* 14 × 10 mm.

In the British Museum, 1900.7–24.1. Bought 1900.

MONSTER in the form of the forepart of a winged boar joined to human legs, in a half-kneeling posture. Hatched border.

Late sixth century B.C.

Cf. the similar monster on the coins of Kyzikos of 520–480 B.C., Regling, *Münze*, pl. VI, 143.

Walters, *Cat.*, no. 439, pl. VIII.

178. *Chalcedony scaraboid.* 13 × 10 mm.

In the Cabinet des Médailles. Acquired through the gift of Pauvert de La Chapelle in 1899.

MONSTER, in the form of a winged boar joined to a bent human leg and buttock. Both forelegs of the boar are indicated, but only one wing. Hatched border.

Late sixth century B.C.

E. Babelon, *Cat., Coll. Pauvert de La Chapelle*, no. 44, pl. V. Furtwängler, *A.G.*, vol. III, p. 444.

179. *Carnelian scarab.* 8 × 6 mm.

From Mytilene. In the Staatliche Museen, Berlin.

MONSTER in the form of the forepart of a boar, combined with the hind-part of a bird. Hatched border.

Probably late sixth century B.C. Cf. the similar monster on the coins of Klazomenai, dated 520–480 B.C., Regling, *Münze*, pl. VI, 162.

Furtwängler, *Beschreibung*, no. 166.

180. *Carnelian scarab.* 9 × 11 mm.

In the Staatliche Museen, Berlin. Acquired in Rome.

MONSTER. Forepart of a horse combined with a human leg. Above is a round ornament. Hatched border.

Late archaic.

Furtwängler, *Beschreibung*, no. 169; *A.G.*, pl. VIII, 70.

181. *Carnelian scarab.* 12 × 9 mm.

In the British Museum, T164. From the Towneley Collection.

MONSTER. Forepart of a lion joined with the forepart of a boar. Dotted border. No marginal ornament.

Late archaic.

Raspe, no. 13586.
Imhoof-Blumer and Keller, pl. XXVI, 56.
Walters, *Cat.*, no. 650, pl. XI ('archaic Etruscan').

182. *Carnelian scarab.* 13 × 11 mm.

In the British Museum, H406. From the Hamilton Collection.

HIPPALEKTRYON. A forepart of a horse joined to the hind-part of a cock is shown galloping to the right. In the field are two bosses. Curving ground line and hatched border. No marginal ornament.

Late archaic.

Raspe, no. 9082.
Imhoof-Blumer and Keller, pl. XXVI, 60.
Walters, *Cat.*, no. 716, pl. XII.

183. *Steatite scarab.* 17 × 12 mm.

From Klazomenai. In the British Museum, 98.11–20.2.
Bought 1898.

HORSE AND RIDER. On a galloping, bridled horse is seated a rider, human up to the waist, but ending above in a wing. The figure is perhaps intended for a winged daemon. Hatched border.

Circa 500 B.C.

Furtwängler, *A.G.*, pl. LXIV, 10, vol. III, p. 444.
Walters, *Cat.*, no. 441, pl. VIII.

184. *Sard scaraboid.* Chipped round the edge. 18 × 13 mm.

In the British Museum, 94.5–7.2. Acquired at the Wills sale, 1894.

WINGED BULL with a bearded human face, is galloping to the right. Only one recurved wing is indicated.
The monster resembles Acheloos (cf. nos. 370, 371), except that he has wings. It has been suggested that the wings were added through influence of the winged boars

on Ionian coins, e.g. those of Klazomenai; cf. Head, *H.N.*², p. 567; *B.M.C.*, Ionia, pl. III, 18.

About 480 B.C.

Furtwängler, *A.G.*, pl. IX, 5.
Lippold, *Gemmen und Kameen*, pl. LXXX, 4.
Beazley, *Lewes House Gems*, p. 30.
Walters, *Cat.*, no. 498, pl. IX.

184a. *Carnelian scarab.* 32 × 23 mm.

Found in Corinth in 1965. In the Corinth Museum, 65.61.35.

WINGED BULL, in profile to the left, with head turned back and one foreleg lifted. Hatched border.

Late archaic.

Cf. the winged bull, also with one foreleg lifted, but with head not turned back, on an early Ionic electrum stater (cf. my fig. 184b), once in the Jameson Collection, no. 1505, (now (?)), and the forepart of a winged bull on coins of Kyzikos (Fritze, *Nomisma*, VII, pl. II, 11).[1]

Here published with the kind permission of Henry S. Robinson.

[1] I owe these references to Mr. Kenneth Jenkins.

(g) *Animals*

More attention than before is now given to the real animal world. The lion, which by now was indigenous only in Northern Greece (cf. Herod., VII, 125, 126; Aristotle, *Hist. animl.*, VI, 31, VIII, 28; Xenophon, *On Hunting*, XI, 1; Pausanias, VI, 5, 4 f.) predominates. He is shown lying down, standing, sitting, ready for the spring, devouring his prey, and pursuing a man (cf. nos. 185–193). In two representations he is carved in the round, in Egyptianizing style. Specially favoured are the contest scenes, in which the lion has sprung on the back of a bull or deer and is biting it in the back (cf. nos. 194–200). Or he is attacking another, rival lion (cf. no. 201). In these representations one can observe once again the combination of the adherence to a given type with a constant variety introduced in details.

Besides lions, we meet animals studied by the Greeks in their immediate surroundings: bulls, and cows suckling their young (nos. 203, 206); rams and antelopes (nos. 214, 215, 210); horses, mules, and donkeys shown rolling on the ground (nos. 207–209); boars and sows (cf. nos. 212, 213); a fierce wolf (no. 202); and a beetle. Many are in lifelike renderings, evincing direct observation.

185. *Carnelian scarab*, cut (or scaraboid (?)). Remains of perforation. 14 × 10 mm.

From Southern Italy. In the Cabinet des Médailles. Gift of Pauvert de La Chapelle in 1899. Once in the Santangelo Collection, Naples.

LION devouring its prey. The lion is shown in profile, with head turned to the front. The bristles along the back

are indicated, and the ribs are prominently marked; all four legs are shown. Hatched border.

Powerful work of the second half of the sixth century B.C.

Cf. the (somewhat later) representation in Berlin, Furtwängler, *Beschreibung*, no. 309.

E. Babelon, *Cat., Coll. Pauvert de La Chapelle*, no. 52, pl. V.

186. *Carnelian scarab.* 13 × 18 mm.

In the Cabinet des Médailles, inv. D2200.

THREE LIONS. They are of different sizes. The one in the middle is the largest, occupying approximately the length of the stone; he is shown in profile, with head frontal, and with only three of his legs indicated. The other two are much smaller, both shown in profile, one to the right, the other to the left; of each only the two legs in the near plane are indicated. Hatched border.

Third quarter of the sixth century B.C.

Furtwängler, *A.G.*, pl. VI, 60.

187. *Emerald (?) scarab.* 18 × 15 mm.

Said to have been found near Pergamon. Present location not known.

LIONESS, with forelegs outstretched, in profile to the right. Ground line. In the field, horizontally at the top, is the inscription ᾿Αριστοτείχης, Aristoteiches, in Ionic script. Hatched border.

Late archaic period, about 500 B.C.

The verb is missing, and the name is given in the nominative. So it is uncertain whether Aristoteiches was the artist or the owner of the stone. Furtwängler thought the artist, because, as he said, the signature is secondary, the design of the lioness is the obviously important thing.

The work is masterly, the fierceness of the animal, ready for attack, is expertly conveyed. Cf. the similar representations on the coins of Cyprus, Regling, *Münze*, no. 271.

Furtwängler, *J.d.I.*, III, 1888, pp. 194 f., pl. VIII, 2 (=*Kleine Schr.*, pp. 185 f., pl. XXVI, 2); *A.G.*, pl. VIII, 43.

188. *Carnelian scaraboid, burnt.* 15 × 19 mm.

In the Staatliche Münzsammlung, Munich. From the Arndt Collection.

LION, in profile to the left, ready to spring on his prey. Both forelegs are lowered, the tail is between the hindlegs, the mouth wide open. Ground line.

About 500 B.C.

Czako and Ohly, *Griechische Gemmen*, no. 10.

189. *Glass scarab.* 14 × 10 mm.

In the British Museum, 1923.4-1.17.

LION, standing in profile to the left. The mane is indicated by stippling. On his back is a cock pecking at a long-stemmed lotus flower. In front of the lion is a lotus plant. Dotted border and cross-hatched exergue.

Last quarter of the sixth century B.C.

A carnelian scarab from which this glass one was evidently moulded in ancient times is illustrated in Lajard, *Introd. à l'étude du culte de Mithra*, pl. 68, fig. 5.

Furtwängler, *A.G.*, pl. VIII, 56.
Walters, *Cat.*, no. 444, pl. VIII.
Lippold, *Gemmen und Kameen*, pl. 84, no. 14.

190. *Carnelian*, mounted in a modern gold ring. 16 × 10 mm.

In the Cabinet des Médailles. Gift of the duc de Luynes in 1862 (no. 298).

SEATED LION, in profile to the left. Both forelegs, but only one hindleg are indicated. Ground line.

Early fifth century B.C.

191. *Rectangular carnelian*, set in a gold swivel ring. L. 14 mm.

In the Metropolitan Museum of Art, New York, 16.174.39. Rogers Fund, 1916.

On the back of the stone is a reclining lion, carved in the round (right ear missing).
Engraving on the flat side: LION DEVOURING PART OF A DEER.

First half of the fifth century B.C.

Richter, *M.M.A. Bull.*, XVI, 1921, pp. 57 f., fig. 1; *Cat.*, no. 55, pl. IX.
Alexander, *Jewelry*, p. 51, fig. 110.

192. *Carnelian.* The upper part is carved in the form of a recumbent lion instead of the usual beetle. The under side is plain. L. 17 mm.

Said to be from Athens. In the British Museum. Bought at a sale in Paris, 1905. From the collection of Sir Arthur Evans.

The style of the lion is Egyptianizing, in archaic style. It may, however, be later, i.e. 'archaizing', for a similar piece in Berlin (cf. Furtwängler, *Beschreibung*, no. 330; Imhoof-Blumer and Keller, pl. XXII, 18) has on the under-side a dolphin and a bird in developed style – unless they were added later?

Burlington Fine Arts Club Exh. Cat., 1904, p. 169, no. L49.

Collection d'un archéologue explorateur (Sale Catalogue), 1905, pl. XI, 23.
Walters, *Cat.*, no. 457, fig. 26.

193. *Bronze ring*, with engraved design on oval bezel. Surface somewhat corroded. 8 × 15 mm.

In the Thorvaldsen Museum, Copenhagen.

LION AND MAN. The man is fleeing headlong to the right, while the lion is standing still, with wide-open mouth, roaring. Hatched border.
Late archaic period. A vivid rendering of an unusual subject.

Fossing, *Cat.*, no. 2013 (not illustrated).

194. *Sard scarab.* 15 × 12 mm.

In the Fitzwilliam Museum, Cambridge. Given by Alfred A. de Pass in 1933. Formerly in the N. Story-Maskelyne Collection.

BULL ATTACKED BY A LION. The lion is biting the bull in the back. His fore-paws, head, and mane are shown in front view, the lower part of his body, standing on the ground, is in profile to the left. All four legs of the bull are indicated. Guilloche border.

Late sixth century B.C.

Furtwängler, *A.G.*, pl. VI, 52.
Burlington Fine Arts Exh. Cat., p. 243, no. O, 49, pl. I.
Sotheby Sale Catalogue of the Story-Maskelyne Collection, July 5, 1921, no. 29, pl. I.
Lippold, *Gemmen und Kameen*, pl. 85, no. 3.

195. *Carnelian scarab.* Chips along the edge. L. 25 mm.

Said to have been found in a tomb at Gela with black-figured vases. In the Metropolitan Museum of Art, New York, 42.11.15. Purchase 1942. Joseph Pulitzer bequest.

LION ATTACKING A BULL. The lion has jumped on the bull's back and is biting it in the hind-quarters. The bull is collapsing, with forelegs bent. The lion is in profile to the right, with head frontal; the bull in profile to the left. All four legs of the bull are indicated, but only the near legs of the lion. Along the whole back of the lion are short lines for the bristles. Hatched border. Marginal ornament of tongues and beads – a rare feature on Greek scarabs (cf. p. 178).

Late sixth century B.C.

Furtwängler, *A.G.*, pl. VI, 51.
Lippold, *Gemmen und Kameen*, pl. 85, no. 14.
Beazley, *Lewes House Gems*, p. 58.
Evans, *Selection*, no. 41.

Richter, *Evans and Beatty Gems*, no. 15; *M.M.A. Handbook*, 1953, p. 147, pl. 125, k; *Cat.*, no. 51, pl. IX.

196. *Chalcedony scaraboid.* 21 × 15 mm.

Said to be from Thebes. In the Museum of Fine Arts, Boston, 98.720. Formerly in the collection of E. P. Warren.

LION ATTACKING A BULL. The lion has jumped on top of the bull, and is biting it in the back. The bull has fallen on its left foreleg, but seems otherwise unperturbed. In the field are a tortoise and a winged solar disk. Ground line. Hatched border.

Furtwängler, *A.G.*, pl. VI, 44.
Osborne, *Engraved Gems*, pl. V, 25, p. 311.

197. *Green jasper scarab.* Fractured. 16 × 13 mm.

In the British Museum, 91.6–25.1. Bought 1891.

LION AND BULL. A lion has sprung on top of a bull and is biting it in the hind-quarters. The bull is shown collapsing, with bent legs and head thrown back. Both heads are frontal, the bodies and legs in profile. Two flowers (?) in the field suggest the out-of-doors. Hatched border.

Late sixth century B.C.

Walters, *Cat.*, no. 483, pl. VIII.

198. *Chalcedony scaraboid*, in its ancient swivel ring and band setting. 19 × 13 mm.

From Curium, Cyprus. In the British Museum. Acquired through the Franks bequest, 1897.

LION DEVOURING A DEAD DEER, standing on top of it, open-mouthed. The lion has bristles along its back.

Around 550 B.C.

For other instances of bristle-lines along the backs of lions, on gems and coins, cf. Beazley, *op. cit.*, pp. 58 f.

Marshall, *Cat. of Finger Rings*, no. 295, pl. VIII.
Beazley, *Lewes House Gems*, p. 58.
Walters, *Cat.*, no. 539, pl. IX.

199. *Carnelian scarab*, mounted in a gold ring. At the back, instead of the usual beetle, a crouching warrior is carved in relief. 17 × 12 mm.

In the Cabinet des Médailles. Gift of the duc de Luynes in 1862 (no. 296).

LION ATTACKING A DEER. The lion has sprung on the back of the deer, and is biting it in the neck. The deer is collapsing, with forelegs bent. Both heads are frontal,

bodies and limbs in profile. The left hindleg of the lion is placed on the left hindleg of the deer. Guilloche border.

Delicate, detailed work of the late archaic period.

200. *Gold ring*, engraved on oval bezel. 16 × 10 mm.

In the Cabinet des Médailles. Gift of the duc de Luynes, in 1862 (no. 526).

LION ATTACKING A BULL. The lion has jumped on the bull from behind, and is biting it in the back. The bull has fallen to the ground, with legs bent in different directions. All four legs of the bull are indicated, only three of the lion. The head of the lion is frontal, the rest in profile; the bull is in profile throughout.

End of the sixth century B.C.

201. *Obsidian scaraboid.* 15 × 13 mm.

From Cyprus. In the British Museum, 1909.6–15.1. Bought 1909. Formerly in the possession of Kleanthes Pierides in Limassol.

TWO LIONS, one on its back, the other on top of it, each biting the other in the stomach. Their bodies and legs are in profile, their heads frontal. In the field are seven Cypriote letters which have been read *a-ri-si-to-ke-le-s*, Ἀριστοκλῆο(ς), 'of Aristokles', evidently the name of the owner. Hatched border.

Late sixth century B.C.

R. Meister, *Berichte der sächs. Ges.*, phil.- hist. Kl., LXIII, 1911, pp. 35 f., pl. 4, fig. 4.
Walters, *Cat.*, no. 450, pl. VIII.

202. *Heavy gold ring*, with engraved design on pointed oval bezel. L. *c.* 35 mm.

From S. Angelo Muxaro. In the Museo Archeologico, Syracuse, inv. 46512.

WOLF, walking. The head is large, the mouth open, the tongue protruding; the mane and ribs are marked.

Probably late sixth century B.C. Provincial Sicilian work.

Orsi, 'La necropoli di S. Angelo Muxaro', *Atti Acc. Scienze, Lett., Arti*, Palermo, XVII, 3, 1932, p. 13, fig. 8.
Pace, *Arte e civiltà della Sicilia antica*, I, 1935, p. 157, fig. 79.
Becatti, *Oreficeria ant.*, no. 303, pl. LXXVI.

203. *Massive gold ring*, with engraved design on pointed oval bezel. L. *c.* 35 mm.

Found in the necropolis of S. Angelo Muxaro, 1909–20. In the Museo Archeologico, Syracuse, inv. 45905.

COW SUCKLING HER CALF. The cow is standing, with head slightly lowered; the calf is shown between her forelegs and hindlegs.

Sixth century B.C. Provincial Sicilian work.

Orsi, 'La necropoli di S. Angelo Muxaro', *Atti Acc. Scienze, Lett., Arti*, Palermo, XVII, 1932, p. 7, fig. 3.
Pace, *Arte e civiltà della Sicilia*, I, 1935, p. 156, fig. 78.
Becatti, *Oreficeria ant.*, no. 302, pl. LXXVI.

204. *Banded agate cone.* Diam. 17 mm.

In the Staatliche Münzsammlung, Munich. From the Arndt Collection.

BULL, moving to the left, with forelegs bent. All four legs are indicated, but only one horn and one ear; the bushy end of the tail is visible at the back of the left hindleg. In the field the Egyptian ankh. Hatched border and cross-hatched exergue.

First half or middle of the fifth century B.C.

Czako and Ohly, *Griechische Gemmen*, no. 19.

205. *Carnelian scaraboid.* 16 × 21 mm.

From Greece. In the Staatliche Museen, Berlin.

BULL, walking to the left, in profile view. All four legs are indicated, but only one horn and one ear. Ground line.

Second quarter of the fifth century B.C.

Imhoof-Blumer and Keller, pl. XIX, 4.
Furtwängler, *Beschreibung*, no. 174; *A.G.*, pl. VIII, 47.

206. *Black jasper scaraboid.* 19 × 15 mm.

In the Staatliche Museen, Berlin.

COW AND CALF. The cow is in profile to the right, with head turned to look at her calf, which is making for the udder. Ground line. Hatched border.

Fine work of the first quarter of the fifth century B.C. The animals are beautifully executed, with direct observation from nature.

Imhoof-Blumer and Keller, pl. XIX, 26.
Furtwängler, *Beschreibung*, no. 175; *A.G.*, pl. VIII, 46.
Lippold, *Gemmen und Kameen*, pl. 90, no. 1.

207. *Sard scarab.* 13 × 9 mm.

From Cyprus. In the British Museum, 96.10–18.2. Bought 1896.

MULE, rolling over on its back. Hatched border.

Late archaic.

Horses, mules, and donkeys rolling on the ground are not uncommon on Greek and Etruscan gems; cf., e.g., nos. 208, 209. As Furtwängler suggested, they may have had a connotation of good luck; or the subject appealed as lending itself to an interesting composition in the elongated field of the gem.

Walters, *Cat.*, no. 446, pl. VIII.

208. *Steatite scaraboid*, mounted on an iron pin (which has discoloured the stone). 17 × 11 mm.

From Klazomenai. In the British Museum, 98.11–20.1. Bought 1898.

DONKEY, rolling over on its back. The body is shown from beneath; the legs are drawn in profile, in different directions; the head and neck are in profile, with both ears indicated. Hatched border.

Perhaps about 500 B.C.

Furtwängler, *A.G.*, pl. LXIV, 11.
Lippold, *Gemmen und Kameen*, pl. LXXXIX, 11.
Walters, *Cat.*, no. 451, pl. VIII.

209. *Sard scarab.* 18 × 13 mm.

In the British Museum, 72.6–4.1154. Acquired from the Castellani Collection in 1872. Once in the Santangelo Collection.

HORSE, about to roll over on the ground. The legs are shown in profile in different directions. Hatched border.

First half of the fifth century B.C.

Imhoof-Blumer and Keller, pl. XVI, 43.
Furtwängler, *A.G.*, pl. XI, 44.
Walters, *Cat.*, no. 486, pl. VIII.

210. *Gold ring*, with a pointed oval, slightly convex bezel. L. of bezel 1·6 cm.

In the British Museum, Fr. 158. Acquired through the Franks bequest, 1897.

ANTELOPE, running, engraved on the bezel. Dotted border.

Late sixth century B.C.

Marshall, *Cat. of Finger Rings*, no. 37 (not illustrated).

211. *Carnelian scarab.* 19 × 12 mm.

Found in Aegina. In the Fitzwilliam Museum, Cambridge. Formerly in the possession of the historian George Finlay,

then of W. Finlay, who in 1877 bequeathed it to the Fitzwilliam.

THE EGYPTIAN BEETLE, with outspread wings. Hatched border.

Beneath is the inscription Κρεοντίδα ἐμί, 'I am (the seal) of Kreontidas', in fifth-century letters, presumably posterior to the engraving of the design, which should be of the archaic period.

Pliny, *H.N.*, XXXVII, 124, says that the scarab beetle, engraved on an emerald, had magical properties.

George Finlay, *Bull. dell'Inst.*, 1840, p. 140.
King, *Antique Gems and Rings*, I, p. 114.
Middleton, *Cat.*, p. IV, no. 4, pl. I.
Furtwängler, *A.G.*, pl. VII, 64.

212. *Chalcedony scaraboid*. Discoloured and chipped along the edge. 21 × 17 mm.

In the Metropolitan Museum of Art, New York, 24.97.47. Fletcher Fund, 1924. From the E. P. Warren Collection.

WILD BOAR, walking to the right, with head lowered. The mane and the rump bristles are separated by a gap. Ground line.

First quarter of the fifth century B.C.

Cf. the boars on the coins of Methymna, *Br. Museum Guide*, pl. 8, no. 21 (dated c. 480 B.C.).

Richter, *M.M.A. Bull.*, XX, 1925, p. 182, fig. 1; *Animals*, pp. 24, 67, pl. XXXVI, fig. 110; *M.M.A. Handbook* (1953), p. 148, pl. 126, b; *Cat.*, no. 60.

213. *Green porphyry scaraboid.* 16 × 11 mm.

From Smyrna. In the Ashmolean Museum, 1892.1483. Acquired through the Chester bequest.

WILD SOW, slowly walking to the left. Hatched border.

Later sixth century B.C.

Cf. the replica Furtwängler, *A.G.*, pl. VII, 67.

Furtwängler, *A.G.*, pl. VI, 67.
Lippold, *Gemmen und Kameen*, pl. 93, no. 7.

214. *Plasma scarab.* 18 × 13 mm.

Probably from the neighbourhood of Klazomenai. In the British Museum. Bought 1891.

RAM, walking to the left. In the field the inscription Μανδρώναξ ('Ionian in script and in the type of name', M. Guarducci), evidently the name of the owner of the stone. Hatched border and shaded exergue.

First half of the fifth century.

Mandronax occurs as the name of a magistrate on fourth-century coins of Klazonenai, and a standing ram appears on the reverses of bronze coins of that city, also of the fourth century B.C.; cf. Head, *H.N.*², p. 568; *B.M.C.*, Ionia, pl. VI, 10–17.

Furtwängler, *A.G.*, pl. IX, 17, and vol. III, p. 106.
Beazley, *Lewes House Gems*, p. 31.
Walters, *Cat.*, no. 445, pl. VIII.
Lippold, *Gemmen und Kameen*, pl. 91, no. 11.

215. *Sapphirine chalcedony scaraboid.* 17 × 13 mm.

From the Ionian Islands. In the Cabinet des Médailles. Acquired through the gift of Pauvert de La Chapelle, 1899.

RAM, standing in profile to the right, with its head a little raised. All four legs are indicated; the wool is marked by small pellets. In the field is the inscription Βρύησις, Bryesis, in Ionic script, no doubt the name of the owner of the stone. The name is apparently unknown; cf. Βρύης.

A masterpiece of the early fifth century B.C.

E. Babelon, *Coll. Pauvert de La Chapelle*, no. 67, pl. VI.
Furtwängler, *A.G.*, pl. IX, 11.
Lippold, *Gemmen und Kameen*, pl. 91, no. 9.

216. *Chalcedony scarab or scaraboid*, cut. 16 × 12 mm.

From Stimmitza, near Dimitzana, in the Peloponnese. In the Museum of Fine Arts, Boston, 27.689. Formerly in the Evans and E. P. Warren Collections.

EWE, getting up from the ground, with legs bent in different directions. She is shorn, except at the neck and top of the head, where the wool is indicated by pellets. Pellets are also used on the long tail, which passes between the legs. In the field, in small, neat letters, the inscription Ερμοτιμο εμι = Ἑρμοτίμου εἰμί, 'I belong to Hermotimos'. 'The script is perhaps Ionian – not Attic since the aspirate is missing' (M. Guarducci). Hatched border. Cf. pl. C.

First half of the fifth century B.C.

The attitude of half rising – or falling – is common in animals of this period.

Cf. the equally fine, if not finer, ram in the Cabinet des Médailles, my no. 215.

Beazley, *Lewes House Gems*, no. 35 bis, pls. 2 and 9.
Richter, *Animals*, fig. 138.

217. *Carnelian scaraboid.* 14 × 10 mm.

From Greece. In the British Museum, 89.5–16.1. Bought 1889.

RAM'S HEAD, in profile to the right. The wool on the head and neck is rendered by stippling, and there are striations on the horn. Hatched border.

First half of the fifth century B.C.

One may compare the contemporary red-figured terracotta rhyta in the form of ram's heads, with similar stipplings and striations. Cf. especially H. Hoffmann, *Attic Red-figured Rhyta*, pl. I, 1, 2 (Berlin); pl. II, 1 (once Goluchow); pl. V, 3, 4 (New York).

Walters, *Cat.*, no. 506, pl. IX.

6. THE DEVELOPED PERIOD OF THE
FIFTH AND FOURTH CENTURIES, *c.* 450–330 B.C.

The engraved gems of the so-called developed or classical period of the fifth and fourth centuries B.C. are on a par with the other products of the time. They show the same styles and similar subjects that one finds in the contemporary sculptures and vase-paintings. Moreover, in the best examples the same high level of conception and execution is attained. It is indeed remarkable that in the restricted space of these gems the engravers were able to produce such outstanding works, and it incidentally shows how widespread was the artistic ability during this epoch, being by no means confined to a few prominent sculptors and painters, but pervading all classes of artists.

Masterpieces are – as in all art – not the rule; but even the more cursory works show great technical ability and a marked sense of composition and spacing. And all are executed in a fluid, expert manner, with a perfected knowledge of human anatomy and naturalistic drapery.

The engraved gems that have survived of this period are not very numerous, in comparison at least with those of the Roman period. The reason is not far to seek. Though sealing had become more general in the fifth century than in the archaic period, the wearing of a sealstone was more or less confined to the upper classes, that is, to the people of property. Moreover, there was no foreign market to which sealstones were exported, as there was for the painted vases. The Etruscans in Italy soon learned to carve their own stones. Only the Persians seem to have employed the Ionian Greeks for the making of their sealstones; and to this circumstance is due the appearance at this time of the so-called Graeco-Persian gems which combine Greek style and execution with Persian subjects (cf. pp. 125 ff.). For, since a sealstone was private property, it naturally had a design chosen by the owner of the seal, according to his liking, not an official emblem.

There are, however, a number of references to sealstones by authors of this period which show that, though the use of a seal was restricted, it was common among the privileged. In the *Clouds* of Aristophanes (331 f.) are ridiculed 'the fine gentlemen with well-kept nails and long hair who wear sealrings', σφραγιδονυχαργοκομήτας; and in the *Ekklesiazousai* (632) grandees are coupled with people who own sealrings. The rhapsodist Hippias tells of going to Olympia with everything that he wore his own handiwork, including an engraved ring and a sealstone (Plato, *Hippias Minor*, 368b). The incident related by Plutarch (*Timoleon*, XXXI) when Timoleon (fourth century B.C.), wishing to decide a dispute among his cavalry officers by lot, 'took a sealring from each of the leaders and mixed them up in his cloak', shows that all these individuals had sealrings as a matter of course. Furthermore, the frequent listing of sealstones among the treasures of the Parthenon in the second half of the fifth and the early fourth century indicates that they were prized possessions, worthy to be dedicated to the goddess. The manner in which they are referred to is revealing. One finds the expression σφραγὶς λιθίνη δακτύλιον ἔχουσα, 'a stone seal having a ring'; or σφραγῖδες ἄνευ δακτυλίων, 'seals without rings'; or σφραγῖδες λίθιναι ψιλαί, 'bare stone seals'. In other words, the sealstone was the important thing at that time. Later, in the Hellenistic period, when the stone had become a ringstone, the expression changes to δακτύλιος λίθον (or σφραγῖδα) ἔχων, 'a ring having a seal'. Cf. Homolle, *B.C.H.*, VI, 1882, pp. 122 f. (the Delian inventories); also my p. 133.

The favourite shape for the gems of this period was the scaraboid, generally large and thick (cf. a–b).

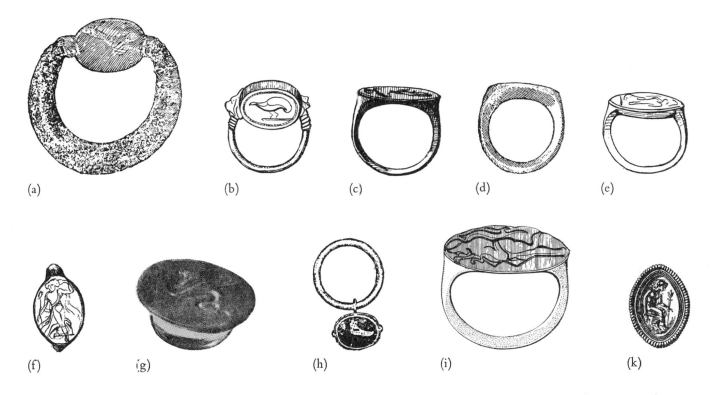

(a) (b) (c) (d) (e)

(f) (g) (h) (i) (k)

It was perforated lengthwise to be worn on a swivel ring, as a pendant or on the finger. Only occasionally unperforated stones appear, evidently to be worn in finger-rings, a custom which later became prevalent. The designs were engraved either on the flat side of the scaraboid, or on the convex side, in which case the convexity is generally not pronounced. Now and then an engraving was placed on both sides of the stone (cf., e.g., no. 238).

In addition to the scaraboid, the scarab form persists, but becomes increasingly less common. Other shapes are four-sided beads, half-barrels, cones, and cylinders, mostly with one side flattened for the engraving (cf. figs. c–f on p. 46). As in the preceding period, other forms are sometimes substituted for the beetle, preferably a lion (cf. nos. 191, 192).

The commonest material was the chalcedony, but the carnelian, agate, rock crystal, jasper, and lapis lazuli were also frequently employed. Glass as a substitute for stone likewise occurs, generally colourless, but occasionally of a deep blue tone. In the Parthenon inventories are cited not only σφραγῖδες ὑάλιναι, glass seals, but sometimes with the word ποικίλα, 'many-coloured', added. These glass gems were moulded from the stone specimens, and actual terracotta moulds used for this purpose have been found, as well as 'replicas' made from the same stone original (cf., e.g., p. 13). In a few cases the original of a glass copy has survived. These glass gems also were worn on rings and set in gold, as again the Parthenon inventories testify: σφραγὶς ὑαλίνη χρυσοῦν δακτύλιον ἔχουσα, and σφραγὶς ὑαλίνη περικεχρυσωμένη (cf. Michaelis, *Der Parthenon*, p. 301, no. 50).

Besides stones set in metal swivel rings, the metal bezels of rings were used for engravings. Those preserved are generally of gold, occasionally of silver; bronze rings were presumably common, but have rarely been found in good condition. The forms of the bezel are oval, pointed oval, and round; often quite large and thick (cf. figs. c–g). Sometimes one finds a scarab executed in gold instead of in stone, with the design engraved on the flat underside (cf. no. 283). Occasionally the stone is set in a metal band and suspended from a plain ring (cf. fig. h). The band or box setting is now and then decorated on its

outer sides with a sumptuous filigree design (cf. fig. i). Furthermore, the device, instead of being cut in intaglio, is sometimes stamped in relief (cf. fig. k) – as was occasionally done in archaic times.

In the choice of subjects the artists continue to show a complete independence of their Oriental predecessors. The majority of the representations are inspired by everyday life. Deities are not frequent, except Nike, and Aphrodite, often with her son Eros. As in the contemporary sculptures and vase-paintings, it was the life of human beings rather than the supernatural that interested the artists. Athletes and particularly women become common subjects. A woman making music, putting on or taking off her clothes, playing with animals; an athlete resting or practising; a child at play; an occasional portrait; these are the themes that now appealed. But scenes from mythology likewise occur: Herakles performing his deeds, Perseus, Kassandra, and so on. They gave opportunity for trying out complicated compositions. Monstrous shapes, such as Medusa, persist but are comparatively rare, and even they are humanized.

Special popularity is enjoyed by animals, not only the lion and the bull in combat, as in earlier days, but single representations of them, as well as of horses, dogs, deer, antelopes, birds, and insects, such as a fly or a beetle. Each is studied with evident absorption, is given its characteristic form and stance, and is then transformed into a work of art, perfectly fitted into the prescribed space. Moreover, simple objects, such as a hazelnut, receive attention.

In all these varied representations, from the middle of the fifth century on, one can note a consummate knowledge of human anatomy and of naturalistic drapery. Foreshortened figures often appear, always correctly drawn. Only linear perspective is imperfectly understood, as is evident in the depiction of couches, chairs, footstools, tables, etc., which follow the conventions observable in the vase-paintings.

The encircling border, which had been in regular use in the archaic period, gradually becomes less frequent, and in the fourth century it is finally omitted. The whole space was then made available for the design, and this suited the fluid style now prevalent. The engravings are generally not polished, or only slightly so.

Inscriptions are more frequent in this period than before. They give the name of the owner, again often in abbreviated form; or, more rarely, they refer to the person represented; or they are addressed to the recipient of the object sealed, e.g., χαῖρε, greeting; δῶρον, a gift.

Of particular interest are the signatures of artists, either in the genitive, or the nominative, or, best of all, with the verb ἐποίεσε or ἐποίει, 'made it' added. Among the names preserved is that of the great DEXAMENOS of Chios, the engraver of the portrait in Boston (cf. no. 326), and of the matchless heron in Leningrad (cf. no. 467). Among the other engravers of this period whose names have survived are ATHENADES, ONATAS, and SOSIAS. Two names – PHRYGILLOS and OLYMPIOS – belonged also to two die-cutters of South Italian coins of the same date, and so they may have been identical artists practising in the two related techniques. Less frequently than before, however, does a design used on a coin recur on a gem; and this is natural, for the presiding deities and heroes of the various Greek city states represented on the coins would not necessarily be appropriate designs for the individual owners of seals (cf. pp. 23 f.).

The execution on the best gems even surpasses that on the finest coins. Each was a separate creation, not made for multiplication. The lines on the feathers of Dexamenos' heron (no. 467), and on the mane on the horse from Kerch (no. 418) are engraved with a delicacy and a sureness of touch which have no parallel. Minuteness of workmanship and grandeur of conception here find their highest expression.

The c. 250 specimens here presented will bear out the eminence of the products of this time. The

illustrations – both those in original size and those magnified – will, I hope, constitute a valuable supplement to the extant sculptures of the fifth and fourth centuries, and add still further to our appreciation and knowledge of this incomparable age. The styles of the eminent sculptors active during this epoch – Myron, Pheidias, Polykleitos, Praxiteles, Skopas, and Lysippos – will be recognized here and there. But it will also be apparent that the gem engravers, like the vase-painters, were essentially independent artists, doubtless influenced by the attainments of their prominent contemporaries, but practising their craft not as copyists but as creators.

I have arranged my material in a number of different groups:

(a) Standing male figures, at rest and in action.

(b) Standing female figures, at rest and in action, nude and draped.

(c) Seated figures, male and female.

(d) Crouching, kneeling, and reclining figures, male and female.

(e) Heads, both male and female.

(f) Compositions including more than one figure: riders, chariots, et al.

(g) Monsters, including fantastic creatures such as Centaurs.

(h) Animals: quadrupeds, birds, insects, etc.

(i) Objects and Inscriptions.

The examples in each group are placed in approximately chronological order, but it must again be stressed that the dates given are only relative, not necessarily absolute. At the time when the great sculptors and painters were achieving mastery in naturalistic representation, i.e., in the freedom of the stance and in foreshortening, it is evident that some gem-engravers kept abreast with the new discoveries, while others lagged behind.

The juxtaposition of some of the representations will again bring out – what we have already observed during the archaic period – the constant repetition of a given type, always, however, with slight changes. Exact reproduction was not practised. Each figure was a separate creation within the framework of the accepted type.

(a) Standing male figures, at rest and in action

Occasionally the strict profile view is shown, but generally the three-quarter one is favoured. In the latter the interrelation of the various muscles is at first not correctly rendered (cf., e.g., nos. 218, 219). Presently, however, the representations become more naturalistic, with only an occasional lingering stiffness in the pose (cf. nos. 220–222). Finally the three-quarter view is achieved with consummate ease, both in front and back stances (cf. especially nos. 225, 227, 229, 230, 234, 235).

The subjects shown in my selection include figures taken from daily life, such as an athlete, or an archer with his dog; but more commonly they are mythological – Hermes, Herakles, Perseus with the severed head of Medusa, Diomedes with the Palladion, Odysseus, and Eros.

218. *Green plasma scaraboid.* 18 × 14 mm.

Found near Limassol, Cyprus. In the British Museum, 92.11–28.1. Bought 1892.

ARCHER, about to shoot an arrow from his bow. With his left hand he holds the bow, as well as some reserve arrows, in his right the arrow he is shooting; his quiver hangs from his left side. He is nude and wears a peaked

cap. A dog is by his side, looking up at him enquiringly. The archer is shown in profile, but with the rectus abdominis and the right leg frontal. Line border.

About 450 B.C.

Furtwängler, *A.G.*, pl. IX, 21.
Lippold, *Gemmen und Kameen*, pl. 65, no. 8.
Walters, *Cat.*, no. 527, pl. IX.

219. *Carnelian scaraboid*, mounted in a gold ring. 15 × 20 mm.

In the Cabinet des Médailles. Gift of the duc de Luynes in 1862 (no. 274).

ACHILLES AT THE TOMB OF PATROKLOS. He is shown bending forward, with the left hand raised to his head, with the right holding two spears. He is nude and wears a pilos helmet; his legs are crossed. The trunk is shown in three-quarter view, the head and limbs are in profile, except the left leg which is turned frontal. The tomb is designated by a fluted column, against which a dolphin is placed. Short ground line. Hatched border and marginal ornament.

Around the middle of the fifth century B.C.

The desolation of Achilles is admirably conveyed in his posture and immobile face.

E. Babelon, *Cabinet des antiques*, pl. V, 12.
Pierres gravées, Guide du visiteur (1930), p. 142, no. 274 (not ill.).

220. *Gold ring*, with engraved design on bezel. 11 × 16 mm.

In the Museum of Fine Arts, Boston, 28.598. Formerly in the Bourguignon and E. P. Warren Collections. Bought by Bourguignon in Constantinople.

HERMES, standing in three-quarter view to the left, holding a phiale in the right hand, the kerykeion in the left; his left elbow rests on an Ionic column. A chlamys hangs down his back and is fastened at the neck with a brooch. Short ground line.

The pose, with the weight of the body on the right leg, and the left flexed and set back, is in the so-called Polykleitan stance. The somewhat hard modelling of the rectus abdominis points to a date not in the full-blown second half of the fifth century, but near its middle.

Cf. the figure on an Etruscan sard scarab in the Museum of Lecce, Beazley, *op. cit.*, pl. A, 22, which furnishes an instructive comparison between a Greek prototype and an Etruscan derivative.

Furtwängler, *A.G.*, pl. LXI, 32.

Burlington Fine Arts Club Exh., 1904, p. 235, no. O, 16 (not ill.).
Beazley, *Lewes House Gems*, no. 48, pl. 3.

221. *Gold ring*, with engraved design on oval bezel. 19 × 16.5 mm.

In the Staatliche Museen, Berlin. From the Stosch Collection.

HERAKLES, nude, beardless, with short, curly hair, is shown standing, with his weight on the right leg, the left flexed. In the left hand he holds his club, in the right a cup. The head is in profile, the trunk in three-quarter view, ably foreshortened.

Second half of the fifth century B.C.

Furtwängler, *Beschreibung*, no. 291; *A.G.*, pl. X, 42.
Lippold, *Gemmen und Kameen*, pl. 37, no. 13.

222. *Silver ring*, with engraved design on oval bezel. 14 × 18 mm.

Found in a tomb near Montemesola, contrada Gigliano. In the Museo Nazionale, Taranto. Acquired 1903.

PERSEUS, flying to the right, the severed head of Medusa in one hand, the curved knife (harpe) in the other. He wears a cap with lappets and scales, a chlamys, fastened at his neck and flying behind his back, and winged shoes.

Near the middle of the fifth century B.C.

The three-quarter view is not yet correctly shown, the trunk being frontal, the head, left leg, and left arm in profile, and the right leg partly frontal, partly in profile. But the general effect of forward movement is well conveyed.

On representations of Perseus worn in rings cf. Langlotz, *Der triumphirende Perseus*, p. 35.

Becatti, *Oreficeria ant.*, no. 328, pl. LXXXI.

223. *Chalcedony scaraboid*. 19 × 15 mm.

From Larnaca, Cyprus. In the Ashmolean Museum, 1892.1489. Acquired through the Chester bequest.

SATYR, dancing to the right, holding a branch in his right hand, a thyrsos in his left. The chest is shown almost frontal, the rest in profile.

Second half of the fifth century B.C.

The transition between the upper and the lower parts of the trunk is not yet successfully rendered: a strange combination of a free stance and an imperfect rendering of foreshortening.

Furtwängler, *A.G.*, pl. XII, 42.
Lippold, *Gemmen und Kameen*, pl. 15, no. 1.

224. *Chalcedony scaraboid*, yellowish-brown. Fractured at top. 17 × 22 mm.

In the Fitzwilliam Museum, Cambridge.

YOUTH, bending down to caress his dog, which looks up at him affectionately. The youth is nude and holds a jagged stick in his left hand. Hatched border.

End of the fifth century B.C.

The subject is familiar from other representations, on gems as well as in sculpture, during the later sixth and the fifth century B.C. A comparison with nos. 218 ff. will bring out the new freedom now attained both in the modelling of the body and in the stance.

King, *Ancient Gems and Rings*, I, p. 107.
Middleton, *Cat.*, p. VII, no. 10, pl. I.
Furtwängler, *A.G.*, vol. III, p. 107, fig. 76.

225. *Rock crystal scarab*, mounted in a modern ring. Slightly fractured round the edge. 18 × 11 mm.

In the Cabinet des Médailles. Gift of the duc de Luynes in 1862 (no. 263).

SATYR. He is quietly standing, in a more or less frontal view, with the head in profile. With one hand he holds an empty, pointed amphora by the handle upside down on his shoulder, while the other hand is extended with fingers spread. The stance is the 'Polykleitan', with the weight on the right leg, the left flexed. Hatched border.

Second half of the fifth century B.C.

The turn of the body in slight three-quarter view, with the farther side of the trunk slightly foreshortened, is successfully rendered.

Furtwängler, *A.G.*, pl. XII, 37.
Pierres gravées, Guide du visiteur (1930), p. 139, no. 263 (not ill.).
Lippold, *Gemmen und Kameen*, pl. 14, no 6.

226. *Sard scaraboid*. 17 × 12 mm.

From Athens (?). In the British Museum, 90.5–12.1. Bought 1890.

SILENOS, walking to the right, carrying a full wineskin on his back. With his left hand he holds the mouth of the wineskin, with his right the ends of the cord passed around it. He is nude, bald, bearded, and has horse's ears. Hatched border. Cf. pl. B.

Third quarter of the fifth century B.C.

Though the right shoulder and back are in strict profile views, the rectus abdominis muscle is shown almost frontal; but the pose, the expression, and the execution, are all of the first order.

Furtwängler, *A.G.*, pl. IX, 27, and vol. III, p. 142.
Walters, *Cat.*, no. 516, pl. IX.
Lippold, *Gemmen und Kameen*, pl. 13, no. 6.

227. *White jasper scaraboid*. 21 × 25 mm.

In the Ashmolean Museum, 1892.1480. Acquired through the Chester bequest.

WARRIOR, nude, advances to the left, a pilos hat on his head, a chlamys on his left shoulder. In his right hand he holds a spear, and on his left arm is strapped his shield. He is shown in three-quarter back view, with head and legs in profile. Ground line.

Somewhat cursory work of the fifth to fourth century B.C.

The rendering of the three-quarter view is excellent, except that the further shoulder is made too prominent.

For the pose, Furtwängler aptly compares the stele of Lisias, Pottier, *B.C.H.*, IV, 1880, pl. 7, pp. 408 ff.

Furtwängler, *A.G.*, pl. XII, 27.

228. *Gold ring*, with engraved design on oval bezel. 17 × 11 mm.

Found at Taranto, in the 'terreni of Ayala Valvadono'. In the Museo Nazionale, Taranto.

ODYSSEUS, with pilos hat and stick, is walking to the right, accompanied by his dog. A mantle covers the lower part of his body. Thick ground line.

Fourth century B.C.

Though, as has been pointed out, the dog is here not actually shown as recognizing his master, it seems clear that Odysseus was represented, rather than merely a shepherd, for the pilos hat and general attitude would seem to indicate it.

Breglia, *Japigia*, X, 1939, p. 27, no. 31, fig. 16.
Becatti, *Oreficeria ant.*, no. 329, pl. LXXXI.

229. *Chalcedony scaraboid*, besprinkled with yellow jasper. Fractured at bottom. 21 × 26 mm.

From Crete. In the Staatliche Museen, Berlin.

ODYSSEUS, bending forward, with right hand extended, as if speaking, and the right foot placed on a rock. In his left hand he holds a sheathed sword. He wears a pilos hat, and has his mantle rolled round his left arm. The upper part of his body is in three-quarter view, the rest in profile to the left. Thick ground line.

Fourth century B.C.

The torsion of the body is admirably drawn. It is evident that the rendering of the three-quarter view now no longer presents difficulties.

Furtwängler, *Beschreibung*, no. 316; *A.G.*, pl. XIII, 12. Lippold, *Gemmen und Kameen*, pl. 43, no. 9.

230. *Garnet*, set in the bezel of a plain gold ring of Roman date (second century A.D.). 18 × 14 mm.

In the British Museum, T17. From the Towneley Collection.

HERAKLES AND THE HYDRA. He is brandishing his club in his right hand and with his left is squeezing one of the Hydra's seven heads. The Hydra's body is coiled round Herakles's left leg. Ground line.

First half of the fourth century B.C.

Cf. the similar design on a gem in Berlin, Furtwängler, *Beschreibung*, no. 6484; also the coins of Stymphalos, *B.M.C.*, Peloponnese, pl. 37, no. 4.

Marshall, *Cat. of Finger Rings*, no. 351. Imhoof-Blumer and Keller, pl. XXVI, 12. Walters, *Cat.*, no. 603, pl. X.

231. *Gold ring*, with engraved design on an oval, slightly convex bezel. L. of bezel 16 mm.

In the British Museum, 72.6–4.104. Acquired from the Castellani Collection in 1872.

HERAKLES. He is standing in three-quarter view beside the apple tree, in the Garden of the Hesperides. From his left arm hangs the lion's skin; in his right hand he holds the club. The snake is coiled round the trunk of the tree. Ground line.

Fourth to third century B.C.

A more cursory representation of the composition shown in no. 230, but in reversed direction.

Marshall, *Cat. of Finger Rings*, no. 1087, pl. XXVII.

232. *Banded agate bead*, flattened on one side. 10 × 22 mm.

From Epeiros. In the British Museum, 92.7–21.1. Bought 1892.

ATHLETE, in profile to the right, in the act of binding his boxing glove round the right forearm. He is shown standing on what looks like a plinth, and Furtwängler therefore suggested that the figure may be intended for a statue dedicated by a victorious boxer. But there is no taenia, and the 'plinth' is very low. Perhaps it is merely a ground line with an empty exergue beneath? Hatched border at sides.

Late fifth century B.C.

A fine example of the new freedom attained in the representation of the human figure during this period.

Furtwängler, *A.G.*, pl. IX, 30, and vol. III, pp. 126, 139. Lippold, *Gemmen und Kameen*, pl. 56, no. 6. Jüthner, *Antike Turngeräthe*, p. 72, no. 7. Walters, *Cat.*, no. 562, pl. X.

233. *Carnelian ringstone*. 12 × 15 mm.

In the Staatliche Museen, Berlin. Acquired from Athens.

EROS, about to shoot an arrow from his bow. In the field is the inscription Ὀλύμπιος, Olympios, presumably the signature of the artist. Ground line.

Finished work of the fourth century B.C.

On Olympios cf. pp. 16 f.

Furtwängler, *J.d.I.*, III, 1888, pp. 119 ff., pl. III, 7; *Beschreibung*, no. 351; *A.G.*, pl. XIV, 8.

234. *Smoky chalcedony scaraboid*. 22.5 × 27.5 mm.

From Kythera. In the Museum of Fine Arts, Boston, 27.703. Formerly in the collection of E. P. Warren, who bought it from Rhousopoulos in 1898.

DIOMEDES CARRYING OFF THE PALLADION. He moves cautiously to the right, with the statue on the palm of his left hand and a sword in his right; a cloak hangs from his left shoulder and arm. The palladion, diminutive, is in the usual archaistic style and posture, brandishing a spear in its raised right hand, a shield on its left arm, and wearing a crested helmet and a tight-fitting belted peplos. Ground line. Cf. pl. B.

First half of the fourth century B.C.

The foreshortening of the trunk is admirably drawn and the stealthy gait successfully conveyed.

Cf. the coins of Argos, *B.M.C.*, Peloponnese, pl. XXVII, 12, 13. The subject becomes especially popular on gems of the Roman period (cf. vol. II of this book).

Burlington Fine Arts Club Exh., 1904, p. 240, no. O, 38 (not ill.). Beazley, *Lewes House Gems*, no. 58, pl. 4.

235. *Chalcedony ringstone*, slightly convex on engraved side. 13 × 20 mm.

In the Staatliche Museen, Berlin.

ACTOR, in the act of putting on a satyr's mask. He wears a short, furry apron. A filleted thyrsos is by his side, propped against his left shoulder. He is shown in three-

quarter view, with the left leg in profile, and the raised right arm deeply engraved. Ground line. One may suppose that the actor was a member of the chorus in a satyr play.

The anatomical details are beautifully rendered in the finished style of the fourth century B.C. 'Technically a great achievement' (Natter).

Cf. the later near-replica in the Cabinet des Médailles,

Babelon, *Cabinet des Antiques*, pl. v, 4; *Pierres gravées, Guide du visiteur* (1930), p. 138, no. 72.

Gravelle, *Recueil de pierres antiques*, II, 29.
Ficoroni, *Le maschere sceniche e le figure comiche* (1736), pl. 13.
Natter, *Traité*, pl. 21, p. 33.
Wieseler, *Theatergebäude und Denkmäler des Bühnenwesens* (1851), pl. 6, no. 4, p. 47.
Furtwängler, *Beschreibung*, no. 350; *A.G.*, pl. XXXIII, 42.

(b) *Standing female figures, at rest and in action, nude and draped*

The same progression in the understanding of naturalistic form may be observed in the rendering of the female figures as in the male. Here too the three-quarter view was studied with intense interest, and its rendering became progressively freer both in stance and modelling. The representation of drapery also reflects the changes in style familiar from contemporary sculptures.

The subjects in this selection include scenes from daily life as well as from mythology – Aphrodite, Athena, Nike, Muses, and Maenads.

236. *White jasper scaraboid.* A few chips along the edge. 15 × 18 mm.

From Spezia. In the Ashmolean Museum, 1892.1487. Acquired through the Chester bequest.

NUDE WOMAN, taking a piece of drapery from a tall stele. She has long hair, which falls down her back and is tied with a fillet round her head. She is shown in profile to the right, except the trunk which is in three-quarter view, with both breasts prominently indicated. Ground line.

For a similar representation cf. the impression on a terracotta weight from Phaistos, D. Levi, *Annuario*, XLIII–XLIV, N.S. XXVII–XXVIII, 1965–66, p. 587, figs. 23a, 23b.

Third quarter of the fifth century B.C.

Furtwängler, *A.G.*, pl. XII, 34.
D. Levi, *op. cit.*, p. 588, fig. 24.

237. *Gold ring*, with engraved design on the oval bezel. A few small scratches on the surface. 14 × 20 mm.

Said to be from Macedonia. In the Metropolitan Museum of Art, 06.1124; Rogers Fund, 1906.

NUDE GIRL, stretching herself, or practising a dance. By her side is a klismos, with her mantle laid on it. The body is drawn in two contrasting three-quarter views, with both breasts and both buttocks indicated – an impossible position. Both arms are raised behind her head, and the head is turned in three-quarter view; one foot is in profile, the other is shown in three-quarter view. Only two

of the four chair-legs are indicated. Cf. pl. B.

Second half of the fifth century, perhaps still in the third quarter, as indicated by the imperfect rendering of the three-quarter view. (For a figure in a similar pose, but in a more developed style, cf. Furtwängler, *A.G.*, vol. III, p. 134, fig. 93.) The figure fills the space in a masterly fashion, enough free space being left to suggest a continuing movement.

The presence of the chair with a garment on it suggests that the woman may be stretching herself rather than dancing, though dancers appear in similar poses; cf. Séchan, in Daremberg and Saglio, *Dict.*, s.v. saltatio, p. 1039, fig. 6066; Emmanuel, *La danse grecque*, figs. 420–426.

E. Robinson, *M.M.A. Bull.*, II, 1907, p. 123, no. 4, fig. 2.
F. Poulsen, *Art and Archaeology*, XII, 1921, p. 248.
Alexander, *Jewelry*, p. 53, fig. 119, and *M.M.A. Bull.*, XXXV, 1940, p. 213.
Becatti, *Oreficerie*, no. 338, pl. LXXXIV.
Richter, *M.M.A. Handbook*, 1953, p. 149, pl. 126, e; *Cat.*, no. 77.

238. *Carnelian scaraboid*, partly discoloured. Engraved on both sides, one of which is slightly convex. 18 × 25 mm.

Said to be from Kastorea, Macedonia. In the Metropolitan Museum of Art, 11.196.1. Rogers Fund, 1911. Once in the Evans Collection.

(1) WOMAN, standing by a louterion (wash-basin), with her left hand placed on its edge, and with the other hold-

ing up her himation, ready to put it on. Body and head are in slight three-quarter views, in opposite directions, the limbs mostly in profile. The support of the washbasin is in the form of a fluted column. Double ground line and hatched border.

(2) HERON, for which see no. 458.

About 450–430 B.C.

On louteria cf. Pottier in Daremberg and Saglio, *Dict.*, s.v. louter, louterion, and the references there cited. They could be large enough to contain 50 gallons of water (cf. Athenaios, V, 207 f.).

On scaraboids engraved on both sides cf. Beazley, *op. cit.*, p. 57.

Imhoof-Blumer and Keller, pl. XXII, 10 (heron)
Furtwängler, *A G.*, pl. XII, 38, 39, and vol. III, p. 128.
Beazley, *Lewes House Gems*, pp. 57, 60.
Lippold, *Gemmen und Kameen*, pl. 95, no. 4 (heron).
Richter, *M.M.A. Bull.*, VII, 1912, p. 98; *M.M.A. Handbook* (1953), p. 149, pl. 126, g; *Cat.*, no. 73, pl. XII.

239. *Agate*, cut and burnt. 15 × 10 mm.

In the Fitzwilliam Museum, Cambridge.

WOMAN, standing before a burning altar. In one hand she holds an oinochoe by the handle, with the other a patera filled with offerings (of fruits ?). She wears a chiton and a himation. The altar is decorated with a wreath. Ground line.

Second half of the fifth century B.C.

King, *Ancient Gems and Rings*, I, p. 396, vignette.
Middleton, *Cat.*, p. v, no. 6, pl. I.

240. *Chalcedony scaraboid*, mounted in a modern ring. 12 × 16 mm.

In the Cabinet des Médailles. Gift of the duc de Luynes in 1862 (no. 254).

WOMAN, holding an ear of wheat in the left hand, the right brought to her waist. She wears a chiton, a himation, and an earring. Her hair is done up in a knot at the back of her head. Short ground line and line border.

Third quarter of the fifth century B.C.

Perhaps intended to represent Demeter, as Furtwängler suggested – or merely a daily-life scene?

Furtwängler, *A.G.*, pl. XII, 29.
Lippold, *Gemmen und Kameen*, pl. 22, no. 1.

241. *Sard*, oblong slice. Fractured at top. 20 × 11 mm.
In the British Museum, Blacas 39. From the Blacas Collection.

WOMAN, standing by a stele and holding a grooved oinochoe by the handle. She wears a long chiton with overfold and has a himation draped over both arms.

Late fifth century B.C., as indicated by the transparency of the folds over the legs.

Raspe, no. 8350.
Gori, *Museum Flor.*, II, pl. 73, fig. 2.
Reinach, *Pierres gravées*, pl. 65, p. 65.
King, *Arch. Journal*, XXIV, 1867, p. 301; *Antique Gems and Rings*, II, pl. XLIIA, fig. 6.
Walters, *Cat.*, no. 561, pl. X.

242. *Carnelian scaraboid*, formerly set in a silver ring, now destroyed. 18 × 12 mm.

Found by Ohnefalsch-Richter in 1884 near the eastern gateway of the acropolis of Curium, Cyprus. In the British Museum, 89.11–11.1. Bought 1889.

ATHENA, holding the akrostolion of a ship in the right hand, while the left is placed on her shield, behind which is a spear. On her right is a large snake. She is shown in three-quarter view, with the head in profile, and wears a crested Attic helmet, and a belted peplos (no aegis). Her long hair falls down her back and her shoulders. Ground line.

Late fifth to early fourth century B.C.

The attribute suggests that the figure reproduces a statue erected after a victory at sea. The pose is reminiscent of the Athena Parthenos, and it is interesting to have such an 'echo' in a period not far removed in time from Pheidias' work. In the Roman period representations of the Athena Parthenos were of course common.

J. L. Myres and Ohnefalsch-Richter, *Cat.*, *Cyprus Museum*, p. 7.
Conze, *Arch. Ztg.*, 1884, cols. 165 ff.
A. S. Murray, *Classical Review*, IV, 1890, pp. 132 f.
G. F. Hill, *B.M.C.*, Cyprus, p. XLIV, note 1.
Furtwängler, *A.G.*, pl. IX, 33, and vol. III, p. 126.
Rossbach, in *R.E.*, VII, 1, s.v. Gemmen, col. 1076.
Lippold, *Gemmen und Kameen*, pl. XX, 3.
Walters, *Cat.*, no. 515, pl. IX.

243. *Gold ring* with engraved design on oval bezel. 15 × 20 mm.

In the British Museum, Fr 300. Acquired through the Franks bequest, 1897. Said to have been found in Phokaia.

WOMAN, standing in front of an altar and sprinkling incense on it which she has taken from a receptacle in her left hand. On the altar an eagle is sitting. The woman

wears a long chiton and a himation; also a pendant ear-ring. She is drawn in a three-quarter view, with the head in profile. There is an attempt to show the farther side of the altar, but it is drawn in a downward instead of up-ward direction. Cf. pl. B.

A masterly work probably of the late fifth century B.C.

Marshall, *Cat. of Finger Rings*, no. 59, pl. II.
Rossbach, in *R.E.*, VII, 1, s.v. Gemmen, col. 1076.

244. *Gold ring*, with engraved design on bezel. Ht. 21 mm.

In the Louvre, Bj 1086. Acquired from the Davillier Col-lection in 1890.

ATHENA, standing, in front view, with head turned in profile to the right. She holds a spear and a shield, and wears a helmet, a long, girded chiton with overfold, and bracelets.

Cursory but expressive work of the fourth century B.C.

De Ridder, *Bijoux antiques*, no. 1086.

245. *Chalcedony scaraboid*. Fractured, with a largish piece missing at the top. 33 × 24 mm.

From Syria. In the Ashmolean Museum, 1892.1488. Acquired through the Chester bequest.

APHRODITE, standing in three-quarter view, resting her right hand on a column, with a dove perched on her extended left hand. She wears a mantle which covers the lower part of her body. Ground line.

Fourth century B.C. 'Statuarisches Motiv' (Furtwängler).

On the convex back of the stone, busts of Sarapis and Isis, confronted, have been engraved in Roman times.

Furtwängler, *A.G.*, pl. XII, 22.

246. *Gold ring*, with engraved design on pointed oval, slightly convex, bezel. 17 × 23 mm.

From Kerch. In the British Museum, 85.4–17.1. Acquired from the Vernon Collection in 1885.

NIKE ERECTING A TROPHY, fastening a shield to a tree-trunk, a large nail in her left hand, a hammer in her right. She wears a himation round the lower part of her body; also a necklace with pendants, and bracelets. Her hair is tied in a knot at the top of her head. The upper part of her body is foreshortened, the rest is in profile, except the right foot, which is in three-quarter view, and the left foot, which is frontal. In the field is the inscription, in two lines (the upper much worn): Παρμένων βασιλεῖ,

'Parmenon to the king'. A present by Parmenon to Alex-ander the Great (?) (Furtwängler).

Fourth century B.C.

Cf. the coins of Agathokles, c. 310–304 B.C., *B.M.C.*, Sicily, p. 195.

Bull. Nap., I, 1843, p. 120.
Furtwängler, *J.d.I.*, IV, 1889, p. 205; *A.G.*, pl. IX, 44.
Marshall, *Cat. of Finger Rings*, no. 51, pl. II.
Lippold, *Gemmen und Kameen*, pl. 33, no. 5.

247. *Chalcedony scaraboid*. 33 × 27 mm.

In the British Museum, 65.7–12.86. Acquired from the Castellani Collection in 1865.

NIKE ERECTING A TROPHY, adding a sword to the other weapons. She has a mantle draped round the lower part of her body, leaving the torso bare. Beside the trophy is a two-barbed spear, with a sash tied to it, on which is the inscription Ὀνάτα, 'of Onatas', presumably the name of the artist (see pp. 16, 18). Thick ground line.

The style points to the fourth century B.C.

The modelling of the nude body, the folds of the drapery, and the feathers of the wings – of which one is seen from the inner, the other from the outer side – are beautifully rendered by an expert hand.

King, *Antique Gems and Rings*, II, pl. 26, fig. 8.
Babelon, *La gravure*, p. 125.
Furtwängler, *J.d.I.*, III, 1888, p. 204, pl. VIII, 10 = *Kleine Schriften*, II, p. 196, pl. 26, fig. 10; *A.G.*, pl. XIII, 37, and vol. III, p. 126.
Lippold, *Gemmen und Kameen*, pl. 33, no. 8.
Walters, *Cat.*, no. 601, pl. X.

248. *Gold ring*, with engraved design on round bezel. 24 × 25 mm.

In the Ashmolean Museum, 1918.62. Gift of E. P. Warren.

NIKE ERECTING A TROPHY. She wears a mantle, loosely draped round the lower part of her body. Both wings are indicated. On the trophy are placed a helmet, a cuirass, and a shield.

Fourth century B.C.

249. *Glass*, set in a gilt bronze ring. Convex on engraved side. 23 × 13 mm.

In the Ashmolean Museum, 64 (Fortnum 708). Acquired through the Fortnum bequest.

MUSE, standing by an Ionic column, holding a mask in her right hand and a lighted torch in her left. She is

shown mostly in three-quarter view to the left, and wears a chiton and a himation. Ground line.

First half of the fourth century B.C.

250. *Garnet*, set in a gold ring. Convex on engraved side. 11 × 18 mm.

In the Ashmolean Museum, 60 (Fortnum 130). Acquired through the Fortnum bequest.

WOMAN, in three-quarter view, to the right, holding a kithara in her left hand, the plektron in her right. She wears a long, girded, sleeved chiton and her hair is tied at the back of her head with a fillet. Ground line.

First half of the fourth century B.C.

251. *Gold ring*, with engraved design on oval bezel. L. of bezel 21 mm.

In the British Museum, 65.7–12.59. Acquired 1865.

APHRODITE, standing, holding a dove on her extended right hand, the left placed on her hip. In front of her is a diminutive Eros, holding up a wreath; behind her a fluted Ionic column with her garment placed on it. She is nude and wears a diadem, bracelets, and anklets. Eros, also nude, has his hair done up at the top of his head. Ground line.

Fourth century B.C., about the time of the Knidian Aphrodite, or somewhat earlier.

Furtwängler, *A.G.*, pl. IX, 47.
Marshall, *Cat. of Finger Rings*, no. 58, pl. II.
Lippold, *Gemmen und Kameen*, pl. 25, no. 1.

252. *Gold ring*, with engraved design on oval bezel. 18 × 23 mm.

Found in Taranto. In the Museo Nazionale, Taranto, inv. 10006. Acquired in 1923.

YOUNG WOMAN, standing by a column, resting her left elbow on it, and holding a wreath in her right hand. She wears a sleeveless, girded chiton with overfold, bracelets, and an earring. She is shown partly in three-quarter view, partly in profile. Ground line.

Fourth century B.C.

Breglia, *Japigia*, X, 1939, p. 29, fig. 17, no. 32.
Becatti, *Oreficeria ant.*, no. 333, pl. LXXXII.

253. *Sard ringstone*. Fractured at bottom, and restored as kneeling on an altar. 20 × 14 mm.

In the British Museum, Cra 25. From the Cracherode Collection.

MAENAD, rushing to the right, with head thrown back, holding her thyrsos in the right hand, a wreath in the left. She wears a long, belted chiton, and over it an animal's skin. The thyrsos has a sash tied on it.

The transparency of the folds is in line with late fifth- and early fourth-century work.

Furtwängler considered the stone an ancient copy of a fifth-century original; Rossbach a fifth-century original. It is true that the carving is more linear than is usual in the fifth century B.C.; but there seems to be nothing in the style that points to a later period.

Raspe, no. 5100.
Furtwängler, *A.G.*, pl. XIV, 18.
Rossbach, in *R.E.*, VII, 1, 1910, s.v. Gemmen, cols. 1073 f.
Walters, *Cat.*, no. 600, pl. X.

254. *Gold (electron) ring*, with engraved design on oval bezel. 16 × 11 mm.

From Kythnos. In the Staatliche Museen, Berlin.

MAENAD, rushing to the right, with head thrown back and loose hair flying. In her right hand she holds half a goat, in the left a wreath. She wears a sleeveless chiton, which leaves her right breast bare. Short, thick ground line.

Early fourth century B.C. – the time of the Epidauros sculpture.

Furtwängler, *Beschreibung*, no. 288; *A.G.*, pl. X, 33.

255. *Quadrangular chalcedony*, with back facetted. 26 × 16 mm.

Found in the theatre of Dionysos, Athens. In the Staatliche Museen, Berlin.

MAENAD, walking on tiptoe to the left, holding a sword in the right hand, a thyrsos in the left. She wears a girded chiton, which leaves her left breast bare, a sphendone in her hair, and a pendant earring. The upper part of the body is in three-quarter view, the rest in profile. Ground line.

About 400 B.C. The dignified pose is in line with late fifth- and early fourth-century renderings.

Furtwängler, *Beschreibung*, no. 334; *A.G.*, pl. XIII, 11.
Lippold, *Gemmen und Kameen*, pl. 19, no. 2.

256. *Black jasper scaraboid*. 25 × 23 mm.

From Greece. In the British Museum, 74.3–5.48. Bought 1874.

MAENAD, holding a mask in her extended right hand,

and a filleted thyrsos in her left. She wears a chiton and a himation. Ground line.

Fourth century B.C.

Furtwängler, *A.G.*, pl. XIII, 21, and vol. III, p. 142.
Walters, *Cat.*, no. 517 (not illustrated).

257. *Gold ring*, engraved on pointed oval bezel. 8 × 16 mm.

From Syria. In the Cabinet des Médailles. Gift of the duc de Luynes in 1862 (no. 521).

AGAVE, with head thrown back, holding the severed head of Pentheus in the left hand, a sword in the right. She wears a sleeveless chiton with an animal's skin over it, and a fillet, tied twice round her loose, long hair. Her body is in three-quarter view, the head in profile. Hatched ground line.

Late fifth century B.C.

For the type of ring cf. Marshall, *Cat. Finger Rings*, pp. XL–XLI, nos. XI, XII.

Babelon, *Cabinet des antiques*, pl. XLVII, 11.

258. *Gold ring*, with engraved design on bezel. Ht. 17 mm.

In the Louvre, 1051. Acquired from the Campana Collection in 1862.

MAENAD, in ecstasy, with head thrown back, is moving forward on tiptoe, holding a filleted thyrsos in her left hand and a snake in the right. She wears a girded chiton, which leaves the right breast bare. Short ground line.

Late fifth to early fourth century B.C.

De Ridder, *Bijoux antiques*, no. 1051.

259. *Amethyst four-sided bead*, perforated lengthwise. L. 15 mm.

In the British Museum, Blacas, 199. Formerly in the Strozzi and the Blacas Collections.

FOUR DANCING MAENADS, one engraved on each of the four sides, all different from one another.
(1) Advances to right, with head lowered; wears chiton and holds himation in both hands.
(2) Advances to left, with head thrown back, and holding up a snake in her right hand; wears chiton and himation, one end of which she grasps in the right hand.
(3) Advances to the right, with head thrown back; wears belted chiton and holds himation spread out in both hands.
(4) Advances to right, with head thrown back, in three-quarter back view; wears belted chiton and holds himation spread out in both hands.
Each has a ground line.

Fourth century B.C.

Maffei, *Gemme antiche*, III, pl. 57.
King, *Arch. Journal*, XXIV, 1867, p. 300.
Furtwängler, *A.G.*, pl. X, 49.
Walters, *Cat.*, no. 608, fig. 35, pl. X.

260. *Gold ring*, with engraved design on pointed oval bezel. Ht. of bezel 18 mm.

From the necropolis of Taranto. In the Museo Nazionale, Taranto.

GIRL, dancing, standing on tiptoe, with the left arm raised, the right lowered to her waist. She wears a short chiton, of which the lower part swells out in her rapid circular movement. Short ground line.

Early fourth century B.C.

Becatti, *Oreficeria ant.*, no. 327, pl. LXXX.

(c) *Seated figures, male and female*

In the seated figures naturally the same development can be observed as in the standing ones. An additional interest here is an occasional attempt of showing the seat in depth (cf. nos. 261, 271, 277). They are among the first experiments in linear perspective.

In the selection here given will be found a number of masterpieces – e.g., the seated woman with her maid, an early work by Dexamenos (no. 277); the woman and the youth playing the trigonon (nos. 264, 278); the Philoktetes in Berlin (no. 263); and the famous Scythian or Persian in the Hermitage (no. 262). They are worthy contemporaries of the Parthenon marbles.

261. *White and brown jasper scaraboid*. Chipped at the bottom. 21 × 18 mm.

From Sparta. In the Ashmolean Museum, 1892.1485. Acquired through the Chester bequest.

YOUTH, seated on a chest. He is nude, and has a wreath in his hair; he is shown in three-quarter view, with both hands lowered, the left placed on his knee, the right on the seat; the latter is also in three-quarter view.

Second half of the fifth century B.C.

Whereas the three-quarter view of the youth – both head and body – are correctly and ably drawn, that of the chest is faulty, indicating the known lack of complete knowledge of linear perspective by the Greeks.

Furtwängler, *A.G.*, pl. XII, 24.
Lippold, *Gemmen und Kameen*, pl. 56, no. 10.

262. *Gold ring*, with engraved design on oval bezel. 21 × 14 mm.

Found at Kerch. In the Hermitage.

A PERSIAN OR SCYTHIAN, testing an arrow. He is seated on a folding-stool, holding the arrow in both hands, his

bow hanging from his left forearm. He has a long beard and wears a tiara with lappets, a jacket with tight-fitting sleeves, trousers decorated with a design of dotted rhomboids, and shoes. He is drawn in three-quarter view, with the right leg frontal; but the folding stool is simply drawn in the front plane, without any indication of the further legs. Above is the inscription: Ἀ]θηνάδης, Athenades (on whom see p. 17). Ground line. Cf. pl. B.

Second half of the fifth century B.C.

The foreshortening of the head and body, and the un-Greek physiognomy are drawn with accomplished skill. The figure used to be interpreted as a Scythian, but is now thought to be a Persian, on account of the costume.

Stephani, *Compte rendu*, 1861, pl. VI, 11, p. 153.
S. Reinach, *Ant. du Bosphore*, p. 338, p. 137.
Furtwängler, *J.d.I.*, III, 1888, p. 198, pl. VIII, 3; *A.G.*, pl. X, 27.
Maximova, *Ancient Gems and Cameos*, 1926, pl. II, 7 (in Russian); *Arch. Anz.*, 1928, col. 670, fig. 25.
Lippold, *Gemmen und Kameen*, pl. 66, no. 2.

263. *Carnelian ringstone*. 13 × 11 mm.

In the Staatliche Museen, Berlin.

PHILOKTETES, seated on a rock, looking into the distance. His head rests on his right hand, his long hair is unkempt, his expression full of sadness. Beside him are his bow and his quiver, filled with arrows. His body and legs are turned to the left, the head to the right and upward. Ground line.

About 400 B.C.

Able rendering of a complicated pose. The desolation of Philoktetes is admirably conveyed in a restrained manner.

Overbeck, *Gallerie heroischer Bildw.*, pl. XXIV, 10.
Furtwängler, *Beschreibung*, no. 349; *A.G.*, pl. X, 29.

264. *Sard bead*, with one side flattened. Burnt. 21 × 14 mm.

From Corfu (?). In the British Museum, 68.1–10.424. Acquired from the Woodhouse Collection, 1868.

YOUTH, seated on a rock, playing the trigonon (triangular harp), plucking the strings with both hands. He has a mantle draped round the lower part of his body. The trunk and both feet are foreshortened; the rest is in profile.

Second half of the fifth century; time of the Parthenon sculptures, and evincing the same quiet grandeur.

King, *Antique Gems and Rings*, II, pl. XVIIB, fig. 9; *Handbook*, pl. XLIX, 4.
Lippold, *Gemmen und Kameen*, pl. LIX, 7.
Furtwängler, *A.G.*, pl. XIV, 14, and vol. III, pp. 126, 139.
Walters, *Cat.*, no. 563, fig. 33, pl. X.
Herbig, *Ath. Mitt.*, LIV, 1929, p. 175, fig. 225.

265. *Rock crystal scaraboid*. 24 × 18 mm.

In the Ashmolean Museum, 1892.1478. Acquired through the Chester bequest.

PAN, perched on a rock, a bird on his outstretched left hand, a round fruit (?) in his right. His chest is shown more or less frontal, the rest in profile to the right.

Cursory but vivid work of the fifth to fourth century B.C.

Furtwängler, *A.G.*, pl. XII, 40.

266. *Carnelian scarab*. 16 × 12 mm.

In the British Museum, 98.7–15.5. Acquired from the Morrison Collection, 1898.

EROS, seated on a rock and holding his bow in both hands. He is nude and wears a taenia in his hair. The edge of the farther wing is indicated. Hatched border.

Third quarter of the fifth century B.C.

Morrison Sale Catalogue, 1898, pl. I, 38.
Walters, *Cat.*, no. 464, pl. VIII.
Lippold, *Gemmen und Kameen*, pl. 25, no. 9.

267. *Carnelian ringstone.* 9 × 12 mm.

In the Staatliche Museen, Berlin. From the Demidoff Collection.

NEGRO BOY, sleeping, shown in front view, his head inclined to the right, both hands clasped on his left knee; he is nude, and has short, curly hair. The legs are foreshortened; the right foot is drawn in profile, the left frontal. Dotted border.

Second half of the fifth century B.C.

A masterly rendering of a difficult pose. To appreciate the advance in naturalistic representation since archaic times, one must compare this design with that on the ring in the Cabinet des Médailles, my no. 85.

Furtwängler, *Beschreibung*, no. 347; *A.G.*, pl. X, 26.
Lippold, *Gemmen und Kameen*, pl. 66, no. 5.

268. *Chalcedony scarab*, burnt. 18 × 23 mm.

In the National Museum, Athens, Numismatic section, inv. 885. Gift of K. Karapanos, 1910–11.

PHILOKTETES, nude, is seated on his himation placed on a rock, with the left hand resting on the rock, the right lowered to his wounded foot. Hatched border.

Late fifth century B.C.

Svoronos, *Journal internationale d'archéologie numismatique*, XV, 1913, no. 330.

269. *Veined gray agate scaraboid.* Fractured along the edge. 21 × 16 mm.

Found on the coast of the Black Sea in Asia Minor. In the Cabinet des Médailles. Acquired through the gift of Pauvert de La Chapelle, 1899.

YOUTH, seated on the ground, with left leg bent, in the act of binding a strap round his right leg. In the field the ligature of eta and delta. Hatched border. Curving ground line, to indicate the uneven terrain.

Fifth to fourth century B.C.

E. Babelon, *Coll. Pauvert de La Chapelle*, no. 83, pl. VI.
Furtwängler, *A.G.*, pl. XXXI, 9.
Lippold, *Gemmen und Kameen*, pl. 57, no. 5.

270. *Silver ring*, with engraved design on the round bezel. 22 × 23 mm.

In the Cabinet des Médailles. Gift of the duc de Luynes in 1862 (no. 517).

ZEUS, seated on a throne, holding his sceptre in the left hand, with the right pouring a libation from a phiale on the garlanded altar by his side. A Nike is flying toward him, a wreath in both extended hands. He wears a taenia in his long hair, and a mantle draped round the lower part of his body; his feet are on a footstool. The throne has turned legs and a straight back, the latter drawn with an attempt at perspective, whereas the seat is shown in the near plane only, with the farther legs not indicated. The Nike wears a girded chiton and has her hair tied at the back of her head. In the field a ligature of the capital letters lambda and epsilon. Ground line.

Fourth century B.C.

The general type is that used also by Pheidias for the statue of Zeus at Olympia. For an approximately contemporary example cf. the Zeus on coins of Praisos, Crete, dated 380–350 B.C.; Franke and Hirmer, *Die griechische Münze*, pl. 166, right; and on related representations of the Roman period see Richter, *Hesperia*, XXXV, 1966, pp. 166 ff., pls. 53, 54. For the type of ring cf. Marshall, *Cat. of Finger Rings*, no. CXVII, p. XLI.

271. *Gold ring*, with engraved design on pointed oval bezel. Surface worn. 13 × 19 mm.

In the British Museum, 67.5–8.402. From the Blacas Collection; acquired in 1867.

WOMAN, seated on a diphros, leaning her head on her left hand. She wears a sleeved chiton, and a himation round the lower part of her body. The head is drawn in three-quarter view; the upper part of her body is almost frontal, the legs and arms are more or less in profile, but with the right foot and the hands frontal or foreshortened. All four legs of the diphros are indicated. In the field is the inscription: Φιλ . . . καω (the middle is illegible).

Perhaps round the middle of the fifth century.

Newton, *Guide to the Blacas Collection*, p. 29, no. 14.
Furtwängler, *A.G.*, pl. IX, 35.
Marshall, *Cat. of Finger Rings*, no. 48, pl. II.

272. *Gold ring*, with engraved design on pointed oval bezel. 10 × 17 mm.

From Beyrout. In the British Museum, Fr 164. Acquired through the Franks bequest, 1897.

SELENE (?). A female figure, apparently intended for Selene, is seated on the crescent moon, with head and both arms raised. On her left hand is a flat tray, on which

are placed two upright branches. She wears a long, belted chiton and a himation round the lower part of her body; also a sakkos wound round her head, and a necklace with pendants. The upper part of her body is shown frontal, head and legs in profile. In the field are seven stars.

Around the middle of the fifth century B.C.

Marshall, *Cat. of Finger Rings*, no. 45, pl. II.

273. *Gold ring*, with engraved design on pointed oval bezel. 11 × 18 mm.

In the Cabinet des Médailles. Gift of the duc de Luynes in 1862 (no. 515).

MOURNER. A woman is seated on a diphros, with the left hand raised to her head, the right lowered to the seat. The left foot rests on a footstool. She wears a sleeved chiton, a himation pulled over the back of her head, a diadem, a necklace, bracelets, and an earring. Her trunk is in three-quarter view, the rest in profile. Only two legs of the diphros are indicated. Thick, hatched ground line.

Third quarter of the fifth century B.C.

The three-quarter view of the chest is not yet successfully rendered.

The attitude is that of mourning, used, for instance, in the well-known statue and relief in the Vatican (Helbig-Speier, *Führer*[4], nos. 123, 341), where the wool basket identifies the woman as Penelope – but employed also for other persons. The presence of a diadem on this ring has suggested the interpretation of Aphrodite mourning for Adonis (so labelled in the Cabinet des Médailles).

E. Babelon, *Cabinet des antiques*, pl. XLIX, 17.
Furtwängler, *A.G.*, pl. X, 34.

274. *Gold ring*, with engraved design on pointed oval bezel. 15 × 10 mm.

Found in Taranto. In the Museo Nazionale, Taranto.

WOMAN, seated on a klismos, holding a bird in the left hand, and letting the right arm hang down by her side over the back of the klismos (which is mostly hidden by that arm). She wears a sleeved, girded chiton, a himation round her legs, a necklace, an earring, and a sakkos on her head. All four legs of the klismos are indicated. Thick ground line, decorated with triangles.

Fourth century B.C.

Becatti, *Meidias*, p. 194, pl. XVI, 1; *Oreficeria ant.*, no. 325, pl. LXXX.

275. *Gold ring*, with engraved design on rounded bezel. 10 × 18 mm.

In the Metropolitan Museum of Art, 16.174.36. Rogers Fund, 1916.

WOMAN, seated on a klismos. She is looking at herself in a mirror, which she holds in her right hand, while in the lowered left she grasps a wreath. She wears a long, girded chiton, and a himation round the lower part of her body. Her trunk and the disk of the mirror are foreshortened. The webbing of the chair is indicated beneath the rail of the seat. Only two legs of the klismos are drawn.

Late fifth century B.C.

For the type of ring cf. Marshall, *Cat. of Finger Rings*, p. XLI, no. C, XII.

Alexander, *Jewelry*, p. 53, fig. 118.
Richter, *M.M.A. Bull.*, XVI, 1921, pp. 57 f.; *M.M.A. Handbook*, 1953, p. 149; *Cat.*, no. 84, pl. XV; *Furniture* (1966), fig. 186.

276. *Gold ring*, with engraved design on rounded bezel. A few fractures along the edge. 10 × 14 mm.

In the Metropolitan Museum of Art, 41.160.451. Bequest of W. G. Beatty, 1941.

WOMAN, seated on a klismos, is twining a wreath. In front of her is a draped, female herm, mounted on a three-stepped base. She wears a long, girded chiton, and a himation draped round the lower part of her body; also a necklace, a pendant earring, and a fillet in her hair, which is tied at the back of her head, with the loose ends going in different directions. One of the farther legs of the chair is indicated. The seat-rail is ridged to mark the webbing of the chair. Double ground line, the upper one ridged.

Late fifth or early fourth century B.C.

For the type of ring cf. Marshall, *Cat. of Finger Rings*, p. XLI, no. C, XII.

Richter, *Evans and Beatty Gems*, no. 37; *M.M.A. Handbook*, 1953, p. 149; *Cat.*, no. 85, pl. XV.

277. *Chalcedony scaraboid*. 21 × 16 mm.

In the Fitzwilliam Museum, Cambridge. From the Leake Collection. Said to be from the Morea.

WOMAN, seated on a diphros, looking at herself in the mirror held up for her by a maid. She wears a girded, sleeveless chiton, and a himation, which covers the lower part of her body and is pulled up over her left shoulder; also a sakkos. The little maid wears a sleeveless, girt

chiton with overfold, and holds a wreath in her left hand. Only three legs of the diphros are indicated, and the underside of the seat is drawn as a triangle, in the manner of this period (cf., e.g., my *Furniture of the Greeks, Etruscans, and Romans* (1966), fig. 112). The attempt to show the right foot in a three-quarter view is not wholly successful. Above is the inscription Μίκης, 'of Mika', perhaps the name of the woman; behind the woman is the name Dexamenos, Δεξαμενός, evidently the signature of the famous artist of that name. Both inscriptions are retrograde in the impression. Hatched border. Ground line. Cf. pl. A.

Third quarter of the fifth century. Cf. the similar compositions on Attic grave reliefs.

On Dexamenos cf. pp. 15 f., 17. The engraving, though competent, is not of the same calibre as the portrait and the two herons signed by Dexamenos. It has been thought to be perhaps his earliest extant work.

Middleton, *Cat.*, p. VII, no. 11, pl. I.
King, *Antique Gems*, I, p. 123.
Furtwängler, *J.d.I.*, III, 1888, pp. 202 ff., pl. VIII, 6; *A.G.*, pl. XIV, 1.
Lippold, *Gemmen und Kameen*, pl. 64, no. 1.

278. *Rock crystal scaraboid.* Chipped along the edge. 30 × 35 mm.

Found in Greece about 1819. In the British Museum, 1920.12-19.1. Bought 1920. Formerly in the possession of Sir Patrick Ross and of Mrs. C. R. Cockerell.

MUSICIAN. A woman is sitting on a throne playing the trigonon (triangular harp), with fingers touching the strings on either side. She wears a belted chiton and a himation draped round her legs. Her hair is gathered into a tuft at the top of her head. Her legs are crossed, with the right foot in three-quarter view. The throne has turned legs and a straight back with palmette finials; only three of its four legs are indicated, and its back is not foreshortened – that is, it is drawn in the manner customary at this time. Ground line and hatched border. Cf. pl. A.

Third quarter of the fifth century B.C.

The lines of the chiton and of the harp are engraved with extreme delicacy, and the movement of the fingers is expertly rendered.

P. O. Broensted, *Voyages et recherches dans la Grèce*, II (1830), p. 277, and vignette on p. III.
King, *Handbook*, pl. 49, fig. 3, p. 228.
Furtwängler, *A.G.*, pl. XIV, 20, and vol. III, p. 137.
Burlington Fine Arts Club Exh., 1904, p. 181, no. L153, pl. 63.
Beazley, *Lewes House Gems*, p. 49.
Walters, *Cat.*, no. 529, pl. IX.
Herbig, *Ath. Mitt.*, LIV, 1929, p. 170, fig. 2.

279. *Gold ring*, with embossed design on the oval bezel of a decorated box setting. L. of bezel 22 mm.

From Tarentum. In the British Museum, 72.6-4.146. Acquired from the Castellani Collection in 1872.

WOMAN, seated on a diphros, holding a sceptre terminating in a lotus bud, while the other hand is lowered to the seat. Her feet rest on a footstool. She wears a chiton and a himation. Guilloche and beaded borders.

Expert work of the late fifth century B.C.

Marshall, *Cat. of Finger Rings*, no. 218, p. 38, fig. 45, and pl. VI. See my fig. k on p. 75.

280. *Chalcedony scaraboid.* 32 × 25 mm.

From Achaia. In the British Museum, 91.6-29.1. Bought 1891.

GIRL WRITING. She is sitting on a rock, a stylus in the right hand, a writing tablet in the left. She wears a long-sleeved chiton and a himation with round weights at its corners. Her hair is tied in a tuft at the top of her head. Ground line.

Fifth to fourth century B.C.

Furtwängler, *A.G.*, pl. XXXI, 12.
Lippold, *Gemmen und Kameen*, pl. 64, no. 7.
Walters, *Cat.*, no. 533, pl. IX.

281. *Chalcedony scaraboid.* 24 × 19 mm.
In the Staatliche Museen, Berlin. Acquired in Germany in 1887.

A WOMAN, seated on the plinth of a stele, is being approached by Nike, who holds out a wreath to crown her. Both wear himatia, loosely draped round the lower parts of their bodies. Ground line.

Fourth century B.C.

Furtwängler thought that the woman might be the personification of some locality; Rossbach suggested Aphrodite. Or is she a woman who died, and is sitting at her tomb, as so often on Attic tombstones? But then the presence of the Nike would be unusual.

Collection Castellani, vente Al. Castellani, Rome, 1884, no. 989.
Furtwängler, *Beschreibung*, no. 319; *A.G.*, pl. XIII, 18.
Rossbach, *R.E.*, VII, 1, s.v. Gemmen, col. 1076.

282. *Gold ring*, with engraved design on bezel. 7 × 20 mm.

In the Louvre, Bj 1094. Acquired in 1920 from the Messaksoudes Collection, and said to have been found at Kerch.

WOMAN, seated on a diphros, holding a mirror in her extended right hand. She wears a long, sleeved, girded chiton; her hair is done up in a knot at the back of her hair. Only two legs of the diphros are indicated. Dotted ground line.

Fourth century B.C.

De Ridder, *Bijoux antiques*, no. 1094.

283. *Gold scarab*, inserted in a gold ring. 10 × 16 mm.

From Taranto, tomb 342 of the arsenal; discovered 1909. In the Museo Nazionale, Taranto.

WOMAN, seated on a diphros, her head bowed, one arm resting on the edge of the stool, the other holding a fold of her mantle. She wears a long, sleeved chiton, and a himation draped round her legs and brought up to cover the back of her head.
Inscribed in relief, above, on the mantle, vertically: HΛE; lower down, not in relief, but lightly incised, there appear two more letters, one a *kappa*, the other read by Becatti as a *rho*. Intended for the name Elektra? Double ground line.

Fourth century B.C.

The attitude is the usual one for mourning, and so, appropriately, chosen for Elektra.

Breglia, *Japigia*, X, 1939, pp. 30 f. no. 35, fig. 19.
Becatti, *Oreficeria ant.*, no. 332, pl. LXXXI.

284. *Gold ring*, with engraved design on oval bezel. Ht. of bezel 17 mm.

In the British Museum, F1140. Acquired through the Franks bequest, 1897.

APHRODITE, seated on a diphros, holding Eros on her knees. She wears a sakkos, a long chiton, a himation over the lower part of her body, and earrings. Three legs of the diphros are indicated. Ground line.

Fourth century B.C.

Proc. of the Society of Ant., 2nd series, VIII, p. 375, fig. 2.
Marshall, *Cat. of Finger Rings*, no. 62, fig. 19.

285. *Light brownish chalcedony*, burnt. Fractured here and there. 23 × 30 mm.

From Kyparissos, Laconia. In the Staatliche Museen, Berlin.

WOMAN, seated on a diphros, is balancing a stick on the index finger of her right hand. She wears a sakkos and a himation round the lower part of her body. Three legs of the diphros are indicated. Ground line.

Late fifth or early fourth century B.C.

Furtwängler, *Beschreibung*, no. 313; *A.G.*, pl. XIII, 10.

286. *Gold ring*, with engraved design on round bezel. 20 × 21 mm.

From Constantinople. In the Ashmolean Museum, 41a (Fortnum, 116). Acquired through the Fortnum bequest.

WOMAN, seated on a diphros, in front of a thymiaterion, into which she is sprinkling incense with her right hand; the left is lowered to the seat. She wears a sleeved, girded chiton. The diphros has a stretcher; only two of its legs are indicated. Ground line.

Fifth to fourth century B.C.

287. *Gold ring*, with engraved design on pointed oval, slightly convex bezel. 13 × 20 mm.

From Poli-tis-Chrysokhou, Cyprus. In the British Museum, 91.8–6.86. Presented by the Cyprus Exploration Fund, 1891. Found in a tomb with objects datable around 400 B.C.

ATHENA, seated on the ground, the left hand placed on the shield beside her, the right holding an owl. She wears a three-crested helmet, a long, belted chiton, and a himation draped round the lower part of her body. Profile and three-quarter views are successfully combined.
In the field the inscription Ἀναξίλης, in Ionic script and dialect. Its prominence suggests that Anaxiles was the owner of the ring.

Late fifth century B.C.

Munro, *J.H.S.*, XII, 1891, pp. 321 ff., pl. 15.
Furtwängler, *A.G.*, pl. IX, 41, and vol. III, p. 131.
Marshall, *Cat. of Finger Rings*, no. 52, pl. II.
Lippold, *Gemmen und Kameen*, pl. 20, no. 7.

288. *Gold ring*, with engraved design on oval, slightly convex bezel. 12 × 19 mm.

In the British Museum, 1905.11.2.2. Acquired 1905.

WOMAN, seated on the stern of a ship, decorated with an aphlaston, and looking down at the sea where a dolphin is swimming. Her right hand is placed on the deck, the left is hanging down. She wears a long chiton and a himation. At the left is the ship's ladder.

Probably early fourth century B.C.

On coins of Histiaia, Euboea, of 313–265 B.C., the nymph Histiaia (with her name inscribed) is represented sitting on the stern of a galley; cf. *B.M.C.*, Central Greece, pl. XXIV, 6 f.

Marshall, *Cat. of Finger Rings*, no. 66, pl. III.

289. *Pale green glass scaraboid.* 26 × 22 mm.

In the British Museum.

WOMAN, holding out a flower in her left hand. She is shown sitting with crossed legs on raised ground, indicated by curving lines, and wearing a long chiton and himation. Hatched border.

Second half of the fifth century.

Able foreshortening of the right upper leg.

Furtwängler, *A.G.*, pl. LXV, 7, and vol. III, p. 135.
Walters, *Cat.*, no. 577 (not illustrated).

290. *Oval sard ringstone*, slightly burnt, and broken at bottom. 18 × 13 mm.

In the British Museum, 72.6–4.1349. Acquired from the Castellani Collection in 1872.

APHRODITE (?), seated on a diphros, her right hand placed on her knee, the left round a nude boy, who stands beside her and holds out his right hand (the legs are missing). She wears a chiton, which leaves her right breast bare, a himation round the lower part of her body, a decorated diadem, a necklace with pendants, and a bracelet on her right wrist. Aphrodite and Eros? But the boy seems to have no wings. Thick ground line.

Late fifth century B.C.

Furtwängler, *A.G.*, pl. X, 31.
Walters, *Cat.*, no. 599, pl. X.

291. *Burnt scaraboid*, set in a gold swivel ring. 16 × 22 mm.

Found in a funerary vase near Kerch. In the Hermitage.

APHRODITE, seated on a rock, is nursing Eros, who is standing before her, stooping to her breast. She wears a

chiton, a himation, shoes, a necklace, bracelets, and a beaded fillet in her long hair. She is drawn mostly in three-quarter view, expertly rendered.

Fifth to fourth century B.C.

Stephani, *Compte-rendu*, 1863, p. XI, and 1864, pp. 183 ff., pl. 6, 1.
Furtwängler, in Roscher's *Lexikon*, I, s.v. Eros, col. 1368; *A.G.*, pl. XIII, 4.
Lippold, *Gemmen und Kameen*, pl. 24, no. 1.

(d) *Crouching, kneeling, and reclining figures, male and female*

What has been said about the standing and seated figures applies equally to the crouching and reclining. They also show the changing styles of the fifth and fourth centuries. And here too we meet masterpieces: the Eros, for instance, in Boston (no. 307); the woman with a crane, in the British Museum (no. 297); and the Kassandras in New York and Boston (nos. 293, 294) – all superbly executed in three-quarter views. The crouching warrior in the British Museum (no. 309) shows a difficult problem in foreshortening successfully solved. Of special interest are also the six representations of women crouching in the act of washing or dressing, shown in three-quarter, front, and back views (nos. 298–303). They are the predecessors of the famous Crouching Aphrodite by Doidalses. Nos. 296, 297 show two reclining figures, one an accomplished work of the late fifth century.

292. *Carnelian flat scaraboid*, mounted in a gold swivel ring. Cut, 21 × 16 mm.

In the Cabinet des Médailles. Gift of the duc de Luynes in 1862 (no. 91).

NIKE, playing with knucklebones. She is shown in a crouching position, with large wings, wearing a sleeve-

less chiton, a himation round the lower part of her body, a necklace, and a large pendant earring; her hair is tied at the top of her head, with ends falling loose. Ground line.

Fifth to fourth century B.C.

For the motif cf. Furtwängler, *Coll. Sabouroff*, text to pl. 92.

Furtwängler, *A.G.*, pl. XIV, 27.
Pierres gravées, Guide du visiteur (1930), p. 143, no. 91 (not ill.).
Lippold, *Gemmen und Kameen*, pl. 32, no. 8.

293. *Sard ringstone*, discoloured. Slightly convex on engraved side. 16 × 22 mm.

From Granitza in Doris. In the Museum of Fine Arts, Boston, 27.704. Formerly in the collection of E. P. Warren, who acquired it from Rhousopoulos in 1898.

KASSANDRA. She has fled to the palladion and is clasping it with her right arm, while with her left hand she tries to pull up the mantle that covers the lower part of her body. Her long, wavy hair falls loose down her back. A bracelet is on her left wrist. The palladion is in the customary archaistic style, and is shown wearing an Attic helmet, a chiton, a mantle, and a bracelet; on the left arm a shield is strapped, in the raised right hand is a spear (shown passing behind the head instead of in front). According to Beazley, there is a faintly marked gorgoneion on its left breast (not visible in the photograph or the impression). The base of the statue is in two degrees, the lower one rectangular, the upper rounded, with a thin projecting slab on top of it.

Fourth century B.C.

The nude body is beautifully modelled in three-quarter view.

Furtwängler, *A.G.*, pl. XIV, 26.
Burlington Fine Arts Club Exh., 1904, p. 239, no. O, 33 (not ill.).
Beazley, *Lewes House Gems*, no. 62, pls. 3 and 10.
Lippold, *Gemmen und Kameen*, pl. 43, no. 7.

294. *Gold ring*, with engraved design on oval bezel. Scratches in the field. 17 × 20 mm.

In the Metropolitan Museum of Art, 53.11.2. Rogers Fund, 1953.

KASSANDRA, taking refuge at the palladion. She has fallen on her knees and is clasping the statue with the left arm, while with the right hand she holds a corner of her mantle. Her head is thrown back and her hair falls loosely down her back. She wears a sleeveless, belted chiton, which leaves the right breast bare, and a himation draped round the lower part of her body. The palladion is in the usual stiff, archaistic posture, with girded chiton, shield, spear, helmet, and aegis; from the shield is seen descending a long, stiff, knotted fillet, ending in a large tassel. The figure is mounted on a base in two degrees. The altar on which Kassandra is kneeling is indicated only by a striated line, which also serves as the ground line. In the field is the inscription Κασσάνδρα.

Early fourth century B.C.

For the form of the ring cf. Marshall, *Cat. of Finger Rings*, p. XLI, no. C XII.
On knotted fillets with tassels on palladia cf. those on fourth-century Corinthian coins, *B.M.C.*, Corinth, pl. XII, 6, etc.
For other Greek gems of this period with the name of the person inscribed cf. Furtwängler, *A.G.*, e.g., vol. III, p. 136, and my no. 283.
To the list of palladia given by Lippold, in *R.E.*, XVIII, 3, 1949, s.v. Palladion, cols. 190 ff., may be added, e.g., the marble relief in the Villa Borghese, Helbig, *Führer*³, no. 537, and a plaster relief in the Louvre, MND195 – as well as this gem.

Richter, *Cat.*, no. 80, pl. XIV.

295. *Gold ring*, with engraved design on oval bezel. 12 × 15 mm.

Found in Taranto, in tomb 342 of the arsenal, together with no. 283. In the Museo Nazionale, Taranto.

NIKE, kneeling on an Ionic capital, with both arms extended, and holding the akrostolion of a ship in one hand.

Fourth century B.C.

Breglia, *Japigia*, x, 1939, p. 30, no. 33, fig. 18.
Becatti, *Oreficeria ant.*, no. 336, pl. LXXXIV.

296. *Gold ring*, with engraved design on oval bezel. Considerably worn. 15 × 20 mm.

Found at Curium, Cyprus. In the British Museum, 96.2–1.154. Acquired through the Turner bequest, 1896.

WOMAN, reclining, with right arm extended, the left by her side. Drapery is spread beneath her and round her arms and right leg. She is nude but wears a sakkos, a necklace with pendants, an earring, and bracelets.

Fourth century B.C.

Excavations in Cyprus, pl. IV, 7 (Curium), and pl. XIII, 16, p. 82.
Furtwängler, *A.G.*, vol. III, p. 132.
Marshall, *Cat. of Finger Rings*, no. 61, pl. II.

297. *Chalcedony scaraboid*. Chipped round the edge. 21 × 15 mm.

In the British Museum, 72.6–4.1332. Acquired from the Castellani Collection in 1872.

WOMAN, reclining, stroking the head of a crane or heron. A large winged ant is flying toward her outstretched hand. She wears a sakkos and a mantle loosely draped

round the lower part of her body. The couch on which she is resting is merely suggested by a curving rail.

End of fifth century B.C. Expert work.

Herons, cranes, and other birds were domestic pets in ancient Greece, and so are frequently represented in the interiors of houses.

Imhoof-Blumer and Kenner, pl. XXIV, 8.
Furtwängler, A.G., pl. XIII, 20.
Lippold, Gemmen und Kameen, pl. 63, fig. 5.
Beazley, Lewes House Gems, p. 60 f.
Walters, Cat., no. 531, pl. IX.

298. *Carnelian scarab*, with white particles. Chipped along the edge. 16 × 12 mm.

From Athens. In the Staatliche Museen, Berlin.

NUDE WOMAN, crouching to the left, shown mostly in profile and three-quarter back views (but with frontal toes on the left foot!). With one hand she is pulling up a piece of drapery, the right is extended with fingers spread. Double ground line. Hatched border.

The straight lines of the drapery, the drawing of the hair by straight ridges and the still somewhat imperfect rendering of the three-quarter view suggest a date before the fourth century B.C.

Furtwängler, Beschreibung, no. 298; A.G., pl. XIII, 23.
Lippold, Gemmen und Kameen, pl. 63, no. 6.

299. *Gold ring*, with engraved design on bezel. 11 × 15 mm.

In the Louvre, Bj 1050.

CROUCHING APHRODITE in profile to the left. She is nude and holds a piece of drapery in her right hand. On her head she has a sakkos. Ground line.

Fifth to fourth century B.C.

De Ridder, Bijoux antiques, no. 1050.

300. *Chalcedony scaraboid.* 17 × 15 mm.

In the Cabinet des Médailles.

WOMAN WASHING HER HAIR. She is crouching in front of a basin (louterion), with both hands manipulating her long hair. Ground line.

Cursory but effective work of the fifth to fourth century B.C.

Chabouillet, Cat., no. 1103.
Furtwängler, A.G., pl. XII, 31.
Lippold, Gemmen und Kameen, pl. 63, no. 3.

301. *Chalcedony scaraboid*, set in a modern mount. 19 × 15 mm.

In the Cabinet des Médailles.

WOMAN, crouching, in profile to the right, holding a piece of drapery in front of her. Thick ground line. Cf. pl. B.

Fourth century B.C.
A masterpiece.

Furtwängler, A.G., pl. XII, 35.
Pierres gravées, Guide du visiteur (1930), p. 18, no. 1549 bis, pl. VII.
Lippold, Gemmen und Kameen, pl. 63, no. 10.

302. *Lapis lazuli scaraboid.* 29 × 22 mm.

From Athens. In the British Museum, 1921.7-11.4. Bought 1921. Successively in the collections of Finlay, Rhodes, Story-Maskelyne, and Arnold-Forster.

NUDE WOMAN, crouching to the right and holding up her chiton with both hands to pass it over her head. The upper part of her body is in three-quarter view, the rest in profile. Short ground line.

Later fifth century B.C.

King, Antique Gems and Rings, II, pl. 23, no. 2; Handbook, pl. 56, no. 2.
Furtwängler, A.G., pl. XII, 33.
Burlington Fine Arts Club Exh., 1904, p. 188, pl. CVIII, no. M39.
Sotheby Sale Catalogue of the Story-Maskelyne Collection, July 4th, 1921, no. 36, pl. 2.
Walters, Cat., no. 530, pl. IX.

303. *Chalcedony scaraboid.* 19 × 23 mm.

From Spezia. In the Ashmolean Museum, 1892.1468. Acquired through the Chester bequest.

NUDE WOMAN, crouching to the left, with both arms extended, in the act of putting on her garment. Her trunk is in three-quarter view, the left foot in back view, the rest more or less in profile. Ground line.

Fifth to fourth century.

Furtwängler, A.G., pl. XII, 34.

304. *Agate scaraboid.* 25 × 21 mm.

From Sparta. In the British Museum, 1902.6-18.1. Bought 1902.

WARRIOR, crouching, a spear in his left hand, and a shield strapped to his right arm. He is nude and wears a conical cap. Ground line.
As the shield is held in his right, and the spear in his left

hand, the design must exceptionally have been made to be seen on the stone instead of the impression.

Second half of the fifth century B.C.

Walters, *Cat.*, no. 528, pl. IX.

305. *Sard scaraboid*, slightly burnt and rather flat. 22 × 18 mm.

From Tarsus. In the British Museum, 88.10–19.1. Bought 1888.

YOUTH, crouching, with right leg extended, is putting on his shoe. He is nude, except for the chlamys that flies behind him, and a double-crested pilos hat, tied beneath his chin.

Second half of the fifth century B.C.

Furtwängler, *A.G.*, pl. XXXI, 13.
Lippold, *Gemmen und Kameen*, pl. 53, no. 14.
Walters, *Cat.*, no. 559, pl. X.

306. *Sard octagonal cone.* 15 × 11 mm.

In the British Museum, 79.6–17.1. Bequeathed by Sir W. C. Trevelyan, 1879.

CHILD, sitting on the ground, with both hands stretched out to a bunch of grapes hanging on a vine branch.

Second half of the fifth century B.C.

Furtwängler, *A.G.*, pl. X, 30.
Beazley, *Lewes House Gems*, p. 52.
Walters, *Cat.*, no. 609, pl. X, fig. 36.

307. *Amethystine chalcedony scaraboid.* 22 × 18 mm.

Said to be from Asia Minor. In the Museum of Fine Arts, Boston, 27.700. Formerly in the collection of E. P. Warren, who bought it in London, 1898.

THE CHILD EROS, squatting on the ground, leaning on his right hand, while he extends his left toward a goose, which is trying to make its escape with wings spread. On the ground are two knucklebones with which Eros has been playing before the arrival of the goose. He is winged, nude, with short hair, and has an amulet suspended on a string from his right shoulder. The upper part of his body is in three-quarter view, the rest in profile, except the right foot which is drawn in full back view.

Fifth to fourth century B.C.

Cf. the similar but still finer Eros signed by Phrygillos, Furtwängler, *A.G.*, pl. XIV, 6.

Furtwängler, *A.G.*, pl. LXIV, 15.
Burlington Fine Arts Club Exh., 1904, p. 229, no. O, 1 (not ill.).
Beazley, *Lewes House Gems*, no. 56, pl. 4.
Lippold, *Gemmen und Kameen*, pl. 28, no. 11.

308. *Sard ringstone.* Broken in two; chips missing. 13 × 15 mm.

Found in Catania, Sicily. In the Metropolitan Museum of Art, 42.11.25. Purchase, 1942, Joseph Pulitzer bequest. From the Evans Collection.

HERAKLES, STRANGLING THE NEMEAN LION. He is in a half-kneeling position, and has both arms round the lion's neck. The head of the lion appears, in front view, below Herakles' right arm; its paws are digging into Herakles' right leg; its right hindleg is on the ground, with the tail curving between it and the hero's extended left leg. Ground line.

About 400 B.C.

The two figures are expertly modelled in their complicated positions. The design is practically identical with that on the gold coins of Syracuse by Euainetos and Kimon; cf. Regling, *Münze*, pl. XXVIII, 580. Evans, in *Syracusan Medallions and their Engravers*, pp. 117 ff., pl. V, 5, therefore suggested that the gem served as an official seal, and was cut by Euainetos. Cf. my p. 24.

Keller, *Antike Tierwelt*, I, pl. II, 1.
Furtwängler, *A.G.*, pl. IX, 49, and vol. III, p. 126.
Evans, *Syracusan Medallions and their Engravers*, pp. 117 ff.; *Selection*, no. 56.
Richter, *Evans and Beatty Gems*, no. 35; *M.M.A. Handbook*, 1953, p. 149; *Cat.*, no. 76, pl. XII.

309. *Chalcedony.* 'Apparently sliced from a scaraboid' (Walters); 'ringstone' (Furtwängler). Somewhat injured. 16 × 13 mm.

In the British Museum, RPK19. From the Payne Knight Collection.

WARRIOR, crouching, about to throw the stone in his right hand at some adversary. In his left hand he holds two spears. He wears a short, belted chiton, perhaps a pilos hat (the stone is fractured at that point), and a panther's skin over his left arm. Ground line.

About 400 B.C.

A work of extraordinary power. The complicated pose is admirably drawn, with body and limbs correctly rendered in their various positions, including the foreshortened right leg.

Furtwängler, *A.G.*, pl. X, 48.
Walters, *Cat.*, no. 558, pl. X.

(e) *Heads, male and female*

Representations of single heads become more frequent in the developed period than before, due to an increased interest in individuality. Among the examples here presented several are idealized heads, both of deities and human beings. Nos. 324 ff., however, are undoubtedly portraits, rendered in the early, generalizing style current at the time. They take their place among the earliest-known portraits in Greek art. One is the famous specimen signed by Dexamenos (no. 326), another the head in Berlin (no. 324). Remarkable studies are also the head of a negress in Boston (no. 323), and the head in Naples (no. 319), signed by Sosias, which resembles the type on a Sicilian coin.

310. *Carnelian scarab.* 16 × 13 mm.

In the British Museum, Blacas 71. From the Blacas Collection.

HEAD OF A YOUTH, wearing a pilos hat, tied with a string under the chin. The eyelashes are indicated. Hatched border. No marginal ornament.

Late fifth century B.C.

A late example of a scarab. Cf. the similar head on the tetradrachms of Melos, Regling, *Münze*, no. 451 (dated 440–400 B.C.).

Bull. dell'Inst., 1831, p. 105, no. 8.
King, *Arch. Journal*, XXIV, 1867, p. 211; *Antique Gems and Rings*, II, pl. XII, 3; *Handbook*, pl. 76, fig. 1.
Furtwängler, *A.G.*, pl. XIV, 31, and vol. III, p. 126.
Walters, *Cat.*, no. 508, pl. IX.
Lippold, *Gemmen und Kameen*, pl. 57, no. 2.

311. *Green jasper scarab.* 17 × 14 mm.

In the British Museum, Blacas 25. From the Blacas Collection.

BEARDED MALE HEAD, evidently intended for a deity (Zeus?). The hair is rolled up round the head and rendered by fine, straight lines. Inscribed in the field at the back E E. Hatched border.

Second half of the fifth century B.C.

King, *Arch. Journal*, XXIV, 1867, no. 507, pl. IX; *Antique Gems and Rings*, II, pl. 10, fig. 6.
Middleton, *Engraved Gems*, p. 112, fig. 25; *Lewis Gems*, p. 35, fiig 7.
Walters, *Cat.*, no. 507, pl. IX.

312. *Gold (electron) ring*, with engraved design on oval bezel. 10 × 15 mm.

In the Staatliche Museen, Berlin. Purchased in Italy.

MASK OF A WREATHED SILENOS, in front view, with large staring eyes, open mouth, and a wild expression.

Second half of the fifth century B.C.

Furtwängler, *Beschreibung*, no. 285; *A.G.*, pl. X, 36.
Lippold, *Gemmen und Kameen*, pl. 14, no. 5.

313. *Gold ring*, with engraved design on oval bezel. 17 × 20 mm.

From Sicily. In the British Museum, 72.6–4.927. Acquired from the Castellani Collection in 1872.

HEAD OF ATHENA, in front view. She wears a triple-crested helmet, earrings, and a necklace with pendants. Locks frame the face right and left. Though the head is frontal, the crests of the helmet are drawn in profile.

Perhaps last quarter of the fifth century B.C.

Furtwängler, *A.G.*, pl. IX, 40.
Marshall, *Cat. of Finger Rings*, no. 68, pl. III.
Lippold, *Gemmen und Kameen*, pl. 20, no. 8.

314. *Yellow agate scarab.* 21 × 16 mm.

From Lentinello, near Syracuse. In the British Museum, 72.6–4.1138. Acquired from the Castellani Collection in 1872.

FEMALE HEAD, in front view. The hair is indicated by perpendicular ridges along the forehead and temples and is tied at the top of the head in a knot, with protruding loose ends. She wears earrings and a necklace with pendants. The expression is serious. Hatched border.

Probably late fifth century B.C.

Furtwängler, *A.G.*, pl. XIV, 37.
Walters, *Cat.*, no. 509, pl. IX.

315. *Sard scarab.* 18 × 12 mm.

In the British Museum, 1920.12–21.4. Bought 1920.

HEAD OF A WOMAN, in profile to the right. Her hair is tied in a tuft at the top of the head, with ends loose. She wears an earring and a necklace with a single pendant. In the field is a crescent. Hatched border.

Probably late fifth century B.C.

The type resembles no. 314.

Sotheby's Sale Catalogue, 7th Dec., 1920, lot 244.
Walters, *Cat.*, no. 510, pl. IX.

316. *Gold ring*, with engraved design on oval bezel. 13.5 × 11 mm.

From Curium, Cyprus. In the British Museum, 96.2–1.189. Acquired with the Turner bequest, 1896.

FEMALE HEAD, wearing a pendant earring, a beaded necklace, and a fillet in her wavy hair.

Fourth century B.C.

Excavations in Cyprus, pl. XIII, 17, p. 83.
Marshall, *Cat. of Finger Rings*, no. 67, pl. III.

317. *Gold ring*, with engraved design on oval bezel. 17 × 12 mm.

Found in South Russia. In the Ashmolean Museum, 1885.490.

YOUTHFUL HEAD, in front view, wearing a chlamys, and wings (?) in the hair; above is a blossom, placed horizontally.

Fifth to fourth century B.C.

E. A. Gardner, *J.H.S.*, V, 1884, p. 70, pl. XLVII, 7.

318. *Agate scaraboid.* 18 × 15 mm.

From Ithome. In the British Museum, 78.1–11.13. Bought 1875.

FEMALE HEAD, wearing a band round which the hair is gathered up from her temples and back. Beneath the neck line is the inscription Eos, so probably the goddess of Dawn is intended.

The style is still somewhat severe, with the eye not in correct profile; so the date should be not later than about the middle of the fifth century B.C.

Furtwängler, *A.G.*, pl. XIV, 33.
Lippold, *Gemmen und Kameen*, pl. 32, fig. 7.
Walters, *Cat.*, no. 518, pl. IX.

319. *Chalcedony scaraboid.* Slightly convex at the back. 17 × 20 mm.

Provenance not known. In the National Museum, Naples. (The illustration shows the head as it appears in a *cast* of the intaglio.)

FEMALE HEAD, in profile to the right. The long hair is looped up behind; on the skull it radiates from the apex, with wavy strands round forehead and temples, and little curls escaping from the mass here and there. The eyeball protrudes; eyelashes are indicated along the lower lid and at the inner corner of the upper lid. The lips are short and full. At the top, the inscription Σωσίας, Sosias, probably the signature of the artist, for the letters are comparatively inconspicuous. Hatched border.

On Sosias see pp. 16, 18.

Late fifth century B.C.

Similar in style to the heads on the Syracusan coins of the late fifth century, especially those signed by Eumenes and Euainetos, with similar hair-do, and with the same stray curls, short, full lips, and indication of eyelashes, as well as the same squarish proportions of the face; cf. G. F. Hill, *Coins of Ancient Sicily*, pl. III; Rizzo, *Monete greche della Sicilia*, pl. XLIII, 4, pl. XLIII, 3; Regling, *Münze*, no. 579.

Richter, *A.J.A.*, LXI, 1957, p. 263, pl. 80, fig. 1 (from a cast instead of an impression).

320. *Gold ring*, with engraved design on pointed oval bezel. 13 × 19 mm.

In the British Museum, 84.4–9.1. Acquired from the Castellani Collection in 1884.

FEMALE HEAD, in profile to the right. She wears a sakkos beneath which her wavy hair protrudes, a large earring with pendants, and a necklace with a single pendant.

A sensitive work of the second half of the fifth century B.C.

Froehner, *Sale Cat. of the Castellani Coll.*, Rome, 1884, p. 115, no. 871.
Middleton, *Engraved Gems*, p. 31.
Furtwängler, *A.G.*, pl. IX, 38.
Marshall, *Cat. of Finger Rings*, no. 53, pl. II.
Lippold, *Gemmen und Kameen*, pl. 64, no. 4.

321. *Carnelian scarab.* 15 × 11 mm.

In the Thorvaldsen Museum, Copenhagen.

FEMALE HEAD, in profile to the right.

Last quarter of the fifth century B.C.

A late example of the use of the scarab form.

Furtwängler, *A.G.*, pl. XIV, 32.
Fossing, *Cat.*, no. 9, pl. I.

322. *Gold ring*, with engraved design on round bezel. 23 × 20 mm.

From Constantinople. In the Ashmolean Museum, 43 (Fortnum, 115).

FEMALE HEAD, wearing a necklace, in profile to the right. In the field, surrounding the design, are Cypriote letters.

Late fifth century B.C.

323. *Sard scarab*. Fractured. 15 × 19 mm.

In the Museum of Fine Arts, Boston, 23.581. Formerly in the possession of Charles Newton-Robinson, from whom E. P. Warren bought it in 1901.

HEAD OF A NEGRESS. She wears a sakkos, from which her curly hair protrudes front and back; also an earring, and a beaded necklace with a pendant (part of which is missing).

Toward the end of the fifth century B.C.

One of the finest representations of the negro type in Greek art; unfortunately not complete.

Furtwängler, *A.G.*, pl. XII, 43.
Burlington Fine Arts Club Exh., 1904, p. 236, no. O, 23 (not ill.).
Beazley, *Lewes House Gems*, no. 52, pl. 3.
Lippold, *Gemmen und Kameen*, pl. 65, no. 2.

324. *Gold (electron) ring*, with engraved design on oval bezel. 16 × 12 mm.

In the Staatliche Museen, Berlin. From the Stosch Collection.

PORTRAIT HEAD, of a bearded, elderly man, in profile to the right. His brow is furrowed, baldness is starting. The expression is serious, observant. Under the chin is added a penis, evidently as an apotropaic symbol.

Second half of the fifth century B.C.

Important as an early example of individualized portraiture. The date is indicated not only by the style of the head, but by the form of the ring (with its slightly curved bezel, the hoop angular near the bezel and then becoming rounded), and by the material, 'neither of which occurs later than the fifth century B.C.' (Furtwängler).

Jahn, *Berichte der sächs. Ges.*, 1855, p. 73, note 172.
Furtwängler, *Beschreibung*, no. 287; *A.G.*, pl. X, 35.
Jacobsthal, *Melische Reliefs*, p. 156, fig. 35.
Lippold, *Gemmen und Kameen*, pl. 67, no. 4.
Richter, *Rendiconti Acc. Pont. Rom.*, XXXIV, 1961–62, pp. 54 f., fig. 24.

325. *Gold ring*, with engraved design on pointed oval bezel. Surface worn. 15 × 10 mm.

From Kerch, South Russia. In the Ashmolean Museum, 1885.484.

PORTRAIT HEAD, of a bearded man, in profile to the right.

Late fifth century B.C.

E. A. Gardner, *J.H.S.*, V, 1884, pl. 47, 6, p. 70.
Beazley, *Lewes House Gems*, pl. A, no. 29.
Jacobsthal, *Melische Reliefs*, p. 156, fig. 35.
Richter, *Rendiconti Pont. Acc. Rom.*, XXXIV, 1961–62, p. 57, fig. 25.

326. *Yellow jasper scaraboid*, mottled with red. 16 × 20 mm.

Said to have been found in a tomb at Kara in Attica about 1860. It passed into the possession first of Admiral Soteriades, then of Rhousopoulos, and then into the collections of A. J. Evans and E. P. Warren. Now in the Museum of Fine Arts, Boston, 23.580.

PORTRAIT OF A BEARDED MAN, in profile to the right. In the field above, in two horizontal lines, the signature of the artist: Δεξαμενὸς ἐποίε (for ἐποίει). Line border. Cf. pl. A. On Dexamenos see pp. 15, 16, 17.

Third quarter of the fifth century B.C.

That the head is intended for a portrait there can be no doubt. The individuality of the man comes out particularly in the expression of the prominent eye (with the iris marked), the long nose, and the sensitive, half-open mouth with prominent upper lip. The undulating lines of hair and beard, of the eyebrows and eyelashes (on both upper and lower lid) are drawn with the greatest delicacy. Evans suggested that it might represent Kimon; but see Furtwängler, *A.G.*, vol. III, p. 138, and my *Portraits of the Greeks*, p. 102.

Stephani, *Compte-rendu*, 1868, pl. I, 12.
King, *Antique Gems and Rings*, I, p. 400.
Evans, *Rev. arch.*, XXXII, 1898, pp. 337 ff.
Furtwängler, *J.d.I.*, III, 1888, pl. VIII, 8; *A.G.*, pl. XIV, 3, pl. LI, 8, and vol. III, p. 138.
Burlington Fine Arts Club Exh., 1904, p. 233, no. O, 13 (not ill.).
Beazley, *Lewes House Gems*, no. 50, pl. 3.
Richter, *Rend. Acc. Pont. Rom.*, XXXIV, 1961–62, p. 54, fig. 23.
Cf. also the books on Greek portraits where this famous head is mostly included.

327. *Glass scaraboid*, almost colourless. 27 × 24 mm.

In the Fitzwilliam Museum, Cambridge. From the Leake

Collection. Said to be from Greece. Obtained in the Morea by Col. Leake.

PORTRAIT HEAD, of a bearded man, in profile to the left.

Late fifth century B.C.

The head is strongly idealized, in the manner of the fifth century B.C.; but the portrait-like element is evident.

Middleton, *Cat.*, p. VI, no. 9 (not ill.).
Furtwängler, *A.G.*, pl. X, 44 ('freier Stil des 5. Jahrh.'; 'wohl Herakles').
Richter, 'Greek Portraits', IV, *Collection Latomus*, LIV, pp. 20 f., fig. 17. (Kimon?); *Rendiconti della Pont. Accad. Rom. di Archaeol.*, XXXIV, 1961–62, p. 57, fig. 26; *Portraits of the Greeks*, p. 102.

328. *Gold ring*, with engraved design on oval bezel. 12 × 17 mm.

In the Cabinet des Médailles, 65A14001. Gift of the duc de Luynes in 1862 (no. 524); said to be from Agrigentum.

PORTRAIT OF A BEARDED, MIDDLE-AGED MAN, in profile to the right. He has short, curly hair and wears an earring.

Fourth century B.C.

For the type of ring cf. Marshall, *Cat. of Finger Rings*, p. XLI, no. XII (early fourth century B.C.).

On account of the earring, Furtwängler thought that the man was perhaps a barbarian. But the facial type with its pensive expression seems Greek.

Furtwängler, *A.G.*, pl. X, 43.

(f) *Compositions in which more than one figure is included*

The compositions consist of riders (nos. 329 ff., one with a horse in back view, the man in profile, no. 331), and chariots (nos. 334–340). Some of the latter are closely related to the representations on Sicilian coins of the late fifth century B.C. and to the sculptures of the time, e.g., the Echelos relief in Athens (no. 1783), the so-called Lycian sarcophagus in Istanbul (Lippold, *Gr. Plastik*, pl. 75, 2), and the silver phialai in New York (Richter, *A.J.A.*, XLV, 1941, pp. 363 ff., and LIV, 1950, pp. 357 ff.). All show similar conventions regarding the design of the various heads and legs of the horses, and similar attempts to solve the difficult task of indicating the two wheels of the chariot. At the end I have placed for comparison a biga driven by a Nike (no. 341), of a later date, where the foreshortening of the wheels is more competently rendered, but where the fiery action of the earlier representations has been largely lost.

Then come particularly ambitious compositions, e.g., Hades seizing Persephone (no. 342); Diomedes thrown before his man-eating horses (no. 343); a man and a boy engaged in milking a ewe (no. 347); Herakles with the nymph Nemea (no. 344), and carrying off the tripod (no. 345); the familiar theme of Nike about to sacrifice an animal (nos. 348, 349); and Danaë receiving Zeus' shower of gold (no. 346). All are designed with a new freedom and with evident interest in showing the figures in depth. But this is throughout achieved merely by overlapping forms, not yet with any use of linear perspective, not even when a piece of furniture is included (cf. no. 346).

329. *Carnelian ringstone*. Fractured at top (head and right arm missing). 22 × 17 mm.

In the Staatliche Museen, Berlin. From the Stosch Collection.

HORSEMAN, in a rocky landscape. He is riding a rearing horse, holding a spear downwards in his left hand, and with the right arm evidently raised. He wears a chlamys, which is waving in the wind at his back. Hatched border.

Spirited work of the fifth century B.C. The imperfect foreshortening of the upper part of the body indicates a date before the middle.

Furtwängler, *Beschreibung*, no. 348; *A.G.*, pl. X, 16.

330. *Gold ring*, with engraved design on the bezel. Diam. 26 mm.

Found in the tomb of Golenata Mogila near Duvanlij,

Bulgaria. In the National Museum, Sofia, inv. 1639.

A NUDE YOUTH, riding a galloping horse, in profile to the left. Below is the inscription Σκυθοδόκο, 'of Sky-thodokos', evidently the owner's name.

First half of the fifth century, before the Parthenon horses.

Filow, *Die Grabhügelnekropole bei Duvanlij in Südbulgarien* (Sofia, 1934), pp. 191 ff., pl. VIII, 4 and 9.
Becatti, *Oreficeria antica*, no. 306, pl. LXXVI.

331. *Gold ring*, with engraved design on pointed oval bezel. 8 × 17 mm.

From Tarquinia. In the British Museum, 93.5–25.3. Acquired 1893.

BOY, sitting on a rearing horse. He is shown in profile to the right, whereas the horse is drawn in different directions: the front part (including both forelegs) in profile to the right, the hind-quarters in back view, the tail in profile to the left, and the hoofs in profile to the right and left. The boy is nude (with the serratus magnus indicated). In his right hand he holds the reins; both legs are hanging down on one side. The horse has a decorated neck band. Ground line under the horse's back hoofs. Hatched border.

The as yet primitive perspective and avoidance of fore-shortening, as well as the rendering of the features, with the eye not yet in correct profile, place the engraving in the first half of the fifth century B.C., perhaps in the second quarter.

Furtwängler, *A.G.*, pl. IX, 36 ('strenger Stil').
Marshall, *Cat. of Finger Rings*, no. 43, pl. II. ('Middle of fifth century B.C.')
H. Cahn, *Die Münzen der sizilischen Stadt Naxos*, pp. 45 ff., pl. 10, R.
Boardman, *Antike Kunst*, X, 1967, p. 27, no. N43, pl. 7 ('early fifth century B.C.').

332. *Carnelian scarab*, burnt. Fractured along the edge, and at bottom and back. 22 × 15 mm.

From Greece. In the Cabinet des Médailles. Acquired through the gift of Pauvert de La Chapelle in 1899.

POSEIDON OR NEREUS, riding on a hippocamp, holding a trident in one hand, in the other the reins. He is nude except for a chlamys, which is fastened at his neck and is waving in the wind behind. The body is shown in three-quarter view, the rest in profile views, with the head turned back. The horse wears a band round its chest. Hatched border.

Fifth to fourth century B.C.

E. Babelon, *Coll. Pauvert de La Chapelle*, no. 86, pl. VI.
Furtwängler, *A.G.*, vol. III, p. 146, fig. 227.
Lippold, *Gemmen und Kameen*, pl. 5, no. 4.

333. *Gold ring*, with engraved design on pointed oval bezel. L. of bezel 21 mm.

In the British Museum, 84.4–9.2. Acquired from the Castellani Collection in 1884.

YOUTH, riding a galloping horse. He holds the reins in both hands and also a spear in his right. His hair and chlamys fly loose behind him. The youth's body is correctly foreshortened; both his feet are indicated and all four legs of the horse. Cf. pl. C.

Spirited and accomplished work of the fourth century B.C.

Cf. the somewhat similar design on the coins from Tarentum, Head, *H.N.²*, p. 61, fig. 30, dated 334–302 B.C.

Froehner, *Castellani Sale Cat.*, Rome, 1884, p. 116, no. 879.
Middleton, *Engraved Gems*, p. 31.
Furtwängler, *A.G.*, pl. IX, 39, pl. LI, 20.
Marshall, *Cat. of Finger Rings*, no. 49, pl. II.
Richter, *Animals*, fig. 73.
Lippold, *Gemmen und Kameen*, pl. 55, no. 1.

334. *Mottled red jasper scaraboid*. Fractured along the edge. 32 × 21 mm.

Said to have been found at Trikkala in Thessaly. In the Metropolitan Museum of Art, 42.11.19. Purchase, 1942. Joseph Pulitzer bequest.

TWO-HORSE CHARIOT. A youth is driving a chariot with two galloping horses, holding the reins in the left hand and a goad in the uplifted right. He wears a long, girded chiton and has straight hair. The horses wear belly-bands; they are shown in profile, except the head of the near horse, which is in three-quarter view. Both wheels of the chariot are indicated, the farther one much smaller than the near one. Ground line. Cf. pl. C.

Late fifth century B.C.

Evans, *Selection*, no. 47.
Alexander, *M.M.A. Bull.*, 1942–43, p. 145, fig. 6, p. 147.
Richter, *Evans and Beatty Gems*, no. 26; *M.M.A. Handbook*, 1953, p. 149; *Cat.*, no. 79, pl. XIII.

335. *Chalcedony scaraboid*. Fractured round edge. 17 × 26 mm.

In the Cabinet des Médailles.

FOUR-HORSE CHARIOT. The charioteer (head mostly missing) is leaning forward, holding the reins in both

hands, and also a whip in his right. The horses are galloping, with all four heads in profile. Both chariot wheels are indicated.

Late fifth to early fourth century B.C.

Cf. the Syracusan decadrachms of *c.* 400–390 B.C., Hill, *Select Greek Coins*, pl. LII, I.

Chabouillet, *Cat.*, no. 1866.
Furtwängler, *A.G.*, pl. IX, 54.

336. *Gold ring*, with engraved design on convex bezel. 28 × 25 mm.

From Magna Graecia. In the British Museum, B134. Acquired from the Burgon Collection in 1842.

NIKE, driving a four-horse chariot. She holds the reins in her left hand, a long kentron in the right, and wears a long, belted chiton. The horses have their hindlegs on the ground, the forelegs lifted. They are drawn in profile, but with some of the heads in slight three-quarter view. Both wheels of the chariot are indicated, the far one only in part, the near one foreshortened; also part of the axle, but not the body. Ground line.

Late fifth century B.C.

Cf. the decadrachms of Katania by Euainetos, of *c.* 413–404 B.C., Hill, *Select Greek Coins*, pl. L, 3.

Middleton, *Engraved Gems*, p. 31.
Fontenay, *Les bijoux anciens et modernes* (1887), p. 29.
Furtwängler, *A.G.*, pl. IX, 46.
Marshall, *Cat. of Finger Rings*, no. 42, pl. II.
Lippold, *Gemmen und Kameen*, pl. 33, no. 4.

337. *Carnelian scarab*, mounted in an ancient gold swivel ring. Transverse hole remains, but back cut off. 26 × 17 mm.

In the Cabinet des Médailles. Gift of the duc de Luynes in 1862 (no. 89).

NIKE, driving a four-horse chariot with galloping horses. She holds the reins in both hands, and in the right also the goad (kentron). The horses are partly in three-quarter view. Both wheels of the chariot are indicated in foreshortened form. Ground line.

Late fifth century B.C.

Cf., e.g., the decadrachms of Akragas of *c.* 413–406, Hill, *Select Greek Coins*, pl. LI, 2.

Furtwängler, *A.G.*, pl. IX, 53.

338. *Chalcedony scaraboid*. 26 × 20 mm.

In the Museum of Fine Arts, Boston, 23.582. Formerly in the collection of E. P. Warren. Bought in Athens.

CHARIOTEER, about to turn in a two-horse chariot. The action is suggested by the different renderings of the driver's hands and by the different stances of the horses – one still in full gallop with its head in strict profile, the other partly rearing with its head in three-quarter view. The charioteer is beardless, with long hair, and wears a long chiton, of which the folds at the bottom are blown back by the wind; he holds the reins in both hands, and has no whip. Ground line. Cf. pl. C.

A masterly work of about 400 B.C.

Furtwängler, *A.G.*, pl. LXV, 4.
Beazley, *Lewes House Gems*, no. 55, pl. 4.
Lippold, *Gemmen und Kameen*, pl. 54, no. 5.

339. *Chalcedony scaraboid*. Fractured at bottom. 24 × 36 mm.

From Garma, Jajarm, North Persia. In the British Museum, 1919.11–17.1. Bought 1919.

NIKE, driving a two-horse chariot, holding the reins in both hands and also a whip in the left. She wears a belted chiton and her hair is done up in a knot at the top of her head. She is drawn in profile, but with the farther wing spread out to the right. The horses are in profile, except the head of the near horse which is turned to the front. The two wheels of the chariot are somewhat foreshortened and placed side by side in front of the body of the chariot, which is drawn frontal, with both its handles showing.

Fourth century B.C.

This is an interesting example of the primitive perspective still current in the full-blown developed period, in which the various parts of the representation are seen from different points of sight, not unified. A chariot presented special difficulties in this respect.

Walters, *Cat.*, no. 569, pl. X.

340. *Carnelian scaraboid*, with engraved design on convex side. 27 × 17 mm.

In the Metropolitan Museum of Art, 42.11.18. Purchase, 1942, Joseph Pulitzer bequest. From the Evans Collection.

CHARIOT. A man is driving a four-horse chariot in full gallop, holding the reins in both hands and the goad in his left. He has short hair and wears a long, girded, sleeveless chiton. The horses have their hindlegs on the ground, their forelegs lifted high; they have belly-bands, and peytrels on their chests. Some of their heads and chests are drawn in three-quarter view, others in profile. There is also an attempt at perspective in the drawing of the chariot, of which the diminutive farther wheel is

shown in an impossible place behind the third horse's hindlegs. Ground line.

Second half of the fourth century B.C.

Furtwängler, *A.G.*, pl. IX, 52.
Evans, *Selection*, no. 46.
Lippold, *Gemmen und Kameen*, pl. 55, no. 3.
Richter, *Evans and Beatty Gems*, no. 38; *M.M.A. Handbook*, 1953, p. 149, pl. 126, k; *Cat.*, no. 98, pl. XVII.

341. *Carnelian*, set in an enamelled mount. 20 × 24 mm.

In the Cabinet des Médailles, 1543.

NIKE, driving a two-horse chariot. She wears a long, sleeved chiton with overfold, and holds both reins in her right hand, the goad in her left. The body of the chariot is not indicated, but both wheels with their axles are drawn, in more or less correct perspective.

Fourth century or later in a probably Roman reproduction.

Mariette, *Pierres gravées*, II, pl. CXIX.
Chabouillet, *Cat.*, no. 1543.

342. *Chalcedony scaraboid*, mounted in a silver swivel ring. Slightly chipped along the edge. The silver is corroded. 19 × 15 mm.

From Cyprus. In the Metropolitan Museum of Art, 74.51.4199 (C.E.17). Purchased by subscription, 1874–76. From the Cesnola Collection.

HADES SEIZING PERSEPHONE. She has let fall her lighted torch and looks up with alarm at her captor. His right hand is at her breast, the left (not indicated) at her back. He is bearded and his hair is rolled up over a fillet at the back of his head; he wears a long, girded chiton, and a himation hanging down from his shoulders. She wears a long, sleeved chiton, twice girded, a sakkos, and an earring. Both figures are shown partly in slight three-quarter views, partly in profile; his right foot is frontal, the left in profile. Her feet are lifted off the ground; both are drawn in profile, except the toes of her left foot which are almost frontal, with all five toes indicated. Ground line and line border.

About 460–450 B.C.

In spite of its quiet grandeur, the group conveys the idea of capture. The different planes of the two superimposed figures are successfully differentiated.

In most contemporary scenes of the rape of Persephone the chariot is present (cf. Zancani Montuoro, *Atti e Memorie d. Soc. Magna Graecia*, n.s. I, 1954, pp. 7 ff.). For a related composition, but more animated, cf. Overbeck,

Kunstmythologie, pl. XVIII, 12a. For the Persephone cf. also the nymphs on the tetradrachms of Himera, of 480–440 B.C.; Regling, *Münze*, pl. XVIII, 381–383.

Cesnola, *Cyprus*, pl. XXXIX, 2; *Atlas*, III, pl. XXVII, 9.
Furtwängler, *A.G.*, pl. IX, 32.
Myres, *Handbook*, no. 4199.
Beazley, *Lewes House Gems*, p. 42.
Richter, *M.M.A. Handbook*, 1953, p. 148, pl. 126, a; *Cat.*, no. 68, pl. XI.

343. *Greenish stone*, resembling plasma, probably cut from a scarab. 14 × 17 mm.

In the Staatliche Museen, Berlin. From the Stosch Collection.

DIOMEDES, king of Thrace (?), lying in a crib, with four horses at the back, one of which has its head lowered to his neck; two have their heads turned toward each other; the fourth is placed opposite to a man, who has some object in his left hand (a receptacle?). At the left is a palm tree. Hatched border.

Fifth century B.C., perhaps toward the middle.

Furtwängler interpreted the scene as king Diomedes thrown before his man-eating horses, one of which was beginning to bite him; the man in the background he thought might have been intended for Herakles. And this seems indeed a possible explanation, though no parallel representations are known in other branches of Greek art. The subject was, however, popular on gems, for there are several replicas, cited by Furtwängler, *A.G.*, II, p. 50.

Winckelmann, *Mon. ined.*, no. 68, p. 93 ('Abderos and Diomedes').
Imhoof-Blumer and Keller, pl. XVI, 72 ('Vier Rennpferde welche von ihrem tot auf der Bahre liegenden Herrn Abschied nehmen').
Furtwängler, in Roscher's *Lexikon*, s.v. Herakles, col. 2202; *Beschreibung*, no. 299; *A.G.*, pl. X, 7.
Lippold, *Gemmen und Kameen*, pl. 38, no. 2.

344. *Chalcedony scaraboid*. 35 × 28 mm. Chipped round the edge.

Found in the Punjab. In the British Museum, 90.9–20.1. Bought 1890.

HERAKLES AND THE NYMPH NEMEA. Herakles, nude, bearded, is standing with his right foot placed on the slain Nemean lion and with both hands extended to receive a hydria from a female figure, presumably Nemea, the nymph of the place. He is drawn in profile, but with the muscles of the trunk indicated in three-quarter view. Above, Eros is flying with a wreath. Behind Herakles is his club. Nemea wears a belted chiton with overfold.

Staccato ground line, perhaps to indicate the uneven terrain.

The imperfect rendering of Herakles' trunk suggests a date not far removed from the middle of the fifth century B.C.

For the motif of Herakles needing a rest after the slaying of the Nemean lion one may compare the metope from Olympia.

Furtwängler, *A.G.*, pl. XII, 25, and vol. III, pp. 125, 143.
Jacobsthal, *Melische Reliefs*, p. 151, fig. 30.
Lippold, *Gemmen und Kameen*, pl. 36, fig. 1.
Walters, *Cat.*, no. 524, pl. IX.

345. *Carnelian scarab.* Fractured at top. 18 × 13 mm.

In the Cabinet des Médailles.

THE DISPUTE OVER THE TRIPOD. Herakles has lifted the tripod to his left shoulder and is preparing to walk off with it, his head turned back to look at Apollo, who stands behind him, with one hand extended. Both are nude; Apollo has a wreath on his head, and holds a bow in his left hand; a shield is strapped to his arm. Herakles holds his club in the right hand. Ground line with exergue, decorated with hatched triangles. Hatched border. No marginal ornament.

Second half of the fifth century B.C.

Caylus, *Recueil des ant.*, IV, 34, 5.
Chabouillet, *Cat.*, no. 1760.
Furtwängler, *A.G.*, pl. X, 18.

346. *Red jasper scaraboid*, with white streaks. 13 × 18 mm.

Said to be from Greece. In the Museum of Fine Arts, Boston, 98.716.

DANAË, standing by a couch and holding out the kolpos of her chiton with both hands to receive Zeus' shower of gold. The leg of the couch is of the rectangular type, with cut-out incisions, and volutes at the top; on it are two pillows. A mattress is placed on the railing. There is no attempt to show the farther leg. Hatched border.

Fifth to fourth century B.C.

Osborne, *Engraved Gems*, pl. VIII, 12, p. 319.
Furtwängler, *A.G.*, pl. LXI, 36.
Lippold, *Gemmen und Kameen*, pl. 47, no. 3.

347. *Gold ring*, with engraved design on pointed oval bezel. L. of bezel 19 mm.

From Tharros, Sardinia. In the British Museum. 56.12–23.941. Acquired in 1856.

EWE BEING MILKED. The ewe is held between the knees of a bearded, crouching man, while a boy, who is seated on the ground, is engaged in the milking. Both boy and man wear tunics round the lower parts of their bodies. On the left is a tree, placed obliquely, following the direction of the border; on the right a lotus flower. Hatched border.

Cursorily but vividly rendered in the style of the middle of the fifth century B.C.

Marshall, *Cat. of Finger Rings*, no. 44, pl. II.

348. *Gold ring*, with engraved design on oval bezel. 24 × 18 mm.

Found in the Crimea. In the Hermitage.

NIKE, about to sacrifice a hind. She is sitting astride on its back, holding up its head with the left hand, the sword in her right. She wears a sleeveless, girt chiton with overfold, and her two large wings are spread out to the right and left. The hind has fallen to the ground, with all its legs bent, and an expression of pain in its eye. Ground line.

Late fifth century B.C.

The style recalls the reliefs of the Nike Balustrade.

S. Reinach, *Ant. du Bosphore*, pl. XVIII, 4, 7.
Imhoof-Blumer and Keller, pl. XVII, 33, p. 109.
Furtwängler, *A.G.*, pl. X, 46.
Maximova, *Ancient Gems and Cameos*, pl. II, 6. In Russian.

349. *Chalcedony scaraboid.* Engraved on convex side. 40 × 31 mm.

In the British Museum, 68.5–20.30. From the Pulsky Collection. Acquired in 1868.

NIKE SLAYING A BULL. She is standing astride on the animal, holding up its muzzle with her left hand, and is about to slay it with the spear held in her right. She wears a belted chiton with overfold, and a cap-like sakkos, knotted at the top. The trunk is drawn almost frontal. The rest in profile view.

Fifth to fourth century B.C.

Walters, *Cat.*, no. 568 (not ill.).

350. *Sard scarab.* 6·5 × 17 mm.

In the Museum of Fine Arts, Boston, 27.722. From the Tyszkiewicz Collection. 'Sent from Constantinople' (Froehner).

HERAKLES THROTTLING THE NEMEAN LION. Herakles, nude, bearded, with short hair, has both hands at the lion's throat. The lion, open-mouthed, is digging

his right paw into Herakles' body; on the shoulder is a 'bow-like ornament' (see below). Hatched border. No winglets or marginal ornament on the scarab.

Around the middle of the fifth century B.C. Probably Greek rather than Etruscan work.

As Furtwängler pointed out, the bow-like ornament on the lion's shoulder points to Persian influence. Such influence would seem strange in an Etruscan stone. Moreover, the absence of a marginal ornament may also point to a non-Etruscan origin. Both Furtwängler and Beazley, therefore, hesitated whether to call the gem Etruscan or Greek. I too have moved it from one category to another several times, finally deciding on the Greek.

Furtwängler, *A.G.*, pl. LXI, 20.
Beazley, *Lewes House Gems*, no. 86, pl. 3.
Lippold, *Gemmen und Kameen*, pl. 37, no. 2.

351. *Carnelian pendant*, in the form of a lotus flower. 25 × 25 mm.

From Athens. In the British Museum, Blacas 234. Acquired from the Blacas Collection.

Engraved on two sides:
(1) Two SIRENS, confronted, one playing the kithara, the other a double flute.
(2) Two LITTLE BOYS, confronted, one holding a bird, the other stretching out his hands toward it.

Careful work of the second half of the fifth century B.C.

A rare example of two single figures combined to form one composition. For another Siren fluting cf. the stone in Cambridge, Furtwängler, *A.G.*, pl. IX, 23.

Stackelberg, *Gräber der Hellenen*, pl. 74, nos. 8, 9.
Imhoof-Blumer and Keller, pl. XXVI, I.
Furtwängler, *A.G.*, pl. XIII, 17, 19.
Lippold, *Gemmen und Kameen*, pl. 79, figs. 12, 14.
Weicker, *Seelenvogel*, p. 169.
Beazley, *Lewes House Gems*, p. 52.
Walters, *Cat.*, no. 564, fig. 34, pl. X.

(g) *Monsters and hybrid figures*

The interest of the Greek artist in depicting monsters and hybrid figures so conspicuous in early Greek art, and maintained to some extent in the archaic period, considerably waned during the fifth and fourth centuries, their place being taken by scenes from actual life. Nevertheless, the centaur, the sphinx, the siren, the chimaera, the Scylla, etc., which play a prominent role in Greek mythology, continue to appear on the gems.

Nos. 352 ff. show a selection of such representations, including a Centaur about to hurl a vase at an opponent (no. 357), a Centauress drinking from a cup (no. 356), two specially fine Scyllas in the Cabinet des Médailles and in Berlin (nos. 363, 364), and a masterly design of a galloping sea-horse, in the British Museum (no. 365).

352. *Flat agate*, perhaps cut from a scarab. Discoloured and chipped along the edge. 10 × 13 mm.

In the Metropolitan Museum of Art, 81.6.14. Gift of John Taylor Johnstone, 1881. From the Nott and King Collections.

CENTAUR. He is galloping to the right, in the act of shooting off an arrow from his bow. A panther's skin is knotted at his neck, with hind paws and tail marked and flying in the wind behind. His human trunk is in three-quarter view, the rest in profile. In the field are a branch and five stars. Hatched border.

About 460–450 B.C.

The constellation of the Sagittarius, the ninth sign of the zodiac was conceived by the Greeks as a shooting Centaur. The order of the stars on the stone approximately corresponds to the principal stars in the constellation. This is one of the earliest representations of the Sagittarius in Greek art. For a list of such representations cf. Roscher's *Lexikon*, s.v. Kentauren, col. 1058.

King, *Antique Gems and Rings*, II, copper pls., 1st grp., III, 25.
Richter, *M.M.A. Handbook*, 1953, p. 148; *Cat.*, no. 67, pl. XI.

353. *Carnelian scaraboid*, with engraving on the convex side. Mounted in a gold frame. 22 × 17 mm.

In the Staatliche Münzsammlung, Munich. From the Arndt Collection.

CENTAUR, walking to the right, with head turned back. One hand is raised, as if greeting someone, in the other is a branch. The equine body is in profile, the human trunk mostly frontal, with a slight attempt at foreshortening.

About 460 B.C.

Czako and Ohly, *Griechische Gemmen*, no. 21.

354. *Chalcedony*, probably cut from a scaraboid. 22 × 17 mm.

In the British Museum. Bought 1885. Only the upper part is ancient, the lower part has been restored in gold. The dividing line is visible in the photograph of the original.

CENTAUR, fleeing to the right. He has been struck in his back by an arrow, which he is trying to extract with his left hand. He is in the form of a horse with the upper part of his body human, except for the ears. An animal's skin is tied round his neck and is flying behind. In the field are inscribed the two letters X I, evidently the beginning of the owner's name. Hatched border.

Second half of the fifth century, time of the Parthenon.

A masterpiece; unfortunately not complete.

Babelon, *La gravure*, p. 116, fig. 83.
Furtwängler, *A.G.*, pl. XIII, 30, and vol. III, p. 126.
Lippold, *Gemmen und Kameen*, pl. 76, no. 4.
Walters, *Cat.*, no. 557, pl. X.

355. *Agate scaraboid*. Fractured right and left. 19 × 14 mm.

From Cyprus. In the British Museum, 1907.5–16.2. Bought 1907.

CENTAUR, carrying off a woman in his arms. He is bearded and has human form with the hind part of a horse attached to his back. She wears a long chiton reaching to the ankles. Hatched border.

Last quarter of the fifth century B.C.

Walters, *Cat.*, no. 519, pl. IX.

356. *Rock crystal scaraboid*. Fractured at top and around edge. 27 × 29 mm.

In the Cabinet des Médailles. Gift of Mr. Dubois.

CENTAURESS, drinking out of a cup (kotyle), which she is filling from a rhyton with the protome of a sea-horse. She has a human body, to which the hind-quarters of a horse are attached at the back. Ground line.

First half of the fourth century B.C.

On female Centaurs see now D. E. Strong, 'A Lady Centaur', *British Museum Quarterly*, XXX, 1966, pp. 36 ff.

E. Babelon, *Cabinet des antiques*, p. 210, pl. LVI, 20.
Roscher, in Roscher's *Lexikon*, s.v. Kentauren, col. 1077, note (doubts authenticity).
Chabouillet, *Cat.*, no. 1689.
Furtwängler, *A.G.*, pl. XII, 41.
Lippold, *Gemmen und Kameen*, pl. 75, no. 11.

357. *Sard ringstone*. Chipped at sides, and pared round edge. 18 × 25 mm.

In the Museum of Fine Arts, Boston, 27.725. From the Boulton Collection. Acquired in 1911.

A CENTAUR, of powerful build, bearded and with long hair, has his right arm around a volute-krater, evidently about to hurl it at some adversary. The equine body is attached to a completely human form, of which the trunk is shown frontal, head and limbs in profile, except the left leg which is foreshortened.

Probably fifth to fourth century B.C.

The scene is presumably an excerpt from a representation of the contest of Centaurs and Lapiths at the marriage feast of Peirithoos. On some of the Parthenon metopes the Centaurs also appear with vases in their hands about to hurl them (cf., e.g., British Museum, no. 307).

Boulton Sale Catalogue, no. 26, 4.
Beazley, *Lewes House Gems*, no. 91, pl. 3 (Etruscan or Italiote).

358. *Sard ringstone*. 19 × 14 mm.

In the British Museum, Blacas, 363. From the Blacas Collection.

SPHINX, seated, with head raised, scratching her shoulder with her raised left paw. The upper part of the body is in three-quarter view, the head is tilted back and almost frontal, the legs are in profile, and the wings frontal. In the field is the inscription Θαμύρου, considered modern by Furtwängler, ancient by others. (M. Guarducci thinks it may be ancient.) Curving ground line and hatched border.

Second half of the fifth century B.C.

Bracci, *Commentaria*, II, pl. 113, p. 241.
Raspe, pl. IV, no. 129.
Stosch, *Gemm. Ant. Cael.*, pl. 69.
S. Reinach, *Pierres gravées*, pl. 137, no. 69, p. 183.
Koehler, *Gesammelte Schriften*, III, p. 199.
Stephani, *Angebliche Steinschneider*, pp. 22, 36.
Boeck, *C.I.Gr.*, no. 7196.

Furtwängler, *J.d.I.*, III, 1888, pl. XI, 19, and IV, 1889, p. 71; *A.G.*, pl. X, 58.
Imhoof-Blumer and Keller, pl. XXVI, 42.
Lippold, *Gemmen und Kameen*, pl. 78, no. 10.
Walters, *Cat.*, no. 602, pl. X.

359. *Chalcedony scaraboid.* Ht. 28 mm.

In the National Museum, Athens, inv. 884. Gift of K. Karapanos in 1910–11.

SPHINX, seated in profile to the left. She has recurving wings. Ground line.

Fifth century B.C.

Svoronos, *Journal international d'archéologie numismatique*, XV, 1913, no. 464.

360. *Rock crystal scaraboid*, mounted in a gold swivel ring. 20 × 28 mm.

In the Cabinet des Médailles. Gift of the duc de Luynes in 1862 (no. 289).

SEATED SPHINX, with recurving wings. Her hair is done up in a roll at the back of her head. Two forelegs are indicated but only one hindleg. Ground line.

Second half of fifth century B.C.

Furtwängler, *A.G.*, pl. XII, 48.
Lippold, *Gemmen und Kameen*, pl. 78, no. 11.

361. *Chalcedony scaraboid.* Fractured at bottom and round edge. 20 × 16 mm.

In the British Museum, 41.7-26.197. Acquired from the Stewart Collection in 1841.

SPHINX, seated in profile to the right. She has wavy hair, covering her ears. Ground line.

About 400 B.C.

Furtwängler, *A.G.*, pl. XIV, 12.
Lippold, *Gemmen und Kameen*, pl. 78, fig. 2.
Walters, *Cat.*, no. 520, pl. IX.

362. *Milky chalcedony scaraboid.* 22 × 19 mm.

In the Cabinet des Médailles, 1513ter = M2847.

SIREN, playing the kithara, in profile to the left, but with the body in slight three-quarter view (both breasts are indicated). Ground line.

Second half of the fifth century B.C.

363. *Rock crystal scaraboid*, mounted in a gold ring. Chipped along the edge. 24 × 18 mm.

In the Cabinet des Médailles. Gift of the duc de Luynes in 1862 (no. 264).

SCYLLA, in profile to the left. She is human down to the waist, and then has the body and tail of a fish at the back, and the forepart of a dog in front. The human part is shown wearing a sakkos, a belted peplos, and an earring.

Fine work of the second half of the fifth century B.C.

Perrot and Chipiez, *Histoire de l'art*, III, p. 442, fig. 315.
Pierres gravées, Guide du visiteur (1930), p. 139, no. 264 (not ill.).

364. *Greenish transparent glass scaraboid.* Fractured along edge. 22 × 16 mm.

In the Staatliche Museen, Berlin.

SCYLLA, in profile to the left. The upper part is in the form of a woman, from the waist down it becomes a large fish, and at the bottom emerge foreparts of dogs (now mostly broken off). She wears a sakkos and a girded, sleeveless chiton.

Delicate work of the second half of the fifth century B.C. Similar to the preceding.

Furtwängler, *Beschreibung*, no. 301; *A.G.*, pl. XIII, 32.
Lippold, *Gemmen und Kameen*, pl. 6, no. 2.

365. *Gold ring*, with engraved design on bezel. 26 × 29 mm.

From Reggio, Calabria. In the British Museum, 98.5-18.1. Acquired in 1898.

SEA-HORSE, galloping to the right. Only one wing is indicated but both forelegs, the farther one in lower relief than the nearer, to suggest the distance. Cf. pl. C.

Sensitive, expert work of the fourth century B.C., beautifully spaced in the large, oval field.

Furtwängler, *A.G.*, pl. LXIV, 14.
Marshall, *Cat. of Finger Rings*, no. 84, pl. III.
Lippold, *Gemmen und Kameen*, pl. 82, no. 14.

366. *Chalcedony scarab.* 13 × 15 mm.

In the National Museum, Athens, Numismatic section, inv. 927. Gift of K. Karapanos, 1910–11.

SEA-HORSE, swimming, in profile to the left. It has the form of a horse ending in a large fish tail. The forelegs are indicated, the hindlegs disappear in the water, which is indicated by a series of wavy lines.

Fifth to fourth century B.C.

Svoronos, *Journal international d'archéologie numismatique*, XV, 1913, no. 457.

367. *Sardonyx ringstone.* 21 × 15 mm.

In the Numismatic section of the National Museum, Athens, inv. 389. Gift of K. Karapanos, 1911.

TRITON, swimming to the left. He holds a trident in his left hand and in his right a trumpet-shaped sea-shell (?), into which he is blowing. His chest and shoulders are frontal, the lower part of his human trunk is foreshortened, and his scaly fish-body with winding tail, as well as his bearded head, are in profile. Below are coils, signifying the sea.

Second half of the fifth century.

Svoronos, *Journal international d'archéologie numismatique*, XV, 1913, no. 309.

368. *White jasper scaraboid.* 16·5 × 20·5 mm.

In the Ashmolean Museum, 1921.1219. From the Story-Maskelyne Collection.

GRIFFIN, with left foreleg raised, in profile to the right. Ground line.

Fifth to fourth century B.C.

Furtwängler, *A.G.*, pl. IX, 58.
Burlington Fine Arts Club Exh., 1904, p. 188, no. M, 38, pl. CVIII.
Sale Catalogue of the Story-Maskelyne Collection of Ancient Gems, 4th–5th July, 1921, no. 3, pl. I.
Lippold, *Gemmen und Kameen*, pl. 80, no. 12.

369. *Milky quartz scaraboid*, cut. 13 × 15 mm.

In the British Museum, 1921.7–11.5. Bought 1921. Formerly in the Story-Maskelyne and Arnold-Forster Collections.

CHIMAERA, running to the left. Thick ground line.

Fourth century B.C.

Cf. the coins of Sikyon, *B.M.C.*, Peloponnese, pl. VII, 17.

Furtwängler, *A.G.*, pl. XXXI, 7.
Burlington Fine Arts Club Exh., 1904, p. 189, pl. 108, no. M40.
Sale Catalogue of the Story-Maskelyne Collection, 4th–5th July, 1921, no. 42.
Walters, *Cat.*, no. 598, pl. X.

370. *Black jasper ringstone*, set in a modern mount. 9 × 10 mm.

In the Staatliche Museen, Berlin.

ACHELOOS, crowned by a flying Nike. He has a horned, bearded human head, and stands in profile to the right, with head turned to the front. Ground line.

Fifth to fourth century B.C.

The same composition, both to the left and to the right, occurs on didrachms of Neapolis of *c.* 450–340 B.C. and later; cf. Head, *H.N.*², pp. 38 f., figs. 16, 17. The worship of Acheloos was widespread in South Italy, especially in Neapolis, since he was the father of Parthenope. 'The flying Nike is doubtless an allusion to some Neapolitan victory' (Seltman, *Greek Coins*², p. 122). It has been surmised that the gem was worn on the ring of someone connected with that victory.

Furtwängler, *Beschreibung*, no. 356.

371. *Sard scarab*, cut, mounted in a modern gold ring, concealing the margin. 14 × 11 mm.

In the British Museum, Blacas 666. From the Blacas Collection.

ACHELOOS, represented as a bull with a human face. He is shown walking to the right, in profile with head turned frontal. Above him is a flying Nike holding a wreath. Ground line and hatched border.

Similar to the preceding.

Imhoof-Blumer, pl. XXVI, 46.
Walters, *Cat.*, no. 768, pl. XIII.

372. *Sard scaraboid*, set in gold band in an ancient swivel ring. 12 × 8 mm.

From Cyprus (?). In the British Museum. Acquired through the Franks bequest, 1897.

MONSTER, the head, shoulders, and forelegs are in the form of a bull; at the back are the wing and tail of a bird.

Marshall, *Cat. of Finger Rings*, no. 294.
Walters, *Cat.*, no. 523, pl. IX.
A. Roes, *Rev. arch.*, 1934, October, p. 147.

(h) *Animals*

As is well known, animals played an important part in Greek art during the classical period of the fifth and fourth centuries. Their beautiful forms and their agility evidently appealed. This growing interest in animal life is also reflected in the representations of the gems. Moreover, the animals are now accurately observed from life – at least those which were familiar to the Greeks, either as objects of the chase, or as household companions. Only a few wild animals like the lion, which were no longer prowling around Greek lands, had to be fashioned from 'memory', and the representations of them accordingly show a lack of direct observation (cf., e.g., nos. 374, 375).

The illustrations here given indicate the wide and varied field at the disposal of the artist. First comes the lion, of which the old popularity has now somewhat subsided, though his attacks on bulls, deer, and horses remain favourite designs, and are skilfully adapted to the round and oval fields of the stones (cf. nos. 373–386). One can observe here once again the frequent repetition of an adopted type, with constant variations. Particularly remarkable is the stance of the attacking lion which has jumped on the back of its victim – with one hindleg placed on the outstretched hindleg of the bull or deer or horse (cf. nos. 379, 380, 382, 383, 385). The convention was evidently copied from the Orient and appears also in sculpture (cf., e.g., N. M. Kontoleon in Χαριστήριον εἰς A. K. Ὀρλάνδον, I (1965), pp. 398 ff., pls. v, vi); and remained in force for a long time.

The bull and the cow remain popular (cf. nos. 387 ff.), and to them are joined charming representations of calves playing in the fields (nos. 400, 402, 403). There are also fine renderings of the boar (cf. no. 404) and of a wild sow, with two of her young (no. 405); of a bear running headlong as if pursued (nos. 406, 407); and of a fox shown approaching a bunch of grapes growing on a vine-branch (no. 409). An attractive scene (only partly preserved) appears on a stone in Copenhagen, representing several animals quietly listening to Orpheus' music (no. 408). Groups of animals appear also on two four-sided stones in Oxford and the British Museum (nos. 410, 411), including a wolf, a panther, a dog, and a lizard. (Cf. also the animals on the contemporary Graeco-Persian stones, e.g., the hyena and the reindeer (no. 517).

The horse occurs on several gems as a single design, including three masterpieces: a horse standing, with broken reins, in Boston (no. 421), a horse arriving riderless at the goal, in the Hermitage (no. 418), and a horse being attacked by a griffin, where its pain is depicted with a novel understanding of animal suffering (no. 422).

Other specially fine pieces are a donkey, in Boston (no. 423) 'a remarkable study of decrepitude'; two grazing deer in Boston and Berlin (nos. 433, 435); and a goat in London (no. 441). Noteworthy also is the group of a Pan about to hit an obstinate goat, which refuses to get up and gives Pan an angry look (no. 444).

Nos. 445–448 show four studies of dogs – one about to be bitten by a wasp (no. 445); another gnawing a bone (no. 446); a third peacefully sleeping while tethered to a tree (no. 447); and a fourth cautiously approaching some insect (no. 448) – all lifelike renderings. So are also three Bactrian camels (nos. 428–430).

Then comes a splendid assortment of birds – several herons (or cranes?), among them the famous one in the Hermitage signed by Dexamenos, an unrivalled masterpiece of glyptic art (cf. no. 467); the flying goose in the British Museum (no. 456); and a falcon in three-quarter back view, in Berlin (no. 470).

Included also are a quail (?) (no. 453), an eagle flying with a snake in its beak (no. 451), a cock and a hen (no. 452), and a peacock (no. 457). For a parrot cf. the Graeco-Persian stone, no. 518.

The smaller animals now also received the attention of the gem-engraver. Here included are a frog about to jump (no. 471); a crab (no. 476); two grasshoppers, one perched on an ear of wheat (nos. 474–475); a fly and a bee (nos. 479, 478); and, most remarkable of all, a wasp, with the veining on its wings and its slender body expertly rendered (no. 477). On no. 473 are two dolphins swimming side by side. As one looks at these little masterpieces one is reminded of the tradition that the great Pheidias carved such tiny things as a grasshopper, a bee, and a fly (cf. Julian Imperator, *Epist.*, 8; Nicephor. Gregor., *Hist.*, VIII, 7).

Our pleasure in viewing some of these representations is enhanced by the fact that they recall the sights familiar in Greece today. Travelling round the country one still encounters many of the animals that the Greeks engraved on their seals – donkeys, mules, and horses, browsing in the meadows; goats everywhere; eagles flying over the mountains of Delphi; and of course dogs, wild and tame. Absent, however, on the gems is any indication of the surrounding landscape. Only an occasional tree or flower or shrub is made to suggest the out-of-doors.

(a) Quadrupeds

373. *Chalcedony scaraboid.* 18 × 13 mm.

In the Cabinet des Médailles, no. E16.

LION, walking rapidly, in profile, to the left, with his mouth wide open as if roaring.

Fifth century B.C.

374. *Bluish-gray chalcedony scaraboid.* 19 × 28 mm.

In the Metropolitan Museum of Art, 07.286.121. Rogers Fund, 1907.

LION, prowling, in profile, to the left. Slightly curving ground line.

Second half of the fifth century B.C.

The dog-like type of lion, with short mane, recalls the lions of the Nereid Monument. Cf. also the lion, Furt-wängler, *A.G.*, pl. XI, 34.

Richter, *Animals*, fig. 22; *Hesperia*, Supplement VIII, 1949, pl. 35, no. 5; *Cat.*, no. 101, pl. XVIII.

375. *Banded agate sliced barrel*, with engraved design on flat side. 28 × 10 mm.

In the Museum of Fine Arts, Boston, 27.694. Formerly in the collections of A. J. Evans and E. P. Warren, who bought it about 1895. It was once in the possession of a priest at Taranto.

LIONESS, crouching for the spring. Her mouth is wide open, with teeth and tongue showing. Though a lioness,

with udders, she is represented with a mane, the artist evidently not being familiar with the beast in real life. Cf. pl. C.

Second half of the fifth century B.C.

Furtwängler, *A.G.*, pl. IX, 59.
Burlington Fine Arts Club Exh., 1904, p. 241, no. O, 45 (not ill.).
Beazley, *Lewes House Gems*, no. 65, pl. 5.
Richter, *Animals*, fig. 23.
Lippold, *Gemmen und Kameen*, pl. 84, no. 13.

376. *Sard scaraboid*, burnt. 27 × 23 mm.

In the British Museum, 98.7–15.4. Acquired 1898. Formerly in the Morrison Collection.

LION, advancing to the left, with head turned back and right paw raised.
Apparently meaningless bosses in the field. Ground line.

Second half of the fifth century B.C.

Morrison Sale Catalogue, 1898, no. 30.
Furtwängler, *A.G.*, pl. LXIV, 16.
Lippold, *Gemmen und Kameen*, pl. 86, fig. 5.
Walters, *Cat.*, no. 535, pl. XI.

377. *Rock crystal scaraboid*, with remains of the gold swivel ring. 28 × 21 mm.

From Cumae. In the British Museum, 1900.6–14.1. Bought 1900.

LION, walking, with its mouth wide open as if roaring. In front of him is a plant, at the back the ankh, symbol of life and prosperity.
Ground line and hatched exergue. Line border.

Second half of the fifth century B.C.

Walters, *Cat.*, no. 542, pl. IX.

378. *Chalcedony scaraboid.* 23 × 17 mm.

From Rhodes. In the British Museum, 1903.7-15.1. Bought in 1903.

LION, walking quietly to the left. Ground line.

Second half of the fifth century B.C.

Walters, *Cat.*, no. 541, pl. IX.

379. *Chalcedony scaraboid.* Fractured and chipped. 27 × 21 mm.

In the British Museum, 88.10-18.1. Bought 1888.

LION ATTACKING A BULL. The lion has sprung on the bull from behind and is biting its back, forepaws dug into its body, and hindpaw placed on its extended left hindleg. The bull is collapsing, with two legs bent under, the others outstretched.

Second half of the fifth century B.C.

Cf. the coins of Akanthos of after 424 B.C., *British Museum Guide*, pl. 10, no. 10.

Walters, *Cat.*, no. 537, pl. IX.

380. *Sapphirine chalcedony scaraboid.* 16 × 21 mm.

In the Fitzwilliam Museum, Cambridge. From the Leake Collection.

LION ATTACKING A BULL. He has sprung on the bull from behind and is biting it in the back; two of his legs are on the bull's body, one hindleg on its left hindleg. The bull is collapsing, with legs bent, the head lifted in agony. The lion's head is shown frontal; he has no mane.

Second half of the fifth century B.C.

Middleton, *Cat.*, p. v, no. 7, p. li.

381. *Chalcedony scaraboid*, mounted in a silver swivel ring. Chipped along the edge. 20 × 24 mm.

In the Cabinet des Médailles. Gift of the duc de Luynes in 1862 (no. 205).

LION ATTACKING A BULL. The lion has jumped on the bull from behind and is biting it in the back. The bull has fallen to the ground; two of its legs are bent under, the others outstretched.

Second half of the fifth century B.C.

Pierres gravées, Guide du visiteur (1930), p. 137, no. 205 (not ill.).

382. *Chalcedony scaraboid.* 22 × 28 mm.

In the British Museum, 72.6-4.1134. Acquired from the Castellani Collection in 1872.

LION ATTACKING A HORSE. The lion has jumped on the horse from behind and is biting it in the back, with forepaws dug into its body and hindpaws placed on its extended right hindleg. In scale the lion is smaller than the horse.

Second half of the fifth century B.C.

Imhoof-Blumer and Keller, pl. XVI, 68.
Walters, *Cat.*, no. 536, pl. IX.

383. *Sard scaraboid.* 18 × 15 mm.

From Greece. In the British Museum, 91.6-25.3. Bought 1891.

LION ATTACKING A DEER. The lion has jumped on the deer from behind and is biting it in the back. The deer has collapsed, with legs placed in different directions. One hindpaw of the lion is on the deer's outstretched hindleg. Only one antler of the deer is indicated, but all four legs.

Second half of the fifth century B.C.

Walters, *Cat.*, no. 540, pl. IX.

384. *Gold ring*, with engraved design on bezel. 14 × 20 mm.

In the Louvre, Bj 1085.

LION ATTACKING A DEER. He has jumped on the deer from behind and is biting it in the back. The deer has fallen to the ground, with legs bent under, but head erect.

Fifth to fourth century B.C.

De Ridder, *Cat. des bijoux*, no. 1085.
H. Hoffmann and P. F. Davidson, *Greek Gold*, no. 113.

385. *Chalcedony scaraboid.* Yellowing brown. 38 × 30 mm.

Said to have been found in the East. In the Cabinet des Médailles. Acquired through the gift of Pauvert de La Chapelle in 1899.

LION ATTACKING A DEER. The lion is biting the deer in the back with forepaws digging into its hindquarters, and hindpaws placed on its outstretched left hindleg. The deer has sunk to the ground, its left forelegs still lifted, and its head turned in slight three-quarter view, with both antlers shown. Ground line. On the convex side of the stone is an Arabic inscription.

Second half of the fifth century B.C.

Babelon, *Cat., Coll. Pauvert de La Chapelle*, no. 59, pl. v.
Furtwängler, *A.G.*, vol. III, p. 447, fig. 229 ('das Schulterblatt des Löwen erinnert an persischen Stil').

386. *Rock crystal scaraboid.* 20 × 15 mm.

In the British Museum, Blacas, 622. Acquired from the Blacas Collection.

LION ATTACKING A DEER. The lion has sprung on the deer from behind and is biting its back. One of the lion's hindlegs is still on the ground, the other is placed on the deer's hindquarters. Hatched border.

Late fifth century B.C.

Furtwängler, *A.G.*, pl. XIII, 36.
Lippold, *Gemmen und Kameen*, pl. 85, fig. 9.
Walters, *Cat.*, no. 538.
Richter, *Animals*, p. 50, fig. 21.

387. *Chalcedony scaraboid*, in a box setting once attached to a gold ring. 28 × 23 mm.

From Syria. In the British Museum, 1912.11–12.1. Bought 1912.

BULL, in profile to the left, with head lowered, as if butting. Ground line.

Later fifth century B.C.

The ring is of type CXX in Marshall's *Cat. of Finger Rings*, p. XLII, there assigned to the fourth century B.C.
For the bulls on this and the following gems, cf. those on the coins of Thourion of *c.* 425–350 B.C., shown in similar attitudes; Head, *H.N.²*, pp. 85 ff., etc.

Walters, *Cat.*, no. 585, pl. X.

388. *Chalcedony scaraboid.* 22 × 18 mm.

In the British Museum, 89.8–5.1. Bought 1889.

BULL, in profile to the left, with head lowered and right foreleg lifted. Ground line.

Fifth century B.C.

Walters, *Cat.*, no. 544, pl. IX.

389. *Sapphirine chalcedony scaraboid*, cut. 23 × 17 mm.

In the Museum of Fine Arts, Boston, 23.585. Formerly in the collection of E. P. Warren, who bought it at Ruvo in 1898–99.

PLUNGING BULL, in profile to the right, with head turned in three-quarter view. Ground line.

About 400 B.C.

Burlington Fine Arts Club Exh., 1904, p. 228, no. O, 3 (not ill.).

Beazley, *Lewes House Gems*, no. 79, pl. 4.
Richter, *Animals*, fig. 97.

390. *Chalcedony scaraboid*, speckled with yellow jasper. 22 × 18 mm.

In the Staatliche Museen, Berlin, Acquired in Athens.

BUTTING BULL, in profile to the left, with head turned to the front in three-quarter view.

Fourth century B.C.

Imhoof-Blumer and Keller, pl. XIX, 12.
Furtwängler, *Beschreibung*, no. 310; *A.G.*, pl XI, 31.

391. *Pale brown chalcedony scaraboid*, set in a modern mount. 21 × 17 mm.

In the Fitzwilliam Museum, Cambridge. Given by Alfred A. de Pass, in 1933.

BULL, in profile to the left, with the head turned in three-quarter view, and the left foreknee on the ground. Ground line.

Late fifth century B.C.

Furtwängler, *A.G.*, pl. IX, 19.
Burlington Fine Arts Club Exh. Cat., p. 190, M47, pl. CVIII.
Sotheby Sale Cat. of the Story-Maskelyne Coll., July 5th, 1921, no. 33.
Lippold, *Gemmen und Kameen*, pl. 90, no. 7.

392. *Carnelian scarab.* 14 × 20 mm.

In the National Museum, Athens, Numismatic Section, inv. 489. Gift of K. Karapanos.

BULL, standing in profile to the right, with head turned to the front, and with the left foreleg lifted. Ground line.

Late fifth century B.C.

Svoronos, *Journal international d'archéologie numismatique*, XV, 1913, no. 488.

393. *Carnelian*, chipped along the edge. The back of the stone is in the form of a recumbent lion. L. 20 mm.

In the Metropolitan Museum of Art, 26.31.380. Bequest of Richard B. Seager, 1926.

BULL, in profile to the left, walking with head turned in three-quarter view. Hatched border.

Last quarter of the fifth century B.C.

Richter, *M.M.A. Handbook*, 1953, p. 149; *Cat.*, no. 103, pl. XVIII.

394. *Rock crystal scaraboid.* 27 × 19 mm.

In the British Museum, 65.7–12.87. Acquired from the Castellani Collection in 1865.

BULL, walking slowly to the left, with lowered head. Ground line.

Last quarter of the fifth century B.C.

Imhoof-Blumer and Keller, pl. XIX, 9.
Furtwängler, *A.G.*, pl. XI, 32.
Lippold, *Gemmen und Kameen*, pl. 90, fig. 11.
Walters, *Cat.*, no. 543, pl. IX.

395. *Banded agate scaraboid.* 22 × 17 mm.

From Southern Italy. In the Cabinet des Médailles. Acquired through the gift of Pauvert de La Chapelle in 1899.

FOREPART OF A BULL, in profile to the right, with head turned in three-quarter view, and forelegs placed as if swimming.

Last quarter of the fifth century B.C.

Cf. the coins of Samos, *B.M.C.*, Ionia, pl. XXXIV, XXXV, XXXVI, and of Gela, Head, *H.N.²*, p. 140, fig. 73.

E. Babelon, *Coll. Pauvert de La Chapelle*, no. 63, pl. V.
Furtwängler, *A.G.*, vol. III, p. 447.

396. *Chalcedony scaraboid.* 14 × 19 mm.

In the Staatliche Münzsammlung, Munich. From the Arndt Collection.
From Mazaca (Caesarea), in Cappadocia.

FOREPART OF A BULL, in profile to the left, with left foreleg bent under, the other lowered. Only one horn and one ear are indicated.

Second half of the fifth century B.C.

Cf. the forepart of a bull on the coins of Samos, shown in a similar attitude – with one leg bent under – *British Museum Guide*, pl. 8, no. 29 ('latter end of the fifth century B.C.').

Lippold, *Gemmen und Kameen*, pl. 91, no. 3.
Czako and Ohly, *Griechische Gemmen*, no. 11.

397. *Banded sard*, set in a modern gold ring. 18 × 12 mm.

In the British Museum, T208. From the Towneley Collection.

BULL CALF, slowly walking to the right. Ground line.

Late fifth century B.C.

Raspe, no. 13046.
Walters, *Cat.*, no. 607, pl. X.

398. *Agate scaraboid*, black streaked with grey. 16 × 13 mm.

In the Museum of Fine Arts, Boston, 21.1211. Formerly in the Tyszkiewicz Collection. 'Sent from Constantinople' (Froehner).

BULL CALF, standing with head lowered. Cf. pl. C.

Late fifth century B.C.

Froehner, *Sale Cat. of the Tyszkiewicz Collection*, no. 269.
Burlington Fine Arts Club Exh., 1904, p. 241, no. O, 43 (not ill.).
Beazley, *Lewes House Gems*, no. 76, pl. 4.
Richter, *Animals*, fig. 99.

399. *Chalcedony ringstone*, slightly convex on the engraved side. Fractured. 25 × 19 mm.

Said to be from Constantinople. In the Staatliche Museen, Berlin. Once in the Pourtalès Collection.

COW, slowly walking to the right. Ground line.

Fine work of the fifth to fourth century B.C., with all details carefully observed; comparable to the bronze statuette in the Cabinet des Médailles, Babelon and Blanchet, *Cat.*, no. 1157; Richter, *Animals*, fig. 98.

Imhoof-Blumer and Keller, pl. XIX, 24.
Furtwängler, *Beschreibung*, no. 357.

400. *Chalcedony scaraboid*, cut. 20 × 30 mm. Lower edge missing.

In the Staatliche Museen, Berlin.

TWO CALVES, playing together, one jumping up at the other. Ground line.

Second half of the fifth century B.C.

Furtwängler, *Beschreibung*, no. 193; *A.G.*, pl. XI, 16.

401. *Gold ring*, with engraved design on bezel. 15 × 11 mm.

In the Louvre, Bj 1043. Acquired from the Campana Collection in 1862.

BULL, standing in profile to the left, with head turned to the front. Beaded border.

Slight work of the fifth century B.C.

De Ridder, *Bijoux antiques*, no. 1043.

402. *Chalcedony scaraboid.* 23 × 19 mm.

In the Bowdoin College Museum of Art, Brunswick, Maine, 1915.76. Gift of E. P. Warren.

BULL CALF, standing in profile to the left. A bell is hanging from its neck. Slightly curving ground line.

Second half of the fifth century B.C.

Beazley, *Lewes House Gems*, p. 66, pl. B, 5.

403. *Chalcedony scaraboid.* 13 × 16 mm.

In the Ashmolean Museum, 1922.15.

BULL CALF, bounding to the left. Cf. pl. C.

Fifth to fourth century B.C.

404. *Carnelian cylinder.* Engraved on one rounded side. Ht. of cylinder 32 mm.

From Crete (?). In the Ashmolean Museum, 1938.961. Gift of Sir Arthur Evans.

BOAR, standing in profile to the left, with the head in slight three-quarter view (both ears are indicated). Ground line.

Later fifth century B.C.

405. *Chalcedony scaraboid.* 16 × 11 mm.

In the Museum of Fine Arts, Boston, 27.692. Formerly in the collection of E. P. Warren, who bought it in Athens in 1911.

WILD SOW, walking to the left, with two young between her legs. The bristles of the mane and rump are separated by a gap, in which the bristles are much shorter. Ground line. Hatched border.

Third quarter of the fifth century B.C.

Boars and wild sows, with or without young, are common on Greek gems of the archaic and free styles; cf. the list given by Furtwängler, *A.G.*, III, p. 105, to which may be added those in New York, *Cat.*, nos. 59–62, and in Boston, Beazley, *op. cit.*, 70, 71.
Similar boars and sows appear on Ionian coins, with the same gap between mane and rump bristles; cf., e.g., *British Museum Guide*, pl. 8, no. 21 (Methymna); Regling, *Münze*, pl. VI, 150 (staters struck during the Ionian Revolt). On the rendering of mane and bristles cf. Furtwängler, *Goldfund von Vettersfelde*, pp. 23 f.; Beazley, *Lewes House Gems*, 63.

Beazley, *Lewes House Gems*, no. 70, pl. 5.

406. *Chalcedony scaraboid.* 30 × 23 mm.

In the Staatliche Münzsammlung, Munich. From the Arndt Collection.

BEAR, running headlong to the right, as if pursued. All four legs are indicated, but only one ear. Thick ground line.

Second half of the fifth century B.C.

Lippold, *Gemmen und Kameen*, pl. 88, no. 2.
Maximova, *Arch. Anz.*, 1928, col. 673, fig. 27d.
Czako and Ohly, *Griechische Gemmen*, no. 13.

407. *Chalcedony scaraboid.* Chipped round edge. 21 × 17 mm.

In the Museum für Kunst und Gewerbe, Hamburg. From the collection of Dr. J. Jantzen, Bremen.

BEAR, running headlong to the left, as if pursued. All four legs are indicated and both ears.
Perhaps an extract from a bear hunt.

Second half of the fifth century B.C.

Cf. no. 406.

Zazoff, *Arch. Anz.*, 1963, cols. 59 ff., no. 11, fig. 3.
Lullies, *Griechische Plastik, Vasen, und Kleinkunst*, Leihgaben aus Privatbesitz, Kassel, Staatliche Kunstsammlungen, 1964, no. 75.

408. *Carnelian ringstone.* Left part missing. 15 × 15 mm.

In the Thorvaldsen Museum, Copenhagen.

ORPHEUS AMONG THE ANIMALS. Of Orpheus only the lyre is preserved. Facing him are an eagle, a wolf, a ram, and a goat, lying quietly together in a rocky landscape and listening to Orpheus' music. They are shown one below the other, on different levels, the eagle perched at the top, then the wolf, standing with head erect, then the ram, recumbent, and lastly the goat (only the upper part is preserved). Growing plants are visible among the rocks.

Fifth to fourth century B.C.

For representations on vases of animals listening spellbound to Orpheus' music cf. Gruppe, in Roscher's *Lexicon*, s.v. Orpheus, cols. 1177, 1190 ff., 1199 ff., and Ziegler in *R.E.*, XVIII, 1 (1939), s.v. Orpheus, cols. 1311 f., and the references there cited.

Cades, III, B 158.
Gruppe, in Roscher's *Lexikon*, s.v. Orpheus, col. 1201.
Stephani, *Compte rendu*, 1881, p. 103, no. 10.
Furtwängler, *A.G.*, pl. XIV, 40.
Lippold, *Gemmen und Kameen*, pl. 48, no. 9.
Fossing, *Cat.*, no. 10, pl. I.

409. *Chalcedony scaraboid*, cut. Fractured at the bottom and on one side. 21 × 16 mm.

In the Ashmolean Museum, 1892.1494. From Trikka, Thessaly. Acquired through the Chester bequest.

A FOX, walking after a bunch of grapes growing on a vine-branch. His hindlegs are still on the rocky ground, the forelegs are already on the branch, within easy reach of the grapes. Flowers are growing among the rocks. Cf. pl. C.

Second half of the fifth century B.C.

A remarkably lifelike representation.

Furtwängler, *A.G.*, pl. IX, 62.
Gow, *J.H.S.*, XXXIII, 1913, p. 216, fig. 4.
Lippold, *Gemmen und Kameen*, pl. 87, no. 5.

410. *Chalcedony four-sided prism.* All four sides are engraved. L. *c.* 21 mm.

In the Ashmolean Museum, 1925.134. Once in the collections of Furtwängler and Wyndham Cook.

Each side is decorated with the figure of an animal:
(1) DOG, running, in profile to the left.
(2) FOX, with bushy tail, running, in profile to the left.
(3) LIZARD, seen from the top, but with legs indicated on either side.
(4) HERON OR CRANE, standing on both legs, in profile to the left.

Fifth to fourth century B.C.

Burlington Fine Arts Club Exh., 1904, p. 255, no. O, 95, pl. CXII.
Lippold, *Gemmen und Kameen*, pl. 88, no. 10.

411. *Chalcedony rectangular bead.* 15 × 5 mm.

From Sicily. In the British Museum, 72.6–4.1262. Acquired from the Castellani Collection in 1872.

Engraved on each of its four sides:
(1) LION, slowly walking to the right.
(2) HORSE, walking with head lowered.
(3) OX, walking.
(4) PANTHERESS, walking, a thyrsos with a sash in her left forepaw.
Under each animal is a ground line.

Fifth to fourth century B.C.

Furtwängler, *A.G.*, vol. III, p. 134.
Walters, *Cat.*, no. 605, pl. X.

412. *Chalcedony scaraboid*, yellowish grey, mounted in a silver swivel ring. Cracked at the back. The silver is corroded. 22 × 14 mm.

From Cyprus. In the Metropolitan Museum of Art, 74.51.4198 (C.E.22). Purchased by subscription, 1874–76.

HORSE, in the act of lying down. The legs are bent, the head lowered. The mane is hogged and the tail is hatched in a herring-bone pattern. The body and legs are shown in profile, the head in front view.

Inscribed above, in large letters, Στησικράτης, Stesikrates, in Ionic script, evidently the name of the owner of the stone. Ground line and line border.

Middle of the fifth century B.C.

Cesnola, *Cyprus*, pl. XL, 14; *Atlas*, III, pl. XXVII, 2.
Keller, *Die antike Tierwelt*, I, pl. III, no. 11, p. 230.
Imhoof-Blumer and Keller, pl. XVI, 42.
Myres, *Handbook*, no. 4198.
Richter, *Animals*, pp. 17, 60, fig. 72; *M.M.A. Handbook*, 1953, p. 149; *Cat.*, no. 105, pl. XVIII.
Grace, *Hesperia*, IV, 1935, p. 427.

413. *Carnelian scaraboid.* Fractured along the edge. 15 × 12 mm.

In the Cabinet des Médailles. Acquired through the gift of Pauvert de La Chapelle in 1899.

RIDERLESS HORSE, galloping to the right, the bridle in its mouth. Hatched border.

Second half of the fifth century B.C.

E. Babelon, *Coll. Pauvert de La Chapelle*, no. 65, pl. VI.
Furtwängler, *A.G.*, vol. III, p. 447.

414. *Carnelian scaraboid.* 16 × 21 mm.

From Crete. In the Staatliche Museen, Berlin.

HORSE, with bridle and broken reins, galloping to the left.

Second half of the fifth century B.C.

Imhoof-Blumer and Keller, pl. XVII, 40.
Furtwängler, *Beschreibung*, no. 303; *A.G.*, pl. XIV, 16.
Lippold, *Gemmen und Kameen*, pl. 89, no. 14.

415. *Chalcedony scaraboid.* Chipped round the edge. 17 × 23 mm.

In the Royal Cabinet of Coins and Gems, The Hague.

HORSE, galloping to the left, with hindlegs on the ground, the forelegs lifted. It has a forelock and a short, striated mane. Ground line.

Last quarter of the fifth century B.C.

Monnaies et Médailles, XXVIII, June 19th–20th, 1964, no. 63.
Guépin, *Hermeneus*, XXXV, p. 283, fig. 3; *Bulletin Antieke Beschaving*, 1966, p. 53, fig. 6.

416. *Sard scaraboid.* Fractured at bottom. 20 × 15 mm.

In the British Museum, H412. From the Hamilton Collection.

HORSE, galloping to the right, Above is an olive twig; at the bottom a plant (?), mostly broken away. Hatched border.

Late fifth century B.C.

Raspe, 13241.
Imhoof-Blumer and Keller, pl. XVI, 45.
Walters, *Cat.*, no. 550, pl. X.

417. *Glass scaraboid.* Surface corroded. 20 × 29 mm.

In the National Museum, Athens, Numismatic section, inv. 847. Gift of K. Karapanos, 1910–11.

HORSE, grazing, in profile to the right. Ground line.

Second half of the fifth century B.C.

Svoronos, *Journal international d'archéologie numismatique*, XV, 1913, no. 494.

418. *Yellowish jasper scaraboid,* sprinkled with red. Chipped around the edge. 22 × 18 mm.

Found in a grave at Kerch, together with an archaic Greek gem (Furtwängler, *A.G.*, pl. VIII, 52) and with Attic vases of the end of the fifth century B.C. In the Hermitage.

RACE-HORSE. It has arrived at the goal riderless, with loose, broken reins. The goal is indicated by a post, to

which has been tied a fillet, and which seems to have been surmounted by some object now broken away. Irregular ground line. Hatched border.

Second half of the fifth century B.C.

The rendering of the horse in fiery action is beyond praise.

Stephani, *Compte rendu*, 1859, p. X, and 1860, p. 90, pl. IV, 10.
Imhoof-Blumer and Keller, pl. XVI, 62.
Furtwängler, *A.G.*, pl. XIV, 15.
Beazley, *Lewes House Gems*, p. 48.
Lippold, *Gemmen und Kameen*, pl. 89, no. 6.

419. *Rock crystal scaraboid.* Chipped along the edge. 28 × 23 mm.

From Lecce. In the British Museum, 1909.5-25.1. Bought 1909.

HORSE, galloping to the right, with bridle flying loose behind.

Fourth century B.C.

Walters, *Cat.*, no. 588, pl. X.
Wuilleumier, *Tarente*, p. 368.

420. *Chalcedony*, in modern setting. 15 × 16 mm.

In the Fitzwilliam Museum, Cambridge. Given by Alfred A. de Pass, in 1933. No. De Pass, 19.

HORSE WALKING, in profile to the right. Ground line.

Fifth to fourth century B.C.

Cf. the horse on the coins of Larisa, Thessaly, *British Museum Guide*, pl. 22, no. 24.

421. *Smoky chalcedony ringstone.* Cut and chipped around the edge. 20 × 15 mm.

From Messenia (Rhousopoulos). In the Museum of Fine Arts, Boston, 27.698. Formerly in the Postolakka Collection in Athens; then successively in the possession of Rhousopoulos and of Hartwig, from whom, in 1895, it was bought by E. P. Warren.

HORSE, standing with one foreleg lifted, the broken reins hanging down from its mouth. Inscribed in the field, in two lines: Ποτα|νεα, according to Beazley the genitive of the name Potaneas – not otherwise known – evidently the name of the owner of the stone. Hatched ground line and hatched border. Cf. pl. A.

Perhaps around 440 B.C.

All details are carefully observed and sensitively rendered: in the head the loose skin under the mouth, the delicate nostrils, and the wide-open eye with upper and lower lids differentiated; on the body, the creases at the neck, the folds of skin at the junction of forelegs and body, the slightly protruding ribs, and the depressions on the hindquarters. Admirable also are the delicate lines for the mane and tail. And yet all details are subordinated to the design of the whole. The engraving has been attributed to Dexamenos, in whose period the stone belongs. But whatever his name, he was not only a great artist, but a lover of horses.

Imhoof-Blumer and Keller, pl. XVI, 37.
Furtwängler, *A.G.*, pl. IX, 31, pl. XIV, 5, pl. LI, 9.
Bulle, *Neue Jahrbücher*, V, 1900, pl. I, 21, p. 686.

Burlington Fine Arts Club Exh., 1904, p. 237, no. O, 26 (not ill.).
Beazley, *Lewes House Gems*, no. 67, pls. 4 and 10.
Lippold, *Gemmen und Kameen*, pl. 89, no. 3.

422. *Chalcedony scaraboid*, mounted in a silver ring. 20 × 27 mm.

In the Cabinet des Médailles. Gift of the duc de Luynes in 1862 (no. 200).

GRIFFIN ATTACKING A HORSE. The griffin has sprung on the horse from behind and is biting it in the back, with forelegs dug into its body, and hindlegs placed on its outstretched left hindleg. The horse rears, with three of its legs off the ground; the eye is breaking; the tongue protrudes. Ground line. Cf. pl. A.

Second half of the fifth century B.C.

The contrast between the rapacious griffin and the suffering horse is rendered in masterly fashion, with the restraint characteristic of the period.

Cf. the griffin attacking a horse on a late red-figured lekane from South Russia, *Stephani, Compte rendu de la comm. impérial*, S. Pétersbourg, 1861, pl. II, no. 3, pp. 29 ff., where, however, the expression of the horse is generalized.

Mansell, *Gaz. arch.*, II, 1876, p. 131 (with drawing).
Furtwängler, *A.G.*, pl. XXXI, 3.
Beazley, *Lewes House Gems*, pp. 49, 62.
Lippold, *Gemmen und Kameen*, pl. 81, no. 7.

423. *Gold ring*, with engraved design on bezel. 19 × 11 mm.

In the Museum of Fine Arts, Boston, 27.701. Formerly in the E. P. Warren Collection. Bought in Sicily, 1901.

DONKEY. The body is emaciated, with protruding bones, inflated belly, and a sore on the neck. Cf. pl. C.

Early fourth century B.C.

The patient suffering of the donkey is rendered with penetrating observation.

Burlington Fine Arts Club Exh., 1904, p. 250, no. O, 74 (not ill.).
Beazley, *Lewes House Gems*, no. 83, pl. 3.
H. Hoffmann and P. F. Davidson, *Greek Gold*, no. 110.

424. *Streaked sard scaraboid*, in a modern mount. 17 × 12 mm.

In the Museum of Fine Arts, Boston. Formerly in the E. P. Warren Collection.

MULE, walking to the right. Line border.

Later fifth century B.C.

Beazley, *Lewes House Gems*, no. 69, pl. 4.

425. *Carnelian ringstone*, convex on the engraved side. 14 × 11 mm.

In the Staatliche Museen, Berlin.

TWO WOLVES TEARING A DONKEY TO PIECES. The donkey has fallen on its side, with legs outspread, mouth open, eye breaking. Below are three oblique lines to indicate the ground. Hatched border.

Fourth century B.C.

The agony of the donkey is graphically conveyed.

Imhoof-Blumer and Keller, pl. xv, 62.
Furtwängler, *Beschreibung*, no. 360.

426. *Carnelian scaraboid*. 13 × 18 mm.

In the Staatliche Münzsammlung, Munich. From the Arndt Collection.

PEGASOS, drinking, with head lowered. The water is indicated by oblique lines. Both wings are drawn and all four legs. Hatched border.

Fourth century B.C.

Czako and Ohly, *Griechische Gemmen*, no. 23.

427. *Carnelian ringstone*. 13 × 9 mm.

In the Staatliche Museen, Berlin.

TWO WINGED HORSES, standing alongside each other, one with head erect, the other with it thrust downward. All eight legs are indicated, but only two wings. Ground line. Hatched border.

Fourth century B.C.

Furtwängler, *Beschreibung*, no. 361; *A.G.*, XLV, 43.
Lippold, *Gemmen und Kameen*, pl. 82, no. 9.

428. *Chalcedony scaraboid*. Fractured on one side and chipped along the edge. 33 × 24 mm.

In the British Museum, 1903.7-15.1. Bought 1892.

BACTRIAN CAMEL, with two humps, walking to the left. Irregular ground line. Cf. pl. C.

Second half of the fifth century B.C.

Furtwängler, *A.G.*, pl. XII, 49.
Lippold, *Gemmen und Kameen*, pl. 89, fig. 7.
Walters, *Cat.*, no. 547, pl. x.

429. *Chalcedony scaraboid*, discoloured. 21 × 17 mm.

In the British Museum, 91.6-25.4. Bought 1891.

BACTRIAN CAMEL, with two high humps, slowly walking to the left. Line border.

Second half of the fifth century B.C.

Walters, *Cat.*, no. 546, pl. X.

430. *Chalcedony scaraboid.* 16 × 22 mm.

In the Ashmolean Museum, 1892.1355. Gift of the Rev. J. C. Murray Aynsley.

CAMEL, kneeling, in profile to the right. Only two legs are indicated.

Fifth to fourth century B.C.

431. *Chalcedony scaraboid.* 25 × 18 mm.

In the Cabinet des Médailles.

ANTELOPE. It is shown with legs bent – perhaps in the act of rising. All four legs are indicated (the right hindleg very slightly), but only one horn and one ear. The figure is placed obliquely on the stone.

Near the middle of the fifth century B.C.

Cf. the similar representations on the scaraboid in New York (*Cat.*, no. 113) and on a stone in a private collection in New York.

Imhoof-Blumer and Keller, pl. XVII, 41.
Chabouillet, *Cat.*, no. 1047.
Pierres gravées, Guide du visiteur (1930), p. 14, no. 1047 (not ill.).

432. *Light yellow chalcedony scaraboid.* There are a few chips. 17 × 21 mm.

In the Metropolitan Museum of Art, New York, 49.43.6. Posthumous gift of Joseph Brummer, through Ernest Brummer, 1949.

GAZELLE, perhaps in the act of rising. Two forelegs are indicated, but only one hindleg, one horn, and one ear. Similar to the preceding, with a few variations in the position of the legs and of the tail.

Second half of the fifth century B.C.

Richter, *Hesperia*, Supplement VIII, 1949, p. 298, pl. 36, no. 4; *Cat.*, no. 113.

433. *Light brown sard scaraboid*, cut; the perforation still visible. *c.* 21 × 15 mm.

In the Staatliche Museen, Berlin. Acquired from the Demidoff Collection in 1838.

DEER BROWSING, in profile to the left. Lightly engraved ground line.

Delicate work of the late fifth century B.C.

Both the stance and the anatomical details are beautifully rendered. There is a replica of this design in Boston (cf. my no. 435); cf. also the similar stones cited by Beazley, *Lewes House Gems*, p. 65.

Cades, *Impr. gem.*, cl. 15, 135.
Imhoof-Blumer and Keller, pl. XVII, 21.
Furtwängler, *Beschreibung*, no. 304; *A.G.*, pl. XIV, 13.
Lippold, *Gemmen und Kameen*, pl. 92, no. 9.

434. *Transparent, colourless glass*, perhaps sliced. Scratches in the field. 21 mm.

In the Metropolitan Museum of Art, 42.11.20. Purchase, 1942, Pulitzer bequest. From the Evans Collection.

FALLOW DEER, browsing, with head lowered, in profile to the left, with the head turned in slight three-quarter view. Irregular ground line.

Cast from the late fifth-century scaraboid in Berlin, my no. 433, either in ancient or modern times, with a scratched ground line added.

There is an impression of the Berlin gem in Cades, *Impr. gem.*, cl. 15, 135.

Evans, *Selection*, no. 48.
Richter, *Evans and Beatty Gems*, no. 25; *Cat.*, no. 108, pl. XIX.

435. *Sard*, probably cut from a scaraboid. 22 × 17 mm.

In the Museum of Fine Arts, Boston, 21.1209. Formerly in the Boulton and E. P. Warren Collections. Bought by Warren in 1917.

FALLOW DEER, browsing. Ground line.

Late fifth century B.C.

Similar to no. 433.

Sale Catalogue of the Boulton Collection, part of no. 42.
Beazley, *Lewes House Gems*, no. 74, pls. 5, 10.
Richter, *Animals*, fig. 148.

436. *Agate scaraboid.* 19 × 22 mm.

In the British Museum, 72.6–4.1135. Acquired from the Castellani Collection in 1872.

DEER, struck by a spear in its shoulder, is falling on its knees. The spear is drawn in two directions, perhaps to suggest the motion. Irregular ground line.

End of fifth century B.C.

Imhoof-Blumer and Keller, pl. XVII, 20.
Furtwängler, *A.G.*, pl. XI, 27.
Walters, *Cat.*, no. 548, pl. X.
Lippold, *Gemmen und Kameen*, pl. 92, no. 3.

437. *Agate scaraboid*, brownish. 17 × 13 mm.

In the British Museum, 65.7–12.118. Acquired from the Castellani Collection in 1865.

DEER, bounding to the left.

Imhoof-Blumer and Keller, pl. XVII, 19.
Walters, *Cat.*, no. 549, pl. X.

438. *Sardonyx ringstone.* 14 × 10 mm.

In the Staatliche Museen, Berlin.

GRIFFIN ATTACKING A DEER. It has jumped on the deer from behind, and is biting it in the back; it has a dentated mane, and its wings are outspread. The deer has fallen to the ground, its legs bent in different directions, the head erect. Ground line.

Fourth century B.C.

Cf. the griffin attacking a hind on a red-figured lekane from South Russia, Stephani, *Compte rendu*, 1861, no. 2.

Imhoof-Blumer and Keller, pl. XXV, 61.
Furtwängler, *Beschreibung*, no. 364; *A.G*, pl. XIII, 39.

439. *Bluish chalcedony scaraboid.* 28 × 20 mm.

From Athens. In the Staatliche Museen, Berlin.

HOUND ATTACKING A HIND. It has jumped on the hind's back and is biting it in the neck. The hind is collapsing, with forelegs bent and head turned back.

Second half of the fifth century B.C.

Imhoof-Blumer and Keller, pl. XVII, 23.
Furtwängler, *Beschreibung*, no. 307.

440. *Round carnelian scaraboid*, engraved on both sides. 18 × 19 mm.

In the Staatliche Münzsammlung, Munich. From the Arndt Collection.

(1) On the flat side: DEER, standing beside a palm tree, on a curving ground line, perhaps to indicate hilly ground. Both antlers are indicated.
(2) On the convex side: BEE, for which see no. 478.

First half of the fourth century B.C.

Cf. the bee and forepart of a stag, with a palm tree at the back, on tetradrachms of Ephesos, dated *c.* 394 B.C. or later; Head, *H.N.²*, p. 573, fig. 295; *B.M.C.*, Ionia, pl. IX, 8; *British Museum Guide*, pl. 19, no. 35, dated 400–336 B.C.

Czako and Ohly, *Griechische Gemmen*, nos. 16, 17.

441. *Rock crystal scaraboid*, set in the original swivel ring. Chipped along the edge. 23 × 18 mm.

In the British Museum, 1905.6–6.3. Bought at a sale in Paris, 1905.

WILD GOAT, slowly walking to the left. Only one horn is indicated, but both ears. Hatched border.

Late fifth century B.C.

Cf. the goats on the coins of Ainos *British Museum Guide*, pl. 21, no. 5 (400–336 B.C.), and the bronze statuette in the Musée d'Art et d'Histoire, Geneva, C1165, Deonna, *Catalogue des bronzes figurés antiques*, no. 105; Richter, *Animals*, fig. 128 (late fifth century B.C.).

Collection d'un archéologue explorateur, pl. 2, no. 28.
Beazley, *Lewes House Gems*, p. 64, pl. A, 28.
Walters, *Cat.*, no. 590, pl. X.

442. *Rock crystal scaraboid.* Chipped along the edge. 29 × 22 mm.

From Lecce. In the British Museum, 1909.5–25.2. Bought 1909.

GOAT, walking to the right. Both horns and both ears are indicated. Ground line.

Fifth to fourth century B.C.

Cf. the goat on the coins of Ainos of about 421–365 B.C., Hill, *Select Greek Coins*, pl. LVI, 2; Richter, *Animals*, fig. 132.

Beazley, *Lewes House Gems*, pp. 64, 67.
Walters, *Cat.*, no. 591, pl. X.
Richter, *Animals*, p. 70, fig. 131.
Wuilleumier, *Tarente*, p. 368.

443. *Carnelian scaraboid*, mounted in a gold swivel ring. L. 22 mm.

In the Staatliche Münzsammlung, Munich. From the Arndt Collection.

WILD GOAT, running at full speed to the left, legs outspread, tail raised. All four legs are indicated, but only one horn and one ear.

Fifth century B.C.

Czacho and Ohly, *Griechische Gemmen*, no. 20.

444. *Carnelian scaraboid.* The back not finished and the perforation not completed. 14 × 24 mm.

In the Staatliche Münzsammlung, Munich.

PAN WITH GOAT. He has seized it by its beard, and is about to hit it with the curved stick (pedum) in his right hand. The goat is lying on the ground, with bent legs, obstinately refusing to get up; its head is turned toward Pan, with its mouth open, and an angry look.

Cursory, but spirited work of the fifth century B.C.

The expression of the goat is particularly remarkable.

Czako and Ohly, *Griechische Gemmen*, no. 22.

445. *Carnelian scarab.* 16 × 12 mm.

In the Cabinet des Médailles. Acquired through the gift of Pauvert de La Chapelle (in 1899), who had purchased it at the sale of the Al. Castellani Collection in 1884.

A DOG is sitting in profile to the left, with one foreleg lifted and the head turned back in profile to the right – evidently to look at the wasp which has just landed on its back. Only one hindleg of the dog is indicated, but both forelegs, and both wings of the wasp. In the field is a fly, shown as if seen from above. Hatched border. Marginal ornament.

Fifth century B.C.

As Babelon said, there is no need to interpret the dog as Argos, Odysseus' dog; the scene, with wasp and fly, and with the dog shown somewhat breathless, with open mouth, and with tongue and teeth indicated, is more likely to be a simple animal study.

Froehner, *Sale Catalogue of the A. Castellani Collection*, 1884, no. 961.
E. Babelon, *Coll. Pauvert de La Chapelle*, no. 68, pl. VI.
Furtwängler, *A.G.*, vol. III, p. 446.
Lippold, *Gemmen und Kameen*, pl. 85, no. 8.

446. *Agate sliced barrel*, banded. 20 × 14 mm.

In the Ashmolean Museum, 1925.136. From the Wyndham Cook Collection, no. 449.

DOG, gnawing a bone, in profile to the right.

Second half of the fifth century B.C.

A life-like rendering of a familiar scene – then as now. Cf. the similar representation on a carnelian half-barrel in New York, Richter, *Cat.*, no. 117.

447. *Black jasper scaraboid*, in a gold-band setting and mounted in a gold-plated bronze ring. Convex on the engraved side. 12 × 17 mm.

From Cyprus. In the Metropolitan Museum of Art, 74.51.4226 (C.E.23). Purchased by subscription, 1874–76. From the Cesnola Collection.

SLEEPING HOUND, tethered to a tree trunk by its collar. Shown in profile to the right, with the head turned to the front. Ground line and hatched border.

Second half of the fifth century B.C.

A life-like rendering. Cf. the similar design, but without the tree trunk, on an Etruscan scarab, Furtwängler, *A.G.*, pl. XVIII, 61. The subject is common on gems of the Roman period.

Cesnola, *Cyprus*, pl. XL, 15.
Myres, *Handbook*, no. 4226.
Richter, *Animals*, pp. 32, 75, fig. 165; *M.M.A. Handbook*, 1953, p. 149; *Cat.*, no. 118, pl. XX.

448. *Chalcedony scaraboid.* Chipped along the edge. 18 × 25 mm.

In the Cabinet des Médailles, E16.

DOG, in profile to the left, cautiously approaching a little animal – some insect, to judge by its size. Ground line.

Second half of the fifth century B.C.

449. *Chalcedony scaraboid.* 14 × 20 mm.

From the Piraeus. In the Ashmolean Museum, 1892.1543. Acquired through the Chester bequest.

SHE-WOLF ATTACKING A HARE, in profile to the left. She has seized the little hare with both forepaws while it was fleeing full speed; her mouth is open, with teeth showing.

Fifth to fourth century B.C.

450. *Chalcedony scaraboid.* Chipped here and there. 19 × 15 mm.

In the Cabinet des Médailles, M5448.

POMERANIAN DOG, slowly walking to the left. All four legs and both ears are indicated. Ground line.

Fifth to fourth century B.C.

Perrot and Chipiez, *Histoire de l'art*, IX, pl. I, 11.
Maximova, *Arch. Anz.*, 1928, col. 674, fig. 28d.
Lippold, *Gemmen und Kameen*, pl. 87, no. 9.

(β) *Birds*

451. *Carnelian scaraboid.* 20 × 17 mm.

In the British Museum, 72.6-4.1164. Acquired from the Castellani Collection in 1872.

EAGLE, flying to the right, with a coiled snake in its claws. Both wings are indicated, one behind the other.

Second half of the fifth century B.C.

Cf. the somewhat earlier eagles with snakes on the coins of Elis, *British Museum Guide*, pl. 12, no. 41; Franke and Hirmer, *Die griechische Münze*, pl. 155, top left, dated 460–452 B.C. (where the further wing of the eagle is placed beneath the body, instead of alongside the near wing).

Imhoof-Blumer and Keller, pl. XX, 48.
Walters, *Cat.*, no. 552, pl. X.

452. *Rock crystal scaraboid*. Chipped along the edge. 19 × 14 mm.

In the British Museum, 91.6–24.1. Bought 1891.

COCK TREADING A HEN. Its tail is placed downward; the further wing is indicated by striations.

Around the middle of the fifth century B.C.

For an Etruscan version of the subject cf. no. 752.

Furtwängler, *A.G.*, pl. IX, 26.
Lippold, *Gemmen und Kameen*, pl. 96, fig. 5.
Walters, *Cat.*, no. 555, pl. X.

453. *Carnelian scarab*, mounted in a gold swivel ring. 11 × 17 mm.

In the Metropolitan Museum of Art, 41.160.497. Bequest of W. G. Beatty, 1941.

A SHORT-TAILED BIRD (a guinea hen or a quail?), slowly walking to the right, with head lowered, evidently looking for food. Ground line and hatched border.

A life-like rendering probably of the end of the fifth century B.C.

Richter, *Animals*, fig. 197; *Evans and Beatty Gems*, no. 24; *M.M.A. Handbook*, 1953, p. 149; *Cat.*, no. 125, pl. XXI.

454. *Sard*, slightly convex, in a box setting attached to a gold ring. 20 × 13 mm.

From Beyrouth. In the British Museum. Acquired through the Franks bequest, 1897.

PIGEON, standing quietly to the right, with an alert expression. Ground line and hatched border. On the under-side of the setting is embossed an Eros in a half-kneeling pose.

Early fourth century B.C.

Cf. the pigeons on the coins of Paphos of *c.* 400 B.C., not far removed in date from the stone; *B.M.C.*, Cyprus, pl. VIII, 9; Richter, *Animals*, fig. 199.

Marshall, *Cat. of Finger Rings*, no. 350; p. 63, fig. 71 (under-side with Eros).
Beazley, *Lewes House Gems*, p. 68.
Walters, *Cat.*, no. 560, pl. X.

455. *Hyacinthine sard scaraboid*. 12 × 15 mm.

Said to have been found in Egypt. In the Museum of Fine Arts, Boston, 23.586. Formerly in the Tyszkiewicz, Evans, and E. P. Warren Collections.

CARRIER PIGEON, flying to the right, with a small roll suspended by a string from its beak. The action of the flight is indicated both by the spread wings and the position of the legs.

Early fourth century.

Cf. the pigeon alighting, on the coins of Sikyon of the early fourth century B.C.; *B.M.C.*, Peloponnese, pl. VII, 18; Richter, *Animals*, fig. 204.

Froehner, *Coll. Tyszkiewicz*, pl. 24, no. 3.
Furtwängler, *A.G.*, pl. IX, 28.
Burlington Fine Arts Club Exh., 1904, p. 170, no. L, 59 (not ill.).
Beazley, *Lewes House Gems*, no. 81, pl. 5.
Lippold, *Gemmen und Kameen*, pl. 94, no. 10.

456. *Banded onyx scarab*. 16 × 11 mm.

In the British Museum. From the Cracherode Collection.

WILD GOOSE FLYING. The feathers of the body are indicated by long, delicately engraved lines, those of the wings by long lines with added hatching. Part of the second wing appears behind the near wing. Similarly, the second leg is shown alongside the near one. The continuous line formed by legs and neck admirably conveys the forward movement.

Second half of the fifth century B.C.

Cf. the flying goose on a gold ring in the Hermitage, from Nikopol, Stephani, *Compte rendu*, St. Pétersbourg, 1864, p. 182. pl. V, 10; Furtwängler, *A.G.*, X, 14; Richter, *Animals*, fig. 198.

Imhoof-Blumer and Keller, pl. XXII, 30.
Keller, *Antike Tierwelt*, II, pl. I, 15.
Furtwängler, *J.d.I.*, III, 1888, p. 201; *A.G.*, pl. XIV, 2, and vol. III, p. 126.
Lippold, *Gemmen und Kameen*, pl. 95, fig. 7.
Beazley, *Lewes House Gems*, p. 49.
Walters, *Cat.*, no. 511, pl. IX.

457. *Sard scaraboid*, slightly burnt. 17 × 13 mm.

In the British Museum, Blacas 298. Acquired from the Blacas Collection.

PEACOCK, with tail spread, is standing on two coiled snakes. It is shown in frontal view, with the head turned in profile to the right.

Perhaps early fourth century B.C.

Walters, *Cat.*, no. 554, pl. x.
Richter, *Animals*, p. 39 (with drawing).

458. *Carnelian scaraboid*, partly discoloured. Engraved on both sides. 19 × 25 mm.

Said to be from Kastorea, Macedonia. In the Metropolitan Museum of Art, New York, 11.196.1. Rogers Fund, 1911. Once in the Evans Collection.

HERON, spreading its wings; on its head is an aigrette. It is drawn in profile to the right, except the wings which are frontal. Below the feet are two stones, to indicate the pebbly ground (?). Hatched border, interrupted below the feet.

Probably third quarter of the fifth century B.C.

For the design on the other side of the stone cf. no. 238, where the bibliography is given.
On the difficult distinction between herons and cranes cf. Beazley, *Lewes House Gems*, p. 59. Dionysios of Halikarnassso, *De avibus*, II, p. 18, mentions that *some* birds of this species have aigrettes on their heads (ἐπὶ τῆς κεφαλῆς πλόκαμος), but whether this is a distinction between herons and cranes is not said. For the sake of simplicity I follow Beazley in calling all the birds of this type on the gems herons.

Richter, *Cat.*, no. 73, B.

459. *Agate barrel*, greyish with reddish-brown mottling. Chipped at the perforations. Ht. 29 mm.

In the Metropolitan Museum of Art, 42.11.17. Purchase, 1942, Joseph Pulitzer bequest. From the Evans Collection.

HERON, standing, with lowered head, a snake in its beak, an aigrette on its head. Thick ground line.

Second half of the fifth century B.C.

Richter, *Evans and Beatty Gems*, no. 22; *M.M.A. Handbook*, 1953, p. 149; *Cat.*, no. 122, pl. XXI.

460. *Banded agate cylinder*, with one side planed for the engraving. 17 × 18 mm.

From Athens. In the Staatliche Museen, Berlin.

HERON, standing on the left leg, with right leg raised, in profile to the right. There is no aigrette. Ground line.

Second half of the fifth century B.C.

Imhoof-Blumer and Keller, pl. XXII, 2.
Furtwängler, *Beschreibung*, no. 332.

461. *Banded agate cylinder*, flattened on the engraved side. 10 × 18 mm.

Said to be from Greece. In the Museum of Fine Arts, Boston, 98.721. From the Tyszkiewicz Collection.

HERON, standing on the left foot, with the right raised, in profile to the right. Ground line.

Second half of the fifth century B.C.

Froehner, *Collection Tyszkiewicz*, pl. 24, 1.
Furtwängler, *A.G.*, pl. IX, 29.
Osborne, *Engraved Gems*, pl. 8, no. 19, p. 320.

462. *Bluish chalcedony scaraboid*. 19 × 14 mm.

From the Peloponnese. In the Staatliche Museen, Berlin.

HERON, standing on the left leg, the other raised, in profile to the left. On its head is an aigrette.

Second half of the fifth century B.C.

Imhoof-Blumer and Keller, pl. XXII, 11.
Furtwängler, *Beschreibung*, no. 311; *A.G.*, pl. XIV, 17.
Lippold, *Gemmen und Kameen*, pl. 95, no. 10.

463. *Carnelian ringstone*. 14 × 19 mm.

In the Staatliche Museen, Berlin.

HERON, walking quickly to the right, with wings spread, after a snake. The snake is coiled and ready for attack.

Second half of the fifth century B.C.

Cf. Stephani, *Compte rendu*, 1865, p. 99, note 1.

Imhoof-Blumer and Keller, pl. XXIII, 6.
Furtwängler, *Beschreibung*, no. 353 ('Dem Stil des Olympios verwandt').

464. *Banded agate barrel*, with engraving on the cut side. Ht. 26 mm.

In the Bowdoin College Museum of Art, Brunswick, Maine. Gift of E. P. Warren.

HERON, standing on one leg, the other lifted. An aigrette on the head. Ground line.

Second half of the fifth century B.C.

Similar, but slighter work than the examples in Berlin and Boston, nos. 460–462, 466.

Beazley, *Lewes House Gems,* pp. 49, 59, pl. B, 4.

465. Chalcedony scaraboid. 23 × 16 mm.

From Kameiros, Rhodes (see *infra*). In the British Museum, 62.5–30.9. Acquired in 1862.

HERON, with the antlers of a deer instead of an aigrette. It is standing on its left leg, with the right raised, and the head lowered, as if looking for food.

Late fifth century B.C.

The stone was found inside an alabaster vase which also contained a gold reel (Marshall, *British Museum Cat. of Jewellery,* no. 2067) and the pelike by the Marsyas Painter with Peleus and Thetis (British Museum, E424; Schefold, *Kertcher Vasen,* pl. XVI, a; Beazley, *R.F.V.²,* p. 1475, no. 4), both dated in the fourth century B.C.

Torr, *Rhodes,* pl. I, fig. C.
Imhoof-Blumer and Keller, pl. XXVI, 59.
Furtwängler, *A.G.,* pl. XI, 30.
Beazley, *Lewes House Gems,* p. 60.
Lippold, *Gemmen und Kameen,* pl. 83, fig. 3.
Walters, *Cat.,* no. 553, pl. X.

466. Chalcedony scaraboid. 15·5 × 20 mm.

In the Museum of Fine Arts, Boston, 21.1206. Formerly in the collection of E. P. Warren, who bought it in Athens in 1900.

HERON, in profile to the left, standing on its left leg, and with the right lifted. An aigrette on the head. Line border. Ground line. Cf. pl. A.

Second half of the fifth century B.C.

In style and delicacy of the engraved lines close to the flying heron by Dexamenos (no. 467).

Furtwängler, *A.G.,* III, p. 446, fig. 228 (attributed to Dexamenos).
Belle, *Neue Jahrbücher,* v. 1900, pl. I, 20.
Burlington Fine Arts Club Exh., 1904, p. 250, no. O, 76.
Beazley, *Lewes House Gems,* no. 66, pls. 5 and 6.
Richter, *Animals,* fig. 193.
Lippold, *Gemmen und Kameen,* pl. 95, no. 6.

467. Bluish chalcedony scaraboid, mounted in a modern ring. 21 × 16 mm.

Found in a grave at Kerch, together with the agate cylinder engraved with a griffin (Furtwängler, *A.G.,* pl. XI, 41) and Attic vases of the period of the Peloponnesian War. In the Hermitage.

HERON flying to the left. Both wings are indicated, and both legs, one behind the other. On the head is an aigrette.
Below, on two horizontal lines, the signature of the artist: Δεξαμενὸς ἐποίε Χῖος, Dexamenos of Chios made it (ἐποίε for ἐποίει). Line border. Cf. pl. A.

Second half of the fifth century B.C.

The lines indicating the feathers of the wings and body are incised with great delicacy, and the motion of flying, with wings spread, legs outstretched, head erect, is rendered with superlative skill. The spacing of the design – in which the signature plays a part – is also masterly.

On Dexamenos cf. pp. 15 f., 17.

Stephani, *Compte rendu,* 1861, pl. VI. 10, pp. 147 ff.
King, *Antique Gems,* I, p. 407.
Imhoof-Blumer and Keller, pl. XXII, 9.
Furtwängler, *J.d.I.,* III, 1888, pl. VIII, 9, pp. 200 f.; *A.G.,* pl. XIV, 4.
Maximova, *Ancient Gems and Cameos,* pl. II, 3. (In Russian.)
Lippold, *Gemmen und Kameen,* pl. 95, no. 5.
Richter, *Animals,* fig. 196.

468. Agate scaraboid, mounted in a gold swivel ring. 20 × 14 mm.

Found in a grave on the peninsula of Tama. In the Hermitage.

HERON, with an aigrette on its head, is standing on one leg on rocky ground, with head turned back. In front of it is a grasshopper.
In the field is the inscription Δεξαμενός, evidently the signature of Dexamenos (see p. 15). Hatched border. Cf. pl. A.

Second half of the fifth century B.C.

Again a masterly work.

Stephani, *Compte rendu,* 1865, pl. III, 40, pp. 95 ff.; 1864, p. XI.

469. Carnelian scraboid, engraved on the convex side. 18 × 13 mm.

In a private collection.

HERON, with aigrette, curved neck, and lowered head, is about to pounce on a fly. The latter is peacefully sitting somewhere, with all four legs outstretched, unaware of what is going to happen.

Second half of the fifth century B.C.

The cautious approach of the bird is admirably conveyed. There is no ground line and no surrounding border, so the field is unencumbered, and the composition, in spite

of its small scale, has spaciousness, suggesting the out-of-doors.

Richter, *A.J.A.*, LXI, 1957, p. 264, pl. 81, no. 4.

470. *Chalcedony ringstone.* 20 × 14 mm.

In the Staatliche Museen, Berlin.

FALCON, in three-quarter back view, with head turned to the left, is standing on one leg, the other raised. The feathers are very lightly incised.

Fifth to fourth century B.C.

An unusual subject, expertly rendered.

Furtwängler, *Beschreibung*, no. 358; *A.G.*, pl. XIII, 33. Lippold, *Gemmen und Kameen*, pl. 94, no. 1.

(γ) *Insects, etc.*

471. *Smoked agate scaraboid.* 12 × 9 mm.

In the British Museum, 65.7–12.114. Acquired from the Castellani Collection in 1865.

FROG, seen from the top, with its forelegs placed forward and the hindlegs bent, as if about to jump, or swimming (?). Hatched border.

Middle of the fifth century B.C.

Cf. the somewhat earlier frogs on the coins perhaps of Seriphos, *British Museum Guide*, pl. 5, no. 46; Franke and Hirmer, *Die griechische Münze*, pl. 162, bottom, middle; Richter, *Animals*, fig. 232.

Walters, *Cat.*, no. 556, pl. X.

472. *Gold ring*, with embossed design on bezel. L. of bezel 17 mm.

In the British Museum. Acquired from the Castellani Collection in 1872. Said to have been found at Kephallenia.

FROG. It is shown stretched out at full length, with the head half hidden by one of the rosettes at either end of the bezel.

Probably fourth century B.C.

On the frog as a charm, cf. M. Fränkel, *J.d.I.*, I, 1886, pp. 48 ff.

Marshall, *Cat. of Finger Rings*, no. 220, pl. VI.

473. *Chalcedony scaraboid*, burnt. 27 × 22 mm.

In the British Museum, 74.3–5.20. Bought 1874.

TWO DOLPHINS, swimming together in life-like attitudes.

Cursory work of the fourth century B.C.

Cf. the fine single dolphin on a chalcedony scaraboid of the second half of the fifth century B.C. in the Museum of Fine Arts, Boston, 27.690, Richter, *Animals*, fig. 227. Dolphins were of course common representations on the coins of sea-bound Greece and Southern Italy, e.g. of Abdera, Zankle, Tarentum, Syracuse. On the coins – as also on the gems – they appear either singly or in pairs, swimming either in the same direction, or in opposite directions.

Walters, *Cat.*, no. 593, pl. X.

474. *Quadrangular chalcedony*, 18 × 11 mm.

From Greece. In the Staatliche Museen, Berlin.

GRASSHOPPER, in profile to the left. The two forelegs are indicated, but only one hindleg.
Finely executed, with accurate rendering of details.

Third quarter of the fifth century B.C.

Imhoof-Blumer and Keller, pl. XXIII, 35. Furtwängler, *Beschreibung*, no. 333; *A.G.*, pl. XI, 42. Richter, *Animals*, fig. 221. Keller, *Die antike Tierwelt*, II, pl. II, 6.

475. *Sard scarab*, chipped along the edge. 19 × 13 mm.

In the British Museum, 1229. From the Towneley Collection.

GRASSHOPPER, sitting on an ear of corn. Above is a butterfly, seen from above, with four wings indicated.

Second half of the fifth century B.C.

A charming thumb-nail sketch of a meadow.

The markings on wings and body, the antennae, the joints of the legs are all nicely observed, and so is the attitude, the stolid expression being particularly remarkable. The ear of corn is also rendered in detail, and is not inferior to those on the coins of Metapontum. For a grasshopper sitting on a rose cf. the gold ring, Stephani, *Compte rendu*, 1860, p. 91, pl. IV, 12.

Raspe, no. 512. Walters, *Cat.*, no. 512 (not illustrated). Imhoof-Blumer and Keller, pl. XXIII, 32. Richter, *Animals*, fig. 222.

476. *Pale-green glass scaraboid.* Chipped along the edge. The surface has suffered. 15 × 19 mm.

From Beyrouth. In the British Museum, 83.6–21.6. Bought 1883.

CRAB.

Fifth to fourth century B.C.

Cf. the crabs on the coins of Akragas, and of Kos, *British Museum Guide*, pl. 19, no. 44 (dated 400–336 B.C.).

Walters, *Cat.*, no.594 (not illustrated).

477. *Carnelian ringstone*. 19 × 11 mm.

In the Staatliche Museen, Berlin. From the Stosch Collection.

WASP.

Hatched border.

Fifth to fourth century B.C.

The slender body and delicate wings are beautifully rendered.

Imhoof-Blumer and Keller, pl. XXIII, 47.
Furtwängler, *Beschreibung*, no. 362.

478. *Round carnelian scaraboid*, engraved on both sides. 18 × 19 mm.

In the Staatliche Münzsammlung, Munich. From the Arndt Collection.

BEE, seen from above, with legs and wings outspread.

First half of the fourth century B.C.

Cf. the bees on the tetradrachms of Ephesos of 400–336 B.C., *British Museum Guide*, pl. 19, no. 35.

For the deer on the other side of this gem cf. no. 440.

Czako and Ohly, *Griechische Gemmen*, no. 16.

479. *Chalcedony scaraboid*. 17 × 12 mm.

From Taranto. In the Ashmolean Museum, 1892.1475. Acquired through the Chester bequest.

FLY, seen from above, with legs indicated on either side.

Second half of the fifth century B.C.

Cf. the still finer fly on the 'lost' scarab, Furtwängler, *A.G.*, pl. X, 53; Richter, *Animals*, fig. 219.

Furtwängler, *A.G.*, pl. IX, 50.
Lippold, *Gemmen und Kameen*, pl. 97, no 14.

(i) *Objects and Inscriptions*

At this time there appear also simple objects, apparently studied for their own sake – the first 'still-life' representations in Western art. They include a kithara (no. 480), the sole of a human foot (no. 481), two clasped hands (no. 482), and a beautifully designed hazel-nut (no. 483) – evidently observed from life by an artist able to depict its salient features – its shape and the texture of its surface.

Included here also are some inscriptions that form the sole design of the gem, two of which are apparently abbreviations of the name of the owner (nos. 484, 485), one with the full name in the genitive (no. 487).

480. *Mottled jasper scaraboid*. 28 × 25 mm.

In the Ashmolean Museum, 1921.1926. Gift of Sir John Beazley. Once in the Story-Maskelyne Collection.

KITHARA, with seven strings, seen in front view.

Fifth to fourth century B.C.

Cf. the kitharas on the coins of the Chalcidian League dated 400–336 B.C., *Br. Mus. Guide*, pl. 22, nos. 12–14.

Select Exhibition of Sir John and Lady Beazley's Gifts, 1912–1966, no. 643.

481. *Chalcedony scaraboid*. 10 × 12 mm.

From Cyprus. In the Ashmolean Mus., 1896.1908.0.14.

Gift of E. P. Warren. Once in the Tyszkiewicz Collection.

RIGHT FOOT, seen from below. In the field a Cypriote inscription, read (by Furtwängler) *u-ki-pi-si*. Hatched border.

Fifth to fourth century B.C.

Furtwängler, *A.G.*, pl. IX, 18.
Lippold, *Gemmen und Kameen*, pl. 98, no. 18.

482. *Sard scarab*. 13 × 10 mm.

From Apulia. In the British Museum, 73.1–11.13. Acquired from the Castellani Collection in 1872.

TWO RIGHT HANDS CLASPED, one with a bracelet, the

other without; therefore probably intended for male and female. Inscribed in the field, above and below the hands: Χαῖρε καὶ σύ. Hatched border and marginal ornament.

About 400 B.C.

For the inscription cf. Beazley, *Lewes House Gems*, no. 102, and the references there cited. It was evidently considered an appropriate greeting on rings.

Clasped hands became especially popular devices on rings and coins of the Roman period, when they sometimes signified 'faith', fides, cf. Boyancé, 'La main de Fides', in *Hommages à Jean Bayet, Collection Latomus*, LXX, 1964, pp. 101 ff.; Mattingly, *Roman Coins* (1966 ed.), pl. XXXIX, 3, 4.

Heydemann, *Bull. dell'Inst.*, 1869, p. 55, no. 9.
Furtwängler, *A.G.*, pl. IX, 34.
Beazley, *Lewes House Gems*, p. 85.
Walters, *Cat.*, no. 513, pl. IX.
Wuilleumier, *Tarente*, p. 518.

483. *Chalcedony scaraboid*, bleached. 12 × 14 mm.

In the Museum of Fine Arts, Boston, 27.693. Formerly in the collection of E. P. Warren, who bought it in Athens in 1901.

HAZEL-NUT. Hatched border.

Probably late in the fifth century B.C.

A beautifully observed Greek nature study, of which all too few have survived.

Burlington Fine Arts Club Exh., 1904, p. 250, no. O, 72 (not ill.).
Beazley, *Lewes House Gems*, no. 68, pl. 5.

484. *Agate scaraboid*. 16 × 12 mm.

From Lesbos. In the British Museum. Presented by Mr. D. Colnaghi, 1854.

Inscribed, in two lines, in large letters, ΙΣΑΓΟΡ, Isagor; that is, the name Isagoras, either in the nominative or genitive – evidently that of the owner of the stone.

Fifth century B.C.

Furtwängler, *A.G.*, vol. III, p. 136.
Walters, *Cat.*, no. 595, pl. X.

485. *Brown agate scaraboid*. 19 × 15 mm.

In the British Museum, 88.10–12.2. Presented by the Rev. G. J. Chester, 1888. At least four letters: ΒΥΕΩ combined in a monogram.

Monograms are rare on Greek gems.

Perhaps fourth to third century B.C.

Walters, *Cat.*, no. 596, pl. X.

486. *Gold ring*, with inscription on oval bezel. L. of bezel 10 mm.

In the Ashmolean Museum, 78 (Fortnum 801). Found in a child's grave in Kerch. Acquired through the Fortnum bequest.

The inscription, in punctured letters, reads: Αὐλείνης πνεῦμα, 'Auleine's spirit'.

Fourth to third century B.C.

487. *Gold ring*, with inscription engraved on round bezel. 25 × 24 mm.

In the Ashmolean Museum, Oxford, 1921.864.

The inscription, in two lines, reads: Ξενοδόκας, genitive of the woman's name Xenodoka (in Doric). The forms of the letters point to the fifth century B.C.

7. GRAECO-PERSIAN GEMS, ABOUT 450–330 B.C.

The so-called Graeco-Persian gems are closely related to the Greek of the developed period. They are identical in forms and materials and in the style of the engravings. Only the subjects are Persian. They represent Persian nobles in their favourite pastimes of riding, hunting, and fighting; or single Persians at rest or conversing with women. The hunting and fighting scenes perhaps record specific exploits – memorable feats performed by the owner of the seal, such as a lion brought to bay, a boar transfixed, an enemy vanquished; and the single figures may be in the nature of portraits. Single women are also not infrequently represented, generally engaged in indoor occupations. Their aristocratic bearing shows that they were in no way in a servile position. Animals are likewise favourite subjects, including those native in the East. Occasionally monstrous shapes occur.

All these representations are executed in the spirited, facile style characteristic of Ionian work, with occasional foreshortening, which, as is well known, had become a major interest with Greek artists during this period. So close, in fact, are the representations on these stones to the contemporary Greek that, when no Persian is present, in the pictures of animals for instance, it is sometimes difficult to distinguish between the two. They were evidently made by the same artists.

The chief form used for the stones was the scaraboid, which lent itself particularly well to the broad style of the scenes represented. It is often quite large, imparting a certain spaciousness to the designs. In addition, a rectangular stone with one side facetted was popular (cf. fig. b), as well as an oblong, four-sided form (cf. no. 505). The cone and the cylinder also occur, but generally only for the examples in pure or semi-Persian style (cf. fig. a). The scarab was not used.

Generally there is no encircling border around the design; but now and then, for the figures at rest, a ground line is added.

Bluish chalcedony is the favourite material used, as it is in the contemporary Ionian Greek stones. Rock crystal, jasper, agate, and steatite also occur, but less frequently. Glass sometimes was used as a substitute for stone.

In spirit and content, as well as in technique, these engraved stones are in marked contrast to the 'Achaemenian' of the archaic period of the sixth and the early fifth centuries. There the favourite subjects are those current in the Orient: daemons, divinities and priests engaged in religious functions, and kings performing glorious deeds. And they are executed in the precise, repetitious, Oriental manner, with never an attempt at foreshortening.

In view of these circumstances, the best explanation for the 'Graeco-Persian' gems seems to be that they were executed by Greeks for Persian clients. As is well known, during the later fifth and the fourth century close relations existed between the two peoples. The Greek victories over Persia during the first half of the fifth century had saved Greece from Persian domination, but the Persian empire nevertheless remained the greatest power in the East. Our literary sources tell us that during Persia's early successes many Greeks had been transferred to Persia, including the whole population of Eretria (cf. Herod., VI, 20, 119); and after the peace of Antalkidas in 387 B.C. Persian suzerainty over the Greeks of Asia Minor was again proclaimed. Xenophon's *Anabasis* makes clear the high standing of Greek mercenaries. Persian

patronage was naturally welcomed by Greek traders, physicians, and artists. Though the Persian nobles felt themselves superior to the Greeks, and the Greeks regarded the Persians as 'barbarians', there was no objection on either side to profitable contacts.

There is, moreover, concrete evidence for this relationship. First there is the building inscription from Susa, in which it is specifically recorded that Ionian and Sardian stone-cutters were assigned a part of the work on the Palace.[1] Then there are the two figures engraved in pure Greek style of *c.* 510–500 B.C. – by way of a doodle – on a fragment of the sculptured shoe of Darius from the Palace of Persepolis.[2] Further-more, on some Graeco-Persian gems 'Graeco-Persian' figures are combined with figures in pure Greek style: e.g., on a four-sided carnelian from Kerch in the Hermitage, where a bearded Greek man wearing a himation and playing with a dog and a nude Greek dancing girl appear together with a Persian in the typical Graeco-Persian style[3] (no. 505); and on a facetted chalcedony in a private collection, where among representations of animals in 'Graeco-Persian' style a Hermes appears in pure Greek, Polykleitan style.[4]

There is also the statement by Pliny (*N.H.*, XXXIV, 68) that the sculptor Telephanes of Phocaea worked for Darius and Xerxes. And there is the parallel case of the Greek artists of the time working in Lycia,[5] Phrygia,[6] Egypt,[7] and Cyprus.

There seems, therefore, to be no difficulty in supposing that Greek gem-engravers furnished Persian noblemen with their seals. Naturally, these Greek artists had to accommodate themselves to Persian requirements, and to choose their subjects from the Persian world. And in the course of time the Greeks in their turn were doubtless influenced by their Persian contacts and sometimes instilled an Oriental flavour into their representations.

The alternative theory, advanced by some authorities, that these Graeco-Persian sealstones were made by Persians under Greek influence, does not seem likely. There is too much of the Greek spirit in the representations to make Oriental workmanship possible.[8] Significant also is the fact that when during the

[1] Cf. e.g., Frankfort, 'Achaemenian Sculpture', *A.J.A.*, L, 1946, p. 9.

[2] Richter, *A.J.A.*, L, 1946, p. 28, fig. 26.

[3] Stephani, *Compte-rendu de la comm. imp. arch.*, 1882, pl. 5, nos. 1, 1a; Richter, *Archaeologica Orientalia in Memoriam Ernst Herzfeld* (1952), p. 192, pl. XXX, 9, 10. With the dancing girl compare no. 237 in this book.

[4] Cf. Richter, *op. cit.*, pl, XXX, 1, 2. In a private collection.

[5] Cf., e.g., the Harpy Tomb in the British Museum, Pryce, *Catalogue of Sculpture*, B 287.

[6] Cf. the reliefs from Ergheli of the first half of the fifth century B.C., Macridy, *B.C.H.*, XXXVII, 1913, pp. 340 ff., pls. VI–IX; Mendel, *Cat.*, III, p. 569; Picard, *Manuel*, pp. 412 f., figs. 415, 416.

[7] Cf. Edgar, *Catalogue général de Caire, Greek Sculpture*, no. 27431, pp. 3 f., pl. I.

[8] On the much discussed question of the origin of the Graeco-Persian sealstones cf., e.g., Furtwängler, *A.G.*, III (1900), pp. 116 ff.

Dalton, *The Treasure of Oxus*, 1926.

Moortgart, 'Hellas und die Kunst der Achaemeniden', *Mitt. d. altorient. Ges.*, II, 1926, pp. 18 ff.

T. Knipowitsch, *Recueil de l'Ermitage*, III, pp. 41 ff.

Von Bissing, 'Ursprung und Wesen der persischen Kunst', *Sitzungsberichte der Bayr. Akad. d. Wiss.*, phil.-hist. Kl., 1927.

Maximova, 'Griechisch-persische Kleinkunst in Kleinasien nach den Perserkriegen', *Arch. Anz.*, 1928, cols. 649 ff.

Coomaraswamy, *Bulletin of the Museum of Fine Arts, Boston*, XXXI, 1933, pp. 21 ff.

Rodenwaldt, *Sitzungsber. d. preuss. Akad. d. Wiss.*, phil.-hist. Kl., XXVII, 1933, pp. 1028 ff.

Schefold, *Eurasia Septentrionalia Antiqua*, XII, 1937, pp. 72 ff.

Gadd, in Pope, *A Survey of Persian Art*, I, 1938, pp. 383 ff.

Frankfort, *Cylinder Seals* (1939), pp. 220 ff.; *A.J.A.*, L, 1946, pp. 6 ff. *The Art and Architecture of the Ancient Orient* (1954), pp. 225 ff.

Luschey, *Die Phiale* (1939), passim.

Porada, *Mesopotamian Art in Cylinder Seals* (1946), pp. 68 f., and *Corpus of Ancient Near Eastern Seals, I, Coll. Morgan Library* (1948), pp. 104 ff.

Richter, 'Greeks in Persia', *A.J.A.*, L, 1946, pp. 15 ff.; *Hesperia*, Supplement VIII, 1949, pp. 291 ff.; 'Greek Subjects on Graeco-Persian Sealstones', *Archaeologica Orientalia in Memoriam Ernst Herzfeld* (1949), pp. 195 ff.

Seyrig, 'Cachets achéménides', *Arch. Orient. . . .* (1949), pp. 195 ff.

Erdmann, *Forschungen und Fortschritte*, XXVI, 1950, pp. 150 ff.

Cf. also on the general question of the relation of Greeks and Persians: R. Ghirshman, *Perse: Proto-iraniens, Mèdes, Achéménides*, 1963, pp. 331 ff.; Guépin, 'On the Position of Greek Artists under Achaemenid Rule', *Persica*, I, 1963–64, pp. 34 ff.

fourth century fewer Greek artists worked in Persia, the Persians continued the style of the earlier works in an inferior manner.[1]

These Graeco-Persian gems have been found over a large area – not only in Persia, Asia Minor, Lydia, Anatolia, Southern Russia, and Greece, but as far East as Taxila in India.[2] This wide distribution is easily explained by the fact that the Persians travelled extensively, taking their sealstones with them, as well as by the active commerce of the time.

It is probable, however, that the majority of the stones were executed in Persia itself for resident Persians; for the representations show an intimate knowledge not only of Persian life and customs, but of Persian dress and accoutrements.[3] The Persian men, for instance, are shown wearing long-sleeved tunics and trousers, with sometimes a short-sleeved second tunic or jacket added, with belt; a headdress with flaps (the so-called tiara); and shoes (pulled over the trousers). And the women appear with long-sleeved tunics, kept in place by belts. Occasional variations may be explained by such gems having been executed by Greeks in Greece, not resident in Persia; and the difference in the representations of the costumes on the gems and on the reliefs from Persepolis is accounted for by the change of mode recorded by Herodotos.

The accoutrements are likewise correctly rendered on these engraved gems – the Persian weapons, including the bow-case, the saddle-cloth, the fillets tied on the horses' tails, the dangles on the women's belts and fillets. In contrast, the representations of Persians on Attic vases are often not trustworthy, since Athenian artists were evidently not always intimately acquainted with Persian customs.

Significant also is the fact that the animals represented on the sealstones are often those native in the East – the bear, the hyena, the reindeer, the parrot, and a breed of horse with receding forehead and curving nose.

The picture which these Graeco-Persian stones presents is indeed revealing. The Near East was becoming cosmopolitan. The Persians by their military prowess and administrative ability had conquered a vast empire. The Greeks through their artistic genius and enterprise gained access to this new world. They travelled, they traded, they fought other people's battles, and, above all, they adapted their art to the taste and requirements of their patrons. As a result their culture spread far and wide – even before Alexander's conquest of the East.

In the engravings here presented come first a number of strongly Orientalizing examples, datable in the late sixth and earlier fifth century B.C., that is, preceding the Graeco-Persian stones proper. The subjects are still from the Oriental repertoire, and so is the style, except that the contact with Greece has somehow modified it in the direction of greater freedom (cf. nos. 488–494). Then come the Graeco-Persian gems proper (nos. 495 ff.), in which the scenes are taken from daily life, and the style is that prevalent in Ionian Greece during the second half of the fifth and the first half of the fourth century. They show lively hunting scenes – among which the boar-hunt[4] plays a conspicuous part (nos. 495–501); and scenes from

[1] I may quote Dr. Herzfeld's trenchant comment in a letter to me dated 10th Sept., 1946: 'Man kann sagen, wenn schon in Susa . . . Griechen mitarbeiteten, um so mehr in Persepolis, wo die Skulpturen ihre Arbeit dokumentieren. . . . Als es keine griechischen Künstler mehr gab, konnten die ungeübten einheimischen Arbeiter unter Artaxerxes II und III nichts andres thun als die älteren Werke sklavisch in ganz inferiorer Technik nachzuahmen. Die griechische Mitarbeit erklärt also die Schöpfung und den unmittelbaren Verfall.'

[2] Cf., e.g., S. Reinach, *Antiquités du Bosphore, passim*; Butler, *A.J.A.*, XVI, 1912, p. 478, and *Sardis*, I, p. 85; Goetze, *Berytus*, VIII, 2, 1944; G. M. Young, *Ancient India*, I, 1946, pp. 33 f.; von der Osten, *Oriental Institute Publications*, XXX, 1931, p. 91, no. 879a.

[3] On Persian dress cf. especially Gow, *J.H.S.*, XLVIII, 1928, pp. 150 ff.; Schoppa, *Die Darstellungen der Perser in der griechischen Kunst* (Diss. Heidelberg, 1933), pp. 46 ff.; Schmidt, *Persepolis*, I, p. 225.

[4] On this dangerous sport cf. Keller, *Antike Tierwelt*, I, pp. 389 ff.

Persian home life; i.e., Persian women engaged in household occupations, or making music, or playing with their children, or in converse with men (nos. 503 ff.). One crowded scene represents a horseman pursuing a chariot with two occupants (no. 502).

The animals show great variety. They consist of lions, boars, a lynx, an antelope, a bull, a fox sniffing at a grasshopper (nos. 511 ff.), and – on two facetted stones – a reindeer, a hyena, a bear, a lizard, and a parrot (nos. 517, 518). There are no great masterpieces among them comparable to some on the contemporary Greek stones – e.g., the horse on no. 418, or the herons on nos. 467, 468 – but all are vividly rendered, often in violent action. And they so closely resemble their Greek counterparts in general style that it is often difficult to distinguish between the two. In fact, some of the animals placed in my Greek section may belong here, and vice versa.

488. *Brown chalcedony scarab.* 17 × 13 mm.

From Halikarnassos. In the British Museum, 1914.4–15.1. Bought 1914.

A PERSIAN, standing in front of a lion, a sword in his right hand, the left extended. He wears a belted tunic and a tiara. The upper part of his body is frontal, the rest in profile. The lion is standing on his hindlegs, with head turned back. A little dog is jumping up at him. In the field above are a disk and crescent. Ground line. Line border.

Probably latter part of the sixth century B.C.

Walters, *Cat.*, no. 432, pl. VII.

489. *Chalcedony scaraboid,* burnt. Mounted in its ancient gold setting. 28 × 17 mm.

In the Cabinet des Médailles, Paris. Gift of Pauvert de La Chapelle, 1899.

A PERSIAN ABOUT TO SLAUGHTER A BULL. In one hand he holds the animal by its left hindleg, in the other he has a curved knife; his left foot is raised to the bull's horn. He wears a sleeveless, belted chiton, which leaves his left leg bare, and a taenia in his hair. The upper part of his body is shown in front view, the rest in profile, including the head. Above is a solar disk. Cross-hatched exergue and hatched border.

About 500 B.C. (?).

For a similar representation, also in the Cabinet des Médailles, cf. Chabouillet, *Cat.*, no. 1023.

E. Babelon, *Cat., Coll. Pauvert de La Chapelle,* no. 36, pl. LV.

490. *Chalcedony cylinder.* Ht. 20 mm.

In the Staatliche Museen, Berlin.

HORSE, with saddle-cloth, bridle, reins, and top-knot,

is walking slowly to the right. Above is the winged solar disk, familiar from Persian monuments.

About 500 B.C. (?).

Furtwängler, *Beschreibung,* no. 180.

491. *Bluish chalcedony scaraboid.* 21 × 29 mm.

In the Hermitage.

WINGED, HORNED LION, with human face, in profile to the left. Both forelegs but only one hindleg are indicated. Ground line.

Lajard, *Culte de Mithra,* pl. XLIV, 9.
Furtwängler, *A.G.,* pl. XI, 18.

492. *Chalcedony scaraboid.* 18 × 25 mm.

In the Cabinet des Médailles.

WINGED, HORNED LION, walking to the left, with mouth open and its tufted tail lifted. All four legs are indicated, but only one wing and one horn.

Chabouillet, *Cat.*, no. 1087.

493. *Bluish chalcedony scaraboid.* 23 × 17 mm.

From Sparta. In the Staatliche Museen, Berlin.

WINGED LION, with a human head, walking to the left. He is bearded, has a thick nose, and wears a crown. Curving ground line.

Cf. Lajard, *Mithra,* pl. XLVI, 13.
Furtwängler, *Beschreibung,* no. 187; *A.G.,* pl. XI, 20.

494. *Chalcedony scaraboid.* 25 × 18 mm.

From Sparta. In the Staatliche Museen, Berlin.

MONSTER, in the form of a winged, horned lion, with the hindlegs of an eagle, walking to the left. Its mouth

is wide open, with tongue and teeth showing. Only one horn is indicated. Ground line.

Furtwängler, in Roscher's *Lexikon*, s.v. Gryps, col. 1775; *Beschreibung*, no. 188; *A.G.*, pl. XI, 19.
Lippold, *Gemmen und Kameen*, pl. 81, no. 11.

495. *Chalcedony scaraboid.* 28 × 21 mm.

In the Staatliche Museen, Berlin.

BOAR-HUNT. A Persian, riding a galloping horse, is about to spear a boar which is coming toward him. A hound is running alongside. The Persian wears a tiara, a sleeved, belted jacket, trousers, and shoes. The horse has a saddlecloth, and its tail is tied with a string ending in dangles.

Second half of the fifth century B.C.

Imhoof-Blumer and Keller, pl. XIX, 61.
Furtwängler, *Beschreibung*, no. 182; *A.G.*, pl. XI, 3.

496. *Light brownish chalcedony scaraboid,* high-domed. Considerably chipped along the edge and at the perforations. 21 mm.

In the Metropolitan Museum of Art, 41.160.433. Bequest of W. G. Beatty, 1941.

PERSIAN HORSEMAN, shooting an arrow at an attacking lion. He wears a tiara, a long-sleeved tunic, trousers, and shoes. The horse rears, frightened by the approaching lion; it has a saddle-cloth on its back, a peytrel on its chest, and a bridle with reins; the ends of its tail are tied with a fillet. In the usual convention the string of the bow is not made to pass across the man's face.

Fifth to fourth century B.C.

Cursory but spirited work. The tense action is excellently conveyed.

Richter, *Evans and Beatty Gems*, no. 31; *Hesperia*, Supplement VIII, 1949, p. 294, pl. 34, no. 1; *Cat.*, no. 137, pl. XXII.

497. *Chalcedony scaraboid.* Chipped round edge; largish piece missing at left side. 27 × 23 mm.

In the Fitzwilliam Museum, Cambridge, E2, 1864. From the Leake Collection.

TWO PERSIANS HUNTING. There are two superimposed groups, one directed to the right, the other to the left. Above is a Persian on horseback about to shoot an arrow at a lion, which is rushing against him. Below is another Persian, also on horseback, about to spear an attacking boar. Both wear the Persian dress – tiara, jacket with tight-fitting sleeves, trousers, and shoes. The horses

are in full gallop; they have saddle-cloths, and their tails are tied with fillets.

Second half of the fifth century B.C.

King, *Antique Gems and Rings*, I, p. 372 (drawing).
Middleton, *Cat.*, p. XI, no. 24.
Furtwängler, *A.G.*, pl. XI, 1.

498. *Chalcedony scaraboid.* 25 × 20 mm.

In the National Museum, Athens, Numismatic section, inv. 890. Gift of K. Karapanos, 1910–11.

PERSIAN SPEARING A BOAR, which is running toward him. He wears a tiara, a sleeved jacket, trousers, and shoes. In one hand he holds the spear, in the other a piece of fringed drapery, using it as a shield.

Second half of fifth century B.C.

Svoronos, *Journal international d'archéologie numismatique*, XV, 1913, no. 626.

499. *Chalcedony scaraboid,* with agate layers at the back. Mounted in modern setting. 25 × 19 mm.

In the Fitzwilliam Museum, EI, 1864. From the Leake Collection.

A PERSIAN ON HORSEBACK, about to throw his spear against a deer, already wounded with a spear. The man wears a tiara, a tunic, trousers, and shoes; he holds the reins in his left hand. The horse has a saddle-cloth. On the deer only one antler is indicated.

Second half of the fifth century, about the time of the Parthenon frieze, to judge by the style of the horse.

King, *Antique Gems and Rings*, I, p. 316, vignette.
Middleton, *Cat.*, p. IX, no. 16, pl. I.
Furtwängler, *A.G.*, pl. XI, 4.

500. *Chalcedony scaraboid,* burnt. Fractured on each side. Originally *c.* 29 × 22 mm.

From Ithome, Messenia. In the Staatliche Museen, Berlin.

PERSIAN HORSEMAN WITH A COMPANION. The latter is holding with both hands a trident spear, ready to transfix the fox lying by his side, on which he has placed his left foot. The fox has evidently been brought back from the hunt. Both men wear tiaras, sleeved, belted tunics, trousers, and shoes. The rider has in addition a short cloak, shown blowing in the wind at his back. The horse has a fringed saddle-cloth, and its tail is tied with a string ending in dangles. Ground line.

Fifth to fourth century B.C.

Furtwängler, *Beschreibung*, no. 183; *A.G.*, pl. XI, 13.

501. *Chalcedony scaraboid*, burnt. 27 × 22 mm.

In a private collection.

PERSIAN HORSEMAN, galloping to the right and turning round to spear a fox. He wears trousers, a long-sleeved tunic, a sleeveless, belted jacket, a tiara, and shoes. With the left hand he holds the reins, in his raised right hand a spear with a three-pronged end (like that held by the man on foot in no. 500). The trunk of his body and the right leg are more or less in three-quarter view. The horse has a fringed saddle-cloth; it has the distinctive receding forehead and curving nose.

A. U. Pope and P. Ackerman, *A Survey of Persian Art*, I, p. 390, fig. 89 (drawing).
Richter, *A.J.A.*, LXI, 1957, p. 264, pl. 81, no. 6.

502. *Sard scaraboid*. Edges chipped. 24 × 18 mm.

From Mesopotamia. In the British Museum, 1911.4–15.1. Bought 1911. Engraved on both sides.

(1) MOUNTED PERSIAN ATTACKING TWO MEN IN A CHARIOT drawn by two horses. The horseman has his spear lifted for the blow, holding it in both hands; he wears the regular Persian attire – a tiara, a sleeved jacket, trousers, and shoes, as well as a chlamys floating behind him. The two men in the chariot both look back at their pursuer. The charioteer sits in front, holding the reins in both hands; he wears a sleeved jacket and a cap-like helmet. The other man holds up a bow and arrow in his left hand and with the other seems to be grasping the horseman's spear. He wears a belted chiton (not a sleeved jacket as does the charioteer), and a cap-like helmet. Presumably the 'passenger' in the chariot is a Greek, for on Graeco-Persian stones, as far as I know, the Persians always attack Greeks, not fellow-Persians. All three horses are shown in full gallop, with forelegs lifted. That of the horseman has a saddle-cloth. Ground line.
(2) On the flat side: HOUND, seated in profile to the left, with head turned to the right. Part of the head is missing; also the lower part of the legs. Hatched border.

Perhaps fourth century B.C. An unusually crowded composition for a Graeco-Persian stone.
Walters, *Cat.*, no. 435, pl. VII.
Maximova, *Arch. Anz.*, 1928, col. 668, note 5, fig. 26 (on col. 671).

503. *Pink, pear-shaped, stone pendant*. Engraved on both convex sides. Ht. 26 mm.

From Cyprus. In the British Museum, 1909.6–15.2. Bought 1909.

(1) A WOMAN, seated on a stool, covered with drapery, is holding out a bird and a flower to a little girl who stretches out both arms toward them. The woman has long hair falling down her back in a plait and tied at the bottom with a string ending in dangles; she wears a long chiton, a necklace, and a diadem. The girl wears a belted chiton, and her hair is likewise done up in a plait which falls down her back. Ground line.
The scene has also been interpreted as a goddess with a worshipper (cf. Walters and Maximova, *loc. cit.*).
(2) A PERSIAN MAN AND WOMAN conversing. He wears a tiara, a long-sleeved jacket, trousers, and shoes. She has a long, belted, wide-sleeved chiton, and her hair is done up in a plait falling down her back and ending in dangles. Ground line.
Cf. the similar scene Furtwängler, *A.G.*, pl. XII, 11.

Walters, *Cat.*, no. 436, fig. 24, pl. VII.
Maximova, *Arch. Anz.*, 1928, col. 662, fig. 18b.

504. *Chalcedony scaraboid*, engraved on both sides. Fractured at one end. 25 × 17 mm.

In the Museum of Fine Arts, Boston, 03.1013.

(1) On the convex side: A PERSIAN WOMAN, seated on a diphros, with a bird perched on her left hand, while a child is coming toward her. She wears a tight-fitting, sleeved garment and a long veil that falls down her back. The child wears a short, belted tunic, and stretches out both arms toward the woman.
(2) On the flat side: A PERSIAN WOMAN, also seated on a diphros, and similarly dressed, is playing the tri-angular harp (trigonon). Before her is a Pomeranian dog, listening to the music.

Cursory work of the second half of the fifth century B.C.

Osborne, *Engraved Gems*, pl. VI, 19 a and b.

505. *Four-sided carnelian*, mounted on a ring. Engraved on all four sides. Ht. 22 mm.

Found at Kerch. In the Hermitage.

(1) A PERSIAN, standing to the right, holding a bow in both hands. He wears a tiara, a sleeved, belted jacket, and trousers. The feet are missing.
(2) A BEARDED GREEK MAN, wearing a himation, and playing with his dog.
(3) COCK-FIGHT. The two cocks confront each other, and are placed transversely.
(4) NUDE GIRL, dancing or stretching herself.

The fact that on this stone a Persian, comparable to the Persians who regularly appear on Graeco-Persian stones, is combined with three purely Greek representations, is an important argument in favour of Greek execution of these sealstones (cf. pp. 125-127).

Compte-rendu de la comm. imp. arch., 1882, pl. v, 1 and 1a.
Richter, *Archeologica Orientalia in Memoriam Ernst Herzfeld*, p. 194, pl. xxx, 9, 10.

506. *Chalcedony scaraboid.* 26 × 19 mm.

From Megalopolis. In the Staatliche Museen, Berlin.

A PERSIAN WOMAN, holding a cup and ladle in one hand and an alabastron in the other, is walking slowly to the right. She wears a long, tight-fitting chiton, with wide sleeves, and a necklace; her long, plaited hair falls down her back, ending in dangles. Her bosom and buttocks are prominent.

Second half of the fifth century B.C.

Furtwängler, *Beschreibung*, no. 181; *A.G.*, pl. xi, 6.
Lippold, *Gemmen und Kameen*, pl. 65, no. 7.

507. *Chalcedony scaraboid.* 26 × 19 mm.

In the British Museum. Acquired from the Castellani Collection in 1872.

PERSIAN WOMAN, standing to the left, holding a flower in one hand, a wreath in the other. She wears a close-fitting, wide-sleeved chiton, and her hair hangs down her back in a long plait, ending in dangles.

Furtwängler, *A.G.*, pl. xi, 10.
Walters, *Cat.*, no. 433, pl. vii.
Gow, *J.H.S.*, xlviii, 1928, pl. x, 3.
Maximova, *Arch Anz.*, 1928, col. 656, fig. 11.

508. *Sard scaraboid.* 18 × 13 mm.

From Eretria. In the British Museum, 95.5-11.7. Bought 1895.

PERSIAN WOMAN, standing to the left, holding a flower in each hand. She wears a long, wide-sleeved chiton and a himation. Her hair is done up in a long plait which falls down her back and ends in dangles. Ground line.

Second half of the fifth century B.C.

Walters, *Cat.*, no. 434, pl. vii, c. 480.
Gow, *J.H.S.*, xlviii, 1928, pl. x.

509. *Banded agate half barrel*, brownish with white bands. Ht. 20 mm.

In the Metropolitan Museum of Art, 25.78.100. Fletcher Fund, 1925. From the Wyndham Cook Collection. Once in the possession of Professor Furtwängler.

PERSIAN WARRIOR, standing at ease, in front view, with head turned in profile to the left. He holds a spear in his right hand, the left is brought to his waist; he wears a tiara, a sleeved, girded jacket, trousers, and shoes; a bow in its case is hanging from his belt. The folds of the sleeves and trousers are indicated by pellets. Line border.

Second half of the fifth century B.C.

The head has an almost portrait-like quality. A successful attempt to depict the features of an un-Greek, 'barbarian' type.

Burlington Fine Arts Club Exhibition, 1904, p. 255, no. o, 98, pl. cxii.
Smith and Hutton, *The Cook Collection*, no. 58, pl. 3.
Christie's *Sale Catalogue of the Cook Collection*, July 14th–16th, 1925, p. 72, 1925, p. 72, no. 448.
Gow, *J.H.S.*, xlviii, 1928, pl. x, 10.
Richter, *M.M.A. Bull.*, xxi, 1926, p. 286; *Hesperia*, Supplement viii, 1949, p. 294, pl. 34, no. 5; *M.M.A. Handbook*, 1953, p. 149, pl. 126, h; *Cat.*, no. 132, pl. xxii.

510. *Chalcedony scaraboid.* Fractured along the edge. 24 × 18 mm.

In the Ashmolean Museum, 1921.2.

PERSIAN MAN AND WOMAN. He is seated on a backless throne, with both hands stretched out to receive the cup and bottle being brought him by the woman. He wears a tiara, sleeved jacket, trousers, shoes, and mantle; his long hair is tied at the back. She wears a wide-sleeved, girded chiton, and her hair is done up in a long pigtail, ending in dangles. The throne has turned legs and is covered with close-fitting drapery, decorated with a cross-hatched pattern. A cushion serves him as a footstool. In the field, and on the convex back of the stone is a kufic inscription, which has been dated in the Ummayad period, with text from the Koran. Ground line.

Second half of the fifth century B.C.

511. *Agate scaraboid*, slightly burnt. 29 × 26 mm.

In the British Museum, 98.7-15.3. Acquired from the Morrison Collection, in 1898.

LYNX, standing to the left, with both forelegs extended and the tail between its hindlegs. Above is the Persian winged disk. Ground line.

Second half of the fifth century B.C.

Morrison Sale Catalogue, 1898, pl. i, no. 29.

Furtwängler, *A.G.*, III, p. 145, fig. 103.
Walters, *Cat.*, no. 534, pl. IX.

512. *Chalcedony scaraboid.* 23 × 18 mm.

In the Cabinet des Médailles, M6000.

LION, running to the left at full speed, as if pursued. All four legs are indicated.

Presumably Graeco-Persian, of the second half of the fifth century B.C.

Pierres gravées, Guide du visiteur (1930), p. 14, M6000, pl. VI.

513. *Bluish chalcedony scaraboid.* Fractured along the edge. 22 × 27 mm.

In the Metropolitan Museum of Art, 41.160.443. Bequest of W. G. Beatty, 1941.

WILD BOAR, running headlong to the left. Evidently conceived as part of a hunting scene.

Spirited work of the second half of the fifth century B.C.

Richter, *Animals*, pp. 24, 68, fig. 115; *Evans and Beatty Gems*, no. 33; *Hesperia*, Supplement VIII, 1949, p. 294, pl. 35, no. 1; *M.M.A. Handbook*, 1953, p. 149, pl. 126, i; *Cat.*, no. 140, pl. XXIV.

514. *Chalcedony scaraboid.* 27 × 19 mm.

In the Cabinet des Médailles (1198ter).

BOAR, running to the left, as if pursued (extract from a boar-hunt?).

Second half of the fifth century B.C.

515. *Sard scaraboid.* Fractured on both sides. 20 × 17 mm.

In the British Museum, 65.12–14.53. Acquired from the Christy Collection, 1865.

BOAR, in full gallop to the left, as if pursued.

Second half of the fifth century B.C.

Imhoof-Blumer and Keller, pl. XIX, 47.
Walters, *Cat.*, no. 551, pl. X.

516. *Chalcedony facetted stone*, with a single engraving on the flat, lower side. 31 × 19 mm.

In the National Museum of the Terme, Rome, inv. 80647.

BOAR, standing still, with tail raised. All four legs are indicated, but only one ear.

Cursory work of the fifth to fourth century B.C.

In spite of the much too long snout, the animal is presumably intended for a boar.

517. *Rose-coloured rectangular agate*, with one side flat, the other cut into five facets. Each of the six sides bears an engraved design. Perforated horizontally. 15 × 20 mm.

In the Metropolitan Museum of Art, 49.437. Posthumous gift of Joseph Brummer, through Ernest Brummer, 1949. (a) On the flat side: PERSIAN HORSEMAN, shooting an arrow at a reindeer. The horse is shown in front view, with head turned in profile to the left; the horseman is also in front view, but with the head turned in profile to the right, and the legs in profile to right and left. He wears a tiara, a long-sleeved tunic, trousers, and shoes. The string of his bow is made to pass behind his head. The horse has a bridle, reins, and peytrel. The reindeer is running full speed in profile to the right, but with both antlers shown frontal. (b) On each of the five facets is represented an animal: a seated lion, a reindeer, an antelope, a hyena – all three running at full speed – and a plunging bull. The reindeer is shown with a single antler.

Second half of the fifth century B.C.

For the plunging bull cf. the similar representations on contemporary pure Greek stones (cf., eg., no. 389).

Richter, *Hesperia*, Supplement, VIII, 1949, pp. 296, 298, pl. 31, nos. 4–7, pl. 32, nos. 1, 2; *Cat.*, no. 138, pl. XXIII.

518. *Rectangular gray agate*, with reddish-brown markings, with one side flat, the other cut into five facets. Perforated horizontally. Large chip on one side, and fractured along the edge. 16 × 16 mm.

In the Metropolitan Museum of Art, L1812. Lent by the American Numismatic Society, 1919. Said to be from near Bagdad. Formerly in the collections of D. Osborne and E. T. Newell.

(a) On the flat side: PERSIAN HORSEMAN, spearing a boar. Horse and rider are shown in front view with heads and legs more or less in profile. The man wears a tiara, a long-sleeved tunic, trousers, and shoes.
(b) On the rectangular field is a parrot; on the elongated sides are: a bear, a hyena, a fox sniffing at a grasshopper, and a lizard.

Second half of the fifth century B.C.

Cf. the stone in Leipzig with similar representations of a bear, a hyena, and a lizard, Furtwängler, *A.G.*, pl. XI, 7.

Osborne, *Engraved Gems*, pl. VI, 18, a, b.
Richter, *Animals*, figs. 210, 236; *Hesperia*, Supplement VIII, 1949, p. 294, pl. 32, nos. 3–8; *Cat.*, no. 139, pl. XXIV.
Maximova, *Arch. Anz.*, 1928, col. 674, fig. 28c.

8. THE HELLENISTIC PERIOD, ABOUT 325-100 B.C.

With the changes brought about by the conquests of Alexander the Great, Greek art assumed a different aspect. It was no longer, so to speak, self-contained. Contact with an enlarged world is reflected in a greater variety of styles, techniques, and subjects. This cosmopolitan character makes it more difficult to divide the products of the Hellenistic age into clearly defined chronological groups. Whereas in the preceding centuries it was possible to date individual specimens fairly exactly and to trace a steady development by quarter-centuries, and even sometimes by decades, one must now mostly confine oneself to dividing the gems – like the sculptures – into two chief categories: early Hellenistic of the late fourth and the earlier third century; and late Hellenistic of the later third and the second century B.C. Moreover, the late Hellenistic gems are often difficult to separate from the Graeco-Roman of the first century B.C., which closely follow the Hellenistic styles. (Several of these problematical examples are included in this Hellenistic section, since their style is characteristic of that period, though the date of execution may be 'Roman'.)

A few chronological landmarks, however, exist. It is clear that at first, in the early Hellenistic epoch, the styles created by the great masters of the fourth century – by the sculptors Praxiteles, Skopas, and Lysippos, and by the painters whose works are now lost – were continued by the artists of the succeeding period. One can distinguish three separate tendencies: the graceful, soft style associated with Praxiteles; the emotional, pathetic one supposedly characteristic of the works of Skopas; and the realistic direction initiated by Lysippos. But, as in other branches of Hellenistic art, so in the engraved gems, the fourth-century styles were not merely imitated, but progressively developed and accentuated to form independent original creations. Thus one finds almost exaggeratedly attenuated and softly modelled figures, faces in which strong feeling is superbly represented, and figures in contorted stances in expertly realistic style.

The choice of subjects also changes in the Hellenistic period from that current in the preceding. In the mythological field deities are still prevalent. Especially popular are Dionysos with his turbulent satyrs and maenads, as well as Aphrodite and her retinue of Eros, Psyche, and Hermaphrodite. The head of Medusa is also favoured and is now given the expression of pathos dear to the artists of the time. There are, moreover, newcomers, such as Sarapis and Isis, importations from Egypt. Minor deities, for instance, Galene, Glaukos, and Okeanos, make their entry. The formerly so popular Greek heroes still appear, but in diminished numbers. Daily-life scenes and animals are favoured; and in addition simple objects – vases, utensils, masks, symbols. A good idea of the latter may be obtained from the hundreds of clay impressions of intaglios found at Selinus, datable before 249 B.C., the year of the second destruction of the city (cf. Salinas, *Not. d. Scavi*, 1883, pls. VII-XV).

Furthermore, portraiture assumes an important place among the representations on gems, as it does in contemporary sculpture. Here too an increased interest in individuality can be observed, resulting in naturalistic masterpieces. They are the immediate forerunners of the Roman Republican portraits.

Noteworthy also is a tendency to archaize, which had made its appearance in the fifth and fourth centuries, but now becomes increasingly popular.

In the shapes of the gems an important change takes place. The perforated scarabs and scaraboids are replaced almost entirely by unperforated stones set in rings. They are either flat on one side and convex on the other, or convex on both sides; occasionally convex on one side and concave on the other. The

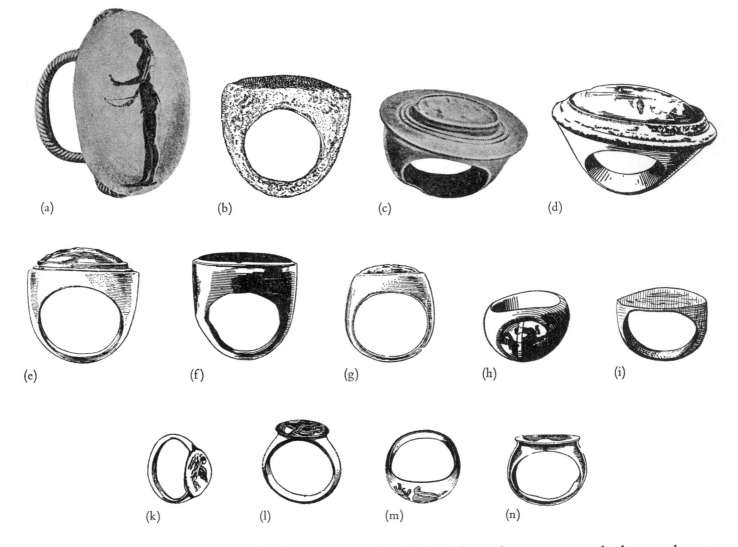

(a) (b) (c) (d)

(e) (f) (g) (h) (i)

(k) (l) (m) (n)

convexity is sometimes pronounced. The conquest of India by Alexander, moreover, had opened up to the Greeks a wealth of precious stones, in addition to the former semi-precious ones. And so the hyacinth, garnet, beryl, topaz, amethyst are now eagerly sought after and skilfully used to gain the maximum effect of their brilliant colouring. In addition, however, the semi-precious varieties – the rock crystal, carnelian, sard, agate, and sardonyx – remained in favour. Glass, especially of brownish tints, also frequently occurs. The stones are often of considerable size (cf., e.g., fig. a), set in large rings, some of which have been preserved. A characteristic form is that with a plain hoop, flat on the inside, expanding upward, sometimes with a raised setting (cf. figs. b–f). Metal rings with engravings on their bezels are likewise common. The bezels are of various shapes – rounded, oval, offset, or continuous with the hoop (cf. figs. i–n).

Inscriptions giving the name of the owner, or signifying the person represented, are hardly known. But several signatures of artists appear, and are of course of primary interest. Outstanding personalities, each known, however, by a single product, are Athenion, Daidalos, Pheidias, Boethos, Agathopous, Apollonios I (cf. pp. 16, 18f.). No signed work of Pyrgoteles, whom we know from a statement by Pliny (xxxvii, 8; vii, 125) to have been the preferred artist of Alexander (cf. p. 16), has unfortunately been preserved. Whether the many representations of Alexander on intaglios and cameos can be attributed to him is a moot question.

An important technical innovation of this period is the cameo, in which the design, instead of being

worked in intaglio, is carved in relief. Relief carving (or stamping) had, as we saw, occasionally been practised in earlier times – at the backs of scarabs, for instance, where figures of various shapes were sometimes substituted for the beetle; or when stamped figures in relief were used instead of intaglios on gold rings. In the Hellenistic period, however, reliefs appear for the first time as decorations in their own right. The impetus for this innovation came doubtless from the East; for the widespread custom in those luxury-loving regions of using precious and semi-precious stones to adorn not only rings but all manner of other objects, such as vases, utensils, musical instruments, and even shoes and garments, is attested by many statements of ancient writers. One hears of cups decorated with stones in Persia: λιθοκόλλητα ποτήρια (Theophrastos, *Char.*, 23); of metal tables, chairs, and utensils set with precious stones in India (Strabo, xv, 69); of the Indian king Sojuthes appearing before Alexander wearing shoes with gold soles adorned with precious stones and carrying a stick set with beryls. This love of display was then sometimes practised by the Hellenistic kings, as is indicated, for instance, by Athenaios' famous description of the procession of Ptolemy II, where not only cups but clothes and armour are cited as decorated with precious stones (Athen. v, 499, c, d). In the Delian inventories are listed libation bowls adorned with stones, dedicated to the Syrian queen Stratonike (Homolle, *B.C.H.*, VI, 1882, p. 32, lines 30 f.): φιάλαι χρυσαῖ βασιλίσσης Στρατονίκης ἀναθέματα.

In Greek lands, however, the use of precious stones was fortunately not confined to ostentation. The stones were given artistic form by being carved into sculptural shapes. Practically only in Hellenistic jewellery were uncarved stones used – very skilfully and discreetly – to add by their variegated colours to the richness of the general effect.

The cameos served both as ornaments and as dedications; but that the smaller ones were worn in rings is shown by the actual examples that have been found in tombs (cf., e.g., Stephani, *Compte-rendu*, 1880, pl. III, 9; S. Reinach, *Ant. Bosph.*, pl. XV, 115 – with coins of Lysimachos).

The material used for the newly introduced cameos was mostly the Indian sardonyx, of which the different layers – sometimes as many as six, ranging from dark brown to ivory – were utilized to form truly effective creations. Among the masterpieces of the period the two cameos in Leningrad and Vienna (cf. nos. 610, 611) occupy a prominent place; and so do the reliefs on the famous Tazza Farnese in Naples (cf. no. 596). These and some other outstanding pieces are included in this book. They may be said to enlarge our knowledge of Hellenistic art in a new medium. Many a composition lost in sculpture and painting may in some manner be preserved in these cameos, sometimes superbly executed. For their comparatively large size, compared with the intaglios, fitted them for the representation of scenes containing a number of figures.

It has been thought that the technique of carving cameos originated in Alexandria. There is, however, no definite evidence for this theory. Alexandria was of course a prominent art centre of the time, but it was after all only one of several. The provenances give no clue, for cameos have come to light all over the Hellenistic world, and, being easily transportable, could be found far away from their place of origin. The subjects, though occasionally pointing to Egypt (cf. no. 596), are more often taken from the general repertoire of the time. The two large examples in Vienna and Leningrad (cf. nos. 610, 611) are sometimes cited as reinforcing the theory of the Alexandrian origin of the cameo technique; but this would only be so if one interprets the couple represented as a Ptolemaic ruler and his wife, which does not seem likely (cf. *infra*). In any case, once the cameo had been introduced, the innovation found favour and spread

over the whole Hellenistic world – Egypt, Asia Minor, South Russia, Greece, Italy, etc.; and then became exceedingly popular in the Roman period.

Now and then the precious and semi-precious stones were worked not in relief, but in the round – either in one tone, e.g., in the gray agate, or in the various tones of the Indian sardonyx. The so-called Coupe des Ptolémées in Paris, probably of Hellenistic rather than of Roman date, can give an idea of the masterly treatment of this material.

The Hellenistic gems here presented illustrate the prevalent themes and stylistic tendencies observable also in contemporary sculptures. Compared to the preceding periods, there is now an extended repertoire of subjects, stances, and compositions; and when a well-known theme is repeated, more animation is generally imparted to it. This new emotional quality is evident not only in the expressions, but above all in the freedom of the stances and the often contorted postures. The figures are now shown from every conceivable angle, front, back, and three-quarters, always with perfect ease and expertly rendered. The struggles of the former centuries may be said now to find their consummation. It is also clear, however, that this very realism imparts to these Hellenistic representations a certain restlessness. The serenity of the classical age has given place to a new search for variety and actuality.

I have grouped my material more or less according to subjects, but within these categories I have tried to place the various pieces in roughly chronological order. When possible I have put first the examples that seemed more closely allied to their classical predecessors, followed by those which seemed later in style on account of their increased realism. The occasional juxtaposition of figures in similar stances will bring out that even in this late period of Greek art the old principle of adherence to a given type was not totally abandoned; cf., e.g., nos. 544–546, 580–582.

My groups are as follows:

(a) Nos. 519–537: Male figures, at first quietly standing in upright poses; then becoming increasingly animated, effeminate, and contorted. In two remarkable groups of Herakles and a Centaur (nos. 529, 530) the expression of agony recalls those of the Laokoon, of the giants of the Pergamene frieze, and of some heads found at Sperlonga. A seated boxer (no. 532) brings to mind the famous bronze statue in the Terme Museum, the youth with one leg raised (no. 531) that of the so-called Jason.

(b) Nos. 538–565: Female figures, at first in relatively quiet, upright poses (nos. 538–543); then leaning against columns and shields, with a consequent twist to their bodies (nos. 544 ff.); or leaning forward, and then becoming increasingly elongated and restless. Nos. 556 ff. show a number of female figures in sitting, crouching, and kneeling postures, first relatively quiet, then becoming more restless, with arms and legs going in different directions.

There are many masterpieces among these representations, e.g., the crouching Aphrodite in the Hermitage (no. 559), comparable to the marble statue in Rhodes; the Kassandra in Boston (no. 558); the Athena holding a helmet, in the British Museum, signed by Onesas (no. 553), a not unworthy successor of the Athena Lemnia; the Aphrodite arming, signed by Gelon, in Boston (no. 552); the Muse tuning a lyre, signed by Onesas, in Florence (no. 544); the Maenad in the Hermitage (no. 541); and the Nike writing on her shield, in New York (no. 554), a small version of the Nike of Brescia. All are valuable accessions to our store of Hellenistic statues, and have the advantage of showing the composition complete, not in a fragmentary state, as is so often the case in the marble and bronze sculptures.

(c) Nos. 566–582 show a number of Hellenistic heads, both male (nos. 566–574) and female (nos. 575–

582), with 'idealized' features, that is, not portraits. (The portraits are grouped together later.) In the male group are several representations of Herakles, one of Sarapis, and two (nos. 573, 571) – evidently late Hellenistic – of a silenos and of Helios; lastly a caricature (no. 574). In the female group are included four representations of the nymph Galene, shown swimming, all evidently reproducing the same type with slight variations (nos. 579–582).

(d) Then come designs showing several figures in a composition. They consist of riders and animal groups, each in its way exemplifying the contrast between the earlier and the later compositions and conceptions in Greek art of these familiar subjects. Cf. nos. 583–589.

(e) Lastly come a few famous Hellenistic cameos, ending with the Farnese cup (nos. 590–596). (Those of Roman date, which constitute by far the larger part of the surviving cameos, are to be treated in the second volume of this work.)

N.B. – It goes without saying that with the well-known difficulty of assigning dates to Hellenistic sculptures (see p. 133), the 'progression' here attempted is merely relative, not absolute; for in Hellenistic times different styles, early and late, were often practised side by side.

(a) *Male figures, mostly standing*

519. *Chalcedony or plasma (?) ringstone*, slightly convex on engraved side. 18 × 10 mm.

In the British Museum, Cra 42. From the Cracherode Collection.

ACHILLES (?), standing to the right, leaning against a column and holding a sheathed sword in his left hand. A himation is draped round the lower part of his body. Ground line.

Early Hellenistic.

Raspe, no. 8015.
Walters, *Cat.*, no. 1178 (not illustrated).

520. *Sard ringstone*, burnt. 23 × 16 mm.

Found by J. T. Wood on the site of the temple of Artemis, Ephesos.

In the British Museum, 74.7–10.347. Acquired in 1874.

ATHLETE BEING CROWNED BY NIKE. He is shown in three-quarter view, holding an olive twig in his left hand, and with a mantle rolled round his right arm. Nike is standing on tiptoe behind him, holding up a wreath to his head; she wears a chiton, belted. Ground line.

Early Hellenistic.

Walters, *Cat.*, no. 1198, pl. XVII.

521. *Garnet ringstone*, mounted in a gold-plated iron ring. Convex on the engraved side. 7 × 11 mm.

In the British Museum. Acquired through the Franks bequest in 1897. Formerly in the Braybrooke Collection.

APOLLO, standing by a tripod, which is mounted on a column, and round which a serpent is entwined. In his right hand he holds a taenia, in the left some round object. He is nude and has long hair, done up in a knot at the back of his head.

Third century B.C.

A late version of a familiar subject.

Marshall, *Cat. of Finger Rings*, no. 1458, pl. XXXIII.
Walters, *Cat.*, no. 1150 (not ill.).

522. *Garnet ringstone*, convex on the engraved side. 21 × 9 mm.

In the British Museum. 72.6–4.1183. Acquired from the Castellani Collection in 1872.

DIONYSOS, standing in an almost frontal position, with his right arm lowered to a column by his side, and holding a filleted thyrsos in his left hand. A himation is draped round the lower part of his body. Ground line.

Third century B.C.

Walters, *Cat.*, no. 1162 (not illustrated).

523. *Chalcedony ringstone*, speckled with yellow jasper. Convex on engraved side. 30 × 19 mm.

In the Staatliche Museen, Berlin. Acquired from Athens.

DIONYSOS, in three-quarter back view, leaning against a column. He is nude, and wears high boots, and a fillet with flowers in his hair. In his right hand he holds a kantharos, in the left a filleted thyrsos. His mantle is hanging from the column by his side. Ground line.

Third century B.C.

Furtwängler, *Beschreibung*, no. 1036.

524. *Glass, imitating sard, ringstone.* Convex on engraved side. Fractured at left, top and bottom. 28 × 15 mm.

In the British Museum, 1923.4-1.140.

APOLLO, standing in nearly frontal view, with his left elbow resting on a column, and holding with both hands a piece of drapery spread out behind him. He is nude and in his hair is a radiated diadem. Above his left shoulder appears a quiver, and in the field, above his right arm, is an object, partly broken away, which I take to be a bunch of laurel twigs, tied by a fillet (note the little leaves near Apollo's head). Ground line.

Third century B.C.

Cf. the Roman intaglios in Berlin with Apollo standing and holding laurel twigs in one hand, Furtwängler, *Beschreibung*, nos. 2654-2657; and the sealing from Cyrene, *Annuario*, N.S. XLI-XLII, 1963-64, pp. 66, 67, nos. 1 ff.

Walters, *Cat.*, no. 1219 (not illustrated).

525. *Sard ringstone.* 19 × 11 mm.

In the Staatliche Museen, Berlin.

TRITON, in almost frontal pose, holding a trident in his right hand, a steering-oar in the left. He has human form to the waist, and then terminates in two large fish bodies, coiled to the right and left. Below are two dolphins, swimming side by side, symbolizing the sea. Hatched border.

Fourth to third century B.C.

Gravelle, *Pierres gravées*, II, 33.
Furtwängler, *Beschreibung*, no. 354; *A.G.*, pl. XXXIII, 40.
Lippold, *Gemmen und Kameen*, pl. 6, no. 6.

526. *Banded agate ringstone*, brown and white. Fractured at top. 14 × 26 mm.

In the Metropolitan Museum of Art, 81.6.9. Gift of John Taylor Johnston, 1881. From the King and the Schaaf-hausen Collections.

DIONYSOS, standing in profile to the left, holding a kantharos in the left hand, and a filleted thyrsos in the right. He wears a long chiton and a himation, one end of which is thrown over the left shoulder. Ground line.

Fourth to third century B.C.; the style is archaizing.

For similar representations on gems cf. Furtwängler, *A.G.*, pl. XXV, 23, vol. III, p. 133, fig. 92; Lippold, *Gemmen und Kameen*, pl. 13, no. 7; Walters, *Br. Mus. Cat.*, no. 1025; D. K. Hill, *Journal of the Walters Art Gallery*, VI, 1943, pp. 67 f., fig. 7.

Raspe, no. 4202.
King, *Antique Gems*, pl. II; *Antique Gems and Rings*, II, wood-cuts, pl. XXVII, 4, 1, copperplates, group II, 24; *Handbook*, pl. LVIII, 1.
Furtwängler, *A.G.*, pl. XXIV, 42.
Richter, *M.M.A. Handbook*, 1953, p. 150; *Cat.*, no. 145, pl. XXV.

527. *Glass, imitating sard, ringstone.* Convex on engraved side. 38 × 18 mm.

In the British Museum, 1923.4-1.146.

HERAKLES, nude, beardless, is walking to the right, with both arms tied at his back. He has his club and bow, and the lion's skin is hanging from both his forearms. At his right shoulder is a small, winged Eros – now in command. Ground line.

Third century B.C.

The restless pose and detailed modelling form a strong contrast with the earlier renderings.
On Herakles with Eros cf. Furtwängler, in Roscher's *Lexikon*, I, 2, s.v. Herakles, cols. 2248 f. Sometimes Eros is represented as actually tying Herakles' arms, cf., e.g., Walters, *Cat. of the Br. Mus.*, nos. 1876, 3153.

Walters, *Cat.*, no. 1224, pl. XVI.

528b. *Amethyst*, mounted in a modern ring. 19 × 13 mm.

In the Fitzwilliam Museum. Bequeathed by Mr. Shannon, in 1937 (no. 26).

HERAKLES, bearded, nude, is walking to the right, with his hands tied behind his back. His club is under the left armpit, and from his left arm hangs also the lionskin. At his right shoulder is a small, winged figure. Ground line. The composition is similar to the preceding, but with differences: In the figure at Herakles' shoulder (female?) the leg is too long and does not properly connect with the upper part of the body. The tail of the lion is too long, and its forepaws are clumsily rendered. The right fore-arm of Herakles (on which a rope is tied) is made too

prominent to pass to his back; the foreshortening of his trunk is not quite successful; the toes of his left foot are not in the right position for walking; there is a world-weary expression in his face. All these features would be surprising in an ancient work of the developed period, and so arouse suspicion. The design, in fact, seems to have been copied from a gem of the Roman period in the Archaeological Museum in Florence (Furtwängler, *A.G.*, pl. xxx, 8), where, however, everything is correctly and expertly rendered. I illustrate it here, no. 528a, next to the London and Fitzwilliam stones, for the differences between them are very instructive – Hellenistic, Roman, and eighteenth century (?).

As Furtwängler, in Roscher's *Lexikon*, I, 2, s.v. Herakles, cols. 2248 f., pointed out, the motif of Herakles bound, in the presence of Eros (the strong man subdued by Love) exercised a strong appeal during the eighteenth century, and there are many modern copies of the scene, generally with a female figure substituted for Eros. A drawing of such a gem, in this case with an undoubtedly female figure, was published by Overbeck in *Berichte der sächsischen Gesellschaft*, 1865, pp. 43 ff.; cf. Furtwängler, *loc. cit.*, and my fig. above.

The Fitzwilliam stone has not before been published. It is here included with the kind permission of the authorities of the Fitzwilliam Museum.

529. *Chalcedony ringstone.* 42 × 33 mm.

In Furtwängler's time in a private collection in Leipzig. Now? Said to be from Alexandria.

HERAKLES AND A CENTAUR. Herakles has seized the rearing Centaur by the hair, and is about to strike him with his club. The lion's skin is hanging from his left

shoulder, with ends flying, and from the right shoulder his bow and quiver are suspended by a baldric. The Centaur's forelegs are raised, one hindleg is placed on a quadrangular 'step', the other is on the ground.

Along the right edge is the inscription Σῶσις ἐποίει, Sosis made it, in letters 'assignable to the third century B.C.' The name is known as that of a sculptor of the third century B.C. (cf. Loewy, *Inschriften*, no. 150). Cf. my pp. 16, 19. Ground line.

Later Hellenistic.

The energetic stance of Herakles forms an effective contrast with that of the suffering Centaur, and the same contrast is seen in their expressions – one full of fiery action, the other of agony. The Centaur's lifted head, framed by hair and beard, is in fact comparable to that of the Laokoon.

The 'step' on which the Centaur has placed one leg was interpreted by Furtwängler as signifying the entrance of the house of Dexamenos in Olenos, the father of Deianeira, whom the Centaur Eurytion attempted to carry away, and for which he is being punished by Herakles. This version of the story became popular in later times instead of the incident with Nessos.

Furtwängler, *A.G.*, pl. lxv, 11, and vol. iii, p. 448.
Lippold, *Gemmen und Kameen*, pl. 37, no. 11.

530. *Sard scarab*, slightly convex on engraved side. The beetle is cursorily worked. Fractured at top and piece missing at bottom. 24 × 18 mm.

In the British Museum, H373. From the Hamilton Collection.

HERAKLES AND A CENTAUR. Herakles, nude, is standing with one foot on a prostrate Centaur, holding him by the hair, and is about to strike him with his club. The Centaur has fallen on his knees and lifts both arms in supplication. His agony is vividly expressed in his face.

Third to second century B.C.

The scarab is unusually large and is one of the rare instances of its use in the Hellenistic period.

Furtwängler, *A.G.*, pl. lxv, 10.
Lippold, *Gemmen und Kameen*, pl. 36, fig. 8.
Beazley, *Lewes House Gems*, p. 87.
Walters, *Cat.*, no. 565, pl. x.

531. *Jacinth ringstone.* Lower part is missing. Convex on engraved side. 15 × 15 mm.

In the British Museum, 72.6–4.1343. Acquired from the Castellani Collection in 1872.

YOUTH, putting on a greave on his left leg. He is standing in three-quarter view, with his left leg raised, and his head turned frontal. Wavy, long hair surrounds his head in mane-like fashion.

In the field, to the right, on two horizontal lines, the signature of the gem-engraver Pheidias: Φειδίας ἐπόει.

Third century B.C.

The vivid expression and the mane-like hair recall portraits of Alexander the Great. The stance of the figure is found in a number of statues of the Hellenistic period, for instance in the so-called Jason (cf. Furtwängler, *Beschreibung der Glyptothek*, no. 287), as well as on gems (cf. Raspe, no. 9277).
On the engraver Pheidias cf. my pp. 16, 18.

Furtwängler, *J.d.I.*, III, 1888, p. 209, pl. VIII, 13; *A.G.*, pl. XXXIV, 18, and vol. III, p. 163.
E. Babelon, *La gravure*, p. 130; in Daremberg and Saglio, *Dictionnaire*, II, s.v. Gemmes, p. 130.
Walters, *Cat.*, no. 1179, pl. XVII.

532. *Carnelian* mounted in its original gold ring. 20 × 26 mm.

Said to have been found in a sarcophagus on the Sacred Way between Athens and Eleusis. Formerly in the Evans Collection; now in that of Professor Rõs in Switzerland.

YOUNG BOXER, sitting on a backless throne, or diphros, in three-quarter view. He is nude and wears a fillet in his hair, so he presumably has carried off a victory; on his arms, prominently displayed, are his boxing-gloves. On the seat is placed his mantle. All four legs of the seat are shown (one below the youth's right foot). Ground line.

The strong torsion of the figure, the animated face, and the elaborately turned legs of the seat point to the Hellenistic period; cf. my *Furniture*[2], p. 22. The three-quarter view is expertly rendered.
One may compare the bronze statue of a seated boxer in the Terme Museum, and contrast the seated youth, in a similar pose, but rendered in the quiet fifth-century style, in the Ashmolean Museum (my no. 261).

Richter, *A.J.A.*, LXI, 1957, p. 268, pl. 80, no. 16 (in the text referred to by mistake as no. 17). I owe my knowledge to this stone and the illustrations to the kindness of Professor Bloesch.

533. *Garnet*, set in a gold ring, convex on the engraved side. 19 × 10 mm.

In the Ashmolean Museum, 61 (Fortnum, 135). Acquired through the Fortnum bequest.

MARSYAS, standing in three-quarter back view, with his hands tied to the tree at his back. He is bearded and has long hair and two horns. Ground line.

Fourth to third century B.C.

An interesting, successful attempt to show the body in three-quarter back view.
For other representations of Marsyas bound to a tree and about to be flayed cf. Jessen in Roscher's *Lexikon*, s.v. Marsyas, cols. 2455 f., and my vol. II.
For the type of ring, with plain hoop expanding upward toward a flaring shoulder, cf. Marshall, *Cat. of Finger Rings*, p. XLII, no. XXIII (dated third century B.C.), and Brizio, *Mon. Ant.*, IX, cols. 666 f., pl. III, 6, 6a, col. 681, pl. V, 2, 2a, and cols. 732 ff., where rings are published of this form, found in tombs at Montefortino in Umbria and dated 395–283 B.C.

534. *Gold ring*, with engraved design on bezel. L. of bezel 14 mm.

From Kephallenia. In the British Museum, 67.5–8.414. Acquired from the Blacas Collection, 1867.

EROS, flying to the right, holding out a wreath in both his hands. His hair is tied at the top of his head. Though the figure is drawn in profile, the trunk is in three-quarter view. Above, the inscription χαῖρε, 'hail' – doubtless meant for the recipient. Dotted ground line – to indicate the air rather than the solid earth (?).

Fourth to third century B.C.

Newton, *Guide to the Blacas Collection*, p. 29 (14).
Marshall, *Cat. of Finger Rings*, no. 102, pl. IV.

535. *Gold ring*, with engraved design on round bezel. 20 × 21 mm.

In the Ashmolean Museum, 44 (Fortnum 117). Acquired through the Fortnum bequest.

EROS, standing in front of a lighted torch, with the left hand extended toward it, the right placed on his hip. Double ground line, the top one hatched.

Fourth to third century B.C.

536. *Gold ring*, with design on oval bezel. L. of bezel 20 mm.

In the British Museum. Acquired from the Franks bequest in 1897.

YOUTH, in almost frontal view, holding a lighted torch downward in his left hand, and the right arm raised, with fingers spread. A chlamys hangs from his arms. Thick, hatched ground line.

Third century B.C. or later.

The lively pose and triumphal air suggest that the youth was a winner in a torch race.

Marshall, *Cat. of Finger Rings*, no. 1066, pl. XXVII.

537. *Sard ringstone.* 15 × 13 mm.

In the Staatliche Münzsammlung, Munich. From the Arndt Collection.

ACTOR, performing a dance (?). He stands with his left foot on the ground, the right raised, one hand brought to his face, the other laid on his knee. He wears a short tunic and a mask with long hair and branches issuing from the top. His head is turned frontal, the body is in three-quarter view, the limbs in profile. On the ground are a fluted vase, and a pedum (?), which acts as a ground line.

Third century B.C. or later.

Czako and Ohly, *Griechische Gemmen*, no. 24 ('vermummter Kulttänzer').

(b) *Female figures in various positions*

538. *Yellow chalcedony ringstone.* 22 × 15 mm.

In the British Museum, 89.8-10.39. Bought 1889.

MUSE (?), standing in a frontal position, with head turned to the left, holding a lyre in the left hand, the plektron in the right. She wears a long, sleeveless chiton, a himation, and a head-band. Double ground line.

Early Hellenistic, in the fourth-century tradition.

If a Muse is intended, she is not shown in any of the usual stances; so she may be a simple human being.

Walters, *Cat.*, no. 1153, pl. XVII.

539. *Green agate scaraboid.* Surface weathered. 20 × 15 mm.

In the British Museum, 1905.7-11.5. Bought 1905.

OMPHALE, in the guise of Herakles. She has put on the lion's skin over her long chiton, and shoulders the club in her right hand. Ground line.

The subject is common in the Roman period, but this should be an early Hellenistic example, as shown also by the use of the scaraboid shape.

Walters, *Cat.*, no. 572, pl. X.

540. *Sard ringstone,* convex on engraved side. 20 × 12 mm.

In the British Museum, 1923.4-1.127. Acquired in 1923.

MUSE, standing by a column, holding a lyre in both hands. She wears a mantle round the lower part of her body and right shoulder. Ground line.

Probably third century B.C.

Walters, *Cat.*, no. 1151, pl. XVII.

541. *Carnelian ringstone.* 28 × 13 mm.

In the Hermitage (M602).

MAENAD, standing in three-quarter view to the left and holding a filleted thyrsos over her right shoulder. She wears a chiton and a himation, and in her hair is an ivy wreath. Ground line.

Hellenistic, fourth to third century B.C. Expertly carved.

The stance is quiet, but there is a twist to the body.

Furtwängler, *A.G.*, pl. XIV, 28.

542. *Gold ring,* with engraving on the oval bezel. 17 × 23 mm.

From Tarentum. In the National Museum, Naples, inv. 124688.

LEDA AND THE SWAN. She is standing by a pillar, with both arms raised to embrace the swan, which is perched on the pillar, with wings erect, neck bent, and beak near Leda's lips. She is nude, and her hair is done up at the top of her head; her garment is hanging from the pillar. On the projecting plinth of the pillar sits a little Eros, holding a bow, and with a quiver by his side. In the field, on the right, is the inscription Παζαλίας, Pazalias, either the artist's or the owner's name. There are small balls at the ends of the strokes of the letters. Ground line.

Third century B.C.

A work of great beauty, post-Praxitelean in style and conception.

For the type of ring cf. Marshall, *Cat. of Finger Rings*, pl. II, nos. 54, 58, 59.

Breglia, *Cat.*, p. 40, no. 97, pl. XVIII, 2.
Becatti, *Oreficeria antica*, no. 339, pl. LXXXIV.

543. *Brown onyx*, set in a gold ring. 16 × 11 mm.

In the Louvre, 1250. Acquired from the Campana Collection, 1862.

UPPER PART OF A WOMAN, in profile to the right, but with both breasts indicated. Only her right arm, with fingers spread, is included. She wears a himation loosely draped round her body.

Third century B.C.

De Ridder, *Bijoux antiques*, no. 1250.
Coche de la Ferté, *Les bijoux antiques*, pl. XXIV, 1.

544. *Yellow glass ringstone*. Scratches on surface. Mounted in a modern setting. 20 × 25 mm.

In the Museo Archeologico, Florence, inv. 14741.

A YOUNG WOMAN, PERHAPS A MUSE, standing, leaning against a column and tuning her lyre. She wears a long chiton, which leaves her right shoulder bare. On the column is mounted a small statue (bearded?). Behind the column is inscribed the signature of the artist, in two horizontal lines Ὀνησᾶς ἐποίει, 'Onesas made it'. Ground line. Cf. pl. B.

A masterly work of the third century B.C. An ancient glass gem, cast from a Hellenistic stone.

On Onesas cf. my pp. 16, 18. Cf. the similar compositions on several glass gems in Berlin, Furtwängler, *Beschreibung*, nos. 3624–3636.

Bracci, 88.
Raspe, 3440.
Gori, *Mus. flor.*, II, pl. 4.
C.I., no. 7231.
S. Reinach, *Pierres gravées*, pl. 48, no. 4.
Brunn, *Griech. Künstler*, II, pp. 354 f.
Furtwängler, *J.d.I.*, III, 1888, pp. 212 f., pl. VIII, 16=*Kleine Schriften*, II, pp. 204 f., pl. 26, fig. 16; *A.G.*, pl. XXXV, 23.

545. *Carnelian ringstone*, 'mounted in a fibula probably of the Byzantine period' (Chabouillet). 40 × 26 mm.

Brought from the Orient. In the Cabinet des Médailles. Acquired in 1852.

THE GODDESS FORTUNE, standing, with one elbow placed on a column, holding two cornucopias in the left hand, a filleted sceptre in the right. Ground line.

Probably third century B.C.

Chabouillet, *Cat.*, no. 1724.

546. *Light green glass ringstone*, engraved on both convex sides. Broken in two pieces and reattached; slightly corroded. 18 × 27 mm.

In the Metropolitan Museum of Art, 41.160.445. Bequest of W. G. Beatty, 1941.

WOMAN STANDING, to the right, her right elbow placed on a column, a bird on her extended left hand. She wears a himation draped round the lower part of her body; her hair is done up in a chignon at the back of her head. Behind her is a filleted staff. Thick ground line.

Third century B.C.

Somewhat cursory execution. For the seated woman on the other side of the gem cf. no. 556 – which, curiously enough, is executed with greater care, though presumably by the same artist.

Richter, *Evans and Beatty Gems*, no. 46; *M.M.A. Handbook*, 1953, p. 150; *Cat.*, no. 156, pl. XXVI.

547. *Garnet ringstone*, with engraved design on convex side. L. 25 mm.

In the Walters Art Gallery, Baltimore, 42.1228. Formerly in the Collection of Henry Walters.

APHRODITE AND EROS. Aphrodite is standing in an almost frontal pose, her right hand placed on a pillar, with the left holding up the mantle draped round the lower part of her body. She wears armlets and bracelets. On her left shoulder appears the upper part of a small Eros, in frontal view.

Third to second century B.C.

D. K. Hill, *Journal of the Walters Art Gallery*, VI, 1943, p. 66, fig. 6.

548. *Agate ringstone*, strongly convex on the engraved side. Fractured at bottom. 23 × 13 mm.

In the British Museum, T360. From the Towneley Collection.

NIKE, standing in a three-quarter pose, with head turned to the front. In her left hand she holds a long, filleted palm branch, the right is extended. She wears a himation and has two large wings, drawn foreshortened. In the field, on the two sides, are the letters εφχ | λο (?); 'ancient (?)' (M. Guarducci).

Third to second century B.C.

A charmingly vivacious pose and alert expression.

Walters, *Cat.*, no. 1170, pl. XVII.

549. Sard ringstone, convex on the engraved side. 21 × 12 mm.

In the British Museum, 65.7-12.141. In a modern setting. Acquired from the Castellani Collection in 1865.

ATHENA, walking on tiptoe to the left, holding her spear in the right hand and the shield on her left arm. The spear has a taenia tied on it. She wears a crested Attic helmet and a long, belted chiton, with aegis. Ground line.

Third to second century B.C.

The light, dancing pose is far removed from the early stately representations of Athena.

Walters, *Cat.*, no. 1144, pl. XVII.

550. Sard ringstone, convex on the engraved side. Fractured at the bottom. 36 × 23 mm.

From Tartus Antaradus. In the Ashmolean Museum, 1892.1515.

MAENAD, standing in three-quarter view, with her right elbow resting on a column, and holding a thyrsos in her right. She wears a sleeveless chiton and a himation, one corner of which she grasps in her left hand. Ground line.

Third century B.C.

The pronounced twist of her body is in line with Hellenistic taste.

551. Smoky quartz ringstone, convex on the engraved side. 26 × 20 mm.

From Halos, Thessaly. In the British Museum, 1907.3-13.1. Acquired 1907.

APHRODITE AND EROS. Aphrodite is standing to the right, with both forearms extended toward Eros, who is about to shoot off an arrow. She wears a long chiton and has her hair done up in a knot at the back of the head. Eros, nude, winged, is perched on a rock in a half-kneeling position, in three-quarter view; he holds his bow in the left hand, the arrow in the right. Ground line.

Cursory but vivid work of the third century B.C.

Cf. the ancient clay sealing, with a similar design – but with the Aphrodite shown seated on a diphros and the Eros standing on a table – from Selinus, dated in the third century B.C., Salinas, *Not. d. Scavi*, 1883, p. 305, pl. VI, no. 402, LXXX. See also my p. 2.

Walters, *Cat.*, no. 1156, pl. XVII.

552. Garnet ringstone, convex on the engraved side, set in a gold ring, which is inscribed χαῖρε inside the hoop. 17 × 23 mm.

In the Museum of Fine Arts, Boston, 21.1213. Formerly in the Evans and E. P. Warren Collections. Found in a tomb at Eretria with other objects, including terracotta statuettes, datable at the end of the third century B.C.; cf. Kourouniotes, *Eph. Arch.*, 1899, p. 228; Beazley, *loc. cit.*, and pl. facing p. 85, fig. 4.

APHRODITE ARMING. She is shown in three-quarter back view, in the act of inserting her left arm into the grip of her shield, which she holds by the rim with her right hand. A spear is leaning against her left shoulder. She is standing with her weight on the right leg, and the left placed on some raised object. The lower part of her body is enveloped in a mantle, one edge of which is brought up to her left shoulder. Her hair is gathered in a knot at the back of the head. In the field is the signature of the artist: Γέλων ἐπόει, lightly incised, on two lines. Ground line.

Third century B.C.

On Gelon cf. pp. 16, 18.

The foreshortening of the body and of the shield is expertly rendered. The modelling of the soft body is in the style of the post-Praxitelean period – effortless, without much detail and with a twist of the body. The subject of Aphrodite arming is common in the Hellenistic period, both in sculpture and painting. For the inscription χαῖρε on the hoop cf. nos. 172, 534.

Furtwängler, *A.G.*, pl. LXVI, 4.
Burlington Fine Arts Club Exh., p. 174, no. L, 90 (not ill.).
Beazley, *Lewes House Gems*, no. 102, pl. 7.

553. Sard ringstone, convex on the engraved side. Missing from the knees down and restored in gold. 17 × 16 mm. (original length *c.* 25 mm.).

In the British Museum, RPK 68. Acquired from the Payne Knight Collection.

ATHENA, standing in three-quarter view, holding her helmet in the right hand and her spear in the left. By her side is her shield, on which she rests her left elbow. She wears a chiton with long overfold. In the field is the inscription Ὀν⟨η⟩σᾶς ⟨ἐ⟩πο⟨ίησε⟩. Ground line.

On Onesas cf. pp. 16, 18.

A Hellenistic version of the Lemnian Athena.

The inscription was considered ancient by Brunn and Furtwängler, modern by Walters.

Brunn, *Geschichte der gr. Künstler*, II, p. 522.
Furtwängler, *J.d.I.*, III, 1888, p. 214; *A.G.*, pl. XXXIV, 43, and vol. III, p. 163; *Masterpieces*, p. 14, note 4.
Lippold, *Gemmen und Kameen*, pl. 21, fig. 10.
Walters, *Cat.*, no. 1143, pl. XVII.

554. *Brownish glass ringstone*, convex on the engraved side. Chipped along the edge. 15 × 19 mm.

In the Metropolitan Museum of Art, 41.160.505. Bequest of W. G. Beatty, 1941.

NIKE, with one foot placed on a rock, writing on a shield. A himation is loosely draped round the lower part of her body. Her long hair is tied in a chignon at the back of her head, with one lock descending down her neck. Ground line.

Third century B.C.

The motif is common on Hellenistic and Roman gems and coins. It appears in full-size sculpture in the Nike of Brescia.

Richter, *Evans and Beatty Gems*, no. 45; *M.M.A. Handbook*, 1953, p. 150; *Cat.*, no. 153, pl. XXVI.

555. *Carnelian ringstone*, convex on the engraved side, 23 × 14 mm.

In the De Clerq Collection, Paris. From Amrit.

APHRODITE, standing on tiptoe, in profile to the right, holding shield and spear. A mantle is loosely draped around her. Ground line.

Third century B.C.

The twist of the body is less pronounced than in no. 552.

De Ridder, *Catalogue, Collection De Clercq*, VII, 2, no. 2841, pl. X.
Beazley, *Lewes House Gems*, p. 86, pl. B, 7.

556. *Light green glass ringstone*, engraved on both convex sides. Broken in two and reattached. Chipped along the edge. 18 × 27 mm.

In the Metropolitan Museum of Art, 41.160.445. Bequest of W. G. Beatty, 1941.

MUSE, sitting on a rock and holding a lyre in her right hand; a mantle covers the lower part of her body, and her hair is done up in a chignon at the back of her head. Ground line.
For the design on the other side cf. no. 546.

Third century B.C. Expertly carved.

Richter, *Evans and Beatty Gems*, no. 46; *M.M.A. Handbook*, 1953, p. 150; *Cat.*, no. 156, pl. XXVI.

557. *Glass intaglio, imitating garnet*, strongly convex on engraved side; set in a gold ring with a decorated border. L. of bezel 25 mm.

In the British Museum. Acquired through the Franks bequest, 1897.

GIRL, seated on a rock. She has a himation draped round the lower part of her body, and holds a corner of it in one hand.

Third century B.C.

Marshall, *Cat. of Finger Rings*, no. 366, pl. XI.
Walters, *Cat.*, no. 1232.

558. *Sard ringstone*, convex on engraved side. 15 × 21 mm.

In the Museum of Fine Arts, Boston, 27.713. From the E. P. Warren Collection. Bought from Lambros in 1908.

KASSANDRA, crouching at the palladion. She is in a half-kneeling position, her head bowed, with her left hand clasping the image, in her right hand a sprig of olive. A mantle is draped round her left leg and arm. Her hair is wreathed with laurel and falls loosely in undulating locks on her back and shoulders. The palladion is clothed in a long, belted chiton and has a crested helmet and shield, with a central gorgoneion, and a spear. It is placed on a plinth set on a base. Ground line.

The delicate modelling of the body seems to place this gem in the Hellenistic rather than in the Roman period.

There is a replica, also in Boston, with slight variations, e.g., the palladion has no spear and there is a boss instead of a gorgoneion on her shield.

Beazley, *Lewes House Gems*, no. 93, pls. 7, 10.
Chase-Vermeule, *Handbook*, p. 187, no. 177.

559. *Carnelian ringstone*, with engraving on convex side. 12 × 18 mm.

In the Hermitage, M575.

CROUCHING APHRODITE, holding a mirror in her right hand, and a corner of her drapery in her raised left. Her long hair falls loosely on her shoulders. The head and trunk are shown in three-quarter view, the rest more or less in profile.

Hellenistic, third century B.C.

The pose – a development of the earlier renderings of the crouching Aphrodite (cf. nos. 298–303) – is similar to that of the famous marble Aphrodite from Rhodes.

Furtwängler, *A.G.*, pl. XXXIII, 43.

560. *Carnelian ringstone*, mounted in a gold ring. 24 × 15 mm.

From Vulci. In the Louvre, 1259. From the Campana Collection. Acquired 1862.

KASSANDRA, sitting on the altar of Athena, and clasping the image with both hands. She wears a girded chiton and a himation, and her hair is done up in a knot at the back of her head. The statue of Athena is in the usual archaizing style, in the 'Promachos' pose, wearing a girded peplos and a helmet, and holding spear and shield. The altar is wreathed, and shown in perspective. Ground line.

Third to second century B.C.

The pronounced twist of the body is in line with the taste of the times.

De Ridder, *Bijoux antiques*, no. 1259.

561. *Brown glass ringstone*, mounted in a gold-plated bronze ring. Cracked across the middle. Convex on the engraved side. The gilding of the ring has partly disappeared. 14 × 32 mm.

In the Metropolitan Museum of Art, 17.194.27. Gift of J. Pierpont Morgan, 1917. From the Gréau Collection.

APHRODITE, standing in almost frontal view, with her right elbow resting on a column, and holding her mantle with both hands. She has large pendant earrings.

Third to second century B.C.

For the type of ring cf. Marshall, *Cat. of Finger Rings*, p. XLII, no. C, XXIII.

Froehner, *Gréau Collection*, pl. CLXXIV, 26.
Richter, *M.M.A. Handbook*, 1953, p. 150; *Cat.*, no. 157, pl. XXVI.

562. *Glass, imitating sard, ringstone*, convex on the engraved side. 23 × 13 mm.

In the British Museum, 1923.4–1.135.

APHRODITE, standing in front view, leaning against a column by her side, and holding in her right hand a corner of the mantle which is loosely draped over her back and right leg. Her left hand is raised and apparently holds a lock of her hair. Ground line.

Third to second century B.C.

Walters, *Cat.*, no. 1213 (not ill.).

563. *Dark blue glass ringstone.* 25 × 18 mm.

In the Staatliche Museen, Berlin. From the Panofka Collection.

APHRODITE, standing in three-quarter front view, her left forearm placed on a column. In her right hand she holds a bird by its wings. A mantle is draped round the lower part of her body and her left arm. Ground line.

Third century B.C.

Furtwängler, *Beschreibung*, no. 1055.

564. *Light green glass ringstone*, convex on both sides. 18 × 24 mm.

In the Staatliche Museen, Berlin. From the Bartholdy Collection.

MAENAD, in three-quarter back view, rushing to the left, her head thrown back, arms outspread, a severed human head (of Pentheus?) in her left hand. She has long hair and wears a transparent, girt chiton, flying in the wind. Ground line.

Spirited work of the later Hellenistic period.

Furtwängler, *Beschreibung*, no. 1068.

565. *Gold ring*, with engraved design on oval bezel. 11 × 15 mm.

Found in 1916 on the contrada Vacarella of Taranto. In the Museo Nazionale, Taranto.

NUDE GIRL, kneeling, with head raised, and both hands brought up to the nape of her neck. Her long hair falls loosely down her back. Behind her, horizontally across her back, is what looks like a rake. Thick ground line.

Fourth to third century B.C.

What the significance of the rake (?) might be is uncertain.

Breglia, *Japigia*, X, 1939, p. 27, no. 30.
Becatti, *Oreficeria ant.*, no. 337, pl. LXXXIV.

(c) *Heads, male and female, exclusive of portraits*

566. Agate (?) ringstone, burnt. Fragmentary. 25 × 20 mm.

In the British Museum, 89.8–3.1. Purchased, 1889.

HEAD OF A YOUTH, in profile to the left. He wears an ivy-wreath in his short curly hair, and has large, wide-open eyes.

Fourth to third century B.C.

Walters, *Cat.*, no. 1192, pl. XVII.

567. Sard ringstone. 20 × 14 mm.

In the Ashmolean Museum, 1921.1233. Gift of Sir John Beazley. Once in the Story-Maskelyne Collection.

HEAD OF HERAKLES, in profile to the right. He wears the lion's skin on his head, knotted on his chest.

Third century B.C.

The expression somewhat resembles that of Alexander.

Sotheby Sale Catalogue of the Story-Maskelyne Collection, 4th–5th July, 1921, no. 100.
Select Exhibition of Sir John and Lady Beazley's Gifts, 1912–1966, no. 656, pl. LXXXIV.

568. Sard ringstone, convex on both sides. In a modern setting. 18 × 15 mm.

In the Ashmolean Museum, 1892.1508. Acquired through the Chester bequest. Formerly in the Tecco Melchiore Collection.

HEAD OF ZEUS AMMON, in three-quarter view to the left. He is bearded and has curly hair; both ram's horns are indicated.

Hellenistic period.

The foreshortening of the right eye has not been successful.

569. Sard ringstone, broken across the middle. 27 × 22 mm.

In the British Museum, 90.6–1.171. Acquired from the Carlisle Collection in 1890.

BUST OF HERAKLES, in profile to the right. He wears the lion's skin on his head, tied in a knot at his throat, and has rows of short curls round his forehead.

Walters, *Cat.*, no. 1177, pl. XVII.

570. Rock crystal ringstone, convex on both sides. Chipped along the edge. 16 × 20 mm.

In the Metropolitan Museum of Art, 81.6.18. Gift of Jon Taylor Johnston, 1881. From the King Collection.

BUST OF SARAPIS, in almost frontal view. He wears a chiton and a mantle; on his head is the modius, decorated with a leaf pattern.

Hellenistic work, inspired by fourth-century representations of Zeus. Expertly engraved.

For similar representations cf. the carnelian in Berlin, 1105 (Furtwängler, *A.G.*, pl. XXXIII, 28), and the stones in England (Furtwängler, *A.G.*, pl. XXXVIII, 43, 44, pl. XLI, 2).

Richter, *Cat.*, no. 146, pl. XXV.

571. Sard ringstone, slightly convex on engraved side. 15 × 10 mm.

In the British Museum, Cra.24. From the Cracherode Collection.

BUST OF HELIOS, in three-quarter view. He has flowing locks, surrounded by rays. His brows are lifted. The expression is one of pathos. There is a certain resemblance to Alexander the Great.

Raspe, no. 3064.
Furtwängler, *A.G.*, pl. XXXIII, 30.
Ujfalvy, *Type physique d'Alexandre le Grand*, pp. 137, 141, fig. 42.
Schreiber, *Bildnisse Alexanders des Gr.*, p. 210, note 35.
Walters, *Cat.*, no. 1167, pl. XVII.

572. Glass ringstone, mounted in a modern ring. 19 × 15 mm.

In the Fitzwilliam Museum, Cambridge. From the Shannon Collection. Acquired in 1937, no. 33 (6).

HEAD OF HERAKLES, in profile to the right. He is bearded and wears a laurel wreath.

Early Hellenistic.

The deep-set eyes, the projection of the lower part of the forehead, and the curly hair recall the Herakles Farnese in Naples attributed to Lysippos. The head on the gem is beautifully preserved, including the finely curved nose.

For a closely similar, also Hellenistic, head, found recently at Pantikapaion, cf. Maximova, in *Materialy i issledovanija po archeologii,* S.S.S.R., no. 103, 1962, p. 193, no. 7 (ill.); and on the general type cf. Furtwängler, in Roscher's *Lexikon,* I, 2, s.v. Herakles, cols. 2169 f.

Middleton, *Engraved Gems,* p. VI, no. 9 (not ill.).

573. *Sardonyx ringstone.* 23 × 16 mm.

In the Numismatic section of the National Museum, Athens, inv. 768. Gift of K. Karapanos, 1911.

BUST OF A SILENOS, in profile to the right. He wears a mantle and an ivy-wreath.

Wonderfully expressive head of the late Hellenistic period, beautifully modelled.

Svoronos, *Journal international d'archéologie numismatique*, xv, 1913, no. 306.

574. *Bronze disk.* 15 × 17 mm.

From Alexandria. In the Ashmolean Museum, 1888.339. Gift of the Rev. G. J. Chester.

CARICATURE OF THE HEAD OF A MAN, in profile to the left. He wears a mantle, and a cap tied with a string at the back.

Hellenistic period.

575. *Sard ringstone*, in a modern mount. 18 × 16 mm.

In the Ashmolean Museum, 1892.1498. Acquired through the Chester bequest. Formerly in the Tecco Melchiore Collection.

HEAD OF A WOMAN, wearing a veil – or the end of her himation – over the back of her head, in profile to the right.

Hellenistic period.

576. *Peridot ringstone*, convex on both sides. 17 × 15 mm.

In the Ashmolean Museum, 1892.1497. Acquired through the Chester bequest. Formerly in the Tecco Melchiore Collection.

HEAD OF A MAENAD, with an ecstatic expression, in profile to the left. She wears an ivy-wreath in her long, curly hair.

Third century B.C.

577. *Sard ringstone*, in a modern mount. 14 × 11 mm.

In the Ashmolean Museum, 1892.1545. Acquired through the Chester bequest.

FEMALE BUST, in profile to the right. Drapery on the left shoulder. The right breast is shown frontal instead of in profile or in three-quarter view.

Hellenistic or Roman period.

578. *Gold ring*, with engraved design on bezel. 10 × 14 mm.

In the Louvre, Bj 1053. From the Campana Collection. Acquired in 1862.

HEAD OF A WOMAN, in slight three-quarter view. She has long, curly hair and wears a necklace.

Hellenistic period.

De Ridder, *Bijoux antiques*, no. 1053.

579. *Glass, imitating beryl, ringstone*, convex on engraved side. 20 × 14 mm.

In the British Museum, 1923.4-1.141.

GALENE. Head and right shoulder of the Nereid Galene, swimming to the right. Her long, curly hair falls down her back. Below are curving lines to indicate her drapery.

Third century B.C.

The detailed description of an engraved gem in the *Anthology* (IX, 544) has given the clue for the identification of the figure as Galene: 'Tryphon coaxed me, the Indian beryl, to be Galene, the goddess of Calm, and with his soft hands let down my hair. Look at my lips smoothing the liquid sea, and my breasts, with which I charm the windless waves. Did the envious stone but consent, you would soon see me swimming, as I am longing to do' (tr. W. R. Paton).

There are many replicas of this type. Besides those here illustrated cf., e.g., those in Berlin (Furtwängler, *Beschreibung*, nos. 4792.6271–73); in Leningrad (Furtwängler, *A.G.*, pl. xxxv, 13, 14); in Copenhagen (Fossing, *Cat., Thorvaldsen Gems*, nos. 1100–1103). Some are of Hellenistic date, others Roman. A similar design occurs on coins of the Roman Republic, struck by Q. Crepereius Rocus, *c*. 70 B.C.; cf. Grueber, *British Museum, Coins of the Roman Republic*, pl. 43, nos. 1, 2; Sydenham, *Roman Republican Coinage* (1952 ed.), p. 131, no. 796 (there interpreted as representing Amphitrite). For the male counterpart 'Leander' cf. no. 601.

Walters, *Cat.*, no. 1221, pl. XVI.

580. *Light purple glass, imitating amethyst, ringstone.* Surface pitted. 19 × 13 mm.

In the British Museum, 1923.4-1.142.

GALENE, swimming to the right. Replica of no. 579. Evidently moulded from the same original.

Walters, *Cat.*, no. 1222 (not ill.).

581. *Sard ringstone*, in a modern mount. 13 × 16 mm.

In the Ashmolean Museum, 1892.1554. Acquired through the Chester bequest.

GALENE, swimming to the right. Similar to the preceding.

Hellenistic or Roman period.

582. *Dark blue glass ringstone*, convex on both sides. 17 × 23 mm.

In the Metropolitan Museum of Art, 17.194.28. Gift of J. Pierpont Morgan, 1917. From the Gréau Collection.

GALENE, swimming to the right. Similar to the preceding.

Third century B.C.

Froehner, *Gréau Collection*, pl. CLXXIV, 11.
Richter, *Cat.*, no. 150, pl. XXV.

(d) *Designs showing several figures in a composition*

583. *Sard ringstone*, mounted in a gold ring. Convex on the engraved side. 12 × 16 mm.

From Perugia. In the British Museum, 72.6–4.161. Acquired from the Castellani Collection in 1872.

WARRIOR, riding a galloping horse, and holding a long spear in one hand, a large round shield in the other. He wears a cuirass and a helmet.

Expert Hellenistic work, full of verve and energy.

Marshall, *Cat. of Finger Rings*, no. 385, pl. XII.
Walters, *Cat.*, no. 1009.

584. *Carnelian ringstone*. 16 × 13 mm.

In the Staatliche Museen, Berlin.

THREE YOUTHS, each wearing helmet and chlamys, riding alongside one another to the right. The centre one is a little ahead of the other two; the far one is a little behind the near one. Of the horses, the far one is restless and lifts its head; the near one turns its head to the front; the head of the middle one is in profile. Ground line and hatched border.

Probably third century B.C.

The composition is masterly. In the tiny allotted space the three horsemen are designed in a convincing and lively manner, each differentiated from the other. An old problem is here ably solved in a naturalistic manner.

Furtwängler, *Beschreibung*, no. 6442.

585. *Gold ring*, with an engraved design on quasi-circular bezel, and with a plain hoop expanding upward. 10 × 12 mm.

In the Cabinet des Médailles. Gift of the duc de Luynes in 1862 (no. 520).

THE TWO DIOSKOUROI. Each holds his horse by the bridle with one hand and grasps a spear in the other. One is shown frontal, the other in three-quarter view. Mantles cover their backs. Only the foreparts of the horses appear – in three-quarter view. Ground line.

Third century B.C.

For the type of ring cf. Marshall, *Cat. of Finger Rings*, p. XLII, no. XXVI.

586. *Gold ring*, with engraved design on round bezel. Diam. of bezel 14 mm.

In the British Museum, 72.6–4.73. Acquired from the Castellani Collection in 1872.

NESSOS AND DEIANEIRA. He is galloping to the right, carrying Deianeira on his back and stretching out both his arms. She is sitting astride, with her head hidden behind Nessos' body. She wears a chiton and a himation. Drapery (held by the Centaur?) is flying in the wind. Below, the ground is indicated by horizontal lines and vertical plants; so not water. Line border.

Third century B.C.

As Marshall pointed out, the representation follows the version of the legend given in Sophokles' *Trach.*, 555 ff., in which Nessos carries off Deianeira and is killed by Herakles' arrow; not at close quarters with a sword as represented on archaic monuments.

For a similar representation on a small Roman mosaic in Madrid (48 × 38 cm.) – copied from a Hellenistic painting (?) – cf. Quilling, in Roscher's *Lexikon*, III, s.v. Nessos, cols. 285 ff. (ill.); E. Bethe, *Arch. Anz.*, VIII, p. 8; Quilling, *Aus städtischen und privaten Sammlungen in Frankfurt a.M.*, 1898.

Marshall, *Cat. of Finger Rings*, no. 104, pl. IV.

587. *Carnelian ringstone.* Chipped along upper edge. 19 × 12 mm.

In the Musées Royaux d'Art et d'Histoire, Brussels, inv. no. R2176.

LION ATTACKING AN ANTELOPE. He has jumped on his victim from behind and is biting it in the back, with head shown almost frontal. The antelope has fallen, with three legs bent under, the left hindleg extended; and on this hindleg are placed both hindpaws of the lion, in the usual convention (cf., e.g., nos. 379, 380, 383).

Fourth to third century B.C.

The composition is similar to that in the fifth-century representations nos. 383–386, but is more animated. Cf. also the engraving of a lion devouring a dolphin on a gold ring in Boston (98.795), Hoffmann and Davidson, *Greek Gold*, no. 114.

Furtwängler, *A.G.*, pl. XXXI, 6.

588. *Sard ringstone*, nearly circular. 15 × 15 mm.

From Poseidonia. In the British Museum, 72.6–4.1342. Acquired from the Castellani Collection in 1872.

LION ATTACKING A BULL. The lion has jumped on top of the bull and is biting it in the back. The bull has its right foreleg bent and its head is raised in agony. The lion's hindlegs are perched on a rock. Ground line, on which little plants are growing, to show the out-of-doors. Hatched border.

I take this to be Greek Hellenistic rather than late Etruscan or Italic, as did Walters; but the line between the two is often difficult to draw .

Walters, *Cat.*, no. 783, pl. XIII.

589. *Carnelian ringstone.* 13 × 13 mm.

In the Staatliche Museen, Berlin.

SNAKE AND ICHNEUMON, confronted. Each views its adversary, with head raised, ready for the attack. At the back are waterplants to indicate the locality. Thick ground line.

Probably Hellenistic period.

A vivid rendering of animal life in its unending contest, shown in a characteristically abbreviated landscape. The snake was identified by Imhoof-Blumer and Keller as an '*Aspis Naja Hajé*', a species of African viper.

Imhoof-Blumer and Keller, pl. XXIII, 10.
Furtwängler, *Beschreibung*, no. 6458; *A.G.*, pl. XXXIII, 48.

Finally I may mention two impressions of Hellenistic seals on a terracotta loom-weight, found in Corinth in 1965, and now in the Corinth Museum. (Cf. p. 3.) 589a. One represents a cock with an elephant's trunk on its head, and armed with shield and spear.

589b. The other shows a lively satyr with a kantharos on its raised right foot, into which he is pouring wine from the wineskin he is carrying on his back. It is a little Hellenistic masterpiece.

Both are here illustrated with the kind permission of Mr. Henry S. Robinson. Cf. now Daux, Chronique, *B.C.H.*, vol. 90, 1966, p. 753, fig. 4.

Another impression on a terracotta loom-weight has recently (1967) been found at Satrianum in Lucania. It represents an ape on top of a jackal or fox, and is dated by the excavators *c.* 330 B.C. (to be published by R. Holloway).

(e) *Cameos, exclusive of portraits*

590. *Agate cameo.* 30 × 35 mm.

In the National Museum, Naples, inv. 25862. From the Farnese Collection.

HEAD OF SARAPIS, in slight three-quarter view. He wears a kalathos (modius) decorated with a pattern of olive leaves.

The soft modelling points to a Hellenistic date.

Real Museo di Napoli (*Museo Borbonico*), IV (1832), pl. XXXIX, 2.
Overbeck, *Zeus*, Gemmentafel, 4, 14, p. 320.
Furtwängler, *A.G.*, pl. LIX, 10.
Lippold, *Gemmen und Kameen*, pl. 4, no. 1.

591. *Sardonyx cameo.* Chipped round the edge. 70 × 60 mm.

In the Museo Archeologico, Venice, 2619. Found at Ephesos.

BUST OF ZEUS, wearing an oak wreath on his head and an aegis on his left shoulder. He is bearded and has long, flowing curls and deep-set eyes.

Spirited Hellenistic work, probably of the second century B.C.

Visconti, *Sopra un antico cammeo*, 1793, in *Opere varie*, I (1827), pl. 16, pp. 191 ff.
Krause, *Pyrgoteles*, pl. I, 10, p. 271.

Müller-Wieseler, *Denkmäler*, II, pl. I, 5.
Lenormant, *Nouvelle galerie mythol.*, pl. VI, 1, p. 30.
King, *Antique Gems and Rings*, II, pl. 16, 4.
Overbeck, *Kunstmythologie*, II, Zeus, Gemmentafel III, 3, p. 243; *Göttinger Nachrichten*, 1874, p. 584.
Heydemann, *Mitt. aus den Antikensamml. in Ober- und Mittelitalien*, p. 16.
Furtwängler, *A.G.*, pl. LIX, 8.
Lippold, *Gemmen und Kameen*, pl. 2, no. 2.
B. Forlati Tamaro, *Il Museo Archeologico del Palazzo Reale di Venezia*, Itinerari, no. 88, 1953, p. 16, illustration on p. 58.

592. *Sardonyx cameo*, white on brown. Mounted in a Turkish ring. 18 × 11 mm.

In the Museum of Fine Arts, Boston, 27.750. Formerly in the Collection of E. P. Warren. Bought in 1899 from Dr. W. Hayes Ward of New York, who acquired it in or near Bagdad.

APHRODITE AND EROS. She is standing in a nearly frontal position, her weight on her right leg, her head inclined toward her right shoulder, to look at the little Eros who is fluttering there. She wears a transparent chiton which leaves her right shoulder and breast bare, and a himation round the lower part of her body; on the back of her head is a veil. Below is the stump of a tree. In the field is the incuse signature of the artist: Πρώταρχος ἐποίει, 'Protarchos made it'.

The soft modelling of the body points to Hellenistic workmanship.

On Protarchos cf. pp. 16, 19 and no. 593.

Babelon, *Cat. des camées antiques*, p. XL.
Furtwängler, *A.G.*, vol. III, pp. 447 f., fig. 230 ('Die Schrift ist ganz hellenistischer Art und weist etwa auf das zweite Jahrhundert v. Chr.').
Beazley, *Lewes House Gems*, no. 128, pl. 8 ('lettering of signature points . . . to the 2nd century B.C.').
Vollenweider, *Steinschneidekunst*, pp. 23 ff., 96, pl. 13, nos. 1, 3 (dated in the early first century B.C.).

593. *Sardonyx cameo.* In a modern mount. 25 × 20 mm.

In the Museo Archeologico, Florence, inv. 14439.

EROS, nude, riding on a lion and playing the kithara. The lion is walking quietly to the right. Ground line. Beneath is the inscription Πρώταρχος ἐπόει,' Protarchos made it'; like the design, cut in relief out of the white layer of the stone, which accounts for the lack of accurate definition in some of the letters. Beneath the inscription is left a streak of white.

Later Hellenistic.

Cf. the other work signed by Protarchos, no. 592. It is noteworthy that in this piece Protarchos cut his signature in relief and spelled the verb *epoei*, in no. 592 the signature is incuse and the verb spelled *epoiei*; and yet they seem to refer to the same man (cf. Furtwängler, *loc. cit.*).

Gori, *Mus. Flor.*, II, no. 11.
S. Reinach, *Pierres gravées*, pl. 48, no. 11.
Furtwängler, *J.d.I.*, III, 1888, p. 218, pl. VIII, 20; *A.G.*, pl. LVII, 1.
Vollenweider, *Steinschneidekunst*, pp. 24 f., 95, pl. 12, no. 1 (dated in the early first century B.C.).

594. *Sardonyx cameo*, with the relief worked in the white layer of the stone. 35 × 30 mm.

In the National Museum, Naples, inv. 25848. Once in F. Ursinus' possession.

ZEUS, driving a chariot, drawn by four rearing horses, over two giants with serpents' tails. He holds his thunderbolt in the right hand, the sceptre and the reins in the left; a himation covers the lower part of his body. One of the giants is still defending himself, a torch in one hand; the other is lying supinely on the ground. All eight forelegs of the horses are indicated, but only one pair of hindlegs (so as not to interfere with the giants' snakes); also both chariot wheels are shown, the farther one in part. Wheels, chariot, horses, giants are all shown going in different directions, often not related to one another. Below is the signature of the artist 'Αθηνίων, Athenion.

On Athenion cf. p. 18.

The style is Hellenistic baroque, of the third to second century B.C., comparable to the figures of the Pergamene altar. It is instructive to compare this restless composition with the late fifth-century quadrigas on coins and gems.

Winckelmann, *Mod. ined.*, no. 10.
Bracci, *Memorie*, I, 30, p. 161.
Raspe, no. 986, pl. 19.
Real Museo di Napoli (Museo Borbonico), XII (1856), pl. XLVII.
S. Reinach, *Rev. arch.*, 3rd ser., XXV, 1894, pp. 290 f.
Müller-Wieseler, *Denkmäler*, II, pl. III, 34.
Lenormant, *Chefs-d'œuvre de l'art antique*, I, 2, pl. 23, 1.
Overbeck, *Kunstmythologie*, II, Zeus, Gemmentafel V, 2, p. 39.
Furtwängler, *A.G.*, pl. LVII, 2; *J.d.I.*, III, 1888, pp. 215 f., pl. 8, 19 = *Kleine Schriften*, II, pp. 207 f., pl. 26, fig. 19.
Pesce, *Museo Nazionale di Napoli, Oreficeria*, 1932, p. 66, fig. 31, 2.
Lippold, *Gemmen und Kameen*, pl. 3, no. 4.

595. *Indian sardonyx cameo*, broken on the left side. At present 30 × 27 mm.

In the Staatliche Museen, Berlin. Formerly in the Strozzi Collection.

PAN, bearded, with goat's legs, leading a chariot drawn

by two goats. He has a wineskin on his left shoulder, and a panther's skin is hanging from his left arm. In his right hand he holds the reins. The goats have ivy wreaths round their necks. The back portion with the chariot is missing.

Hellenistic work of the first rank. Third to second century B.C.

Gori, *Mus. Florent.* (1732), I, 2, pl. 9214 (reversed).
Furtwängler, *Beschreibung*, no. 11060, pl. 65; *A.G.*, pl. LII, 1.

596. *The so-called Tazza Farnese,* in sardonyx of several layers, engraved in relief on both sides. Diam. 20 cm.

Was acquired in 1471 by Lorenzo Medici from the treasures collected by Pope Paul II. Came to Naples with the Farnese Collection. In the National Museum, Naples, inv. 27611.

On the under, convex side: GORGONEION, as the central figure of an aegis, surrounded by locks and serpents.
On the upper, concave side: GROUP OF EIGHT FIGURES, carved out of the differently coloured layers of the stone:
(1) In the centre, an Egyptian sphinx, recumbent, in profile to the right, with drapery and uraeus serpent on head.
(2) Seated on the sphinx, in a half-reclining position, is a woman, resting one arm on the head of the sphinx, and holding up two ears of wheat in the right hand. She wears a chiton, with Isis-like knot between the breasts, a taenia and bracelets; her hair has the typical Egyptian corkscrew curls.
(3) A little higher up, to the left, is a bearded man, leaning against a tree trunk, and holding a cornucopia by its rim; the lower part of his body is covered by a himation.
(4) Striding from the right appears a youth, holding in his right hand what has been interpreted as a plough, round which a rope is coiled, and in his left hand what looks like a knife; from his left forearm hangs a bag. He wears a mantle, which covers the lower part of his body and is knotted on his left shoulder. His head is turned and he is looking upward.
(5) Above are two flying youths, one holding his mantle in bow-like fashion in both hands, the other blowing a horn-like shell.
(6), (7) To the right, in two registers are two seated female figures, one holding a bowl, the other a cornucopia. Both are partly nude, with drapery round the lower parts of their bodies. Behind them rise six ears of wheat.

The scene has been differently interpreted – as the apotheosis of Alexander or of one of the Ptolemies; or as Nile with Isis and Horus, etc. That it is to be connected with Egypt is indicated by the sphinx, and the fruitfulness of the land is suggested by the cornucopias, the plough, and the little bag doubtless containing seed. The flying

figures have been interpreted as wind gods, and the two seated figures as Horai.

For a list of explanations and the old bibliography cf. Furtwängler, *A.G.*, text to pls. LIV, LV. Recently an important factor in the interpretation has been thought to be the doubtless portrait-like features of the woman reclining on the sphinx. Charbonneaux suggested that she represents Cleopatra I (regent 181–176 B.C.), rather than Euthenia, the wife of Nile, which had been Furtwängler's idea.

Other interpretations and the different datings (ranging from the third to the later first century B.C.) will be found in the bibliography here appended. That the date is Hellenistic, rather than Roman, seems indicated by the superb, fluid workmanship and also by the expression of pathos in the gorgoneion. The most probable date would, therefore, seem to be in the second century B.C.

The preservation is excellent, the only missing piece being the lower part of the right hand of one of the seated women on the right, with the edge of the cornucopia.

Selected bibliography:

Scipione Maffei, *Osservazioni letterarie,* II, 1738, pp. 339 ff.
Visconti, *Museo Pio Clementino,* III, tav. d'agg. CI.
Millingen, *Ancient unedited Monuments,* Series II, 1828, pl. 17.
Uhden, *Abh. Berl. Akad.,* 1835, pp. 487 ff.
Real Museo di Napoli, Museo Borbonico, XII, 1851, pl. 47, with text by Quaranta.
King, *Antique Gems and Rings,* II, pl. 14, 6.
Brunn, *Sitzungsber. d. bayr. Akad.,* 1875, pp. 337 ff.
Drexler, in Roscher's *Lexikon,* II, col. 448.
E. Babelon, *La gravure,* pp. 140 f.
O. Rossbach, in *R.E.,* VII, 1, 1910, s.v. Gemmen, cols. 1081 f.
Furtwängler, *A.G.,* pls. LIV, LV (assigned to the 'Ptolemäer-Epoche').
Ruesch, *Guida,* pp. 400 ff., no. 1858.
Lippold, *Gemmen und Kameen,* pls. 99, 100.
Schefold, *Charites für E. Langlotz* (1957), pp. 195 f. (dated 40–30 B.C.); *Ath. Mitt.,* 71, 1956 (1959), p. 220.
Charbonneaux, *Mon. Piot,* L, 1958, pp. 91 ff. (dated at the time of the Altar of Pergamon).
Thiermann, *Hellenistische Vatergottheiten* (1959), p. 108.
Bastet, *Bull. van de Vereeniging . . . te 's Gravenhage,* XXXVII, 1962, pp. 1 ff. (dated *c.* 100 B.C.).
Möbius, *Bayer, Akad. d. Wiss., philos.-hist. Kl., Abh.,* N.F., Heft 59 (1964), pp. 31 ff. (dated by him *c.* 100 B.C. – not in the second century B.C. as I had mistakenly stated in *Gnomon,* 1965, p. 429).
Segall, 'Tradition und Neuschöpfung in der frühalexandrinischen Kleinkunst', 119./120. *Berliner Winckelmannsprogramm* (1966), p. 36: 'eines der eindruckvollsten Werke der frühhellenistischen Synthese in Form und Inhalt'.
Basted, *Bull. Ant. Besch.,* 1967, pp. 146 ff. (review of Segall's book).

(f) *Hellenistic portraits*

The portraits which appear on Hellenistic gems, either in intaglio or in relief as cameos, can occasionally be identified with known personalities through their likeness to those on the coins, where happily the inscriptions give the names. There evidently arose in the Hellenistic period the custom of wearing the portrait of a ruler on one's ring [1] – a practice which became common in Roman imperial times. Some of these gems are great works of art, and all amplify in welcome fashion our knowledge of Hellenistic portraiture.

The material here presented is divided into five groups: (α) Portraits of Alexander and other rulers of Macedon. (β) Portraits of Ptolemaic kings and queens. (γ) Portraits of other rulers. (δ) Portraits which seem to be of private individuals. (ε) Portraits which – to judge by their physiognomies – represent Romans, but – to judge by their style – were executed by Hellenistic artists.

(α) PORTRAITS OF ALEXANDER THE GREAT AND OTHER MACEDONIAN RULERS

Some of the portraits of Alexander are securely, others tentatively identifiable. Included here are the two famous cameos in Vienna and in Leningrad on which, it has been plausibly thought, Alexander appears with his mother Olympias. They rank among the finest products of Hellenistic art (nos. 610, 611).

The other Macedonians here shown are those on the well-known cameo in the Cabinet des Médailles with a bust of what appears to be Philip V (not Perseus as was formerly thought); and on an intaglio in the British Museum with a portrait of Perseus. Though the features of the two rulers are not unlike, their expressions markedly differ (nos. 608, 609).

For a list of possible portraits of Alexander on gems – intaglios and cameos – cf. Gebauer, *Ath. Mitt.*, 63-64, 1938-39, pp. 25–32.

597. *Quartz ringstone*, engraved on the convex side. Set in a modern mount. 24 × 24 mm.

In the Ashmolean Museum, 1892.1499. Bought at Beyrouth. Acquired through the Chester bequest.

HEAD OF ALEXANDER THE GREAT, with taenia and the ram's horns of Ammon, in profile to the right.

Late fourth to third century B.C.

Cf. the similar heads on the Lysimachos coins and on the sealings from Cyrene, Maddoli, *Annuario*, N.S., xxv–xxvi, 1963–64, pp. 96 f., nos. 457, 458.

598. *Brown glass ringstone*, convex on the engraved side. 18 × 20 mm.

In the Staatliche Museen, Berlin.

PORTRAIT HEAD OF A YOUNG MAN, in profile to the right. His hair is combed in different directions. There is no taenia.

Third century B.C.

The head resembles, as Furtwängler said, the portraits of Alexander and of Demetrios Poliorketes (306–283 B.C.), especially, I think, the latter; cf. my *Portraits of the Greeks*, fig. 1744. But in the absence of a taenia, one cannot be sure that a ruler was represented.

Furtwängler, *Beschreibung*, no. 1090.

599. *Sardonyx ringstone*. 18 × 16 mm.

In the British Museum, 72.6–4.1338. Acquired from the Castellani Collection in 1872.

[1] Cf. on this subject now Instinsky, *Die Siegel des Kaisers Augustus*, pp. 15 ff.

HEAD OF ALEXANDER THE GREAT, in profile to the right. He has large, wide-open eyes, long, flowing hair, and wears a taenia.

Cf. the youthful head in marble of Alexander in the Akropolis Museum; Bieber, *Alexander the Great*, pl. III, fig. 5; Richter, *Portraits of the Greeks*, fig. 1727; also the similar head on an eighteenth-century gem inscribed 'Pyrgoteles', Dalton, *Engraved Gems of the Post-Classical Period in the British Museum*, no. 1032.

Ujtalvy, *Type physique d'Alexandre*, p. 141, fig. 42.
Schreiber, *Bildnis Alexanders*, p. 211.
Walters, *Cat.*, no. 1180, pl. XVII.

600. *Grayish-brownish chalcedony ringstone*, mounted in a gold and enamel frame. 27 × 22 mm.

In the Cabinet des Médailles.

PORTRAIT HEAD, PROBABLY OF ALEXANDER THE GREAT, with flowing locks. He wears a taenia of which the tasselled end is seen against the neck.

Cursory work of the Hellenistic or Roman period.

The flowing hair, the large eyes, the shape of the nose, the half-open mouth, all recall the portraits of Alexander; only the chin is made more prominent than usual. 'Perhaps a Cappadocian or Pontic ruler, cf., e.g., Newell, *Royal Greek Portrait Coins*, pl. IV, no. 4' (K. Jenkins).

Mariette, *Pierres gravées*, II, no. 84 (= Mithradates).
Chabouillet, *Cat.*, no. 2048 (= Alexander).
Pierres gravées, Guide du visiteur (1930), p. 32, no. 2048 (not ill.)(= Alexander).

601. *Chalcedony ringstone*, mounted in an eighteenth-century gold ring. 29 × 25 mm.

In the Royal Cabinet of Coins and Gems, The Hague.

BUST OF A YOUNG RIVER-GOD, with long, loose locks, conceived as swimming. The head is in profile, the bust in slight three-quarter view. Drapery envelops the shoulders. In the wide-open eye the pupil and iris are indicated.

Hellenistic period.

Cf. the similar examples Furtwängler, *A.G.*, pl. XXXV, 8, 9, 11, 12, pl. XXXVIII, 28. The type used to be identified as Leander, who swam every night to his beloved Hero. Sometimes, and especially in this example, the features resemble those of Alexander the Great.

602. *Carnelian ringstone*. Fractured at the top. 15 × 21 mm.

In the Museo Archeologico, Florence, inv. 14757.

HEAD OF HERAKLES, in profile to the left. He wears a laurel wreath in his hair, and a lion's skin knotted at his neck. His hair is short and curly, and he has whiskers, but no beard. In front, under the chin, is the signature of the artist: 'Ονησᾶς, Onesas.

Hellenistic period, of the third century B.C.

The features bear some resemblance to Alexander.

On Onesas cf. pp. 16, 18 and nos. 544, 553.

Milani, *Museo Archeologico di Firenze*, pl. CXXXV, 2.
Furtwängler, *A.G.*, pl. XXXV, 26; *J.d.I.*, III, 1888, pp. 213 ff., pl. VIII, 17=*Kleine Schriften*, II, p. 205, pl. 26, fig. 17.
Lippold, *Gemmen und Kameen*, pl. 35, no. 2.

603. *Carnelian ringstone*. 29 × 20 mm.

In the Hermitage, M609.

ALEXANDER, standing in almost front view, with head turned in profile to the left. He holds the thunderbolt in his right hand, a sheathed sword in his left, and from his left forearm hangs the aegis. On the ground are a shield (seen from the inside, with handles marked), and an eagle looking up at Alexander. In the field, conspicuously under the right arm, is the inscription NEICOY, Νείσου, 'of Neisos'. Ground line.

Accomplished work of the late fourth to third century B.C.

The style of the figure is Lysippian, and it may, therefore, have been inspired by a portrait statue of Alexander by Lysippos. Furthermore, as a famous painting by Apelles at Ephesos showed Alexander in the guise of Zeus, with the thunderbolt (cf. Pliny, *N.H.*, XXXV, 92; Plutarch, *Alexander*, 4), the stone may have had some connection with this painting. 'Cf. also the early Hellenistic silver medallion of Babylon, *B.M.C.*, Arabia, etc., pl. XXII, 18, where an Alexander holding a thunderbolt appears' (K. Jenkins).

The inscription is evidently posterior to the engraving. Furtwängler suggested that Neisos was probably the owner of the gem in Roman times.

Wolters, *Ath. Mitt.*, XX, 1895, p. 511 (= Seleukos Nikator).
Furtwängler, *J.d.I.*, II, 1888, pl. XI, 26, and IV, 1889, pp. 67 ff.; *A.G.*, pl. XXXII, 11, p. 158, with note 1.
Maximova, *Ancient Gems and Cameos*, pl. III, no. 2. In Russian.
Gebauer, *Ath. Mitt.*, vol. 63–64, 1938–39, p. 27.
Bieber, *Alexander the Great in Greek and Roman Art*, fig. 25, p. 38.

604. *Massive gold ring*, with engraved design on rounded bezel. A few scratches in the field. 20 × 25 mm.

Said to be from Sovana in the Marenna. In the Metropolitan Museum of Art, 10.132.1. Rogers Fund, 1910. From the E. P. Warren Collection.

HEAD OF HERAKLES, wearing the lion's skin, with paws fastened round the neck. It is shown in three-quarter view, with large, protruding eyes.

Probably of the fourth century B.C.

The type occurs on coins of Cilicia; cf. *B.M.C.*, Lycaonia, Isauria, and Cilicia, pl. XXIX, 6 (dated in the time of Pharnabazos, 379–374 B.C. – a reference I owe to the late E. T. Newell). A similar head on the coins of Kos (*B.M.C.*, Caria and Islands, pl. XXXI, 13), datable *c.* 200 B.C., seems to be of a later type. The form of the ring is also apparently pre-Hellenistic; cf., e.g., Marshall, *Cat. of Finger Rings*, p. XLI, no. C, XVI, and pl. II, 58. It is, therefore, doubtful that Alexander is represented on the ring, as has been thought by some.

Richter, *M.M.A. Bull.*, V, 1910, p. 276; *M.M.A. Handbook*, 1953, p. 150, pl. 126, 1; *Cat.*, no. 81, pl. XIV.
Bieber, 'The Portraits of Alexander the Great', *Proceedings of the American Philosophical Society*, XCIII, 1949, pp. 302, 412, fig. 56; *Alexander the Great in Greek and Roman Art*, no. 62, pl. XXXI.

605. *Sardonyx cameo.* 18 × 22 mm.

In the National Museum, Athens, Numismatic section, inv. 19. Gift of K. Karapanos, 1910–11.

HEAD, PRESUMABLY MEANT FOR ALEXANDER THE GREAT, in profile to the right, wearing a taenia in his long, curly hair. He looks upward and his mouth is slightly open.

Hellenistic or Roman.

Svoronos, *Journal international d'archéologie numismatique*, XV, 1913, no. 781.

606. *Sardonyx cameo.* 19 × 23 mm.

In the National Museum, Athens, Numismatic section, inv. 317. Gift of K. Karapanos, 1910–11.

PORTRAIT HEAD OF A YOUNG MAN, in profile to the right, wearing a taenia in his hair. His mouth is slightly open, he looks upward, and he has long and curly hair. Presumably meant for Alexander the Great, like the similar head, no. 605.

Hellenistic or Roman.

Svoronos, *Journal international d'archéologie numismatique*, XV, 1913, no. 780.

607. *Agate cameo*, mounted in a gold and enamelled frame by Josias Belle under Louis XIV. 90 × 80 mm.

In the Cabinet des Médailles.

BUST OF ALEXANDER THE GREAT (?), in high relief, wearing helmet, chlamys, and baldric. The bust is in front view, the head in three-quarters.

Hellenistic, third century B.C.

Chabouillet, *Cat.*, no. 158 ('le camée n'est peut-être pas exempte de retouches modernes').
E. Babelon, *La gravure*, p. 129, fig. 101; *Catalogue des camées*, no. 220, pl. XXI.
Furtwängler, *A.G.*, vol. III, p. 159.
Pierres gravées, Guide du visiteur (1930), p. 77, no. 220, pl. XV.

608. *Carnelian cameo*, mounted in a gold and enamelled frame. 70 × 50 mm.

In the Cabinet des Médailles, A10666.

PORTRAIT BUST OF PHILIP V, king of Macedon (220–179 B.C.), in three-quarter back view. He wears the aegis and the Macedonian causia (pointed helmet), on which is represented a combat of a Centaur and a Lapith (perhaps an excerpt from a larger composition?).

Hellenistic, third to second century B.C.

The portrait was identified by Lenormant, E. Babelon, Furtwängler, and others as probably representing king Perseus; but I am inclined to agree with Möbius that it resembles rather the coin types of Philip V, for the face is suaver and less 'puckered' than in the portraits of Perseus.

Lenormant, *Bull. archéol. de l'Athenaeum français*, 1855.
Millin, *Mon. inédits*, I, p. 201 (= Odysseus).
E. Babelon, *Catalogue des camées*, no. 228, pl. 22.
Chabouillet, *Cat.*, no. 159.
Furtwängler, *A.G.*, vol. III, p. 159, fig. 113.
Pierres gravées, Guide du visiteur (1930), p. 99, no. 228, pl. XXIII.
Möbius, 'Alexandria und Rom', *Bayer. Akad. d. Wiss.*, philos.-hist. Kl., N.F., Heft 59, 1964, p. 21, pl. IV, 2.
Richter, *Portraits of the Greeks*, p. 257.

609. *Lapis lazuli ringstone.* 17 × 16 mm.

In the British Museum, Blacas 545. From the Blacas Collection.

PORTRAIT OF PERSEUS OF MACEDON (179–168 B.C.), wearing a winged helmet with a crest in the form of a cock's head. Behind the neck is a sheathed sword. The portrait on the gem closely resembles that on a tetradrachm of Macedon, inscribed Βασιλέως Φιλίππου, which was identified as representing not Philip V, but his son Perseus, and struck by Perseus during his father's lifetime; cf. G. F. Hill, *Num. Chron.*, 3rd ser., XVI, 1896, p. 36, pl. 4, fig. 2; Head, *H.N.²*, p. 233, fig. 146. In the *British Museum Guide*, 1959, however, it was identified as Philip V. The

expression seems to me to resemble that of king Perseus, with his often puckered face, rather than the bland one of Philip V. Cf. my *Portraits of the Greeks*, p. 257, fig. 1749.

King, *Arch. Journal*, XXIV, p. 215; *Antique Gems and Rings*, II, pl. 47, fig. 5.
Walters, *Cat.*, no. 1183, pl. XVII (=Perseus).

610. *Sardonyx cameo*, of nine layers. The neck and the crest of the helmet are restored. 115 × 113 mm.

In the Kunsthistorisches Museum, Vienna, inv. IX A81. Formerly in Cologne; cf. J. Hoster and E. Neuffer, *Köln*, 1959, Heft IV.

MALE AND FEMALE PORTRAIT HEADS, conjoined, in profile to the left. The man wears a helmet decorated with a snake on the bowl, a thunderbolt on the cheek-piece, and a horned head of Ammon on the side. The woman wears an ornamented diadem, and a veil.

A masterpiece of Hellenistic glyptic art.

The two individuals have been differently identified, either as belonging to the Ptolemaic dynasty, i.e., as Ptolemy II Philadelphos and his wife Arsinoë, or as Ptolemy VI Philometor and his wife Kleopatra; or as Alexander the Great and his mother Olympias. As Furt-wängler pointed out, the bony structure of the man's face is different from the fleshy countenances of the Ptolemies; the emblems on his helmet – snake, thunder-bolt, and head of Ammon – would fit Alexander; and there is a distinct similarity between his features and those of Alexander on the coins of Lysimachos (a thin, slightly curved nose, a protruding forehead, and a large eye with an intense expression). So Alexander he seems to be; and if so, then the woman should be Olympias, for the two are regularly associated, e.g., on the contorniates.

E. O. Mueller, *Annali dell'Inst.*, XII, 1840, pp. 262 ff.
Sacken and Kenner, *Die Sammlungen des kk. Münzen- und Antiken-Cabinetes* (1866), p. 423, no. 21.
Schneider, *Album der Antikensammlung*, pl. 39, 1, p. 15.
King, *Antique Gems and Rings*, I, p. 284; *Handbook*, p. 214, pl. 23, 1.
Furtwängler, *A.G.*, pl. LIII, 1.
Eichler and Kris, *Die Kameen*, pl. I.
Bernoulli, *Alexander*, pp. 126 ff.
Gebauer, *Ath. Mitt.*, vol. 63–64, 1938–39, p. 31.
Bieber, *Alexander the Great in Greek and Roman Art*, pl. II, fig. 4.
Richter, *The Portraits of the Greeks*, pp. 254 f., fig. 1709.

Möbius, 'Alexandria u. Rom', *Bayer. Akad. d. Wiss., philos-hist. Kl., Abh.*, N.F., Heft 59, 1964, p. 17 (=Ptolemy II and Arsinoë II – not Alexander and Arsinoë II as I stated by mistake in my review in *Gnomon*, 1965, p. 429).

611. *Sardonyx cameo*, of three layers. 155 × 122 mm.

In the Hermitage. First in the possession of the Gonzagas of Mantua, then successively of Queen Christine, of Duke Odescalchi, and of Queen Josephine, who, in 1814, gave it as a present to the emperor of Russia.

TWO PORTRAIT BUSTS, ONE MALE, ONE FEMALE, con-joined, in profile to the left. Very like the cameo in Vienna, no. 610, with some differences: the snake on the bowl of the helmet is winged and has a star above its head; the bowl of the helmet is decorated with a laurel wreath, and it has no cheek-pieces; there is an incipient beard on the man's cheek and upper lip; on his left shoulder and breast appears an aegis with the head of Medusa near the front, and a winged, bearded head further back; the man wears a cuirass; the woman, instead of the elaborately decorated diadem, has a laurel wreath above her curly hair, and wears a chiton, a himation, and a necklace.

As Furtwängler said, the large eye of the young man, with its upward look, makes this head resemble the coin por-traits of Alexander even more than does the head in Vienna, no. 610. Like the Vienna cameo this example is a masterly example of the cameo technique.

Museum Odescalchum, seu effigies deorum cons. imp. etc., ab Amling aeri incisae, Rome, 1707, pl. 1, with the caption 'Olimpia e Alessandro, nel tesoro di S.A. il duca Odescalchi'.
Causeus, *Romanum Museum* (1746), I, pl. 18.
Visconti, *Ic. gr.*, III, pp. 295 ff., pl. XII, 3.
Lenormant, *Trésor de numismatique, rois grecs*, II (1849), p. 163, pl. 84.
Krause, *Pyrgoteles*, pl. I, 21, pp. 265 ff.
Müller-Wieseler, *Denkmäler alter Kunst*, I, no. 226a, pl. LI.
King, *Handbook*, p. 213, pl. 22, 2.
Babelon, *La gravure*, p. 135, fig. 104; in Daremberg and Saglio, *Dictionnaire*, fig. 3515.
Furtwängler, *A.G.*, pl. LIII, 2.
Maximova, *Ancient Gems and Cameos*, 1926, pl. IV (in Russian); *Cameo Conzaga*, 1924.
Lippold, *Gnomon*, II, 1926, pp. 142 ff. (review of Maximova's *Cameo Gonzaga*).
Gebauer, *Ath. Mitt.*, vol. 63–64, 1938–39, p. 31.
Richter, *The Portraits of the Greeks*, pp. 254 f.

(β) PORTRAITS OF PTOLEMAIC KINGS AND QUEENS

For some reason the portraits of the Ptolemies and their wives were popular on gems – to judge at least by the extant material. In the following series are shown Ptolemy I with his wife Berenike I, and several perhaps representing Ptolemy II, Ptolemy III, Ptolemy VI. Included also are the splendid engravings on two gold rings in the Louvre, which also should represent some Ptolemy (nos. 625, 626).

The portraits of the queens are often so generalized that their identification is problematical. Several, however, *seem* to represent Berenike I, Berenike II, Arsinoë II, Berenike III, and Arsinoë III (nos. 627 ff.). On some of the gems appear jugate heads of Sarapis and Isis, where at least Isis appears to have portrait-like features, and may have been intended, it has been thought, for a Ptolemaic queen.

On the numbers assigned to the later Ptolemies cf. now H. Volkmann in *R.E.*, xxiii, 2 (1959), cols. 1600 ff. and the references there cited, and my *Portraits of the Greeks*, pp. 259 ff. The discovery that the son of Ptolemy VI actually acted as regent and so should be called Ptolemy VII has made it necessary to change the numbers of all the succeeding Ptolemies.

612. *Glass ringstone*, light reddish, convex on both sides. Edge chipped. 19 × 18 mm.

In the Thorvaldsen Museum, Copenhagen.

HEADS OF PTOLEMY II PHILADELPHOS AND HIS WIFE ARSINOË II, in profile to the right, conjoined. Ptolemy wears a taenia in his hair and a chlamys is indicated below his neck, fastened with a brooch on his right shoulder. Arsinoë also wears a taenia, and drapery is indicated at her neck. Behind Ptolemy is a small round shield, foreshortened. Above is the inscription: Ἀδελ[φῶν].

The gem was moulded (in ancient times) from the well-known gold tetradrachm, struck by Ptolemy III Euergetes (246–221 B.C.), with Ptolemy I and his wife on the obverse, and Ptolemy II and his wife on the reverse; cf. Svoronos, *Ta nomismata ton Ptolemaion*, III, pl. XIV, 18–21; Head, *H.N.²*, p. 851, fig. 376; Seltman, *Greek Coins²*, pl. LVIII, 7; Richter, *The Portraits of the Greeks*, fig. 1781.

For another instance in which a gem was moulded in glass from a coin cf. Kibaltchitch, *Gemmes de la Russie méridionale*, pl. IX, 279, which reproduces the reverse of a tetradrachm of Demetrios Poliorketes; cf. Newell, *The Coinage of Poliorcetes*, pl. XI.

Furtwängler, *A.G.*, pl. XXXII, 10.
Fossing, *Cat.*, no. 33, pl. I.
Richter, *The Portraits of the Greeks*, p. 262.

613. *Agate cameo*, yellowish-green with black particles. 30 × 21 mm.

In the Kunsthistorisches Museum, Vienna, inv. IX.1948. Acquired in 1878. Formerly in the collection of Fürst Ysenburg in Offenbach.

PORTRAIT BUST OF A MAN WITH CURLY HAIR, in three-quarter view, to the left. Drapery covers shoulders and chest. The portrait has generally been identified as representing Ptolemy I Soter, whose coin types it undoubtedly resembles.

It was considered ancient by von Sacken, von Schneider, Furtwängler, Delbrück, and Rossbach. But Eichler and Kris, who had the advantage of studying the stone in Vienna day after day, have pronounced themselves against its antiquity: 'Gegen den antiken Ursprung dieses ob seiner Qualität mit Recht hochgeschätzten Steines erheben sich ernste Bedenken, die sowohl auf dem ungewöhnlichen Material, und auf dem Mangel jeglicher Altersspur an der völlig intakten glatten Oberfläche, wie auch auf dem Stil besonders der klassizistisch anmutenden Drapierung und der pathetisch repräsentativen Bildnisauffassung beruhen. Die sehr lockere Haarbehandlung findet gleichfalls in der Glyptik des 18. Jahrhunderts Parallelen; vgl. etwa den auch in der Oberflächenbehandlung eng verwandten Cameo des Girolamo Rossi (Kat. no. 560, pl. 80), und für die Auffassung und Formensprache, dessen Intaglio, Lippert-Daktyliothek (1767), I, 147. Man war versucht, die Zuschreibung an diesen Künstler zu erwägen.' After studying the photograph kindly sent me by Dr. Noll and here published, I too feel that the stone should be an eighteenth-century work rather than an ancient one. The dreamy expression has a modern flavour, and the arrangement of the drapery, which is neither a chiton nor a himation, makes one pause.

Von Sacken, *Archäolog.-epigr. Mitt. aus Österr.*, III, 1879, p. 137; *Jahrbuch der kunsthistorischen Sammlungen*, II, pp. 30 f., pl. I, 6, 6a, pp. 30 f.
Von Schneider, *Album der Antiken-Sammlung des allerhöchsten Kaiserhauses* (1895), pl. XXXIX, 2, p. 15.
Furtwängler, *A.G.*, pl. LIX, 3, and vol. III, p. 165.

Delbrück, *Antike Porträts*, pl. 58, no. 14.
Rossbach, in *R.E.*, VII, I, s.v. Gemmen, col. 1082.
Eichler and Kris, *Die Kameen im Kunsthistorischen Museum*, 1927, no. 640, pl. 80.
Richter, *The Portraits of the Greeks*, p. 261.

614. *Sardonyx ringstone.* 35 × 25 mm.

In the Cabinet des Médailles.

PORTRAIT BUST, in profile to the right, wearing taenia and a chlamys, fastened with a brooch on the right shoulder. In the field, at the back of the head, is engraved a little man leaning on a staff; and in front a quadruped. Below is the inscription, apparently added in modern times, Αὔλου, i.e., the signature of the well-known gem engraver Aulos of the Augustan period.

Hellenistic period.

Mariette identified the portrait as representing Ptolemy II Philadelphos, 285–246 B.C., to whom it bears some resemblance (e.g., in the upward look). Chabouillet called him 'a king of Asia, perhaps of Commagene').

Mariette, *Pierres gravées*, II, no. 87.
Chabouillet, *Cat.*, no. 2054.
S. Reinach, *Pierres gravées*, pl. 105, no. 87.
Pierres gravées, Guide du visiteur (1930), p. 32, no. 2054 (not ill.).

615. *Sardonyx ringstone*, mounted in a modern jewelled frame. 36 × 28 mm.

In the Cabinet des Médailles.

PORTRAIT BUST, wearing an ivy wreath, a chlamys, and a cuirass.

Hellenistic period.

Identified by Mariette and Chabouillet as representing Ptolemy XI (now XII) Dionysos Auletes, king of Egypt, 80–58, 55–51 B.C., to whose coin portraits, however, it bears little resemblance. It seems rather to resemble Ptolemy II, e.g., in the large, pensive eyes, and the somewhat pudgy face; cf. my *Portraits of the Greeks*, figs. 1781, 1801.

Mariette, *Pierres gravées*, II, no. 89.
Chabouillet, *Cat.*, no. 2060.
Pierres gravées, Guide du visiteur (1930), p. 132, no. 2060 (not ill.).

616. *Carnelian ringstone*, mounted in a gold ring. 12 × 8 mm.

In the De Clercq Collection, Paris. Formerly in the Peretié Collection.

PORTRAIT BUST OF A YOUNG HELLENISTIC RULER,

in profile to the right. He wears a taenia and a chlamys, and has curly hair, descending to the nape of his neck. His mouth is slightly open, the nose short, the eye deep-set, the forehead protruding in its lower part.

Third to second century B.C.

De Ridder compared the heads of Ptolemy V Epiphanes (210–180 B.C.) to which there is a distinct resemblance; cf. my *Portraits of the Greeks*, figs. 1832a, 1832b.

De Ridder, *Catalogue Collection De Clercq*, no. 2863.

617. *Reddish jasper ringstone.* 17 × 11 mm.

In the De Clercq Collection, Paris.

PORTRAIT BUST OF A YOUNG HELLENISTIC RULER, in profile to the right. His mouth is slightly open, his nose is straight, his deep-set eyes look upward. He wears a taenia and a chlamys, fastened on his right shoulder with a brooch.

Perhaps third century B.C.

De Ridder suggested that the portrait represented some Ptolemy, as indeed the fleshy forms of the face would indicate. The upward look brings to mind Ptolemy II Philadelphos, 285–246 B.C.; cf. my *Portraits of the Greeks*, figs. 1781 ff. K. Jenkins suggests 'perhaps Ptolemy IV'.

De Ridder, *Catalogue Collection De Clercq*, VII, 2, no. 2862.

618. *Amethyst ringstone*, convex on engraved side. In a modern mount. 18 × 25 mm.

From Kafr es Sheikh, Egypt. In the Ashmolean Museum, 1892.1503. Acquired through the Chester bequest.

PORTRAIT BUST OF A HELLENISTIC RULER, probably of Ptolemy II (285–246 B.C.) or Ptolemy III (246–221 B.C.). He wears a taenia and a chlamys.

Hellenistic period, third century B.C.

Bonacasa, *Annuario*, 1959–60, pp. 567 ff.
Richter, *The Portraits of the Greeks*, p. 262, fig. 1784.

619. *Sardonyx ringstone*, in two layers. 32 × 37 mm.

In the Hermitage, M614.

BUST OF A HELLENISTIC RULER, wearing a taenia and a chlamys fastened on the right shoulder. The head is in profile to the right, the bust in three-quarter view.

Hellenistic, third century B.C.

Furtwängler suggested that the head might represent Antiochus II, king of Syria, 261–246 B.C. I see an even greater resemblance to Ptolemy II of Egypt, 285–246 B.C.,

who appears with the same fleshy forms and large up-turned eye; cf. my *Portraits of the Greeks*, figs. 1781–1801.

Furtwängler, *A.G.*, pl. XXXII, 26.

620. *Carnelian ringstone*, mounted in a modern gold and enamelled frame. 23 × 18 mm.

In the Cabinet des Médailles.

PORTRAIT BUST, wearing a taenia, a chlamys fastened on both shoulders, and a cuirass.

Hellenistic period.

Identified by Chabouillet as Ptolemy II Philadelphos, king of Egypt, 285–246 B.C. But the expression on this stone seems less dreamy, more energetic than on the coin types of that king. It seems to resemble rather Ptolemy III Euergetes, who reigned 246–221 B.C.; cf. especially the coin in Boston, my *Portraits of the Greeks*, fig. 1813. 'There is also some resemblance to the coin types of Antiochus IV of Syria' (K. Jenkins).

Chabouillet, *Cat.*, no. 2056.
Pierres gravées, Guide du visiteur (1930), p. 32, no. 2056 (not ill.).

621. *Carnelian ringstone*, mounted in a modern gold and enamelled frame. 20 × 17 mm.

In the Cabinet des Médailles.

PORTRAIT BUST, wearing a taenia and a chlamys fastened on both shoulders, evidently representing Ptolemy VI Philometor, king of Egypt, 181–145 B.C.

Hellenistic period.

Identified as Ptolemy VI by Chabouillet, and it certainly is like the coin types of that king; cf. my *Portraits of the Greeks*, fig. 1838. Furtwängler, however, saw a resemblance to the portraits of Alexander the Great on the coins of Lysimachos.

Chabouillet, *Cat.*, no. 2057.
Furtwängler, *A.G.*, pl. XXXI, 17, pl. XXXII, 4.
Lippold, *Gemmen und Kameen*, pl. 70, no. 9.
Pierres gravées, Guide du visiteur (1930), p. 32, no. 2057 (not ill.).
Richter, *The Portraits of the Greeks*, p. 266.

622. *Carnelian ringstone*. 19 × 17 mm.

In the Cabinet des Médailles.

PORTRAIT BUST, wearing taenia and cuirass.

Hellenistic period.

Identified by Chabouillet as Ptolemy VI, like no. 621. But it resembles the coin type less, and is younger in appearance.

Chabouillet, *Cat.*, no. 2058.
Pierres gravées, Guide du visiteur (1930), p. 32, no. 2058 (not ill.).

623. *Carnelian ringstone*, mounted in a modern frame. 14 × 12 mm.

In the Cabinet des Médailles, 65A13933.

PORTRAIT BUST, wearing a taenia. The bust is almost frontal, the head is turned to the left in profile view. On the bust are two hoofed legs, evidently of an animal's skin, worn on the back.

Hellenistic period.

Identified by Chabouillet as Ptolemy XI (now XII) Dionysos Auletes, king of Egypt, 80–58, 55–51 B.C. And it bears some resemblance to the coin types; cf. my *Portraits of the Greeks*, fig. 1855.

For a small bronze head probably representing this Ptolemy Auletes cf. Seyrig, in *Hommages à Jean Charbonneaux, Rev. arch.*, 1968 (forthcoming).

Mariette, *Pierres gravées*, II, no. 22 (called 'bacchant').
Chabouillet, *Cat.*, no. 2059.
Pierres gravées, Guide du visiteur (1930), p. 32, no. 2059 (not ill.).
S. Reinach, *Pierres gravées*, pl. 99, no. 22.

624. *Sardonyx ringstone*. 16 × 15 mm.

In the Cabinet des Médailles, 65A13928.

PORTRAIT BUST, evidently of a Hellenistic ruler, wearing a laurel wreath and a chlamys.

Hellenistic period.

Identified by Chabouillet as Ptolemy II Philadelphos, king of Egypt, 285–246 B.C.; but, as Mr. Kenneth Jenkins suggests, the features, with the long, pointed nose seem to resemble rather the coin portraits of Ptolemy XII Auletes (cf. my *Portraits of the Greeks*, p. 266, figs. 1855, 1856) or 'some late Seleucid'.

Chabouillet, *Cat.*, no. 2055.
Pierres gravées, Guide du visiteur (1930), p. 32, no. 2055 (not ill.).

625. *Gold ring*, with engraved design on oval bezel. 19 × 26 mm.

In the Louvre, Bj 1093. From the Coll. Napoléon III.

BUST OF A HELLENISTIC RULER, in profile to the right, wearing taenia, tunic, and chlamys. He has a long, thin, pointed nose, wide-open eyes, a small, protruding chin, and slight whiskers along the jaws.

Probably second century B.C.

Identified by Blum (*B.C.H.*, XXXIX, 1915, pp. 23 ff.), as Ptolemy VI Philometor, 181–145 B.C.; by others as

Antiochos IV of Syria, 175–164 B.C.; by Coche de la Ferté as Ptolemy V or VI; by C. Küthmann as Ptolemy XIII; by Furtwängler as some late Ptolemy whose portrait is not known from the coins. Recently a coin has come to light with a portrait strikingly resembling the portrait on this ring – with the same long, pointed, thin nose, which is its distinctive feature – inscribed *Basileou Ptolemaiou* (cf. Dawson Kiang, *Am. Num. Mus. Notes*, x, 1962, pp. 69 ff., pl. XIV, 1). So the portrait in question should represent a Ptolemy. But, as no surname, like Philometor or Epiphanes, is added on this coin, one does not yet know which particular Ptolemy is intended. K. Jenkins tentatively suggests Ptolemy V Epiphanes in his later years.

Furtwängler, *A.G.*, pl. XXXI, 26.
Sieveking, *Rev. arch.*, 1903, I, pp. 343 ff.
Blum, *B.C.H.*, XXXIX, 1915, pp. 23 ff.
De Ridder, *Bijoux antiques*, no. 1093.
C. Küthmann, 'Zwei Goldringe des Louvre mit Portrait Ptolemaios XIII', *Blätter für Münzfreunde*, VI, 1934–36, pp. 481 ff.
Lippold, *Gemmen und Kameen*, pl. 70, no. 2.
Coche de la Ferté, *Les bijoux antiques*, pl. XXVI, 3, p. 69.
Laurenzi, *Enc. Arte Antica*, 1958, p. 43, s.v. Antioco IV.
Kiang, *Am. Num. Soc. Museum Notes:* x, 1962, pp. 69 ff., pl. XIV, 3.
Richter, *The Portraits of the Greeks*, p. 266, fig. 1837b.

626. *Gold ring*, with engraved design on rectangular bezel. 25 × 34 mm.

In the Louvre, Bj 1092. From the Coll. Napoléon III.

PORTRAIT BUST OF A HELLENISTIC RULER, in profile to the right. He wears the double crown of Egypt, over which a taenia is tied, and, instead of the usual chlamys, a broad Egyptian collar, decorated with Egyptian ornaments. The features are the same as in no. 625, with the same distinctive thin, long, pointed nose; and here too there are slight whiskers along the jaws.

Probably second century B.C.

Evidently the same person as in no. 625, but here with a more energetic expression, and decked out with Egyptian paraphernalia.

Furtwängler, *A.G.*, pl. XXXI, 25.
Sieveking, *Rev. arch.*, 1903, I, pp. 343 ff.
Blum, *B.C.H.*, XXXIX, 1915, pp. 23 ff.
De Ridder, *Bijoux antiques*, no. 1092.
Lippold, *Gemmen und Kameen*, pl. 70, no. 5.
Coche de la Ferté, *Les bijoux antiques*, pl. XXVI, 4, p. 69.
Laurenzi, *Enc. Arte Antica*, 1958, s.v. Antioco IV, p. 43.
Kiang, *Am. Num. Soc. Museum Notes*, x, 1962, pp. 69 ff., pl. XIV, 2.
Richter, *The Portraits of the Greeks*, p. 266, fig. 1841.

627. *Iron ring with gold intaglio.* 25 × 21 mm.

In the Ashmolean Museum, Fortnum 36. Acquired through the Fortnum bequest.

PORTRAIT OF A MIDDLE-AGED WOMAN, in profile to the left. She wears a bead necklace, an earring, and a garment of which the upper edge is shown at her neck. Her hair is carved in a series of parallel striations, terminating in a plaited bun-like knot at the back of her head.

This sympathetic lady has been thought to represent Berenike I, wife of Ptolemy I Soter, 323–285 B.C. Besides the portrait that appears in conjunction with her husband, struck by Ptolemy II (Head, *H.N.*², p. 851, fig. 376; my *Portraits of the Greeks*, fig. 1779), where the female head is generalized, there are coins struck in the Cyrenaica by her son Magas (*ibid.*, fig. 1776), with what has been thought to be her portrait. To this head that on the Oxford intaglio bears a distinct resemblance – in the coiffure, the shape of the nose, and the prominent chin – so that it could have been carved in her later years.

628. *Glass, imitating sard, ringstone.* 20 × 20 mm.

In the British Museum, 1923.4–1.147.

PORTRAIT HEAD OF A WOMAN, in profile to the right. She wears earrings, a fillet wound twice round her hair, and a veil over the back of her head.

Perhaps intended for Berenike II, wife of Ptolemy III Euergetes, 246–221 B.C.

Cf. the coin types *B.M.C.*, The Ptolemies, pl. XIII; Head, *H.N.*², p. 852, fig. 377; Richter, *The Portraits of the Greeks*, figs. 1820, 1821.

Walters, *Cat.*, no. 1227, pl. XVI.

629. *Bronze ring*, with engraved design on oval bezel. 23 × 29 mm.

In the Metropolitan Museum of Art, 41.160.420. Bequest of W. G. Beatty, 1941.

PORTRAIT HEAD OF A WOMAN, in profile to the right, wearing a taenia. Her hair is looped up at the back. There is a gold, round inset in the field, behind the neck.

Second half of the third century B.C.

Perhaps Berenike II.

Richter, *Cat.*, no. 149, pl. XXV.

630. *Brown glass ringstone.* 25 × 18 mm.

In the Staatliche Museen, Berlin.

PORTRAIT HEAD OF A WOMAN, in profile to the right, wearing a taenia tied at the back of her head.

Resembles Berenike II.

Furtwängler, *Beschreibung*, no. 1097.

631. *Brown glass ringstone.* 20 × 23 mm.

In the Staatliche Museen, Berlin.

PORTRAIT HEAD OF A WOMAN, in profile to the right, wearing a veil over the back of her head, a fillet wound three times round her hair, and a pendant earring.

Probably third century B.C.

Furtwängler, *Beschreibung*, no. 1093, saw a resemblance to Arsinoë II and Berenike II.

632. *Brown glass ringstone.* 15 × 19 mm.

In the Staatliche Museen, Berlin.

PORTRAIT HEAD OF A WOMAN, in profile to the right, wearing a veil over the back of her head, a fillet wound three times round her hair, and a pendant earring.

Third century B.C.

Perhaps again Berenike II, older than in nos. 628–631.

Schlichtegroll, *Pierres gravées*, pl. 24.
Furtwängler, *Beschreibung*, no. 1091.

633. *Carnelian*, set in the oval bezel of a gold ring. 26 × 20 mm.

Found in Egypt. In the British Museum. Acquired through the Franks bequest, 1897.

PORTRAIT HEAD OF A WOMAN, in profile to the right, wearing a wreath of corn and a veil over the back of her head.

Perhaps portrait of Arsinoë II (316–269 B.C., idealized as Demeter).

Marshall, *Cat. of Finger Rings*, no. 367, pl. XI.
Walters, *Cat.*, no. 1185, pl. XVII.

634. *Sard ringstone.* 23 × 19 mm.

In the Ashmolean Museum, 1892.1504. Acquired through the Chester bequest. Once in the Tecco Melchiore Collection.

PORTRAIT HEAD OF A HELLENISTIC QUEEN, in profile to the right, wearing a taenia and a veil over the back of her head. Probably intended for Berenike II.

Hellenistic period.

635. *Chalcedony ringstone*, strongly convex on the engraved side. 26 × 31 mm.

In the Museum of Fine Arts, Boston, 27.711. Formerly in the Tyszkiewicz and E. P. Warren Collections. Said by Froehner to have been found in Phoenicia; according to another source, it came from near Tarsos, cf. Beazley, *op. cit.*, p. 80.

PORTRAIT OF AN EGYPTIAN QUEEN, characterized as Isis by the disk within cow's horns on her head. She wears a diadem with long, fringed ends. The plaits of her hair end in corkscrew curls, in Egyptian fashion. The cheeks and chin are full, the nose is straight, the lips are parted. On the shoulder the chiton and himation are indicated. In the field, at the left, is the inscription Λυκομήδης, Lykomedes, perhaps the name of the artist; cf. p. 18. The omicron is indicated as a dot.

The full face suggests a Ptolemaic queen – perhaps Arsinoë II, wife of Ptolemy II Philadelphos, 285–246 B.C. Cf. the coin types with her portrait, *B.M.C.*, Ptolemies, pl. 8, no. 3; *British Museum Guide*, pl. 33, fig. 21, and especially pl. 34, fig. 25; Richter, *The Portraits of the Greeks*, figs. 1781, 1802.

Froehner, *Collection Tyszkiewicz*, pl. XXIV, 17, p. 24.
Furtwängler, *J.d.I.*, IV, 1889, p. 80, pl. I, 2; *A.G.*, pl. XXXII, 31.
Sale Cat. of the Tyszkiewicz Collection, pl. XXVII, 292.
Burlington Fine Arts Club Exh., 1904, p. 241, no. O, 41 (not ill.).
Beazley, *Lewes House Gems*, no. 95, pl. 6.

636. *Hyacinthine sard ringstone*, with engraving on convex side. Top of head missing. Ht., as preserved, 20 mm.

In the Walters Art Gallery, Baltimore, 42.1339. Formerly in the Marlborough and Evans Collections. The upper part of the head was once restored in gold.

PORTRAIT BUST OF A YOUNG WOMAN, wearing chiton, himation, a necklace, and a taenia. Her hair is carved in striated ridges, ending in a knot at the back of the head. In the field, at the back of the neck, is the signature of the artist: Νίκανδρος ἐπόει, 'Nikandros made it'.

On Nikandros cf. pp. 16, 18.

The head bears some resemblance to Berenike II, wife of Ptolemy III, of Egypt, 246–221 B.C. (cf. my *Portraits of the Greeks*, figs. 1820, 1821), and may have been intended for her – in a less idealized form than usual. At all events the style points to the third century B.C.

Story-Maskelyne, *The Marlborough Gems*, 1870, p. XVI, p. 75, no. 447.
Middleton, *The Engraved Gems of Classical Times*, p. 74.
Furtwängler, *J.d.I.*, III, 1888, pp. 210 f., pl. VIII, 14; *A.G.*, pl. XXXII, 30, and vol. III, p. 163.
Burlington Fine Arts Club Exh., 1904, p. 173, no. L, 86.

D. K. Hill, *Journal of the Walters Art Gallery*, VI, 1943, pp. 64 f., fig. 1.

637. *Hyacinth ringstone*, convex on the engraved side. 19 × 12 mm.

In the Museo Archeologico, Florence, inv. 14977.

PORTRAIT BUST OF A HELLENISTIC QUEEN, wearing a taenia, a wreath of ears of wheat, and a veil over the back of her head. Her hair is rendered in ridges, with 'Libyan' locks in front of the ear.

Perhaps intended for Arsinoë III, as suggested to me by K. Jenkins; cf. my *Portraits of the Greeks*, figs. 1833, 1834.

Gori, *Mus. Flor.*, II, 97, 3.
S. Reinach, *Pierres gravées*, pl. 73.
Furtwängler, *A.G.*, pl. XXXIII, 2 (Arsinoë II or Berenike II).

638. *Gold ring*, with engraved design on bezel. L. of bezel, 21 mm.

In the British Museum, 65.7-12.55. Acquired from the Castellani Collection, 1865.

BUSTS OF SARAPIS AND ISIS, shown side by side. Sarapis wears a wreath and an Osiris vessel instead of the usual modius on his head. Isis, also wreathed, has a lotus bud and two ears of wheat on her head.

Cf. the similar representation on a silver Ptolemaic tetradrachm, *B.M.C.*, Ptolemies, pl. XVIII, 8; Svoronos, *Ton Ptol. Bas.*, II, 1123 f., 1136. On the gem, Sarapis has the regular features of the late Zeus type; but the female head has portrait-like features, and may represent a Ptolemaic queen in the guise of Isis. (For a contrary opinion cf. Drexler, in Roscher's *Lexikon*, s.v. Isis, cols. 517 ff.)

King, *Antique Gems and Rings*, I, p. 337, note.
Marshall, *Cat. of Finger Rings*, no. 95, pl. IV.

639. *Gold ring, with an engraved garnet.* 21 × 15 mm.

Said to have been found, together with two bracelets and some silver coins, in Syria, shortly before 1955. Acquired in Beyrouth, and now in the Oriental Institute in Chicago, acc. no. A29790.

JUGATE HEADS OF ZEUS-SARAPIS AND ISIS. Sarapis wears the lotus bud upon a crown of laurel leaves, Isis the symbol of the globe and horns mounted on a crown of wheat heads. Similar to the preceding.

Third to second century B.C.

Kraeling, *Archaeology*, VIII, 1955, pp. 256 ff., figs. 1, 5, 6 (dated late third century B.C.).

640. *Amethyst ringstone.* 16 × 11 mm.

In the British Museum, 72.6-4.1273. Acquired from the Castellani Collection in 1872.

BUSTS OF SARAPIS AND ISIS, side by side, looking upward. Each wears a lotus headdress, and drapery on the shoulders. Similar to the preceding.

Walters, *Cat.*, no. 1175 (not ill.).

641. *Gold ring*, with engraved design on oval bezel. 24 × 29 mm.

In the Hermitage.

PORTRAIT BUST OF A WOMAN, in profile to the right, wearing taenia, a chiton, and a beaded necklace. Her hair is combed back from the face, and is then arranged in curving ridges, ending in a bun-like knot at the back of her head.

Third century B.C.

Perhaps like no. 637 intended for Arsinoë III (as suggested to me by Kenneth Jenkins).

Furtwängler, *A.G.*, pl. XXXII, 33.

642. *Garnet ringstone.* Fractured at the bottom. 19 × 19 mm.

In the British Museum, 90.1-1.60. Acquired from the Carlisle Collection in 1890.

PORTRAIT HEAD OF A WOMAN, in profile to the right. The hair is rendered in striated ridges, and then gathered in a knot at the nape of the neck. She has large eyes, a thin nose, and a small, full-lipped mouth.

Furtwängler, *A.G.*, pl. XXXII, 38.
Walters, *Cat.*, no. 1193, pl. XVII.

643. *Gold ring*, with engraved design on oval bezel. 30 × 25 mm.

Found in a tomb at Mottola. In the Museo Nazionale, Taranto.

PORTRAIT HEAD OF A WOMAN, in profile to the left. Her hair is done up in the so-called melon coiffure, with striated ridges ending in a knot at the back of her head. The edge of her himation appears at the base of her neck, and she wears a necklace and a pendant earring.

Third century B.C.

Becatti, *Oreficeria ant.*, no. 334, pl. LXXXIII.

(γ) PORTRAITS OF OTHER – MOSTLY HELLENISTIC – RULERS

Here included are portraits tentatively identified as the lawgiver Lykourgos of Sparta (no. 644), on one gem perhaps together with some Spartan king – Kleomenes III or Areos (no. 645); Nabis of Sparta (no. 648); Seleukos III of Syria (no. 655); Antiochos VII Sidetes of Syria (no. 656); Antiochos VIII Grypos of Syria (no. 657), etc. More reliably identified are several portraits of Mithradates VI Eupator of Pontos (nos. 649–652); a splendid head of Philetairos of Pergamon (no. 653); Juba I of Numidia (no. 668); and perhaps Juba II of Mauretania (no. 669).

Moreover, interesting suggestions have been made concerning some of the heads as perhaps representing Ariobarzanes I of Cappadocia (no. 662); Laodike, wife of Mithradates IV of Pontos (no. 667), and Eumenes II of Pergamon (no. 654).

644. *Amethyst ringstone,* 15 × 10 mm.

In the Cabinet des Médailles. Acquired in 1847. Once in the collection of the French minister (ambassador) in Athens.

BUST OF LYKOURGOS (?), in profile to the right, with plentiful hair and longish beard, wearing a mantle.

Perhaps still Hellenistic period.

The portrait was identified by Chabouillet as representing the law-giver Lykourgos, and there is indeed a certain resemblance to the coin types. (Cf. *B.M.C.*, Peloponnesus, pl. XXIV, 7–8; my *Portraits of the Greeks*, figs. 376–378, p. 92.)

Chabouillet, *Cat.,* no. 2039.

645. *Sardonyx ringstone.* 16 × 15 mm.

In the Cabinet des Médailles.

PORTRAIT BUSTS OF A BEARDED MAN AND A YOUNG BEARDLESS ONE CONJOINED, both in profile to the right. The bearded one has a taenia and a mantle; of the other only the front part of the head is visible.

Hellenistic period.

Interpreted by Chabouillet as Lykourgos and Kleomenes III, kings of Lacedaemon. The beardless head indeed resembles the portrait that appears on some Lacedaemonian coins and which was thought to represent Kleomenes III by Seltman (*Greek Coins*², p. 256, pl. LXII, 7), but which is thought by others to represent King Areos (cf. *British Museum Guide,* 1959, p. 54, pl. 29, fig. 14).

Visconti, *Ic. gr.,* I, pl. XLI, 1.
Chabouillet, *Cat.,* no. 2040.

646. *Black jasper ringstone.* 16 × 15 mm.

In the British Museum. Presented by Mr. George Eastwood, 1866.

PORTRAIT HEAD OF A HELLENISTIC RULER, wearing a taenia and an elephant's skin on his head. His eye is wide open, his lips are slightly parted, and he has a deep furrow on his forehead.

The elephant's skin suggests that the portrait is that of an African prince. For Alexander the Great it seems too old and not sufficiently idealized – though it does resemble the early coin portraits of Alexandria (cf. my *Portraits of the Greeks*, fig. 1721). Perhaps Agathokles of Syracuse who, after his victory over the Carthaginians (c. 300 B.C.), struck some coins bearing a head with an elephant's skin, possibly his portrait; cf. Seltman, *Greek Coins*², pl. LX, 5). (This suggestion I found in a pencilled note in the British Museum Catalogue of the Staff Library.)

Walters, *Cat.,* no. 1188, pl. XVII ('unknown African prince').

647. *Carnelian ringstone,* mounted in a modern gold ring. 13 × 16 mm.

In the Cabinet des Médailles. Acquired through the bequest of Philippe de Saint-Albin in 1878.

PORTRAIT HEAD OF A YOUNGISH MAN, in profile to the right. He wears a close-fitting helmet, tied with a cord under the chin and leaving the ear exposed.

The portrait was identified by Babelon as Timoleon of Corinth, who was sent to Sicily to help combat the Carthaginians, and then tried to establish democratic governments in the various Sicilian cities (346 B.C. and later). The general appearance of the portrait, and a

second half of fourth century date would fit Timoleon, but as no certified portrait of him on coins exists, one cannot be sure.

For a head on a Syracusan coin, thought perhaps to portray Timoleon, cf. Seltman, *Greek Coins²*, pp. 193 f., pl. XLV, 9. It is strongly idealized, is bearded, and wears a helmet.

E. Babelon, *Guide au Cabinet des Médailles*, p. 59, no. 2047 bis. *Pierres gravées, Guide du visiteur* (1930), p. 32, no. 2047 bis, pl. IX (there identified as Timoleon).

648. *Carnelian ringstone.* 21 × 26 mm.

In the Museum of Fine Arts, Boston, 98.727. Formerly in the Tyszkiewicz Collection.

PORTRAIT HEAD OF A BEARDED MAN, in profile to the right, wearing a laurel wreath tied with a string at the back of the head.

Since there is the wreath the portrait may be that of a Hellenistic ruler. Hardly Perseus of Macedon (179–168 B.C.), however; more probably Nabis, king of Sparta, 207–192 B.C. (cf. Seltman, *Greek Coins²*, pl. LXII, 8) – as suggested to me by Kenneth Jenkins.

Furtwängler, *A.G.*, pl. XXXI, 27 (Perseus of Macedon?). Osborne, *Engraved Gems*, pl. XVI, 6, p. 344 (Perseus of Macedon?). Lippold, *Gemmen und Kameen*, pl. 68, no. 7 (Hellenistischer König).

649. *Amethyst ringstone,* convex on the engraved side. 18 × 26 mm.

In the Museo Archeologico, Florence, inv. 14948.

PORTRAIT HEAD OF MITHRADATES VI EUPATOR, THE GREAT, king of Pontos (120–63 B.C.). He wears a tasseled taenia in his long, curly hair.

Identified through resemblance to the coin types; cf. Head, *H.N.²*, p. 501, fig. 263; Newell, *Royal Greek Portrait Coins*, p. 42, nos. 3, 4; *B.M.C.*, Pontus, etc., pl. IX; Richter, *The Portraits of the Greeks*, p. 275, figs. 1928, 1929.

Gori, *Mus. Flor.*, I, 25, 10. S. Reinach, *Pierres gravées*, pl. 13. Furtwängler, *A.G.*, pl. XXXII, 29. Lippold, *Gemmen und Kameen*, pl. 70, no. 4.

650. *Transparent yellowish-green glass ringstone.* 32 × 22 mm.

In the British Museum, 1923.4–1.148.

PORTRAIT HEAD OF MITHRADATES VI EUPATOR, king of Pontos (120–63 B.C.). He has flowing locks and wears a taenia of which the ends are visible on his neck.

Similar to no. 649.

Walters, *Cat.*, no. 1228, pl. XVI.

651. *Carnelian ringstone.* Fractured at top. 15 × 13 mm.

In the British Museum, 90.6–1.64. Acquired from the Carlisle Collection in 1890.

PORTRAIT HEAD OF A YOUNG MAN, with curly hair and with a slight beard and moustache. He wears a chlamys, fastened on both shoulders. The expression is one of youthful energy.

Perhaps also a portrait of Mithradates VI Eupator, king of Pontos (120–63 B.C.), as was suggested by Furtwängler; cf., e.g., *B.M.C.*, Pontus, etc., pl. VIII.

Furtwängler, *A.G.*, pl. XXXII, 20. Walters, *Cat.*, no. 1187, pl. XVII.

652. *Sardonyx ringstone,* of two layers. c. 38 × 41 mm.

In the Hermitage.

PORTRAIT OF MITHRADATES VI EUPATOR, king of Pontos (120–63 B.C.) (?). He wears a taenia with loose ends, a cuirass, and over it a chlamys, fastened on each shoulder with a brooch ornamented with a star; beneath each brooch is a thunderbolt.

Furtwängler identified the portrait as Mithradates VI, since he thought that the physiognomy with its upturned look, straight nose, parted lips, prominent Adam's apple, was like the coin types of that king. But the similarity is not, I think, as striking as in nos. 649, 650.

Furtwängler, *A.G.*, pl. XXXII, 17. Maximova, *Ancient Gems and Cameos*, pl. III, 5 (in Russian).

653. *Yellow chalcedony, sprinkled with jasper, ringstone.* 28 × 23 mm.

In the British Museum, 72.6–4.1333. Acquired from the Castellani Collection in 1872.

PORTRAIT OF PHILETAIROS, ruler of Pergamon (282–263 B.C.). He wears a chlamys fastened on his right shoulder, and has short curly hair, closely adhering to the skull.

Third century B.C.

The resemblance to the portraits of Philetairos on the coins is striking; but the portrait on the gem is even finer. It is a marvellously lifelike likeness, the strong

personality of Philetairos being successfully conveyed in the serious expression, the firmly closed mouth, and the prominent chin. There is no taenia; so Furtwängler thought that the gem must date from Philetairos' lifetime, before his deification, rather than from a later period. But, as has been pointed out, the absence of a taenia or wreath on a gem or in sculpture has not the same significance as it has on a coin. Many of the posthumous sculptured portraits of Alexander have neither diadem nor divine attribute, whereas the coin types invariably represent the heroized or deified Alexander with the taenia; cf. U. Westermark, *loc. cit.*, who would date the gem *c.* 230–220 B.C.

Furtwängler, *A.G.*, pl. XXXIII, 10, and vol. III, p. 135.
Walters, *Cat.*, no. 1184, pl. XVII.
U. Westermark, *Das Bildnis des Philetairos von Pergamon*, pl. 24, no. 2, pp. 47 ff.
Richter, *The Portraits of the Greeks*, p. 273, fig. 1916.
E. Boehringer, 'Ein Ring des Philetairos', in *Corolla L. Curtius*, p. 116, pl. 35, no. 1.

654. *Fragment of a glass cameo*, with two dark blue and one white layer. The right half is missing. Ht., 36 mm.

In the Staatliche Museen, Berlin. From the Bartholdy Collection. Acquired in 1827.

VICTORIOUS HELLENISTIC RULER, standing in a two-horse chariot, proceeding slowly to the left. He holds a sceptre in his left hand and extends the right, with fingers spread. He wears a taenia and a cuirass. The chariot is being driven by Athena, of whom only the right arm and spear remain. Below the ground line is the inscription Ἀθηνίω[ν], Athenion, on whom see pp. 16, 18 and no. 594. A glass fragment in the British Museum (no. 1645 in the 1888 catalogue), evidently moulded from the same original, supplies the Athena on the right.

Hellenistic, perhaps second century B.C.

The head has portrait-like features. Furtwängler suggested that he was intended for Eumenes II of Pergamon (197–159 B.C.). The occasion must have been the celebration of a victory. The composition was frequently used in Roman times for a triumphal emperor or general.

There is only one extant coin with the portrait of Eumenes II; cf. my *Portraits of the Greeks*, fig. 1917.

Furtwängler, *J.d.I.*, III, 1888, pp. 113 ff., pl. III, 3; IV, 1889, p. 85; *Beschreibung*, no. 11142, pl. 67; *Kleine Schriften*, II, p. 289, pl. 25, 3.

655. *Plasma ringstone*, mounted in a modern gold frame to serve as a pendant. 31 × 27 mm.

In the Cabinet des Médailles.

PORTRAIT BUST, wearing taenia and a chlamys, presumably of a Hellenistic king.

Identified by Chabouillet as Seleukos III, king of Syria (226–223 B.C.), through its similarity to the coin types, cf. *B.M.C.*, Syria, Seleucid kings, pl. VII, 6 f.; Imhoof-Blumer, *Porträtköpfe*, pl. III, 15, p. 29; Richter, *The Portraits of the Greeks*, fig. 1873. K. Jenkins suggests Ariarathes IX of Cappadocia (formerly called Ariarathes V).

Caylus, *Recueil*, VI, p. 138, pl. XLII, no. 1.
Chabouillet, *Cat.*, no. 2052.
Pierres gravées, *Guide du visiteur* (1930), p. 32, no. 2052 (not ill.).

656. *Garnet ringstone*, set in a gold ring. 16 × 12 mm.

In the De Clercq Collection, Paris.

PORTRAIT OF A MAN, wearing taenia and chlamys, in profile to the right. The mouth is a little open, the nose slightly curved, the eye wide open, the forehead protruding in its lower part. He has curly hair descending to the nape of the neck.

Tentatively identified as Demetrios II Nikator, of Syria (146–142 and 129–125 B.C.), by De Ridder. But he has a straight nose on the coin types (cf. my *Portraits of the Greeks*, fig. 1894). I see a likeness to Antiochos VII Sidetes, of Syria (139–129 B.C.) (cf. *ibid.*, fig. 1898). According to K. Jenkins, the portrait is 'clearly a late Seleucid, either Antiochos VII Sidetes or Antiochos VIII Grypos'.

De Ridder, *Cat.*, *De Clercq Coll.*, no. 2861, pl. XX.

657. *Carnelian ringstone*. 31 × 24 mm.

In the Cabinet des Médailles.

PORTRAIT BUST OF ANTIOCHOS VIII GRYPOS, king of Syria (121–96 B.C.). He wears a taenia with tasseled ends, a chlamys, and a cuirass.

Hellenistic period, second century B.C.

Identified by Chabouillet, through comparison with the coin types, as Antiochos VIII Grypos (cited by mistake as Antiochos III); cf. Imhoof-Blumer, *Porträtköpfe*, pl. IV, 5; Head, *H.N.²*, p. 770, fig. 340; *British Museum Guide* (1959), pl. 44, no. 14; my *Portraits of the Greeks*, figs. 1900,

1901. The resemblance in the large, aquiline nose, the prominent chin, and the energetic expression is indeed striking. Furtwängler, on the other hand, interpreted the portrait as Mithradates VI, surnamed the Great, who has, however, a very differently shaped nose; cf. my *Portraits of the Greeks*, figs. 1928, 1929.

Chabouillet, *Cat.*, no. 2053.
Pierres gravées, Guide du visiteur (1930), p. 32, no. 2053 (not ill.).
Mariette, *Pierres gravées*, II, pl. 88.
S. Reinach, *Pierres gravées*, pl. 105.
Furtwängler, *A.G.*, pl. XXXII, 25.

In Seleucid Babylonia, on the site of the temple of the ancient city of Uruk (modern Warka), have been found sealings of clay, bitumen, etc., impressed from engraved gems (cf. p. 2). Several of these bear the portraits of Seleucid kings, and from a comparison with the coin types can be tentatively identified. Some are inscribed χρεοφυλακικὸς ἐν Ὄρχοις (or Ὄρχων), 'registrar of the public debt in Uruk', and most of them exist in several examples.

The following are among the most interesting:

No. 658, now in the Ashmolean Museum, seems to represent Seleukos III; cf. Rostovtzeff, *Yale Classical Studies*, III, 1932, p. 26, pl. IV, 1; Driver, *J.H.S.*, XLIII, 1923, p. 55, fig. 1; my *Portraits of the Greeks*, fig. 1873.

No. 659, now in the Staatliche Museen, Berlin, VA2247, should represent Antiochos IV; cf. *B.M.C.*, Seleucid Kings, pl. XII, 1–3, 5, 6, 13–16; Rostovtzeff, *op. cit.*, p. 28, pl. V, 1, 2; my *Portraits of the Greeks*, fig. 1884.

No. 660. A similar, less well preserved, example in Brussels; cf. Speleers, *Catalogue des intailles et impreints orientaux des Musées Royaux du Cinquantennaire*, 1917, p. 238, no. 207; Rostovtzeff, *op. cit.*, p. 28, no. 2.

No. 661, in Berlin, VA6146, resembles somewhat the coin types of Demetrios II with an elephant's headdress; cf. *B.M.C.*, pl. XVIII, 9; Rostovtzeff, *op. cit.*, p. 45, pl. VI, 2; Jordan, *Uruk-Warka*, p. 65, no. 17, pl. 87, c; Le Rider, *Suse sous les Séleucides et les Parthes* (1965), p. 309, pl. LXXIV, no. 28 (there identified as Antiochos IV).

For other sealings with portrait heads, more tentatively identified as representing Seleucid kings, cf. R. H. McDowell, 'Stamped and inscribed objects from Seleucia on the Tigris', *University of Michigan Studies*, Humanistic Series, vol. XXXVI, 1935, pp. 44 ff., pls. I, II.

662. *Clear sard ringstone.* 20 × 14 mm.

In the Museum of Fine Arts, Boston, 27.716. From the collection of E. P. Warren. Bought in 1899 from W. T.

Ready, who said that it was found on the Euphrates. Furtwängler, *loc. cit.*, said that it came from the East, and was at one time (1887) in the possession of Mr. Lau.

PORTRAIT BUST OF A CLEAN-SHAVEN MAN, with a wrinkled forehead, wearing an Oriental headdress and a club-shaped torque. Drapery is indicated on his shoulder. The headdress consists of a peaked cap with three flaps, one hanging down the back, the others folded together in front (cf. Beazley, *op. cit.*, pp. 82 f.).

Furtwängler suggested that the man was a ruler of Kommagene, Armenia (cf. Imhoof-Blumer, *Hellenistische Porträtköpfe*, pl. VI, 9) or of Persepolis, *ibid.*, pl. VII, 27). Kenneth Jenkins, however, has made the interesting proposal that the head may be a portrait of Ariobarzanes I Philoromaios of Cappadocia (96–63 B.C.), with whose coin types it has in common the curving nose, the marked indentation at the bridge of the nose, and the firm chin. The realistic style of the head on the gem would also favour this identification.

Furtwängler, *A.G.*, pl. XXXI, 23, and vol. III, p. 154.
Beazley, *Lewes House Gems*, no. 98, pl. 6.
Lippold, *Gemmen und Kameen*, pl. 70, no. 8.

663. *Lapis lazuli ringstone*, set in a gold ring. 20 × 16 mm.

In the British Museum. Acquired through the Franks bequest, 1897. Once in the Demetri Collection.

PORTRAIT HEAD OF A MAN, wearing a close-fitting cap-like helmet. He has a false Egyptian beard under his chin, a thin nose, wide-open eyes, and furrows on his forehead. On the front of the helmet is a disk.

The physiognomy hardly seems Greek. Perhaps of some Oriental potentate? The ring in which the stone is set is of a third century B.C. type (cf. Marshall, *loc. cit.*); but the portrait would seem to be of the second century B.C.

Marshall, *Cat. of Finger Rings*, no. 384, pl. XII.
Walters, *Cat.*, no. 1191, pl. XVII.

664. *Yellow chalcedony ringstone.* 25 × 21 mm.

Perhaps from Constantinople. In the British Museum, 1910.6–14.1. Formerly in the Ionides Collection. Presented by Mrs. Zarifi, 1910.

PORTRAIT BUST OF A MIDDLE-AGED MAN, with a short, pointed beard, a long moustache, and pouches under the eyes. He wears a fez-like cap and a chlamys.

Third to second century B.C.

The un-Greek physiognomy points to some Oriental ruler. The fez-like headgear is paralleled by that worn by

some barbarians on the columns of Trajan and Marcus Aurelius. A replica, in Syriam garnet – without the pouches under the eyes, and, therefore, younger-looking – was once in the Tyszkiewicz Collection and is now in Boston; cf. my no. 665.

Burlington Fine Arts Club Exh., 1904, p. 210, no. M, 136, pl. CXII.
Beazley, *Lewes House Gems*, p. 82, pl. B, 10.
Walters, *Cat.*, no. 1182, pl. XVII.

665. *'Syriam' garnet ringstone*, the back convex. 22 × 27 mm.

Said to have been found at Suleimanieh in Turkish Kurdistan, near the Persian frontier. In the Museum of Fine Arts, Boston, 27.710. Formerly in the Tyszkiewicz Collection, then in that of E. P. Warren.

PORTRAIT BUST OF A BEARDED MAN, wearing a fez-like cap, and a chlamys fastened on the right shoulder, not with the usual brooch, but with a knot and bow.

Third to second century B.C.

The portrait resembles that in the British Museum (my no. 664), and was once considered to be a modern copy. But its genuineness has been endorsed by Furtwängler and Beazley; and it would indeed be surprising as a modern work. The same device of fastening the chlamys with a bow and knot instead of with a brooch appears on Ptolemaic coins; cf. Head, *H.N.²*, p. 851, fig. 376.

Froehner, *Collection Tyszkiewicz*, pl. XXIV, 12.
Furtwängler, *A.G.*, pl. XXXI, 24, and vol. III, pl. 691.
Sale Cat. of the Tyszkiewicz Collection, pl. XXVII, 289.
Beazley, *Lewes House Gems*, no. 97, pl. 6.
Lippold, *Gemmen und Kameen*, pl. 70, no. 7.

666. *Mottled sard ringstone*. 15 × 13 mm.

In the British Museum, 1924.5–18.1. Bought 1924.

HEAD OF A YOUNG HELLENISTIC PRINCE. He has thick, curly hair and wears a taenia. The horns of Ammon are visible round his ear.

Walters thought that the portrait might represent Magas, who acted as governor of Cyrene during the second period of Ptolemaic domination, 308–285 B.C., of whom, however, no coin types exist. Kenneth Jenkins has suggested that it may portray Ariarathes V of Cappadocia, 163–130 B.C. (formerly given to Ariarathes IV; but cf. Mørkholm, *Num. Chron.*, 1962, pp. 407 ff., and 1964, pp. 21 ff.), whose coin types it resembles (cf. *B.M.C.*, Galatia, Cappadocia, and Syria, pl. VI, 2; my *Portraits of the Greeks*, fig. 1936).

Walters, *Cat.*, no. 1182*, pl. XVII.

667. *Bluish chalcedony ringstone*, slightly convex on engraved side, domed at the back. Chipped on one side. 15 × 19 mm.

Said to have been found at Amisos (Eski Samsoun). In the Metropolitan Museum of Art, 42.11.24. Purchase, 1942, Joseph Pulitzer bequest. From the Evans Collection.

PORTRAIT HEAD OF A WOMAN. She wears a taenia, and may, therefore, represent a royal personage. Her hair is parted on one side and tied at the back. A fold of her chiton appears below the neck.

The rendering of the soft flesh, the wavy hair, and delicate features is masterly. Kenneth Jenkins has suggested to me that it may portray Laodike, wife of Mithradates IV Philopator Philadelphos, king of Pontos, 169–150 (?) B.C. Cf. the coin where she appears with her husband, but where only the front of the head is visible; cf. T. Reinach, *Recueil*, I, I², (1925), pl. I, no. 13, and *L'histoire par les monnaies* (1920), p. 127, pl. VI, 3; Pauly-Wissowa, *R.E.*, XII, 1 (1924), col. 708, no. 22.

Evans, *Selection*, no. 63.
Richter, *Evans and Beatty Gems*, no. 44; *M.M.A. Handbook*, 1953, p. 150, pl. 126, m; *Cat.*, no. 148, pl. XXV.

668. *Lapis lazuli ringstone*, mounted in a modern frame. 16 × 12 mm.

In the Cabinet des Médailles.

PORTRAIT BUST OF JUBA I, king of Numidia (60–46 B.C.), wearing taenia and chlamys, and with a sceptre placed against the right shoulder.

Identified by Chabouillet as representing Juba I, to whose coin types it indeed bears a striking resemblance; cf. my *Portraits of the Greeks*, fig. 2004. Here too is the sceptre and the abundant hair that appear on the coins.

Mariette, *Pierres gravées*, II, no. 91.
Chabouillet, *Cat.*, no. 2062.
Pierres gravées, Guide du visiteur (1930), p. 32, no. 2062, pl. IX.
S. Reinach, *Pierres gravées*, pl. 105, no. 91.

669. *Carnelian ringstone*. 15 × 11 mm.

In the Cabinet des Médailles.

PORTRAIT BUST, PROBABLY OF JUBA II, king of Mauretania (25 B.C.–A.D. 23–24). He wears a taenia; the bust form is that of the contemporary Augustan portraits, though it appears also in Hellenistic times.

Identified by Chabouillet as Juba II, to whose coin portraits it bears a distinct resemblance; cf. my *Portraits of the Greeks*, fig. 2005.

Chabouillet, *Cat.*, no. 2063.

Pierres gravées: Guide du visiteur (1930), p. 32, no. 2063 (not ill.).

670. *Carnelian ringstone*, mounted in a modern ring. 15 × 10 mm.

In the Cabinet des Médailles, Paris. Gift of the duc de Luynes in 1863 (no. 150).

PORTRAIT HEAD OF A YOUNG MAN, wearing a taenia, in profile to the right. Tentatively identified (in the *Guide*) as Juba II. If it represents him it would be a very generalized likeness – but 'a variety of physiognomies appears on the coins' (K. Jenkins).

Pierres gravées, Guide du visiteur (1930), p. 144, no. 150 (not ill.).

671. *Sardonyx ringstone.* 13 × 15 mm.

In the Cabinet des Médailles, 65A13938.

PORTRAIT BUST OF A BEARDED MAN, in profile to the right. He wears a chlamys and has a ram's horn above the ear.

Hellenistic or Roman period.

As Chabouillet said, the horn of Ammon should point to an African prince.

Chabouillet, *Cat.*, no. 2065.

672. *Agate ringstone.* Red streaked with white. 17 × 15 mm.

In the Cabinet des Médailles, 65A13937.

PORTRAIT BUST OF A HELLENISTIC KING, wearing a crested helmet decorated with stars, and a cuirass. He holds a round shield and two spears.

Chabouillet, *Cat.*, no. 2064 ('roi ou prince numide inconnu').

(δ) PORTRAITS OF 'UNKNOWNS'

Some are apparently of private individuals, since they wear no taenia (nos. 673–682). First come two problematical heads. Then some on which a name is inscribed – presumably that of the artist: Daidalos (no. 675), Skopas (no. 676), and Apollonios (nos. 677, 678). In each case the verb 'made it' is missing, so it is possible that the name refers to the owner of the stone and is not a signature. One (no. 680) – an outstanding piece – is signed by the artist Philon.

673. *Agate ringstone.* 21 × 20 mm.

In the Cabinet des Médailles.

PORTRAIT HEAD, in profile to the left, wearing the skin of an elephant's head. Inscribed below: ΑΛΕΕΠΒ, in Greek capital letters.

Hellenistic period.

The inscription was completed by Caylus, quoting Pellérin, as: Alexandros Epiphanes Basileus, and the portrait accordingly identified as Ptolemy IX Alexander I of Egypt (107–101 B.C.), (now called Ptolemy X). Chabouillet, on the other hand, read the inscription as signifying: Alexandros Epeiroton Basileus, and identified the portrait as that of Alexander I, king of Epeiros (342–330 (?) B.C.).

Unfortunately, no portrait of Alexander of Epeiros exists for comparison, since the head of Zeus appears on his coins (cf. Head, *H.N.²*, p. 322, fig. 180). Moreover, Kenneth Jenkins has pointed out to me that there is considerable doubt whether this Alexander was ever strictly

king of Epeiros (see Franke, *Die antiken Münzen von Epirus*, especially pp. 249 ff., who thinks that he was only king of the Molossians). So it seems best to class the portrait on the gem among the unknowns.

Caylus, *Recueil d'antiquités*, v, p. 149, pl. LIII, no. IV.
Chabouillet, *Cat.*, no. 2050.

674. *Carnelian ringstone*, mounted in a modern gold frame. 20 × 15 mm.

In the Cabinet des Médailles. Acquired in 1855 by Lenormant for the Bibliothèque Impériale.

PORTRAIT HEAD OF A WOMAN, wearing the Oriental tiara and a beaded necklace. Perhaps Amastris, queen of Paphlagonia, *c.* 300 B.C.?

Hellenistic period.

Identified as Amastris by Lenormant. The portrait on the coin types (cf. Head, *H.N.²*, p. 505, fig. 264) has, however, been considered to be male, and the figure on the reverse, with the inscription *Amastrios basilisses*, to be

the personification of the city; so that there is no portrait of this queen available for comparison. Nevertheless, the identification on general grounds seems likely enough.

Chabouillet, *Cat.*, no. 2051.
Pierres gravées, Guide du visiteur (1930), p. 32, no. 2051, pl. IX.

675. *Hyacinth ringstone*, convex on engraved side. 26 × 19 mm.

In the De Clercq Collection, Paris.

PORTRAIT BUST OF A YOUNG MAN, in profile to the right. He has short, curly hair and wears a chlamys, fastened with a brooch on his right shoulder. At the left is the inscription Δαίδαλος, Daidalos (on whom see pp. 16, 18).

Third century B.C.

De Ridder, *Collection de Clercq, Cat.*, VII, 2, no. 2854, pl. XX.
Furtwängler, *A.G.*, vol. III, p. 163.
Rossbach, in *R.E.*, XIII, s.v. Gemmen, col. 1083.

676. *Hyacinth ringstone*, engraved on convex side. 22 × 16 mm.

In the Archaeological Institute of the University of Leipzig.

PORTRAIT OF A YOUNG MAN, in profile to the right. He is clean shaven, has short hair, and a friendly, wide-awake expression. Below is the inscription Σκόπας, Skopas, presumably the signature of the artist.

Hellenistic period, third to second century B.C.

On Skopas cf. pp. 16, 19.

Furtwängler, *J.d.I.*, VIII, 1893, pp. 185 f., pl. II, 2 ('griechische Arbeit der Diadochenzeit'); *A.G.*, pl. XXXIII, 8, and L, 13. Vollenweider, *Steinschneidekunst*, pp. 26, 96, pl. 15, figs. 1, 3 (there dated in the first century B.C.).

677. *Garnet ringstone*, mounted in gold swivel ring. Bezel, 23 × 28 mm.

Found at Kerch. In the Walters Art Gallery, Baltimore, 57.1698. Formerly in the Morrison and Evans Collections.

PORTRAIT HEAD OF A YOUNG MAN, with curly hair and whiskers. At the bottom, under the neck, is the inscription: 'Απολλωνί [ος or ου], 'of Apollonios', either the signature of the artist (cf. p. 18), or referring to the proprietor of the gem. The last two letters are somewhat indistinct, as the writer had little space left, on account of the protrusion of the neck.

It has been suggested (first in the *Morrison Sale Catalogue*) that the portrait represents Asandros, king of the Bos-

phorus (47–16 B.C.), on account of its resemblance to the coin portraits of that king, cf. *B.M.C.*, Pontus, etc., p. 48, pl. X, 9, 11; Imhoof-Blumer, *Porträtköpfe*, pl. V, 6. But the resemblance is not marked, certainly not compelling. And there are difficulties in the identification. There is no taenia in the gem portrait – though this could be due to the fact that the portrait was made before Asandros became king; or, as sometimes on gems, etc., that it was simply omitted. More serious is the fact that the style hardly fits the first century B.C., but points to the third century B.C., the time of Ptolemy II, III, and IV of Egypt. The full face also resembles the fleshy physiognomies of the Ptolemies. That the letters of the inscription do not resemble those of the signatures of the Apollonios who signed several gems of the Roman period was pointed out by Furtwängler. If the inscription on the gem is a signature, it would refer to another Apollonios, which of course is a common enough name.

Sale Catalogue of the Morrison Collection (1898), no. 261, pl. II. Furtwängler, *A.G.*, pl. LXIII, 36, and vol. III, p. 163.
Evans, *Selection*, no. 65, pl. IV.
D. K. Hill, *Journal of the Walters Art Gallery*, VI, 1943, pp. 62 ff., figs. 2, 3.

678. *Carnelian ringstone*. Fractured at the top. Diam. 21 mm.

In the National Museum, Athens, Numismatic Section, inv. 594. Gift of K. Karapanos, 1910–11.

PORTRAIT BUST OF A MAN, in profile to the right, wearing taenia and chlamys. At the back of the head is the inscription 'Απολλώνιος, the name either of the artist or of the owner of the seal.

Hellenistic period, perhaps of the third century B.C.

Since there is the taenia it should be the portrait of a Hellenistic ruler. 'Perhaps a Seleucid – Antiochos III' (K. Jenkins). In the other portrait inscribed by Apollonios, in Baltimore (no. 677), the name is in the genitive, whereas on this stone it is in the nominative.

Svoronos, *Journal international d'archéologie numismatique*, XV, 1913, no. 355.

679. *Bronze ring*, with design in relief on bezel. 26 × 32 mm.

In the National Museum, Athens, Numismatic Section, inv. 639. Gift of K. Karapanos, 1910–11.

PORTRAIT BUST OF A YOUNG MAN, wearing a chlamys, in profile to the left.

Probably Hellenistic period.

Svoronos, *Journal international d'archéologie numismatique*, XV, 1913, no. 952 (not ill.).

680. *Silver ring*, with engraving on the bezel. 15 × 20 mm.

Said to have come from Asia Minor. Once in the Tyszkiewicz Collection, then in that of P. Arndt. Present location not known.

PORTRAIT OF A YOUNG MAN, in profile to the right. He has a sensitive face, with drooping eyelids, a straight, pointed nose, thin cheeks, and short hair. Round his shoulders drapery is indicated. Below is the inscription Φίλων ἐπόει. The Φ is not visible in the impression, but half of it is said to remain on the original (Tyszkiewicz).

The workmanship is of the first order, evidently Hellenistic, perhaps of the third to second century B.C., as indicated also by the use of ἐπόει instead of ἐποίει in the inscription. It is the only signed work of Philon that has survived (cf. p. 19). The physiognomy is that of a not very vigorous man, presumably Greek rather than Roman.

Furtwängler, *J.d.I.*, III, 1888, p. 206, pl. VII, 11; *A.G.*, pl. XXXIII, 13; *Kleine Schriften*, II, pp. 198 f., 284, pl. 26, no. 11.

681. *Carnelian ringstone*. Ht. 16 mm.

In the Staatliche Münzsammlung, Munich. From the Arndt Collection.

PORTRAIT HEAD OF A YOUNG MAN, in profile to the left. He has shortish hair, whiskers, and a short beard.

Probably second to first century B.C.

The physiognomy is evidently Greek. Cf. the portraits of Hellenistic rulers of that time, e.g., that of Nikias of Kos, *B.M.C.*, Caria, pl. XXXII, 13; Richter, *The Portraits of the Greeks*, p. 274, fig. 1920.

Ohly and Czako, *Griechische Gemmen*, no. 26.

682. *Garnet ringstone*. Chipped round the edge. 21 × 17 mm.

In the Cabinet des Médailles, 2056A.

TWO HEADS CONJOINED, in profile to the right. Each wears a wreath, so perhaps rulers are intended. The features are generalized, though apparently portraits are intended. In the field, above, are two stars. 'May the persons, therefore, represent the Dioskouroi?' (K. Jenkins).

(ε) PORTRAITS OF ROMANS, ENGRAVED BY HELLENISTIC ARTISTS

Of special interest are several fine heads executed in Hellenistic style, but, to judge from their physiognomies, not of Greeks but of Romans. They have in common not only the un-Greek physiognomies and the fluid style, but certain epigraphical characteristics – in those examples where signatures are added (nos. 685, 686, 689): though the letters are cursive they have either no balls at the ends or only very small ones; the omikron and theta are generally smaller than the other letters; and the verb is mostly given as ἐπόει, instead of as ἐποίει as regularly later. Moreover, they are written less carefully than in the Augustan period, and they appear on the side of the head instead of at the top or below. This group of portraits was first studied by Furtwängler in *J.d.I.*, III, 1888, p. 208; *A.G.*, vol. II, p. 162, text to pl. XXXIII, 9, 14, 15, 16, 24, and vol. III, p. 165, and dated in the third to second century B.C. – a date which has now apparently been confirmed by a gem with these same characteristics (no. 689), found, according to seemingly reliable reports, with two bracelets and coins, as well as with another gem, datable in that period. The veristic style of these heads leads directly to the Roman portraits of the Republican epoch.

683. *Chalcedony ringstone*. 15 × 14 mm.

In the British Museum (90.6–1.59). Acquired from the Carlisle Collection, 1890.

PORTRAIT HEAD OF AN ELDERLY MAN. He is clean shaven, and has short, straight hair, a lined face, intelligent eyes, thin lips, and a serious expression. There is a wart next to the chin. The pupil and the outline of the iris are indicated in relief.

Probably second century B.C.

The physiognomy of the man points to his being a Roman, but the execution should be Hellenistic Greek.

Furtwängler, *A.G.*, pl. XXXIII, 14, and vol. III, p. 166.
Beazley, *Lewes House Gems*, p. 85.
Walters, *Cat.*, no. 1190, pl. XVII.
Richter, *J.R.S.*, XL, 1955, p. 44, pl. VI, 23.

684. *Black jasper ringstone.* 14 × 17 mm.

In the Museum of Fine Arts, Boston, 27.715. Formerly in the Ludovisi, Tyszkiewicz, and E. P. Warren Collections.

PORTRAIT OF A CLEAN SHAVEN, ELDERLY MAN. He has short hair, bushy eyebrows, observant eyes, a furrowed brow, a hooked nose, a very prominent lower lip, a double chin, and a short, thick neck. The mouth is firmly closed and the jaws are prominent. These features, together with the direct gaze, give the face a resolute air. The individual was evidently a Roman, though the work must be late Hellenistic Greek of the third to the second century B.C.

As in no. 687, the ear is misshapen, a technical mishap.

Froehner, *Collection Tyszkiewicz*, 1892, pl. XXIV, 10; *Sale Cat. of the Tyszkiewicz Collection*, 1898, pl. XXVII, 288.
Furtwängler, *J.d.I.*, III, 1888, pp. 108 f.; *A.G.*, pl. XXXIII, 16, pl. LI, 25, and vol. III, p. 165.
Burlington Fine Arts Club Exh., p. 241, no. O, 42 (not ill.).
Beazley, *Lewes House Gems*, no. 101, pl. 6.
Lippold, *Gemmen und Kameen*, pl. 69, no. 2.

685. *Beryl ringstone.* Strongly convex on the engraved side. 21 × 18 mm.

In the Museo Archeologico, Florence, inv. 14968. Known since the seventeenth century.

PORTRAIT HEAD OF A MIDDLE-AGED, CLEAN-SHAVEN MAN, with a strong, discontented countenance. In the field, at the back of the neck, in two horizontal lines, is the inscription ʼΑγαθόπους ἐποίει, 'Agathopous made it'.

Furtwängler read the verb as ἐπόει, but the excellent photograph of the original sent me by Mr. Caputo shows it to be ἐποίει and so read by M. Guarducci.

On Agathopous cf. pp. 16, 18.

The person represented, to judge by his sober countenance, was evidently a Roman, but the fluid modelling (note particularly the mouth) points to the late Hellenistic period as the time of execution. And this is indicated also by the forms of the letters (e.g., the smallness of the theta and the omicron), as pointed out to me by M. Guarducci and G. Daux. So a late Hellenistic date round 100 B.C. would seem to be likely.

The rendering of the hair in a number of slightly curving tufts may be compared with, e.g., that of Karneades (cf. my *Portraits of the Greeks*, figs. 1694 ff.), and of other late Hellenistic portraits (cf. Hafner, *Späthellenistische Bildnisplastik*, passim).

That the gem engraver Agathopous should be identical with the aurifex of that name mentioned in an inscription (*CIL*, VI, 3945–3948) is rendered hypothetical by the fact that Agathopous is not an uncommon name; cf., e.g.,

Pape, *Eigennamen*, s.v. ʼΑγαθόπους, where several persons of that name (from Athens, Sparta, Thera, Miletos) are cited; and to which may now be added one from Phrygia, cf. Lane, *Berytus*, XV, 1964, p. 24, no. 13 (a reference I owe to R. Higgins). In a portrait, of course, certain personal characteristics, like a thick neck, would be represented regardless of period. For the form of the bust in Hellenistic times cf., e.g., the coins with the portrait of Antiochus IV Epiphanes (175–164 B.C.).

Gori, *Mus. Flor.*, II, I.
S. Reinach, *Pierres gravées*, pl. 48, 122.
Furtwängler, *J.d.I.*, III, 1888, p. 211, pl. VIII, 15; *A.G.*, pl. XXXIII, 9.
Vollenweider, *Steinschneidekunst*, p. 78, pl. 90, nos. I, 2 (there dated in the middle of the first century A.D.).

686. *Gold ring*, with round bezel, in which is inserted a plate of lighter gold with the engraving. 33 × 29 mm.

From Capua. In the Museo Nazionale, Naples, inv. 25085.

PORTRAIT HEAD OF A BEARDLESS, MIDDLE-AGED MAN, in profile to the right. He has straight hair, a thin, tightly closed mouth, prominent eyebrows, and deep-set eyes. At the back of the head is the signature of the artist, in two lines: ʽΗρακλείδας ἐποίει, 'Herakleidas made it'.

The portrait probably represents a Roman, as suggested by the serious, resolute expression; but again the style of the engraving, and the character of the letters of the inscription point to a Hellenistic date, perhaps in the later third century B.C.

On Herakleidas cf. pp. 16, 18.

Minervini, *Bull. Nap.*, N.S., 3, 1855, p. 178.
Bull. dell'Inst., 1855, p. XXXI f.
Munro, *J.H.S.*, XII, 1891, pp. 322 f.
Furtwängler, *A.G.*, pl. XXXIII, 15; *J.d.I.*, III, 1888, p. 207 = *Kleine Schriften*, II, pp. 199 f., pl. 26, 12.
Lippold, *Gemmen und Kameen*, pl. 71, no. 2.
Breglia, *Cat.*, no. 152, pl. XVIII, 8.
Vollenweider, 'Das Bildnis des Scipio Africanus', *Museum Helveticum*, XV, 1958, pp. 27 ff.
Becatti, *Oreficerie ant.*, no. 508, pl. CXLV.

687. *Sard ringstone*, slightly convex on the engraved side. Crown of head missing and restored in gold. 17 × 20 mm.

In the Museum of Fine Arts, Boston. Formerly in the Ludovisi, Tyszkiewicz, and E. P. Warren Collections.

PORTRAIT OF A CLEAN-SHAVEN, THIN-LIPPED MAN. His forehead is wrinkled, the hair recedes at the temples. The ear is misshapen (evidently an accident in the carving), the pupil incised.

The physiognomy seems Roman rather than Greek.

There is a modern glass copy of this stone in the Stosch Collection in Berlin (4th class, no. 323); cf. Winckelmann, *Description des pierres gravées*, p. 450 (there described as ancient); cf. Beazley, *loc. cit.*

Froehner, *Collection Tyszkiewicz*, pl. XXIV, 5.
Furtwängler, *A.G.*, pl. XXXIII, 24.
Beazley, *Lewes House Gems*, no. 100, pl. 6.
Lippold, *Gemmen und Kameen*, pl. 67, no. 10.

688. *Gold ring*, with engraved bezel. 15 × 16 mm.

Formerly in the Staatliche Museen, Berlin. Lost or destroyed during the last war.

BUST OF A MAN, in profile to the right. He has short hair and an incipient moustache and beard on the chin. In the field at the back are two Latin letters: ΛV.

The style is similar to that of the preceding; and the physiognomy appears here also to be that of a Roman.

For the type of ring cf. Marshall, *Cat. of Finger Rings*, p. XLII, no. XXIII.

Furtwängler, *Beschreibung*, no. 963; *A.G.*, pl. XXXIII, 17.

689. *Gold ring with engraved garnet.* 25 × 20 mm.

Like no. 639 said to have been found together with two gold bracelets and some silver coins in Syria, and acquired in Beyrouth in 1953. Now in the Oriental Institute, Chicago, acc. no. A29789.

PORTRAIT HEAD OF A MAN, in profile to the right. He has short hair, a wrinkled brow, a thin-lipped, closely shut mouth, a prominent jaw, and a determined expression. Inscribed on the right side Μηνόφιλος ἐπόει, 'Menophilos made it'.

Third to second century B.C.

Like the preceding, he evidently represents a Roman, executed by a Hellenistic artist. The type of ring, with hoop expanding upward, likewise testifies to a third or second century date; cf. Marshall, *Cat. of Finger Rings*, p. XLII, no. XXIII (dated third to second century B.C.) and under no. 688. Furthermore, the *latest* of the coins said to have been found with the rings and bracelets were reportedly of the time of Tryphon (142–139 B.C.).
On Menophilos cf. p. 18.

Kraeling, *Archaeology*, VIII, 1955, pp. 256 ff., figs. 1, 7 (there dated in the late third century B.C.).

(ζ) LATE HELLENISTIC PORTRAITS OF GREEKS AND ROMANS

Lastly I present several heads datable in the first century B.C. – two with Roman physiognomies (nos. 690, 691), the others apparently Greeks (nos. 692–695). By the first century B.C. Roman rule had become firmly established East and West, and Greeks and Romans were living more or less amicably side by side, with the Greek artists working for their new patrons. We find at this time an interesting phenomenon. Just as the features of Titus Quinctius Flamininus, the conqueror of the Spartan Nabis in 192 B.C., were transformed to resemble a Greek physiognomy (cf. my *Portraits of the Greeks*, p. 258, fig. 1761), so now, as time went on, Greeks sometimes assume a Roman aspect (cf. Furtwängler, *J.d.I.*, III, 1888, p. 209, note 3, who refers to such examples on coins). This change is of course particularly evident in some of the heads of Greek cosmetai.

690. *Lava (black agate) ringstone*, set in a modern mount. 39 × 30 mm.

In the Royal Cabinet of Coins and Gems, The Hague. From the Massimi and De Thoms Collections.

PORTRAIT HEAD OF A CLEAN-SHAVEN MAN, in profile to the right. He has short, curly, closely adhering hair, a long, thin nose, deep-set eyes, and a prominent chin; in front of the ear is a wart.

The portrait evidently represents a Roman of the Repub-

lican period of the first century B.C., but executed by a Greek. The Comte de Thoms had suggested C. Coelius Caldus (in de Jonge's publication), which was rejected by Furtwängler, since it did not sufficiently resemble the coin portraits; cf. Bernoulli, *Römische Ikonographie*, I, Münztafel I, 21, 22). Furtwängler himself tentatively suggested Cicero, but that too seems doubtful.

De Jonge, *Le Comte de Thoms, Les antiquités de son cabinet* (1745), no. 927, pl. II, 7.
Furtwängler, *A.G.*, pl. XLVII, 13.

Lippold, *Gemmen und Kameen*, pl. 71, no. 7.
Guépin, *Bulletin van de Vereeniging tot Bevordering der Kennis van de Antieke Beschaving te 's-Gravenhage*, XLI, 1966, p. 56, fig. 15.

691. *Terracotta ringstone*, with design in relief. Diam. 38 mm.

In the Numismatic section of the National Museum, Athens, inv. 986.

PORTRAIT BUST OF AN ELDERLY, CLEAN-SHAVEN MAN, in profile to the left, wearing a mantle on his shoulders, and a wreath or cap on his head.

The type somewhat resembles that in no. 690, and may represent the same man grown older, as pointed out by Mr. Guépin.

Svoronos, *Journal international d'archéologie numismatique*, XV, 1913, no. 850.
Guépin, *Bulletin van de Vereeniging tot Bevordering der Kennis van de Antieke Beschaving te 's-Gravenhage*, XLI, 1966, p. 56, fig. 14.

Nos. 692–695 show four sealings from the Nomophylakion at Cyrene, which, like similar sealings, owe their survival to a fire which turned the clay on which they were impressed into terracotta, whereas the papyri to which they were attached were destroyed. Cf. on such sealings my pp. 2 f. and the references there cited.

The building in which the sealings from Cyrene were found could be dated to the first century B.C., and hence the portraits here shown represent Greeks of that late period, when Cyrene belonged to the expanding Roman empire. All seem to represent private individuals, presumably portraying the men who deposited their precious records written on papyri in the Nomophylakion, the building in which private and public legal documents were kept for safety. Cf. the recent publication of this material by G. Maddoli, 'Le Cretule del Nomophylakion di Cirene', *Annuario della Scuola Archeologica di Atene*, XLI–XLII, 1963–64 (1965), pp. 39 ff. My references are to this publication. The objects were taken to Italy for purposes of study by Professor Oliviero, but were subsequently returned to the government of Libya.

692. PORTRAIT BUST OF A YOUNG MAN, with curly hair and wearing a mantle, in profile to the right. 15 × 12 mm.

Maddoli, *op. cit.*, pp. 100, 101, no. 499.

693. PORTRAIT HEAD OF A MAN, in profile to the right. 11 × 9 mm.

Maddoli, *op. cit.*, pp. 101, 102, no. 517.

694. PORTRAIT HEAD OF A YOUNG MAN, with closely adhering, curly hair, in profile to the right. 16 × 14 mm.

Maddoli, *op. cit.*, pp. 101, 103, no. 542.

695. PORTRAIT OF AN ELDERLY BEARDED MAN, in profile to the right. 10 × 8 mm.

Maddoli, *op. cit.*, pp. 103, 105, no. 565.

All these heads are of a more or less Greek type.

II. ETRUSCAN GEMS

1. THE EARLY ARCHAIC PERIOD, SEVENTH TO SIXTH CENTURY B.C.

We may begin our study of Etruscan gems with the remarkable gold (and occasionally silver) rings with designs either in relief or incised on elongated chiefly oval bezels.[1] They are early archaic in style and were found almost entirely in Etruria, principally at Vulci and Cerveteri. Isolated specimens have come to light in Rhodes, in Tharros, Sardinia, and in Cyprus. Some, especially those with embossed designs on their bezels, show marked Oriental influence, the favourite subjects being monsters, often heraldically placed. They date from the late seventh and the early sixth centuries, having counterparts in Middle and Late Corinthian vase-paintings. Others, especially those with incised designs, are mostly decorated with figured scenes, such as chariots drawn by fantastic animals, or with single figures in Orientalizing style, or occasionally with scenes from Greek mythology, comparable to Greek vase-paintings of the first half and middle of the sixth century B.C.

In some examples, presumably the earliest, the designs are arranged in several superimposed compartments, as in the Egyptian cartouches, which doubtless served as the prototypes. Presently, however, instead of a division into several compartments, the bezel is made to have a continuous scene, enabling the artist to represent a connected story. As was so often the case, Eastern forms were taken over and then changed to conform to Western taste.

The question has been much discussed whether these decorated gold rings were made by Greeks or by Etruscans, and, if by Greeks, whether they were imported or made locally. Furtwängler (*A.G.*, vol. III, pp. 83 ff.) thought that they were the work of Ionian Greeks made for Etruscans. More recently the prevailing opinion has been that they were of Etruscan workmanship.

The Etruscan origin is indeed indicated not only by the fact that practically all examples have been found in Etruria, but also by the rendering of such details as the form of the chariot, which is Etruscan rather than Greek (cf. no. 716), and the typically Etruscan high, pointed headdresses (tutulus), worn by both men and women (cf. nos. 719, 720) – which, however, also occur in Ionian Greece. And after all, the Etruscans showed high competence in the making of jewellery just at this period – as shown by the gold earrings, bracelets, and fibulae with elaborate decorations in granulation and filigree, some provided with Etruscan inscriptions. Furtwängler, to reinforce his theory of Ionian Greek workmanship, pointed out the close relationship of the representations on the rings and on some Pontic vases. This undoubtedly exists. But these Pontic vases, once thought to have been made by Ionians, are now also considered to be Etruscan. They too have been found exclusively in Italy, not in the Eastern Mediterranean, and of course not in Pontos.

That the designs on the rings show first Oriental and then archaic Greek influence goes without saying.

[1] On these rings see especially Furtwängler, *A.G.*, III, pp. 83 ff.; Higgins, *Jewellery*, p. 215, and *Br. Mus. Cat. of Terracottas*, II, p. 17, note 4; Becatti, *Oreficerie antiche*, pp. 70 ff.; and now John Boardman's articles in *Papers of the British School at Rome*, XXXIV (new series XXI), 1966, pp. 1 ff., and in *Antike Kunst*, X, 1967, pp. 3 ff., where an attempt is made at more precise datings, ranging from the early to the later sixth century B.C. Since, however, much of early Etruscan jewellery can be dated in the late seventh century, it seems best to give the earlier rings a somewhat larger range and to place them *c.* 625-575 B.C. Cf. also Breglia, *Catalogo, Mus. Naz. Napoli*, pp. 109 f.

But this is true of much of early Etruscan art. Whether the influence stemmed from imported Greek works of art or from the presence of Greek artists who had settled in Etruria and worked for Etruscan clients – gradually themselves becoming somewhat Etruscanized – is difficult to say. At all events, that these archaic gold rings can be called Etruscan in the accepted meaning of the term seems assured. They are a unique phenomenon, peculiar to Etruria and not to any other region. And so they are included here as the first Etruscan products in the field of engraved gems.

It has been pointed out that some of the designs on these rings are so lightly engraved that they would make no effective sealings. But, as our illustrations made from the impressions show, the sealings reproduce fairly well. At all events, the rings served as handsome decorations and their generally large size is in line with the Etruscan love of pomp.

In the following selection I have included also some of the examples in the Louvre the authenticity of which was doubted by Furtwängler (cf. *A.G.*, III, p. 84, note 2), but which have been reinstated by E. Coche de la Ferté in his *Bijoux antiques* (1956), p. 78. He pointed out that they are in the same style as the other examples in Italy and elsewhere and that they show the same oxydation; so that short of condemning the whole series as modern – which seems difficult – most of the Louvre specimens must be considered to be ancient. I personally see nothing suspicious in the examples here shown.[1]

696–704. *Gold rings*, with designs in relief, stamped on little plates and inserted in the elongated oval bezels. In the Louvre. From the Campana Collection.

First half of the sixth century B.C. and later.

696. No. 1118. Bezel 40 × 20 mm.

SPHINX AND LION, confronted. Beaded border.

697. No. 1119. Bezel 30 × 13 mm.

TWO SPHINXES, confronted. Hatched border.

698. No. 1120. Bezel 37 × 18 mm.

SPHINX AND CHIMAERA, confronted. Hatched border.

699. No. 1122. Bezel 35 × 18 mm.

SPHINX AND CHIMAERA, confronted. Beaded and hatched borders.

700. No. 1123. Bezel 41 × 18 mm.

WINGED FIGURE BETWEEN A PANTHER AND A SPHINX. Beaded border.

701. No. 1125. Bezel 33 × 15 mm.

MEDUSA BETWEEN A PANTHER AND A LION. Beaded border.

702. No. 1126. Bezel 42 × 22 mm.

WINGED FIGURE BETWEEN A SPHINX AND A HUMAN-HEADED MONSTER. Hatched and chain borders.

703. No. 1127. Bezel 42 × 20 mm.

WINGED FIGURE BETWEEN A SPHINX AND A PANTHER. Beaded border.

704. No. 1128. Bezel 38 × 17 mm.

WINGED FIGURE BETWEEN A SPHINX AND A PANTHER. Beaded border.

De Ridder, *Bijoux antiques*, pp. 100 f.
Coche de la Ferté, *Les bijoux antiques*, p. 78.
Boardman, *Antike Kunst*, X, 1967, pp. 15 f., nos. B IV, 7 (1126), B IV, 8 (1128), B IV, 9 (1127), B IV, 11 (1125), B IV, 12 (1123), B IV, 19 (1118), B IV, 25 (1120), B IV, 27 (1122), B IV, 31 (1119).

705. *Gold ring*, with a representation in relief on the oval bezel. Bezel 23 × 11 mm.

In the Staatliche Museen, Berlin.

SEATED SPHINX AND RECLINING LION, confronted. Both are open-mouthed. In the field, at the left, is a flower.

Sixth century B.C.

[1] Cf. also Boardman, *Antike Kunst*, X, 1967, p. 7, note 13.

Furtwängler, *Beschreibung*, no. 117; *A.G.*, vol. III, p. 87.
Zahn, *Ausstellung*, p. 37, no. 12.
Bruns, *Schatzkammer*, p. 12, fig. 7.
Becatti, *Oreficerie ant.*, no. 279, pl. 72.
Boardman, *Antike Kunst*, X, 1967, p. 16, no. B IV, 18.

706. *Gold ring*, with design in relief on oblong bezel. L. of bezel 21 mm.

In the British Museum (no acc. no.). Formerly in the Avvolta Collection at Tarquinia.

WINGED DAEMON WITH SPHINX AND PANTHER. The daemon is advancing to the right, with head turned back, grasping with one hand the forepaw of the sphinx seated behind him, with the other the forepaw of the panther in front of him. The daemon wears a short chiton; the trunk is shown frontal, the rest more or less in profile; the mouth is open with teeth showing. The sphinx is in profile to the right, the panther in profile to the left, with head turned to the front. Beaded border.

Micali, *Storia*, III, pl. XLVI, 23, p. 69.
Lajard, *Culte de Mithra*, pl. LXIX, 17.
King, *Antique Gems and Rings*, II, pl. LVI, 2; *Handbook²*, pl. XVI, 6.
De Witte, *Cabinet Durand*, no. 2158.
Furtwängler, *A.G.*, pl. VII, 13.
Marshall, *Cat. of Finger Rings*, no. 209, fig. 57, pl. VI.
Boardman, *Antike Kunst*, X, 1967, p. 15, no. B IV, 6.

707. *Gold ring*, with design in relief on oblong bezel. L. of bezel 22 mm.

In the British Museum (no acc. no.). Acquired through the Franks bequest in 1897.

SPHINX AND CHIMAERA, confronted. The sphinx is seated, with left forepaw raised. The chimaera is striding toward her, open-mouthed, with tongue protruding. The chimaera occupies most of the space, so that the sphinx had to be drawn obliquely. Beaded border.

Archaic period.

De Witte, *Cabinet Durand*, no. 2117.
Lajard, *Culte de Mithre*, pl. LXIX, 21.
Marshall, *Cat. of Finger Rings*, no. 210, fig. 38.
Boardman, *Antike Kunst*, X, 1967, p. 16, no. B IV, 24, pl. 4.

708. *Gilt silver ring*, with engraved design on elongated oval bezel, continuous in direction with the ring. Bezel 8 × 16 mm.

In the Ashmolean Museum (Fortnum 52). Acquired through the Fortnum bequest.

The decoration is divided into three superimposed registers:

From top to bottom (1) A WINGED FIGURE, seated on the ground, holding a branch in one hand, the other placed on the ground. A second branch is at the back.
(2) A SIREN, with head turned back.
(3) A GOAT, with bent forelegs.
Beaded border.

Sixth century B.C.

709. *Gold ring*, with engraved design on elongated oval bezel.

From the necropolis of Caere (Cervetri). In the Villa Giulia Museum, inv. 40876.

As in no. 708 the bezel is divided into three superimposed registers.
Top register: WINGED SOLAR DISK, with a lunar segment below it.
Middle register: SEATED SPHINX, shown in profile, with one paw lifted, and an ornament on the head. Both forelegs are indicated, but only one hindleg.
Bottom register: FOUR-WINGED BEETLE, seen from above.
Hatched borders along the outer edge, and between the registers.

Seventh to sixth century B.C.

Becatti, *Oreficerie antiche*, no. 277, pl. LXXII.
Boardman, *Antike Kunst*, X, 1967, p. 12, no. B I, 21.

710. *Gold ring*, with engraved design on elongated oval bezel.

From the necropolis of Caere (Cerveteri). In the Villa Giulia Museum, inv. 40877.

The bezel is divided into three superimposed registers.
Top register: LION, seated, open-mouthed, shown in profile, with only the legs in the near plane indicated.
Middle register: PEGASOS, galloping, accompanied by a dog, both shown in profile. Above is a branch. The further legs of the horse are drawn alongside the near ones, but only the near legs of the dog are indicated.
Bottom register: RUNNING BOAR, shown in profile, with only the near legs indicated.
Hatched borders along the outer edge and between the three registers.

Seventh to sixth century B.C.

Becatti, *Oreficerie antiche*, no. 276, pl. LXXII.
L. Banti, *Il mondo degli Etruschi*, pl. 22, top, left, p. 291.
Boardman, *Antike Kunst*, X, 1967, p. 12, no. B I, 29.

711. *Gold ring*, with incised design on elongated bezel. 27 × 18 mm.

In the Louvre, Bj 1068. From the Campana Collection.

SPHINX AND CHIMAERA, confronted. Between them is a plant, and under the sphinx a bird. Hatched border.

Late seventh to early sixth century B.C.

De Ridder, *Bijoux antiques*, no. 1068.
Boardman, *Antike Kunst*, X, 1967, p. 14, pl. 3 (called Louvre, no. 1069).

712. *Gold ring*, with engraved design on elongated oval bezel. 25 × 12 mm.

In the Louvre, Bj 1069. From the Campana Collection.

A WINGED LION AND A CHIMAERA, confronted. Between them is a flower. Hatched border.

Seventh to sixth century B.C.

De Ridder, *Bijoux antiques*, no. 1069.

713. *Gilt silver ring*, with engraved design on elongated oval bezel. Bezel 21 × 10 mm.

In the Ashmolean Museum, 15 (Fortnum 54). Acquired through the Fortnum bequest.

CHIMAERA AND HORSE, confronted. The chimaera is standing, the horse recumbent. Between them is a tree. In the field, a cross. Hatched border.

Seventh to sixth century B.C.

L. Brown, *The Etruscan Lion*, p. 89, pl. XXXIII, d.
O. Terrosi Zanco, 'La chimera in Etruria durante i periodi orientalizzante e arcaico', *Studi etruschi*, XXXII, 1964, p. 47, no. 5.
Boardman, *Papers of the British School at Rome*, XXXIV (new series XXI), 1966, p. 5, no. 8 ('third quarter of the sixth century B.C.'); *Antike Kunst*, X, 1967, p. 14, no. B II, 38.

714. *Gilt silver ring*, with engraved design on elongated oval bezel. Bezel 13 × 7 mm.

In the Ashmolean Museum, 20 (Fortnum 51). Bought in Rome.

TWO SPHINXES, confronted, with an Orientalizing stand between them. Each sphinx is shown in profile, with head turned back. Two forelegs but only one hindleg are indicated. Hatched border.

Boardman, *Papers of the British School at Rome*, XXXIV (new series XXI), 1966, p. 4, no 7 ('second half of the sixth century B.C.').

715. *Gold ring*, with engraved design on elongated bezel. Bezel 22 × 9 mm.

From Chiusi. In the Cabinet des Médailles. From the Millingen Collection. Gift of the duc de Luynes in 1862 (no. 522).

MONSTER, swimming to the left. It is in the form of a bearded, long-haired man, with arms extended and the hindpart of a fish attached to the waist; below are two fins, and above the foreparts of a lion, of a horse, of a serpent, and a projecting spiral. Hatched border.

First half of the sixth century B.C.

One may compare the three-bodied monster from the Akropolis.

Bull. dell'Inst., 1839, p. 100, no. 4.
Micali, *Storia*, pl. 47, no. 19.
Babelon, *Le cabinet des antiques*, 1888, pl. 47, no. 19.
Furtwängler, *A.G.*, pl. VII, 6.
Lippold, *Gemmen und Kameen*, pl. 6, no. 7.
Boardman, *Antike Kunst*, X, 1967, p. 13, B II, 20.

716. *Gold ring*, with incised design on elongated oval bezel. 27 × 11 mm.

In the Louvre, 1072. From the Campana Collection.

A BEARDED MAN IN A CHARIOT DRAWN BY THREE HORSES, in profile to the right. In front of the chariot is a Siren, also in profile to the right, but with its head turned back. Between the horses' legs is a rosette, and behind the chariot a fern-like plant. The driver holds the reins in both hands, and a whip in his left; he is shown standing, leaning forward. The chariot is of the Etruscan type, with a curved, solid, high front, and solid, low sides with rounded tops; the wheel (only one is indicated) has six spokes. All twelve legs of the horses are drawn. Hatched border.

Sixth century B.C.

This type of chariot is best exemplified by the actual example found in a tomb near Monteleone, now in the Metropolitan Museum of Art (Richter, *Catalogue, Bronzes*, no. 40). It recurs on other Etruscan monuments, e.g., on archaic terracotta reliefs (Milani, *Studi e materiali*, I, 96, fig. 4, p. 101, fig. 8, p. 103, fig. 9), and on the bronze relief from the tomba d'Iside (Milani, *Mon. ined.*, 6). Closely related is the Ionic chariot, which is of the same general type, but where the sides are open, not solid. The Attic chariots are of course quite different.

De Ridder, *Bijoux antiques*, no. 1072.
Coche de la Ferté, *Les bijoux antiques*, pl. IV, 1, p. 78.
Boardman, *Antike Kunst*, X, 1967, p. 13, B II, 14, pl. 3.

717. *Gold ring*, with engraved design on elongated oval bezel. 27 × 13 mm.

In the Louvre, 1071. From the Campana Collection.

TWO MEN ARE SEATED IN A CART-LIKE CHARIOT, drawn by a sphinx and a deer, in profile to the right. In front of the chariot, and facing it, is a doe, represented grazing on a plant. Between the legs of the sphinx is another plant. The driver has a whip in one hand, and lowers the other, but no reins are indicated. The man at the back holds up a stick with a curved, bird-like top. Both wear mantles. The chariot has rounded and angular railings, and the single wheel has six spokes, placed at right angles to one another. Of the sphinx all four legs are indicated; also of the deer, though one hindleg is only tentatively drawn, not properly connected with the body. Hatched border.

De Ridder, *Bijoux antiques*, no. 1071.
Boardman, *Antike Kunst*, X, 1967, p. 13, B II, 11, pl. 2.

718. *Gold ring*, with engraved design on elongated oval bezel. 22 × 10 mm.

In the Louvre, Bj 1070. From the Campana Collection.

TWO FIGURES IN A CART-LIKE CHARIOT, drawn by a sphinx and a deer, in profile to the right. In front of the chariot is a winged figure in rapid flight. The charioteer wears a short tunic and a high, pointed headdress; he holds the reins in both hands, and in the left also the whip. The second figure, at the back of the chariot (a woman?) has long, mane-like hair, and lifts one hand; the lower part of her body is concealed by the chariot. The winged figure in front also wears a short tunic and a high, pointed headdress. Two hatched borders, forming a fish-bone pattern.

Layard, *Mithra* (1847), pl. 69, 25.
Furtwängler, *A.G.*, pl. VII, 5.
De Ridder, *Bijoux antiques*, no. 1070.
R. Siviero, *Gli ori e le ambri*, Napoli (1954), pl. 16.
Boardman, *Antike Kunst*, X, 1967, p. 13, B II, 10, pl. 2.

719. *Gold ring*, with design in relief on elongated oval bezel. 30 × 12 mm.

In the Louvre, Bj 1073. From the Campana Collection.

APOLLO, IN A CHARIOT DRAWN BY TWO WINGED HORSES, IS SHOOTING AN ARROW AT TITYOS, who, preceded by his mother Ge, is fleeing to the left. Two arrows have already struck him, one of which he is trying to extract, turning round to do so. Between the legs of the horses is a running dog. Both Apollo and Tityos are nude and have long hair. Ge wears a pointed headdress and a chiton with decorated borders. The body of the chariot has a high, solid curved front, and curved, open sides, like archaic Greek chariots; both of its sides are indicated, but only one eight-spoked wheel. Beaded border.

The way the body of Tityos is shown, with head and legs in profile, and the trunk strictly in full back view, suggests a date perhaps round 540 B.C.

Cf. the near-replica in the Cabinet des Médailles, from the Durand Collection, Furtwängler, *A.G.*, III, p. 84, fig. 58. A closely similar representation occurs on a Pontic vase in the Cabinet des Médailles, cf. Ducati, *Pontische Vasen*, pp. 17 f., pl. 19; *C.V.A.*, Bibliothèque Nationale, fasc. 1, pl. 28, no. 5, pl. 31.

Braun, *Ann. dell'Inst.*, XIV, 1842, pl. U, p. 224.
Furtwängler, *A.G.*, vol. III, pp. 84 f., fig. 57.
De Ridder, *Bijoux antiques*, no. 1073.
Giglioli, *L'arte etrusca*, pl. 218, 8; *Studi etruschi*, XXVI, 1958, 4, fig. 1.
Coche de la Ferté, *Les bijoux antiques*, p. 78.
Becatti, *Orificerie antiche*, no. 280, pl. LXXII.
Boardman, *Antike Kunst*, X, 1967, p. 15, B IV, 2, pl. 4.

720. *Gold ring*, with engraved design on elongated, oval bezel. 39 × 21 mm.

In the Louvre, Bj 1074. From the Campana Collection.

DRAPED MALE FIGURE DRIVING A CHARIOT DRAWN BY A LION AND A BOAR, in profile to the right. In front of the chariot are two nude male figures, one wearing a pointed headdress, and running at full speed to the right, with arms raised; the other standing, facing the chariot, holding a branch in one hand; in front of them is a branch. The charioteer holds all four reins and a whip in his left hand, while the right is lowered to the front of the chariot. The latter is cursorily drawn, with no sides indicated, and with part of a four-spoked wheel showing at the back in an unnatural place. All eight legs of the animals are shown. Fish-bone border.

De Ridder, *Bijoux antiques*, no. 1074.
Boardman, *Antike Kunst*, X, 1967, p. 13, B II, 7, pl. 2.

721. *Gold ring*, with engraved design on elongated bezel. Bezel 23 × 10 mm.

Provenance not known. Acquired in Genoa. In the National Museum, Naples, inv. 25089.

TWO-HORSE CHARIOT, in profile to the right. The charioteer, bearded, a mantle on his shoulders, holds the reins in both hands, and in addition a whip. In front of the horses is a swan. Hatched border.

Early sixth century B.C.

Layard, *Mithra*, pl. 69, 25.
Furtwängler, *A.G.*, pl. VII, 5.
Breglia, *Catalogo delle oreficerie*, p. 27, no. 27, pl. VI, 2.
Siviero, *Gli ori e le ambri*, pl. 12.
Boardman, *Antike Kunst*, X, 1967, p. 13, B II, 15.

2. THE LATER ARCHAIC PERIOD, ABOUT 525–460 B.C.

Soon after the middle of the sixth century the gold rings with elongated, decorated bezels disappear from the Etruscan tombs and their place is taken by engraved stones. The earliest of these are so purely Greek in style that they were probably importations from Greece, where as we saw the engraving of sealstones had had a continuous history from geometric times to archaic.

It is evident, however, that by the later sixth century the Etruscans had themselves mastered the craft of engraving hard stones and were engaged in a flourishing output of high quality. In fact, the Etruscan engraved gems of this period are among the finest works of art produced in Etruria. Moreover, historically they are of great interest, for they illuminate, better perhaps than any of the other Etruscan products, the relationship between Etruria and Greece. They bear out, in fact, what we also learn from ancient authors concerning the ties that bound Etruria to Greece: One hears that Greek artists settled in Etruria (cf. Pliny, *N.H.*, xxxv, 152 and 154); that the Etruscan cities of Caere (Agylla) and Spina had Treasuries in Delphi; and that when calamities visited them after a crime they had committed they went to Delphi, 'desiring to heal their offence', and then strictly obeyed the injunctions of the Pythian priestess (cf. Herod., I, 167).

It seems likely, therefore, that the original impetus for the engraving of sealstones came from Greece – perhaps through immigrants from Asia Minor and the Islands where Persian aggression just at this time had stimulated a search for new homes – but that soon the Etruscans attempted to engrave sealstones themselves, for gradually the engravings assume an individual character – a certain dryness of execution combined with great attention to detail. And from then on they become more and more independent of their Greek prototypes.

The subjects on the Etruscan stones of this period are taken almost exclusively from Greek mythology. It is indeed surprising how seldom native Etruscan legends and customs are depicted. Representations of Greek heroes enjoyed special popularity. Sometimes, in fact, a Greek type seems to have survived only on these Etruscan engravings. They may, therefore, be said to furnish an enlargement of extant Greek art.

The shape used by the Etruscans for their engraved gems was, throughout, the scarab – as was natural, for it was the current form also in Greece. And once adopted, it persisted as practically the exclusive form. The scaraboid, so popular in fifth-century Greece, appears only exceptionally – as a sort of simplified scarab.[1] It is also noteworthy that in Etruria the scarabs served not only as seals but as ornaments; for they have been found inserted in earrings and as parts of necklaces. Accordingly, in the better, earlier examples the beetle is executed with minute care, ornaments being sometimes added to the back and regularly a vertical border to the base (cf. figs. a, b). This, incidentally, constitutes a useful concrete distinguishing mark between the Etruscan and the Greek scarabs, for in the latter a vertical border (i.e., a marginal ornament) appears only exceptionally, and the beetle is left comparatively plain.

(a) (b)

[1] The carnelian 'ringstone', engraved on both sides, in the Museum of Fine Arts, Boston, 27.663 (E. Richardson, *The Etruscans*, pp. 123 f., pl. xxxiii), if genuine, would be an unicum.

As in the Greek examples, so in the Etruscan, other figures were sometimes substituted for the beetle – a lion, for instance, or a human figure, or the head of a silenos.

The commonest material chosen for the Etruscan stones is the carnelian, which must have been imported in quantity from the East. Its deep brownish-red colour evidently appealed, for it remained popular for several centuries. In addition, there occasionally appear various kinds of agate and, more rarely, gray chalcedony, plasma, and glass.

As we have said, the subjects are practically all derived from Greek mythology, especially from the Homeric and Theban legends. The heroes Perseus, Peleus, Achilles, Odysseus, Ajax, Kapaneus, Polyeidos, Kephalos, Jason, Philoktetes, Meleager, Aeneas, Tydeus, and especially Herakles, occur again and again. By comparison, deities are not frequent; nor are scenes from daily life; and when a figure is represented engaged in a simple activity, such as an athlete practising, it is often transported into the realm of legends by having the name of a hero inscribed. An occasional exception is formed by artisans at work, of which several interesting examples are preserved (cf. nos. 771–773). Animals, which play so prominent a part in the Greek repertoire, rarely occur as single representations, at least in the earlier periods. Monsters are at first rare, but in the later periods sphinxes, centaurs, etc., are not uncommon (cf. p. 181).

The figures are either represented singly, generally in bent or crouching positions, occupying the whole available field, or several, mostly upright, figures are combined in a group. The renderings of the anatomy of the human body and of the folds of drapery closely follow those current in Greece. For instance, in the earliest stones there are still observable three vertical divisions in the rectus abdominis above the navel; but in the stones datable toward the end of the sixth century and in the first decades of the fifth only two such divisions are marked, combined with a rounded arch to indicate the lower boundary of the thorax. That is, the forms correspond to those evolved by the Greek artists of the late archaic period. There is here, however, again a useful concrete distinction between Greek and Etruscan renderings. In the Etruscan the transitions between the muscles are generally accentuated and made more abrupt than in the Greek. Thus the rectus abdominis is shown very prominently and is surrounded by a bulging border, whereas in the Greek these transitions are made to appear more gradual. The postures are mostly the same as in the Greek representations; e.g., one leg is regularly shown in profile, the other in front view.

The renderings of the folds of drapery likewise follow those observable in contemporary Greek representations; that is, they are carved in parallel, wavy lines. But mostly the scheme is simplified, dots sometimes taking the place of lines. The stacked folds current in Greece during the first half of the fifth century are rarely attempted.

The rendering of hair is also simplified in comparison with the Greek. Instead of being shown rolled up behind, with one or two rows of ringlets above the forehead and at the nape of the neck, as was customary in late archaic Greek art, the Etruscans often contented themselves by indicating the hair by straight lines, short or long.

A border regularly surrounds the engraved design. It consists either of hatching (oblique lines), or dots, or, on specially fine stones, of a guilloche pattern. A ground line is often used, sometimes with a decorated exergue below it – a decorative feature not so frequently observable on the Greek scarabs.

Inscriptions, in Etruscan, are not uncommon. They do not, however, give the name of the owner of the stone, or of the artist who engraved it, but refer to the figure represented, as so often in contemporary Greek vase-paintings. Thereby one can recognize many a Greek hero who might otherwise not be

identifiable. But it is also noteworthy that – as we have said – often obviously simple human beings, such as warriors or athletes, are provided with the name of a famous Greek hero; so dear seem to have been the Greek legends to the Etruscans.

The rings in which the archaic Etruscan scarabs were set resemble the Greek swivel rings, except that the ends of the wire on which the scarab revolves are often twisted round the ends of the hoop – which only occasionally occurs in the Greek.

It is interesting to observe that the Etruscan scarabs are, in part at least, contemporary with the so-called Graeco-Phoenician, which, as we saw (cf. p. 32), were prevalent in the Carthaginian outpost of Sardinia. Though geographically the Etruscans and Carthaginians both belonged to the Western Mediterranean, their products evince two quite different mentalities. The scarabs found so plentifully in Sardinia, derive their style and subjects chiefly from the Orient – Egypt, Syria, Phoenicia – with only occasionally some Greek admixture. The Etruscan designs, on the other hand, show only Greek influence, both in their style and almost exclusively in their subjects. This fundamental difference in the products of two neighbouring peoples has been explained by their different spheres of commerce. At all events, it is a fact that, though Sardinian scarabs of green jasper occasionally have been found in Etruscan tombs of the late archaic period, later they are absent. And practically no Etruscan scarabs have turned up in Sardinia. Nor did one class exercise an influence on the other. They are independent phenomena.

THE MIDDLE PERIOD, ABOUT 460–380 B.C.

In the developed period of the second half of the fifth and the early fourth century B.C. the connection between Etruscan and Greek scarabs tends to be less close than before. That is, though the themes and the general style are still taken from Greek models, there is now noticeable an absence of the consecutive development which characterizes the Greek representations. Instead, there is a mixture of archaic and free renderings, which incidentally makes precise dating difficult. Thus, early stances and archaic renderings of hair and drapery are often combined with a developed modelling of the body. Direct intercourse with Greece was evidently interrupted at this time. This is also suggested by the fact that, whereas Attic vases of the later archaic and early classical periods abound in Etruscan tombs, those of the freer styles are less frequent in Etruria proper, though found in other regions, such as Spina. Magna Graecia, which after its victory over the Carthaginians in 480 B.C. became more prominent and enlarged its commerce, now probably became the chief intermediary, supplanting the direct contact between Hellas and Etruria.

In the subjects used for the representations there is, however, at first little change. Throughout the fifth century Greek heroes remain the favourite theme, Herakles enjoying special popularity. Moreover, the old stances and renderings often recur. Then, in the early fourth century, the poses become freer and scenes from the life of women occasionally appear. Throughout, the material remains the beautiful carnelian.

THE LATE PERIOD OF THE FOURTH TO THIRD CENTURY B.C.

In the course of the fourth century B.C. an entirely different style and repertoire make their appearance on Etruscan scarabs. The distinguishing characteristic is an extensive use of the round drill, with little indication of detail, but with an expert sense for the general effect; and this decorative quality is generally heightened by the imparting of a brilliant polish.

As some of these stones are contemporary with the earlier Italic, it is not always possible to distinguish them with confidence. Here I have included as Etruscan those stones in which a copious use is made of the round drill. (The Italic (i.e., Roman Republican) are to appear in the second part of this work.)

As subjects for representation Herakles in various episodes is popular – again sometimes in compositions not paralleled in the extant Greek; e.g., Herakles lifted up by two female figures apparently in a strange version of his apotheosis (cf. no. 807); and Herakles floating on a raft (cf. nos. 800–803). Satyrs enjoy a great vogue, as well as such figures as the Centaur, the Siren, the Chimaera, Medusa, and Pegasos. In fact, all manner of fantastic creatures become common, their shapes lending themselves appropriately to the new style. Among the scenes from daily life horsemen and chariots frequently occur. Inscriptions are hardly used. It was no longer the content that counted, but the effect as a whole.

The scarab continues as the prevalent form, but it is simplified, that is, it is generally left plain, without the decorations that added so much to its attraction, and without the marginal ornament (cf. figs. a–d).

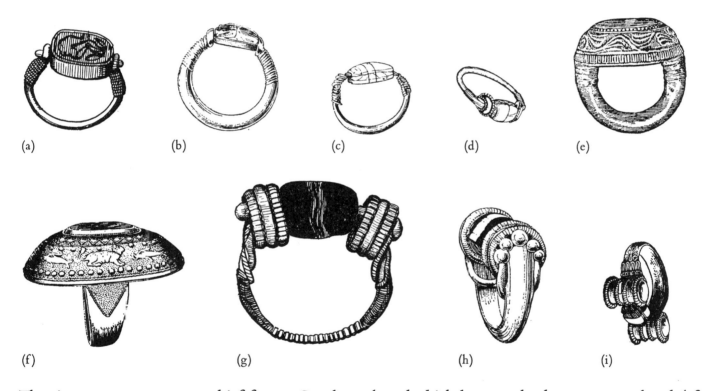

(a) (b) (c) (d) (e)

(f) (g) (h) (i)

The rings now assume two chief forms. One has a broad, thick hoop and a large, convex bezel (cf. figs. e, f); the other is of the swivel type with a hoop ending in rings, shields, or cylindrical ornaments (cf. figs. g–i).

These scarabs, which, on account of the prominent use of the round drill, are often referred to by their

Italian name of *globolo*, are not confined to Etruria. They have been found not only in Tarquinia, Vulci, and Chiusi, that is, in Etruria proper, but all over Central and Southern Italy, and even sometimes in South Russia (cf. Furtwängler, *A.G.*, vol. III, p. 193). It is indeed not certain that the style originated in Etruria. The scarabs were probably made throughout Italy at a time when Rome was gradually becoming mistress of the whole peninsula. A scarab of this class has in fact a Latin inscription. Etruria was being merged into the Latin dominions.

The following presentation of Etruscan scarabs – comprising the late archaic, the middle, and the late periods, and ranging in date from the late sixth to the third centuries B.C. – brings before us many masterpieces of the craft, both in design and execution. This particularly applies to those belonging to the archaic period and the early classical. After that the work considerably deteriorates.

The material is again divided into various categories:

(1) First comes a series of male figures in various attitudes showing the development of anatomical forms, which, it will be seen, closely parallels that in Greek art.

(2) The rest of the material is classified according to subjects, which, as is well known, are of special interest and importance, viz.:

(*a*) Deities.

(*b*) Daemons, monsters, and animals.

(*c*) Centaurs and Satyrs.

(*d*) Daily life scenes.

(*e*) Scenes illustrating the Etruscan interest in augury, oracles, and the bringing the soul to or from the nether regions.

(*f*) Greek legends.

(*g*) In conclusion a few representations in the so-called globolo style are assembled.

Only the first group – which shows the development of anatomical forms – is arranged in approximately chronological order. In the others – arranged according to subjects – I have, however, tried to give the general date in the individual entries, i.e., archaic, or middle Etruscan (second half of the fifth century), or late Etruscan (fourth to third century B.C.).

(1) *Male figures showing the development in the rendering of anatomical forms*

At first the stance is stiff and the body is shown frontal, with the head and limbs mostly in profile. When stooping figures are represented the trunk is merely placed obliquely, without any attempt to show the muscles in torsion. Gradually the interrelation of the different parts of the body is better understood. Finally the pose becomes easy and natural.

722. *Banded agate scarab.* 14 × 11 mm.

In the British Museum, 68.5–20.28. From the Pulsky Collection.

HERAKLES (?). A nude youth, standing on his left foot, is lifting the right to unfasten the thongs of his sandal; the left foot has no sandal. He is balancing himself on the club he holds in his left hand. The chest is frontal, the lower part of the trunk slightly foreshortened, the rest in profile. Hatched border and marginal ornament.

About 500 B.C.

Furtwängler put this stone in his Greek section and interpreted the figure as Herakles. Walters called it Etruscan, since 'the scarab is of the Etruscan type'. The marginal ornament and the prominent ridges used in the anatomical renderings should point to Etruscan rather than Greek execution. Though seemingly an everyday scene, the presence of the club may make the young man into a Herakles.

Furtwängler, *A.G.*, pl. VIII, 54, and vol. III, pp. 95, 99.
Perrot and Chipiez, *Histoire de l'art*, IX, p. 41, fig. 49.
Walters, *Cat.*, no. 648, pl. XI.

723. *Carnelian scarab.* Fractured at the bottom. 14 × 10 mm.

Found in Etruria. In the Cabinet des Médailles. Acquired through the gift of Pauvert de La Chapelle in 1899.

ERYX, mythical king of Sicily, represented as an athlete. He is bending forward, holding a diskos in one hand, ready to hurl it, and the other arm lowered with fingers separated. His trunk and left leg are shown frontal, the rest in profile. In the field his strigil and his aryballos are suspended from a hook; his jumping weights are lying on the ground. At the back is the Etruscan inscription *Eryx*. Hatched border and marginal ornament.

Early fifth century B.C.

The inscription was interpreted by Babelon as referring to Eryx, son of Butas, or of Poseidon and Aphrodite. According to Servius (*ad Aen.*, I, 570; V, 412) he was extraordinarily strong and invited strangers to a boxing contest and then killed those whom he had defeated. He was killed in his turn by Herakles, and his name was given to the mountain in Western Sicily where he was buried (cf. Diodoros of Sicily, IV, 83, 1). This would then be another instance of a simple, everyday scene being converted into a mythological one by the addition of a heroic name on the part of the Etruscan artist.

Instructive is a comparison with the athlete in the similar Greek representation on a stone from Cyprus, Furtwängler, *A.G.*, pl. IX, 6, in the British Museum, my no. 93.

E. Babelon, *Cat. Coll. Pauvert de La Chapelle*, no. 87, pl. VI.
Furtwängler, *A.G.*, vol. III, p. 449, fig. 232.

724. *Carnelian*, probably cut from a scarab, though there is no trace of the perforation. 11 × 14 mm.

In the Staatliche Museen, Berlin.

TYDEUS. A nude youth, stooping to the left, is scraping his right leg with a strigil. The head is in profile, the chest frontal, the lower part of the trunk in slight three-quarter view, arms and legs in profile to right and left, except the right leg, which is frontal, with the foot in profile. In the field is the Etruscan inscription *Tute*, Tydeus (cf. no. 725). Ground line and hatched border. Marginal ornament.

Early fifth century B.C.

The execution is of great finish, with the anatomical details carefully marked, but the stance is unnatural, the figure being made up of parts seen from different points of sight. Especially remarkable is the combination of the left leg in profile to the right with the trunk shown stooping to the left.

Here again the name of a Greek hero was given to a simple athlete. The artist evidently copied some Greek original, and then interpreted it to his liking.

Winckelmann, *Mon. ined.*, no. 106, p. 141.
Raspe, no. 9099, pl. 51.
Müller-Wieseler, *Denk. ant. Kunst*, I, pl. 53, 520.
Köhler, *Ges. Schr.*, V, p. 140.
Fabretti, *C.I.It.*, no. 2545.
Furtwängler, *Beschreibung*, no. 195.

725. *Carnelian scarab.* Fractured along the edge with large pieces missing at top and sides. 15 × 11 mm.

In the Cabinet des Médailles. From the Abati Collection.

TYDEUS, nude, is scraping his right leg with a strigil. His trunk is shown in slight three-quarter view, the right leg is frontal, the rest in profile to the right and left. In the field is the Etruscan inscription *Tute*, Tydeus (cf. no. 724). Ground line. Dotted border and marginal ornament.

Early fifth century B.C. Cf. no. 724.

E. Babelon, *Cat., Coll. Pauvert de la Chapelle*, no. 82, pl. VI.

726. *Sard scarab*, set in a gold ring. Broken across. 9 × 12 mm.

From Vulci. In the Museum of Fine Arts, Boston, 21.1201. Formerly in the possession of Campanari; then in the collection of A. J. Evans.

ATHLETE, nude, in a half-kneeling position, is pouring sand on his thigh from the heap on which he is kneeling. His head, arms, and right leg are in profile, the chest is frontal, the rest of his body is slightly foreshortened, the left leg more or less frontal. Border of dots. Marginal ornament.

About 500–475 B.C.

Burlington Fine Arts Club Exh., 1904, p. 230, no. O, 4 (not ill.).
Beazley, *Lewes House Gems*, no. 40, pls. 3, 9.

727. *Sard scarab.* L. 14 mm.

In the Royal Cabinet of Coins and Gems, The Hague. From the collection of the Comte de Thoms, to whom it was presented by Caylus.

ACHILLES, stooping to the left, putting on his greave. On his left arm is his shield; his sword is hanging by a baldric in the field. The chest and left leg are shown frontal, the lower part of the trunk is slightly foreshortened, the rest more or less in profile. At the back is the Etruscan inscription *Achile*, Achilles. Ground line and hatched border.

First quarter of the fifth century B.C.

Caylus, I, pl. XXX.
Furtwängler, *A.G.*, pl. XVI, 61.
Guépin, *Hermeneus*, 1964, p. 283, fig. 2.

728. *Carnelian scarab.* 14 × 12 mm.

In the Ashmolean Museum, 1953.133.

HERMES, walking to the right, holding the kerykeion in his right hand, a wreath in the left. A mantle is draped over both arms. The chest is in front view, the abdomen in three-quarter, the rest in profile. In the field is an astragalos. Double ground line. Hatched border. No marginal ornament.

About 480 B.C.

Quite Greek in style.

729. *Carnelian scarab*, cut; perforation visible at the back. 11 × 15 mm.

In the Staatliche Museen, Berlin.

KADMOS (?), at the fountain. A nude youth, holding a sword in his right hand and with a shield strapped to his left arm, is stooping to the right, and looking downward. At the right seems to be a rough indication of running water, and between the youth's legs is a jug. The youth is in profile to the right, with the trunk in three-quarter view, the right leg frontal; his long hair is tied at the nape of the neck. Hatched border.

Middle of the fifth century B.C. or a little later.

As Furtwängler suggested, the youth is probably intended for Kadmos looking for water.

Furtwängler, *Beschreibung*, no. 205.

730. *Carnelian scarab.* 15 × 11 mm.

In the British Museum, Blacas 47. From the Blacas Collection.

YOUTH, bending down, looking at the hare sitting on his left arm; in his right hand he holds a shepherd's crook (pedum). His chest is shown frontal, the lower part of the trunk is foreshortened, head and limbs are in profile. Beneath is a plant to indicate the out-of-doors. Hatched border and marginal ornament.

Near the middle of the fifth century B.C.

Furtwängler, *A.G.*, pl. XVII, 5.
Walters, *Cat.*, no. 695, pl. XII.

731. *Carnelian scarab. c.* 15 × 12 mm.

In the Museum für Kunst und Gewerbe, Hamburg. From the collection of Dr. J. Jantzen, Bremen.

YOUTH FILLING A POINTED AMPHORA with the water flowing from a lion's head spout; in his right hand he holds a spear. His trunk and right leg are frontal, the rest in profile. Hatched border. No marginal ornament.

Second half of the fifth century B.C.

The composition occurs for Herakles on both Greek and Etruscan stones, cf., e.g., Furtwängler, *A.G.*, pl. VIII, 39, pl. XVII, 45; Walters, *Br. Mus. Cat.*, no. 665, and my nos. 796–798, but then with the club, instead of the spear. Since Herakles was revered as the finder and bringer of water (cf. Furtwängler, in Roscher's *Lexikon*, s.v. Herakles, cols. 2237 f.), it is possible that on this gem, though the youth has none of Herakles' attributes, and there is no name inscribed, Herakles was nevertheless intended. On the other hand, the Etruscan gem engravers used similar compositions for different people, identified by different names (cf. my p. 180); so that one cannot be sure.

Zazoff, *Arch. Anz.*, 1963, cols. 68 f., no. 15, fig. 4.

732. *Carnelian scarab*, flat and thin. 14 × 10 mm.

In the British Museum, 72.6–4.1331. Acquired from the Castellani Collection in 1872.

WARRIOR, wearing a helmet and a chlamys, and holding a sword, a spear, and a shield. Hatched border and marginal ornament. On the wings of the beetle is engraved a human head.

Second half of the fifth century B.C.

Walters, *Cat.*, no. 684, pl. XII.

733. *Banded agate scarab.* 13 × 8 mm.

In the British Museum, Blacas 106. From the Blacas Collection.

HERMES, standing in a frontal position, looking to the right, and holding his kerykeion in one hand; his petasos is hanging down his back. Hatched border and marginal ornament.

Later fifth century B.C.

Furtwängler, A.G., pl. XVIII, 20.
Walters, Cat., no. 654, pl. XI.

734. *Carnelian scarab*, mounted in a modern gold ring. 17 × 12 mm.

In the Cabinet des Médailles. Gift of the duc de Luynes in 1862 (no. 262).

KEPHALOS (?). A nude, bearded man is holding out a morsel to a dog, which is sitting on its hindlegs, with forelegs extended, in an expectant attitude. In his other hand the man has a pedum (shepherd's crook). He is in a mostly frontal position, with the head in slight three-quarter view. Hatched border. Marginal ornament.

Second half of the fifth century B.C.

The pedum suggests a herdsman, and so Kephalos with his dog Lailaps may be intended – as suggested in the *Guide*.

Pierres gravées, Guide du visiteur (1930), p. 139, no. 262 (not ill.).

735. *Carnelian scarab*. Fractured at top. Originally *c.* 16 × 12 mm.

In the Cabinet des Médailles, 1665 bis.

SATYR, pouring out wine from an amphora, which he holds in both hands. He is standing, with his weight on the right leg, the left flexed, in profile to the left; the trunk and left foot are shown in three-quarter view, the rest more or less in profile. Hatched border. Marginal ornament.

Fifth to fourth century B.C.

736. *Carnelian scarab*. 19 × 15 mm.

In the British Museum, H343. From the Hamilton Collection.

ATHLETE, leaning forward and holding out some object in his right hand, to which a dog is leaping up. In his left hand he holds two spears; in the field at the back is a strigil. The upper part of his body is shown in three-quarter view, the rest in profile. Hatched border and marginal ornament.

Second half of the fifth century B.C.

For the subject cf. nos. 107, 108, 224.

Raspe, no. 8845.
Walters, Cat., no. 691, pl. XII.

737. *Sard scarab*, burnt. 18 × 14 mm.

In the British Museum, H369. From the Blacas Collection.

EROS standing in a quasi-frontal position, pouring a libation from a phiale on a circular altar. He is nude and wears a wreath. At the back is a branch. There is an interesting attempt in one of the wings to show it in three-quarter view. Hatched border and marginal ornament.

Fourth century B.C.

Raspe, no. 8181.
Furtwängler, A.G., pl. XVIII, 39.
Walters, Cat., no. 709, pl. XII.

(2) *Subjects*

(*a*) DEITIES

Deities on Etruscan scarabs are not very common. A few are shown in nos. 738 ff. On one appears a seated Zeus in the traditional pose, holding thunderbolt and sceptre, an eagle by his side (no. 738). Athena is depicted in the early striding stance (nos. 739, 740), or she is seen marching off with the arm she has wrenched off the giant Enkelados (no. 742) – evidently an excerpt of the battle of the gods and giants. There are two representations of Hermes (nos. 745, 746), one (no. 745) a direct copy of a Greek original (cf. no. 122). For representations of him in his capacity of Psychopompos cf. nos. 783, 784.

Included here is also a 'minor' deity, i.e., a nameless winged figure (no. 744).

738. *Sard scarab.* 17 × 12·5 mm.

In the Ashmolean Museum, 1892.1495. Acquired through the Chester bequest.

ZEUS, seated on a throne, holding a thunderbolt in his right hand, a sceptre in his left; an eagle is at his feet. He is shown partly in frontal, partly in profile view, with the head in profile to the left. A mantle envelops the lower part of his body. The throne has turned legs. Hatched border and marginal ornament.

Late fifth century B.C.

739. *Banded agate scarab.* 9 × 12 mm.

In the Hermitage. Once in the possession of S. Vettori.

ATHENA, walking to the right. She wears a crested helmet, a chiton, an aegis hanging down her back, with weights at the bottom and snakes emerging from the

sides, as well as a necklace; and she carries a spear and a shield. Beaded border and cross-hatched exergue.

Last quarter of the sixth century B.C.

Millin, *Pierres gravées inéd.*, pl. 13 (= S. Reinach, *Pierres gravées*, pl. 120).
Köhler, *Gesammelte Schriften*, IV, 1, pl. I, 2.
Müller-Wieseler, *Denkmäler alt. Kunst*, II (1860, 1861), no. 216a.
Furtwängler, *A.G.*, pl. XVI, 11.

740. *Carnelian scarab.* Chipped at top. 12 × 9 mm.

In the British Museum, H363. From the Hamilton Collection.

ATHENA, advancing to the right. She wears a long chiton, from which snakes emerge on either side, and a crested, Attic helmet. In one hand she carries a spear, in the other a shield. Hatched border and marginal ornament.

Early fifth century B.C.

Raspe, no. 1735.
Koehler, *Gesammelte Schriften*, V, p. 147.
Walters, *Cat.*, no. 653, pl. XI.

741. *Agate scarab,* mounted in modern ring. 15 × 11 mm.

In the Thorvaldsen Museum, Copenhagen.

ATHENA, walking to the left, with head turned back. She wears a chiton, an aegis, decorated with zigzags, on her shoulders, and a helmet. In one hand she holds a spear, the other is raised. Beside her is the serpent. Decorated exergue, hatched border, and marginal ornament.

Early fifth century B.C.

Cades, I, H 37.
Bull. dell'Inst., 1831, p. 105, no. 1.
King, *Handbook of Engraved Gems*, pl. 45, 2.
Furtwängler, *A.G.*, pl. XVI, 8.
Fossing, *Cat.*, no. 38, pl. I.

742. *Carnelian scarab,* mounted in a modern ring. 16 × 12 mm.

In the Cabinet des Médailles. Gift of the duc de Luynes in 1862 (no. 252).

ATHENA IN COMBAT WITH THE GIANT ENKELADOS. She has wrenched off one of his arms and is running away with head turned. He is falling backward, his shield still strapped to his arm, his spear in the background. He is nude; she wears a chiton with overfold and what looks like a sakkos, instead of a helmet; on her left arm she has a large round shield. Both trunks are shown frontal, heads and limbs in profile, except the giant's right leg which is frontal. Hatched border and marginal ornament.

Late archaic.

Pierres gravées, Guide du visiteur (1930), p. 139, no. 252 (not ill.).

743. *Carnelian scarab.* 20 × 14 mm.

In the British Museum, 65.7–12.95. Acquired from the Castellani Collection in 1865.

HEAD OF ATHENA, in profile to the left, wearing a crested, Attic helmet with upturned cheekpiece. Hatched border and marginal ornament.

Fifth century B.C.

Walters, *Cat.*, no. 705, pl. XII.

744. *Carnelian,* cut, probably from a scarab. Mounted in a modern ring. 13 × 9 mm.

In the Antikensammlung, Kunsthistorisches Museum, Vienna, inv. IX B 225.

WINGED FEMALE FIGURE, SPRINKLING INCENSE. She is shown stooping in front of a thymaterion, in the act of taking the incense from a small box on her right hand; a casket is suspended by its handle from her right forearm. She wears a long, ungirt chiton. In front is the Etruscan inscription *Elina*, Helen. Ground line.

Fifth to fourth century B.C.

Evidently some Etruscan deity.

Inghirami, *Galleria omerica*, I, 11.
Köhler, *Gesammelte Schriften*, V, 174.
Eckhel, *Choix de pierres grecques*, pl. 40 (=S. Reinach, *Pierres gravées*, pl. 4, no. 40).
Millin, *Gallerie mytholog.* (1811), pl. CLVI, 539.
Furtwängler, *A.G.*, pl. XVIII, 32.
Fabretti, *C.I.It.*, 2522.

745. *Carnelian scarab.* Chipped along edge. 12 × 16 mm.

In the Museum of Fine Arts, Boston, 98.717. Once in the Hamilton Gray Collection.

HERMES, in a half-kneeling position, moving to the right. He holds the kerykeion in his right hand, a neck-lace in his left. He wears a petasos, and has a chlamys hanging from both arms. The upper part of his body is frontal, the rest in profile. Hatched border.

The design is an Etruscan replica of that on the Greek scaraboid in Berlin (cf. my no. 122), and therefore of special interest.

Bull. dell'Inst., 1839, p. 100, no. 11.
Müller-Wieseler, *Denkmäler ant. Kunst*, II, p. 312.
Furtwängler, *A.G.*, pl. XVI, 49.
Osborne, *Engraved Gems*, pl. XII, 10, p. 333.
Lippold, *Gemmen und Kameen*, pl. 9, no. 6.

746. *Carnelian scarab*, burnt. 16 × 11 mm.

In the Ashmolean Museum, 1892.1493. Acquired through the Chester bequest.

HERMES, standing in an almost frontal pose, holding the kerykeion in his left hand, the right lowered to caress the head of a ram (of which only the front part is shown). On his other side is a tall flower. In the field is an inscription, which was read by Furtwängler *MER*, in Latin script, for Mercurios. Hatched border and marginal ornament.

Fourth century B.C.

Furtwängler, *A.G.*, pl. XX, 17.

(b) DAEMONS, MONSTERS, AND ANIMALS

The terrifying daemons and monsters that appear in Etruscan paintings are not current on the sealstones. Instead, milder varieties are occasionally represented – two winged daemons (nos. 747, 748), the chimaera (no. 751), the Greek Minotaur (no. 749), and a strange creature with horns, wings, teats, and two tails (no. 750).

As I have said, animals *per se* seldom appear on Etruscan stones – which seems strange, considering the abundance of such designs on contemporary Greek gems. I include here two interesting examples: a scarab with a design of a cock and hen (no. 752), similar to a Greek version (cf. no. 452); and a ringstone with four hounds attacking a deer, mounted in its original ring (no. 753).

747. *Carnelian scarab*, partly ground down. Fractured at perforation. 16 × 11 mm.

In the British Museum, 59.3–1.107. Acquired from the Nott and Hertz Collections, 1859.

DAEMON, in the form of a nude human figure with two large wings, holding a piece of drapery spread out behind him. He is shown frontal, except the head and the right leg, which are in profile. Hatched border and marginal ornament.

Fifth to fourth century B.C.

Bull. dell'Inst., 1831, p. 106, no. 28.
Sale Catalogue of the B. Hertz Collection, Feb. 1859, no. 692.
Furtwängler, *A.G.*, pl. XVIII, 27.
Walters, *Cat.*, no. 614, pl. XI.

748. *Carnelian scarab.* 18 × 14 mm.

In the British Museum, 65.7–12.92. Acquired from the Castellani Collection in 1865.

WINGED DAEMON, standing with left foot placed on some support, holding a spear in one hand, the other

lowered to his shield; a mantle is draped on both fore-arms. The trunk and right leg are frontal, the rest in profile, including both wings. Hatched border and marginal ornament.

Late fifth century B.C.

Gerhard, *Gesammelte Abhandlungen und kleine Schriften* (1866–1868), pl. XII, 6.
Walters, *Cat.*, no. 659, pl. XI.

749. *Carnelian scarab.* 9 × 12 mm.

In the Staatliche Museen, Berlin. From the collection of E. Gerhard.

THE MINOTAUR, with a human body and the head of a bull, walking to the left, holding a branch in one hand and a vase in the other. The trunk is ably foreshortened. Hatched border.

Second half of the fifth century B.C.

Cursory but vivid work.

Furtwängler, *Beschreibung*, no. 208.

750. *Sard scarab.* 10 × 16 mm.

In the Royal Cabinet of Coins and Gems, The Hague. From the collection of van Hoorn van Vlooswijk.

MONSTER, with pointed snout, horns, wings, teats, and two tails. It is shown from above, but the teats and the attachments of the legs are placed on the two sides of the body, so as to make them visible. Hatched border.

Fifth century B.C.

This form of monster is not otherwise known, and is evidently an Etruscan invention.

Furtwängler, *A.G.*, pl. XVII, 63.

751. *Carnelian scarab.* 13 × 9 mm.

In the Cabinet des Médailles, Paris. Acquired through the gift of Pauvert de La Chapelle in 1899. Formerly in the Martinetti Collection.

CHIMAERA. The hind-quarters are raised and the mouth is wide open – with teeth and protruding tongue show-ing. Both forelegs and both hindlegs are indicated. The goat's forepart is erect; the serpent's head at the end of the lion's tail is clearly marked. Hatched border and marginal ornament.

Late archaic period.

E. Babelon, *Cat., Coll. Pauvert de La Chapelle*, no. 46, pl. V.

752. *Obsidian scarab.* 16 × 13 mm.

From Chiusi. In the British Museum, 72.6–4.1147. Acquired from the Castellani Collection in 1872.

A COCK TREADING A HEN. He is sitting on top of her, pecking at her head. Inscribed *METNA* in Etruscan letters. Dotted border and marginal ornament. Decorated beetle.

Fifth century B.C.

Cf. the similar composition on a Greek rock crystal scaraboid in the British Museum, no. 555, my no. 452.

Imhoof-Blumer and Keller, pl. XXI, 38.
Furtwängler, *A.G.*, pl. XX, 72.
Walters, *Cat.*, no. 759, pl. XIII.
Lippold, *Gemmen und Kameen*, pl. 96, no. 4.

753. *Sard oval ringstone*, set in the convex bezel of a massive gold ring. 20 × 13 mm.

In the British Museum, 65.7–12.62. Acquired from the Castellani Collection in 1865.

STAG AND HOUNDS. The stag has fallen to the ground and is being torn to pieces by four hounds, two on either side of him. The ground is indicated by a thick, curving mass.

Perhaps third century B.C. Hellenistic in style.

A similar composition on a carnelian ringstone in Berlin (Furtwängler, *Beschreibung*, no. 7039) has a tree added in the background, doubtless to indicate the wood in which the scene takes place. And this suggests that the repre-sentations on the gems go back to a larger composition, perhaps in a painting.
For the type of ring cf. Marshall, *Cat. of Finger Rings, British Museum*, pl. X, no. 356 ('Etrusco–Italian').

Imhoof-Blumer, pl. XVII, 29.
Marshall, *Cat. of Finger Rings*, no. 360, pl. XI.
Walters, *Cat.*, no. 790, pl. XIII.

(c) CENTAURS AND SATYRS

Among the centaurs and satyrs here shown are some especially fine examples, e.g., a centaur (no. 754) which recalls those on the Parthenon metopes; a seated satyr singing to the lyre, with the legs ably fore-shortened (no. 758); another in a half-reclining posture, playing the game of kottabos (no. 757); and a

third carrying a nymph in his arms (no. 759), a close copy of a Greek original (cf. no. 159). They show that the line between Greek and Etruscan workmanship is not always easy to draw. An interesting and unusual piece – presumably Etruscan – shows a silenos kneeling in practically front view, with a goat by his side (no. 761).

754. *Carnelian scarab.* 11 × 16 mm.

In the Metropolitan Museum of Art, 42.11.27. Purchase, 1942, Joseph Pulitzer bequest. Formerly in the Capranese and Evans Collections.

CENTAUR. He has been struck by an arrow in his abdomen and has fallen to the ground, with all four legs bent under. On his left arm his shield is strapped; with his right hand he is trying to extract the arrow; his sword has fallen to the ground. His human trunk is shown in three-quarter view, the rest more or less in profile. Hatched border and marginal ornament of beads.

Around the middle of the fifth century B.C., the time of the Parthenon metopes.

Cf. also the fine Greek gem in the British Museum with a wounded Centaur, my no. 354.

Braun, *Bull. dell'Inst.*, 1839, p. 102, no. 26.
Furtwängler, *A.G.*, pl. XVII, 73, and vol. III, p. 195.
Evans, *Selection*, no. 95.
Lippold, *Gemmen und Kameen*, pl. 76, no. 5.
Richter, *Evans and Beatty Gems*, no. 41; *Cat.*, no. 167, pl. XXVIII.

755. *Carnelian scarab.* 17 × 12 mm.

In the British Museum, H341. From the Hamilton Collection.

CENTAUR, holding up stones in both his hands to throw them at some adversary. His knees are bent in the usual attitude signifying motion. He is bearded and has a human body, with a horse's body attached at the back. Over his shoulders is draped an animal's skin. Head and trunk are frontal, the rest is in profile. Hatched border and marginal ornament.

Second half of the fifth century B.C.

Furtwängler, *A.G.*, pl. XVI, 69.
Baur, *Centaurs in Ancient Art*, p. 129, no. 316.
Walters, *Cat.*, no. 661, pl. XI.

756. *Gold ring*, with design in relief on a pointed oval bezel. L. of bezel 19 mm.

In the British Museum, 72.6–4.51. Acquired from the Castellani Collection in 1872.

SATYR, reclining, with both hands clasped behind his head and the legs bent. One arm and one leg are shown above the body. Border of beads and tongues.

Fifth century B.C.

Cf. the similar ring in Berlin, Furtwängler, *Beschreibung*, no. 365 (described as kneeling).

Marshall, *Cat. of Finger Rings*, no. 217, fig. 44 (described as kneeling).

757. *Carnelian scarab.* 13·2 × 10·7 mm.

In the Museum für Kunst und Gewerbe, Hamburg. From the Collection of Dr. J. Jantzen, Bremen.

SATYR, nude, bearded, and wearing a fillet, is playing the game of kottabos. He is half-reclining and supports his head with his left hand; a finger of his right is inserted in the handle of a kylix; one leg is raised, the other bent under, with the sole of the foot showing. The upper part of his trunk is more or less frontal, with a curious indication of the abdomen laid over the left leg; the rest is shown in profile. The couch on which the satyr is lying in this complicated position is not indicated. Hatched border and marginal ornament.

Second quarter of the fifth century B.C.

Zazoff, *Arch. Anz.*, 1963, cols. 63 f., no. 13, fig. 4.

758. *Banded agate scaraboid.* Slightly fractured along the edge. 16 mm.

Said to be from Vetulonia. In the Metropolitan Museum of Art, 35.11.11. Fletcher Fund, 1935.

SATYR, singing to the lyre. He is seated on the ground and holds the plektron with his right hand, and with his left plucks the strings of the lyre; his mouth is wide open. He is nude, bearded, and his hair is done up in a roll at the back of his head. His trunk and right leg are frontal, the head and left leg in profile. Hatched ground line and hatched border. Marginal ornament of beads and tongues.

About 480 B.C.

Cf. the vivacious satyrs by the Brygos Painter, with which the stone is about contemporary; also the somewhat later satyrs on the coins of Naxos, Regling, *Münze*, no. 395.

The scaraboid form suggests Greek execution, but the marginal ornament points to Etruria. Etruscan scaraboids, though rare, are not unknown, cf. two examples in a private collection in Rome, one of which has an Etruscan inscription.

Richter, *M.M.A. Bull.*, XXX, 1935, p. 256; *Annuario*, XXIV–XXVI, 1950, pp. 82 f., fig. 5; *Cat.*, no. 165, pl. XXVIII.
E. Paribeni, *Studi etruschi*, 1937, p. 533.
Beazley, in Caskey and Beazley, *Attic Vase-Paintings in the Museum of Fine Arts, Boston*, II, p. 26.

759. *Banded agate scarab.* 16 × 12 mm.

In the British Museum, 88.10–18.2. Bought 1888.

SILENOS, carrying a nymph in his arms. He has long hair, a horse's tail, and horse's hoofs. She wears a long chiton and a mantle over her shoulders. Cross-hatched exergue and hatched border. No marginal ornament.

First half of the fifth century B.C.

Cf. the Greek version no. 159.

Walters, *Cat.*, no. 612, pl. XI.

760. *Carnelian scarab.* 10 × 13 mm.

In the Cabinet des Médailles, N4371.

SATYR, stooping to the left and holding a wineskin in one hand. He is bearded and has a mantle hanging down his back. In the field are a dolphin and a turtle (?). Hatched border and marginal ornament.

Second half of the fifth century B.C.

761. *Sard ringstone.* Chipped at bottom and pared down at sides. 7 × 18 mm.

Said to be from Salonica (Froehner). In the Museum of Fine Arts, Boston, 27.726. From the Tyszkiewicz Collection.

SILENOS, kneeling in an almost frontal position, with his right arm raised, his left round the neck of a goat. He is bearded and wears an ivy wreath. The goat's head and forelegs are shown frontal; most of its body disappears behind that of the silenos, but their two tails are indicated one above the other. It is a bold attempt at a complicated composition.

Fifth to fourth century B.C.

Froehner, *Collection Tyszkiewicz*, pl. XXIV, 15; *Sale Catalogue of the Tyszkiewicz Collection*, 6th–7th June, 1898, pl. XXVII, 291.
Furtwängler, *A.G.*, pl. XX, 70.
Beazley, *Lewes House Gems*, no. 92, pl. 3.

(d) SCENES FROM DAILY LIFE

At a time when the Etruscans imported many Attic vases with scenes taken from daily life, these subjects could not be totally neglected by the Etruscan gem-engravers. One occasionally, therefore, encounters representations of riders, warriors, and chariots, apparently observed from life. Often, however, such an apparently simple daily life scene is converted into a mythological one by the addition of some hero's name (cf., e.g., no. 780). So, even when there is no inscription one cannot always be certain that a representation from actual life was intended.

Of special interest are several scenes showing artisans at work, which were evidently inspired by local activities (nos. 771–773).

762. *Carnelian scarab.* 16 × 13 mm.

In the Ashmolean Museum, EFG27. Acquired through the Fortnum bequest. Bought in Rome.

WOUNDED HORSEMAN. An arrow has struck him in the back, and he has turned round, trying to extract it with his right hand; to his left arm is strapped a large shield, shown foreshortened. He is bearded, nude, and has long hair. His trunk is frontal, the rest more or less in profile. Ground line. Hatched border. Marginal ornament.

Second half of the fifth century B.C.

Furtwängler, *A.G.*, pl. XVIII, 65.
Lippold, *Gemmen und Kameen*, pl. 53, no. 4.

763. *Carnelian scarab.* 18 × 12 mm.

In the Staatliche Museen, Berlin. Acquired in Perugia in 1844.

HORSEMAN, holding the reins in one hand, his shield and

sword in the other, is galloping to the right, with the body bent backward as if struck by an arrow. Hatched border.

Spirited, cursory work of the fourth century B.C., with much use of the rounded drill.

The various parts of the body are placed in impossible relation to one another, and yet the action is successfully conveyed.

Furtwängler, *Beschreibung*, no. 214.

764. *Carnelian scarab.* 18 × 13 mm.

In the British Museum, 1921.7-11.6. Bought 1921. Formerly in the Story-Maskelyne and Arnold-Forster Collections.

HORSEMAN, riding over an enemy. The latter is lying on the ground, with his legs raised, using his shield as a cover. The rider is nude and holds a banner in one hand and in the other apparently a spear, not the reins. Hatched border and marginal ornament.

Fifth to fourth century B.C.

Furtwängler, *A.G.*, pl. XX, 36.
Sotheby's Sale Catalogue of the Story-Maskelyne Collection, 4th July, 1921, no. 61.
Walters, *Cat.*, no. 815, pl. XIII.

765. *Carnelian scarab.* 15 × 10 mm.

In the British Museum, 72.6-4.1145. Acquired from the Castellani Collection in 1872.

THREE FIGURES, one on horseback. In the foreground lies a man, evidently wounded or knocked down. Another man is approaching from the left, perhaps to assist him, and at the back a third man is galloping to the right – either to escape or to get help? In the field a round boss. Hatched border and marginal ornament. On the convex side of the stone, on the back of the beetle, is a satyric mask in relief.

Fourth century B.C.

Walters, *Cat.*, no. 816, fig. 44 (satyric mask); other side not ill.

766. *Agate scarab.* 18 × 13 mm.

In the British Museum, 72.6-4.1151. Acquired from the Castellani Collection in 1872. Formerly in the Fanelli Collection.

WARRIOR, stepping over a fallen enemy, who is lying on the ground beneath him, with legs raised. The warrior wears a cuirass and holds a sword and a shield; he is shown walking to the right and looking back. Hatched border and marginal ornament.

Middle period, fifth to fourth century B.C.

Furtwängler, *A.G.*, pl. XVIII, 37.
Walters, *Cat.*, no. 688, pl. XII.

767. *Banded agate scarab.* 18 × 30 mm.

In the British Museum, 72.6-4.1141. Acquired from the Castellani Collection in 1872. Formerly in the Fanelli Collection.

HORSEMAN. He is nude and holds a spear in his left hand. The horse has a row of bullae round its neck. Hatched border and marginal ornament.

Fifth to fourth century B.C.

The composition is somewhat confused.

Walters, *Cat.*, no. 683, pl. XII.

768. *Carnelian scarab*, in a gold setting and mounted on a gold ring. 10 × 13 mm.

In the British Museum, 72.6-4.33. Acquired from the Castellani Collection in 1872.

CHARIOTEER. A bearded man, with a mantle wrapped round his shoulders, is driving a two-horse chariot, holding the reins in both hands and a whip in his right. All eight legs of the horses and both their heads are indicated, but only one wheel of the chariot, and only one arm of the man. Hatched border.

Fourth century B.C.

Cf. the Greek representation of this same subject, no. 138.

Nachod, *Rennwagen bei den Italikern*, p. 54, no. 50.
Marshall, *Cat. of Finger Rings*, no. 1631, pl. XXXV.
Walters, *Cat.*, no. 647, pl. XI.

769. *Glass scarab.* 15 × 10 mm.

In the Ashmolean Museum, 1941.347. Acquired through the Evans bequest.

MAN IN A DONKEY CART, in profile to the right. He holds the reins in the right hand, the whip in the left, and wears a tunic and cap. Line border.

Fourth century B.C.

770. *Agate scarab*, mounted in a gold ring. 16 × 12 mm.

In the Cabinet des Médailles. Gift of the duc de Luynes in 1862 (no. 272).

WARRIOR WITH DOG. He wears a Corinthian helmet, cuirass with pteryges, and greaves, and has a spear and

shield in his left hand, while in his extended right he holds a kylix by its handle. On his further side is his dog, walking alongside. Both are shown in strict profile views. Along the upper edge is the mask of a bearded silenos. Hatched border. No marginal ornament.

Fifth century B.C.

E. Babelon identified the scene as Pandareos with the golden dog which he stole from the sanctuary of Zeus in Crete and then entrusted to Tantalos in Asia Minor (cf. Schol., *Odyssey*, XX, 66, XIV, 518; Schol., Pindar, *Ol.*, I, 91a). Furtwängler, on the other hand, interpreted the man as a simple warrior, and compared the silenos head on the wall with 'the face' (πρόσωπον) of the Dionysiac daemon Akratos in the house of Poulytion sacred to Dionysos (cf. Pausanias, I, 2, 5).

Babelon, *Cabinet des antiques*, pl. V, 1, p. 13.
Furtwängler, *A.G.*, pl. VI, 54.
Pierres gravées, Guide du visiteur (1930), pp. 141 f., no. 272 (not ill.).

771. *Carnelian scarab.* 16 × 12 mm.

From Cortona. In the British Museum, 72.6–4.1155. Acquired from the Castellani Collection in 1872.

CARPENTER. A youth is bending down, busily engaged in boring a hole in a piece of furniture by means of a bow drill. He holds the bow in his right hand, giving motion with it to the pointed drill in his left. Before him is the presumably wooden piece of furniture on which he is working – perhaps a buffet, cf. my *Furniture²*, figs. 421, 423). By its side is a pointed instrument. Hatched border and marginal ornament.

Late fifth century B.C.

For the bow drill cf. my p. 5.

Heydemann, *Bull. dell' Inst.*, 1869, p. 55, no. 8.
Middleton, *Engraved Gems*, p. 105, fig. 31, and *The Lewis Collection*, p. 31, fig. 4.
E. Babelon, in Daremberg and Saglio, *Dictionnaire*, V, p. 1469, fig. 3483.
Furtwängler, *A.G.*, pl. XVII, 21.
Walters, *Cat.*, no. 645, pl. XI.

772. *Carnelian scarab.* 14 × 13 mm.

From Chiusi. In the British Museum, 72.6–4.1156. Acquired from the Castellani Collection in 1872.

CARPENTER. A youth is bending down, holding an axe in his left hand and reaching down with his right to some planks (?), placed horizontally on the ground. He is nude and has short, straight hair; a chlamys is hanging from his left shoulder. Hatched border and marginal ornament.

Argos building the ship Argo? Or, perhaps rather a simple artisan at work.

Second half of the fifth century B.C.

Furtwängler, *A.G.*, pl. XVII, 20.
Lippold, *Gemmen und Kameen*, pl. LVII, 14.
Walters, *Cat.*, no. 644, pl. XI.

773. *Carnelian scarab.* 16 × 12 mm.

From Chiusi. In the British Museum, Blacas, 264. Acquired from the Blacas Collection.

A BUILDER (?), or SISYPHOS (?). A nude youth is lifting a heavy, rectangular object in front of a stepped wall. Hatched border and marginal ornament.

Late fifth century B.C.

One might think of the punishment of Sisyphos as the subject of the scene, as did Walters, but Sisyphos is not elsewhere represented as going up steps, but rather as rolling the stone up an incline. So perhaps a builder is here intended, though no tools are shown. Scenes of artisans at work are of course popular on Etruscan stones, cf. nos. 771, 772. Lippold suggested Trophonios, the mythical builder.

Micali, *Ant. Mon.*, pl. 55, fig. 1.
King, *Arch. Journal*, XXIV, 1867, p. 211; *Antique Gems and Rings*, II, pl. XLIb, fig. 10, p. 64; *Handbook*, pl. LXV, 3, p. 235.
Furtwängler, *A.G.*, pl. XVII, 33.
Walters, *Cat.*, no. 617, pl. XI.
Lippold, *Gemmen und Kameen*, pl. 49, no. 9.

774. *Carnelian scarab*, cut; mounted in a modern ring. 17 × 11 mm.

In the Thorvaldsen Museum, Copenhagen.

WOMAN WASHING HER HAIR. She stands before a louterion and presses the water from her long hair (the drops are seen falling). A mantle is draped round her legs and brought up to her right shoulder. Ground line and hatched broder.

Early fourth century B.C.

Cf. the similar representation on another Etruscan gem, Furtwängler, *A.G.*, pl. XVIII, 36, and those on Etruscan mirrors, Gerhard, *Etruskische Spiegel*, V, pl. 102, 2, pl. 148. For Greek prototypes cf., e.g., the stone in the Cabinet des Médailles, Furtwängler, *A.G.*, pl. XII, 31, my no. 300.

Cades, I, K, 18.
Furtwängler, *A.G.*, pl. XVIII, 38.
Fossing, *Cat.*, no. 55, pl. II.

775. *Carnelian scarab.* 14 × 10 mm.

In the British Museum, 65.7-12.100. Acquired from the Castellani Collection in 1865.

TWO MALE FIGURES, one seated (or about to be seated), and another standing, placing one arm on his companion's shoulder. The seated man, shown frontal, has a stick in his right hand, with which he is apparently supporting himself; and he wears a garment around his hips. The other man is nude, and is shown in three-quarter back view. Ground line. Hatched border and marginal ornament.

Middle period.

Furtwängler suggested that an ill man is being seated with the help of a companion. That would explain the action. But one tries to remember a mythological incident that would fit. Philoktetes? A new version?

Furtwängler, *A.G.*, pl. XVII, 34.
Walters, *Cat.*, no. 694, pl. XII.

776. *Gold ring*, with design in relief on bezel. Ht. of bezel *c.* 28 mm.

In the Louvre, Bj 1115. Acquired from the Campana Collection in 1862.

WOMAN AND YOUTH, seated on a diphros, kissing each other. She wears a sleeved chiton and a himation; he only a himation round the lower part of his body. All four legs of the stool are indicated. Beaded border.

Second half of the fifth century B.C.

De Ridder, *Bijoux antiques*, no. 1115.

777. *Gold ring*, with design in relief on the bezel. Ht. of bezel 26 mm.

In the Louvre, Bj 1114.

WOMAN AND YOUTH standing opposite each other, evidently in earnest conversation. Both wear mantles. At the back appears part of a stool or couch. Beaded border.

Second half of the fifth century B.C.

De Ridder, *Bijoux antiques*, no. 1114.

778. *Gold ring*, with design in relief on bezel. Ht. of bezel *c.* 28 mm.

In the Ashmolean Museum, Oxford, Fortnum 84. Acquired through the Fortnum bequest.

WARRIOR WITH HORSE. He is bending forward, with knees bent, holding the horse by the bridle; the horse, to judge by the position of its legs, is galloping to the right, while the youth is trying to pull it back. He wears a helmet, a cuirass over a chiton, and apparently greaves. Dotted ground and dotted border.

Second half of the fifth century B.C.

779. *Banded agate scarab.* 18 × 14 mm.

In the British Museum, 65.7-12.121. Acquired from the Castellani Collection in 1872.

YOUTH, bending down in front of a wash-basin (louterion), into which water is flowing from a lion's-head spout. With his right hand he is placing his cloak on a near-by diphros, apparently preparatory to washing himself (rather than to washing the garment?). Hatched border and marginal ornament.

Fifth to fourth century B.C.

Furtwängler, *A.G.*, pl. XVII, 40.
Walters, *Cat.*, no. 646, pl. XI.

780. *Carnelian scarab.* Fractured at bottom. 12 × 17 mm.

From Toscanella. In the Museum of Fine Arts, Boston, 98.730.

YOUTH BEFORE A FOUNTAIN. He is shown in the act of getting up from his chair (klismos), holding a dog by the leash in his left hand and a stick in his right. A mantle is draped round the lower part of his body and his right forearm. Below, between his legs, is a rock. Above, on the right, appears a lion's-head spout with water flowing out of it; a star and some unidentifiable objects are in the field. The body of the dog is adjusted to fit the shape of the stone. Inscribed, in Etruscan letters *Ataiun*, Aktaion. The klismos is drawn in a would-be three-quarter view, with all four legs indicated – but in false perspective. Hatched border.

Second half of the fifth century B.C.

This is another example of the Etruscan custom of supplying a well-known hero's name to an everyday scene.

Furtwängler, *A.G.*, pl. XVII, 47.
Osborne, *Engraved Gems*, pl. XII, 20, p. 334.
Lippold, *Gemmen und Kameen*, pl. 23, no. 1.

(e) AUGURY; HERMES PSYCHOPOMPOS

Nos. 781–782 illustrate the Etruscan interest in augury. Nos. 783–784 show Hermes as Psychopompos, bringing a soul to or from Hades.

781. *Sard scarab.* 4 × 7 mm.

In the Museum of Fine Arts, Boston, 23.587. From the Bruschi Collection at Corneto (Tarquinia).

YOUTH, bending down to touch a grotesque head with his staff. The youth is nude, except for a chlamys, which hangs from his left arm. The grotesque head is placed on a rock (?); it is evidently oracular, and by touching it the youth is inviting it to speak?

Middle period.

The subject is common on Etruscan and Italic stones of the free style. Generally, however, the oracular head is more human. Sometimes the youth is shown writing down its pronouncements on a diptychon. Cf. on this subject Furtwängler, *A.G.*, III, pp. 245 ff.

Furtwängler, *A.G.*, pl. LXI, 51.
Burlington Fine Arts Club Exh., 1904, p. 235, no. O, 20 (not ill.).
Beazley, *Lewes House Gems*, no. 87, pl. 3.

782. *Banded agate scarab*, cut; perforation remains. 17 × 12 mm.

From Chiusi. In the British Museum, 72.6–4.1238. Acquired from the Castellani Collection, 1872.

HERMES, with petasos, chlamys, and winged shoes, stooping over a vase, from which a bearded head is emerging. In his left hand is his kerykeion; with his right hand he seems to be greeting the head. The vase is placed on what is probably intended for a rock; so the scene is taking place out-of-doors. Hatched border.

Middle period.

The scene has been interpreted as the evoking of a shade from the dead by Hermes. On the general subject cf., e.g., Furtwängler, *A.G.*, vol. III, p. 202; Frazer, *Folk-lore in the Old Testament*, II, pp. 525 ff.; E. Harrison, *Prolegomena to Greek Religion*, p. 43, and *J.H.S.*, XX, 1900, p. 101, fig. 1.

Furtwängler, *A.G.*, pl. XX, 32, and vol. III, p. 202.
Weber, *Aspects of Death*[3], p. 662, fig. 116.
Lippold, *Gemmen und Kameen*, pl. X, 4.
Walters, *Cat.*, no. 765, pl. XIII.

783. *Banded onyx scarab.* 19 × 13 mm.

In the British Museum, H344. Once in the Van Hoorn (?) and Hamilton Collections.

HERMES PSYCHOPOMPOS. He is standing in frontal view, with head turned to the right to look down at a diminutive figure, which he holds on his left arm; in his right hand is his kerykeion, and the petasos is hanging from his neck. The little figure is also partly frontal, with the left arm bent and the head in profile, looking up at Hermes. Below, at the right, is a wavy pattern to indicate water, evidently the river Acheron. So the scene must represent Hermes bringing a soul from or to Hades. Hatched border and marginal ornament.

Second half of the fifth century B.C.

Hermes as Psychopompos is often represented on Italic gems, there evidently influenced by Pythagorean beliefs. The legend has, however, not survived in Greek representations, and we may have here an instance of a survival on Etruscan and Italic gems of a lost Greek myth; cf. Furtwängler, *A.G.*, vol. III, p. 202.

Raspe, no. 2399.
S. Reinach, *Pierres gravées*, p. 127, pl. 121, no. 30.
Koehler, *Gesammelte Schriften*, V, p. 164.
Weber, *Aspects of Death*[3], p. 626, fig. 106.
Heydemann, *Dionysos' Geburt*, p. 36 (interpreted as the birth of Dionysos).
Furtwängler, *A.G.*, pl. XVIII, 12, and vol. III, p. 202.
Lippold, *Gemmen und Kameen*, pl. X, 13.
Walters, *Cat.*, no. 656, pl. XI.

784. *Carnelian scarab*, cut; perforation at the back. 12 × 16 mm.

In the Staatliche Museen, Berlin.

HERMES PSYCHOPOMPOS. He is striding to the left, his kerykeion in his right hand and carrying on his other hand a small male figure. The latter has a twig in its left hand, and raises the right. Hermes is nude, with his petasos hanging from his neck, and a fillet in his short hair. His trunk and left leg are frontal, his arms and legs mostly in profile to the right and left. The head is also in profile, looking down at his precious charge. Hatched border.

Middle of the fifth century or a little later.

The anatomical details are beautifully rendered, but the pose is somewhat awkward.
That the diminutive figure is not the infant Dionysos, as Heydemann thought, was pointed out by Furtwängler. It is clearly intended for a youth, not a child.

Winckelmann, *Mon. ined.*, no. 39, p. 45.
Raspe, no. 2398, pl. 30.
Welcker, *Alte Denkmäler der Kunst*, II[3], pl. 30, 331, p. 251.
Heydemann, *Geburt des Dionysos*, p. 37.
Furtwängler, *Beschreibung*, no. 203.

(f) LEGENDS

By far the commonest subjects on Etruscan gems are the legends, and especially those concerning Greek heroes. Among them Herakles occupies a prominent place. Nos. 785–807 show a goodly selection. We can accompany him there through life: first performing his various deeds – strangling the Nemean lion (nos. 787, 788), battling against the Hydra (no. 791), accompanied by the three-headed Kerberos (no. 793), and the Erymanthian boar (no. 795), killing Kyknos (nos. 789, 790). Or he is seen carrying off Apollo's tripod (no. 794), or shouldering the firmament (no. 792), or fetching water (nos. 796–798), or sailing on a raft (nos. 800–802), or in peaceful converse with Hermes (no. 799).

Finally comes the end. We see Herakles being crowned by Nike for his labours (no. 804), sitting on the funerary pyre (no. 805), being put to sleep by Hypnos (no. 806), and his apotheosis (no. 807). Several of these representations show new compositions, which do not occur in our extant Greek repertoire (e.g., Herakles sailing on a raft) and so are the only indication we have of the existence of these legends.

The Homeric heroes are also especially popular, among them Achilles. We see him receiving his armour from Thetis (no. 818), and mourning for the death of his friend Patroklos (nos. 816, 817), his contest with the Amazon Penthesileia (no. 819), in converse with Ajax (no. 823), wounded (no. 821), and finally his dead body being carried to the Greek lines by Ajax (no. 822).

Other representations include the suicide of Ajax (nos. 812–814), incidents from the adventures of Odysseus (nos. 824 ff.), Philoktetes(?) (no. 830), Kadmos(?) (no. 831), and Protesilaos(?) (no. 859). Especially remarkable is a scene showing the Wooden Horse of Troy with the Greeks climbing out of it (no. 808).

The Theban heroes Kapaneus (nos. 833–835) and Tydeus (nos. 839–843) were other favourites. No. 832 shows a unique representation of the Theban heroes in council.

There also appear Atlas holding up the heavens(?) (no. 852), Perseus cutting off the head of Medusa (no. 854), or walking off with it (no. 855), Ixion bound to the wheel (no. 853), Bellerophon and Pegasos(?) (no. 867), Palamedes(?) inventing the game of draughts (no. 838), Jason about to embark on the ship Argo (no. 845), with the dragon (nos. 846, 847), and the golden fleece (no. 848), Polyidos pulling out little Glaukos from the pithos (no. 866), Phaethon's chariot coming to grief (nos. 849, 850), Oidipous and the sphinx (no. 864), Daidalos(?) (nos. 862, 863), Aeneas carrying Anchises (no. 861). Included is the earliest known representation of Laokoon and his sons attacked by the serpents (no. 851) – quite different from the Vatican group – and an excellent representation of Prometheus bound, with the eagle pecking at his chest (no. 865).

It is a many-sided display, full of interest, both historically and artistically. Evidently the picturesque stories about the Greek heroes had great fascination for the Etruscans; and we may surmise that the élite among them preferred to have such subjects on their sealstones rather than the banquet scenes and monsters that adorn Etruscan tombs.

(a) *Herakles and his Labours*

785. *Carnelian scarab,* slightly burnt. 19 × 15 mm.

In the British Museum H358. From the Hamilton Collection.

HERAKLES, youthful, is standing, holding his club in one hand, the bow in the other; the lion's skin is hanging from his left forearm. He is shown nearly frontal, with head, left leg, and left arm in profile. In the field is a snake and the Etruscan inscription *Herecles*. Hatched border and marginal ornament.

Second half of the fifth century B.C.

Raspe, no. 5886.
Walters, *Cat.*, no. 667, pl. XI.

786. *Carnelian scarab*, elongated. 20 × 14 mm.

In the British Museum, 72.6–4.1148. Acquired from the Castellani Collection in 1872. Formerly in the Vannutelli Collection.

HERAKLES, youthful, standing in more or less front view and leaning on the club that is placed under his left arm-pit. He is nude except for the lion's skin which hangs down his back; the left foot is raised on what seems to be intended for a rock; in the field are his bow and quiver. Hatched border and marginal ornament.

Middle period, second half of the fifth century B.C.

Furtwängler, *A.G.*, pl. XVIII, 26.
Walters, *Cat.*, no. 666, pl. XI.

787. *Banded agate scarab*, burnt. Chipped along the edge. 12 × 17 mm.

Said to be from Falerii. In the Metropolitan Museum of Art, 11.195.2. From the Evans Collection.

HERAKLES THROTTLING THE NEMEAN LION. He is shown crouching, with both arms round the lion's neck. The lion has jumped on Herakles' right shoulder, and is biting his right leg; the head is in front view, the body in profile. Herakles is in profile, except the lower part of the trunk which is in three-quarter view, and the toes of the left foot which are frontal. Hatched border. Marginal ornament of tongues.

Second half of the fifth century B.C.

Furtwängler, *A.G.*, pl. XX, 30, and vol. III, pp. 186, 449.
Lippold, *Gemmen und Kameen*, pl. 35, no. 5.
Richter, *M.M.A. Bull.*, VII, 1912, p. 98; *Cat.*, no. 173, pl. XXIX.

788. *Agate scarab*, mounted in a gold ring. 12 × 15 mm.

In the Louvre, 1200. Acquired from the Campana Collection in 1862.

HERAKLES THROTTLING THE NEMEAN LION. Herakles, nude, beardless, has both arms round the lion's neck. Behind him is his club. Both figures are shown in profile, but the lion's head is turned frontal. In the field are inscribed the letters *Alo(a?)*. Hatched border and marginal ornament.

Second half of the fifth century B.C.

De Ridder, *Bijoux antiques*, no. 1200.

789. *Carnelian scarab*. Slightly burnt. 15 × 11 mm.

Perhaps from Chiusi. In the British Museum, Blacas 335. Acquired from the Blacas Collection.

HERAKLES AND KYKNOS. Herakles is striding forward, his bow in one hand, the club in the other, ready to deliver a crushing blow on Kyknos. Kyknos has fallen to the ground, his right hand is brought to his breast (as if to extract an arrow (?)), on his left arm is his shield. Herakles is nude and beardless, and has the lion's skin draped over his forearms. Kyknos, also nude, wears a Corinthian helmet. Both chests are shown in front view, but in the rectus abdominis there is an attempt at foreshortening. In the field are the Etruscan inscriptions *Herkle* and *Kukne*. Dotted border and marginal ornament.

Fifth century B.C.

Bull. dell'Inst., 1831, p. 106, no. 22.
Micali, *Storia*, pl. 116, fig. 1.
Heydemann, *Annali dell'Inst.*, 1880, p. 81, pl. M, fig. 1.
Mueller-Wieseler, *Denkmäler ant. Kunst*, I, pl. 63, fig. 322.
King, *Arch. Journal*, XXIV, 1867, p. 210.
Fabretti, *C.I. Ital.*, no. 2530.
Furtwängler, *A.G.*, pl. XVI, 20, pl. LI, 4, and vol. III, p. 208.
Lippold, *Gemmen und Kameen*, pl. XXXVII, 3.
Walters, *Cat.*, no. 621, pl. XI.

790. *Carnelian scarab*. 15 × 11 mm.

Found at Civita Castellani. In the Cabinet des Médailles, 65A13960. Acquired through the gift of Pauvert de La Chapelle in 1899.

HERAKLES AND KYKNOS. Herakles is striding forward, brandishing his club, about to hit Kyknos, who has fallen to the ground. Herakles is nude except for the lion's skin hanging from both arms. Kyknos, also nude, wears a helmet and has a shield strapped to his left arm. Both trunks are shown almost frontal, the rest in profile. In the field the two names are inscribed in Etruscan: *Herkle* and *Kukne*. Hatched border and cross-hatched exergue.

Fifth century B.C.

Replica of the preceding.

E. Babelon, *Cat., Coll. Pauvert de La Chapelle*, no. 85, pl. VI.
Furtwängler, *A.G.*, vol. II, p. 311 ('ob antik?').

791. *Carnelian scarab*. 14 × 12 mm.

In the British Museum, T73. From the Towneley Collection.

HERAKLES AND THE LERNAEAN HYDRA. The Hydra is represented as a simple snake with a coiled body and a bearded head. Herakles, in violent movement, has seized

her by the neck and is brandishing his club, ready to slay her. His body, limbs, and head go in different directions. Beneath is a rock to indicate the out-of-doors. Hatched border and marginal ornament.

About 500 B.C.

Raspe, no. 5724.
Furtwängler in Roscher's *Lexikon*, I, s.v. Herakles, col. 2224 (with a list of similar representations); *A.G.*, pl. XIX, 3.
Walters, *Cat.*, no. 722, pl. XII.

792. *Sard scarab*, set in a modern mount. 12 × 18 mm.

In the Museum of Fine Arts, Boston, 27.724. From the E. P. Warren Collection. Bought in Rome in 1911.

HERAKLES, holding up the firmament, which is represented by a crescent moon and a number of stars placed on a curving mass. Herakles, nude, beardless, with short hair, is shown with his trunk and right leg frontal, the head, left leg, and arms more or less in profile. He is standing on rocky ground, with the tree of the Hesperides on his left side; his club is stuck in a rock, with a quiver tied to it, and his bow and a plant are below. In the field is the inscription *Hercle*, Herakles. Hatched border.

Late fifth to early fourth century B.C.

For a different treatment of this subject, with Atlas present, Beazley refers to another stone in Boston, illustrated on his pl. A, 21.

Beazley, *Lewes House Gems*, no. 88, pl. 3.

793. *Carnelian scarab*. 13 × 10 mm.

In the British Museum, 1901.7-3.1. Bought 1901.

HERAKLES AND KERBEROS. Herakles, nude, is striding to the left and holding his club in one hand, while with the other he leads Kerberos by three leashes, each of which is fastened to a collar on the dog's three heads. His trunk is shown frontal, the rest in profile. Kerberos is in profile, with the three heads frontal. Hatched border and marginal ornament.

Late archaic.

Walters, *Cat.*, no. 723, pl. XII.

794. *Carnelian scarab*, broken at bottom. 14 × 11 mm.

In the British Museum, 72.6-14.1165. Acquired from the Castellani Collection in 1872. Formerly in the Vescovali and Vannutelli Collections.

HERAKLES, brandishing his club in his right hand and carrying the Delphic tripod on his left shoulder. By his side is the dog Kerberos, represented with serpents

emerging from its back and with its tail ending in a serpent's head. In the field is a star. There is an attempt in the rectus abdominis to show the torsion of the body from the frontal chest to the profile legs. Dotted border and marginal ornament.

Late archaic.

This is one of the examples in which it is difficult to decide whether the work is Greek or Etruscan. Furtwängler thought Greek, Walters, Etruscan. The marginal ornament on the scarab perhaps weighs the scales in favour of Etruscan.
On the significance of the star in the field cf. Furtwängler in Roscher's *Lexikon*, I, 2, col. 2212 ('Herakles = ein Lichtgott').

Bull. dell'Inst., 1831, p. 106, no. 17.
Furtwängler, in Roscher's *Lexikon*, I, 2, s.v. Herakles, col. 2212; *A.G.*, pl. VIII, fig. 9 (as archaic Greek).
Lippold, *Gemmen und Kameen*, pl. XXXVIII, 13.
Walters, *Cat.*, no. 620, pl. XI.

795. *Carnelian scarab*. 18 × 12 mm.

From Chiusi. In the British Museum, 72.6-4.1140. Acquired from the Castellani Collection in 1872. Formerly in the Fanelli Collection.

HERAKLES AND THE ERYMANTHIAN BOAR. Herakles is moving to the left, brandishing his club in one hand and holding a sheathed sword in the other. A chlamys is fastened below his neck and falls down his back. The boar is moving in the same direction – instead of attacking him. Herakles' body is frontal, the head and right leg in profile, the left leg in three-quarter view. Ground line. Hatched border. No marginal ornament.

First half of the fifth century B.C. Very Greek in style.

Furtwängler, followed by Walters, interpreted the scene as Theseus and the sow of Krommyon. But the animal seems to be a boar, not a sow; so Herakles it should be, unless the artist confused the two stories.

Bull. dell'Inst., 1869, p. 55, no. 7.
Imhoof-Blumer and Keller, pl. XIX, 65.
Furtwängler, *A.G.*, pl. XVIII, 30, and vol. III, p. 190.
Beazley, *Lewes House Gems*, p. 72, pl. A, 25.
Walters, *Cat.*, no. 668, pl. XI.

796. *Banded agate scarab*. 10 × 14 mm.

From Chiusi. In the Museum of Fine Arts, Boston, 27.718. Bought in 1914.

HERAKLES, nude and beardless, stooping to the right and filling a pointed amphora with the water that flows

from a lion's-head spout. Behind him are his club and bow. In the field is the inscription *Hercle*, Herakles. Dotted border.

First half of the fifth century B.C.

Herakles at the fountain is a common subject on engraved gems. Cf. Furtwängler, *A.G.*, pl. VIII, 39 (Greek); pl. XVII, 45, pl. LXI, 23, pl. XIX, 20, pl. XX, 25 (Etruscan and Italiote). Perhaps, as Furtwängler suggested, the scene is to be explained simply as Herakles fetching water for his bath? Otherwise one might think of his contest with Lepreos in the carrying of water (cf. Schering, in *R.E.*, XX, 2, s.v. Lepreos); or of Herakles in the role of water-carrier as protector and discoverer of fountains (cf. Furtwängler, in Roscher's *Lexikon*, I, 2, s.v. Herakles, col. 223). The figure itself hardly suggests Herakles; so one may also explain the representation as taken from a Greek daily-life scene, and converted into a heroic episode by the addition of attributes and an inscribed name; cf. p. 198. For representations of silenoi fetching water cf. W. Martini, *Meddelelser fra Thorvaldsens Museum*, 1965, pp. 72 ff., who gives the correct interpretation of the gems in the Museum; Fossing, *Cat.*, nos. 60, 65, 81.

Beazley, *Lewes House Gems*, no. 43, pl. 9.

797. *Sard scarab*, mounted in a modern gold ring. Slightly chipped along the edge. 11 × 15 mm.

In the Ashmolean Museum, 1921.1234. Formerly in the Maskelyne Collection. Gift of Sir John Beazley.

HERAKLES AT THE FOUNTAIN. He is standing in frontal view, with head turned in profile to the right and feet in profile to the right and left, holding his club downward in his right hand. His lion's skin is knotted on his chest and falls down his back. From a lion's-head spout water is flowing. A pointed amphora is on the ground. Hatched border and marginal ornament.

In the field is the inscription: *Heacle*, Herakles.

Fifth century B.C., combining archaic and developed elements.

Furtwängler, *A.G.*, pl. XX, 25.
Burlington Fine Arts Club Exh., 1904, p. 108, no. M, 12.
Sotheby Sale Catalogue of the Story-Maskelyne Collection, 4th–5th July, 1921, no. 53, pl. II.
Select Exhibition of Sir John and Lady Beazley's Gifts to the Ashmolean Museum, 1912–1966 (1967), p. 170, no. 651, pl. LXXXIV.

798. *Sard scarab*. 14 × 16 mm.

In the Ashmolean Museum, 1892.1492. Acquired through the Chester bequest.

HERAKLES AT THE WELL. He is stooping before the fountain house, one vase on his back, another on the ground; he is nude and bearded. The fountain house is indicated by two columns and the roof, in abbreviated form; behind it is placed Herakles' club for convenient identification. Hatched border and marginal ornament.

Fifth century B.C.

799. *Carnelian scarab*. 18 × 14 mm.

In the British Museum, Blacas 350. From the Blacas Collection.

HERAKLES AND HERMES, conversing. Herakles is standing in front view, with head turned to the right; he wears the lion's skin down his back, and holds his bow in the left hand, while the right is lowered to the quiver which is on the ground, beside his club. Hermes has approached from the right and is shown in three-quarter view, with head and limbs in profile, holding his kerykeion in the right hand, his winged hat in the other; he has a mantle hanging from his left shoulder and wears winged shoes. Ground line with exergue decorated with shaded triangles. Marginal ornament.

Latter part of the fifth century B.C.

Koehler, *Gesammelte Schriften*, V, p. 144.
King, *Arch. Journal*, XXIV, 1867, p. 121.
Furtwängler, *A.G.*, pl. XVIII, 19, and vol. III, pp. 178, 186.
Lippold, *Gemmen und Kameen*, pl. XXXVIII, 1.
Walters, *Cat.*, no. 655, pl. XI.

800. *Sard scarab*. 14 × 10·5 mm.

From Cumae. In the Museum of Fine Arts, Boston, 21.1202. Bought in Rome, 1912.

HERAKLES, beardless and nude, is sailing on a raft supported by six amphorae. With his right hand he holds the upper end of the sail, as well as his bow and arrows; in his left hand he has his club, using it as a rudder. His left elbow rests on a pillow, doubled over. The right leg is in profile, the left bent with the lower part foreshortened. Border of dots and marginal ornament.

First half of the fifth century B.C.

Herakles floating at ease on a raft, apparently supported by amphorae, often appears on Etruscan gems, both early and late (cf. nos. 801–803, and the list given by Beazley, *loc. cit.*, which includes an Etruscan bronze mirror in the British Museum, *Cat.*, no. 627). Various interpretations have been offered for these curious scenes – which never occur on extant Greek gems, vases, etc. Furtwängler (*A.G.*, vol. III, pp. 197 f.) thought that they might connect with Herakles as 'protector of fountains', since he is depicted as standing by a fountain on other scarabs (cf. nos.

796–798). Beazley (*loc. cit.*) suggested that they might have some connection with 'Herakles' western voyage (Pindar, *Nemeans*, III, 32)'. It seems likely that we have here another instance of some lost Greek legend having survived only on Etruscan monuments (cf. p. 178).

Beazley, *Lewes House Gems*, no. 42, pl. 3.

801. *Carnelian scarab.* 13 × 16 mm.

In the Staatliche Museen, Berlin. From the Gerhard Collection.

HERAKLES, on a raft supported by three amphorae. He is sitting on a pointed amphora, his head leaning on his right hand, the club held downward in his left. In front is a tree. Hatched border.

Fourth century B.C.

For the subject see no. 800.

Furtwängler, *Beschreibung*, no. 231; *A.G.*, pl. XIX, 40.

802. *Carnelian scarab.* 11 × 15 mm.

In the Cabinet des Médailles, 1776a.

HERAKLES, reclining on a raft, which is supported by five amphorae. He is nude and holds his club in his right hand; in his left is perhaps an abbreviated indication of the sail (cf. no. 800). Hatched border. No marginal ornament.

Similar to the preceding, q.v.

803. *Carnelian scarab.* 17 × 12 mm.

In the British Museum, 1906.1–16.2. Presented by C. T. Wilson, 1906.

HERAKLES, seated on a raft supported by three amphorae. An abbreviated version of the representation on no. 800, q.v. Hatched border. No marginal ornament.

Walters, *Cat.*, no. 802, pl. XIII.

804. *Sardonyx scarab.* 13 × 16 mm.

In the Cabinet des Médailles. Gift of Baron de Witte, 1848.

HERAKLES BEING CROWNED BY A FEMALE FIGURE, presumably Nike, though she is wingless. Herakles is standing in front of Nike, with one foot placed on a little rock, his club in one hand, the other extended toward 'Nike', who holds a wreath in both raised hands. She wears a long, ungirded chiton and a cap. Herakles is nude and has a sheathed sword hanging by a baldric from his left shoulder. His trunk is shown frontal, the rest more or less in profile. In the field are two stars and an ivy leaf. Beaded border and marginal ornament.

Fourth century B.C.

Cursory work. On the stars cf. no. 794.

Chabouillet, *Cat.*, no. 1778 ('Hercule couronné par une Victoire-Aptère')

805. *Banded agate scarab.* Fractured at top and bottom. 15 × 11 mm.

Found near Viterbo in 1838. Acquired by the British Museum from the Blacas Collection.

HERAKLES, nude, beardless, with short hair, is seated on the funeral pyre, preparatory to his apotheosis. His left hand rests on his club, the lion's skin is knotted under his chin. Hatched border and marginal ornament.

First half of the fifth century B.C.

Bull. dell'Inst., 1839, p. 102, no. 27.
Francke, *Ann. dell'Inst.*, LI, 1879, p. 61.
King, *Arch. Journal*, XXIV, 1827, p. 213.
Furtwängler in Roscher's *Lexikon*, I, 2, s.v. Herakles, col. 2241; *A.G.*, pl. XVI, 64.
Walters, *Cat.*, no. 622, pl. XI.
Lippold, *Gemmen und Kameen*, pl. 37, no. 8.

806. *Sard scarab.* Broken and repaired. Chipped along the edge. A piece of the beetle is missing. 14 × 19 mm.

In the Metropolitan Museum of Art, 55.128.1. Gift of Rupert L. Joseph, 1955.

HERAKLES, BEING PUT TO SLEEP BY HYPNOS (or Thanatos?). He is sitting on a stone, leaning forward on his club, apparently in a state of exhaustion. Behind him stands a bearded, winged figure, shown mostly in front view, with the head turned to one side. Ground line and hatched border. Hatched marginal ornament.

Fourth century B.C.

The subject is common on Etruscan and Italic gems, and on one of them the winged daemon is inscribed *TIELTA*; cf. Richter, *A.J.A.*, LXI, 1957, p. 265, pl. 82, fig. 9) – the meaning of which is, however, not known. Cf. the similar stone in the British Museum, Furtwängler, *A.G.*, pl. XVIII, 28; Richter, *op. cit.*, p. 265, pl. 82, and the references there cited. Perhaps there was a legend that Herakles was put to sleep before his apotheosis.

Richter, *Cat.*, no. 177, pl. XXIX.

807. *Carnelian scarab.* 16 × 13 mm.

In the British Museum, T205, from the Towneley Collection.

HERAKLES' APOTHEOSIS. Herakles, nude, is being lifted up by two female, draped figures, one of which is winged. Below are his club and bow. Ground line and hatched border. Marginal ornament.

Fourth century B.C.

This is apparently a unique version of the myth of Herakles' apotheosis.

Furtwängler, *A.G.*, pl. XIX, 64.
Walters, *Cat.*, no. 801, pl. XIII.

(β) Homeric Legends

808. *Carnelian scarab.* A satyr's face is carved on the back of the beetle. 10 × 14 mm.

Said to be from Populonia. In the Metropolitan Museum of Art, 32.11.7. Fletcher Fund, 1932.

THE WOODEN HORSE OF TROY. Seven Greek warriors are climbing out of it. One, presumably Odysseus, is standing inside, propping up the door with one hand and holding two spears in the other. The other heroes are outside the horse, in various attitudes; one is climbing down the horse's back, with one foot on its hindleg; another is apparently sliding down its neck; the rest are preparing to attack. They are of different sizes, according to the available space. They wear cuirasses, helmets, and carry round shields and spears. The horse has a saddle-cloth on its back. In the field is a crescent. Dotted border and crosshatched exergue. Marginal ornament of beads and tongues.

Early fifth century B.C.

The impression of a large number of men is successfully conveyed, in spite of the small size of the stone. The action takes place in the dead of night with only a crescent of the waning moon to lend some light – as suggested in a fragment of the *Little Iliad*: νὺξ μὲν ἔην μέσση, λαμπρὰ δ' ἐπέτελλε σελήνη (a reference I owe to Sir John Beazley).
For a list of representations of the Trojan Horse cf. now Ervin, *Arch. Deltion*, XVIII, 1963 (1964), pp. 51 ff.

Alexander, *M.M.A. Bull.*, XXIX, 1934, p. 53.
Richter, *M.M.A. Handbook of the Etruscan Collection*, p. 31, figs. 95, 96; *Cat.*, no. 164, pl. XXVII.
Giglioli, *Bull. com.*, LXIX, 1941, fig. 4.
Ervin, *Arch. Delt.*, XVIII, 1963 (1964), p. 53.

809. *Carnelian scarab.* Fractured at the front of the beetle's head. 13 × 17 mm.

Said to be from Southern Etruria. In the Metropolitan Museum of Art, 42.11.28. Purchase, 1942, Joseph Pulitzer bequest.

TWO WINGED FIGURES CARRYING THE DEAD BODY OF A YOUTH. One is male and nude, the other female and wears a chiton and a himation. They, as well as the dead man, are made up of frontal and profile views. Hatched border. Marginal ornament of beads and tongues.

About 480 B.C.

The contrast between the limp body of the dead youth and the energetic carriers is well brought out.
The representation is probably an Etruscan version of the familiar Greek story of the body of Memnon being carried by Hypnos and Thanatos to the place where he is to enjoy immortality. That one of the figures is female instead of both male may be explained as due to a confusion with the legend according to which Eos, the goddess of Dawn and mother of Memnon, carried off her son's body from the battlefield of Troy after he was killed by Achilles. On Greek vase-paintings these two incidents are always kept separate and accurately rendered. Cf. Beazley's discussion in *Lewes House Gems*, pp. 35 f.

Evans, *Selection*, no. 96.
Richter, *Evans and Beatty Gems*, no. 40; *Cat.*, no. 168, pl. XXVIII.

810. *Sard scarab.* 15 × 6 mm.

Said to have been found in Naples. In the Museum of Fine Arts, Boston, 21.1200. Formerly in the Tyszkiewicz and E. P. Warren Collections.

TWO WINGED FIGURES, one male, the other female, carrying a nude, dead man. The male bearer is nude, the female wears a chiton and a himation. Hatched border.

About 500 B.C.

Similar to the preceding, but directed to the right instead of the left.

P. J. Meier, *Ann. dell'Inst.*, LV, 1883, p. 213 (ill.).
Coll. Tyszkiewicz, pl. 24, no. 8.
Furtwängler, *A.G.*, pl. XVI, 22.
F. Parkes Weber, *Aspects of Death and Correlated Aspects of Life*, p. 651, fig. 111.
Burlington Fine Arts Club Exh., 1904, p. 235, no. O, 17 (not ill.).
Beazley, *Lewes House Gems*, no. 38, pl. 3.

811. *Carnelian scarab.* 16 × 13 mm.

In the British Museum, 72.6–4.1158. Acquired from the Castellani Collection in 1872. Once in the Fanelli Collection.

TWO FEMALE WINGED FIGURES CARRYING THE DEAD BODY OF A MAN. The body is shown nude. The women wear long chitons. Hatched border and marginal ornament.

Middle period.

For the subject cf. no. 809.

Weber, *Aspects of Death*[3], p. 651, fig. 113.
Beazley, *Lewes House Gems*, p. 35.
Walters, *Cat.*, no. 680, pl. XII.

812. *Sard scarab*, in a modern setting. 13 × 6 mm.

In the Museum of Fine Arts, Boston, 27.717. From the Boulton Collection.

THE SUICIDE OF AJAX. Ajax, nude, helmeted, is bending forward, about to fall on his sword, of which the hilt is on the ground and the point directed toward his chest; behind him is the scabbard. The upper part of his body is in three-quarter view, the head, arms, and right leg are in profile, the left leg and foot are frontal. Hatched border and marginal ornament.

First quarter of the fifth century B.C.

For similar, earlier representations of this subject cf. the Island gem, no. 57, and the recently discovered metope from Foce del Sele, Zancani, *Mon. Magna Grecia*, n.s., vol. V, 1964, pp. 80 ff., pls. XV, XVI; Van Buren, *A.J.A.*, 69, 1965, p. 361, pl. 88, fig. 3. In both the sword is placed more or less vertically, not obliquely as here and elsewhere.

Sale Catalogue of the Boulton Collection, no. 3.
Beazley, *Lewes House Gems*, no. 41, pls. 3 and 9.

813. *Carnelian scarab*. 14 × 12 mm.

Perhaps from Chiusi. In the British Museum, 72.6–4.1159. Acquired from the Castellani Collection in 1872.

THE SUICIDE OF AJAX. He has thrown himself on his sword, of which the hilt is fixed on a mound of earth on the ground. Blood is pouring from his wound. He is nude and has short, straight hair. The upper part of the body is in slight three-quarter view, the rest more or less in profile. Dotted border and marginal ornament.

Fifth century B.C.

Heydemann, *Bull. dell'Inst.*, 1869, p. 55, no. 5.
Furtwängler, *A.G.*, pl. XVII, 32.
Beazley, *Lewes House Gems*, p. 38, pl. A, 19.
Walters, *Cat.*, no. 635, pl. XI.

814. *Carnelian scarab*, mounted in its original gold swivel ring. 13 × 18 mm.

In the Metropolitan Museum of Art, 41.160.489. Bequest of W. G. Beatty, 1941. Formerly in the Wyndham Cook Collection.

THE SUICIDE OF AJAX. He has fallen on his sword, of which the hilt is stuck in a mound of earth. The blade has gone right through him, with the point shown emerging from his back. He is holding his hands behind him, to keep them out of the way. A chlamys hangs down his back; behind him is his shield, shown foreshortened. The mound is dotted. Hatched border. Marginal ornament of hatched lines.

Early fourth century B.C.

Burlington Fine Arts Club Exh., 1904, p. 207, no. M, 127, pl. 110.
C. H. Smith and A. Hutton, *Catalogue of the Wyndham F. Cook Collection*, 1908, no. 41, pl. II, p. 14.
Beazley, *Lewes House Gems*, p. 38.
Richter, *Evans and Beatty Gems*, no. 42; *Cat.*, no. 172, pl. XXIX.

815. *Carnelian scarab*, mounted in a gold ring. 14 × 11 mm.

In the Fitzwilliam Museum, Cambridge. Bequeathed by Shannon, in 1937 (18, 15).

YOUTH STABBING HIMSELF. He is nude, with long hair, and is shown kneeling, holding the sword in his right hand, the scabbard in his left. The trunk, upper legs and left arm are frontal, the rest in profile. Hatched border and marginal ornament. Perhaps another version of the suicide of Ajax?

816. *Carnelian scarab*, cut. 14 × 12 mm.

In the British Museum, T106. From the Towneley Collection.

ACHILLES, MOURNING THE DEATH OF PATROKLOS. He is sitting on a folding-stool, his head bowed and resting on his right hand. He wears an Attic helmet and a woollen himation (with dots on its surface) round his legs and left lower arm. By his side is a sheathed sword with its baldric. His trunk is shown frontal, the rest in profile. Hatched border.

Late archaic.

H. Brunn, *Ann. dell'Inst.*, 1858, pl. Q, fig. 3, p. 369.
Raspe, no. 8655.
Furtwängler, *A.G.*, pl. XVI, 67.
Walters, *Cat.*, no. 773, pl. XIII.

817. *Carnelian scarab*. 14 × 11 mm.

Said to have been found in a tomb at Tarquinia. In the British Museum. Acquired from the Vidoni and Blacas Collections.

ACHILLES MOURNING THE DEATH OF PATROKLOS. He is seated on a diphros, with his hand brought up to his head. He has longish hair which descends to the nape of his neck, and wears a woollen cloak round the lower part of his body. The upper part of his body is frontal, the rest in profile. In the field the Etruscan inscription *Achle*, Achilles. Thick ground line. Hatched border and marginal ornament.

Late archaic.

The same composition is used for Amphiaraos on an Etruscan gem in Berlin (cf. no. 832), and for Theseus on an Etruscan gem in the Hermitage (Furtwängler, *A.G.*, pl. XVI, 66).

H. Brunn, *Ann. dell'Inst.*, 1858, pl. Q, fig. 1, p. 368.
Furtwängler, *A.G.*, pl. XVI, 65.
Walters, *Cat.*, no. 632, pl. XI.
Lippold, *Gemmen und Kameen*, pl. XLI, 4.

818. *Carnelian pseudo-scarab.* 13 × 11 mm.

In the British Museum, 65.7–12.119. Acquired from the Castellani Collection in 1865.
On the back of the stone, instead of the usual beetle, is carved in low relief a winged female figure.

THETIS AND ACHILLES (?). She holds out a spear and a Corinthian helmet, while he stands in front of her, ready to receive them. She has long hair and wears a long, ungirded chiton; a himation is draped over her left arm. He is bearded and wears a cuirass. With one hand he holds the helmet he is receiving, with the other a shield placed in front of him. Hatched border and exergue with shaded triangles.

Fifth century B.C.

Furtwängler (and tentatively Beazley) interpreted the figure to the left as male, and the scene, therefore, as a simple 'Rüstung'. Walters considered the figure female, and that seems to me also likely.

Körte, *Arch. Ztg.*, XXXV, 1877, p. 117, pl. II, fig. 3 (=the winged figure in relief).
Furtwängler, *A.G.*, pl. XVI, 2, 3, and vol. III, p. 178.
Walters, *Cat.*, no. 651, pl. XI.
Beazley, *Greek Vases in Poland*, p. 2, note 1.

819. *Banded agate scarab.* 18 × 12 mm.

In the British Museum, 68.5–20.20. Acquired in 1868 from the Pulsky Collection.

ACHILLES AND PENTHESILEIA. She has sunk on her knees to the ground, and he is supporting her, holding her up by her right elbow and under her left armpit. He wears an Attic helmet, with a relief on the bowl, a cuirass,

greaves, and a chlamys over his right shoulder; behind him is his spear. Penthesileia wears an Attic helmet, a short chiton, and an obliquely draped himation; on the left arm is her shield; her battle axe has fallen to the ground from her limp right hand. Both figures are shown more or less frontal, with heads and limbs in profile to the right and left. Hatched border and exergue decorated with cross-hatched triangles. Marginal ornament.

Middle period.

The Amazon has been compared with the well-known statue in Vienna; cf. Schneider, *Album der Antikensammlung*, p. 1; Furtwängler, *Meisterwerke*, p. 287, note 2.

Furtwängler, *A.G.*, pl. XX, 24, and vol. III, p. 185.
Walters, *Cat.*, no. 634, pl. XI.

820. *Agate scarab*, gray with white bands. 18 mm.

In the Metropolitan Museum of Art, 21.88.41. Rogers Fund, 1921. Formerly in the collections of Mr. Bale and Story-Maskelyne.

ACHILLES has sunk to the ground, wounded in his right heel by an arrow, which he is trying to extract with his right hand. He is nude and has long hair, tied at the back of his head. His shield is still strapped to his arm; his helmet is on the ground, his spear by his side. Hatched border. Marginal ornament of hatched lines.

Fourth century B.C.

A free rendering of the body is combined with an archaic posture.

Furtwängler, *A.G.*, pl. XX, 54, and vol. III, pp. 195, 206.
Burlington Fine Arts Club Exh., 1904, p. 184, no. M, 15, pl. 108.
Sotheby Sale Catalogue of the Story-Maskelyne Collection, 4th–5th July, 1921, p. 13, no. 64.
Bernardy, *Studi etruschi*, I, 1927, p. 472, pl. LXXI.
Richter, *M.M.A. Bull.*, XVII, 1922, p. 195, fig. 5; *Cat.*, no. 176, pl. XXIX.

821. *Carnelian scarab.* 17 × 12 mm.

In the British Museum, 76.6–4.1149. Acquired from the Castellani Collection in 1872. Formerly in the Nott Collection.

ACHILLES. He has sunk to the ground, struck by the arrow in his heel. On his left arm is still strapped his shield. He has long hair, tied together at the back. The upper part of his body is in three-quarter view, the rest more or less in profile. Hatched border and marginal ornament.

Similar to the preceding.

Bull. dell'Inst., 1834, p. 119, no. 40, and 1869, p. 55, no. 6.
King, *Antique Gems and Rings*, II, pl. 43, fig. 8; *Handbook*, pl. LXVIII, 8.

Furtwängler, *A.G.*, pl. XVIII, 72.
Lippold, *Gemmen und Kameen*, pl. XLI, 13.
Walters, *Cat.*, no. 672, pl. XI.

822. *Carnelian*, with a Siren in relief on the upper side of the scarab. 10 × 14·5 mm.

In the Hermitage. Formerly in the Orléans Collection.

AJAX CARRYING THE DEAD ACHILLES on his left shoulder. Ajax, bearded, is shown in the half-kneeling position signifying motion. He wears a cuirass over a chiton with rounded ends, as well as a jerkin; on his head is a crested Attic helmet. Achilles is nude; his arms and legs hang down limp on either side of Ajax. Beneath, near his hands, is a small, nude, winged figure, doubtless intended for the eidolon of Achilles. It is moving to the right, but its body is frontal. So is the trunk of Ajax, whereas his arms, legs, and head are in profile. In the field the names are inscribed: *Aivas, Achele*. Hatched border and hatched exergue.

About 500 B.C.

Caylus, *Recueil d'ant.*, 4, 31, 1.
Pierres d'Orléans, II, 2, 2 bis (=S. Reinach, *Pierres gravées*, pl. 128).
Köhler, *Gesammelte Schriften*, IV, p. 8; V, p. 136.
Müller-Wieseler, *Denkmäler der Kunst*, II, no. 752.
Furtwängler, *A.G.*, pl. XVI, 19 (drawing of scene on p. 76 of vol. II).

823. *Banded agate scarab*. 18 × 14 mm.

In the British Museum, 72.6–4.1172. Acquired from the Castellani Collection in 1872. Formerly in the Santangelo Collection.

ACHILLES AND AJAX, standing side by side, looking to the left. Achilles holds a spear in his left hand; Ajax's right hand is lowered to hold the rim of the shield by his side. Beside each figure the name is inscribed in Etruscan letters: *Achale*, and *Aifas*. Hatched border and marginal ornament.

Middle period.

Heydemann, *Bull. dell'Inst.*, 1869, p. 55, no. 4.
Furtwängler, *A.G.*, pl. XVIII, 21, and vol. III, p. 185.
Walters, *Cat.*, no. 670, pl. XI.

824. *Carnelian scarab*. 15 × 12 mm.

Perhaps from Chiusi. In the British Museum, 65.7–12.93. Acquired from the Castellani Collection in 1865.

ODYSSEUS, bending over an amphora on the ground. In his right hand he holds a small object, his left is placed on his back. He is nude except for a mantle which falls down his back. In the field is inscribed in Etruscan letters *Uthuze*, Odysseus. Hatched border and marginal ornament.

Middle period.

It has been thought that the scene 'suggests some form of casting lots or voting', or 'Odysseus adding the moly root to Circe's potion' (cf. Walters, *loc. cit.*).
For the form *Uthuze* for Ulysses cf. Fabretti, *Glossarium*, p. 2019.

Brunn, *Bull. dell'Inst.*, 1863, p. 125.
Walters, *Cat.*, no. 674, pl. XII.

825. *Carnelian scarab*, mounted in a modern gold ring. 16 × 12 mm.

In the Cabinet des Médailles. Gift of the duc de Luynes in 1862 (no. 281).

ODYSSEUS, OR ONE OF HIS COMPANIONS, is in the act of untying the wineskin filled with winds, which was given to Odysseus by Aiolos; from it is seen emerging the bearded head of a windgod, blowing out winds, indicated by little strokes. The youth is nude, except for a chlamys tied at the neck and falling down his back; one foot is placed on the skin. Hatched border and marginal ornament.

Second half of the fifth century B.C.

Babelon, *Cabinet des antiques*, 1888, pl. XLVII, 6.
Furtwängler, *A.G.*, pl. XX, 20.
Pierres gravées, Guide du visiteur (1930), p. 143, no. 280 (not ill.).

826. *Carnelian scarab*, mounted in a modern gold ring. 11 × 15 mm.

In the Cabinet des Médailles. Gift of the duc de Luynes in 1862 (no. 280).

ODYSSEUS, OR ONE OF HIS COMPANIONS, in the act of untying the wineskin, the opening of which he holds firmly in his left hand. He is nude except for a chlamys which covers his back. In the field an Etruscan inscription: *Aenlci*. Hatched border.

Middle of the fifth century B.C.

Similar to the preceding.

Babelon, *Cabinet des antiques*, 1888, pl. XLVII, 5.

827. *Banded agate scarab*, mounted in a modern gold ring. 13 × 17 mm.

In the Cabinet des Médailles. Gift of the duc de Luynes in 1862 (no. 283).

COMBAT SCENE. A youth, nude and without weapons, is sitting on the ground, while behind him a nude, helmeted warrior is lifting his sword for attack; opposite him is another nude, helmeted warrior, with shield extended, a spear in his uplifted hand, and one foot placed on the youth's knee. Hatched ground line and beaded border. Marginal ornament.

Second half of the fifth century B.C.

Babelon interpreted the seated youth as Dolon attacked by two Greeks. But Furtwängler pointed out that the man with the spear seems to be protecting rather than attacking the fallen youth, in which case the interpretation of the Trojan spy about to be killed by Odysseus and Diomedes would not be valid. The fact, however, remains that this cannot well be an ordinary combat scene, since the fallen youth has no weapons, and so, the artist, with his Etruscan love of representing Greek heroic scenes, may well have tried to depict the well-known incident in the *Iliad*, and confused the incidents.

E. Babelon, *Cabinet des antiques*, pl. LVI, 10.
Furtwängler, *A.G.*, pl. XX, 4.
Pierres gravées, Guide du visiteur (1930), p. 143, no. 283 (not ill.).

828. *Sardonyx scarab.* 15 × 10 mm.

In the Cabinet des Médailles.

TWO MEN, opposite each other, one seated, the other standing. Both are bearded and have mantles loosely draped on their bodies. Hatched border and marginal ornament.

Second half of the fifth century B.C.

Chabouillet interpreted the scene as Antilochos bidding goodbye to his father Nestor. But the bearded standing man seems too old for the young Antilochos, and as both he and Nestor went to Troy, one would not expect a farewell scene. Here again the Greek legend may have been somewhat misunderstood by the Etruscan artist.

De Witte, *Cat. Durand* (1836), no. 2201.
Chabouillet, *Cat.*, no. 1826.

829. *Carnelian scarab.* 19 × 15 mm.

Found at Chiusi in 1858. In the British Museum, 65.7-12.94. Acquired from the Castellani Collection in 1865.

MACHAON AND PHILOKTETES. Machaon, bearded, is sitting on a folding stool, engaged in putting a bandage round the right ankle of Philoktetes. Philoktetes, beardless, is standing with his wounded leg raised, supporting

himself on a staff held in his right hand. He is turning round to Machaon, gesticulating with his left hand. In the field are two names in Etruscan letters, *Epetus, Acheos*, which may refer to the owner of the gem, or be invented names for the heroes. The identity of the two men in the representation is shown by a similar scene on an Etruscan mirror with the names inscribed: *Pheltete* (Philoktetes) and *Machan* (Machaon); cf. Milani, *Mito di Filottete*, pl. 3, fig. 49. Hatched border and marginal ornament.

Second half of the fifth century B.C.

Bull. dell'Inst., 1859, pp. 5, 82.
Ann. dell'Inst., 1881, p. 280, pl. T, fig. 5.
Milani, *Mito di Filottete* (1879), pp. 105 f.
Türkol in Roscher's *Lexikon*, III, 2, s.v. Philoktetes, col. 2342, fig. 16.
Walters, *Cat.*, no. 730, pl. XII.

830. *Sard scarab*, mounted in a modern ring. 12 × 16 mm.

In the Royal Cabinet of Coins and Gems, the Hague. From the collection of Van Hoorn van Vlooswijk.

YOUTH, stooping to the right, holding his spear in both hands, is in the act of killing a snake on the ground; the point of the spear is touching the head of the snake. A chlamys hangs down the youth's back. Hatched border.

Fifth to fourth century B.C.

Though an inscription is missing, the incident is probably taken from a heroic legend. Furtwängler suggested Philoktetes on the island Chryse, where he was bitten by the snake.

Furtwängler, *A.G.*, pl. XVII, 18.

831. *Green glass scarab*, with blue bands. In a modern setting. 16 × 14 mm.

In the Fitzwilliam Museum, Cambridge. Bequeathed by Shannon in 1937; 15 (14).

PHILOKTETES (?), KADMOS (?). A youth is shown half reclining on his shield, while the serpent has coiled itself round his leg. In the field is a jug. Hatched border.

Second half of the fifth century B.C.

The scene has been interpreted both as pertaining to Philoktetes and to Kadmos. The presence of the jug perhaps points to Kadmos, for according to the legend Kadmos was attacked by a snake while fetching water.

Burlington Fine Arts Club Exh., *Cat.*, 1904, p. 208, M128, pl. CXII (=Philoktetes).
C. H. Smith and C. Amy Hutton, *Catalogue of the Wyndham F. Cook Collection*, II, p. 39, no. 164, pl. VI (=Kadmos).

(γ) Theban Legends

832. *Carnelian scarab.* Sawn in two pieces along the perforation. 18 × 14 mm.

In the Staatliche Museen, Berlin. Once in the possession of Baron Stosch.

COUNCIL OF THE SEVEN ARGIVE HEROES AGAINST THEBES (five only are shown). All are beardless. Three are seated, two are standing at the back. In the middle is Amphiaraos (inscribed *Amph(i)iare*), seated on a diphros, with head lowered, a spear in his right hand, a furry garment (marked by dots) round his legs and left arm. Opposite him is Polyneikes (inscribed *Phulnice*), also seated on a diphros, his head lowered and resting on his right hand; he wears a mantle and has long hair. Behind him, and partly hidden by him, stands Tydeus (inscribed *Tute*), wearing a crested helmet, a cuirass, and greaves, and holding a spear and a shield. Behind Amphiaraos is Parthenopaios (inscribed *Parthanapaes*), seated on a folding-stool, wrapped in a mantle, both hands clasped on his right knee; his head is raised and he has long hair. Behind him and Amphiaraos, as the second standing figure, is Adrastos (inscribed *Atresthe*), striding to the right; he too is in full armour, with a cuirass over a chiton, a crested helmet on his head, and holding a spear and a shield. Ground line. Dotted border.

First half of the fifth century B.C.

The inclusion of five figures in the small space of the stone is a remarkable achievement at this period.

C. Antonioli, *Antica gemma etrusca spiegata ed illustrata, con due dissertazioni*, Pisa, 1757.
Raspe, no. 9098.
Winckelmann, *Mon. ined.*, no. 105, p. 140.
Panofka, 'Gemmen mit Inschriften', *Abh. Berl. Akad.*, 1851, p. 440, pl. II, 5.
Müller-Wieseler, *Denkmäler alter Kunst*, I (1854), pl. 63, 319.
Overbeck, *Gallerie her. Bildw.*, p. 81, pl. III, 2.
King, *Ancient Gems*, pl. 73; *Ancient Gems and Rings*, pl. XLII B, no. 8.
Fabretti, *C.I.It.*, no. 1070.
Furtwängler, *Beschreibung*, no. 194 (with still other references).

833. *Carnelian scarab.* 13 × 20 mm.

In the British Museum, 65.7–12.99. Acquired from the Castellani Collection in 1865.

KAPANEUS, struck by the thunderbolt, has fallen to the ground. His shield is hanging from his limp left arm, his one-edged sword has fallen from his right. He is nude, bearded, and wears a taenia. The bolt passes through his head, with the point visible beneath. The upper part of his body and the sole of his right foot are shown frontal,

the head, arms and left leg in profile. The anatomical details are carefully marked. Hatched border and marginal ornament.

Early fifth century B.C.

Furtwängler, *A.G.*, pl. XVI, 46.
Lippold, *Gemmen und Kameen*, pl. XLV, 14.
Walters, *Cat.*, no. 626, pl. XI.

834. *Banded agate scarab.* 13 × 10 mm.

In the British Museum, 65.7–12.108. Acquired from the Castellani Collection in 1865.

KAPANEUS, struck by the thunderbolt. He is in a half-kneeling position, with head bowed, and left arm raised. A shield is strapped on his left arm, and a mantle hangs down his back. The bolt has transfixed his head (the point is visible beneath). The chest is shown frontal, the lower part of the trunk a little foreshortened, the rest in profile. Hatched border and marginal ornament.

Early fifth century B.C.

Furtwängler, *A.G.*, pl. XVI, 37.
Lippold, *Gemmen und Kameen*, pl. XLVI, 13.
Walters, *Cat.*, no. 625, pl. XI.

835. *Sardonyx scaraboid.* 13 × 10 mm.

In the British Museum, Blacas 467. From the Laurenti and Blacas Collections.
On the back, instead of the usual beetle, is the figure of a boy in relief. He is shown seated on the ground, in a frontal pose, with head bent and turned to one side, hands placed on his left knee.

KAPANEUS. He has been struck by the thunderbolt, and has collapsed on one knee. His sword has fallen from his right hand; to his left arm is still strapped his shield. He is nude and wears a crested helmet. Dotted border and marginal ornament (a guilloche).

First half of fifth century B.C.

Micali, *Storia*, pl. 116, no. 11.
King, *Arch. Journal*, XXIV, 1867, p. 2211.
Overbeck, *Gallerie her. Bildw.*, pl. V, 5.
Furtwängler, *A.G.*, pl. XVI, 6.
Lippold, *Gemmen und Kameen*, pl. 46, no. 9.
Walters, *Cat.*, no. 652, pl. XI.

836. *Carnelian scarab.* 12 × 15 mm.

Said to be from Populonia. In the Metropolitan Museum of Art, 48.11.1. Rogers Fund, 1948.

KAPANEUS, struck by Zeus' thunderbolt. He has fallen on his knees, his spear has dropped from his right hand,

his shield is still strapped on his left arm. The trunk is frontal, with the rectus abdominis and the linea alba indicated, the head and limbs are more or less in profile. The drawing of the right foot is remarkable: the heel is in profile, but the rest is twisted to a back view with all five toes drawn. The details of the handles on the inside of the shield are all nicely indicated; also the thong of the spear, which is drawn in two directions, as if 'in the act of breaking' (Beazley). The thunderbolt is not visible. In the field the Etruscan inscription *Capne*, Kapaneus. Hatched border, and marginal ornament of beads and tongues.

Early fifth century B.C.

Richter, *M.M.A. Bull.*, 1948, pp. 222 f.; *Annuario*, XXIV–XXVI, 1950, pp. 82 f., fig. 3; *Cat.*, no. 163, pl. XXVII.

837. *Banded agate scarab*, in an ancient gold setting. Pierced obliquely with a second hole. 16 × 11 mm.

Said to have been found in a tomb at Potigliano, near the lake of Bolsena in 1838, 'together with a mask-shaped lamp and vases, apparently of late date'. In the British Museum, Blacas 364. Acquired from the Blacas Collection.

KAPANEUS, preparing to arm himself. He is shown stooping to lift his helmet and chlamys from his shield, which is placed before him, with another piece of drapery lying over it. He is nude and beardless. The anatomical details are carefully marked, including the serratus magnus. In the field is the Etruscan inscription *Capne*, Kapaneus. Hatched border and marginal ornament.

Second half of the fifth century B.C.

Were it not for the inscription, the young man would have been interpreted as a simple warrior; cf. p. 180.

Bull. dell'Inst., 1839, p. 102, no. 31.
King, *Arch. Journal*, XXIV, 1867, p. 213.
Furtwängler, *A.G.*, pl. XVII, 39, and vol. III, p. 206.
Lippold, *Gemmen und Kameen*, pl. XLVI, 2.
Walters, *Cat.*, no. 624, pl. XI.

838. *Carnelian scarab.* 16 × 12 mm.

In the British Museum, 68.5–20.19. Acquired from the Pulsky Collection in 1868.

PALAMEDES (?). A nude youth, in a crouching position, with head bent, and holding a staff in his left hand, is apparently absorbed in playing with little stones, of which three are visible on the stand in front of him. Perhaps Palamedes inventing the game of draughts so popular with the Greeks. Hatched border and marginal ornament.

End of fifth century B.C.

Furtwängler, *A.G.*, pl. XVII, 19.
Walters, *Cat.*, no. 630, pl. XI.

839. *Carnelian scarab.* 19 × 14 mm.

Found at Vulci. In the Staatliche Museen, Berlin. Acquired from the Campanari Collection in 1842. Formerly in the possession of the Principe Canino.

TYDEUS, wounded. He is shown sinking to his knees, with both legs off the ground. His sword is still in his right hand, and the shield strapped to his left arm, but his helmet has fallen from his head. He is bearded, nude, and has short, straight hair. The trunk is frontal, the head in profile to the right, the arms and legs also mostly in profile, except the left foot, which is frontal. The helmet is in three-quarter view, with the crest in profile. In the field the Etruscan inscription *Tute*, Tydeus. Hatched border.

Middle of the fifth century B.C., or shortly afterwards. Careful work.

Micali, *Storia*, III, pl. 116, 3.
Fabretti, *C.I. It.*, pl. 40, no. 2155.
Furtwängler, *Beschreibung*, no. 204.
Lippold, *Gemmen und Kameen*, pl. 46, no. 6.

840. *Carnelian scarab*, mounted in an ancient gold swivel ring. 15 × 11 mm.

In the Cabinet des Médailles. Gift of the duc de Luynes in 1862 (no. 271).

TYDEUS, falling backward. His shield is strapped to his arm; from his other hand the curved sword has fallen. The trunk is shown in front view, the rest more or less in profile. Hatched border and marginal ornament.

Early fifth century B.C.

Pierres gravées, Guide du visiteur (1930), pl. 141, no. 271 (not ill.).

841. *Agate scarab*, burnt. 13 × 10 mm.

In the British Museum, Blacas 369. From the Micali and Blacas Collections.

TYDEUS, struck by an arrow in his right leg, is collapsing. Blood is trickling down from his wound. His shield is still strapped on his left arm. He is nude and has short, closely adhering hair. He is shown in profile, with the trunk in slight three-quarter view. In the field is the Etruscan inscription *Tute*, Tydeus. The object behind the upper right leg is probably intended for a rock. Dotted border and marginal ornament.

Second half of the fifth century B.C.

Micali, *L'Italia avanti il dominio dei Romani*, II, p. 172; *Ant. Monum.*, pl. 54, fig. 1.
Furtwängler, *A.G.*, pl. XVII 30.
Lippold, *Gemmen und Kameen*, pl. XLVI, 11.
Walters, *Cat.*, no. 628, pl. XI.

842. *Carnelian scarab*. Mounted in a modern ring. 19 × 12 mm.

In the Fitzwilliam Museum, Cambridge. Bequeathed by Shannon in 1937, no. 12 (13). From the Baron de Sivry's Collection.

TYDEUS, struck in his right leg by an arrow, is collapsing. Blood is streaming from his wound. His shield is still strapped to his left arm, but his hands are loosing their hold. He is shown in profile to the right, with the trunk in slight three-quarter view. In the field the Etruscan inscription *Tute*, Tydeus. Hatched border.

Closely similar to no. 841.

King, *Ancient Gems and Rings*.
Sale Catalogue of the Newton Robinson Collection, no. 103, pl. III.

843. *Agate scarab*, mounted in a modern gold ring. 13·5 × 10 mm.

In the Cabinet des Médailles. Gift of the duc de Luynes in 1862 (no. 270).

TYDEUS, collapsing, with knees bent, and trying with his right hand to extract the spear (shown broken), which has entered his side; a shield is strapped to his left arm. He is nude, bearded, and has short, straight hair. The trunk and left upper leg are shown frontal, the rest in profile. Hatched border and marginal ornament.
Second half of the fifth century B.C.

Pierres gravées, Guide du visiteur (1930), p. 141, no. 270 (not ill.).

844. *Sardonyx scarab*. The engraving is carved in the bottom, dark layer of the stone. 10 × 13 mm.

In the Staatliche Museen, Berlin. From the collection of E. Gerhard.
On the back of the beetle is carved an Egyptian Canopus, in Egyptian style, 'evidently a late addition' (Furtwängler).

HELMETED YOUTH, carrying an open-mouthed, severed head in one hand, and holding his spear in the other; his sheathed sword and shield are on the ground. He is walking to the left, with his trunk in three-quarter view, the head in profile to the right. The severed head is in profile to the left. Hatched border.

About 460–450 B.C.

The figure has been interpreted as Tydeus with the head of Melanippos; but, as Furtwängler pointed out, according to the legend, Tydeus, after receiving Melanippos' head from Amphiaraos, swallowed the brain – whereupon Athena, who had come to heal him of his wound, left in disgust. None of these particulars is here shown. So either Amphiaraos is represented bringing the head of Melanippos to Tydeus; or we have here, as is so often the case, an Etruscan confusion of a Greek legend; or, again, the representation is an every-day scene of a warrior with the head of an enemy. It is also possible that Perseus with the head of Medusa is intended, though he is seldom shown as a warrior (cf. Furtwängler, *A.G.*, text to pl. XXI, 32).

Bull. dell'Inst., 1839, p. 102, no. 28.
Furtwängler, *Beschreibung*, no. 209; *A.G.*, pl. XXI, 32.
Lippold, *Gemmen und Kameen*, pl. 47, no. 7.

(δ) *Various other Legends*

845. *Carnelian scarab*. 16 × 12 mm.

In the British Museum, 72.6–4.1166. Acquired from the Castellani Collection in 1872. Once in the Corelli Collection.

JASON, about to embark on the ship Argo. His petasos is hanging behind his head and a chlamys is wound round his left arm. The upper part of his body is frontal, the rest in profile. Of the ship only the stern and the steering-paddle are indicated. In the field is the Etruscan inscription *Easun*, Jason. Hatched border and marginal ornament.

Fifth century B.C.

Heydemann, *Bull. dell'Inst.*, 1869, p. 55, no. 1.
Micali, *Storia*, pl. 116, fig. 2.
Fabretti, *C.I.I.*, pl. XLIV, no. 2520, and 1st Suppl., p. 81, no. 464.
Walters, *Cat.*, no. 669, pl. XI.

846. *Opaque sard scarab*. 16 × 11·5 mm.

In the Museum of Fine Arts, Boston, 21.1203. Formerly in the Bruschi Collection, Corneto (Tarquinia), then in that of E. P. Warren, who bought it in 1896.

JASON, with helmet, sword, and shield, is issuing from, or being swallowed by, the dragon. The latter is in the form of an enormous snake, with teeth showing in its open mouth. The muscles of Jason's rectus abdominis and the lower boundary of the thorax are prominently marked. Hatched border and marginal ornament.

Second quarter of the fifth century B.C.

Furtwängler, *A.G.*, pl. LXI, 24.
Beazley, *Lewes House Gems*, no. 46, pl. 3.
Lippold, *Gemmen und Kameen*, pl. 48, no. 8.

847. *Carnelian scarab*, burnt. Mounted in a modern gold ring. 20 × 10 mm.

In the Cabinet des Médailles. Gift of the duc de Luynes in 1862 (no. 268).

JASON FIGHTING THE DRAGON. He has grasped the monster with one hand and is plunging his sword into its neck with the other. His trunk is in three-quarter back view, the head and legs in profile. Hatched border and marginal ornament.

Fourth century B.C.

Pierres gravées, Guide du visiteur (1930), p. 140, no. 268 (not ill.).

848. *Green glass ringstone*, mounted in a modern gold ring. 14 × 18 mm.

In the Cabinet des Médailles. Gift of the duc de Luynes in 1862 (no. 183).

JASON, standing in front of a tree, from a branch of which hangs the golden fleece, and round which a serpent is coiled. At the foot of the tree is an altar, on which is a ram's head. Jason wears a helmet and a chlamys, fastened at his neck and hanging down his back. One hand is raised, with fingers extended, with the other he holds his spear and shield. Ground line.
For a replica, in the British Museum, cf. Walters, *Cat.*, no. 1135 (not ill.). Similar also are the stones in Berlin, Furtwängler, *Beschreibung*, nos. 873–875.

Late Etruscan or Italic.

Babelon, *Cabinet des antiques*, 1888, pl. XLVII, no. 12.

849. *Carnelian scarab*, mounted in a gold ring. 11 × 16 mm.

In the Cabinet des Médailles. Gift of the duc de Luynes in 1862 (no. 261).

PHAETHON. He has fallen from his chariot, and is seen lying on the ground in front view, with one arm raised. The horses are drawn in various directions: the one in front, in profile, is plunging down; of another only the profile head and hindquarters are visible; of a third only the profile head and neck; and of the fourth only the hindquarters in back view. The chariot is drawn in curious perspective, with one wheel behind the other. The general confusion is admirably conveyed. Hatched border and marginal ornament.

Second half of the fifth century B.C.

Pierres gravées, Guide du visiteur (1930), p. 139, no. 261 (not ill.).

850. *Carnelian scarab*. 14 × 10 mm.

In the British Museum, 65.7-12.102. Acquired from the Castellani Collection in 1865. Formerly in the Caralli Collection.

PHAETHON. The four-horse chariot is seen with its several parts separated: the charioteer, Phaethon, a small figure with arms extended; the diminutive chariot with its six-spoked wheel; and four large horses placed in two different directions. Hatched border. No marginal ornament.

Second half of the fifth century B.C.

Micali, *Storia*, III, pl. 117, fig. 2.
Imhoof-Blumer and Keller, pl. 16, fig. 75.
Furtwängler, *A.G.*, pl. XVII, 65.
Nachod, *Rennwagen bei den Italikern*, p. 54, no. 51.
Walters, *Cat.*, no. 679, pl. XII.

851. *Carnelian scarab*, 18 × 13 mm.

In the British Museum, 98.7-15.6. Bought 1898. Formerly in the Gerhard, Hertz, and Morrison Collections.

LAOKOON and his two sons attacked by three serpents. Laokoon, bearded, has his left arm round the body of the son on the right, while his right hand is raised to the head of the serpent that is biting his head. A second serpent's head is seen near the calf of the son on the left, and a third head is near the left hand of Laokoon. Hatched border and marginal ornament.
As the stone seems to be datable in the fourth century B.C., it should give us the earliest extant representation of the myth. It is noteworthy that the composition is quite different from that in the Vatican group. Perhaps on that account it was at one time considered suspect; but it was reinstated by Furtwängler. Recently, however, it has again been questioned, with new arguments, by J. Uggeri (*loc. cit.*).
I have discussed the problem with my colleagues in the British Museum, Mr. & Mrs. Denys Haynes, R. Higgins, and D. Strong. They are still inclined to believe in the genuineness of the stone, or at least to give it the benefit of the doubt. The occasionally odd features in the representation are not surprising in a late Etruscan work. Moreover, the carving of the scarab seems convincingly ancient. And would not a modern forger have been more likely to copy the Vatican group, as did the artist of the stone in the Cabinet des Médailles, Chabouillet, *Cat.*, no. 2389 (= my vol. II, no. 752)?

Cat. of the Hertz Coll., 1851, p. 115.
Gerhard, *Arch. Ztg.,* 1851, p. 95, and 1863, p. 95, note.
King, *Arch. Journal,* XXIV, 1867, pp. 46 ff.
Foerster, *J.d.I.,* XXI, 1906, pp. 14 ff., fig. 6.
Hertz Sale Cat., no. 718.
Morrison Sale Cat., pl. I, 54.
Furtwängler, *A.G.,* pl. LXIV, 30, and vol. III, pp. 205, 239, 450.
Walters, *Cat.,* no. 673, pl. XI.
Uggeri, *La Parola del Passato,* LXXX, 1961, pp. 386 ff. (there considered modern).

852. *Carnelian scarab.* 13 × 9 mm.

In the British Museum, 72.6–4.1168. Acquired from the Castellani Collection in 1872. Formerly in the Vannutelli Collection.

ATLAS (?). A nude, bearded man is crouching with legs bent and both arms raised, as if to support something (the vault of heaven (?)). The large, round object on which he seems to be sitting is probably intended for a rock. The pouch-like object with long handle (?) in front of him, on which his foot rests, I am not able to identify. Dotted border and marginal ornament.

Second half of the fifth century B.C.

Walters, *Cat.,* no. 616, pl. XI.

853. *Brown chalcedony scarab.* 19 × 15 mm.

From Lentinelli, Sicily. In the British Museum, 72.6–4.1144. Acquired from the Castellani Collection, 1872.

THE PUNISHMENT OF IXION. He is shown in front view, with head and right leg in profile, and both wrists tied to the rim of a large wheel behind him. He is nude and bearded. In the field the Etruscan inscription, *Ichsiun,* Ixion. Hatched border and marginal ornament.

Fifth century B.C.

Heydemann, *Bull. dell'Inst.,* 1869, p. 55, no. 3.
Furtwängler, *A.G.,* pl. XVIII, 10, and vol. III, p. 177.
Walters, *Cat.,* no. 619, pl. XI.

854. *Carnelian scarab.* 16 × 13 mm.

From Cortona. In the British Museum, 65.7–12.97. Acquired from the Castellani Collection in 1865.

PERSEUS, cutting off Medusa's head with his curved sword (harpe). He is stooping over her, holding the hilt of the sword in his right hand and with his left placing the blade in the right position. He wears a winged hat and has a chlamys falling down his back. Medusa has sunk on her knees, and tries to avert Perseus' right hand with one hand, while in the other she holds a snake. She has human form and wears a long, sleeved chiton as well as

the short himation, diagonally draped, current in the late archaic period. Thick ground line decorated with a tongue pattern. Dotted border and marginal ornament. The unnatural position of Perseus' body, with the right leg in profile to the left and the action to the right, is characteristic of Etruscan representations in the late archaic period.

Braun, *Annali dell'Inst.,* 1858, p. 386; *Mon. dell'Inst.,* VI, pl. XXIV, 3.
Loeschke, *Die Enthauptung Medusas,* p. 12.
Furtwängler, *A.G.,* pl. XX, 22, pl. LI, 13, and vol. III, pp. 181 f., 184.
Lippold, *Gemmen und Kameen,* pl. XLVII, 4.
Walters, *Cat.,* no. 623, pl. XI.

855. *Carnelian scarab.* 13 × 11 mm.

In the Staatliche Museen, Berlin.

PERSEUS, beardless, nude, with wings on his feet, standing in front view, with head in profile to the right; in one hand he holds the severed head of Medusa, in the other the harpe; his wallet (kibisis) is hanging from his left arm. He has just performed his deed, for drops of blood are still trickling from the head of Medusa. The latter is shown in profile view, and is of purely human form, without the customary snakes. In the field is the Etruscan inscription *Pherse,* Perseus. Hatched border and marginal ornament.

First half of the fifth century.

A vivid Etruscan rendering of this familiar Greek legend.

Winckelmann, *Mon. ined.,* no. 84, p. 112.
Köhler, *Gesammelte Schriften,* V, p. 151.
Fabretti, *C.I. It.,* no. 2550.
Furtwängler, *Beschreibung,* no. 201; *A.G.,* pl. XVIII, 9.
Lippold, *Gemmen und Kameen,* pl. 47, no. 5.

856. *Carnelian scarab.* 14 × 10 mm.

In the British Museum, Blacas, 265. From the Laurenti and Blacas Collections.

TANTALOS (?). A beardless man is stooping, with both arms outstretched toward the water below him, indicated by a wavy pattern. Perhaps the punishment of Tantalos in Hades is intended – shown stretching out everlastingly to the water that evades his grasp. Hatched border and marginal ornament.

Second half of the fifth century B.C.

Micali, *Storia,* III, pl. 116, fig. 9.
King, *Arch. Journal,* XXIV, 1867, p. 212; *Antique Gems and Rings,* II, pl. XLI B, fig. 7, p. 64; *Handbook,* pl. 66, fig. 3, p. 235.

Müller-Wieseler, *Denkmäler*, pl. 69, no. 865.
Furtwängler, *A.G.*, pl. XVII, 35.
Lippold, *Gemmen und Kameen*, pl. XLV, 9.
Walters, *Cat.*, no. 618, pl. XI.

857. *Carnelian scarab.* 15 × 12 mm.

In the British Museum, Blacas 112. From the Blacas Collection.

YOUTH KNEELING ON A TORTOISE, to which he is holding out a twig. He has short, straight hair, and wears a chlamys down his back. Hatched border and marginal ornament.

Second half of the fifth century B.C.

Representations of a man riding on a turtle occur on vases, bronzes, gems, all from Italy, as well as on the sixth-century metope from Foce del Sele. For lists of the extant examples cf. Zancani Montuoro and Zanotti-Bianco, *Heraion*, II, pp. 307 ff., and my *Cat. of the New York Engraved Gems* (1956), no. 433 – to which add De Ridder, *Collection de Clercq*, VII, 2, no. 3041.
As the provenances of all the extant examples are Italian, the scenes may represent a mythical founder of a Greek colony in Italy (Phalanthos (?)); or Odysseus (?), cf. Zancani, *loc. cit.*; or it may refer to a lost legend (?), cf. Furtwängler, *A.G.*, vol. II, text on no. 60 of pl. XVII.

King, *Arch. Journal*, XXIV, 1867, p. 212.
Furtwängler, *A.G.*, pl. XVII, 54, and vol. III, p. 207.
Walters, *Cat.*, no. 693, pl. XII.
Lippold, *Gemmen und Kameen*, pl. 49, no. 14.

858. *Carnelian scarab.* 11 × 14 mm.

In the Staatliche Museen, Berlin; acquired 1887. Once in the Tyszkiewicz Collection.

KASTOR, wounded by an arrow. He has sunk on both knees on a mound of earth, and is supporting himself with one hand, while with the other he tries to extract the arrow in his back. He is shown in profile to the right, with his trunk in three-quarter view. In the field is the Etruscan inscription *Castur*, Kastor. Hatched border.

Middle of the fifth century, or a little later.

The body is finely modelled in developed style, approximating the Greek in execution.
This is apparently the only extant representation of the killing of Kastor by Lynkeus, or Idas, sons of Aphareus, during their quarrel about a herd of cattle, as told in the *Kypria* (frgt. 8, ed. Kink); Pindar, *Nem.*, IX, 112 ff.; Apollodoros, III, 11, 3 ff. It is, therefore, one of the instances in which a Greek legend is preserved only on an Etruscan gem-engraving.

Furtwängler, *Beschreibung*, no. 202.

859. *Carnelian scarab.* 15 × 11 mm.

In the British Museum, Blacas, 425. Formerly in the Laurenti and Blacas Collections.

SCENE OF DEPARTURE. Protesilaos and Laodemeia (?). A figure (man or woman (?)), wrapped in a mantle, is sitting on a diphros, while a man, wearing helmet and greaves, and carrying shield and spear, is moving away, with head turned back.
In the field the Etruscan inscription *Laor*. Ground line. Hatched border and marginal ornament.

First quarter of the fifth century B.C.

The scene used to be interpreted as Protesilaos leaving Laodemeia (the inscription being read *Laod* instead of *Laor*); but Furtwängler thought that the seated figure was male and the subject a simple scene of departure. With the known preference of the Etruscans for mythological rather than daily life scenes (cf. p. 180), it would, however, seem possible that the representation is a confused version of the popular myth of Protesilaos and Laodemeia.

Bull. dell'Inst., 1839, p. 102, no. 34.
Inghirami, *Galleria omerica*, II (1829), pl. 177.
Furtwängler, *A.G.*, pl. XVI, 31, and vol. III, p. 194.
Fabretti, *C.I. Ital.*, no. 2524 bis.
Walters, *Cat.*, no. 641.
Lippold, *Gemmen und Kameen*, pl. 52, no. 3.

860. *Carnelian scarab.* 13 × 10 mm.

Found in 1800 at Piscelle, near Perugia. In the British Museum, 49.6–23.5. Acquired at the Stewart Sale in 1849.

ATHLETE (Tarquinius). He is moving to the left, with head turned back, a jumping weight in each hand. The upper part of his body is frontal, the rest in profile. In the field is the Etruscan inscription *Tarchnas* = Tarquinius. Hatched border, and marginal ornament.

Late archaic period.

A Greek athlete is converted into an Etruscan king by the inscription (?).

Vermiglioli, *Iscrizioni perugine*, 2nd ed. (1833), p. 81, pl. 5, no. 2.
Fabretti, *C.I. Ital.*, pl. 36, no. 1074.
Micali, *Storia*, III, pl. 116, no. 6.
Furtwängler, *A.G.*, pl. XVI, 41.
Walters, *Cat.*, no. 643, pl. XI.

861. *Carnelian scarab*, mounted in a modern gold ring. 18 × 13 mm.

In the Cabinet des Médailles. Gift of the duc de Luynes in 1862 (no. 276).

AENEAS CARRYING ANCHISES on his left shoulder. Aeneas, nude, is in a half-kneeling position and holds a spear in one hand, a shield in the other. Anchises is shown as a venerable, bearded man, with a mantle draped over his shoulders, and with one hand grasping the shaft of Aeneas' spear, in the other holding up a fluted phiale – evidently one of the family treasures he was able to carry with him. The trunks of both men are shown in slight three-quarter views, the heads and limbs in profile. Aeneas' shield is seen from the inside, with its various handles clearly marked. Hatched border and marginal ornament.

First half of the fifth century B.C.

E. Babelon, *Cabinet des antiques*, pl. 56, 11.
Furtwängler, *A.G.*, pl. XX, 5.
Pierres gravées, Guide du visiteur (1930), p. 142, no. 276 (not ill.).

862. *Carnelian scarab.* 17 × 14 mm.

In the British Museum, H366. From the Hamilton Collection.

WINGED MALE FIGURE, holding what seem to be an adze in one hand and a frame-saw in the other, is flying over the sea, with knees bent and head thrown back. Below is a wavy pattern to indicate the water, and the Etruscan inscription *Teitle* or *Ipitle*. Hatched border and marginal ornament.

First half of the fifth century B.C.

The figure has been interpreted as Daidalos, but the inscription fits neither Daidalos nor Ikaros. Perhaps this is an Etruscan version of the legend, or one of the daemons versed in handicraft is intended; cf. on this general subject Furtwängler, *J.d.I.*, VI, 1891, pp. 123 f., and *A.G.*, vol. III, p. 240.

Raspe, no. 8736.
King, *Antique Gems and Rings*, I, p. 136 (ill.).
Koehler, *Gesammelte Schriften*, V, p. 171, no. XXII.
Walters, *Cat.*, no. 663, pl. XI.

863. *Carnelian scarab.* 14 × 11 mm.

In the British Museum. From the Blacas Collection.

WINGED MALE FIGURE, rushing to the right. In the right hand he holds what looks like a saw, in the left a hooked instrument. Hatched border and marginal ornament.

The figure has been variously interpreted – as Daidalos, Ikaros, and a daemon. If Eros is intended he has unusual attributes. If Daidalos, he seems somewhat young. If Ikaros, he is carrying Daidalos' tools. Perhaps the best

guess is after all Daidalos – in a common Etruscan confusion.

Rossbach, *D.L.Z.*, X, 1889, col. 750 ('Eros mit Pedum und Falle').
Furtwängler, *A.G.*, pl. IX, 26 ('geflügelter Dämon mit gekrümmtem Pedum und Falle').
Lippold, *Gemmen und Kameen*, pl. XXV, 7 ('Eros mit Pedum und Falle').
Walters, *Cat.*, no. 727, pl. XII ('Daidalos with hooked instrument and saw').

864. *Carnelian scarab.* Slightly chipped round the edge. 15 × 12 mm.

In the Ashmolean Museum, 1936.5. Gift of Mrs. Leslie Milne.

OIDIPOUS AND THE SPHINX. He is standing in profile to the right, with right hand raised, evidently talking to the sphinx, which is perched on a rock in front of him. He is bearded and wears a mantle over his left shoulder. Hatched border and short ground line under Oidipous' right foot.

Fifth to fourth century B.C.

865. *Banded agate scarab*, with gold attachments. Cracked down the middle. 15 × 12 mm.

In the British Museum. Acquired in 1966. Said by the vendor to have been bought in Rome by his father early in the twentieth century.

PROMETHEUS AND THE EAGLE. Prometheus is seated on a rock, with legs outstretched, arms raised, and hands bound, while the eagle is pecking at his chest. The trunk of Prometheus is in three-quarter view, the head almost frontal. Hatched border and marginal border of tongues. The scarab is carefully worked. Near the head seem to be remains of an inscription: PR (*Prumathe* = Etruscan for Prometheus) – or are they mere scratches?

First quarter of the fifth century B.C., perhaps around 490. Greek in style.

The stone was evidently used as the pendant of a necklace; cf., e.g., Marshall, *Cat. of Finger Rings, British Museum*, no. 2273.

On representations of the punishment of Prometheus cf. especially Milchhöfer, 'Die Befreiung des Prometheus', 42. *Winckelmannsprogramm*, 1882; Furtwängler, *A.G.*, vol. III, pp. 73, 204 f., 344, and the references there cited; E. Paribeni, *Enc. dell'Arte Antica*, VI, 1965, s.v. Prometeo, pp. 485 ff.

In ancient art Prometheus appears from the seventh century B.C. down. The engraving on this scarab is perhaps the finest extant. The agony of Prometheus is

movingly depicted – in the restrained early manner – by the half-closed eyes and distorted mouth.

Richter, *The British Museum Quarterly*, XXXII, 1967, pp. 6 ff.

866. *Carnelian scarab*, mounted in a modern swivel ring. 23 × 18 mm.

In the Cabinet des Médailles, Paris. Gift of the duc de Luynes in 1862 (no. 273).

THE SEER POLYIDOS, pulling the body of Glaukos out of the pithos filled with honey (?). According to this interpretation, first advanced by Babelon, the figures to the right and left of the pithos would be the parents of Glaukos, that is, Minos and Pasiphae. All three wear mantles, Pasiphae also has a chiton. Of Glaukos only the head and one arm appear. Ground line, hatched border, and hatched exergue.

Fourth century B.C.

For the myth cf. Bernert, in *R.E.*, XI, 2, s.v. Polyidos, cols. 1653 f., and for representations of it in Greek art col. 1656.
Furtwängler, *loc. cit.*, doubted the interpretation of Polyidos and Glaukos on several gems, including this one; but here the presence of 'Minos' and 'Pasiphae', and the fact that the boy is actually being pulled out of the pithos by the arm would seem to make the interpretation probable. Cf. also Chabouillet, *Collection Fould* (1861), no. 1047; Gaedechens, *Arch. Zeitung*, 1860, p. 69; J. Zingerle, *Archaeologisch-epigraphische Mitt. aus Oesterreich-Ungarn*, XVII, 1894, p. 120.

Babelon, *Cabinet des Antiques*, pl. V, 11; *La gravure*, p. 109, fig. 77; *A.J.A.*, II, 1886, p. 288, pl. VII, 5.
Furtwängler, *A.G.*, text to pl. XXII, 17.
Pierres gravées, Guide du visiteur (1930), p. 112, pl. XXXI.

867. *Blackish-gray chalcedony scarab*, mounted in a gold ring. 10 × 15 mm.

In the Louvre, Bj 1204. Acquired from the Campana Collection in 1862.

BELLEROPHON AND THE CHIMAERA (?). He is riding a wingless horse to the right, holding the reins in one hand and a spear in the other. Below is an animal, in the form, it would seem, of a lion, but without the goat's head that regularly appears in Pegasos. Hatched border and marginal ornament.

Second half of the fifth century B.C.

The absence of the wings in Pegasos and of the goat's head in the chimaera may be explained as due to an Etruscan confusion; for the composition closely parallels the Greek representations of Bellerophon killing the chimaera.

De Ridder, *Bijoux antiques*, no. 1204.

868. *Carnelian scarab*. 20 × 14 mm.

In the British Museum, H406. From the Hamilton Collection.

PEGASOS, rearing. He has a string of beads round his neck. Below is a swan looking up at him; above is a crescent. In the field are modern letters: ΔOSAX. Hatched border and marginal ornament.

Fifth to fourth century B.C.

Raspe, no. 9076.
Koehler, *Gesammelte Schriften*, V, p. 192.
Walters, *Cat.*, no. 715, pl. XII.

869. *Banded onyx scarab*. 18 × 15 mm.

In the British Museum, 1923.4–1.24.

PSYCHE, with butterfly wings, is seated on a diphros, in a sad, pensive attitude, her head supported on her left hand. The head and the upper part of the body are nearly frontal, the rest is more or less in profile. Only three of the four legs of the diphros are indicated. Psyche wears a chiton, and a himation round the lower part of her body. In the field is a bow, evidently an allusion to Eros, for whose departure she is mourning. Hatched border and marginal ornament.

Late fifth century B.C.

The attitude of Psyche is that signifying mourning, and regularly appears in representations of Penelope and on many grave reliefs.

King, *Antique Gems and Rings*, II, p. 66, pl. 44, fig. 1; *Handbook*, pl. 67, fig. 7, p. 236.
Furtwängler, *A.G.*, pl. XVIII, 25, and vol. III, pp. 186, 202.
Walters, *Cat.*, no. 657, pl. XI.

(g) *Representations in the so-called globolo style, with extensive use of the rounded drill and little indication of detail*

Since this style may be of interest to some artists of today working in 'abstract' art, I have assembled here a group of such representations. First come a few where the style is in the making, then those where it is in its final effective form.

870. *Carnelian scarab.* 10 × 15 mm.

In the Staatliche Museen, Berlin.

HERAKLES, standing in a frontal pose, with arms, right leg, and head in profile to the right and left. Hatched border.

Furtwängler, *Beschreibung,* no. 215.

871. *Carnelian scarab.* 16 × 12 mm.

In the British Museum, H814. From the Hamilton Collection.

BELLEROPHON, riding on Pegasos. He holds the reins in one hand, a spear in the other. Hatched border and marginal ornament.

Walters, *Cat.*, no. 807, pl. XIII.

872. *Obsidian or black jasper scarab.* 22 × 18 mm.

In the British Museum, WT1579. Bequeathed by Sir William Temple in 1856.

FOUR HORSES OR DEER, standing side by side. Four heads and eight forelegs are indicated, but only two hind-legs. Line border. No marginal ornament.

It is not clear whether deer with antlers or horses with topknots and manes are intended.

Walters, *Cat.*, no. 880, pl. XIII.

873. *Carnelian scarab.* 9 × 12 mm.

In the British Museum, H324. From the Hamilton Collection.

KERBEROS, crouching in profile to the left, with its three heads turned to the front. Line border. No marginal ornament.

Walters, *Cat.*, no. 846 (not ill.).

874. *Red jasper scarab,* cut, set in a modern mount. 18 × 13 mm.

In the British Museum, 42.7–19.3. Bought in 1842. Formerly in the Nott Collection.

THREE MEN. Two are seated (on rocks?) opposite each other, with a standing figure between them. Each of the seated figures holds a spear. The inscriptions in the field, giving the names – Aga, for Agamemnon; Men, for Menelaos; and Pat, for Patroklos – are considered to be modern. It is likely, however, that a council of heroes was intended. Hatched border and marginal ornament.

Walters, *Cat.*, no. 836, pl. XIII.

875. *Sard scarab.* 15 × 11 mm.

In the Ashmolean Museum, EFG28. Acquired through the Fortnum bequest.

CENTAUR, in profile to the left, holding a stick or branch in each hand. No border and no marginal ornament.

876. *Carnelian scarab.* 17 × 14 mm.

In the British Museum, WT1576. Bequeathed by Sir William Temple in 1856.

CENTAUR, holding a club in one hand and what may be meant for a spear in the other. Below is a star. No border and no marginal ornament.

Walters, *Cat.*, no. 842 (not ill.).

ILLUSTRATIONS

GREEK GEMS

The original stones are reproduced in actual size and shape. The impressions
are shown on a rectangular background generally enlarged three times.

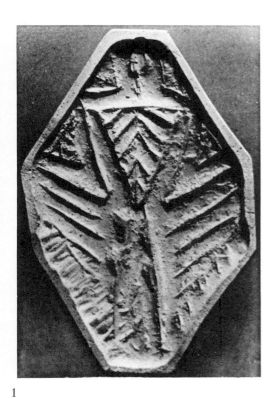

1

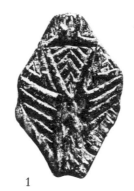

1

4

2

3(2)

4

3(3)

3(2) 3(4)

3(1)

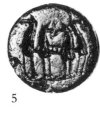

5

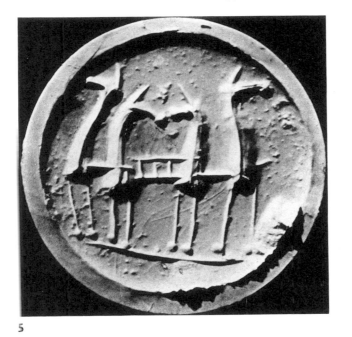

5

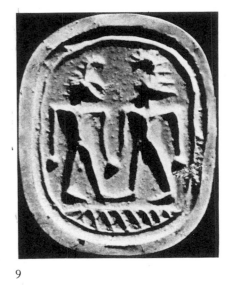

9

GREEK GEMS: GEOMETRIC PERIOD, EIGHTH TO EARLY SEVENTH CENTURY B.C.

6

8(1)

8(2)

8(3)

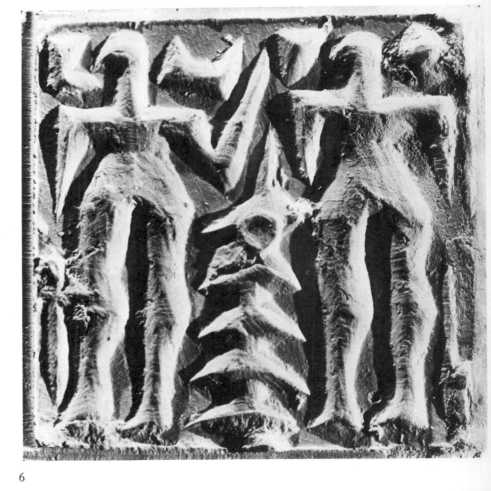

6

11

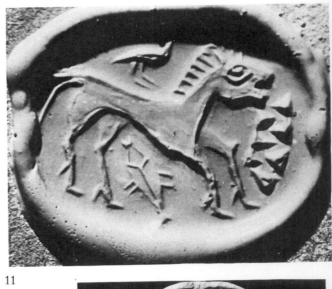

11

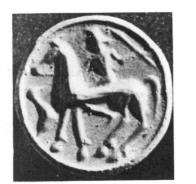

10

10

7

7

GREEK GEMS: GEOMETRIC PERIOD, EIGHTH TO EARLY SEVENTH CENTURY B.C.

12

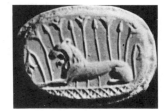

12

13

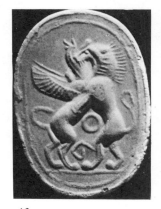

13

14

14

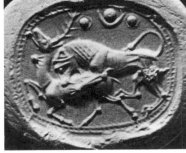

15

15

16

16

17

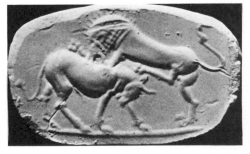

17

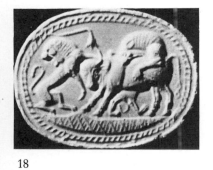

18

18

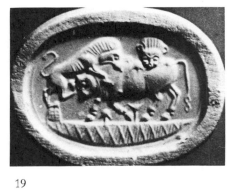

19

19

20

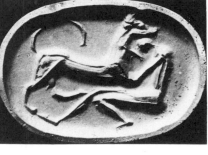

20

21

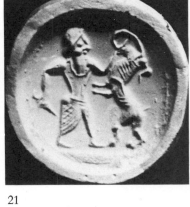

21

GREEK GEMS: PERIOD OF ORIENTAL INFLUENCES, SEVENTH TO EARLY SIXTH CENTURY B.C.

22

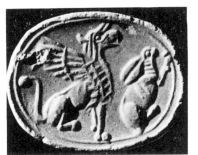

22

23

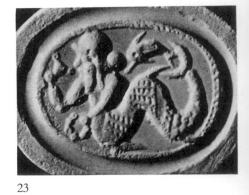

23

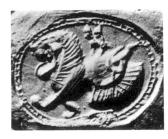

24

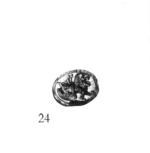

24

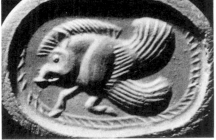

25

25

26

26

27

27

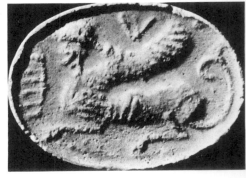

27

28

28

29

29

30

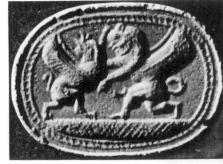

30

31

31

32

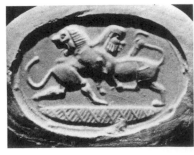

32

GREEK GEMS: PERIOD OF ORIENTAL INFLUENCES, SEVENTH TO SIXTH CENTURY B.C.

33

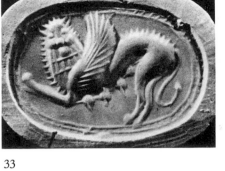

33

34

34

35

35

36

36

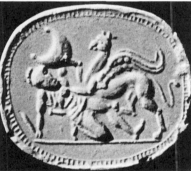

35

37

37

38

38

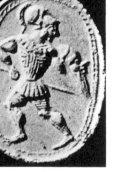

39

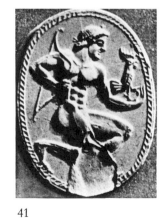

39

40

39

40

41

41

42

42

GREEK GEMS: PERIOD OF ORIENTAL INFLUENCES, MOSTLY EARLY FIFTH CENTURY B.C.

43(1)

43(1)

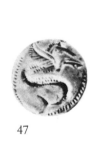

43(2)

43(2)

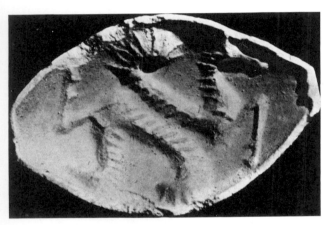

44

44

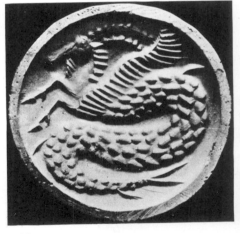

45

45

46(1)

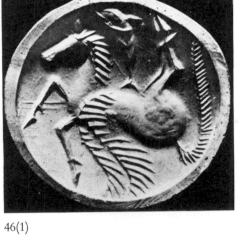

46(1)

46(2)

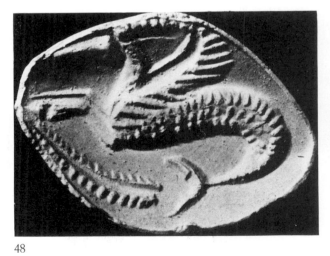

46(2)

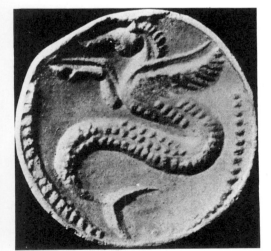

47

47

48

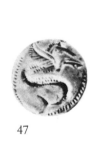

48

ISLAND GEMS, SEVENTH TO SIXTH CENTURY B.C.

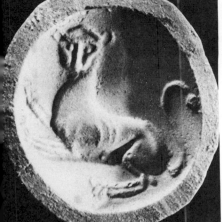

49

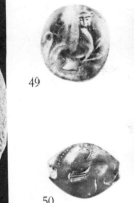

49

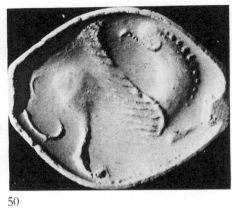

50

50

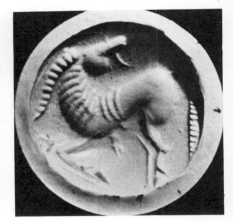

52

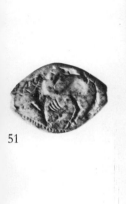

51

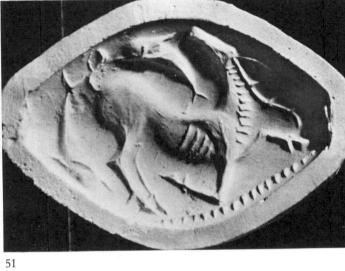

51

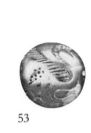

53

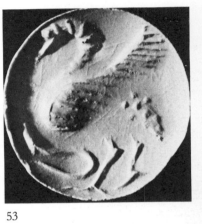

53

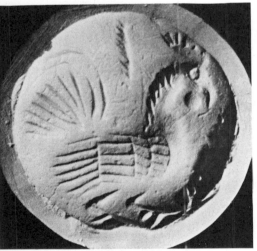

54

54

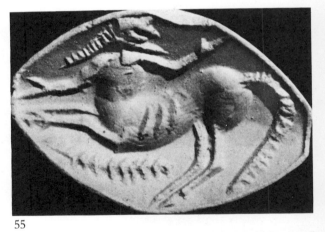

55

55

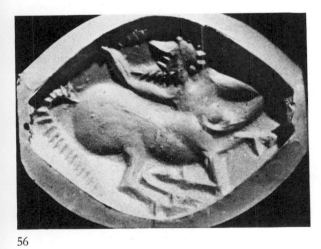

56

57

57

ISLAND GEMS, SEVENTH TO SIXTH CENTURY B.C.

58

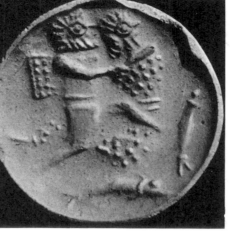

58

59

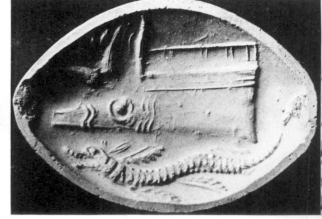

59

60(1)

60(1)

60(2) 60(3)

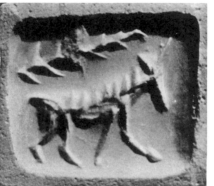

60(3)

60(2)

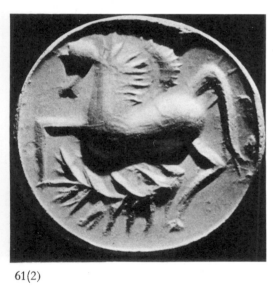

61(2)

61(2) 61(1)

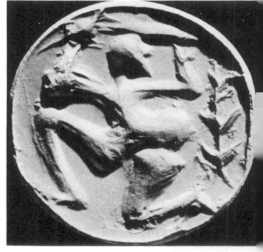

61(1)

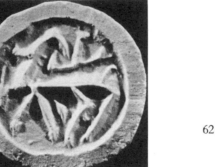

62(1)

62(1)

62(2)

62(2)

ISLAND GEMS, SEVENTH TO SIXTH CENTURY B.C.

63

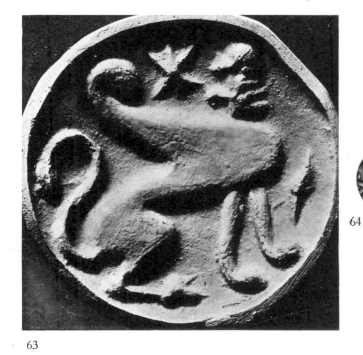

63

64

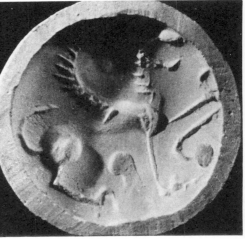

64

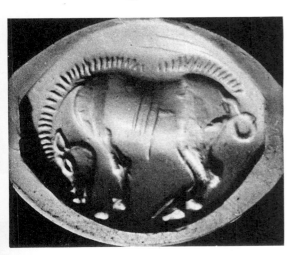

65

66

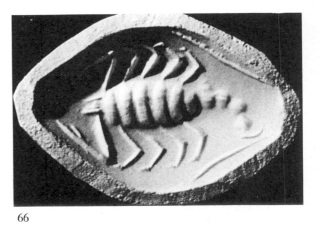

66

67

68

68

69

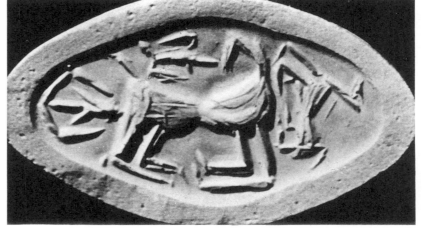

69

ISLAND GEMS, SEVENTH TO SIXTH CENTURY B.C.

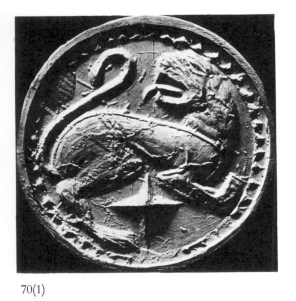

70(1)

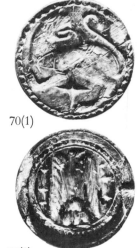

70(1)

70(2)

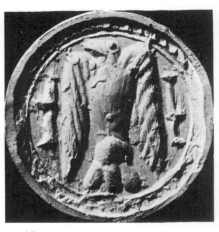

70(2)

71(1)

71(1)

71(2)

71(2)

72(1)

72(1)

72(1)

72(2)

72(2)

76

75(1)

75(2)

IVORY AND BONE DISKS, SEVENTH CENTURY B.C.

79(1)

74(1)

74(2)

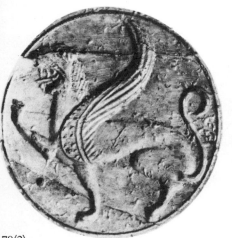

79(2)

77(1)

77(2)

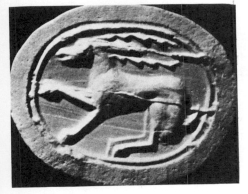

78(1)

78(1) 78(2)

78(3) 78(4)

78(2)

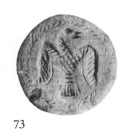

73

78(3)

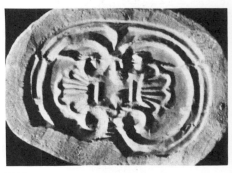

78(4)

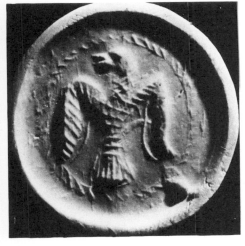

73

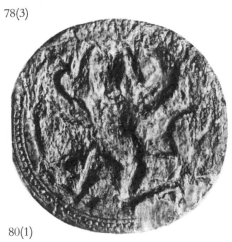

80(1)

80(2)

IVORY AND BONE DISKS, MOSTLY SEVENTH CENTURY B.C.

81

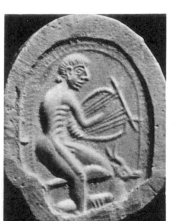

81

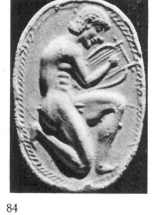

82

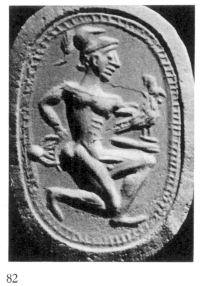

82

83

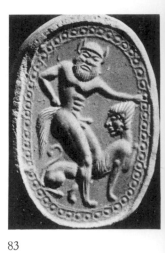

83

84

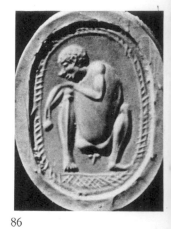

84

85

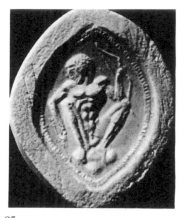

85

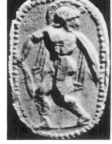

86

87

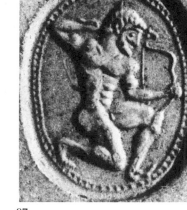

87

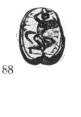

88

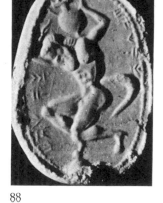

88

89

89

90

90

91

91

92

92

GREEK GEMS: ARCHAIC PERIOD, ABOUT 560–480 B.C.

(a) Nude male figures showing the development in the rendering of the structure of the human body.

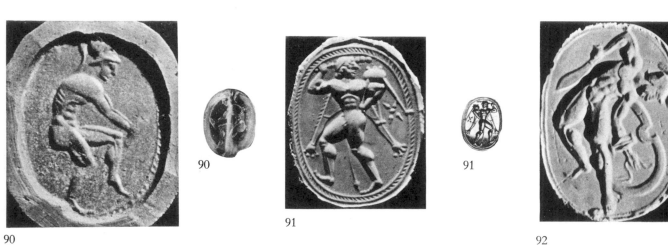

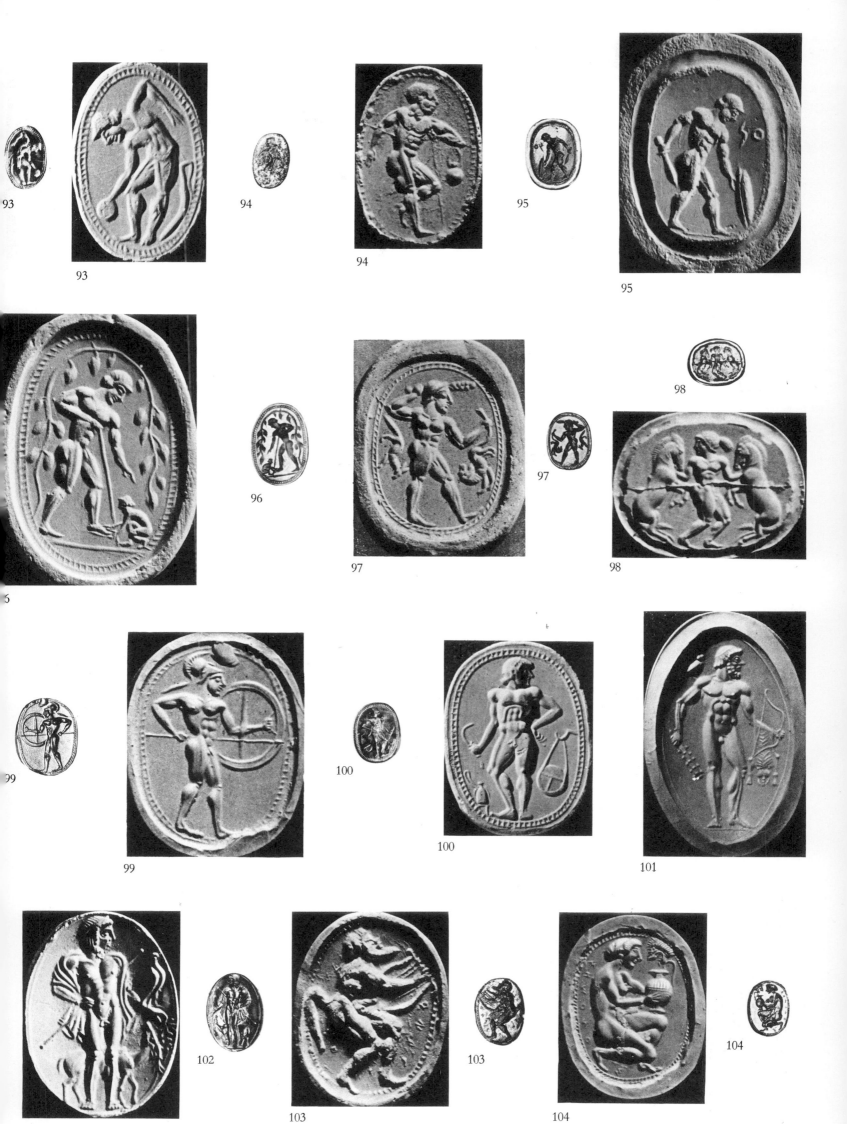

93 94 95

93 94 95

96 98

96 97 98

97

99 100 101

99 100 101

102 103 104

102 103 104

GREEK GEMS: ARCHAIC PERIOD, ABOUT 530–470 B.C.

(a) Nude male figures showing the development in the rendering of the structure of the human body.

106

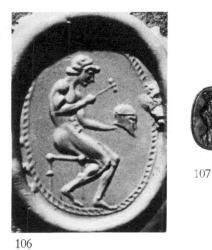

106

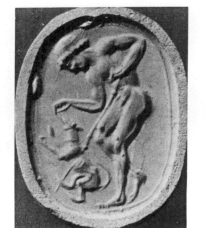

107

108

107

108

105

109

109

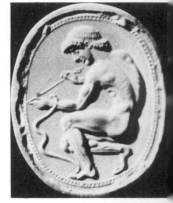

115

115

111

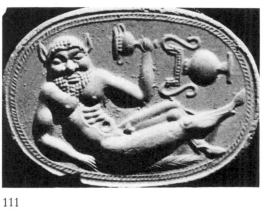

111

112

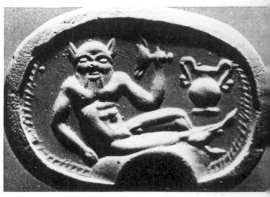

112

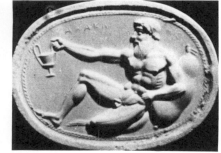

113

113

114

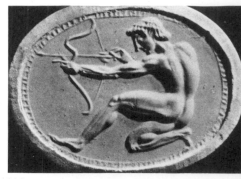

114

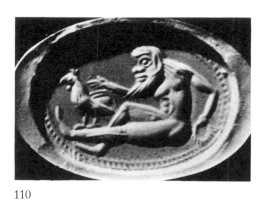

110

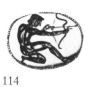

116

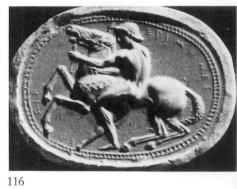

116

GREEK GEMS: ARCHAIC PERIOD, ABOUT 530-480 B.C.

(a) Nude male figures in various poses showing the development in the rendering of the structure of the human body.

117

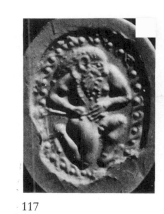

117

117

118

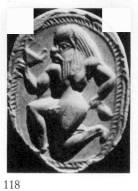

118

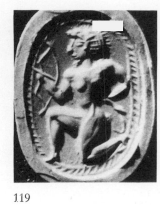

119

120

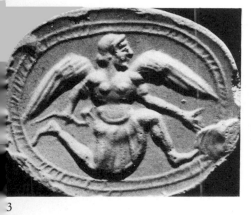

120

121

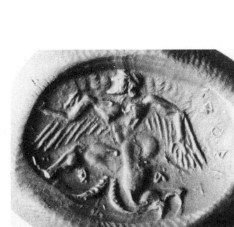

121

121

122

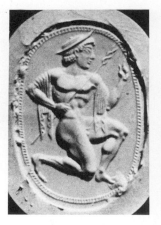

122

123

123

124

125

125

126

126

126

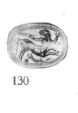

127

127

127

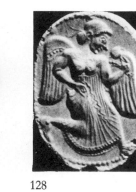

28

128

128

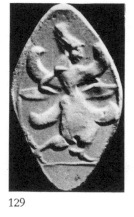

129

129

129

130

130

130

GREEK GEMS: ARCHAIC PERIOD, ABOUT 550–480 B.C.

(b) Figures showing the development in the rendering of rapid motion

131

131

132

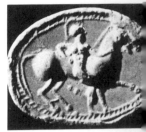

132

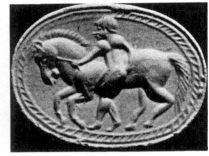

133

133

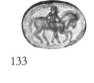

134

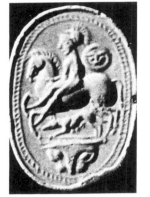

134

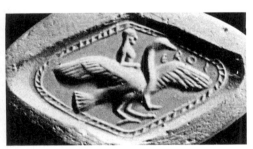

133

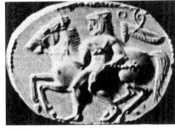

135

136

135

135

136

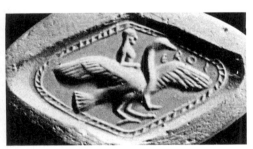

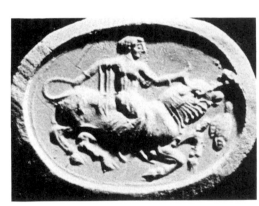

137

137a

137a

137

137

138

138

139

139

140

GREEK GEMS: ARCHAIC PERIOD, ABOUT 550–480 B.C.

(c) Designs showing the development in placing several figures in a composition

141

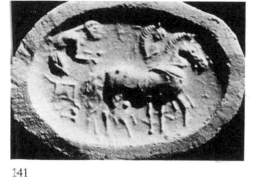

141

142

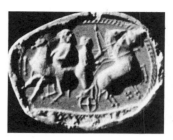

142

143

143

144

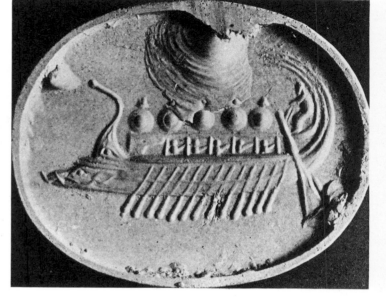

144

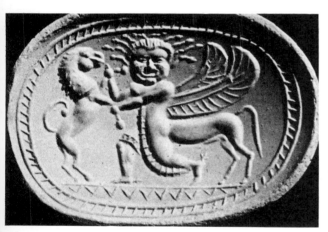

145

145

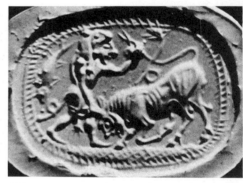

146

147

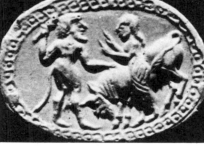

147

148

148

GREEK GEMS: ARCHAIC PERIOD, ABOUT 530–480 B.C.

(c) Designs showing the development in placing several figures in a composition

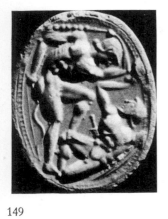

149

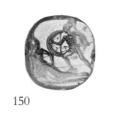

149

150

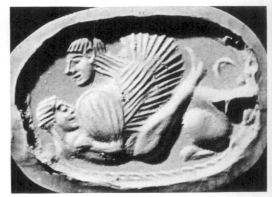

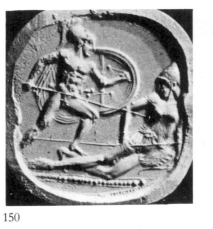

150

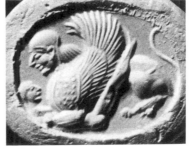

150

153

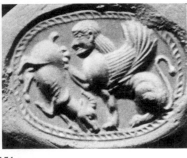

151

151

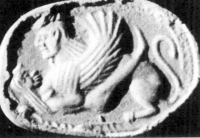

152

152

154

154

155

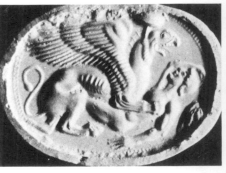

155

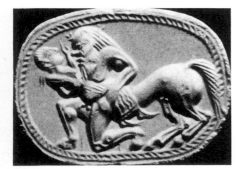

157

157

156

156

158

158

159

159

GREEK GEMS: ARCHAIC PERIOD, ABOUT 550–480 B.C.
(c) Designs showing the development in placing several figures in a composition

160

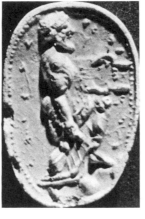

160

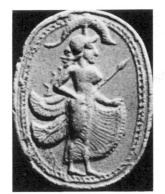

161

161

162

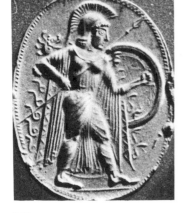

162

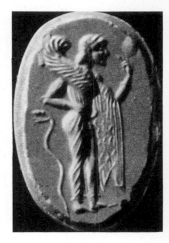

163

163

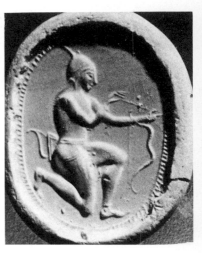

164

164

165

165

166

166

167

167

168

168

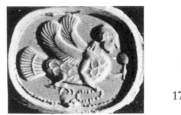

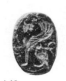

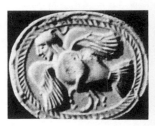

169

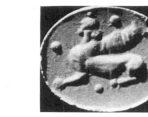

169

170

170

171

171

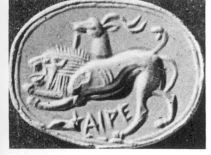

172

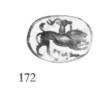

172

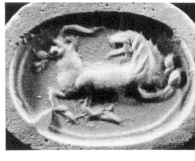

173

173

GREEK GEMS: ARCHAIC PERIOD, ABOUT 530–480 B.C.
(d) Draped figures (160-165)—(e) Heads (166-167)—(f) Monsters (168-173)

174

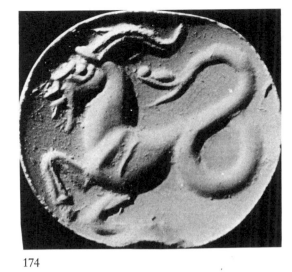

174

175

175

176

176

177

177

178

178

179

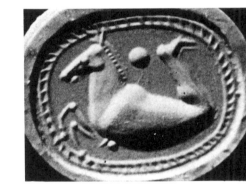

180

181

181

182

182

183

183

184

184

184a

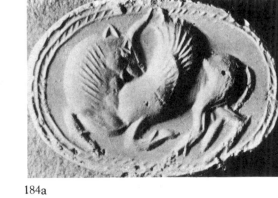

184a

184a

184b (coin)

GREEK GEMS: ARCHAIC PERIOD, ABOUT 530–480 B.C.

(f) Monsters and hybrid figures

185

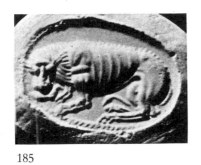

185

186

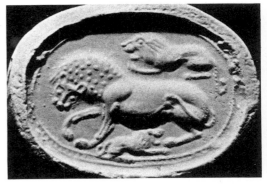

186

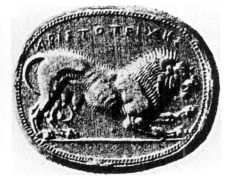

187

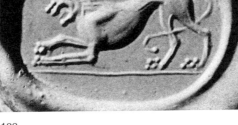

188

188

189

189

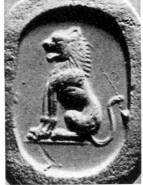

190

190

191

191

191

193

192

193

194

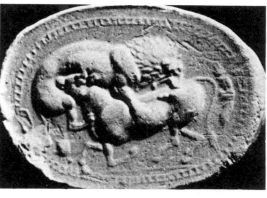

194

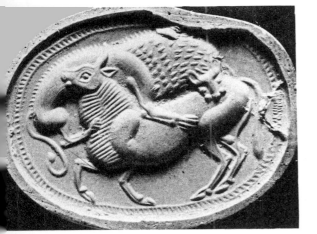

95

195

196

196

GREEK GEMS: ARCHAIC PERIOD, ABOUT 550–480 B.C.

(g) Animals

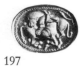

197

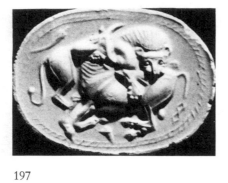

197

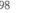

198

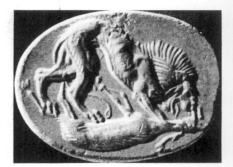

198

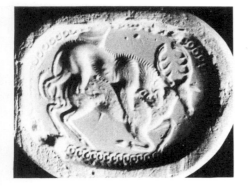

199

199

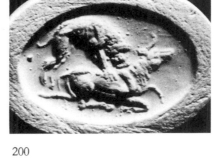

200

200

199

200

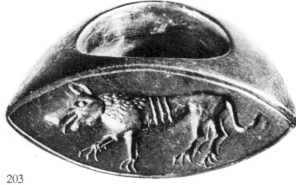

201

201

204

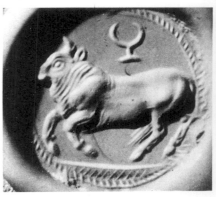

204

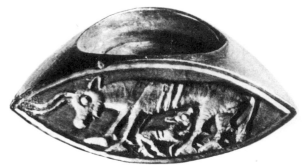

203

202

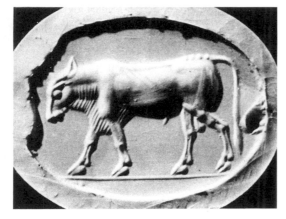

205

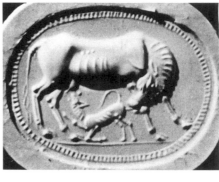

206

GREEK GEMS: ARCHAIC PERIOD, ABOUT 550–475 B.C.

(g) Animals

207

207

208

208

209

209

210

210

210

211

211

211

212

212

212

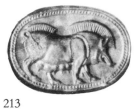
213

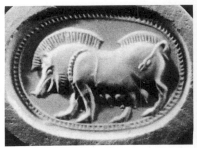
213

213

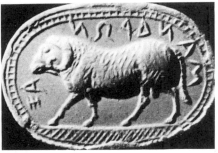
214

214

214

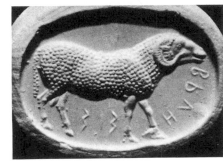
215

215

215

216

216

216

217

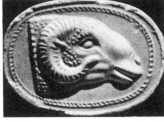
217

GREEK GEMS: ARCHAIC PERIOD, ABOUT 525–450 B.C.

(g) Animals

218

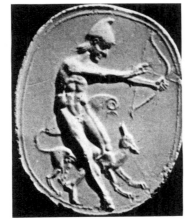

218

219

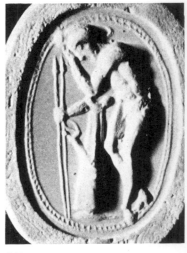

219

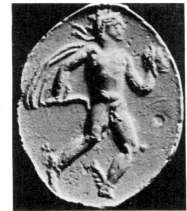

220

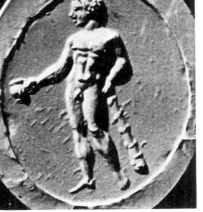
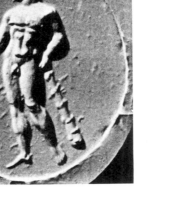

221

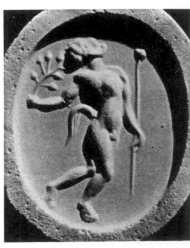

221

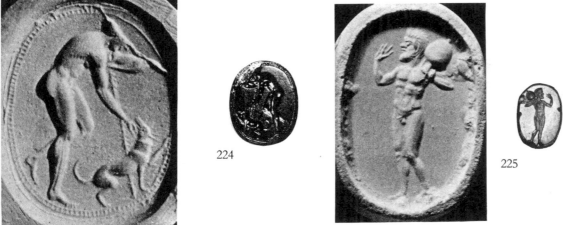

222

223

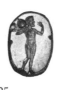

224

225

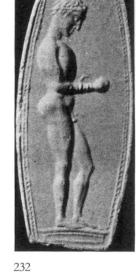

225

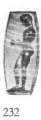

232

232

GREEK GEMS: DEVELOPED PERIOD, ABOUT 450–400 B.C.
(a) Standing male figures at rest and in action

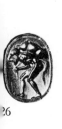

26

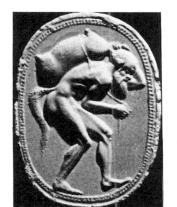

226

227

227

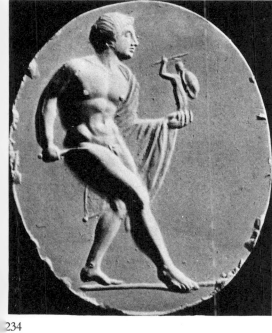

28

228

229

229

230

231

231

233

234

235

235

GREEK GEMS: DEVELOPED PERIOD, ABOUT 450–330 B.C.

(a) Standing male figures at rest and in action

236

236

237

237

239

239

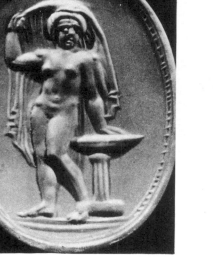

238

238

239

240

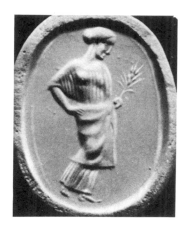

240

241

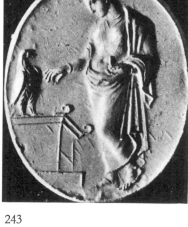

241

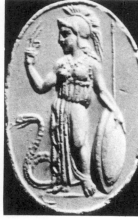

242

242

243

243

244

244

GREEK GEMS: DEVELOPED PERIOD, ABOUT 450-330 B.C.

(b) Standing female figures at rest and in action

245

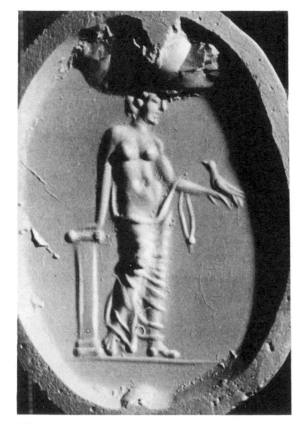

246

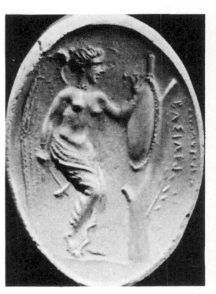

246

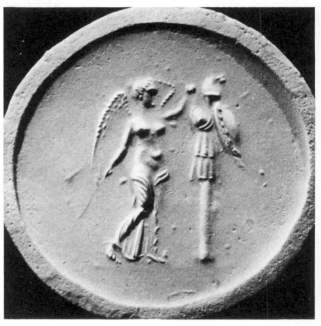

245

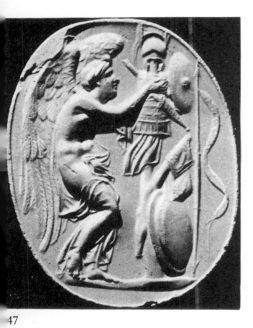

47

247

248

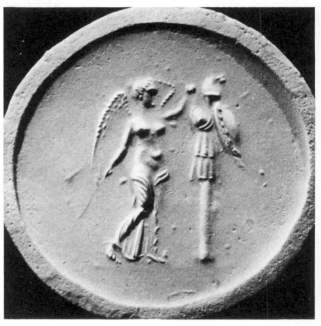

248

249

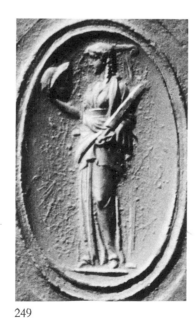

249

250

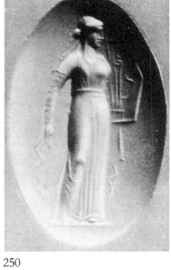

250

GREEK GEMS: DEVELOPED PERIOD, ABOUT 450–330 B.C.

(b) Standing female figures at rest and in action

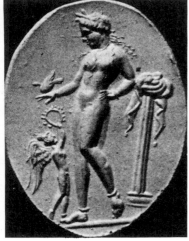

251

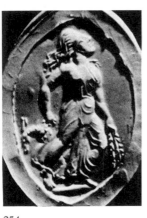

251

252

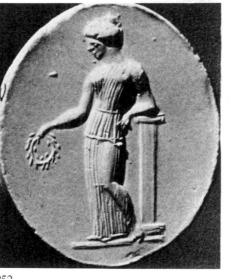

252

253

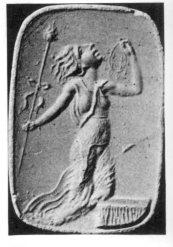

253

254

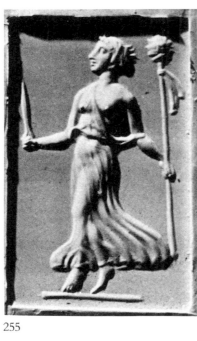

255

256

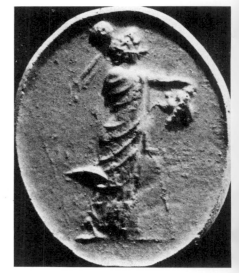

256

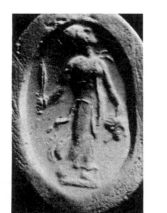

257

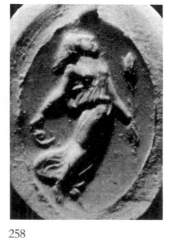

258

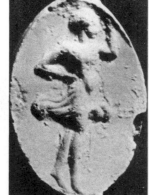

260

259(1)

259(2)

259(3)

259(4)

259(1)

259(1)

259(2)

259(2)

259(3)

259(3)

259(4)

259(4)

257

258

260

GREEK GEMS: DEVELOPED PERIOD, ABOUT 420–330 B.C.

(b) Standing female figures at rest and in action

261

261

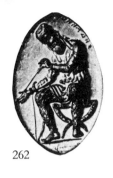

262

262

263

263

264

264

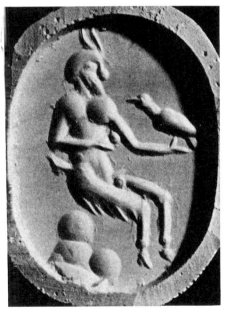

265

265

266

266

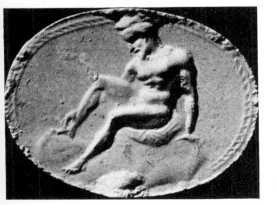

267

267

268

268

269

269

GREEK GEMS: DEVELOPED PERIOD, ABOUT 450–400 B.C.

(c) Seated figures, male and female

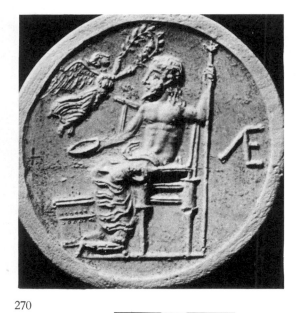

270

270

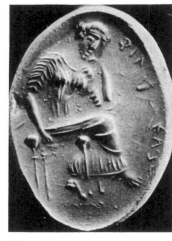

271

271

272

272

273

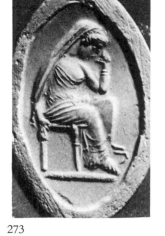

273

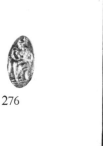

274

274

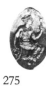

275

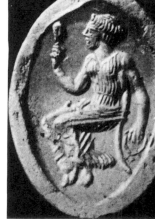

275

276

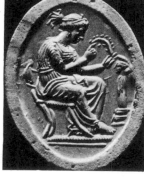

276

279

277

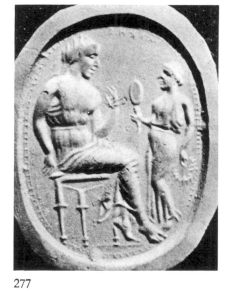

277

278

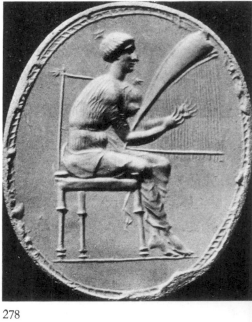

278

GREEK GEMS: DEVELOPED PERIOD, ABOUT 450–380 B.C.
(c) Seated figures, male and female

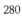

280

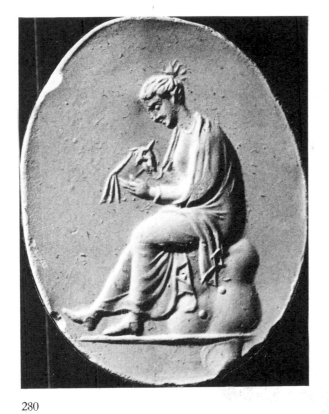

280

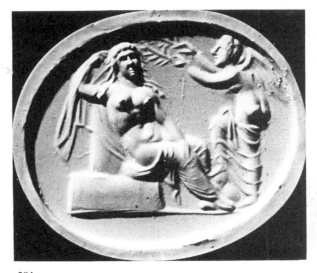

281

282

282

283

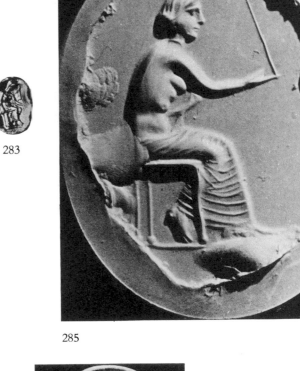

283

285

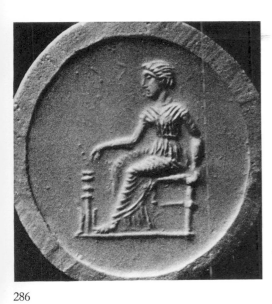

286

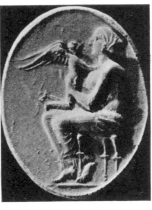

286

284

284

GREEK GEMS: DEVELOPED PERIOD, FIFTH TO FOURTH CENTURY B.C.

(c) Seated female figures

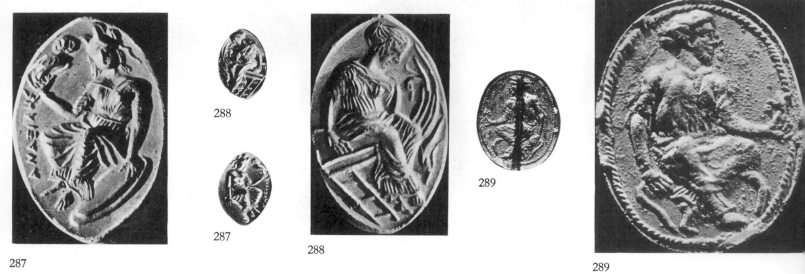

287

288

287

288

289

289

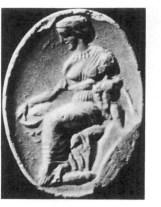

290

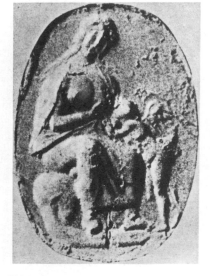

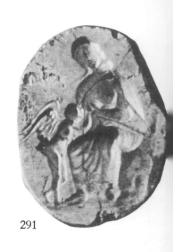

290

291

291

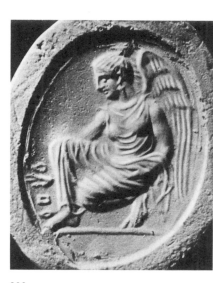

292

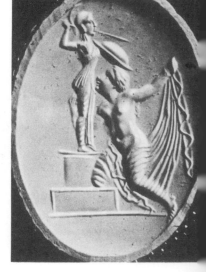

292

293

293

GREEK GEMS: DEVELOPED PERIOD, FIFTH TO FOURTH CENTURY B.C.

(c) and (d) Seated and crouching female figures

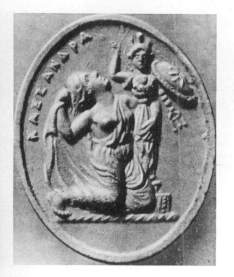

294

294

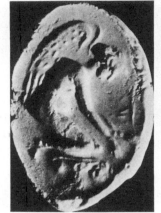

295

295

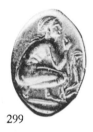

295

296

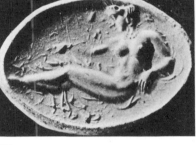

296

297

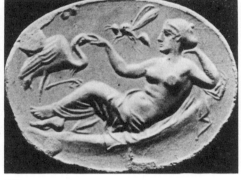

297

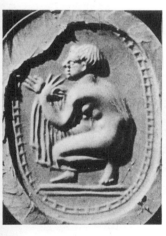

298

298

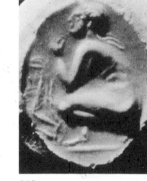

299

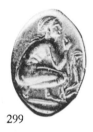

299

300

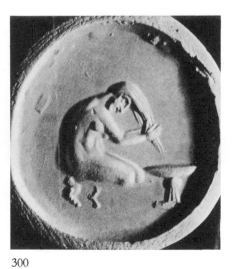

300

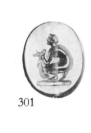

301

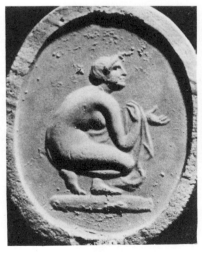

301

GREEK GEMS: DEVELOPED PERIOD, FIFTH TO FOURTH CENTURY B.C.

(d) Crouching and reclining female figures

302

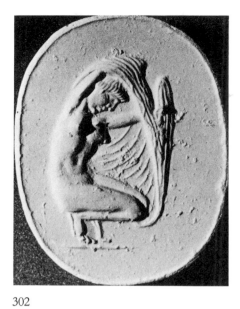

302

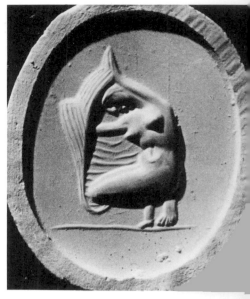

303

303

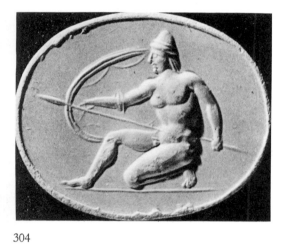

304

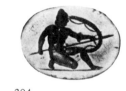

304

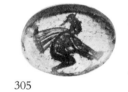

305

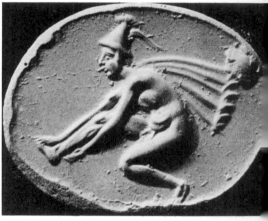

305

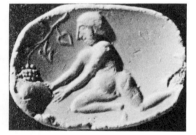

306

306

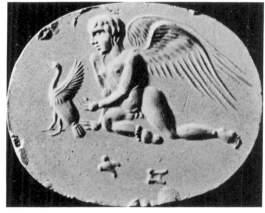

307

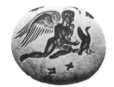

307

308

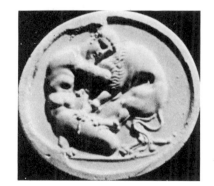

308

309

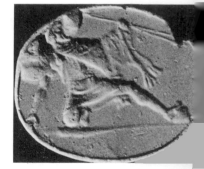

309

GREEK GEMS: DEVELOPED PERIOD, FIFTH TO FOURTH CENTURY B.C.

(d) Crouching figures, male and female

310

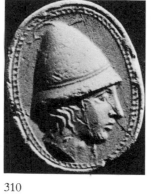

310

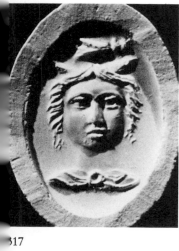

311

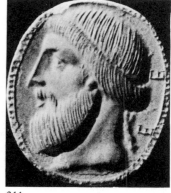

311

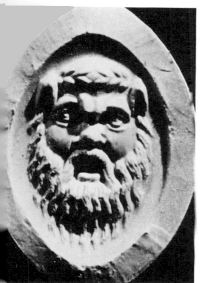

313

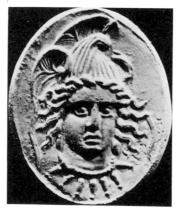

313

314

314

315

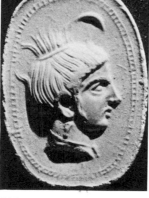

315

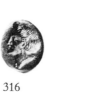

316

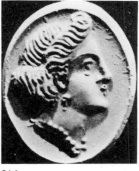

316

317

317

318

318

GREEK GEMS: DEVELOPED PERIOD, FIFTH TO FOURTH CENTURY B.C.

(e) Heads, male and female

319

320

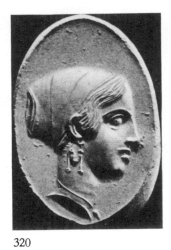

320

321

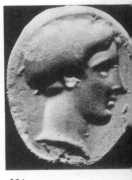

321

322

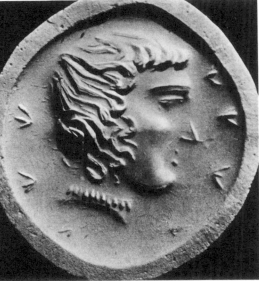

322

323

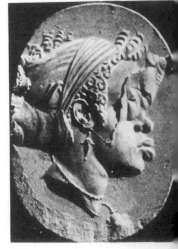

323

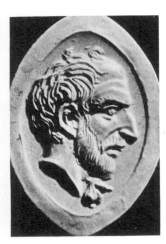

324

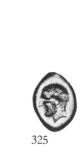

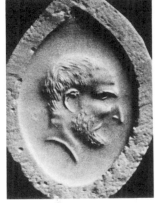

325

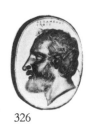

325

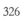

326

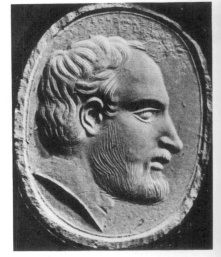

326

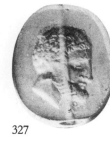

327

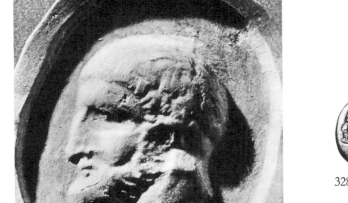

327

328

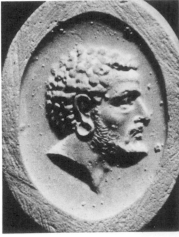

328

GREEK GEMS: DEVELOPED PERIOD, MOSTLY SECOND HALF OF THE FIFTH CENTURY B.C.

(e) Heads, male and female

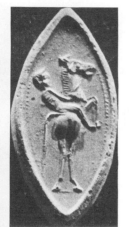

331

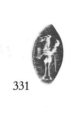

331

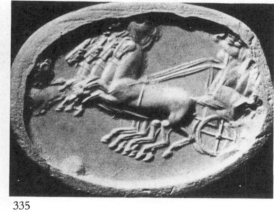

329

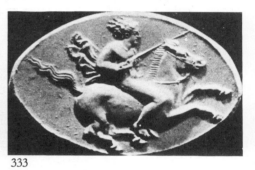

330

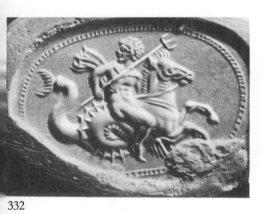

332

332

333

333

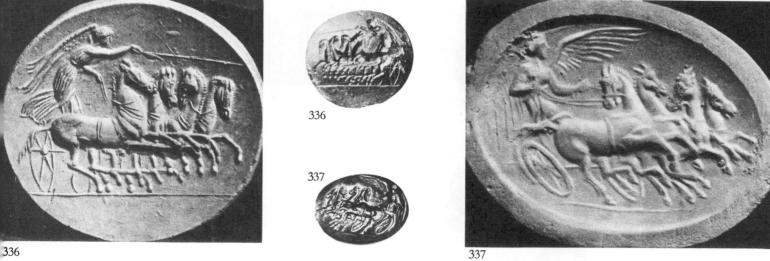

334

334

335

335

336

336

337

337

GREEK GEMS: DEVELOPED PERIOD, FIFTH TO EARLY FOURTH CENTURY B.C.

(f) Compositions in which more than one figure is included

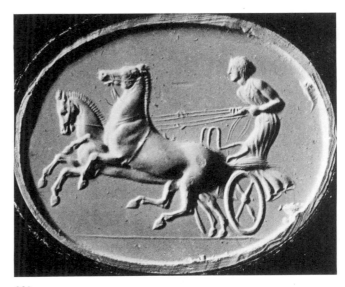

338

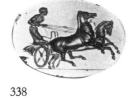

338

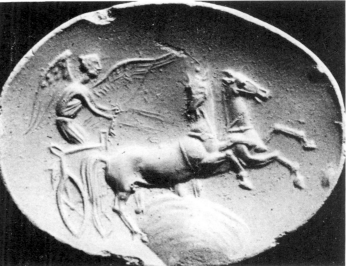

339

339

340

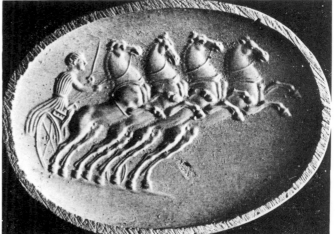

340

GREEK GEMS: DEVELOPED PERIOD, ABOUT 400-330 B.C.
(f) Compositions in which more than one figure is included

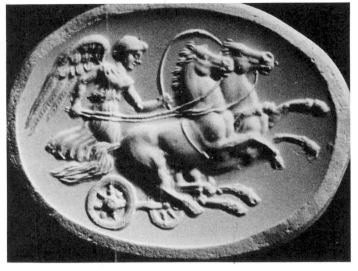

341

341

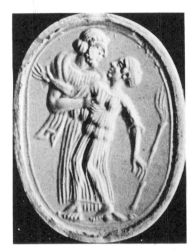

342

342

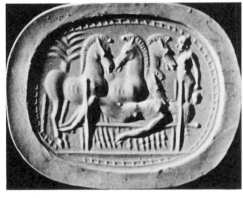

343

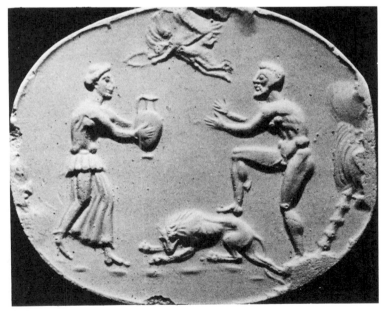

344

344

GREEK GEMS: DEVELOPED PERIOD, FIFTH AND FOURTH CENTURIES B.C.
(f) Compositions in which more than one figure is included

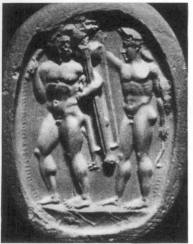

345

345

345

347

347

346

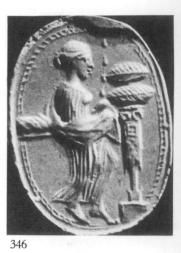

346

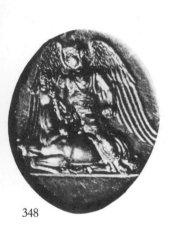

348

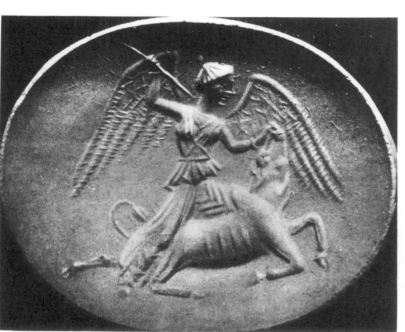

349

350

348

350

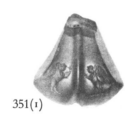

349

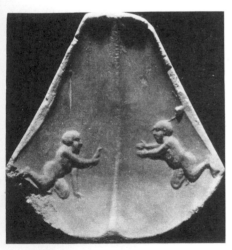

351(2)

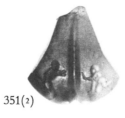

351(1)

351(2)

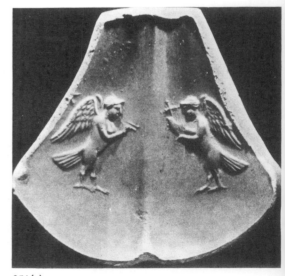

351(1)

GREEK GEMS: DEVELOPED PERIOD, ABOUT 450-380 B.C.

(f) Compositions in which more than one figure is included

353

352

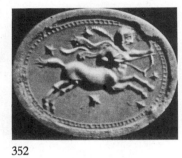

352

354

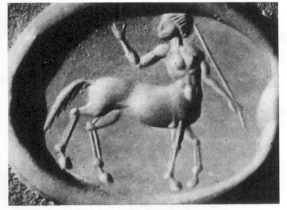

353

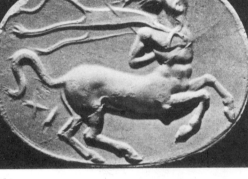

354

355

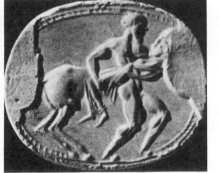

355

356

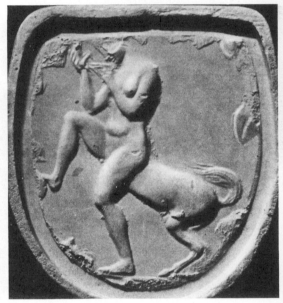

356

357

357

358

358

GREEK GEMS: DEVELOPED PERIOD, ABOUT 450–390 B.C.

(g) Monsters and hybrid figures

359

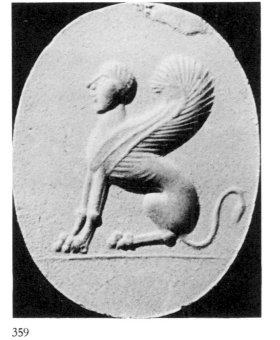

359

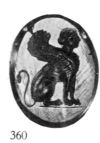

360

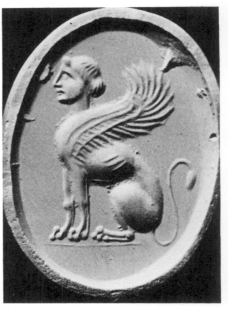

360

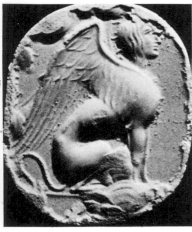

361

361

362

362

361

362

363

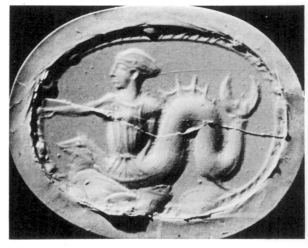

363

364

GREEK GEMS: DEVELOPED PERIOD, ABOUT 450–400 B.C.

(g) Monsters and hybrid figures

365

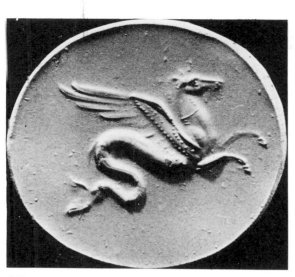

355

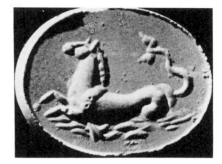

366

366

367

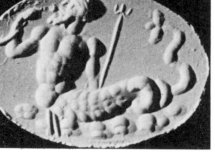

367

368

368

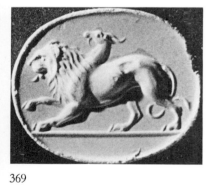

369

369

370

370

371

372

372

GREEK GEMS: DEVELOPED PERIOD, FIFTH TO FOURTH CENTURY B.C.

(g) Monsters and hybrid figures

373

373

374

374

375

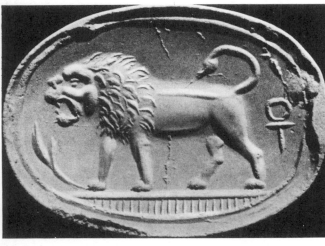

375

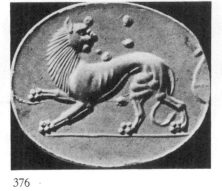

376

376

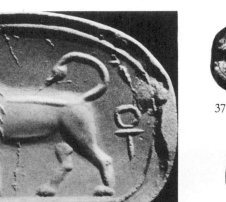

377

377

378

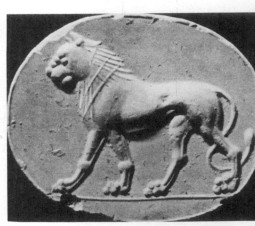

378

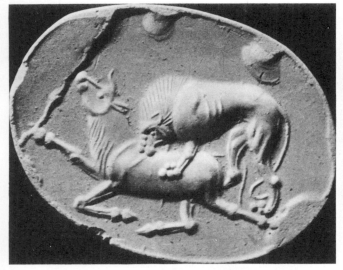

379

379

380

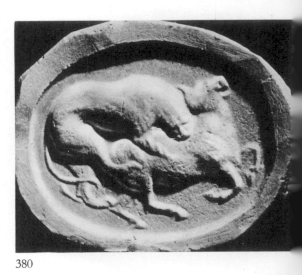

380

GREEK GEMS: DEVELOPED PERIOD, ABOUT 450–400 B.C.

(h) Animals: Quadrupeds

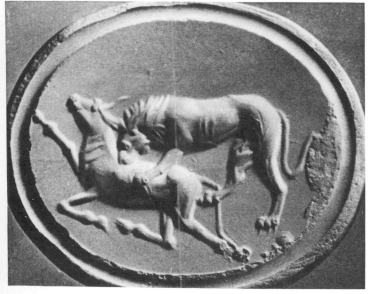

381

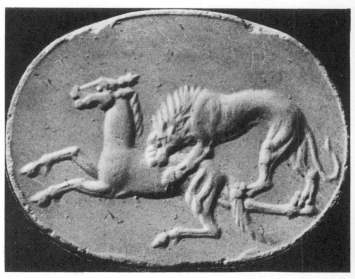

382

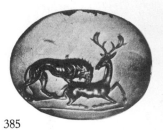

383

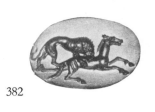

381

382

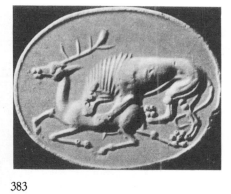

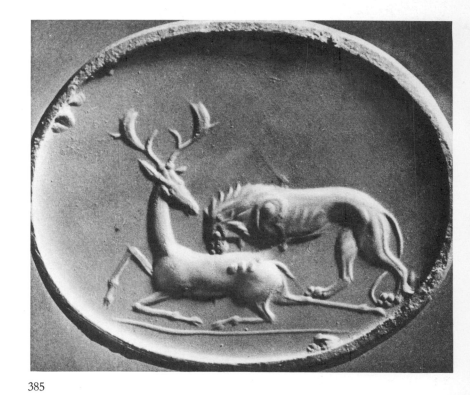

383

384

385

384

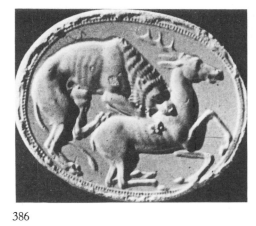

386

386

GREEK GEMS: DEVELOPED PERIOD, ABOUT 450–390 B.C.

(h) Animals: Quadrupeds

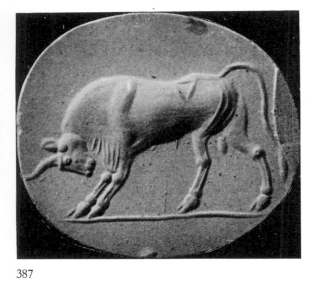

387

387

388

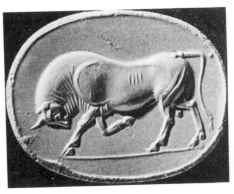

388

389

389

390

391

391

392

392

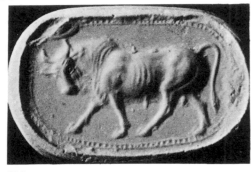

393

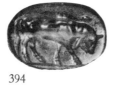

393

394

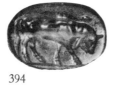

394

GREEK GEMS: DEVELOPED PERIOD, MOSTLY LATER FIFTH CENTURY B.C.

(h) Animals: Quadrupeds

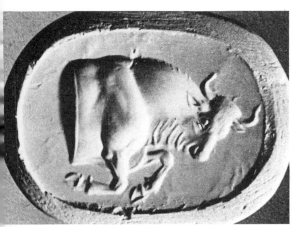

395

395

396

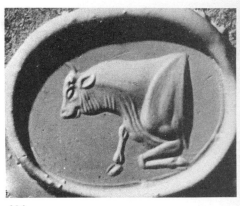

396

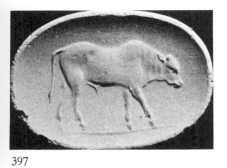

397

397

398

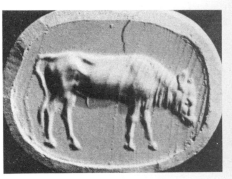

398

99

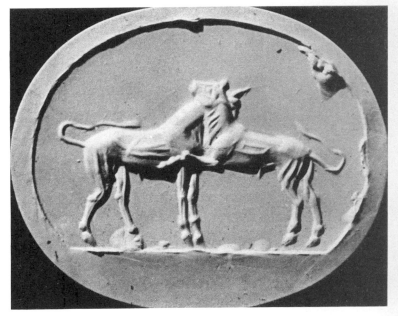

400

401

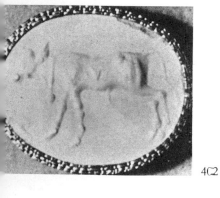

401

402

403

402

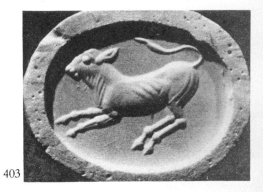

403

GREEK GEMS: DEVELOPED PERIOD, MOSTLY LATER FIFTH CENTURY B.C.

(h) Animals

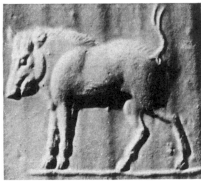

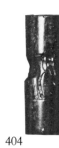

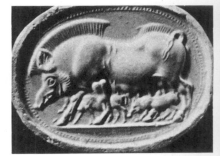

404

404

404

405

405

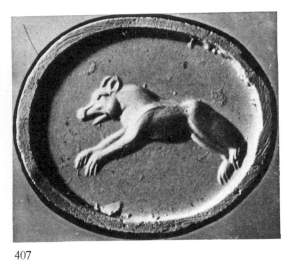

407

406

407

406

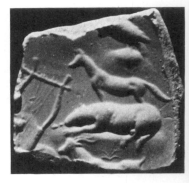

409

409

408

408

411(1)

411(2)

411(2)

411(1)

411(3)

411(4)

411(4)

411(3)

GREEK GEMS: DEVELOPED PERIOD, FIFTH AND FOURTH CENTURIES B.C.

(h) Animals

412

412

413

413

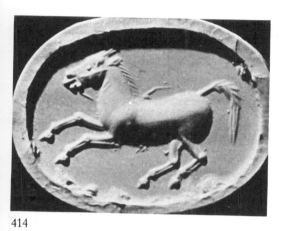

414

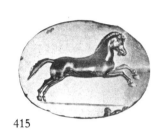

415

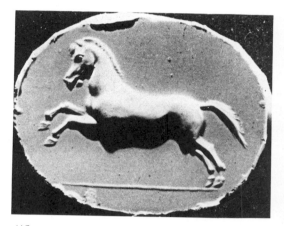

415

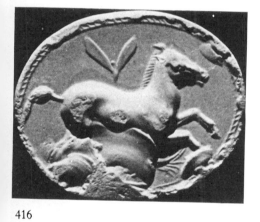

416

416

417

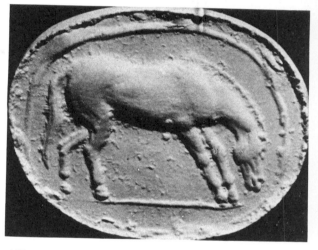

417

410(3)

0(1)

410(4)

410(2)

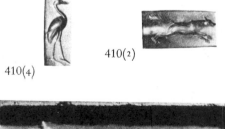

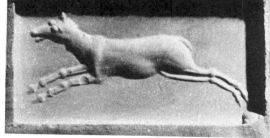

0(2)

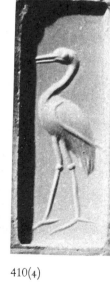

410(3)

410(4)

410(1)

GREEK GEMS: DEVELOPED PERIOD, ABOUT 450-390 B.C.

(h) Animals

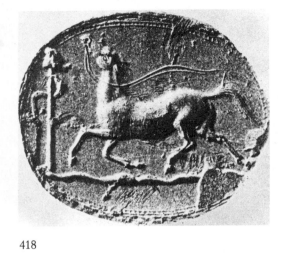

418

419

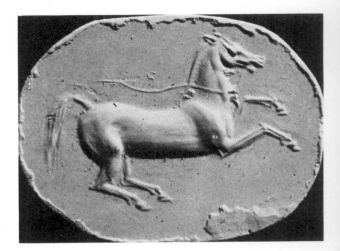

419

420

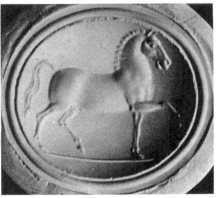

420

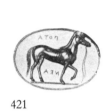

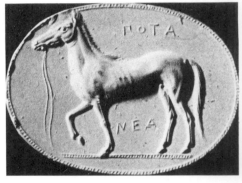

421

421

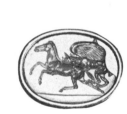

422

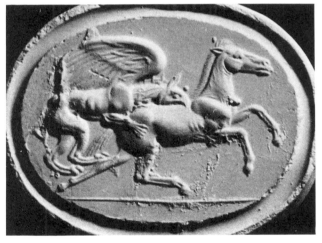

422

423

423

424

424

425

GREEK GEMS: DEVELOPED PERIOD, FIFTH AND FOURTH CENTURIES B.C.
(h) Animals

426

426

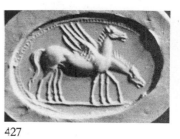

427

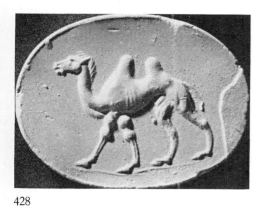

428

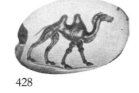

428

429

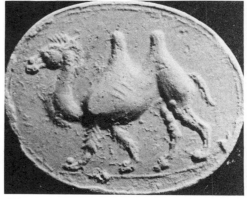

429

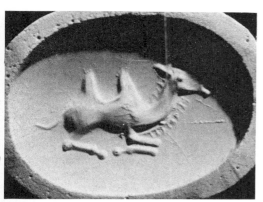

430

430

431

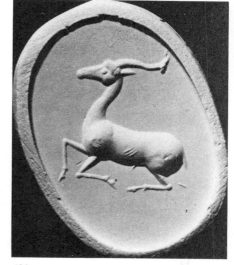

431

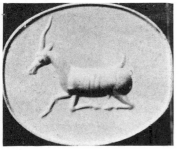

432

432

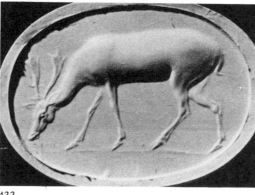

433

433

GREEK GEMS: DEVELOPED PERIOD, FIFTH AND FOURTH CENTURIES B.C.

(h) Animals

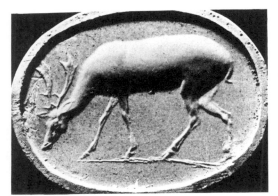

434

434

435

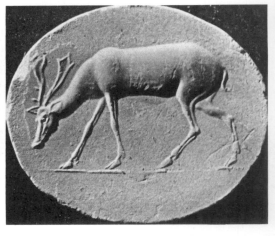

435

436

436

437

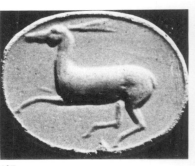

437

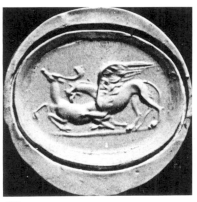

438

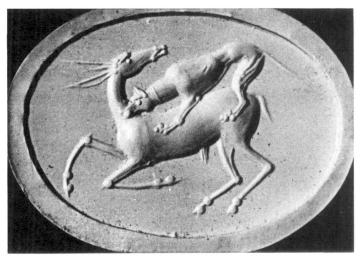

439

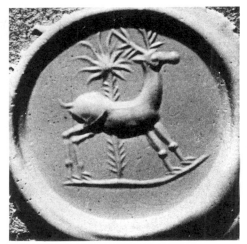

440

440

441

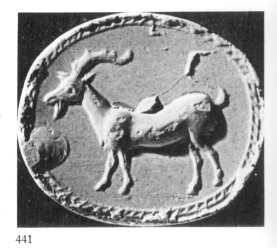

441

GREEK GEMS: DEVELOPED PERIOD, FIFTH AND FOURTH CENTURIES B.C.
(h) Animals:

442

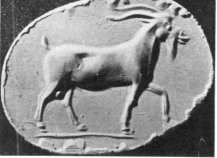

442

443

443

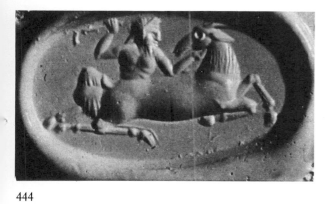

444

444

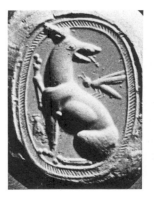
445

445

446

446

447

447

448

450

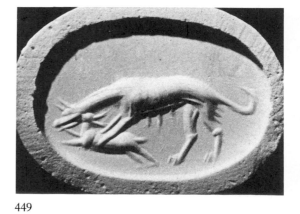

449

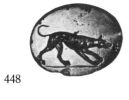

448

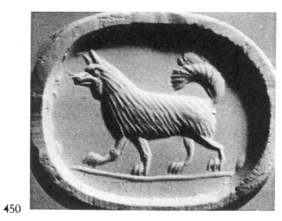

450

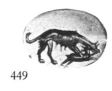

449

GREEK GEMS: DEVELOPED PERIOD, FIFTH AND FOURTH CENTURIES B.C.

(h) Animals

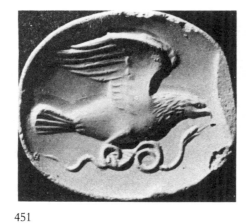

451

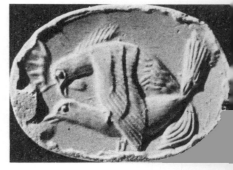

452

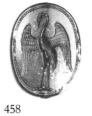

451

452

453

453

454

454

455

455

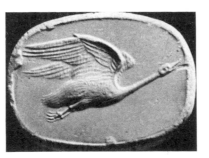

456

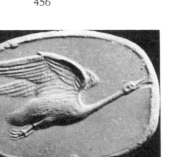

456

457

457

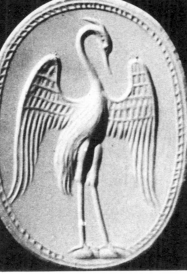

458

458

459

459

GREEK GEMS: DEVELOPED PERIOD, ABOUT 450-380 B.C.

(h) Animals

461

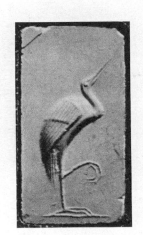

461

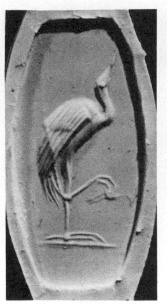

460

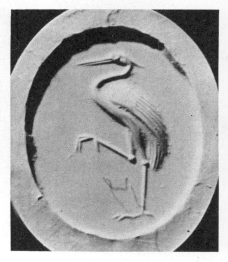

462

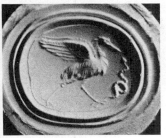

463

464

464

465

465

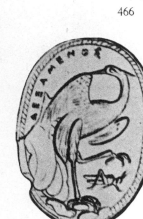

466

466

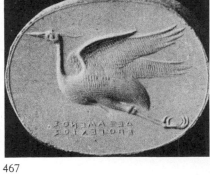

467

467

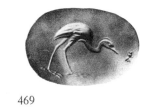

468

469

470

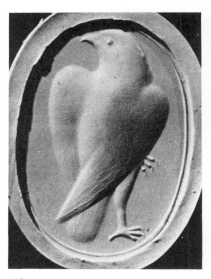

470

GREEK GEMS: DEVELOPED PERIOD, MOSTLY SECOND HALF OF THE FIFTH CENTURY B.C.

(h) Animals

471

471

472

473

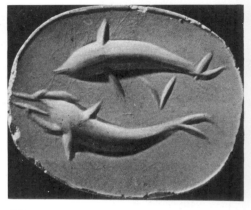

473

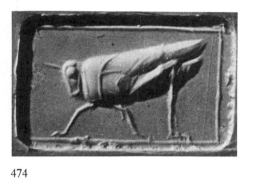

474

475

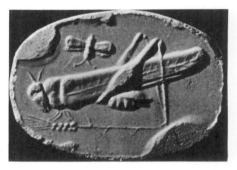

475

476

476

477

478

478

479

479

GREEK GEMS: DEVELOPED PERIOD, FIFTH AND FOURTH CENTURIES B.C.

(h) Animals

481

481

480

482

482

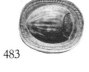

483

484

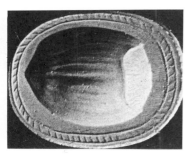

483

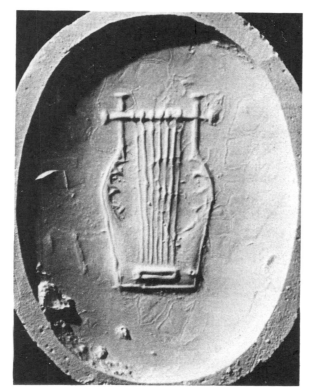

480

484

485

486

486

487

485

GREEK GEMS: DEVELOPED PERIOD, FIFTH CENTURY B.C. AND LATER
(i) Objects and Inscriptions

488

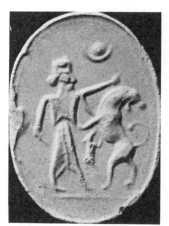

488

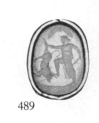

489

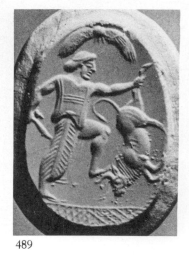

489

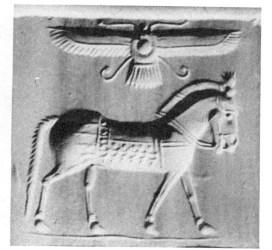

490

491

492

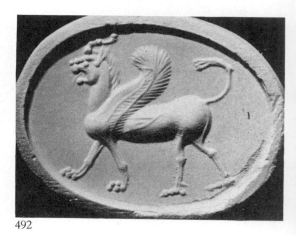

492

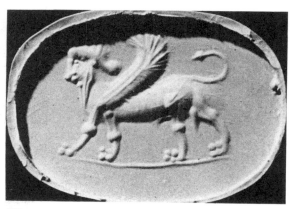

493

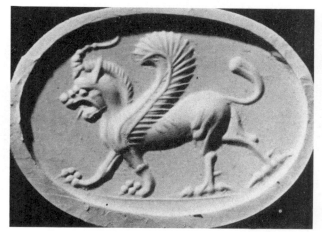

494

496

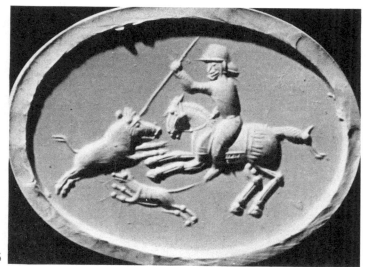

495

496

GRAECO-PERSIAN GEMS:

(1) ORIENTALIZING, LATE SIXTH AND EARLY FIFTH CENTURY B.C. (nos. 488–494)

(2) IN GREEK STYLE, SECOND HALF OF THE FIFTH CENTURY B.C. (nos 495, 496)

497

497

498

498

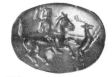

499

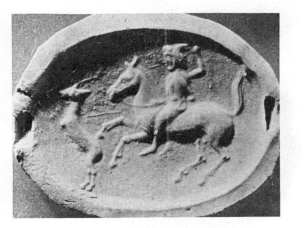

499

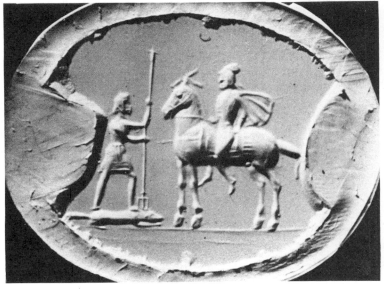

500

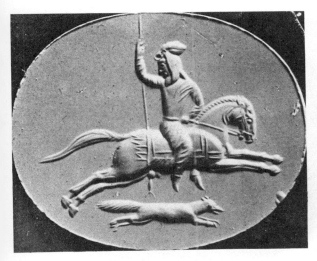

501

502(2)

502(2)

502(1)

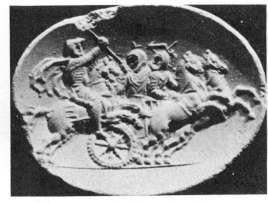

502(1)

GRAECO-PERSIAN GEMS, FIFTH AND FOURTH CENTURIES B.C.

503(1)

503(1)

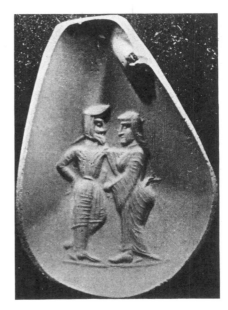

503(2)

503(2)

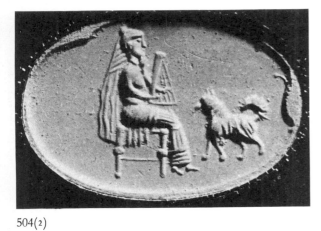

504(2)

504(1)

504(2)

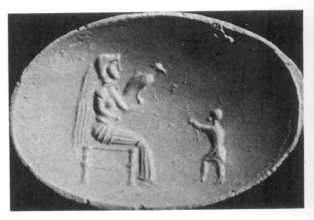

504(1)

505(4)

505

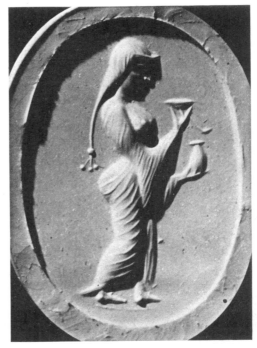

506

GRAECO-PERSIAN GEMS, MOSTLY SECOND HALF OF THE FIFTH CENTURY B.C.

507

507

507

508

508

509

507

510

510

509

511

511

512

512

513

514

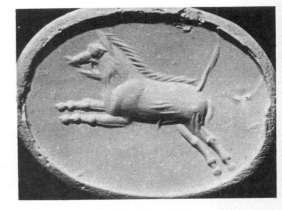

514

13

GRAECO-PERSIAN GEMS, SECOND HALF OF THE FIFTH CENTURY B.C.

515

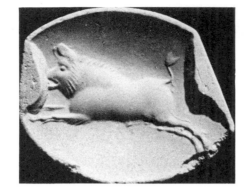

515

516

517

517

517

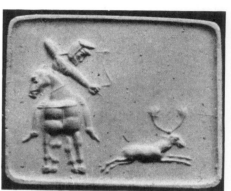

517

517

517

517

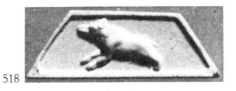

517

517

518

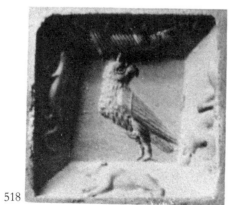

518

518

518

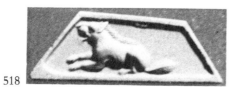

518

518

518

518

GRAECO-PERSIAN GEMS, MOSTLY SECOND HALF OF THE FIFTH CENTURY B.C.

519

5_9

520

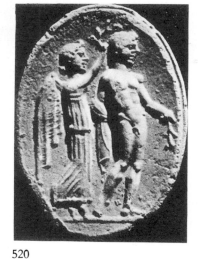

520

521

521

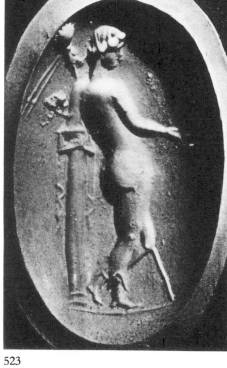

523

522

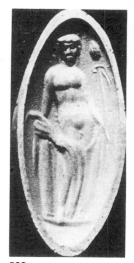

522

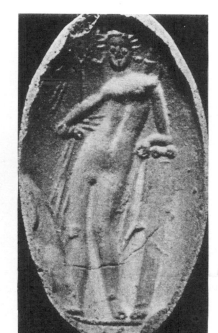

524

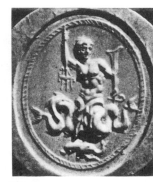

525

526

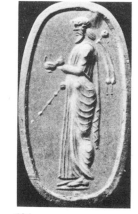

526

524

GREEK GEMS: HELLENISTIC PERIOD, FOURTH TO THIRD CENTURY B.C.

(a) Male figures, mostly quietly standing

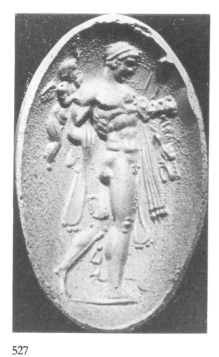

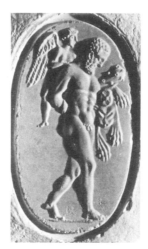

528-a (Roman)

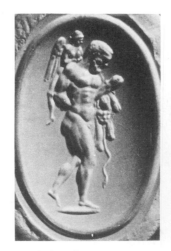

528-b (modern)

527

528-a

528-b

527

529

530

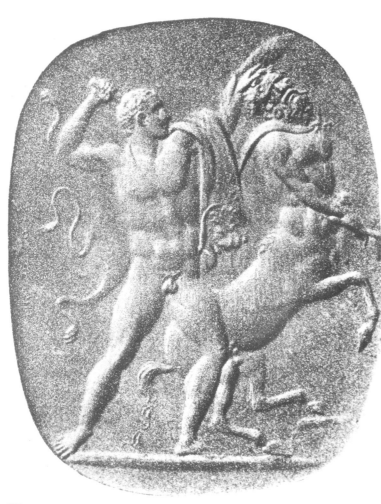

529

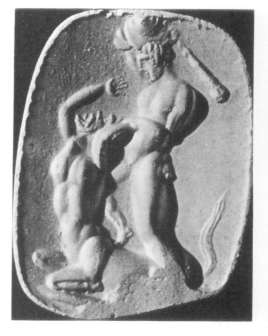

530

GREEK GEMS: LATER HELLENISTIC PERIOD, ABOUT 250-100 B.C.

(a) Male figures in action

531

532

531

531

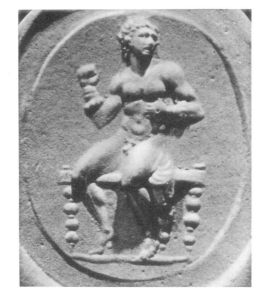

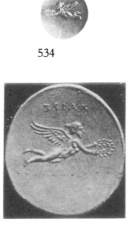

532

532

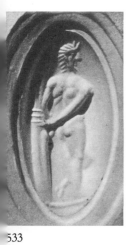

533

533

534

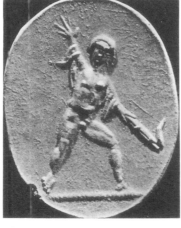

534

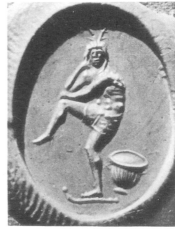

535

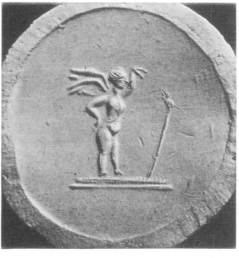

535

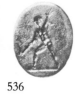

536

532

536

536

537

537

GREEK GEMS: HELLENISTIC PERIOD, ABOUT 300-100 B.C.

(a) Male figures, mostly in action

538

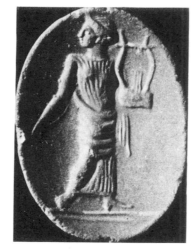

538

539

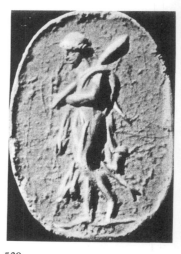

539

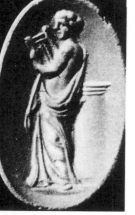

540

540

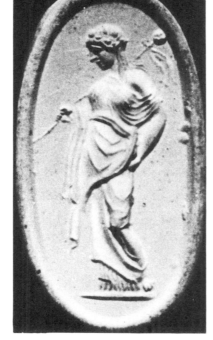

541

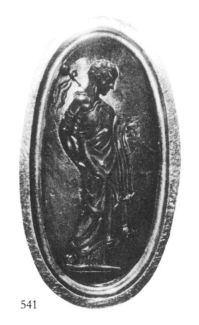

541

542

543

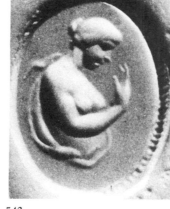

543

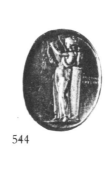

544

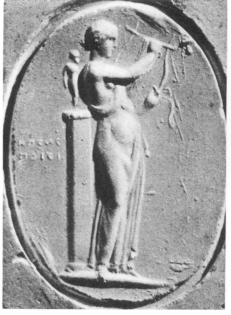

544

GREEK GEMS: EARLY HELLENISTIC PERIOD, ABOUT 330–250 B.C.
(b) Female figures, mostly quietly standing

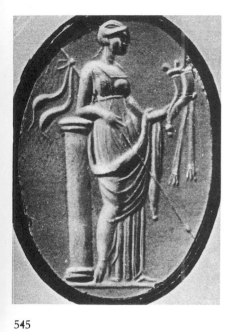

545

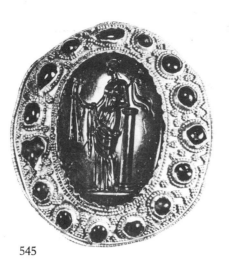

545

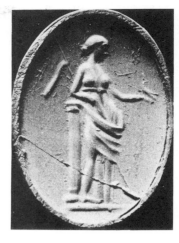

545

546

546

547

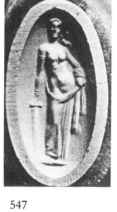

547

548

548

549

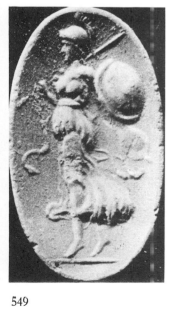

549

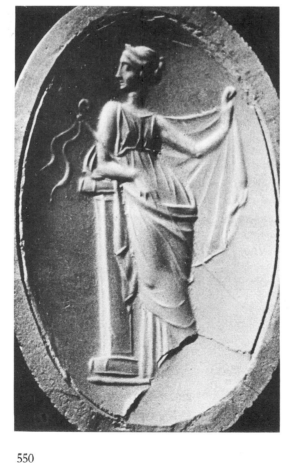

550

550

GREEK GEMS: LATER HELLENISTIC PERIOD, ABOUT 250-100 B.C.

(b) Female figures

551

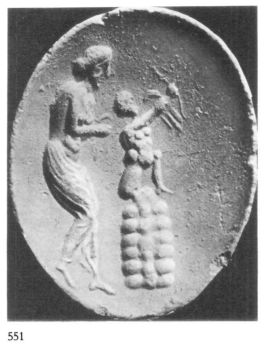

551

552

552

553

553

554

554

555

555

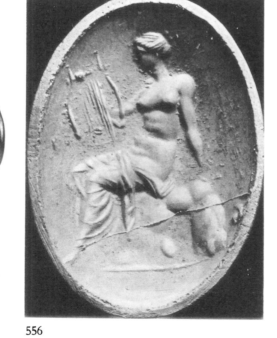

556

556

557

557

GREEK GEMS: HELLENISTIC PERIOD, ABOUT 200-100 B.C.

(b) Female figures in various poses

558

558

559

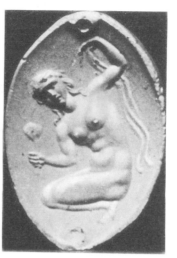

559

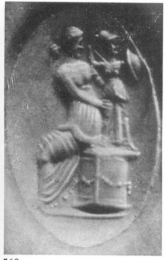

560

560

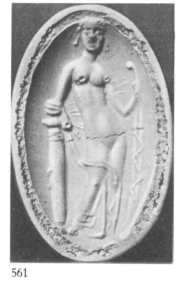

561

561

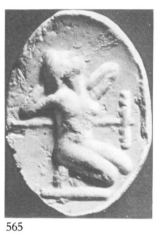

565

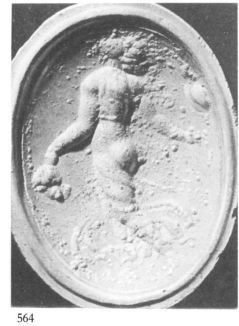

565

562

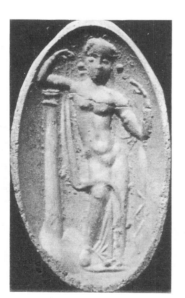

562

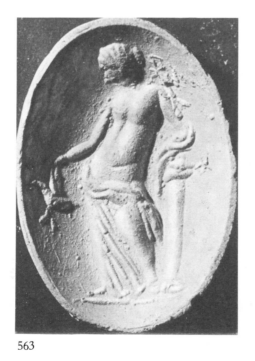

563

564

GREEK GEMS: HELLENISTIC PERIOD, ABOUT 300-100 B.C.

(b) Female figures in various poses

566

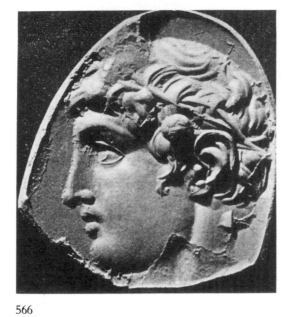

566

566

567

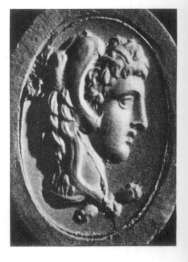

567

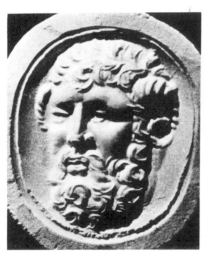

568

568

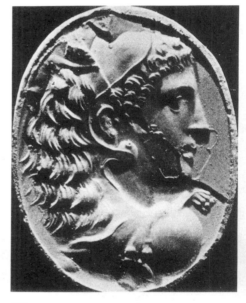

569

569

568

569

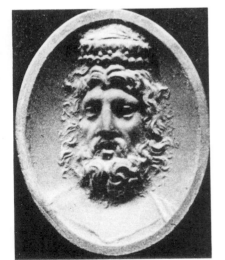

570

570

571

571

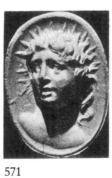

572

572

570

571

572

GREEK GEMS: HELLENISTIC PERIOD, ABOUT 330–250 B.C.

(c) Male heads

573

573

574

574

575

575

576

576

577

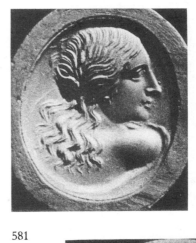

577

578

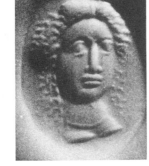

578

581

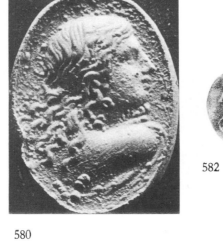

581

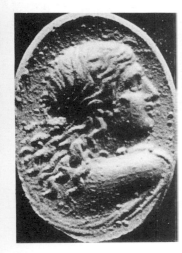

579

579

580

580

580

582

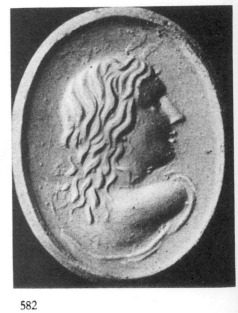

582

GREEK GEMS: HELLENISTIC PERIOD, THIRD AND SECOND CENTURIES B.C.

(c) Male and female heads

583

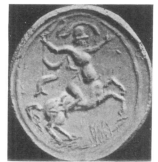

583

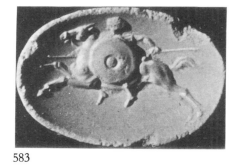

584

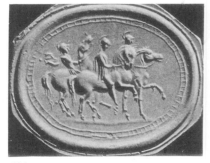

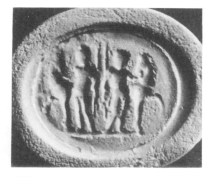

585

585

586

586

587

587

588

588

589

589a

589b

GREEK GEMS: HELLENISTIC PERIOD, ABOUT 330–100 B.C.

(d) Designs showing several figures in a composition

590

591

592

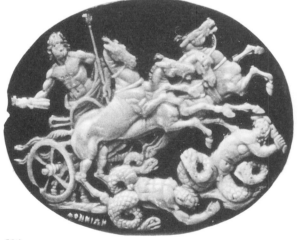

593

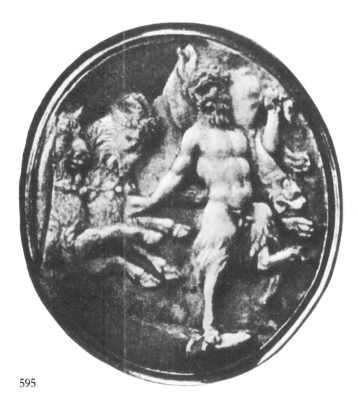

595

594

GREEK GEMS: HELLENISTIC PERIOD, ABOUT 330–100 B.C.

(e) Cameos

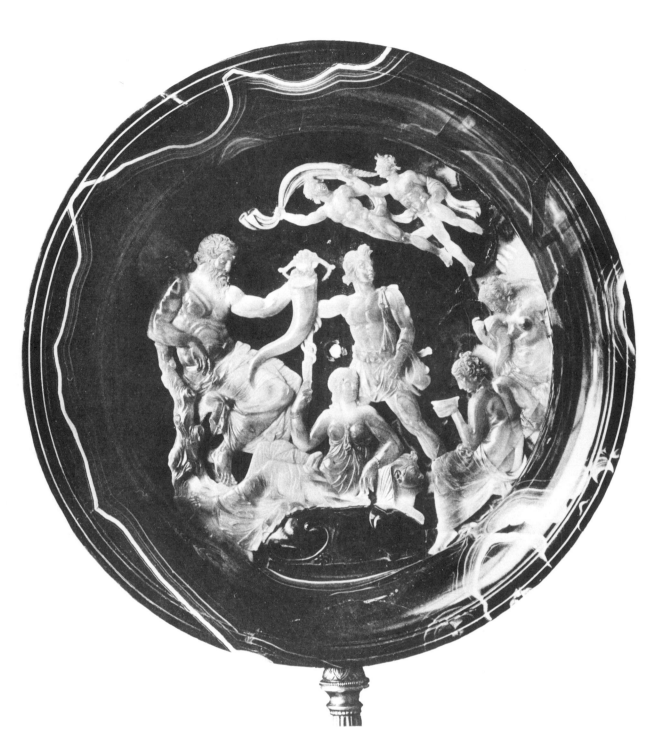

596

GREEK GEMS: HELLENISTIC PERIOD, THE FARNESE CUP, PROBABLY SECOND CENTURY B.C.

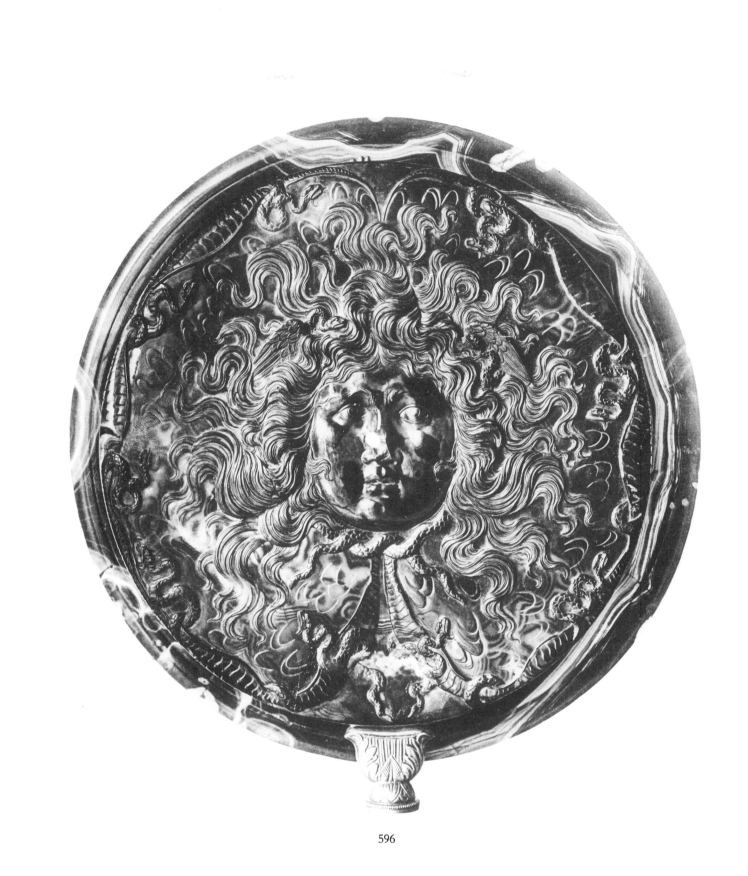

596

GREEK GEMS: HELLENISTIC PERIOD, THE FARNESE CUP, PROBABLY SECOND CENTURY B.C.

597

597

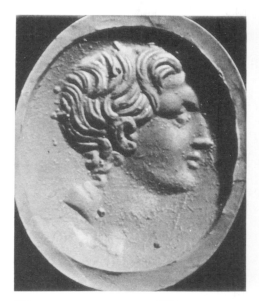

598

599

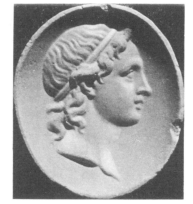

599

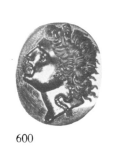

600

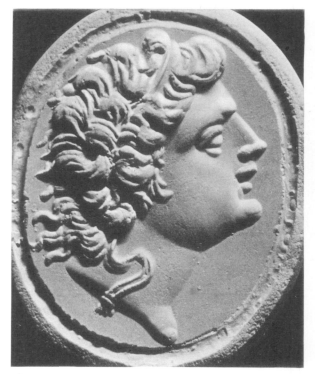

600

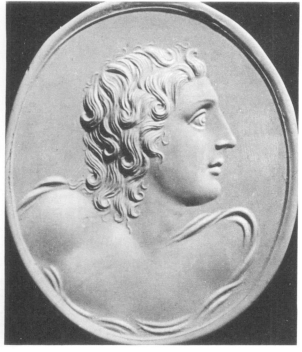

601

601

602

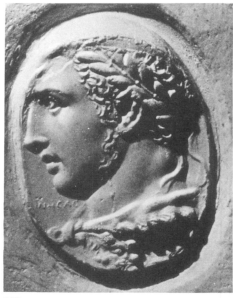

602

GREEK GEMS: HELLENISTIC PERIOD, ABOUT 330-300 B.C. AND LATER
(f) Portraits of Alexander the Great or resembling him

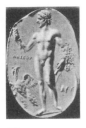

603

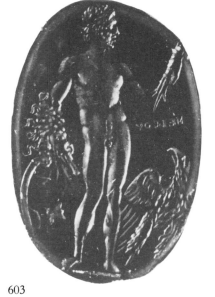

603

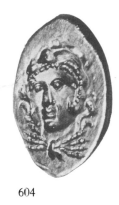

604

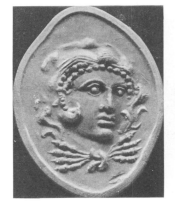

604

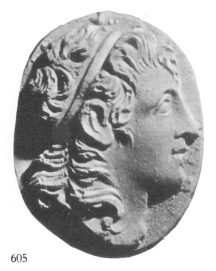

605

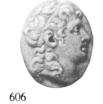

605

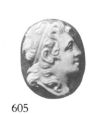

606

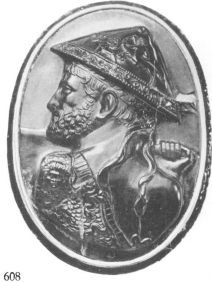

608

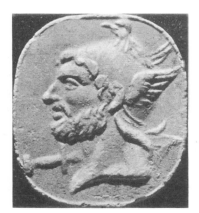

609

609

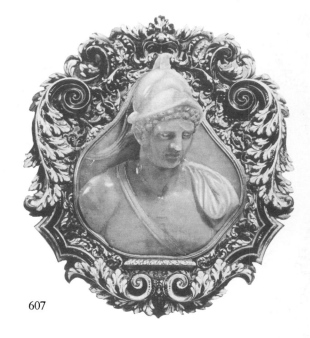

607

GREEK GEMS: HELLENISTIC PERIOD, ABOUT 330–150 B.C.

(f) Portraits of Macedonian rulers: Alexander, Philip V (608) and Perseus (609)

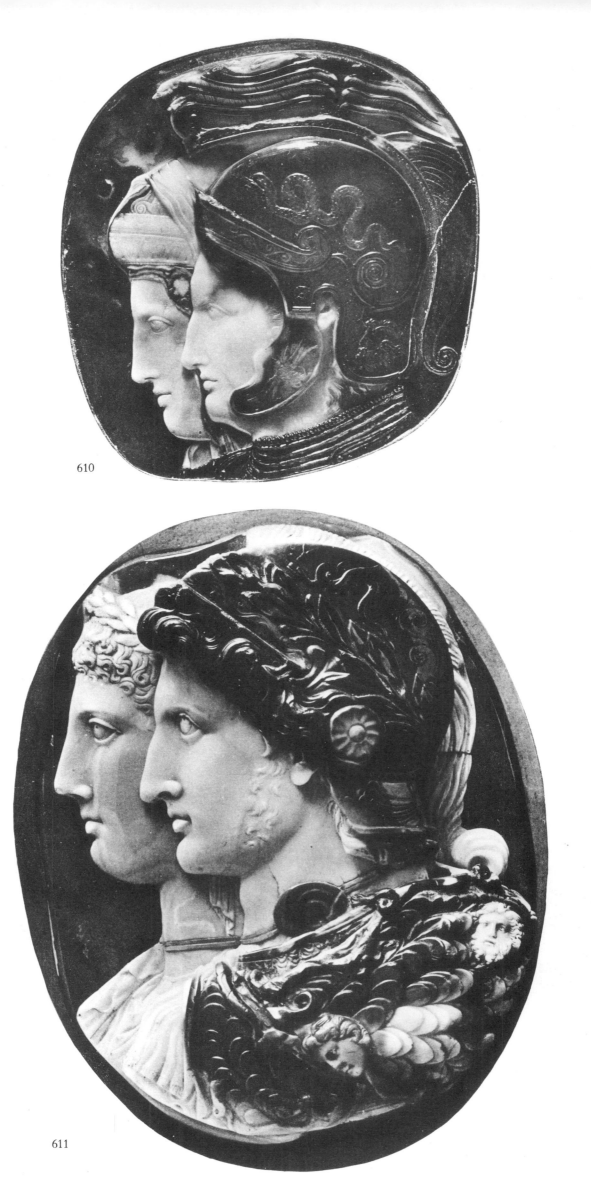

610

611

GREEK GEMS: HELLENISTIC PERIOD, FOURTH TO THIRD CENTURY B.C.
Portraits probably of Alexander and his mother Olympias

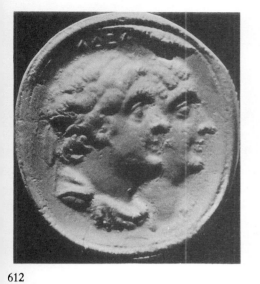

612

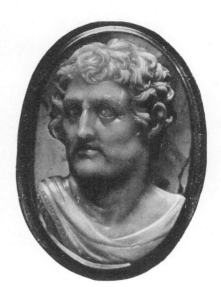

613 (Modern ?)

612

614

614

616

616

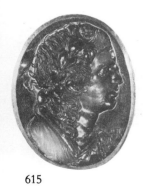

615

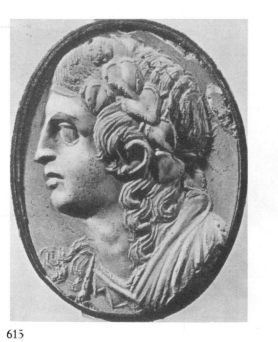

615

617

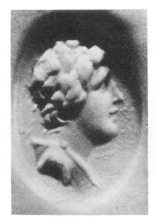

617

GREEK GEMS: HELLENISTIC PERIOD, MOSTLY THIRD AND SECOND CENTURIES B.C.
Portraits of Ptolemaic kings

618

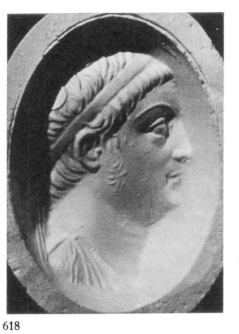

618

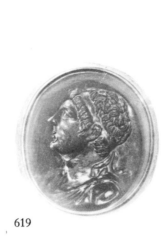

619

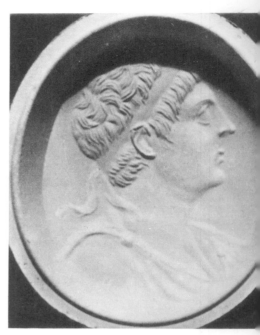

619

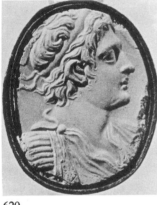

620

620

621

621

622

622

623

624

625

GREEK GEMS: HELLENISTIC PERIOD. THIRD TO FIRST CENTURY B.C.
Portraits of Hellenistic rulers

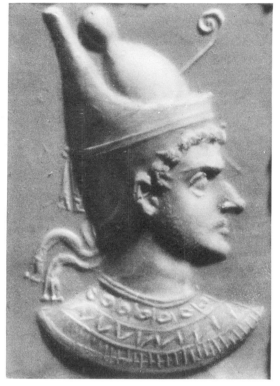

626

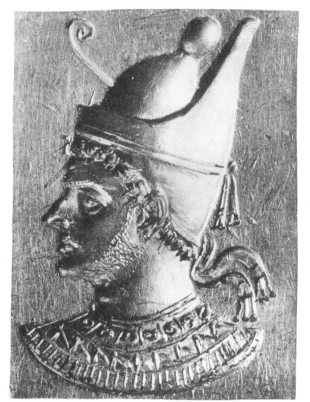

626

627

627

627

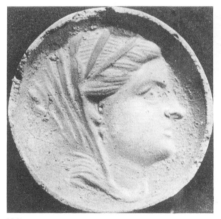

628

628

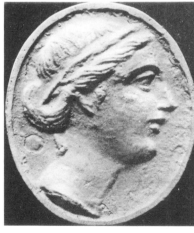

629

629

629

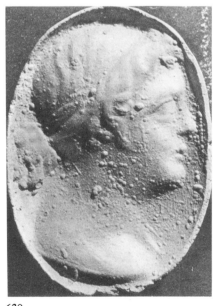

630

GREEK GEMS: HELLENISTIC PERIOD. THIRD AND SECOND CENTURIES B.C.
Portraits of Hellenistic kings and queens

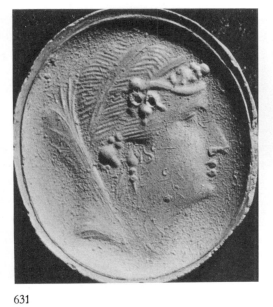

631

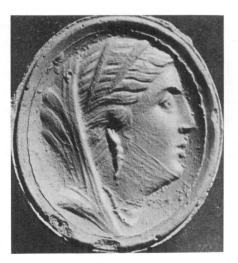

632

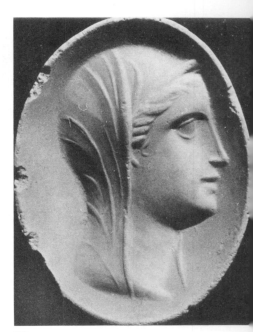

633

634

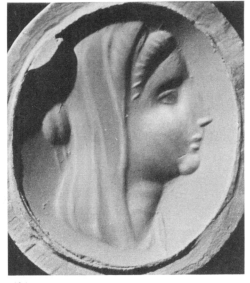

634

633

636

635

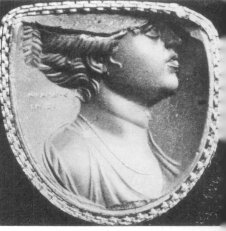

636

635

GREEK GEMS: HELLENISTIC PERIOD, THIRD CENTURY B.C.
Portraits of Hellenistic queens

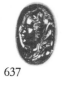

637

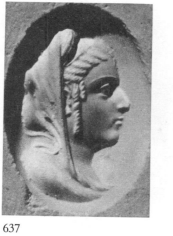

637

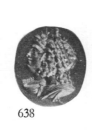

638

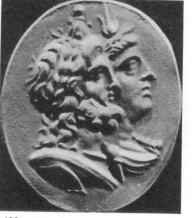

638

9

639

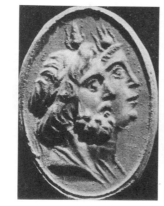

640

640

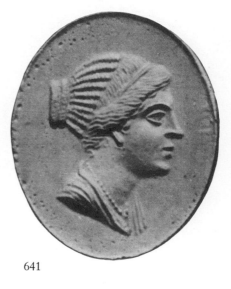

641

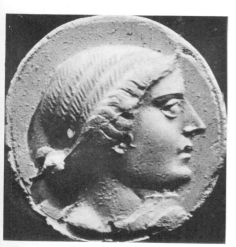

642

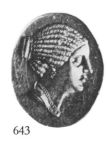

642

643

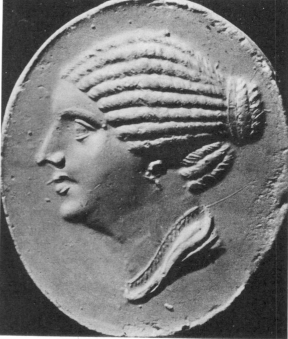

643

GREEK GEMS: HELLENISTIC PERIOD, THIRD CENTURY B.C.
Portraits mostly of Hellenistic queens

644

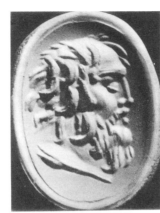

644

645

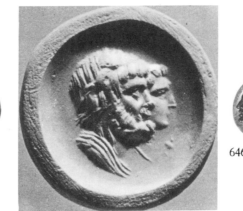

645

646

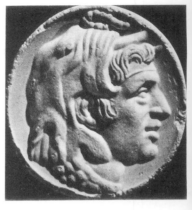

646

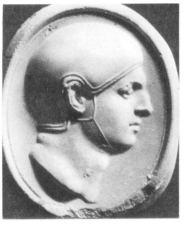

647

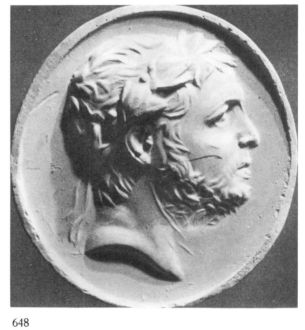

648

648

647

648

649

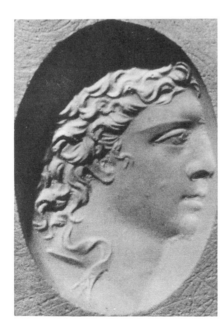

649

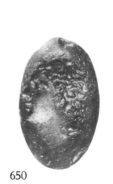

650

650

GREEK GEMS: HELLENISTIC PERIOD, LATE FOURTH TO FIRST CENTURY B.C.
Portraits of various rulers, including Mithradates VI of Pontos (649, 650)

651

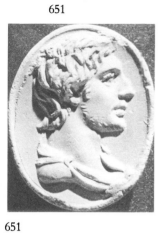

651

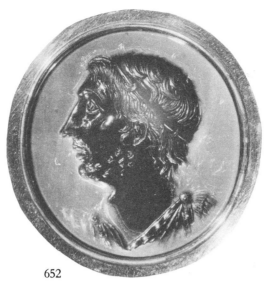

652

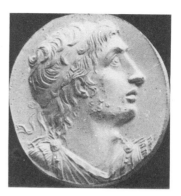

652

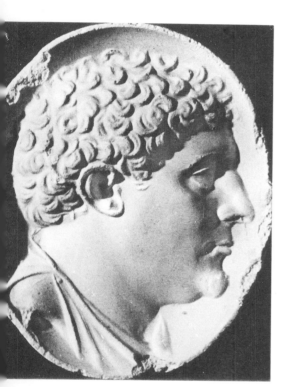

653

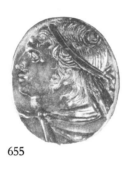

655

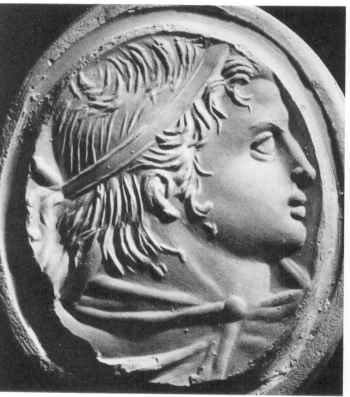

655

656

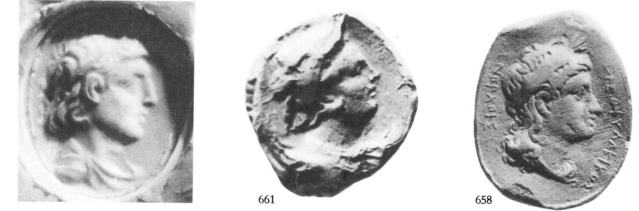

656

661

658

GREEK GEMS: HELLENISTIC PERIOD, THIRD TO FIRST CENTURY B.C.
Portraits of various Hellenistic rulers, including Philetairos of Pergamon (653)

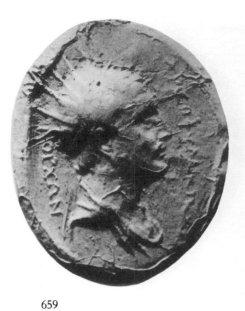

659

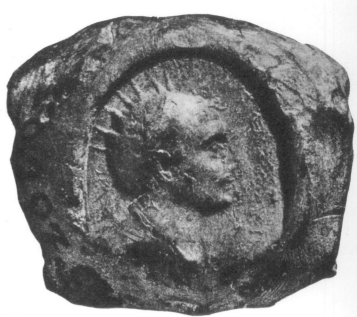

660

657

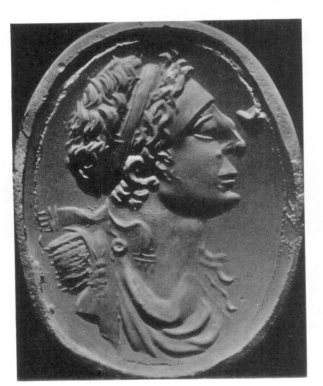

657

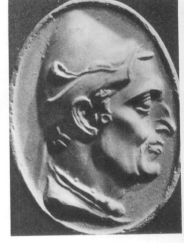

662

662

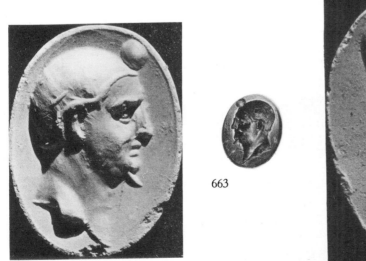

663

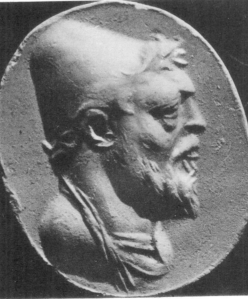

663

664

664

GREEK GEMS: HELLENISTIC PERIOD, SECOND AND FIRST CENTURIES B.C.
Portraits of various Hellenistic rulers

665

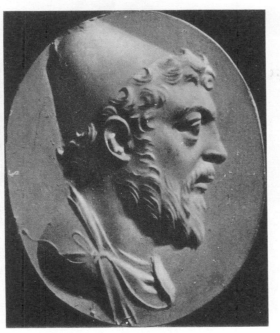

665

666

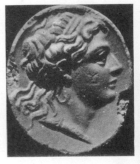

666

667

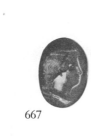

667

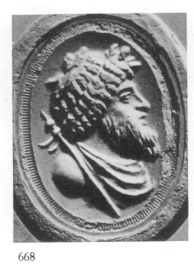

668

668

669

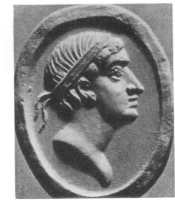

669

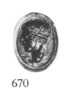

670

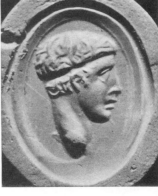

670

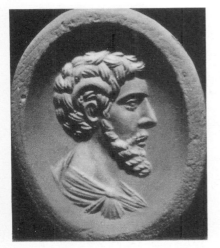

671

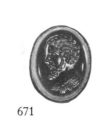

671

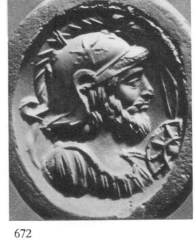

672

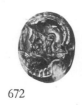

672

GREEK GEMS: HELLENISTIC PERIOD, THIRD TO FIRST CENTURY B.C.
Portraits of various Hellenistic rulers

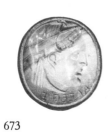

673

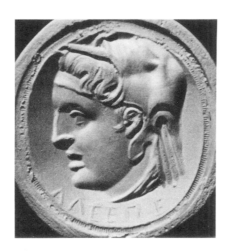

673

674

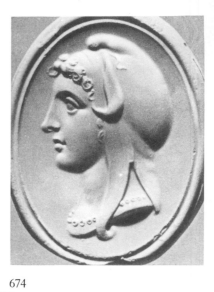

674

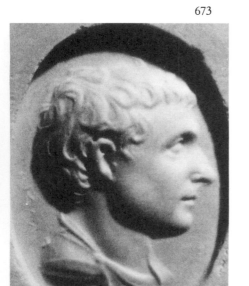

675

675

676

676

677

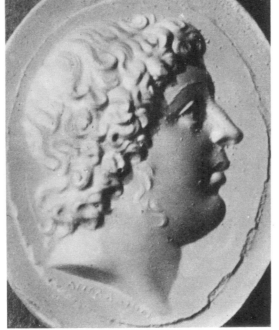

677

678

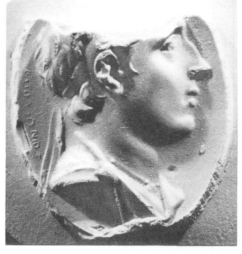

678

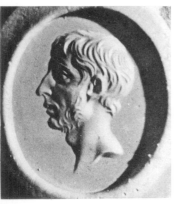

681

681

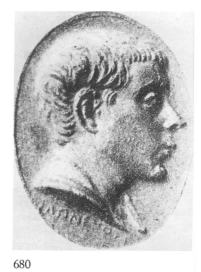

680

GREEK GEMS: HELLENISTIC PERIOD, THIRD TO FIRST CENTURY B.C.

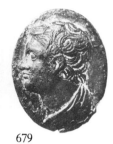

679

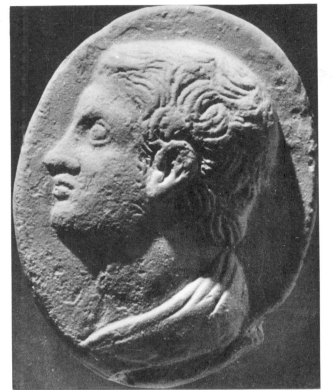

679

682

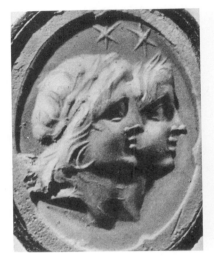

682

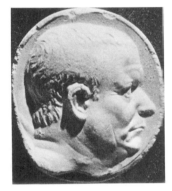

683

683

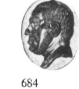

684

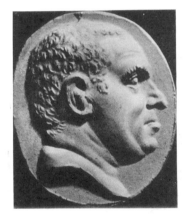

684

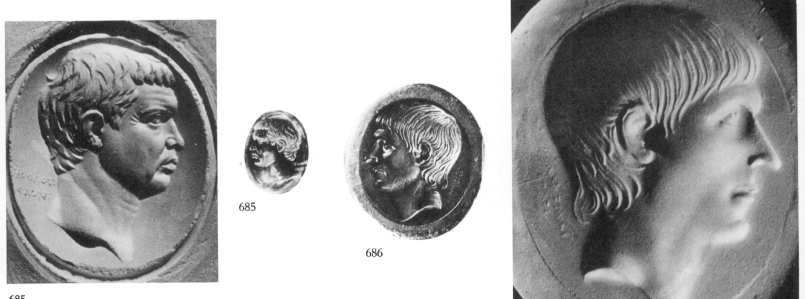

685

685

686

686

GREEK GEMS: HELLENISTIC PERIOD. THIRD TO FIRST CENTURY B.C.
Portraits mostly of Romans (683–686)

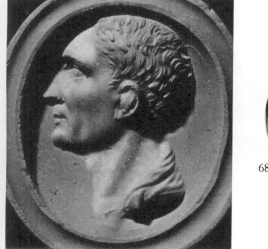

687

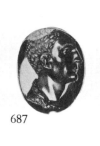

687

689

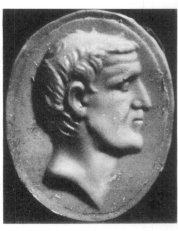

688

689

689

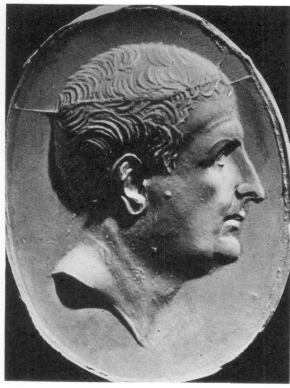

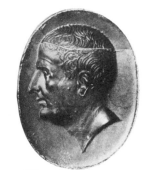

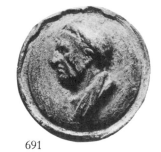

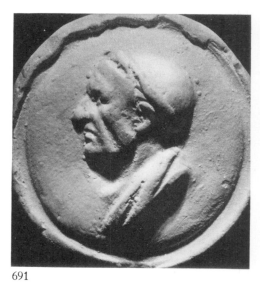

690

690

691

691

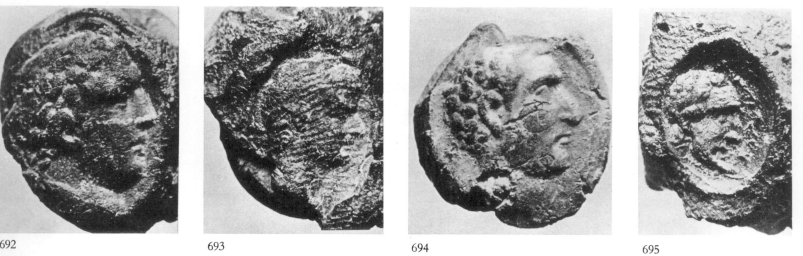

692

693

694

695

GREEK GEMS: HELLENISTIC PERIOD, THIRD TO FIRST CENTURY B.C.
Unidentified portraits of Romans (687-691) and Greeks (692-695)

ETRUSCAN GEMS

696

697

698

699

696

697

698

699

700

701

702

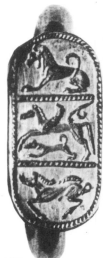

703

704

705

706

707

708

708

709

710

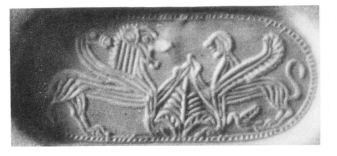

711

711

712

712

ETRUSCAN GEMS: EARLY ARCHAIC PERIOD, SEVENTH TO SIXTH CENTURY B.C.
Gold and silver rings with designs in relief (696-707) and engraved (708-712)

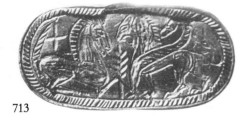

713

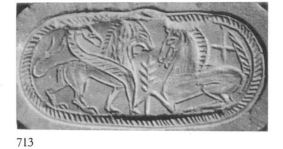

713

715

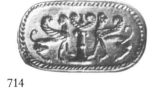

714

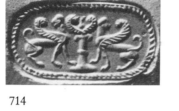

714

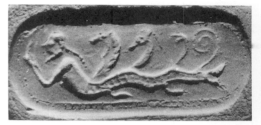

715

716

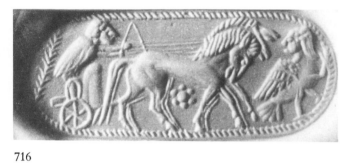

716

716

717

718

718

717

719

719

720

720

721

ETRUSCAN GEMS: EARLY ARCHAIC PERIOD, SEVENTH TO SIXTH CENTURY B.C.

Gold and silver rings with designs in relief (719) and engraved

722

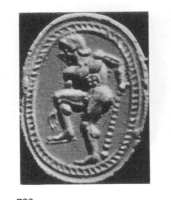

722

723

723

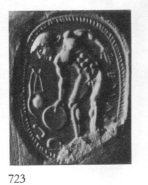

723

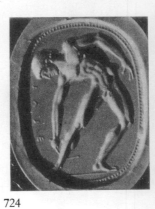

724

722

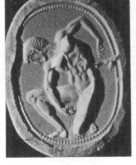

723

724

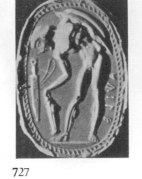

724

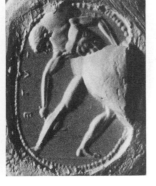

725

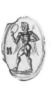

725

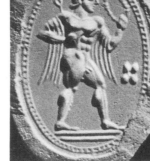

726

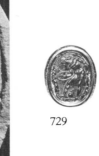

726

727

727

727

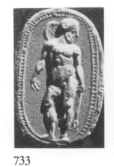

731

ETRUSCAN GEMS: LATE ARCHAIC AND MIDDLE PERIODS, ABOUT 500–400 B.C.
Male figures showing the development in the rendering of anatomical forms

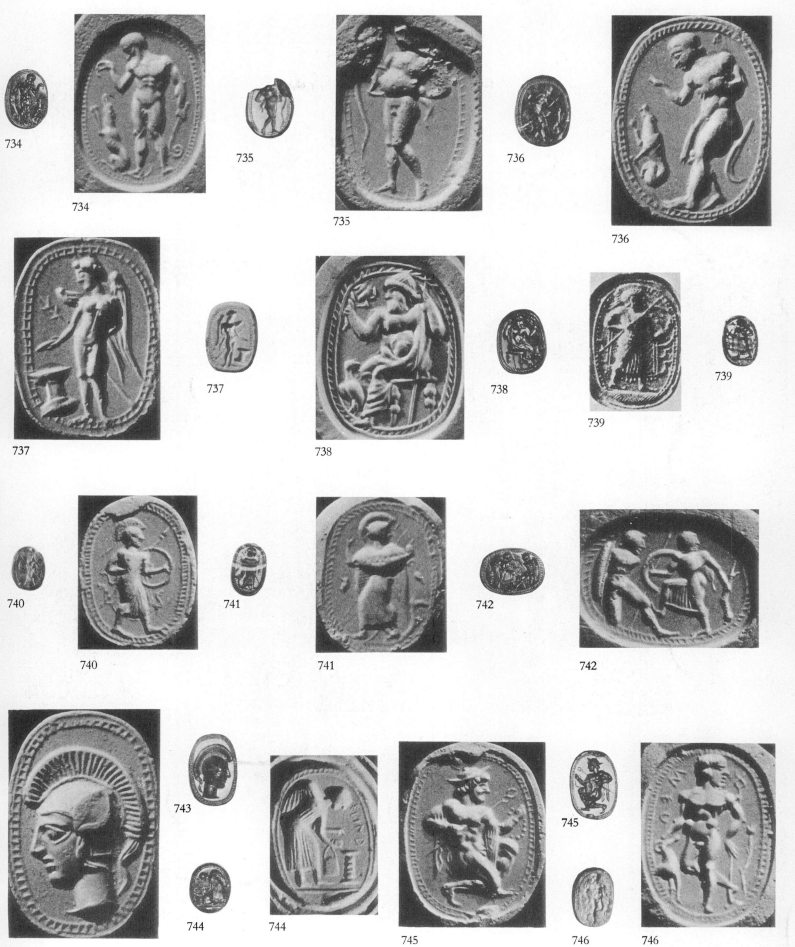

734

734

735

735

736

736

737

737

738

738

739

739

740

740

741

741

742

742

743

743

744

744

745

745

746

746

ETRUSCAN GEMS, LATE SIXTH TO FOURTH CENTURY B.C.

Male figures showing the development in the rendering of anatomical forms (734–737); Deities (738–746)

747

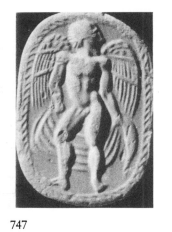

747

748

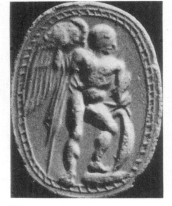

748

751

751

749

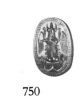

750

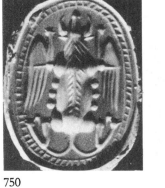

750

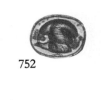

752

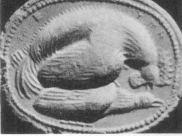

752

753

753

754

754

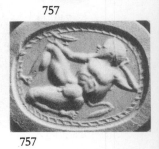

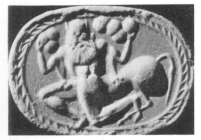

755

755

756

757

757

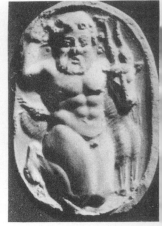

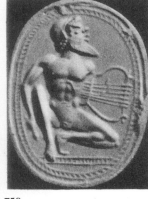

758

758

759

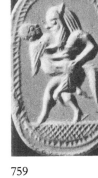

759

760

760

761

ETRUSCAN GEMS, SIXTH TO FOURTH CENTURY B.C.
Daemons, monsters, animals, centaurs, and satyrs

762

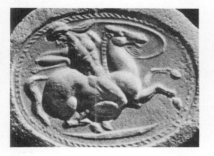

762

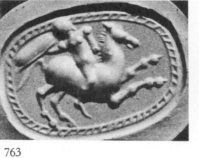

763

764

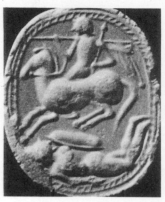

764

765

765

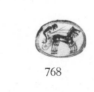

766

766

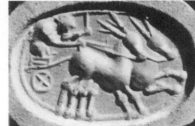

767

767

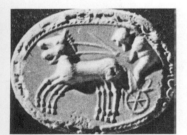

768

768

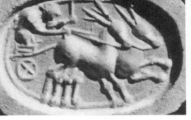

769

769

769

770

770

771

771

772

772

ETRUSCAN GEMS, FIFTH TO FOURTH CENTURY B.C.
Scenes from daily life

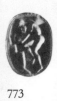

773

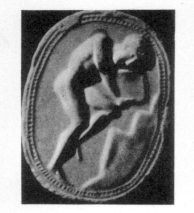

773

774

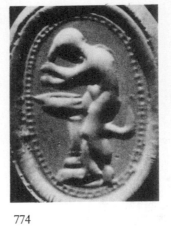

774

775

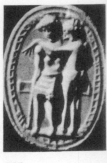

775

776

777

778

779

780

781

779

780

781

782

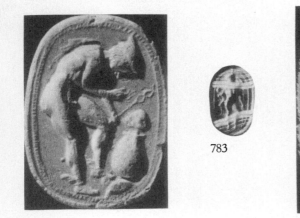

782

783

784

783

784

ETRUSCAN GEMS, FIFTH TO FOURTH CENTURY B.C.
Scenes from daily life (773-780); Augury (781, 782); Hermes Psychopompos (783, 784)

785

785

786

786

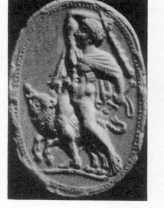

787

788

788

789

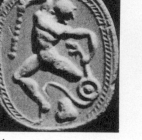

789

789

790

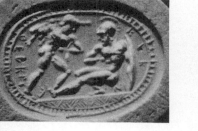

790

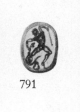

791

791

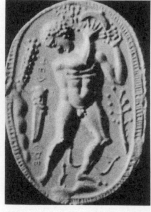

792

792

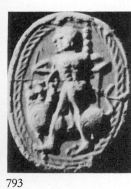

793

793

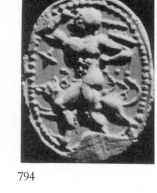

794

794

795

795

ETRUSCAN GEMS, LATE SIXTH TO FIFTH CENTURY B.C.
Legends: Herakles and his Labours

796

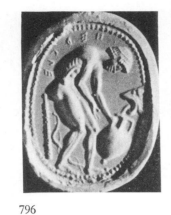

796

797

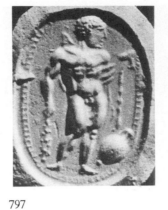

797

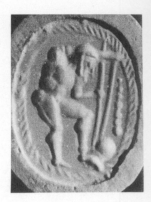

798

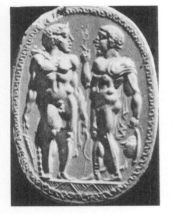

799

799

800

800

800

801

802

802

803

803

804

804

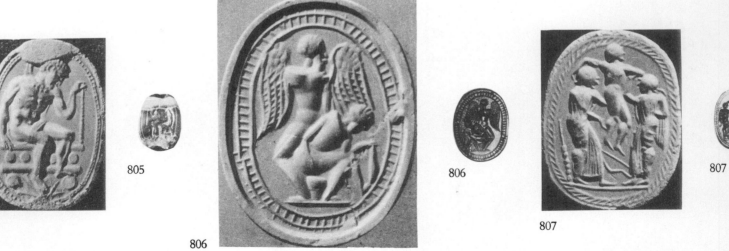

805

805

806

806

807

807

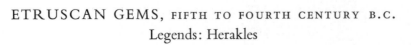

ETRUSCAN GEMS, FIFTH TO FOURTH CENTURY B.C.
Legends: Herakles

808

809

810

808

808

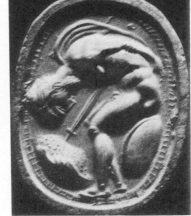

809

810

811

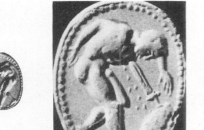

811

812

812

813

814

814

815

815

813

813

816

816

816

817

818

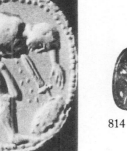

818

818

ETRUSCAN GEMS, ABOUT 500–300 B.C.
Homeric Legends: The Trojan Horse, Memnon (?), Ajax, Achilles

819

820

821

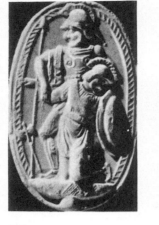

819

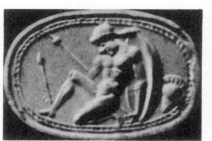

820

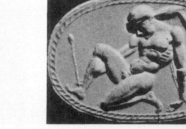

821

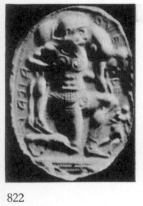

822

822

823

823

824

824

825

825

826

826

827

827

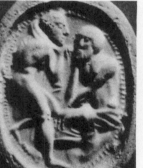

828

828

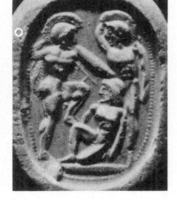

829

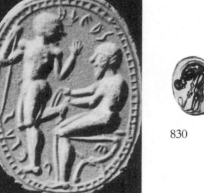

829

830

830

831

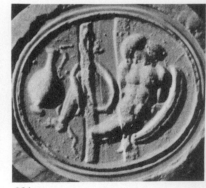

831

ETRUSCAN GEMS, ABOUT 500–350 B.C.
Homeric Legends (continued)

832

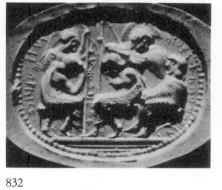

832

833

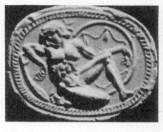

833

834

834

835

835

836

836

836

837

837

838

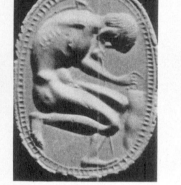

838

839

839

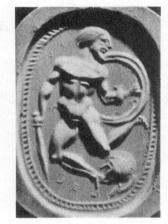

839

840

840

841

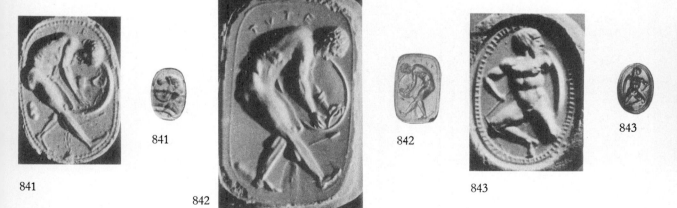

841

842

842

843

843

844

ETRUSCAN GEMS, ABOUT 500–400 B.C.
Theban Legends

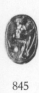

845

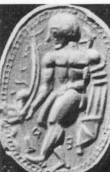

845

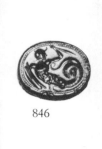

846

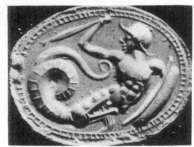

846

847

847

848

849

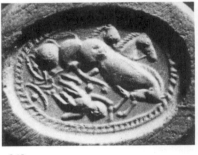

849

848

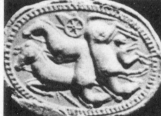
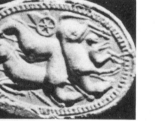

850

850

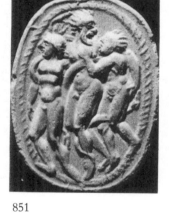

851

851

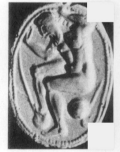

852

852

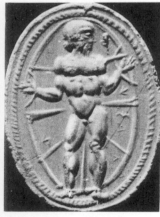

853

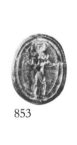

853

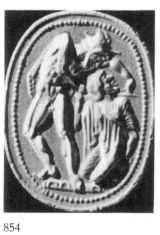

854

854

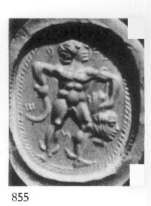

855

ETRUSCAN GEMS, ABOUT 500–350 B.C.
Various Legends: Jason, Phaethon, Laokoon, Atlas (?), Ixion, Perseus

856

856

857

857

858

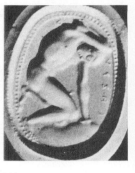

858

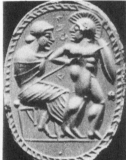

859

859

860

860

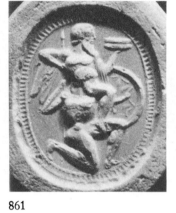

861

861

862

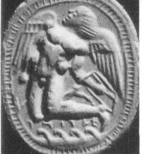

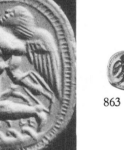

862

863

863

864

864

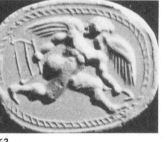

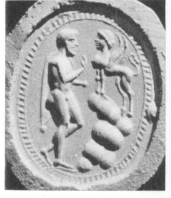

865

865

865

865

865

866

866

ETRUSCAN GEMS, FIFTH AND FOURTH CENTURIES B.C.
Various Legends

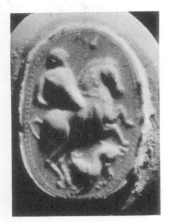

867

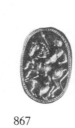

867

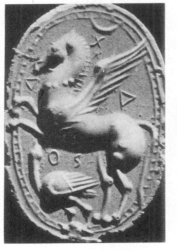

868

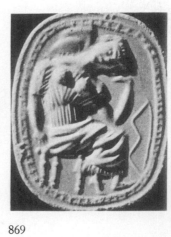

869

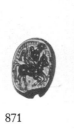

868

869

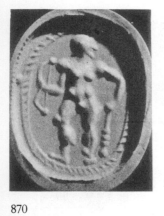

870

871

872

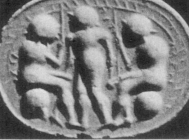

872

871

873

873

874

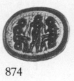

874

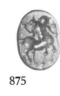

875

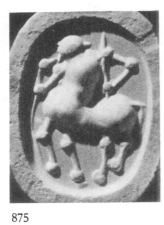

875

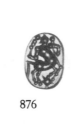

876

876

ETRUSCAN GEMS, ABOUT 450-300 B.C.
Various Legends (867-869); Representations in the 'globolo' style (870-876)

BIBLIOGRAPHY OF THE CHIEF BOOKS AND ARTICLES, FROM THE RENAISSANCE TO MODERN TIMES, ON GREEK, ETRUSCAN, AND ROMAN ENGRAVED STONES AND RINGS

L. Agostini, *Le gemme antiche figurate* (with text by Agostini and B. Bellori), I (1657), II (1669), 2nd ed. 1686.

C. Alexander, 'Greek Gems and the Animal World', *M.M.A. Bulletin*, 1942, pp. 144 ff.

M. Alföldi, *Die konstantinische Goldprägung*, 1963.

— *Early Rome and the Latins*, 1963. (Pls. XIII, XIV contain gems of the Roman Republican Period.)

J. Arneth, *Monumente der kk. Münz- und Antiken-Cabinettes*, 1849.

M. Astruc, *Catálogo descriptivo de los entallos procedentes de distintos sitios de la colonización oriental de la península conservados en el Museo Arquélogo Nacional, Mem. de los mus. arquelógicos*, 1954, pp. 110 ff.

E. Babelon, *Le Cabinet des antiques à la Bibliothèque Nationale*, 1887.

— *La Gravure en pierres fines, camées et intailles*, 1894.

— *Catalogue des camées antiques et modernes de la Bibliothèque Nationale*, 2 vols., 1897.

— *Collection Pauvert de La Chapelle, intailles et camées donnés au département des médailles et antiques de la Bibliothèque Nationale*, 1899.

— *Guide illustré du Cabinet des Médailles et antiques de la Bibliothèque Nationale*, 1901.

— in Daremberg and Saglio, *Dictionnaire des antiquités*, II, 2 (1918), s.v. Gemmae, pp. 1471 ff.

E. B(abelon), *Le Cabinet des Médailles et Antiques, Notice historique et Guide du Visiteur*, 1924.

J. Babelon, *Mon. Piot*, XLV, 1951, pp. 77 ff.

F. Bartolozzi, *Gems from the Antique*, one hundred and eight plates.

H. Bauer, *Edelsteinkunde*, 1896.

J. D. Beazley, *The Lewes House Collection of Ancient Gems*, 1926.

— *Sale Catalogue of the Story-Maskelyne Coll.*, q.v.

G. Becatti, *Oreficerie antiche dalle Minoiche alle Barbariche*, 1955, passim.

L. Beger, *Thesaurus Brandenburgicus*, 3 vols., 1696–1701.

J. J. Bernoulli, *Römische Ikonographie*, I, II 1, II 2, II 3, 1882–1894.

— *Griechische Ikonographie, mit Ausschluss Alexanders und der Diadochen*, I, II, 1901, passim.

B. Y. Berry, *A Selection of Ancient Gems from the Collection of B.Y.B.*, 1965.

H. Blümner, *Technologie und Terminologie der Gewerbe und Künste bei den Griechen und Römern*, III, 1884, Die Verarbeitung der Edelsteine, pp. 279 ff; Die wichtigsten Edel- und Halbedelsteine der Alten, pp. 227 ff.

J. Boardman, *Island Gems, A Study of Greek Seals in the Geometric and Early Archaic Periods*, 1963.

— 'Archaic Finger Rings', *Antike Kunst*, X, 1967, pp. 1 ff.

— *Engraved Gems, The Ionides Collection*, 1968.

— *Archaic Greek Gems, Schools of Artists in the Sixth and Early Fifth Century* (forthcoming).

C. Bonner, 'Studies in Magical Amulets', *University of Michigan Studies*, Humanistic Series, XLIX, 1950.

Christie's Sale Catalogue of the *Boulton* Collection, Dec. 12, 1911.

D. A. Bracci, *Memorie degli antichi incisori che scolpirono i loro nomi in gemme e cammei*, I, 1784, II, 1786.

L. Breglia, 'Le oreficerie del Museo di Taranto', *Iapigia*, N.S. X, 1939, pp. 5 ff.

— *Catalogo delle oreficerie del Museo Nazionale di Napoli*, 1941.

— in *Enciclopedia dell'arte antica*, III, 1960, s.v. Glittica.

N. Breitenstein, *Fra Nationalmuseets Arbejdsmark*, 1942, pp. 91 ff.

H. Brunn, *Geschichte der griechischen Künstler*, vol. II (1st ed. 1859, 2nd ed. 1889), Die Gemmenschneider, pp. 303 ff.

G. Bruns, 'Staatskameen des 4. Jahrh. n. Chr.', 104. *Winckelmannsprogramm*, 1948.

H. Bulle, 'Die Steinschneidekunst im Altertum', *Neue Jahrbücher der antiken Kunst*, V, 1900, pp. 661 ff.

F. Buonarotti, *Osservazioni istoriche sopra alcuni medaglioni antichi*, 1698.

Burlington Fine Arts Club Exh. of Greek Art, 1904, pp. 159 ff.

Cabinet des Médailles, *Pierres gravées, Guide du Visiteur*, 1930.

T. Cades, *Collection of Impressions of Gems*, accompanied by short descriptions; cf. the lists in *Bull. dell. Inst.* 1831, pp. 102 ff., 1834, pp. 113 ff., 1839, pp. 99 ff.

R. Calza, Articles in the *Enciclopedia dell'arte antica*, under various names of gem engravers.

— *Iconografia romana del tardo impero* (forthcoming).

S. Casson, 'Some Greek Seals of the Geometric Period', *The Antiquaries Journal*, VII, 1927, pp. 38 ff.

Sale Catalogue of the *Al. Castellani Collection*, March 26–27, 1884 (by W. Froehner).

A. C. P. Caylus, *Recueil d'antiquités*, vols. I–VII, 1752–1768.

A. Chabouillet, *Catalogue général et raisonné des camées et pierres gravées de la Bibliothèque Impériale*, 1858.

— *Description des antiquités et objets d'art composant le Cabinet de M. Louis Fould*, 1861, pls. VIII–X.

— 'Études sur quelques camées du Cab. d. Méd.', *Gaz. arch.*, X, 1885, pp. 396 ff., XI, 1886, pp. 16 ff., 130 ff., 169 ff.

V. Chapot, in Daremberg and Saglio's *Dictionnaire des ant.*, IV, 2, s.v. signum.

G. H. Chase, *A Guide to the Classical Collection, Museum of Fine Arts, Boston*, 1950, *passim*. Abbr. Chase, *Guide*; 2nd ed., amplified, by C. Vermeule.

G. Siena Chiesa, 'Gemme di età repubblicana al Museo di Aquileia', *Aquileia Nostra*, XXXV, 1964, pp. 2 ff.

— *Gemme del Museo Nazionale di Aquileia*, 1966 (contains only Republican and Imperial Roman gems).

C. Clairmont, *Antinous, Die Bildnisse des Antinous*, 1966.

L. Claremont, *The Gem-Cutter's Craft*, 1906.

E. Coche de la Ferté, *Les Bijoux antiques*, 1956, *passim*.

— *Le Camée Rothschild, un chef-d'œuvre du IVᵉ siècle après J.-C.*, 1957.

Collection d'un archéologue explorateur, Sale Catalogue, Paris, 1905, May 5–8.

A. Conze, 'Das Vorbild der Diomedesgemmen', *J.d.I.*, IV, 1889, pp. 87 ff.

Catalogue of the Wyndham F. Cook Collection, by C. F. Smith and A. Hutton.

Corpus Inscr. grec., IV, (1877), nos. 7029, 7372.

Crome, F., 'Göttinger Gemmen in Auswahl beschrieben', *Nachrichten von der Gesellschaft d. Wiss. zu Göttingen*, philol.-hist. Kl., 1931, Heft 1.

L. Curtius, 'Ikonographische Beiträge zum Porträt der römischen Republik und der Julisch-Claudischen Familie,' *Röm. Mitt.*, XLVII, 1932, pp. 202 ff., *passim*.

— 'Falsche Kameen', *Arch. Anz.*, 1944/45, cols. 1 ff.

O. M. Dalton, *Catalogue of the Engraved Gems of the Post-Classical Periods*, British Museum, Dept. of British and Medieval Antiquities, 1915.

R. Delbrück, *Antike Porträts*, 1912, *passim*.

— *Die spätantiken Kaiserporträts*, 1933, *passim*, and pls. 73–75.

W. Deonna, 'Gemmes antiques de la Collection Duval au Musée d'Art et d'Histoire de Genève', *Aréthuse*, II, 1925, pp. 26 ff.

F. Duemmler, 'Archaische Gemmen von Melos', *Ath. Mitt.*, XI, 1886, pp. 170 ff.

T. Dumersan, *Notice des monuments exposés dans le Cabinet des Médailles* (1819).

J. H. von Eckhel, *Choix des pierres gravées du cabinet impérial des antiques*, 1788.

F. Eichler and E. Kris, *Die Kameen im Kunsthistorischen Museum, Wien*, 1927.

Enciclopedia dell' arte antica e orientale, cf. under the names of the gem engravers (by L. Breglia, R. Calza, G. S. Mansuelli, Panvini Rosati, and others).

A. J. Evans, *An Illustrative Selection of Greek and Greco-Roman Gems*, 1938. (Abbreviated *Selection* or *Gems*.)

B. M. Felletti Maj, 'Iconografia romana imperiale da Severo Aless. a M. Aurelio Carino', *Quaderni e Guide d'Archeologia*, II, 1958.

E. Fiesel, 'Etruskische Gemmen, Inschriftliche Denkmäler des Museum of Fine Arts in Boston', *Studi etr.*, X, 1936, pp. 399 ff.

W. Fol, *Catalogue du Musée Fol*, II, Antiquités: glyptique et verrerie, 1875.

Musée Fol, Choix d'intailles et des camées antiques, gemmes et pâtes, 1875–1878.

E. Fontenay, *Les Bijoux anciens et modernes*, 1887.

L. Forrer, *Biographical Dictionary of Medallists, Coin-, Gem-and Seal-Engravers . . .* , 8 vols., 1904–1930.

C. D. E. Fortnum, 'Notes on some of the Antique and Renaissance Gems and Jewels in Windsor Castle', *Archaeologia*, XLV, 1877, pp. 1 ff.

P. Fossing, *Catalogue of the Antique Engraved Gems and Cameos, Thorvaldsen Museum*, 1929.

W. Froehner, *La Verrerie antique. Description de la Collection Charvet*, 1879.

— *Collection Julien Gréau, Verrerie antique*, 1903. See also under *Tyszkiewicz*.

H. Fuhrmann, 'Zur Datierung des Licinius-Kameos', *Schweizer Münzblätter*, 17, 1967, pp. 58 ff.

A. Furtwängler, 'Phrygillos', *Études archéol. dédiées à M. Leemans*, Leiden, 1885 = *Kleine Schriften*, II, 1913, pp. 145 f.

— Eine Eros und Psyche-Gemme, *Arch. Ztg.*, XLII, 1884, cols. 17 f., *J.d.I.*, III, 1888, pp. 73 f. = *Kleine Schriften*, II, 1913, pp. 145 f.

— 'Studien über die Gemmen mit Künstlerinschriften', *J.d.I.*, III, 1888, pp. 105 ff., IV, 1889, pp. 46 ff. = *Kleine Schriften*, II, 1913, pp. 147 ff.

— 'Gemme des Künstlers Skopas', *J.d.I.*, VIII, 1893, pp. 185 f. = *Kleine Schriften*, II, 1913, pp. 292 f.

— *Beschreibung der geschnittenen Steine im Antiquarium, Berlin*, 1896.

— *Die antiken Gemmen*, I–III, 1900.

A. P. N. Galeotti, *F. Ficoroni Gemmae antiquae litteratae*, 1758.

Ganschnietz, in Pauly-Wissowa, *R.E.*, 2. Reihe, I, A, I (1914), s.v. Ringe, cols. 807–841.

K. Gebauer, 'Alexanderbildnis und Alexandertypus', *Ath. Mitt.*, 63/64, 1938/39, pp. 25 ff. (portraits on gems).

H. Gebhart, *Gemmen und Kameen*, 1925, pp. 187 ff.

E. Gerhard, 'Gemmenbilder', *Arch. Ztg.*, VII, 1849, cols. 49 ff.

F. W. Goethert, 'Zum Bildnis der Livia', in *Festschrift Andreas Rumpf*, 1952, pp. 93 ff.

V. von Gonzenbach, 'Römische Gemmen aus Vindonissa', *Zeitschrift für schweiz. Archäologie und Kunstgeschichte*, XIII, 1952, pp. 79 ff.

A. F. Gori, *Museum Florentinum*, Gemmae antiquae ex thesauro mediceo . . . 1732–1766.

— *Dactyliotheca Smithiana*, 1767.

Lévesque de Gravelle, *Recueil de pierres gravées*, I, II, 1732, 1737.

A. Greifenhagen, *Berliner Museen*, N.F., Sonderheft zur Wiederöffnung der Antikensammlung am 28. Mai 1960, pp. 12–19.

J. P. Guépin, 'Antieke Kunst in Nederlandse Musea', *Hermeneus*, XXXV, 1964, pp. 282 ff.

— 'Geschnittene Steine in den Haag', *Bulletin van de Vereeniging tot Bevordering der Kennis van de Antieke Beschaving te 's-Gravenhage*, XLI, 1966, pp. 50 ff. Generally abbreviated *Bull . . . Ant. Besch.*

— 'Othryades', ibid. pp. 57 ff.

Sotheby's Sale Catalogue of the *Guilhou Collection*, Nov. 9–12, 1937.

H. von Heintze, 'Studien zu den Porträts des 3. Jahrhunderts nach Chr.', *Röm. Mitt.*, 73/74, 1966/67, pp. 190 ff.

— 'Römische Glyptik und Münzprägekunst', in *Propyläen Kunstgeschichte*, vol. II, 1967, pp. 281–286.

F. Henkel, *Die römischen Fingerringe der Rheinlande und der benachbarten Gebiete*, 1913.

Catalogue of the Hertz Collection, 1351.

R. Higgins, *Greek Jewellery*, 1961, passim.

D. K. Hill, 'Some Hellenistic Carved Gems', *Journal of the Walters Art Gallery*, VI, 1943, pp. 60 ff.

— 'Gem Pictures', *Archaeology*, XV, 1962, pp. 121 ff.

H. Hoffmann and P. H. Davidson, *Greek Gold Jewelry from the Age of Alexander*, 1965, passim.

F. Imhoof-Blumer and P. Gardner, *A Numismatic Commentary on Pausanias*, reprinted from *J.H.S.* 1885, 1886, 1887. A new edition by N. Oikonomides, entitled: *Ancient Coins illustrating Lost Masterpieces of Greek Art*, 1964.

F. Imhoof-Blumer and O. Keller, *Tier- und Pflanzenbilder auf Münzen und Gemmen*, 1889 (generally abbreviated Imhoof-Blumer and Keller).

H. Imhoof-Blumer, *Porträtköpfe auf römischen Münzen der Republik und der Kaiserzeit* (2nd ed.), 1892.

H. U. Instinsky, *Die Siegel des Kaisers Augustus, Ein Kapitel zur Geschichte und Symbolik des antiken Herrschersiegels*, 1962.

O. Jahn, 'Der Raub des Palladions', *Philologus*, I, 1846, pp. 40 ff.

L. C. de Jonge, *Notice sur le Cabinet des médailles du roi des Pays-Bas*, 1824.

— *Catalogue d'empreintes du Cabinet des pierres gravées de Sa Majesté le Roi des Pays-Bas, Grand-Duc de Luxembourg*, 1837.

H. Jucker, 'Porträtminiaturen von Augustus, Nero und Trajan', *Schweizer Münzblätter*, XIII/XIV, 1964, pp. 81 ff.

— 'Ein Kameo-Porträt des Commodus, *Schweizer Münzblätter*, XVI, 1966, Heft 64, pp. 161 ff.

O. Keller, *Thiere des klassischen Alterthums*, 1887.

— *Die antike Tierwelt*, I, 1909, II, 1913.

T. B. Kibaltchitch, 'Gemmes de la Russie méridionale de la collection Kibaltchitch', 1910. In Russian.

C. W. King, *Antique Gems, Their Origin, Uses and Value*, 1866.

— *Archaeological Journal*, XXIV, 1867, pp. 203 ff., 300 ff.

— *Antique Gems and Rings*, 1872.

— *Handbook of Engraved Gems*, 2nd ed., 1885.

C. A. Klotz, *Über den Nutzen und Gebrauch der alten geschnittenen Steine*, 1768.

K. E. Kluge, *Handbuch der Edelsteinkunde*, 1860.

A. E. Knight, *The Collection of Camei and Intaglii at Alnwick Castle, Known as 'The Beverley Gems'*, 1921 (privately printed).

H. K. E. Koehler, *Abhandlung der geschnittenen Steine mit den Namen der Künstler*, Gesammelte Schriften, ed. by L. Stephani, vol. III, 1851.

C. H. Kraeling, 'Hellenistic Gold Jewelry', *Archaeology*, VIII, 1955, pp. 256 ff.

K. Kraft, 'Über die Bildnisse des Aristoteles und des Platon', *Jahrbuch für Numismatik und Geldgeschichte*, XIII, 1963 (deals with Greek portraits on glass gems of the Roman period).

J. H. Krause, *Pyrgoteles oder die edlen Steine der Alten*, 1856.

De La Chau and Le Blond, *Description des princip. pierres grav. du duc d'Orléans*, I (1780), II (1784). (The Orléans collection later went to the Hermitage.)

F. Lajard, *Introduction à l'étude du culte public et des mystères de Mithra*, 1847.

— *Recherches sur le culte et les mystères de Mithra en Orient et Occident*, 1867.

J. Laurie, 'Médaillon constantinien', in *Revue numismatique*, 5th series, XVI, 1954, pp. 227 ff.

K. Levezow, *Über den Raub des Palladiums auf den geschnittenen Steinen des Alterthums*, 1801–1804.

P. D. Lippert, *Die Daktyliothek*, 1767. Supplement, 1776.

G. Lippold, 'Das Bildnis des Heraklit', *Ath. Mitt.*, vol. 36, 1911, pp. 153 ff.

— *Gemmen und Kameen des Altertums und der Neuzeit*, 1922.

H. P. L'Orange, *Spätantike Kaiserporträts*, 1933.

— *Apotheosis in Ancient Portraiture*, 1947.

R. Lullies, *Griechische Plastik, Vasen und Kleinkunst, Leihgaben aus Privatbesitz, Kassel*, 1964.

R. H. Mac Daniel, 'Stamped and Inscribed Objects from Seleucus on the Tigris', *University of Michigan Studies*, XXV, 1935.

G. Maddoli, 'Le Cretule del Nomophylakion di Cirene', *Annuario*, XLI–XLII, 1963–1964, pp. 39 ff.

P. A. Maffei, *Gemme antiche figurate date in luce da Dom. de' Rossi coile sposizioni di P. A. Maffei*, 1707–1709.

G. S. Mansuelli, in *Enc. dell' arte antica . . .* , I (1958), s.v. Alessandro Magno.

P. J. Mariette, *Traité des pierres gravées*, I, II, 1750.

M. Calvani Marini, 'Una gemma incisa tardoromana', *Boll. d'Arte*, 1965, pp. 153 ff.

Marlborough Collection, *Choix des pierres antiques gravées du cabinet du duc de Marlborough*, 1848.

Christie's Sale Catalogue of the Marlborough Gems, June 28 ff., 1875.

F. H. Marshall, *Catalogue of the Finger Rings, Greek, Etruscan and Roman, British Museum*, 1907.

W. Martini, 'Drei etruskische Skarabäen', *Meddelser fra Thorvaldsens Museum*, 1965, pp. 72 ff.

M. H. N. Story-Maskelyne, *The Marlborough Gems, being a collection of works in Cameo and Intaglio, formed by George, third Duke of Marlborough*, 1870 (privately printed).

M. I. Maximova, *Kameya Gonzaga*, 1924.

— *Antichnie resnie kamni Ermitazha*, 1926. In Russian. (=*Ancient Gems and Cameos*.)

— *Arch. Anz.*, 1928, cols. 649 ff.

— *Villes antiques du littoral de la Mer Noire*, 1955. In Russian. Pp. 437–445 are on engraved gems.

Marion du Mersan, *Histoire du Cabinet des Médailles*, 1838.

— Département des Médailles, *Description sommaire des monuments exposés* (1867).

G. Micali, *Storia degli antichi popoli italiani*, III, 1836, *passim*.

J. H. Middleton, *The Engraved Gems of Classical Times, with a Catalogue of the Gems in the Fitzwilliam Museum*, 1891.

— *The Lewis Collection of Gems and Rings in the possession of Corpus Christi College, Cambridge*, 1892.

A. Milchhoefer, *Anfänge der Kunst in Griechenland*, 1883.

A. L. Millin, *Introduction à l'étude des pierres gravées*, 1797.

— *Mémoire sur quelques pierres gravées représentant l'enlèvement du palladium*, 1812.

— *Pierres gravées inédites tirées des plus célèbres cabinets d'Europe*, 1817, 1825.

H. Möbius, 'Römischer Kameo in Kassel', *Arch. Anz.*, 1948/49, pp. 102 ff.

— 'Zum grossen Pariser Cameo', in *Festschrift für Friedrich Zucker*, 1954, pp. 265 ff.

— 'Der grosse Stuttgarter Kameo', *Schweizer Münzblätter*, XVI, 1966, Heft 63, pp. 110 ff.
(Both reprinted in Möbius' *Studia Varia*, 1967.)

B. de Montfaucon, *L'Antiquité expliquée*, 1719 and 1724.

Sale Catalogue of the Morrison Collection of gems and antiquities, June 1898.

E. Müntz, *Les Précurseurs de la Renaissance*, 1882.

A. S. Murray, A. H. Smith, and H. B. Walters, *Excavations in Cyprus*, 1900.

J. L. Myres, *Handbook of the Cesnola Collection of Antiquities from Cyprus, Metropolitan Museum of Art*, 1914, pp. 410 ff.

L. Natter, *Catalogue des pierres gravées . . . de Mylord Comte de Bessborough* (1761).

— *Traité de la méthode antique de graver en pierres fines comparée avec la méthode moderne*, 1754.

C. T. Newton, *Guide to the Blacas Collection*, 1867.

P. de Nolhac, 'Les Collections d'antiquités de Fulvio Orsino', *Mélanges d'archéologie et d'histoire*, IV, 1884, pp. 153–172.

R. Noll, 'Der Jupiter-Kameo', *Anzeiger für Altertumswissenschaft*, XX, 1967, cols. 127–129.

Museum Odescalchum, sive Thesaurus antiquarum gemmarum quae a serenissima Christina Suecorum regina collectae in Museo Odescalcho adservantur, et a Petro Sancte Bartolo quondam incisae, nunc primum in lucem proferuntur, 1751.

D. Ohly and G. Kleiner, 'Gemmen der Sammlung Arndt', *Jahrbuch der Kunst*, N.F., II, 1951, pp. 7 ff.

D. Ohly, *Münchner Jahrbuch der bildenden Kunst*, 1951, pp. 11 ff.

D. Ohly and E. V. Czako, *Griechische Gemmen*, 1963.

C. Oman, *Catalogue of Finger Rings, Victoria and Albert Museum*, 1930.

Orléans Collection, *Description des principales pierres gravées du duc d'Orléans*, I, 1780, II, 1784.

D. Osborne, *Engraved Gems, Signets, Talismans and Ornamental Intaglios, Ancient and Modern*, 1912.

J. Overbeck, *Die Bildwerke zum thebischen und troischen Heldenkreis*, 1857.

— *Griechische Mythologie*, I–III, 1871–1889. (Included are plates with gems.)

T. Panofka, 'Gemmen mit Inschriften in den kgl. Museen zu Berlin, Haag, Kopenhagen, London, Paris, Petersburg und Wien', *Phil. Hist. Abh. d. Wiss.*, Berlin, 1851.

J. B. Passeri, *Novus thesaurus gemmarum veterum ex insignioribus dactyliothecis selectarum in explicationibus*, 1781–1788.

G. Perrot and C. Chipiez, *Histoire de l'art dans l'antiquité*, IX, 1911, ch. XIV, La Glyptique, pp. 1–43.

G. Pesce, 'Gemme medicee del Museo Nazionale di Napoli', *RR. Ist. d'Archeologia e Storia dell'Arte*, V, I–II, pp. 50 ff.

F. Poulsen, 'Römische Privatporträts und Prinzenbildnisse', *Kgl. Danske Videnskabernes Selskab, Archaeol.-kunsthist. Meddelelser*, 1939.

R. E. Raspe, *A Descriptive Catalogue of a Collection of Gems cast in coloured paste by James Tassie*, 1791. Abbreviated Raspe.

S. Reinach, *Antiquités du Bosphore Cimmérien, rééditées, avec un commentaire nouveau, . . .*, 1892.

— *Pierres gravées des Collections Marlborough et d'Orléans, des recueils d'Eckhel, Gori, Gravelle, Mariette, Millin, Stosch, réunies et rééditées*, 1895.

S. de Ricci, *Catalogue Guilhou*, 1912.

G. M. A. Richter, *Catalogue of Engraved Gems, Greek, Etruscan and Roman, Metropolitan Museum*, 1st ed. 1920, 2nd ed. 1956.

— 'Gems in Art', *Encyclopaedia Britannica*, 14th ed. 1929, vol. X, pp. 97 ff.

— *Ancient Gems from the Evans and Beatty Collections*, 1947.

— 'The Late "Achaemenian" or "Graeco-Persian Gems"', Commemorative Studies in Honor of Theodore Leslie Shear, *Hesperia*, Supplement VIII, 1949, pp. 291 ff.

— 'Greek Subjects on Graeco-Persian Seal Stones', in *Archaeologica Orientalia in Memoriam Ernst Herzfeld*, 1952, pp. 189 ff.

— 'Unpublished Gems in Various Collections', *A.J.A.*, LXI, 1957, pp. 263 ff.

— 'Engraved Gems in Cambridge', *Hommages à Léon Herrmann, Coll. Latomus*, XLIX, 1960, pp. 674 ff.

— *The Portraits of the Greeks*, 1965, passim.

A. de Ridder, *Collection de Clercq*, vol. VII, 2, Les pierres gravées, 1911.

— *Catalogue sommaire des bijoux antiques du Musée du Louvre*, 1924.

R. Righetti, *Gemme e cammei delle Collezioni Comunali*, 1955.

— *Opere di glittica del Museo Sacro e Profano, Città del Vaticano*, 1955.

— 'Gemme del Museo Nazionale Romano alle Terme Diocleziane', *Rend. Pont. Acc.*, XXX–XXXI, 1957–1959, pp. 213 ff.

D. M. Robinson, 'The Robinson Collection of Gems, Seals, Rings and Earrings', *Hesperia* Supplement VIII, 1949, Commemorative Studies in honor of T. L. Shear, pp. 305 ff.

Sale Catalogue of the Newton Robinson Collection, 1909.

L. Ross, *Reisen auf den griechischen Inseln des Ägäischen Meers*, III, 1840–1845, pp. XI–XII, 21.

O. Rossbach, *Arch. Zeitung*, XLI, 1883, pp. 69 ff.

— in *R.E.*, VII, 1, 1910, s.v. Gemmen, cols. 1052 ff.

M. Rostovtzeff, 'Seleucid Babylonia, Bullae and Seals of Clay with Greek Inscriptions', *Yale Classical Studies*, III, 1932, pp. 1 ff.

E. von Sacken und F. Kenner, *Die Sammlungen des kgl. Münz- und Antiken Cabinettes* 1866, pp. 409 ff.

A. Sambon, 'Sur la classification des intailles italiotes avec le secours de la numismatique', *Corolla Numismatica*, 1906, pp. 275 ff.

G. Sangiorgi, *Röm. Mitt.*, XLVIII, 1933, pp. 284 ff.

— *Pantheon*, X, 1937, pp. 144 ff.

K. Schefold, 'Das Deuten von Sagenbildern', *Gymnasium*, LXI, 1954, pp. 285 ff.

A. H. F. von Schlichtegroll, *Choix des principales pierres gravées de la collection Stosch*, 1792–1805.

R. von Schneider, *Album der Antikensammlung*, Wien, 1895, pls. 39–44.

Th. Schreiber, 'Studien über das Bildnis Alexanders des Grossen', *Abh. d. philolog.-hist. Kl. d. sächsischen Ges. d. Wiss.*, XXI, no. 3.

W. Schwabacher, *Schweizerische Numismatische Rundschau*, XLV, 1966, pp. 191 ff. (review of M.-L. Vollenweider's *Steinschneidekunst* from the numismatic standpoint).

R. Siviero, *Gli ori e le ambre del Museo Nazionale di Napoli*, 1954.

A. H. Smith, *A Catalogue of Engraved Gems in the British Museum*, 1888.

G. F. H. Smith, *Gemstones*, 1st ed. 1912, 13th ed. revised by F. C. Phillips, 1958, again revised 1962.

Catalogue of the Collection of Antique Gems formed by James, Ninth Earl of Southesk, edited by his daughter Lady Helena Carnegie, 1908.

R. Steiger, 'Gemmen und Kameen im Römermuseum Augst', *Antike Kunst*, IX, 1966, pp. 29 ff.

L. Stephani, Articles in *Comptes-rendus de la Commission Impériale*, St. Petersburg, from 1859 to *c.* 1882, on the gems found in South Russia.

— 'Angebliche Steinschneider', *Compte-rendu . . .*, 1861, pp. 152 ff.

Sotheby's Sale Catalogue of the Story-Maskelyne Collection of Ancient Gems, July 4–5, 1921 (text by J. D. Beazley).

M. H. Nevil Story-Maskelyne, Catalogue of the Marlborough Gems.

Ph. von Stosch, *Gemmae antiquae caelatae . . .*, 1724.

S. Stucchi, 'Ritratti della famiglia imperiale constaniniana, Crispo e Costantino II', *Archeologia classica*, II, 1950, pp. 205 ff.

I. Svoronos, 'Dorea K. Karapanou', *Journal international d'archéologie numismatique*, XV, 1913, pp. 157 ff., pls. I–XIV.

— 'Dorea D. Tsibanopoulou', *Journ. int. d'arch. num.* XVII, 1915, p. 71, pls. VI, VII.

E. H. Tölken, *Erklärendes Verzeichnis der antiken vertieft geschnittenen Steine der kgl. preuss. Gemmensammlung*, 1835.

La Collection Tyszkiewicz, Choix de Monuments antiques (text by W. Froehner), 1892.

Sale Catalogue of the Tyszkiewicz Collection, June 6–7, 1898 (text by W. Froehner). Pls. XXXIII, XXXIV contain cameos.

Ch. de Ujfalvy, *Le Type physique d'Alexandre le Grand*, 1902.

F. Ursinus, *Imagines et elogia virorum illustr. et erud. ex antiquis lapid. et nomism. expressae cum annotat. ex bibliotheca Fulvii Ursini*, 1570, Ant. Lafrériy formeis.

— *Illustrium imagines ex ant. marmor. nomismat. et gemmis expressae, quae exstant Romae, major pars apud Fulvium Ursinum*: Editio altera, aliquot imaginibus et J. Fabri ad singulas commentario auctior atque illustrior. Theod. Gallaeus delineabat Romae ex archetypis. 1598 and 1606.

C. Vermeule, 'Greek and Roman Gems, Recent Additions to the Collections', *Bulletin, Museum of Fine Arts, Boston*, LXVI, 1966, pp. 18 ff.

E. Q. Visconti, *Opere varie*, II, pp. 143–371.

— *Iconographie grecque*, I–III, 1924–1926.

P. Vivenzio, *Gemme antiche per la più parte inedite*, 1819.

A. Vives y Escudero, *Estudio de arqueologia cartaginesa: La necropoli de Ibiza*, 1917.

M.-L. Vollenweider, 'Verwendung und Bedeutung der Porträtgemmen für das politische Leben der römischen Republik', *Museum Helveticum*, XII, 1955, pp. 96 ff.

— 'Die Gemmenbildnisse Cäsars', *Antike Kunst*, III, 1960, pp. 81 ff.

— 'Les Portraits romains sur les intailles et camées de la Collection Fol', *Genava*, VIII, 1960, pp. 137 ff.

— 'Gems and Glyptics', in *Encyclopedia of World Art*, VI, 1962, cols. 53 ff.

— *Der Jupiter-Kameo*, Württembergisches Landesmuseum, Stuttgart, 1964.

— *Die Steinschneidekunst und ihre Künstler in spätrepublikanischer und augusteischer Zeit*, 1966.

— *Catalogue raisonné des sceaux, cylindres et intailles, Musée d'Art et d'Histoire de Genève*, vol. I, 1967.

H. B. Walters, *Art of the Greeks*, ch. XI, 1906, 3rd ed., 1934.

— *Art of the Romans*, 1911, *passim.*

— *Catalogue of the Engraved Gems and Cameos, Greek, Etruscan and Roman, British Museum*, 1926.

L. Wenger, in Pauly-Wissowa, *Real-Encyklopädie*, 2. Reihe, II, A, 2, 1923, s.v. signum, cols. 2378 ff.

K. O. Müller and Fr. Wieseler. *Denkmäler der alten Kunst*, third edition by Fr. Wieseler, 1877–1881. (Includes engraved gems cited in this book.)

J. J. Winckelmann, *Description des pierres gravées du feu Baron de Stosch*, 1760.

J. de Witte, *Description des antiquités et objets d'art qui composent le Cabinet du feu M. le chevalier F. Durand*, 1836.

T. Worlidge, *Select Collection of Drawings from curious antique Gems, etched after the manner of Rembrandt*, 1768.

A. N. Zadoks-Josephus-Jitta, *Hermeneus*, 1951, fig. 182.

— *La Collection Hemsterhuis au Cabinet Royal des Médailles à la Haye*, 1952.

— *Bull. Ant. Besch.*, The Hague, XLI, 1966, pp. 191 ff.

— *Schweizer Münzblätter*, XVII, 1967, Heft 65, pp. 25 f.

P. Zazoff, 'Die minoischen, griechischen und etruskischen Gemmen der Privatsammlung Dr. Johannes Jantzen, Bremen', *Arch. Anz.*, 1963, cols. 41 ff.

— 'Ephedrismos', *Antike und Abendland*, XI, 1962, pp. 35 ff.

— 'Gemmen in Kassel', *Arch. Anz.*, 1965, cols. 1 ff.

— 'Die älteste Glyptik Etruriens', *J.d.I.* vol. 81, 1966, pp. 63 ff.

SOURCES OF PHOTOGRAPHS

The illustrations of the gems in this book have been reproduced from the photographs sent me
by the following Museums and Institutions (many taken especially for me):

National Museum, Athens (taken by Mr. Konstantinos Konstantopoulos and by Emile Serafis).
Italian School of Archaeology, Athens.
Walters Art Gallery, Baltimore.
Staatliche Museen, Berlin.
Museum of Fine Arts, Boston.
Bowdoin College Museum, Brunswick, Maine.
Musées Royaux, Brussels.
Fitzwilliam Museum, Cambridge.
Oriental Institute, Chicago.
Thorvaldsen Museum, Copenhagen.
Corinth Museum.
Archaeological Museum, Florence.
Royal Cabinet of Coins and Gems, The Hague.
Museum für Kunst und Gewerbe, Hamburg.
Hermitage, Leningrad.
Archaeological Institute, Leipzig.

British Museum, London (some taken by Mrs. Czako Stresow).
Staatliche Münzsammlung, Munich (all taken by Mrs. Czako Stresow).
Museo Nazionale, Naples.
Metropolitan Museum of Art, New York.
Ashmolean Museum, Oxford.
Museo Nazionale, Palermo.
Cabinet des Médailles, Paris.
Musée du Louvre, Paris (taken by the Archives Photographiques and by Maurice Chuzeville).
Museo Nazionale delle Terme, Rome (some taken by Oscar Savio).
Museo di Villa Giulia, Rome.
Museo Nazionale, Syracuse.
Museo Nazionale, Taranto.
Museo Archeologico, Venice.
Kunsthistorisches Museum, Vienna.

A few have been taken from publications:

Furtwängler, *Antike Gemmen*; Filow, *Die Grabhügelnekropole bei Duvanlij in Südbulgarien*; Salinas, *Notizia degli Scavi*, 1883; Mariette, *Pierres gravées*; Marshall, *Catalogue of Finger-Rings*, British Museum; Richter, Catalogue of Engraved Gems, Metropolitan Museum; *Comptes rendus de la commission imp.*, St. Petersburg.

The drawings of forms of rings were made by I. A. Richter and by Mrs. Spencer Corbett (originally made for my M.M.A. Catalogue of 1956). Almost all the enlarged photographs taken from the impressions are by J. Felbermeyer.

LIST OF INSCRIBED GEMS

The numbers are those of the gems.

57, 103, 104, 109, 113, 116, 124, 164, 187, 201, 211, 214–216, 233, 246, 247, 262, 271, 277, 283, 294, 319, 326, 330, 354, 412, 421, 467, 468, 481, 482, 484, 485, 486, 487, 529, 531, 534, 542, 544, 548, 552, 553, 592, 593, 594, 602, 603, 614, 635, 636, 654, 673, 675, 676, 677, 678, 680, 685, 686, 689, 723, 724, 725, 727, 744, 746, 752, 780, 785, 788, 789, 790, 792, 817, 822, 823, 824, 829, 832, 836, 837, 839, 841, 842, 845, 855, 858, 859, 860, 862, 865(?).
See also pp. 14 ff. 74, 75, 76, 134, 165, 179.

INDEX OF COLLECTIONS

The numbers are those of the gems.

INDEX OF SUBJECTS

The numbers are those of the gems.

GODS, HEROES, AND LEGENDARY FIGURES
Acheloos 146, 147, 370, 371
Achilles 150, 156, 219, 519, 727, 816–818(?), 819–823
Adrastos 832
Aeneas 861
Ajax 57, 156, 812–814, 815(?), 822, 823
Amphiaraos 832
Anchises 861
Aphrodite 245, 251, 284, 290(?), 291, 299, 547, 551, 552, 555, 559, 561–563, 592
Apollo 102, 121(?), 136(?), 137(?), 345, 521, 524, 719
Artemis 4
Athena 161, 163, 242, 244, 287, 313, 549, 553, 739–743
Atlas 852(?)
Bellerophon 867(?), 871
Bes 28–32
Boreas 124
Daidalos 862(?), 863(?)
Danaë 346
Deianeira 147, 586
Diomedes 234, 343
Dionysos 522, 523, 526
Dioskouroi, The 585, 862(?)
Enkelados 742
Eos 318, 809–811(?)
Eros 125, 126, 158, 233, 266, 284, 291, 307, 344, 527, 534, 535, 547, 551, 592, 593, 737
Eryx 723
Europa 137a
Fortune 545
Galene 579–582
Ge 719
Gorgons 75(1), 596
Hades 342
Helios 571
Herakles 3, 35, 58, 87(?), 91, 97, 101, 119, 120, 135, 146–149, 221, 230, 231, 308, 344, 345, 350, 527–530, 567, 569, 572, 602, 604, 722(?), 785–807, 870
Hermes 38, 42(?), 122, 160, 220, 728, 733, 745, 746, 782, 799
Hermes Psychopompos 783, 784
Hyakinthos 136(?), 137(?)
Hypnos 806, 809–811(?)
Isis 34, 638–640
Ixion 853
Jason 845–848
Kadmos 729(?), 831(?)
Kapaneus 833–837
Kassandra 293, 294, 558, 560
Kastor 858
Kephalos 734(?)
Kyknos 149, 789, 790
Laodameia 859(?)
Laokoon 851

Leda 542
Machaon 829
Maenads 159, 253–259, 541, 550, 564, 576
Marsyas 533
Medusa 145, 167, 854, 855
Memnon 809–811(?)
Muses 249, 538(?), 540, 544(?), 556
Nemea 344
Nereus 332(?)
Nessos 3, 586
Nike 127, 128, 162, 246–248, 281, 292, 295, 336–337, 339, 341, 348, 349, 370, 371, 520, 548, 554, 804(?)
Nymph 157
Odysseus 228, 229, 808, 824–826
Oidipous 864
Omphale 539
Orpheus 408
Palamedes 838(?)
Pan 265, 444, 595
Parthenopaios 832
Pegasos 45, 426, 710, 868, 872
Penthesileia 150, 819
Persephone 342
Perseus 222, 854, 855
Phaethon 849, 850
Philoktetes 263, 268, 829, 831(?)
Polyidos 866
Polyneikes 832
Poseidon 332(?)
Prometheus 865
Protesilaos 859(?)
Psyche 869
Sarapis 570, 590, 638, 640
Selene(?) 272
Seven against Thebes, The 832
Sirens 170, 171, 351(1), 362, 708(2), 716
Sisyphos (?) 773
Tantalos 856(?)
Tarquinius 860
Thanatos 806, 809–811(?)
Thetis 818(?)
Tityos 117, 719
Tydeus 724, 725, 832, 839–843, 844(?)
Wooden Horse of Troy, The 808
Zeus 270, 311(?), 591, 594, 738
Zeus Ammon 568
Zeus-Sarapis 639

HEADS AND BUSTS (EXCLUSIVE OF PORTRAITS)
Male 35, 36, 60(2), 74(1), 310–328, 566–582, 566, 590, 591, 601, 602, 604
Female 166, 167, 314, 315, 318–323, 575, 577, 578

INDEX OF PERSONS AND PLACES

The numbers refer to the pages. (For portraits cf. the Index of Subjects)